Art and the Human Experience

ART

A Personal Journey

Teacher's Edition

Acknowledgments

Authors

Marilyn G. Stewart is professor of Art Education at Kutztown University in Kutztown, Pennsylvania, where she teaches courses in art criticism, aesthetics, and art education. She was the 1997–1998 Visiting Scholar

with the Getty Education Institute for the Arts. Known for her ability to translate difficult art education concepts into practical, inquiry-based activities for the classroom, Marilyn is General Editor of the Art Education in Practice series (Davis Publications), and author of Thinking Through Aesthetics, one title in the series. Dr. Stewart is a frequent keynote speaker at meetings and seminars around the country, and serves as a consultant in a variety of national curriculum development and assessment projects.

Eldon Katter is editor of SchoolArts and was president of the National Art Education Association from 1999–2001. He was a professor of art education at Kutztown University for twenty-five years, retiring in

1997. He has taught at the elementary and secondary levels in Illinois, Pennsylvania, and Massachusetts. As a Peace Corps volunteer in the 1960s, Eldon taught art at the Teacher Training Institute in Harar, Ethiopia. He later became an education officer in the Ministry of Education in Kampala, Uganda, while working on the Teacher Education for East Africa Project at Teachers College, Columbia University. Eldon continues to serve as a consultant for school districts on staff and curriculum development and to exhibit his handmade paper works in juried art shows.

Contributing Author

Kaye Passmore is a former art teacher at Notre Dame Academy in Worcester, Massachusetts. She was also the visual arts director for the Notre Dame Academy Summer Arts Institute (grades 3–10) and an adjunct faculty member in Lesley College's national Creative Arts in Learning Master of Education program. She has been an educational media consultant and junior high art teacher in Texas, and has taught Educational Media Production at Boise State University in Idaho.

Editorial Consultants

Laurie Kruger, Special Needs Teacher, Northborough Middle School, Northborough, Massachusetts

Abby Remer, A. R. Arts and Cultural Programs, New York, New York

Nancy Walkup, Project Coordinator, North Texas Institute on the Visual Arts, University of North Texas, Denton, Texas

Educational Consultants

Monica Brown, Laurel Nokomis School, Nokomis, Florida

Beverly C. Carpenter, Amidon Elementary School, Washington, DC

Debra Chojnacky, Les Bois Junior High School, Boise, Idaho

Terry Christenson, Les Bois Junior High School, Boise, Idaho

Ted Coe, Garfield School, Boise, Idaho **Anita Cook**, Thomas Prince School, Princeton, Massachusetts

Dale Dinapoli, Archie R. Cole Junior High School, East Greenwich, Rhode Island

Paula Sanderlin Dorosti, Associate Superintendent, District of Columbia Public Schools

Wendy Dougherty, Northview Middle School, Indianapolis, Indiana

Leah Dussault, Plymouth Middle School, Plymouth, Minnesota

Pamela Flynn, West Hartford Public Schools, West Hartford, Connecticut

Cathy Gersich, Fairhaven Middle School, Bellingham, Washington

Nancy Goan, Fred C. Wescott Junior High School, Westbrook, Maine

Rachel Grabek, Chocksett Middle School, Sterling, Massachusetts

Kerri Griffin, Springhouse Middle School, Allentown, Pennsylvania

Thelma Halloran, Sedgwick Middle School, West Hartford, Connecticut

Lizabeth Lippke Haven, Kamiakin Junior High School, Kirkland, Washington

Grace A. Herron, Hillside Junior High School, Boise, Idaho

Maryann Horton, Camels Hump Middle School, Richmond, Vermont

Anne Jacques, Smith Middle School, Fort Hood, Texas

Alice S. W. Keppley, Penn View Christian School, Souderton, Pennsylvania

Bunki Kramer, Los Cerros Middle School, Danville, California

Patricia Laney, Fletcher-Johnson Education Center, Washington, DC

Marguerite Lawler-Rohner, Fred C. Wescott Junior High School, Westbrook, Maine

Karen Lintner, Mount Nittany Middle School, State College, Pennsylvania

Betsy Logan, Samford Middle School, Auburn, Alabama

Emily Lynn, Smith Middle School, Fort Hood, Texas

Patricia Mann, T.R. Smedberg Middle School, Sacramento, California

Cathy Mansell, Art Consultant, Boise Public Schools, Idaho

Cathy Moore, Sierra School, Arvada, Colorado Phyllis Mowery-Racz, Desert Sands Middle

School, Phoenix, Arizona **Deborah A. Myers**, Colony Middle School,
Palmer, Alaska

Jennifer Ogden, Victor School, Victor, Montana Lorraine Pflaumer, Thomas Metcalf Laboratory School, Normal, Illinois

Sharon Piper, Islesboro Central School, Islesboro, Maine

Abby Porter, C. D. Owen Middle School, Swannanoa, North Carolina

Sandy Ray, Johnakin Middle School, Marion, South Carolina

Connie Richards, William Byrd Middle School, Vinton, Virginia

Sandra Richey, Sweetwater Middle School, Sweetwater, Texas

Roger Shule, Antioch Upper Grade School, Antioch, Illinois

Betsy Menson Sio, Jordan-Elbridge Middle School, Jordan, New York

Karen Skophammer, Manson Northwest Webster Community School, Barnum, Iowa

Evelyn Sonnichsen, Plymouth Middle School, Plymouth, Minnesota

Bob Stimpert, South Junior High School, Boise, Idaho

Laura Crowell Swartz, R. J. Grey Junior High School, Acton, Massachusetts

Ann Titus, Central Middle School, Galveston, Texas

Michael Walden, Gate Lane School, Worcester, Massachusetts

Diana Woodruff, Director of Visual Arts, Acton Public Schools, Massachusetts

© 2002 Davis Publications, Inc. Worcester, Massachusetts, U.S.A. All rights reserved. No part of this publication may be reproduced or transmitted in any form or by any means, electronic or mechanical, including photocopying, recording, or any storage and retrieval system now known or to be invented, except by a reviewer who wishes to quote brief passages in connection with a review written for inclusion in a magazine, newspaper, or broadcast.

Printed in U.S.A.
ISBN: 0-87192-559-1
10 9 8 7 6 5 4 3 2 1 RRD 06 05 04 03 02

Teacher's Edition Contents

CORE Plus Four

T146a

146

Chapter Organizer

Artists as Teachers

Tvi Tviii	Chapter Organizer Lesson Highlights	T172a 172	Chap Artis
Tx Txii Txiv	Studio Lesson Support Materials Scope and Sequence	T198a 198	The Chap Artis
ii iv viii	Student Edition title Student Edition Contents Student Edition Introduction	T224a 224	The Chap Artis
Fo	ii Lesson Highlights x Studio Lesson ii Support Materials v Scope and Sequence iii Student Edition title v Student Edition Introduction T224a 224 Toundations What Is Art? Foundation 1 Chapter Organizer The Whys and Hows of Art Foundation 2 Chapter Organizer Forms and Media Foundation 3 Chapter Organizer Elements and Principles Foundation 4 Chapter Organizer Approaches to Art Temes Art Is a Personal Journey Theme 1 Chapter Organizer Artists as Storytellers Theme 2 Chapter Organizer Artists as Recorders Theme 3 Chapter Organizer Artists as Designers Tasa	The	
			Chap
T2a 2	Chapter Organizer		Artis
			Chap
T18a 18	Chapter Organizer		Artis
		Siu	aem
T32a 32	Chapter Organizer	303	Ackr Artis
			Worl
T -0			Colo
T52a			Bibli Glos
52	Approaches to Art		Spar
The	is Student Edition title is Student Edition Contents iii Student Edition Introduction Foundations What Is Art? Foundation 1 2a Chapter Organizer 2 The Whys and Hows of Art Foundation 2 2a Chapter Organizer 2b Chapter Organizer 2c Elements and Principles 2c Approaches to Art 2d Chapter Organizer 3d Chapter Organizer		Inde
T68a		Tea	cher
68		T334	Prog
			W
T0/-		T334	C
T94a			Р
74			Α
			N
T120a			R
120	Artists as Designers		В
	Theme 4	1341 T3//	N

1/2	Artists as interpreters
T198a 198	Theme 6 Chapter Organizer Artists as Messengers
T224a 224	Theme 7 Chapter Organizer Artists as Inventors
T250a 250	Theme 8 Chapter Organizer Artists as Planners
T276a 276	Theme 9 Chapter Organizer Artists as Pioneers
A PAN	

Theme 5

Chapter Organizer

Text Resources

302	Acknowledgments
303	Artist Guide
306	World Map
308	Color Wheel
309	Bibliography
312	Glossary
316	Spanish Glossary

's Reference Material

T334	Program Overview
T334	Why Themes?
T334	Curriculum Structure
T336	Program Fundamentals
T338	Assessment
T338	Meeting Individual Needs
T339	Relating Other Subjects to Art
T340	Building Support for the Art Program
T341	Maintaining the Artroom
T344	Teacher Bibliography
T348	Internet Resources
T352	The National Visual Arts Standards

CORE PLUS 4

A unique chapter organization allows you to map your own destination.

Foundations

Begin with a sound foundation in art education. These chapters set the

or they can serve as a course in

themselves.

stage for a comprehensive art program

1

Then and Now Lessons

Short on time, but long for history?

These lessons extend the CORE with added historical insight. Together, the interrelated lessons provide a survey of **genres in art history.**

- 1.1 Narrative Art
- 2.1 Documenting Daily Life
- 3.1 Design for Living
- 4.1 Art and Beliefs
- 5.1 Landscape as Art
- 6.1 Symbolism in Portraits
- 7.1 Fantasy in Art
- 8.1 Architecture
- for Living
- 9.1 Traditions of Sculpture

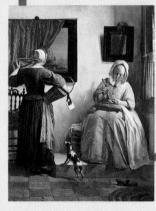

C O

Explore shared artistic traditions. Each theme profiles an inspirational artist. Together these lessons **highlight and explore art's universal themes.**

2

Skills and Techniques Lessons

Learning art's tools and techniques!

Individually, these lessons reinforce the theme with an exploration of different tools and media. Together, they provide an overview of **art's skills and techniques**.

- 1.2 Contour and Gesture Drawing
- 2.2 Tonal Drawing and Shading
- 3.2 Human Proportions
- 4.2 Lettering and Calligraphy
- 5.2 Color Mixing
- 6.2 Monoprinting
- 7.2 Perspective
- 8.2 Three-Dimensional Models
- 9.2 Casting a Relief Sculpture

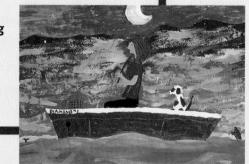

Core Lessons

- 1 An American Storyteller
- 2 Recorder of Daily Life
- 3 A Designer of Fashion
- 4 The Puppeteer as Teacher
- 5 Landscape Interpreter
- 6 An Artist with a Message
- 7 An Inventive Artist
- 8 A Planner from the Start
- 9 A Pioneer in Art

For a comprehensive art education, teach each theme with its Core lesson and four follow-up lessons. Or, choose a series of lessons that match your interests and your schedule.

- F1 The Whys and Hows of Art
- F2 Forms and Media
- F3 Elements and Principles of Design
- F4 Approaches to Art

Create more with the CORE. In addition to concluding the Core lesson, these art activities add to your bank of studio opportunities.

Core Studios

- 1 Picture a Story
- 2 Recording Daily Life
- 3 Drawing on Fashion
- 4 A Teaching Puppet
- 5 Creating Animals with Paint
- 6 Printing Symbols
- 7 Drawing a Fantasy World
- 8 Building an Architectural Model
- 9 Pioneering the Collagraph

Global Destinations Lessons

Tour world cultures past and present.

While supporting the CORE with a global viewpoint, these lessons also collaborate to provide a multicultural art education.

- 1.3 The Kingdom of Dahomey
- of Japan 2.3 Art of Haiti
 - 4.3 Islamic Art of **North Africa**

3.3 Art

- 5.3 Art of China
- 6.3 Aboriginal **Australia**
- 7.3 Art of Puerto Rico
- 8.3 Art of Mexico
- 9.3 Art of Israel

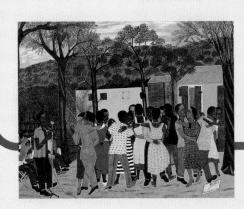

Studio Lessons

Make the most with hands-on learning. Each studio lesson caps off the theme with a summarizing hands-on experience. Together, these activities provide a bank of art activities that apply a range of media and techniques.

1.4 Sculpting a Scene

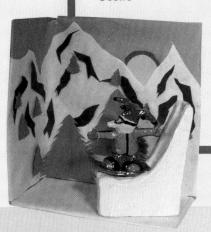

- 2.4 Still-Life **Drawing** 3.4 Creating a
- **Package Design**
- 4.4 Designing a Poster
- 5.4 Wood Constructions
- 6.4 A Linoleum **Block Print**
- 7.4 Building a Wire Sculpture
- 8.4 Corrugated Constructions
- 9.4 Recycling for Sculpture

Chapter Organizer

At-a-glance chapter organizers help you teach as much — or as little — as you wish. Teach the entire theme or just a single lesson. Plan for an individual, a small group, or an entire class. This easy-to-use chart allows you to scan the entire chapter and select the topics, activities, and extensions that match your course structure.

Clear lesson objectives and correlations to the National Visual Arts Standards are provided both at the chapter This quick-check pacing chart and lesson levels. helps you modify lesson plans to meet your individual time constraints. Chapter Organizer continues Choose from: nine-week course one semester course Teaching Through Inquiry More About...Dreamtim Using the Large Reprod two-semester course 1a Select/analyze media, techniques, processes, Explain how symbols are used in Aborigine 3a Integrate visual, spatial, temporal concepts Global Destinations Lesson 6.3 Aboriginal Australia page 212 Pacing: Two or more 45-minute periods Compare the different meanings of similar symbols and patterns used in various parts of Australia. Meeting Individual Teaching Through More About...Ad Assessment Opt 2c Select, use structures, functions. Create a pattern of symbols and lines that sends Highlighting the National Standards 1b Use media/techniques/processes to communicate experiences, ideas:
2a Generalize about structures, functions.
2b Employ/analyze effectiveness of organizationa structures.
2c Select, use structures, functions.
3b Use subjects, themes, symbols, that communicate meaning. Teaching Th Explain what relief printmaking is.
 Understand how artists use line and emphasis to communicate ideas, moods, and feelings in their artworks.
 Create a linoleum print that sends an important message. studio opportunities Using the O Studio Lesson 6.4 A Linoleum Block Print page 216 Pacing: Three or more 45-minute periods that extend each lesson allows you to plan ahead. National Standards 6 Make connections between disciplines. Identify and understand ways other disciplines are connected to and informed by the visual are connected to and interest are arts.
Understand a visual arts career and how it relates to chapter content. National Standards Objectives 5 Assess own and others' work. Learn to look at and comment respectfully on Learn to look at discovering artworks by peers.
 Demonstrate understanding of chapter content

Lesson Highlights

Point-of-use wrap-around support organizes your teaching strategies and highlights teaching options. The gray side margins provide step-by-step lesson plans that focus in on the the book's narrative and artwork. The gold band across the bottom highlights teaching options that take you beyond the text.

Studio Lesson

Step-by-step instructions guide you through a wealth of studio opportunities. Safety issues, assessment strategies, studio supplies, and classroom organization present unique challenges for art instructors. This wrap-around lesson support addresses these unique demands. providing practical tips and sensible solutions when and where you need them.

Practical pacing | strategies chronicle each stage of the studio project.

Studio Lesson 6.4 Studio Lesson
A Linoleum Block Print

Prepare

Pacing

Three or more 45-minute periods: one to consider text and images and to draw; one to carve block; one to print

Objectives

- Explain what relief printmaking is.
- Understand how artists use line and emphasis to communicate ideas, moods, and feelings in their artworks. Create a linoleum print that sends an important message.

Vocabulary

relief print A print made from a design that is raised from a flat back-ground, such as a woodcut. line A mark with length and direc-tion, created by a point that moved across a surface.

across a surrace.

emphasis A principle of design in
which some visual elements are
given more importance than others to
catch and hold the viewer's attention.

Supplies for Engage

photographs from news magazines or newspapers

National Standards 6.4 Studio Le

Line and Emp

~~~~

The Studio Experience is a concise step-bystep walk through of the studio activity.

Idea Generators are a series of prompting questions that encourage critical reflection and creative problem solving.

> Safety Tips alert studio teachers to precautions they may want to consider as well as accident-preventing tools and techniques.

### 6.4 Studio Lesson A Linoleum Block Print

Studio Experience

 Demonstrate tracing around a linoleum block with pencil and drawing a design inside the shape. Guidstudents to make their design dark enough to transfer to the linoleum.

 Demonstrate and custing tools. 2. Demonstrate safe cutting tech-

3. Demonstrate inking the block. Demonstrate inking the block.
 Encourage students to use more than one color on their block, make multiple prints on a sheet of paper, and print on different kinds of papers.

Direct students to select a topic from the list developed in Using the Text, page 217. Have them sketch thumbnails of different arrangements of their subject, such as by reversing light and dark values, adding patterns, making the subject larger or smaller, and using various line widths. Idea Generators

#### Safety Notes

- Provide soft print-making materials
  such as Soft-Kut® or E-Z Cut,
  such as Soft-Kut® or E-Z Cut,
  society to carve which are easier to carve than battleship linoleum.
- Remind students to cut away from their fingers when they use cutting tools

Have students use pencil to write their title, sign their name, and number their print just beneath the lower edge of their print. Explain that the number indicates the print's sequence in a limited print edition, for example, the third of ten prints printed from a block print would be numbered 3/10.

#### Printmaking in the Studio Creating Your Print

- You Will Need sketch paper
- pencil
   linoleum block
- · carving tools

· bench hook

· ink

 brayer construction

paper

1. On sketch paper, trace the edges of your block. Use a soft-teaded (#2) pencil to draw your design inside the lines of the trace. How will you use lines and shapes to best express your message? What part of the image will you emphasize? Think about which areas will print and which will be the color of the paper. With your pencil, fill in the areas that will print. color of the paper. With the areas that will print.

the areas that will print.

2. Carefully lay your design face-down on the include sign face-down on the lock. Make sure that the edges of the block. With your hand, rub the back of the paper to transfer your design onto the block. Check the darkness of the image that is now on the block. Darken any lines that you think are too light.

3. Place the block on a bench hook. Carefully carve away the areas of your design that will not print

4. Use a brayer to roll a thin, even layer of ink onto the raised surfaces of your block.

5. Carefully place your priming paper over the block. Gently rub the back of the paper. When you see the faint impression of your design on the back of the sheet, slowly pull the print away from the block.

Display your artwork. Can your classmates read\* the message of your print? Discuss the ways that you and your classmates used lines of shapes to emphasize your message. What kinds of lines did you use? How did you use lines to create pattern and texture? Where do you see positive and negative shapes? negative shapes

### **Teaching Options**

### Teaching Through Inquiry

Art Production Provide students with two sheets of tracing paper or clear acetate, along with small reproductions of artworks for use artworks in the textbook so that they may analyze how the artist used line, such as by outlining the subject and/or by creating shape, pattern, space, or movement. First, have students trace, on one sheet of paper, the lines that they believe are significent. Then have them use the second sheet to identify the way the artist created emphasis or a center of interest. You may wish to have students work in groups and then share their findings as a class. Art Production Provide students with two

Have students work in groups Have students work in groups of twelve to create a calendar. Instruct groups to have each member design a print for a different month and then make twelve prints, one for each member.

218

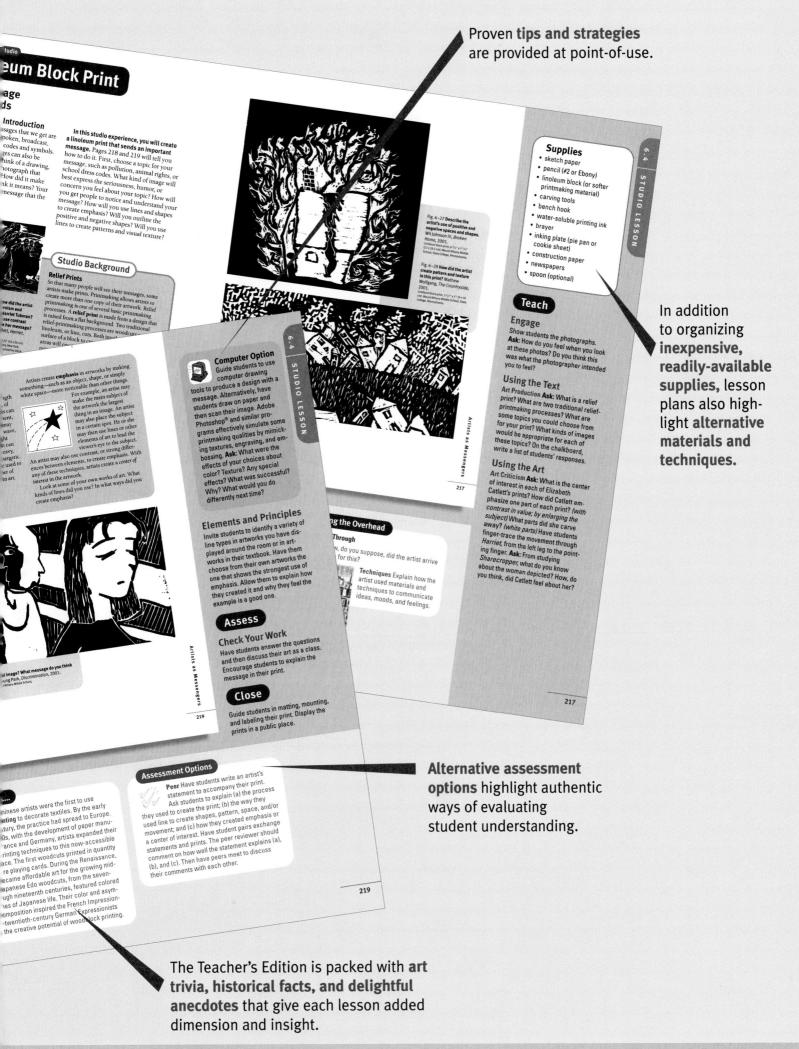

## **Support Materials**

A wealth of support components address any teaching style and meet any instructional need! This rich assortment of support components and visual resources are designed to meet the varied learning needs of the contemporary classroom.

ALL
Support Components
are correlated
at point of use
throughout
the Teacher's
Edition

#### **Teacher's Resource Binder**

The ultimate in teaching support, these reproducible resources reinforce and extend the text through a range of diverse learning strategies. These resources include:

- Chapter Support
- Home/Community Connections
- Manipulatives

18 durable, full-color fine art reproductions (18 x 24") are ideal for classroom display or small-group analysis. Background information on the art and artist is provided on the reverse of each laminated visual.

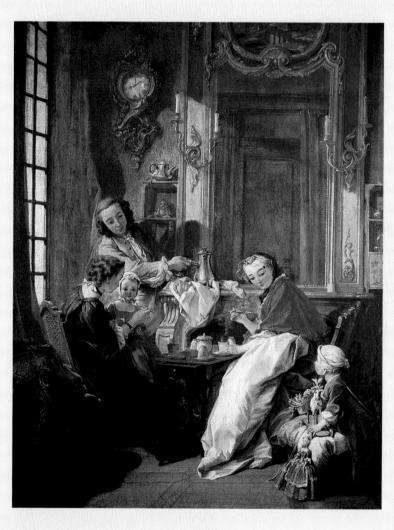

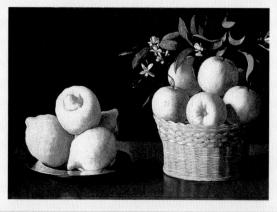

# Overhead Transparencies

27 overhead transparencies, including 9 instructional overlays, add to your visual library in a format that encourages class discussions and detailed group examination.

#### **Student Art Gallery**

This CD-ROM of student art extends the samples of student art provided in the text. Directly inspired by a studio lesson, these samples graphically show the scope of each activity and encourage peer sharing and review.

#### **Careers Videos**

Introduce your students to a variety of artrelated occupations. These in-depth interviews with working professionals explore how each person came to their career, their typical workday, and the skills and training their jobs require. (3 10-minute interviews per tape /9 interviews per set)

#### Slide Sets

10 correlated slide sets (72 slides total) extend the visuals in each theme with a host of vivid slide images. Each set displays a diverse array of artworks reflecting different artists, styles, periods, cultures, and media.

#### The Davis e-Gallery

This electronic museum provides a wealth of images ranging from fine art to architecture to objects designed for everyday use. Easy to search and select, this resource is ideal for lesson support or for individual research.

#### The Davis Web Site

The Davis site contains lesson support, links to instructional sites, student art, and much, much more.

www.davis-art.com

# Scope & Sequence: Foundations

#### **National Standards**

National Standard 1a Students select media, techniques, and processes; analyze their effectivenes and reflect upon their choices.

National Standard 1b Students take advantage of qualities and character istics of art media, techniques, and processes to enhance communication of ideas

National Standard 2a Students ger eralize about the effects of visual structures and functions.

**National Standard 2b** Students employ organizational structures and analyze their effectiveness.

National Standard 2c Students select and use the qualities of structures and function of art to improve communication of ideas.

National Standard 3a Students inte grate visual, spatial, and temporal concepts with content to communicate intended meaning.

National Standard 3b Students use subjects, themes, and symbols that demonstrate knowledge of contexts, values, and aesthetics that communicate intended meaning.

National Standard 4a Students know and compare characteristics of artworks in various eras and cultures.

National Standard 4b Students describe and place a variety of art objects in historical and cultural contexts.

National Standard 4c Students analyze, describe, and demonstrate how factors of time and place influence visual characteristics that give meaning and value to artworks.

National Standard 5a Students compare multiple purposes for creating artworks.

National Standard 5b Students analyze contemporary and historic meanings in specific artworks through cultural and aesthetic inquiry.

National Standard 5c Students describe and compare responses to their own artworks and to artworks from various eras and cultures.

National Standard 6a Students compare the characteristics of works in two or more art forms that share similar subject matter, historical periods, or cultural context.

National Standard 6b Students describe how the principles and subject matter of other disciplines are interrelated with the visual arts.

#### **Student Abilities in Art**

| Perception                                          | Using knowledge of structures and functions                                                       |
|-----------------------------------------------------|---------------------------------------------------------------------------------------------------|
|                                                     | Observing visual, tactile, spatial, and temporal elements in the natural and built environments   |
|                                                     | Observing visual, tactile, spatial, and temporal elements in artworks                             |
|                                                     | Considering use of elements and principles of design                                              |
| rt Production<br>rt History<br>rt Criticism         | Understanding and applying media, techniques, and processes                                       |
|                                                     | Generating ideas for artistic expression                                                          |
|                                                     | Choosing and evaluating a range of subject matter, symbols and ideas                              |
|                                                     | Developing approaches for expressing ideas                                                        |
|                                                     | Exploring expressive potential of art forms, media, and techniques                                |
|                                                     | Reflecting on artistic process, meaning, and quality of work                                      |
|                                                     | Safety in art making                                                                              |
| urt Criticism                                       | Understanding the visual arts in relation to history and cultures                                 |
|                                                     | Investigating historical/cultural meaning of artworks                                             |
|                                                     | Understanding historical/cultural context                                                         |
|                                                     | Developing global and multicultural perspectives                                                  |
|                                                     | Considering styles, influences, and themes in art                                                 |
| Art Criticism                                       | Reflecting upon and assessing the characteristics and merits of their work and the work of others |
| *                                                   | Describing and analyzing details in artworks                                                      |
|                                                     | Interpreting meanings in artworks                                                                 |
|                                                     | Judging merit and significance in artworks                                                        |
| Aesthetics  Presentation  Exhibition,  and Critique | Reflecting upon and assessing the characteristics and merits of their work and the work of others |
|                                                     | Understanding reasons for valuing art                                                             |
|                                                     | Raising and addressing philosophical questions about art and human experience                     |
|                                                     | Forming opinions about art                                                                        |
| Presentation                                        | Reflecting upon and assessing the characteristics and merits of their work and the work of others |
| -                                                   | Keeping a portfolio and sketchbook                                                                |
| and energie                                         | Making work public                                                                                |
|                                                     | Evaluating progress and accomplishments                                                           |
| Learning                                            | Making connections between visual arts and other disciplines                                      |
| for Life                                            | Performing arts connections                                                                       |
|                                                     | Daily life connections                                                                            |
|                                                     | Interdisciplinary connections                                                                     |
|                                                     | Careers                                                                                           |
|                                                     | Community connections                                                                             |
|                                                     | Parent/home involvement                                                                           |
|                                                     | Technology/internet/computer connections                                                          |

| <b>F1</b>                 | The V<br>Hows            | hys and of Art                                   |                            | F2                       | Forms and                  | Media                      | F3                      | Elements a<br>Principles  | nd                         | F4               | A                  | pproac              | hes to /        | Art                        |
|---------------------------|--------------------------|--------------------------------------------------|----------------------------|--------------------------|----------------------------|----------------------------|-------------------------|---------------------------|----------------------------|------------------|--------------------|---------------------|-----------------|----------------------------|
| F1.1 The Functions of Art | F1.2 Subjects and Themes | F1.3 Styles of Art                               | Connect, Portfolio, Review | F2.1 Two-dimensional Art | F2.2 Three-dimensional Art | Connect, Portfolio, Review | F3.1 Elements of Design | F3.2 Principles of Design | Connect, Portfolio, Review | F4.1 Art History | F4.2 Art Criticism | F4.3 Art Production | F4.4 Aesthetics | Connect, Portfolio, Review |
| F1.1 T                    | F1.2 Si                  | F1.3 S                                           | Conne                      | F2.1 Tr                  | F2.2 TI                    | Conne                      | F3.1 E                  | F3.2 P                    | Conne                      | F4.1 A           | F4.2 A             | F4.3 A              | F4.4 A          | Conne                      |
|                           |                          |                                                  |                            |                          |                            |                            |                         |                           |                            |                  |                    |                     |                 |                            |
| •                         |                          | •                                                | •                          |                          | •                          | •                          | •                       | •                         | •                          |                  |                    |                     | •               | •                          |
| •                         | •                        | •                                                | •                          | •                        | •                          | •                          | •                       | •                         | •                          | •                | •                  |                     | •               | <u> </u>                   |
|                           |                          |                                                  |                            |                          |                            |                            | •                       | •                         | •                          | •                | •                  |                     | •               | •                          |
|                           |                          |                                                  |                            |                          |                            |                            |                         |                           |                            |                  |                    |                     |                 |                            |
| •                         | •                        | •                                                | •                          | •                        | •                          | •                          | •                       | •                         |                            |                  |                    | •                   |                 |                            |
|                           |                          |                                                  |                            | _                        |                            |                            |                         |                           |                            |                  |                    |                     |                 |                            |
| •                         | •                        | •                                                | •                          | •                        | •                          |                            | •                       | •                         |                            |                  |                    | •                   | •               |                            |
| •                         | •                        | •                                                | •                          | •                        | •                          |                            | •                       | •                         |                            |                  |                    | •                   | •               |                            |
| •                         | •                        | •                                                | •                          | •                        | •                          | •                          | •                       | •                         | •                          |                  | •                  | •                   |                 |                            |
|                           |                          |                                                  |                            |                          |                            |                            |                         |                           |                            |                  |                    |                     |                 |                            |
|                           |                          |                                                  |                            |                          |                            |                            |                         |                           |                            | •                |                    | •                   |                 |                            |
|                           | •                        |                                                  | •                          |                          | •                          | •                          |                         | •                         | •                          | •                |                    | •                   |                 | •                          |
|                           | •                        | •                                                | •                          | •                        | •                          | •                          | •                       | •                         |                            | •                | •                  | •                   | •               | _                          |
| •                         | •                        | •                                                | •                          |                          | <u> </u>                   |                            | •                       |                           |                            | -                | •                  | •                   |                 |                            |
| •                         |                          |                                                  | •                          |                          |                            |                            |                         |                           |                            |                  |                    |                     |                 |                            |
| •                         | •                        | •                                                |                            | •                        | •                          | •                          | •                       | •                         | •                          | •                | •                  | •                   |                 | •                          |
|                           | •                        |                                                  | •                          |                          |                            | <u> </u>                   | -                       |                           |                            |                  | •                  | Y                   |                 |                            |
|                           | •                        | •                                                | •                          |                          |                            | •                          |                         |                           | •                          |                  | •                  | •                   |                 |                            |
|                           |                          |                                                  |                            |                          |                            |                            |                         |                           |                            |                  |                    |                     |                 |                            |
| •                         | •                        | •                                                | •                          | •                        | •                          | •                          | •                       |                           |                            | •                |                    | •                   | •               |                            |
|                           | -                        |                                                  |                            |                          |                            |                            |                         |                           |                            |                  | •                  |                     | •               |                            |
| •                         |                          | •                                                | •                          | •                        | •                          | •                          | •                       | •                         |                            |                  | •                  |                     | •               |                            |
|                           | 1                        | <del>                                     </del> |                            |                          |                            |                            |                         |                           |                            |                  |                    |                     |                 |                            |
|                           |                          | •                                                | •                          |                          | •                          | •                          |                         | •                         | •                          |                  | •                  | •                   |                 | •                          |
|                           |                          |                                                  |                            |                          |                            |                            |                         |                           |                            |                  |                    |                     |                 |                            |
| •                         | •                        | •                                                | •                          | •                        | •                          | •                          | •                       | •                         | •                          | •                | •                  | •                   | •               | •                          |
|                           |                          |                                                  |                            |                          |                            |                            | <u> </u>                |                           |                            |                  |                    |                     |                 |                            |
|                           |                          |                                                  | •                          |                          |                            | •                          |                         |                           | •                          |                  |                    |                     |                 | •                          |
|                           |                          |                                                  | •                          |                          |                            | •                          |                         |                           | •                          |                  |                    |                     |                 | •                          |
|                           |                          |                                                  | •                          |                          |                            | •                          |                         |                           | •                          |                  |                    |                     |                 | •                          |
|                           |                          |                                                  | •                          |                          |                            | •                          |                         |                           | •                          |                  |                    |                     |                 |                            |
|                           |                          |                                                  | •                          |                          |                            | •                          |                         |                           | •                          |                  |                    |                     |                 | •                          |
|                           |                          |                                                  | •                          |                          |                            | •                          |                         |                           | •                          |                  |                    |                     |                 |                            |
|                           |                          |                                                  |                            |                          |                            |                            |                         |                           |                            |                  |                    |                     |                 |                            |

# Scope & Sequence: Themes 1–3

#### **National Standards**

National Standard 1a Students select media, techniques, and processes; analyze their effectiveness; and reflect upon their choices.

National Standard 1b Students take advantage of qualities and character istics of art media, techniques, and processes to enhance communication of ideas.

National Standard 2a Students generalize about the effects of visual structures and functions.

**National Standard 2b** Students employ organizational structures and analyze their effectiveness.

National Standard 2c Students select and use the qualities of structures and function of art to improve communication of ideas.

National Standard 3a Students inte grate visual, spatial, and temporal concepts with content to communicate intended meaning.

National Standard 3b Students use subjects, themes, and symbols that demonstrate knowledge of contexts, values, and aesthetics that communicate intended meaning.

National Standard 4a Students know and compare characteristics of artworks in various eras and cultures.

National Standard 4b Students describe and place a variety of art objects in historical and cultural

National Standard 4c Students analyze, describe, and demonstrate how factors of time and place influence visual characteristics that give meaning and value to artworks.

National Standard 5a Students compare multiple purposes for creating artworks.

National Standard 5b Students analyze contemporary and historic meanings in specific artworks through cultural and aesthetic inquiry.

National Standard 5c Students describe and compare responses to their own artworks and to artworks from various eras and cultures.

National Standard 6a Students compare the characteristics of works in two or more art forms that share similar subject matter, historical periods, or cultural context.

National Standard 6b Students describe how the principles and subject matter of other disciplines are interrelated with the visual arts.

| Stud | ent | Ahi | lities | in Art |  |
|------|-----|-----|--------|--------|--|
|      |     |     |        |        |  |

| oca a circ / tor            | intes in 740                                                                                      |
|-----------------------------|---------------------------------------------------------------------------------------------------|
| Perception                  | Using knowledge of structures and functions                                                       |
|                             | Observing visual, tactile, spatial, and temporal elements in the natural and built environments   |
|                             | Observing visual, tactile, spatial, and temporal elements in artworks                             |
|                             | Considering use of elements and principles of design                                              |
| Art Production              | Understanding and applying media, techniques, and processes                                       |
|                             | Generating ideas for artistic expression                                                          |
|                             | Choosing and evaluating a range of subject matter, symbols and ideas                              |
|                             | Developing approaches for expressing ideas                                                        |
|                             | Exploring expressive potential of art forms, media, and techniques                                |
|                             | Reflecting on artistic process, meaning, and quality of work                                      |
|                             | Safety in art making                                                                              |
| Art History                 | Understanding the visual arts in relation to history and cultures                                 |
|                             | Investigating historical/cultural meaning of artworks                                             |
|                             | Understanding historical/cultural context                                                         |
|                             | Developing global and multicultural perspectives                                                  |
|                             | Considering styles, influences, and themes in art                                                 |
| Art Criticism               | Reflecting upon and assessing the characteristics and merits of their work and the work of others |
|                             | Describing and analyzing details in artworks                                                      |
|                             | Interpreting meanings in artworks                                                                 |
|                             | Judging merit and significance in artworks                                                        |
| Aesthetics                  | Reflecting upon and assessing the characteristics and merits of their work and the work of others |
|                             | Understanding reasons for valuing art                                                             |
|                             | Raising and addressing philosophical questions about art and human experience                     |
|                             | Forming opinions about art                                                                        |
| Presentation                | Reflecting upon and assessing the characteristics and merits of their work and the work of others |
| Exhibition,<br>and Critique | Keeping a portfolio and sketchbook                                                                |
| and critique                | Making work public                                                                                |
|                             | Evaluating progress and accomplishments                                                           |
| Learning                    | Making connections between visual arts and other disciplines                                      |
| for Life                    | Performing arts connections                                                                       |
|                             | Daily life connections                                                                            |
|                             | Interdisciplinary connections                                                                     |
|                             | Careers                                                                                           |
|                             | Community connections                                                                             |
|                             | Parent/home involvement                                                                           |
|                             |                                                                                                   |

Technology/internet/computer connections

|   | an Storyteller               |                   | ving                        |                        |                       | POTOTOCONOCIONOS O         | THE RESERVE OF THE PARTY OF THE |                            |                           |                  |                        |                            |                                                                                                                                                                                                                                                                                                                                                                                                                                                                                                                                                                                                                                                                                                                                                                                                                                                                                                                                                                                                                                                                                                                                                                                                                                                                                                                                                                                                                                                                                                                                                                                                                                                                                                                                                                                                                                                                                                                                                                                                                                                                                                                                |                       |                       |                  |                    |                            |
|---|------------------------------|-------------------|-----------------------------|------------------------|-----------------------|----------------------------|--------------------------------------------------------------------------------------------------------------------------------------------------------------------------------------------------------------------------------------------------------------------------------------------------------------------------------------------------------------------------------------------------------------------------------------------------------------------------------------------------------------------------------------------------------------------------------------------------------------------------------------------------------------------------------------------------------------------------------------------------------------------------------------------------------------------------------------------------------------------------------------------------------------------------------------------------------------------------------------------------------------------------------------------------------------------------------------------------------------------------------------------------------------------------------------------------------------------------------------------------------------------------------------------------------------------------------------------------------------------------------------------------------------------------------------------------------------------------------------------------------------------------------------------------------------------------------------------------------------------------------------------------------------------------------------------------------------------------------------------------------------------------------------------------------------------------------------------------------------------------------------------------------------------------------------------------------------------------------------------------------------------------------------------------------------------------------------------------------------------------------|----------------------------|---------------------------|------------------|------------------------|----------------------------|--------------------------------------------------------------------------------------------------------------------------------------------------------------------------------------------------------------------------------------------------------------------------------------------------------------------------------------------------------------------------------------------------------------------------------------------------------------------------------------------------------------------------------------------------------------------------------------------------------------------------------------------------------------------------------------------------------------------------------------------------------------------------------------------------------------------------------------------------------------------------------------------------------------------------------------------------------------------------------------------------------------------------------------------------------------------------------------------------------------------------------------------------------------------------------------------------------------------------------------------------------------------------------------------------------------------------------------------------------------------------------------------------------------------------------------------------------------------------------------------------------------------------------------------------------------------------------------------------------------------------------------------------------------------------------------------------------------------------------------------------------------------------------------------------------------------------------------------------------------------------------------------------------------------------------------------------------------------------------------------------------------------------------------------------------------------------------------------------------------------------------|-----------------------|-----------------------|------------------|--------------------|----------------------------|
|   | Core An American Storyteller | 1.1 Narrative Art | 1.2 Contour/Gesture Drawing | 1.3 Kingdom of Dahomey | 1.4 Sculpting a Scene | Connect, Portfolio, Review | Core Recorder of Daily Life                                                                                                                                                                                                                                                                                                                                                                                                                                                                                                                                                                                                                                                                                                                                                                                                                                                                                                                                                                                                                                                                                                                                                                                                                                                                                                                                                                                                                                                                                                                                                                                                                                                                                                                                                                                                                                                                                                                                                                                                                                                                                                    | 2.1 Documenting Daily Life | 2.2 Tonal Drawing/Shading | 2.3 Art of Haiti | 2.4 Still-Life Drawing | Connect, Portfolio, Review | Core A Designer of Fashion                                                                                                                                                                                                                                                                                                                                                                                                                                                                                                                                                                                                                                                                                                                                                                                                                                                                                                                                                                                                                                                                                                                                                                                                                                                                                                                                                                                                                                                                                                                                                                                                                                                                                                                                                                                                                                                                                                                                                                                                                                                                                                     | 3.1 Design for Living | 3.2 Human Proportions | 3.3 Art of Japan | 3.4 Package Design | Connect, Portfolio, Review |
|   |                              |                   |                             |                        |                       |                            |                                                                                                                                                                                                                                                                                                                                                                                                                                                                                                                                                                                                                                                                                                                                                                                                                                                                                                                                                                                                                                                                                                                                                                                                                                                                                                                                                                                                                                                                                                                                                                                                                                                                                                                                                                                                                                                                                                                                                                                                                                                                                                                                |                            |                           |                  |                        |                            |                                                                                                                                                                                                                                                                                                                                                                                                                                                                                                                                                                                                                                                                                                                                                                                                                                                                                                                                                                                                                                                                                                                                                                                                                                                                                                                                                                                                                                                                                                                                                                                                                                                                                                                                                                                                                                                                                                                                                                                                                                                                                                                                |                       |                       |                  |                    |                            |
|   | •                            |                   | •                           |                        | •                     | •                          | •                                                                                                                                                                                                                                                                                                                                                                                                                                                                                                                                                                                                                                                                                                                                                                                                                                                                                                                                                                                                                                                                                                                                                                                                                                                                                                                                                                                                                                                                                                                                                                                                                                                                                                                                                                                                                                                                                                                                                                                                                                                                                                                              | •                          |                           |                  | •                      | •                          | •                                                                                                                                                                                                                                                                                                                                                                                                                                                                                                                                                                                                                                                                                                                                                                                                                                                                                                                                                                                                                                                                                                                                                                                                                                                                                                                                                                                                                                                                                                                                                                                                                                                                                                                                                                                                                                                                                                                                                                                                                                                                                                                              | •                     |                       |                  |                    | •                          |
|   | •                            | •                 | •                           | •                      | •                     | •                          | •                                                                                                                                                                                                                                                                                                                                                                                                                                                                                                                                                                                                                                                                                                                                                                                                                                                                                                                                                                                                                                                                                                                                                                                                                                                                                                                                                                                                                                                                                                                                                                                                                                                                                                                                                                                                                                                                                                                                                                                                                                                                                                                              | •                          | •                         | •                | •                      | •                          | •                                                                                                                                                                                                                                                                                                                                                                                                                                                                                                                                                                                                                                                                                                                                                                                                                                                                                                                                                                                                                                                                                                                                                                                                                                                                                                                                                                                                                                                                                                                                                                                                                                                                                                                                                                                                                                                                                                                                                                                                                                                                                                                              | •                     | •                     | •                | •                  | •                          |
|   | •                            | •                 | •                           | •                      | •                     | •                          | •                                                                                                                                                                                                                                                                                                                                                                                                                                                                                                                                                                                                                                                                                                                                                                                                                                                                                                                                                                                                                                                                                                                                                                                                                                                                                                                                                                                                                                                                                                                                                                                                                                                                                                                                                                                                                                                                                                                                                                                                                                                                                                                              | •                          | •                         | •                | •                      | •                          | •                                                                                                                                                                                                                                                                                                                                                                                                                                                                                                                                                                                                                                                                                                                                                                                                                                                                                                                                                                                                                                                                                                                                                                                                                                                                                                                                                                                                                                                                                                                                                                                                                                                                                                                                                                                                                                                                                                                                                                                                                                                                                                                              | •                     | •                     | •                | •                  | •                          |
|   |                              |                   |                             |                        |                       |                            |                                                                                                                                                                                                                                                                                                                                                                                                                                                                                                                                                                                                                                                                                                                                                                                                                                                                                                                                                                                                                                                                                                                                                                                                                                                                                                                                                                                                                                                                                                                                                                                                                                                                                                                                                                                                                                                                                                                                                                                                                                                                                                                                |                            |                           |                  |                        |                            |                                                                                                                                                                                                                                                                                                                                                                                                                                                                                                                                                                                                                                                                                                                                                                                                                                                                                                                                                                                                                                                                                                                                                                                                                                                                                                                                                                                                                                                                                                                                                                                                                                                                                                                                                                                                                                                                                                                                                                                                                                                                                                                                |                       |                       |                  |                    |                            |
|   | •                            | •                 | •                           | •                      | •                     | •                          | •                                                                                                                                                                                                                                                                                                                                                                                                                                                                                                                                                                                                                                                                                                                                                                                                                                                                                                                                                                                                                                                                                                                                                                                                                                                                                                                                                                                                                                                                                                                                                                                                                                                                                                                                                                                                                                                                                                                                                                                                                                                                                                                              | •                          | •                         | •                | •                      | •                          | •                                                                                                                                                                                                                                                                                                                                                                                                                                                                                                                                                                                                                                                                                                                                                                                                                                                                                                                                                                                                                                                                                                                                                                                                                                                                                                                                                                                                                                                                                                                                                                                                                                                                                                                                                                                                                                                                                                                                                                                                                                                                                                                              | •                     | •                     | •                | •                  | •                          |
|   |                              |                   |                             |                        |                       |                            |                                                                                                                                                                                                                                                                                                                                                                                                                                                                                                                                                                                                                                                                                                                                                                                                                                                                                                                                                                                                                                                                                                                                                                                                                                                                                                                                                                                                                                                                                                                                                                                                                                                                                                                                                                                                                                                                                                                                                                                                                                                                                                                                |                            |                           |                  |                        |                            |                                                                                                                                                                                                                                                                                                                                                                                                                                                                                                                                                                                                                                                                                                                                                                                                                                                                                                                                                                                                                                                                                                                                                                                                                                                                                                                                                                                                                                                                                                                                                                                                                                                                                                                                                                                                                                                                                                                                                                                                                                                                                                                                |                       |                       |                  |                    |                            |
|   | •                            | •                 | •                           | •                      | •                     | •                          | •                                                                                                                                                                                                                                                                                                                                                                                                                                                                                                                                                                                                                                                                                                                                                                                                                                                                                                                                                                                                                                                                                                                                                                                                                                                                                                                                                                                                                                                                                                                                                                                                                                                                                                                                                                                                                                                                                                                                                                                                                                                                                                                              | •                          | •                         | •                | •                      | •                          | •                                                                                                                                                                                                                                                                                                                                                                                                                                                                                                                                                                                                                                                                                                                                                                                                                                                                                                                                                                                                                                                                                                                                                                                                                                                                                                                                                                                                                                                                                                                                                                                                                                                                                                                                                                                                                                                                                                                                                                                                                                                                                                                              | •                     | •                     | •                | •                  | •                          |
|   | •                            | •                 | •                           | •                      | •                     | •                          | •                                                                                                                                                                                                                                                                                                                                                                                                                                                                                                                                                                                                                                                                                                                                                                                                                                                                                                                                                                                                                                                                                                                                                                                                                                                                                                                                                                                                                                                                                                                                                                                                                                                                                                                                                                                                                                                                                                                                                                                                                                                                                                                              | •                          | •                         | •                | •                      | •                          | •                                                                                                                                                                                                                                                                                                                                                                                                                                                                                                                                                                                                                                                                                                                                                                                                                                                                                                                                                                                                                                                                                                                                                                                                                                                                                                                                                                                                                                                                                                                                                                                                                                                                                                                                                                                                                                                                                                                                                                                                                                                                                                                              | •                     | •                     | •                | •                  | •                          |
|   | •                            | •                 | •                           | •                      | •                     | •                          | •                                                                                                                                                                                                                                                                                                                                                                                                                                                                                                                                                                                                                                                                                                                                                                                                                                                                                                                                                                                                                                                                                                                                                                                                                                                                                                                                                                                                                                                                                                                                                                                                                                                                                                                                                                                                                                                                                                                                                                                                                                                                                                                              | •                          | •                         | • •              | •                      | •                          | •                                                                                                                                                                                                                                                                                                                                                                                                                                                                                                                                                                                                                                                                                                                                                                                                                                                                                                                                                                                                                                                                                                                                                                                                                                                                                                                                                                                                                                                                                                                                                                                                                                                                                                                                                                                                                                                                                                                                                                                                                                                                                                                              | •                     | •                     | •                | •                  | •                          |
|   |                              |                   |                             |                        | •                     |                            |                                                                                                                                                                                                                                                                                                                                                                                                                                                                                                                                                                                                                                                                                                                                                                                                                                                                                                                                                                                                                                                                                                                                                                                                                                                                                                                                                                                                                                                                                                                                                                                                                                                                                                                                                                                                                                                                                                                                                                                                                                                                                                                                |                            |                           |                  |                        |                            | •                                                                                                                                                                                                                                                                                                                                                                                                                                                                                                                                                                                                                                                                                                                                                                                                                                                                                                                                                                                                                                                                                                                                                                                                                                                                                                                                                                                                                                                                                                                                                                                                                                                                                                                                                                                                                                                                                                                                                                                                                                                                                                                              |                       |                       |                  |                    |                            |
|   |                              |                   |                             |                        |                       |                            |                                                                                                                                                                                                                                                                                                                                                                                                                                                                                                                                                                                                                                                                                                                                                                                                                                                                                                                                                                                                                                                                                                                                                                                                                                                                                                                                                                                                                                                                                                                                                                                                                                                                                                                                                                                                                                                                                                                                                                                                                                                                                                                                |                            |                           |                  |                        |                            |                                                                                                                                                                                                                                                                                                                                                                                                                                                                                                                                                                                                                                                                                                                                                                                                                                                                                                                                                                                                                                                                                                                                                                                                                                                                                                                                                                                                                                                                                                                                                                                                                                                                                                                                                                                                                                                                                                                                                                                                                                                                                                                                |                       |                       |                  |                    |                            |
|   | •                            | •                 |                             | •                      | •                     |                            |                                                                                                                                                                                                                                                                                                                                                                                                                                                                                                                                                                                                                                                                                                                                                                                                                                                                                                                                                                                                                                                                                                                                                                                                                                                                                                                                                                                                                                                                                                                                                                                                                                                                                                                                                                                                                                                                                                                                                                                                                                                                                                                                | •                          |                           | •                |                        | •                          |                                                                                                                                                                                                                                                                                                                                                                                                                                                                                                                                                                                                                                                                                                                                                                                                                                                                                                                                                                                                                                                                                                                                                                                                                                                                                                                                                                                                                                                                                                                                                                                                                                                                                                                                                                                                                                                                                                                                                                                                                                                                                                                                | •                     |                       |                  |                    | •                          |
|   | •                            | •                 |                             | •                      | •                     | •                          | •                                                                                                                                                                                                                                                                                                                                                                                                                                                                                                                                                                                                                                                                                                                                                                                                                                                                                                                                                                                                                                                                                                                                                                                                                                                                                                                                                                                                                                                                                                                                                                                                                                                                                                                                                                                                                                                                                                                                                                                                                                                                                                                              | •                          |                           |                  | •                      | •                          | •                                                                                                                                                                                                                                                                                                                                                                                                                                                                                                                                                                                                                                                                                                                                                                                                                                                                                                                                                                                                                                                                                                                                                                                                                                                                                                                                                                                                                                                                                                                                                                                                                                                                                                                                                                                                                                                                                                                                                                                                                                                                                                                              | •                     | •                     | •                | •                  | •                          |
|   | •                            | •                 |                             | •                      |                       | •                          | •                                                                                                                                                                                                                                                                                                                                                                                                                                                                                                                                                                                                                                                                                                                                                                                                                                                                                                                                                                                                                                                                                                                                                                                                                                                                                                                                                                                                                                                                                                                                                                                                                                                                                                                                                                                                                                                                                                                                                                                                                                                                                                                              | •                          |                           | •                | •                      | •                          | •                                                                                                                                                                                                                                                                                                                                                                                                                                                                                                                                                                                                                                                                                                                                                                                                                                                                                                                                                                                                                                                                                                                                                                                                                                                                                                                                                                                                                                                                                                                                                                                                                                                                                                                                                                                                                                                                                                                                                                                                                                                                                                                              | •                     | •                     | •                | •                  | •                          |
|   |                              | •                 |                             | •                      | •                     | •                          |                                                                                                                                                                                                                                                                                                                                                                                                                                                                                                                                                                                                                                                                                                                                                                                                                                                                                                                                                                                                                                                                                                                                                                                                                                                                                                                                                                                                                                                                                                                                                                                                                                                                                                                                                                                                                                                                                                                                                                                                                                                                                                                                | •                          | •                         | •                |                        | , •                        | •                                                                                                                                                                                                                                                                                                                                                                                                                                                                                                                                                                                                                                                                                                                                                                                                                                                                                                                                                                                                                                                                                                                                                                                                                                                                                                                                                                                                                                                                                                                                                                                                                                                                                                                                                                                                                                                                                                                                                                                                                                                                                                                              | •                     |                       | •                |                    | •                          |
|   | •                            | •                 | •                           | •                      | •                     | •                          | •                                                                                                                                                                                                                                                                                                                                                                                                                                                                                                                                                                                                                                                                                                                                                                                                                                                                                                                                                                                                                                                                                                                                                                                                                                                                                                                                                                                                                                                                                                                                                                                                                                                                                                                                                                                                                                                                                                                                                                                                                                                                                                                              | •                          | •                         | •                | •                      | •                          | •                                                                                                                                                                                                                                                                                                                                                                                                                                                                                                                                                                                                                                                                                                                                                                                                                                                                                                                                                                                                                                                                                                                                                                                                                                                                                                                                                                                                                                                                                                                                                                                                                                                                                                                                                                                                                                                                                                                                                                                                                                                                                                                              | •                     | •                     | •                | •                  | •                          |
|   | •                            | -                 |                             | •                      | •                     | •                          | •                                                                                                                                                                                                                                                                                                                                                                                                                                                                                                                                                                                                                                                                                                                                                                                                                                                                                                                                                                                                                                                                                                                                                                                                                                                                                                                                                                                                                                                                                                                                                                                                                                                                                                                                                                                                                                                                                                                                                                                                                                                                                                                              | •                          | •                         |                  |                        | •                          | •                                                                                                                                                                                                                                                                                                                                                                                                                                                                                                                                                                                                                                                                                                                                                                                                                                                                                                                                                                                                                                                                                                                                                                                                                                                                                                                                                                                                                                                                                                                                                                                                                                                                                                                                                                                                                                                                                                                                                                                                                                                                                                                              | •                     |                       | •                | •                  | •                          |
|   | •                            |                   |                             |                        |                       | •                          | •                                                                                                                                                                                                                                                                                                                                                                                                                                                                                                                                                                                                                                                                                                                                                                                                                                                                                                                                                                                                                                                                                                                                                                                                                                                                                                                                                                                                                                                                                                                                                                                                                                                                                                                                                                                                                                                                                                                                                                                                                                                                                                                              | •                          |                           |                  |                        | •                          | The state of the s |                       |                       |                  |                    | •                          |
|   |                              |                   |                             |                        |                       |                            |                                                                                                                                                                                                                                                                                                                                                                                                                                                                                                                                                                                                                                                                                                                                                                                                                                                                                                                                                                                                                                                                                                                                                                                                                                                                                                                                                                                                                                                                                                                                                                                                                                                                                                                                                                                                                                                                                                                                                                                                                                                                                                                                |                            |                           |                  |                        |                            |                                                                                                                                                                                                                                                                                                                                                                                                                                                                                                                                                                                                                                                                                                                                                                                                                                                                                                                                                                                                                                                                                                                                                                                                                                                                                                                                                                                                                                                                                                                                                                                                                                                                                                                                                                                                                                                                                                                                                                                                                                                                                                                                |                       |                       |                  |                    |                            |
|   | •                            | •                 |                             | •                      |                       |                            | •                                                                                                                                                                                                                                                                                                                                                                                                                                                                                                                                                                                                                                                                                                                                                                                                                                                                                                                                                                                                                                                                                                                                                                                                                                                                                                                                                                                                                                                                                                                                                                                                                                                                                                                                                                                                                                                                                                                                                                                                                                                                                                                              | •                          |                           | •                |                        | •                          | •                                                                                                                                                                                                                                                                                                                                                                                                                                                                                                                                                                                                                                                                                                                                                                                                                                                                                                                                                                                                                                                                                                                                                                                                                                                                                                                                                                                                                                                                                                                                                                                                                                                                                                                                                                                                                                                                                                                                                                                                                                                                                                                              | •                     |                       | •                |                    | •                          |
|   | •                            |                   |                             |                        |                       |                            | •                                                                                                                                                                                                                                                                                                                                                                                                                                                                                                                                                                                                                                                                                                                                                                                                                                                                                                                                                                                                                                                                                                                                                                                                                                                                                                                                                                                                                                                                                                                                                                                                                                                                                                                                                                                                                                                                                                                                                                                                                                                                                                                              |                            |                           | •                |                        |                            | •                                                                                                                                                                                                                                                                                                                                                                                                                                                                                                                                                                                                                                                                                                                                                                                                                                                                                                                                                                                                                                                                                                                                                                                                                                                                                                                                                                                                                                                                                                                                                                                                                                                                                                                                                                                                                                                                                                                                                                                                                                                                                                                              | •                     |                       | •                |                    |                            |
|   | •                            | •                 |                             | •                      | •                     | •                          | •                                                                                                                                                                                                                                                                                                                                                                                                                                                                                                                                                                                                                                                                                                                                                                                                                                                                                                                                                                                                                                                                                                                                                                                                                                                                                                                                                                                                                                                                                                                                                                                                                                                                                                                                                                                                                                                                                                                                                                                                                                                                                                                              | •                          |                           | •                |                        | •                          |                                                                                                                                                                                                                                                                                                                                                                                                                                                                                                                                                                                                                                                                                                                                                                                                                                                                                                                                                                                                                                                                                                                                                                                                                                                                                                                                                                                                                                                                                                                                                                                                                                                                                                                                                                                                                                                                                                                                                                                                                                                                                                                                |                       |                       | •                |                    |                            |
|   |                              |                   |                             |                        |                       |                            |                                                                                                                                                                                                                                                                                                                                                                                                                                                                                                                                                                                                                                                                                                                                                                                                                                                                                                                                                                                                                                                                                                                                                                                                                                                                                                                                                                                                                                                                                                                                                                                                                                                                                                                                                                                                                                                                                                                                                                                                                                                                                                                                |                            |                           |                  |                        |                            |                                                                                                                                                                                                                                                                                                                                                                                                                                                                                                                                                                                                                                                                                                                                                                                                                                                                                                                                                                                                                                                                                                                                                                                                                                                                                                                                                                                                                                                                                                                                                                                                                                                                                                                                                                                                                                                                                                                                                                                                                                                                                                                                |                       |                       |                  |                    |                            |
|   | •                            |                   | •                           |                        | •                     | •                          | •                                                                                                                                                                                                                                                                                                                                                                                                                                                                                                                                                                                                                                                                                                                                                                                                                                                                                                                                                                                                                                                                                                                                                                                                                                                                                                                                                                                                                                                                                                                                                                                                                                                                                                                                                                                                                                                                                                                                                                                                                                                                                                                              |                            | •                         |                  | •                      | •                          | •                                                                                                                                                                                                                                                                                                                                                                                                                                                                                                                                                                                                                                                                                                                                                                                                                                                                                                                                                                                                                                                                                                                                                                                                                                                                                                                                                                                                                                                                                                                                                                                                                                                                                                                                                                                                                                                                                                                                                                                                                                                                                                                              |                       |                       |                  | •                  | •                          |
|   |                              |                   |                             |                        | •                     | •                          |                                                                                                                                                                                                                                                                                                                                                                                                                                                                                                                                                                                                                                                                                                                                                                                                                                                                                                                                                                                                                                                                                                                                                                                                                                                                                                                                                                                                                                                                                                                                                                                                                                                                                                                                                                                                                                                                                                                                                                                                                                                                                                                                |                            |                           |                  |                        |                            | P3 M2 AVERAGE NA DESTRE                                                                                                                                                                                                                                                                                                                                                                                                                                                                                                                                                                                                                                                                                                                                                                                                                                                                                                                                                                                                                                                                                                                                                                                                                                                                                                                                                                                                                                                                                                                                                                                                                                                                                                                                                                                                                                                                                                                                                                                                                                                                                                        |                       |                       |                  |                    |                            |
|   | •                            | •                 | •                           | •                      | •                     | •                          | •                                                                                                                                                                                                                                                                                                                                                                                                                                                                                                                                                                                                                                                                                                                                                                                                                                                                                                                                                                                                                                                                                                                                                                                                                                                                                                                                                                                                                                                                                                                                                                                                                                                                                                                                                                                                                                                                                                                                                                                                                                                                                                                              | •                          | •                         | •                | •                      | •                          | 10                                                                                                                                                                                                                                                                                                                                                                                                                                                                                                                                                                                                                                                                                                                                                                                                                                                                                                                                                                                                                                                                                                                                                                                                                                                                                                                                                                                                                                                                                                                                                                                                                                                                                                                                                                                                                                                                                                                                                                                                                                                                                                                             | •                     | •                     | •                | •                  | •                          |
|   |                              |                   |                             |                        |                       |                            |                                                                                                                                                                                                                                                                                                                                                                                                                                                                                                                                                                                                                                                                                                                                                                                                                                                                                                                                                                                                                                                                                                                                                                                                                                                                                                                                                                                                                                                                                                                                                                                                                                                                                                                                                                                                                                                                                                                                                                                                                                                                                                                                |                            |                           |                  |                        |                            |                                                                                                                                                                                                                                                                                                                                                                                                                                                                                                                                                                                                                                                                                                                                                                                                                                                                                                                                                                                                                                                                                                                                                                                                                                                                                                                                                                                                                                                                                                                                                                                                                                                                                                                                                                                                                                                                                                                                                                                                                                                                                                                                |                       |                       |                  |                    |                            |
|   |                              |                   |                             |                        |                       | •                          |                                                                                                                                                                                                                                                                                                                                                                                                                                                                                                                                                                                                                                                                                                                                                                                                                                                                                                                                                                                                                                                                                                                                                                                                                                                                                                                                                                                                                                                                                                                                                                                                                                                                                                                                                                                                                                                                                                                                                                                                                                                                                                                                |                            |                           |                  |                        | •                          |                                                                                                                                                                                                                                                                                                                                                                                                                                                                                                                                                                                                                                                                                                                                                                                                                                                                                                                                                                                                                                                                                                                                                                                                                                                                                                                                                                                                                                                                                                                                                                                                                                                                                                                                                                                                                                                                                                                                                                                                                                                                                                                                |                       |                       |                  |                    | •                          |
|   |                              |                   |                             |                        |                       | •                          |                                                                                                                                                                                                                                                                                                                                                                                                                                                                                                                                                                                                                                                                                                                                                                                                                                                                                                                                                                                                                                                                                                                                                                                                                                                                                                                                                                                                                                                                                                                                                                                                                                                                                                                                                                                                                                                                                                                                                                                                                                                                                                                                |                            |                           |                  |                        | •                          |                                                                                                                                                                                                                                                                                                                                                                                                                                                                                                                                                                                                                                                                                                                                                                                                                                                                                                                                                                                                                                                                                                                                                                                                                                                                                                                                                                                                                                                                                                                                                                                                                                                                                                                                                                                                                                                                                                                                                                                                                                                                                                                                |                       |                       |                  | 77                 | •                          |
|   |                              |                   |                             |                        |                       | •                          |                                                                                                                                                                                                                                                                                                                                                                                                                                                                                                                                                                                                                                                                                                                                                                                                                                                                                                                                                                                                                                                                                                                                                                                                                                                                                                                                                                                                                                                                                                                                                                                                                                                                                                                                                                                                                                                                                                                                                                                                                                                                                                                                |                            |                           |                  |                        | •                          |                                                                                                                                                                                                                                                                                                                                                                                                                                                                                                                                                                                                                                                                                                                                                                                                                                                                                                                                                                                                                                                                                                                                                                                                                                                                                                                                                                                                                                                                                                                                                                                                                                                                                                                                                                                                                                                                                                                                                                                                                                                                                                                                |                       |                       |                  |                    | •                          |
|   |                              |                   |                             |                        |                       | •                          |                                                                                                                                                                                                                                                                                                                                                                                                                                                                                                                                                                                                                                                                                                                                                                                                                                                                                                                                                                                                                                                                                                                                                                                                                                                                                                                                                                                                                                                                                                                                                                                                                                                                                                                                                                                                                                                                                                                                                                                                                                                                                                                                |                            |                           |                  |                        | •                          |                                                                                                                                                                                                                                                                                                                                                                                                                                                                                                                                                                                                                                                                                                                                                                                                                                                                                                                                                                                                                                                                                                                                                                                                                                                                                                                                                                                                                                                                                                                                                                                                                                                                                                                                                                                                                                                                                                                                                                                                                                                                                                                                |                       |                       |                  |                    | •                          |
|   |                              |                   |                             |                        |                       | •                          |                                                                                                                                                                                                                                                                                                                                                                                                                                                                                                                                                                                                                                                                                                                                                                                                                                                                                                                                                                                                                                                                                                                                                                                                                                                                                                                                                                                                                                                                                                                                                                                                                                                                                                                                                                                                                                                                                                                                                                                                                                                                                                                                |                            |                           |                  |                        | •                          |                                                                                                                                                                                                                                                                                                                                                                                                                                                                                                                                                                                                                                                                                                                                                                                                                                                                                                                                                                                                                                                                                                                                                                                                                                                                                                                                                                                                                                                                                                                                                                                                                                                                                                                                                                                                                                                                                                                                                                                                                                                                                                                                |                       |                       |                  |                    | •                          |
| - |                              |                   |                             |                        | •                     | •                          |                                                                                                                                                                                                                                                                                                                                                                                                                                                                                                                                                                                                                                                                                                                                                                                                                                                                                                                                                                                                                                                                                                                                                                                                                                                                                                                                                                                                                                                                                                                                                                                                                                                                                                                                                                                                                                                                                                                                                                                                                                                                                                                                |                            |                           |                  | •                      | •                          |                                                                                                                                                                                                                                                                                                                                                                                                                                                                                                                                                                                                                                                                                                                                                                                                                                                                                                                                                                                                                                                                                                                                                                                                                                                                                                                                                                                                                                                                                                                                                                                                                                                                                                                                                                                                                                                                                                                                                                                                                                                                                                                                |                       |                       |                  | •                  | •                          |

# Scope & Sequence: Themes 4-6

#### **National Standards**

National Standard 1a Students select media, techniques, and processes; analyze their effectiveness; and reflect upon their choices.

National Standard 1b Students take advantage of qualities and characteristics of art media, techniques, and processes to enhance communication of ideas

National Standard 2a Students generalize about the effects of visual structures and functions.

**National Standard 2b** Students employ organizational structures and analyze their effectiveness.

National Standard 2c Students select and use the qualities of structures and function of art to improve communication of ideas.

National Standard 3a Students integrate visual, spatial, and temporal concepts with content to communicate intended meaning.

National Standard 3b Students use subjects, themes, and symbols that demonstrate knowledge of contexts, values, and aesthetics that communicate intended meaning.

National Standard 4a Students know and compare characteristics of artworks in various eras and cultures.

National Standard 4b Students describe and place a variety of art objects in historical and cultural contexts.

National Standard 4c Students analyze, describe, and demonstrate how factors of time and place influence visual characteristics that give meaning and value to artworks.

National Standard 5a Students compare multiple purposes for creating artworks.

National Standard 5b Students analyze contemporary and historic meanings in specific artworks through cultural and aesthetic inquiry.

National Standard 5c Students describe and compare responses to their own artworks and to artworks from various eras and cultures.

National Standard 6a Students compare the characteristics of works in two or more art forms that share similar subject matter, historical periods, or cultural context.

National Standard 6b Students describe how the principles and subject matter of other disciplines are interrelated with the visual arts.

| Stud       | ent     | Abi    | lities | in Art     |
|------------|---------|--------|--------|------------|
| ~~ ~ ~ ~ ~ | ~ III 6 | 1 1101 |        | 111 / 11 6 |

| Perception               | Using knowledge of structures and functions                                                       |
|--------------------------|---------------------------------------------------------------------------------------------------|
|                          | Observing visual, tactile, spatial, and temporal elements in the natural and built environments   |
|                          | Observing visual, tactile, spatial, and temporal elements in artworks                             |
|                          | Considering use of elements and principles of design                                              |
| Art Production           | Understanding and applying media, techniques, and processes                                       |
|                          | Generating ideas for artistic expression                                                          |
|                          | Choosing and evaluating a range of subject matter, symbols and ideas                              |
|                          | Developing approaches for expressing ideas                                                        |
|                          | Exploring expressive potential of art forms, media, and techniques                                |
|                          | Reflecting on artistic process, meaning, and quality of work                                      |
|                          | Safety in art making                                                                              |
| Art History              | Understanding the visual arts in relation to history and cultures                                 |
|                          | Investigating historical/cultural meaning of artworks                                             |
|                          | Understanding historical/cultural context                                                         |
|                          | Developing global and multicultural perspectives                                                  |
|                          | Considering styles, influences, and themes in art                                                 |
| rt Criticism             | Reflecting upon and assessing the characteristics and merits of their work and the work of others |
|                          | Describing and analyzing details in artworks                                                      |
|                          | Interpreting meanings in artworks                                                                 |
|                          | Judging merit and significance in artworks                                                        |
| Aesthetics               | Reflecting upon and assessing the characteristics and merits of their work and the work of others |
|                          | Understanding reasons for valuing art                                                             |
|                          | Raising and addressing philosophical questions about art and human experience                     |
|                          | Forming opinions about art                                                                        |
| Presentation             | Reflecting upon and assessing the characteristics and merits of their work and the work of others |
| Exhibition, and Critique | Keeping a portfolio and sketchbook                                                                |
| ,                        | Making work public                                                                                |
|                          | Evaluating progress and accomplishments                                                           |
| Learning                 | Making connections between visual arts and other disciplines                                      |
| for Life                 | Performing arts connections                                                                       |
|                          | Daily life connections                                                                            |
|                          | Interdisciplinary connections                                                                     |
|                          | Careers                                                                                           |
|                          | Community connections                                                                             |
|                          | Parent/home involvement                                                                           |

Technology/internet/computer connections

|                                         | 4                         | Arti                | sts as Te                 | eachers                 |                        |                            | 5                          | Arti                  | sts as In        | terprete         | ers                    |                            | 6                          | Arti                       | sts as M         | essenge                  | ers                      |                            |
|-----------------------------------------|---------------------------|---------------------|---------------------------|-------------------------|------------------------|----------------------------|----------------------------|-----------------------|------------------|------------------|------------------------|----------------------------|----------------------------|----------------------------|------------------|--------------------------|--------------------------|----------------------------|
|                                         | Core Puppeteer as Teacher | 4.1 Art and Beliefs | 4.2 Lettering/Calligraphy | 4.3 Art of North Africa | 4.4 Designing a Poster | Connect, Portfolio, Review | Core Landscape Interpreter | 5.1 Landscapes as Art | 5.2 Color Mixing | 5.3 Art of China | 5.4 Wood Constructions | Connect, Portfolio, Review | Core Artist with a Message | 6.1 Symbolism in Portraits | 6.2 Monoprinting | 6.3 Aboriginal Australia | 6.4 Linoleum Block Print | Connect, Portfolio, Review |
|                                         |                           |                     |                           |                         |                        |                            |                            |                       |                  |                  |                        |                            |                            |                            |                  |                          |                          |                            |
| *************************************** | •                         | •                   |                           | •                       |                        | •                          | •                          |                       |                  |                  |                        | •                          | •                          |                            |                  |                          |                          | •                          |
|                                         | •                         | •                   | •                         | •                       | •                      | •                          | •                          | •                     | •                | •                | •                      | •                          | •                          | •                          | •                | •                        | •                        | •                          |
|                                         | •                         | •                   | •                         | •                       | •                      | •                          | •                          | •                     | •                | •                | •                      | •                          | •                          | •                          | •                | •                        | •                        | •                          |
|                                         |                           |                     |                           |                         |                        |                            |                            |                       |                  |                  |                        |                            |                            |                            |                  |                          |                          |                            |
|                                         | •                         | •                   | •                         | •                       | •                      | •                          | •                          | •                     | •                | •                | •                      | •                          | •                          | •                          | •                | •                        | •                        | •                          |
|                                         |                           | •                   |                           | •                       |                        | •                          |                            |                       | •                | •                | •                      | •                          | •                          |                            | •                |                          |                          |                            |
|                                         | •                         | •                   | •                         | •                       | •                      | •                          | •                          | •                     | •                | •                | •                      | •                          | •                          | •                          | •                | •                        | •                        | •                          |
|                                         | •                         |                     |                           | •                       | •                      | •                          | •                          | •                     | •                | •                | •                      | •                          | •                          | •                          | •                | •                        | •                        | •                          |
|                                         |                           |                     |                           |                         |                        | •                          |                            |                       |                  |                  | •                      |                            |                            |                            |                  |                          | •                        | •                          |
|                                         |                           |                     |                           |                         |                        |                            |                            |                       |                  |                  |                        |                            |                            |                            |                  |                          | ************             |                            |
|                                         | •                         | •                   |                           | •                       |                        |                            |                            | •                     |                  |                  |                        |                            | •                          | •                          |                  |                          |                          | •                          |
|                                         | •                         | •                   | •                         | •                       | •                      | •                          | •                          | •                     | •                | •                | •                      | •                          | •                          | •                          | •                | •                        | •                        | •                          |
|                                         | •                         | •                   | •                         | •                       | •                      | •                          | •                          | •                     |                  | •                | •                      | •                          | •                          | •                          | •                | •                        | •                        | •                          |
|                                         | •                         | •                   |                           | •                       | •                      | •                          | •                          | •                     |                  | •                | •                      | •                          | •                          | •                          | •                | •                        | •                        | •                          |
|                                         |                           | ••••                |                           |                         |                        |                            |                            |                       |                  |                  |                        |                            |                            | -                          |                  |                          |                          |                            |
|                                         | •                         | •                   | •                         | •                       | •                      | •                          | •                          | •                     | •                | •                | •                      | •                          | •                          | •                          | •                | •                        | •                        | •                          |
|                                         | •                         | •                   |                           | •                       | •                      | •                          | •                          | •                     |                  | •                | •                      | •                          | •                          | •                          |                  | •                        | •                        | •                          |
|                                         | •                         |                     |                           | •                       |                        | •                          | •                          |                       |                  | •                |                        | •                          | •                          | •                          |                  | •                        | •                        | •                          |
|                                         |                           | •                   |                           | •                       |                        | •                          | •                          | •                     | •                | •                | •                      |                            | •                          | •                          |                  | •                        |                          | •                          |
|                                         | •                         | •                   | <del> </del>              | •                       |                        | •                          | •                          | •                     |                  | <u> </u>         |                        | •                          | -                          | •                          |                  | •                        |                          | •                          |
|                                         |                           |                     |                           | •                       | •                      | •                          | •                          |                       |                  | •                | •                      |                            | •                          | •                          | •                | •                        | •                        | •                          |
| *************************************** |                           |                     | -                         |                         |                        |                            |                            |                       |                  |                  |                        |                            |                            |                            |                  |                          |                          |                            |
|                                         | •                         | •                   | •                         |                         | •                      | •                          | •                          |                       | •                |                  | •                      | •                          | •                          |                            | •                |                          | •                        | •                          |
|                                         |                           |                     |                           |                         |                        |                            |                            |                       |                  |                  |                        |                            |                            |                            |                  |                          |                          |                            |
|                                         | •                         | •                   | •                         | •                       | •                      | •                          | •                          | •                     | •                | •                | •                      | •                          | •                          | •                          | •                | •                        | •                        | •                          |
|                                         |                           |                     |                           |                         |                        |                            |                            |                       |                  |                  |                        |                            |                            |                            |                  |                          |                          |                            |
|                                         |                           |                     |                           |                         |                        | •                          |                            |                       |                  |                  |                        | •                          |                            |                            |                  |                          |                          | •                          |
|                                         |                           |                     |                           |                         |                        | •                          |                            |                       |                  |                  |                        | •                          |                            |                            |                  |                          |                          | •                          |
|                                         |                           | <del> </del>        |                           |                         |                        | •                          |                            |                       |                  |                  |                        | •                          |                            |                            |                  |                          |                          | •                          |
|                                         |                           |                     |                           |                         |                        | •                          |                            |                       |                  |                  |                        | •                          |                            |                            |                  |                          |                          | •                          |
| 000000000000000000000000000000000000000 |                           |                     |                           |                         |                        | •                          |                            |                       |                  |                  |                        | •                          |                            |                            |                  |                          | •                        | •                          |
|                                         |                           |                     |                           |                         |                        | •                          |                            |                       |                  |                  |                        | •                          |                            |                            |                  |                          |                          | •                          |
|                                         |                           |                     |                           |                         | •                      | •                          |                            |                       |                  |                  | •                      | •                          |                            |                            |                  |                          | •                        | •                          |

# Scope & Sequence: Themes 7–9

#### **National Standards**

National Standard 1a Students select media, techniques, and processes; analyze their effectiveness; and reflect upon their choices.

National Standard 1b Students take advantage of qualities and character istics of art media, techniques, and processes to enhance communication of ideas.

National Standard 2a Students generalize about the effects of visual structures and functions.

National Standard 2b Students employ organizational structures and analyze their effectiveness.

National Standard 2c Students select and use the qualities of structures and function of art to improve communication of ideas.

National Standard 3a Students inte grate visual, spatial, and temporal concepts with content to communicate intended meaning.

National Standard 3b Students use subjects, themes, and symbols that demonstrate knowledge of contexts, values, and aesthetics that communicate intended meaning.

National Standard 4a Students know and compare characteristics of artworks in various eras and cultures

National Standard 4b Students describe and place a variety of art objects in historical and cultural contexts.

National Standard 4c Students analyze, describe, and demonstrate how factors of time and place influence visual characteristics that give meaning and value to artworks.

National Standard 5a Students com pare multiple purposes for creating artworks.

National Standard 5b Students analyze contemporary and historic meanings in specific artworks through cultural and aesthetic inquiry.

National Standard 5c Students describe and compare responses to their own artworks and to artworks from various eras and cultures.

National Standard 6a Students compare the characteristics of works in two or more art forms that share similar subject matter, historical periods, or cultural context.

National Standard 6b Students describe how the principles and subject matter of other disciplines are interrelated with the visual arts.

| Charle |     | AL  | 1:4:  | an Auch |
|--------|-----|-----|-------|---------|
| Stua   | ent | ADI | uties | in Art  |

| Perception                  | Using knowledge of structures and functions                                                       |  |  |  |  |  |  |
|-----------------------------|---------------------------------------------------------------------------------------------------|--|--|--|--|--|--|
|                             | Observing visual, tactile, spatial, and temporal elements in the natural and built environments   |  |  |  |  |  |  |
|                             | Observing visual, tactile, spatial, and temporal elements in artworks                             |  |  |  |  |  |  |
|                             | Considering use of elements and principles of design                                              |  |  |  |  |  |  |
| Art Production              | Understanding and applying media, techniques, and processes                                       |  |  |  |  |  |  |
|                             | Generating ideas for artistic expression                                                          |  |  |  |  |  |  |
|                             | Choosing and evaluating a range of subject matter, symbols and ideas                              |  |  |  |  |  |  |
|                             | Developing approaches for expressing ideas                                                        |  |  |  |  |  |  |
|                             | Exploring expressive potential of art forms, media, and techniques                                |  |  |  |  |  |  |
|                             | Reflecting on artistic process, meaning, and quality of work                                      |  |  |  |  |  |  |
|                             | Safety in art making                                                                              |  |  |  |  |  |  |
| Art History                 | Understanding the visual arts in relation to history and cultures                                 |  |  |  |  |  |  |
|                             | Investigating historical/cultural meaning of artworks                                             |  |  |  |  |  |  |
|                             | Understanding historical/cultural context                                                         |  |  |  |  |  |  |
|                             | Developing global and multicultural perspectives                                                  |  |  |  |  |  |  |
|                             | Considering styles, influences, and themes in art                                                 |  |  |  |  |  |  |
| Art Criticism               | Reflecting upon and assessing the characteristics and merits of their work and the work of others |  |  |  |  |  |  |
|                             | Describing and analyzing details in artworks                                                      |  |  |  |  |  |  |
|                             | Interpreting meanings in artworks                                                                 |  |  |  |  |  |  |
|                             | Judging merit and significance in artworks                                                        |  |  |  |  |  |  |
| Aesthetics                  | Reflecting upon and assessing the characteristics and merits of their work and the work of others |  |  |  |  |  |  |
|                             | Understanding reasons for valuing art                                                             |  |  |  |  |  |  |
|                             | Raising and addressing philosophical questions about art and human experience                     |  |  |  |  |  |  |
|                             | Forming opinions about art                                                                        |  |  |  |  |  |  |
| Presentation                | Reflecting upon and assessing the characteristics and merits of their work and the work of others |  |  |  |  |  |  |
| Exhibition,<br>and Critique | Keeping a portfolio and sketchbook                                                                |  |  |  |  |  |  |
| and chilque                 | Making work public                                                                                |  |  |  |  |  |  |
|                             | Evaluating progress and accomplishments                                                           |  |  |  |  |  |  |
| Learning                    | Making connections between visual arts and other disciplines                                      |  |  |  |  |  |  |
| for Life                    | Performing arts connections                                                                       |  |  |  |  |  |  |
|                             | Daily life connections                                                                            |  |  |  |  |  |  |
|                             | Interdisciplinary connections                                                                     |  |  |  |  |  |  |
|                             | Careers                                                                                           |  |  |  |  |  |  |
|                             | Community connections                                                                             |  |  |  |  |  |  |
|                             | Parent/home involvement                                                                           |  |  |  |  |  |  |
|                             | Technology/internet/computer connections                                                          |  |  |  |  |  |  |

|   | 7                        | Artists as Inventors |                 |                        |                      | Artists as Planners        |                             |                             |                | 9 Artists as Pioneers |                              |                            |                       |                             |                              |                   |                             |                            |
|---|--------------------------|----------------------|-----------------|------------------------|----------------------|----------------------------|-----------------------------|-----------------------------|----------------|-----------------------|------------------------------|----------------------------|-----------------------|-----------------------------|------------------------------|-------------------|-----------------------------|----------------------------|
|   | Core An Inventive Artist | 7.1 Fantasy in Art   | 7.2 Perspective | 7.3 Art of Puerto Rico | 7.4 A Wire Sculpture | Connect, Portfolio, Review | Core Planner from the Start | 8.1 Architecture for Living | 8.2 3-D Models | 8.3 Art of Mexico     | 8,4 Corrugated Constructions | Connect, Portfolio, Review | Core A Pioneer in Art | 9.1 Traditions of Sculpture | 9.2 Casting Relief Sculpture | 9.3 Art of Israel | 9.4 Recycling for Sculpture | Connect, Portfolio, Review |
|   |                          |                      |                 |                        |                      |                            |                             |                             |                |                       |                              |                            |                       |                             |                              |                   |                             |                            |
|   | •                        |                      |                 |                        |                      | •                          | •                           | •                           |                | •                     | •                            | •                          | •                     |                             |                              |                   |                             | •                          |
|   | •                        | •                    | •               | •                      | •                    | •                          | •                           | •                           | •              | •                     | •                            | •                          | •                     | •                           | •                            | •                 | •                           | •                          |
|   | •                        | •                    | •               | •                      | •                    | •                          | •                           | •                           | •              | •                     | •                            | •                          | •                     | •                           | •                            | •                 | •                           | •                          |
|   |                          |                      |                 |                        |                      |                            |                             |                             |                |                       |                              |                            |                       |                             |                              |                   |                             |                            |
|   | •                        | •                    | •               | •                      | •                    | •                          | •                           | •                           | •              | •                     | •                            | •                          | •                     | •                           | •                            | •                 | •                           | •                          |
|   |                          |                      |                 |                        |                      |                            |                             |                             |                |                       |                              |                            |                       |                             |                              |                   |                             |                            |
|   | •                        | •                    | •               | •                      | •                    | •                          | •                           | •                           | •              | •                     | •                            | •                          | •                     | •                           | •                            | •                 | •                           | •                          |
|   | •                        | •                    | •               | •                      | •                    | •                          | •                           | •                           | •              | •                     | •                            | •                          | •                     | •                           | •                            | •                 | •                           | •                          |
|   | •                        | •                    | •               | •                      | •                    | •                          | •                           | •                           | •              | •                     | •                            | •                          | •                     | •                           | •                            | •                 | •                           | •                          |
| - |                          |                      |                 |                        | •                    |                            |                             |                             |                |                       |                              |                            |                       |                             | •                            |                   |                             |                            |
|   |                          | •                    |                 | •                      |                      |                            | •                           | •                           |                |                       | •                            |                            |                       | •                           |                              |                   | •                           | •                          |
|   | •                        | •                    | •               | •                      | •                    | •                          | •                           | •                           | •              | •                     | •                            | •                          | •                     | •                           | •                            | •                 | •                           | •                          |
|   | •                        | •                    | •               | •                      | •                    | •                          | •                           | •                           |                | •                     |                              | •                          | •                     | •                           | •                            | •                 | •                           | •                          |
|   | •                        | •                    | •               | •                      | •                    | •                          | •                           | •                           |                | •                     |                              | •                          | •                     | •                           | •                            | •                 |                             | •                          |
|   |                          |                      |                 |                        |                      |                            |                             |                             |                |                       |                              |                            |                       |                             |                              |                   |                             |                            |
|   | •                        | •                    | •               | •                      | •                    | •                          | •                           | •                           | •              | •                     | •                            | •                          | •                     | •                           | •                            | •                 | •                           | •                          |
|   | •                        | •                    |                 | •                      |                      | •                          | •                           | •                           |                | •                     |                              | •                          | •                     | •                           |                              | •                 |                             | •                          |
|   |                          | •                    |                 | •                      |                      | •                          | •                           |                             |                | •                     |                              | •                          | •                     | •                           |                              |                   |                             | •                          |
|   |                          |                      |                 |                        |                      |                            |                             |                             |                |                       |                              |                            |                       |                             |                              |                   |                             |                            |
|   |                          |                      |                 | •                      |                      |                            | •                           | •                           |                | •                     | •                            | •                          | •                     |                             |                              |                   | •                           |                            |
|   | •                        |                      |                 |                        |                      |                            | •                           |                             |                |                       |                              |                            | •                     |                             |                              |                   | •                           | •                          |
|   | •                        |                      |                 |                        |                      |                            | •                           | •                           |                | •                     |                              |                            |                       | •                           |                              |                   | •                           |                            |
|   |                          |                      | <u> </u>        |                        |                      |                            |                             |                             |                |                       |                              |                            |                       |                             |                              |                   |                             |                            |
|   |                          |                      |                 |                        | •                    | •                          |                             |                             | •              |                       | •                            | •                          | •                     | •                           | •                            | _                 | •                           | •                          |
|   |                          |                      |                 |                        |                      |                            |                             |                             |                | _                     |                              |                            |                       |                             |                              | _                 |                             |                            |
|   | •                        | •                    |                 | •                      | •                    | •                          | •                           | •                           | •              | •                     | •                            | •                          | •                     | •                           | •                            | •                 | •                           | •                          |
|   |                          |                      |                 |                        |                      | •                          |                             |                             |                |                       |                              | •                          |                       |                             |                              |                   |                             | •                          |
|   |                          |                      |                 |                        |                      | •                          |                             |                             |                |                       |                              | •                          |                       |                             |                              |                   |                             | •                          |
|   |                          |                      |                 |                        |                      | •                          |                             |                             |                |                       |                              | •                          |                       |                             |                              |                   |                             | •                          |
|   |                          |                      |                 |                        |                      | •                          |                             |                             |                |                       |                              | •                          |                       |                             |                              |                   |                             | •                          |
|   |                          |                      |                 |                        |                      | •                          |                             |                             |                |                       |                              | •                          |                       |                             |                              |                   |                             | •                          |
|   |                          |                      |                 |                        |                      | •                          |                             |                             |                |                       |                              | •                          |                       |                             |                              |                   |                             | •                          |
|   |                          |                      |                 |                        | •                    | •                          |                             |                             |                |                       | •                            | •                          |                       |                             |                              |                   | •                           | •                          |

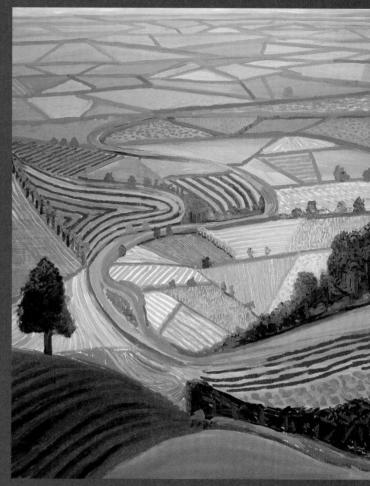

Cover, and above: David Hockney, *Garrowby Hill*, 1998. Oil on canvas,  $60" \times 72"$  (152.4 x 182.9 cm). David Hockney No. 1 Trust.

Art and the Human Experience

# ARI

**A Personal Journey** 

Eldon Katter Marilyn G. Stewart

Davis Publications, Inc. Worcester, Massachusetts

## Foundations What Is Art?

#### Foundation 1

- 2 The Whys and Hows of Art
- 4 The Functions of Art
- 6 Subjects and Themes for Artworks
- 10 Styles of Art
- 14 Connect to...
- 16 Portfolio & Chapter Review

Page 8

Page 19

#### Foundation 2

- 18 Forms and Media
- 20 Two-dimensional Artworks
- 24 Three-dimensional Artworks
- 28 Connect to...
- 30 Portfolio & Chapter Review

#### Foundation 3

- 32 Elements and Principles of Design
- 34 Elements of Design
- 42 Principles of Design
- 48 Connect to...
- 50 Portfolio & Chapter Review

age 54

54

- Foundation 4
  52 Approaches to Art
- 54 Art History
- 56 Art Criticism
- 8 Art Production
- 60 Aesthetics
- 62 Connect to...
- 64 Portfolio & Chapter Review

### Themes Art Is a Personal Journey

#### Theme 1

#### 68 Artists as Storytellers

- 70 Core Lesson An American Storyteller
- 76 1.1 Narrative Art
- 80 1.2 Contour and Gesture Drawing
- 82 1.3 The Kingdom of Dahomey
- 86 1.4 Sculpting a Scene
- 90 Connect to...
- 92 Portfolio & Chapter Review

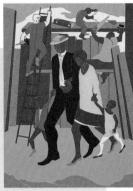

Page 71

Page 104

#### Theme 2

- 94 Artists as Recorders
- 96 Core Lesson Recorder of Daily Life
- 102 2.1 Documenting Daily Life
- 106 2.2 Tonal Drawing and Shading
- 108 2.3 Art of Haiti
- 112 2.4 Still-Life Drawing
- 116 Connect to...
- 118 Portfolio & Chapter Review

#### Theme 3

- 120 Artists as Designers
- 122 Core Lesson A Designer of Fashion
- 128 3.1 Design for Living
- 132 3.2 Human Proportions
- 134 3.3 Art of Japan
- 138 3.4 Creating a Package Design
- 142 Connect to...
- 144 Portfolio & Chapter Review

Page 12:

Printed in U.S.A. ISBN: 0-87192-558-3 10 9 8 7 6 5 4 3 2 1 WPC 05 04 03 02 01 © 2002 Davis Publications, Inc., Worcester, Massachusetts, U.S.A. All rights reserved. No part of this publication may be reproduced or transmitted in any form or by any means, electronic or mechanical, including photocopying, recording, or any storage and retrieval system now known or to be invented, except by a reviewer who wishes to quote brief passages in connection with a review written for inclusion in a magazine, newspaper, or broadcast. Every effort has been made to trace the copyright holders. Davis Publications, Inc., apologizes for any unintentional omissions and would be pleased, in such cases, to add an acknowledgment in future editions.

Theme 4

- 146 Artists as Teachers
- 148 Core Lesson The Puppeteer as Teacher
- 154 4.1 Art and Beliefs
- 158 4.2 Lettering and Calligraphy
- 4.3 Islamic Art of North Africa4.4 Designing a Poster
- 168 Connect to...
- 170 Portfolio & Chapter Review

Page 163

#### Theme 5

- 172 Artists as Interpreters
- 174 Core Lesson Landscape Interpreter
- 180 5.1 Landscape as Art
- 184 5.2 Color Mixing
- 186 5.3 Art of China
- 190 5.4 Wood Constructions
- 194 Connect to...

Page 201

196 Portfolio & Chapter Review

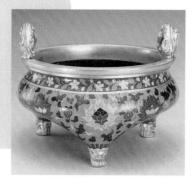

Page 187

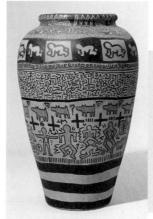

- Theme 6
- 198 Artists as Messengers
- 200 Core Lesson An Artist with a Message
- 206 6.1 Symbolism in Portraits
- 210 6.2 Monoprinting
- 212 6.3 Aboriginal Australia
- 216 6.4 A Linoleum Block Print
- 220 Connect to...
- 222 Portfolio & Chapter Review

----

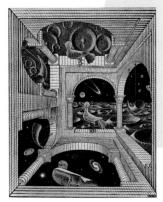

Page 229

| 224 Artists | as Inven | tors |
|-------------|----------|------|
|-------------|----------|------|

226 Core Lesson An Inventive Artist

232 7.1 Fantasy in Art

236 7.2 Perspective

Theme 7

238 7.3 Art of Puerto Rico

242 7.4 Building a Wire Sculpture

246 Connect to...

248 Portfolio & Chapter Review

Page 253

#### Theme 8

250 Artists as Planners

252 Core Lesson A Planner from the Start

258 8.1 Architecture for Living

262 8.2 Three-Dimensional Models

264 8.3 Art of Mexico

268 8.4 Corrugated Constructions

272 Connect to...

274 Portfolio & Chapter Review

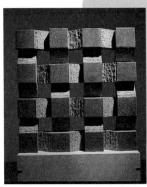

Page 286

#### Theme 9

#### **Artists as Pioneers**

278 Core Lesson A Pioneer in Art

284 9.1 Traditions of Sculpture

9.2 Casting a Relief Sculpture

290 9.3 Art of Israel

294 9.4 Recycling for Sculpture

Connect to... 298

300 Portfolio & Chapter Review

#### Resources

302 Acknowledgments

**Artist Guide** 303

306 World Map

308 Color Wheel

309 Bibliography

312 Glossary

316 Spanish Glossary

321 Index

Motivated by individual insights and beliefs, artists across time have served common roles within their cultures.

Art: A Personal Journey dedicates a chapter to each of these artistic traditions.

Page 100

and narrative art extend the tradition of artists as **Storytellers** 

**Theme 1** Dynamic images

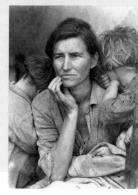

**Theme 2** Through documentaries, photographs, paintings, and prints, artists serve as **Recorders** 

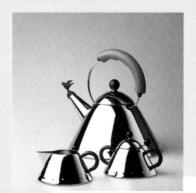

Page 130

Theme 3 By crafting telephones, teapots, cars, and clocks, artists shape our world as

Page 156

**Theme 4** Puppets, posters, billboards, and murals expand the tradition of artists as **Teachers** 

# A Personal Journey

Theme 5 Responding to the forms, patterns, power, and moods of nature, artists act as **Interpreters** 

Theme 7 By breaking, borrowing, and building on traditions, artists adopt the aura of **Inventors** 

**Planners** 

Theme 6 From cave paintings to music videos, artists use signs and symbols in their role as

#### Messengers

Page 202

Page 294

Theme 9 Through their exploration of new materials, techniques, subjects, and styles, artists act as

**Pioneers** 

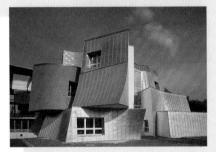

Page 253

Make the most of each chapter!
A unique CORE PLUS 4 chapter organization provides a structured exploration of art with the flexibility to zoom in on topics that interest you.

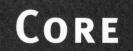

Sample pages from Chapter 6

Each theme opens with a CORE Lesson that provides a comprehensive overview of the topic.

In this theme, you will examine how artists use signs and symbols to communicate a message.

Each theme concludes with a studio activity that challenges you to apply what you have learned in a hands-on art project.

In this studio exercise, you create symbol stamps to be used in a print.

### PLUS 4

4 regular follow-up lessons reinforce and extend the CORE Lesson.

The first lesson examines the theme from the perspective of **art history**.

This lesson studies how artists across time have used symbols in portraits.

The second lesson explores the theme through different skills and techniques. This lesson examines how to use different printmaking styles to communicate a message.

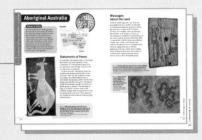

The third lesson looks at the theme from a global or multicultural viewpoint.
This lesson examines the use of symbols in traditional and contemporary Aboriginal art.

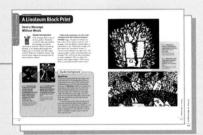

The fourth lesson studies the theme through a **studio activity**. In this project, you create a linoleum block print to send a message.

At the end of each chapter the themes

Connect to...

- Careers
- Technology
- Other Subjects
- Other Arts
- Your World

#### Make the most of each lesson!

There are a number of carefully crafted features that will help you read, understand, and apply the information in each lesson.

# Connecting

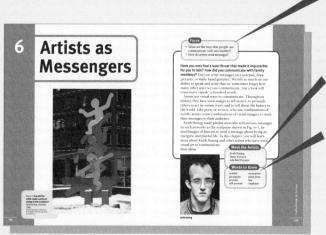

Read with purpose and direction.

Thinking about these Focus questions will help you read with greater understanding.

Meet the Artists.

These are the artists you will study in detail.

Build your vocabulary.
The first time these key terms are used, they are highlighted in bold type and defined. These terms are also defined in the Glossary.

Organize your thoughts. By dividing the lesson into manageable sections, these headings will help you organize the key concepts in each lesson.

### "Read" the visuals I with the text.

Note how the visuals are referenced in the text. Following these connections will help you understand the topic.

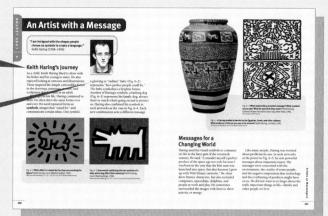

# Images and Ideas

Who made this? When was it made? What is it made of?

These and other important questions are answered by the credits that accompany each visual. This information will help you appreciate the art more fully.

Check Your Understanding! In addition to helping you monitor your reading comprehension, these questions highlight the significant ideas in each lesson.

#### **Don't Miss**

#### **Timelines**

Each **Then and Now** lesson is supported by a timeline that locates the lesson's artworks in history. As you study this timeline, consider how the art reflects the historic events that surround it.

#### **Locator Maps**

Each **Global Destinations** lesson is supported by a map that highlights the lesson's location in the world. As you read this map, consider how the art reflects the geography and culture of the place.

# Work with Your Mind

Make the most of each studio opportunity!

#### Core Studio

An expansive studio assignment concludes and summarizes each CORE Lesson.

#### Studio Lesson

A comprehensive studio lesson caps off each chapter by tying the theme's key concepts together.

### **Sketchbook** Connections

Quick processoriented activities

help you hone your technical and observation skills.

#### Studio Connections

Practical realworld studio projects explore

concepts through hands-on activities.

### Computer Options

An alternative to traditional art

materials, the computer can be used to do all or part of the lesson.

school dress codes. What kind of image will best express the seriousness, humon or concern you feel about your topic? How will you get people to notice and understand you get sepele to notice and understand to create emphasis? Will you use lines and shapes to create emphasis? Will you use lines to create emphasis? Will you use lines to create patterns and visual texture?

artics make price create more the printmaking is processes. And is read a standard learner to the same that the bestians and the of harder learner to the same that the same constant linderum, or lim surface of a bloom to the same to t

So tuan many people was not unary messages, some artists make prints: Printambling allows artists to create more than one copy of their artwork. Relief printamsking is one of severab losse printamsking processes. A relief print is made from a design that is raised from a filt background. Two traditional relief-printruksing processes are woodcuts and linioeleum, or line, cuts. Both involve carving the surface of a block to create an image. The raised areas will create the lines and contriv shaues in the

negative shapes. On the carried block, the artist coats the raised areas with ink and then places a sheet of paper or other material on the inked surface. When he or sh presses down on the poper or material, the inided image is transferred to it. The artist then "pulls the print" by carefully peeling the paper or material away from the block.

Build background knowledge.
Artists regularly draw from the lessons of history. This background information chronicles how artists from the past approached similar artistic endeavors.

Learn from your peers.

An example of student artwork allows you to see how others responded to these hands-on exercises.

# **Think with Your Hands**

Check Your Work
One way to evaluate your art is
through constructive group critiques.
These strategies help you organize
peer reviews.

Fig. 6-28 Now fild the artist Create pattern and feet lin this paint? Machine Wolfgang, The Country 2001.

sketch paper
pencil bench hook
linoleum block
carving tools brayer
construction
paper

#### Try This

1. On sketch paper, trace the edges of your block. Use a soft-leaded (#2) pencil to draw your design inside the lines of the trace. How will you use lines and shapes to best express your message? What part of the image will you emphasize? Think about which areas will print and which will be the color of the paper. With your pencil, fill in the areas that will print.

2. Carefully lay your design face-down on the linoleum side of the block. Make sure that the edges of the trace line up with the With your hand, rub the

trace line up with the edges of the block. With your hand, rub the back of the paper to transfer your design onto the block. Check the darkness of the image that is now on the block. Darken any lines that you think are too light.

bench hook. Carefully carve away the areas of your design that will not

5. Carefully place your printing paper over the block. Gentle rub the bac of the papper. When you see the funt impression of your design on the

#### pull the print awa

Display your artwork. Can your classmate "read" the message of your print? Discuss the ways that you and your classmates used lines and shapes to emphasize your message. What kinds of lines did you use? How did you use lines to create pattern an texture? Where do you see positive and neartise shapes?

wersions of the same design, they can also simulate some programment of the programment with drawing tools, create a line drawing, way the thickness of the lines to create a more interesting result. If necessary, reduce the size of the image. Then copy and passe the size of the image from the programment the triang from times onto one page—two on the top and two on the bottom—to create a secondate of fourths. Channe the center-

In simplest tertus, a line is a mark that and direction. Line is the most basic el art, yet it is the foundation from which create shape, pattern, texture, space, n form, or emphasis in their artworks. A start at one point and bend, wiggle, zig

at one point and bend, wiggle, zigzag, w
loop, or move straight
across an arrawek. It or
be fat, thin, hight, heav
problem, calm, or energ
indeed, line can be use
caspress any number of
caspress any number of

Artists create emphasis in artworks by midst medium—such as on object, shape, or simply this space—more noticeable than other things, the space—more noticeable than other things, the space—more noticeable than other things that shape is the savety of the space of t

interest in the artwork.

Look at some of your own works of art. What kinds of lines did you use? In what ways did you create emphasis?

Fig. 6—29 What makes this a powerful image? What message do you thit the artist was trying to send? Surryoung Park, Discrimination, 2001, lackmeters and, 10° at 10° 94 20 as, Most News Motor School, then follow interested. Artists as Messengers

218

This book explores the shared artistic traditions that unite individual artists across

**time.** Through this exploration, you will examine your own beliefs and motivations and learn why the joy of making and perceiving art is a personal journey.

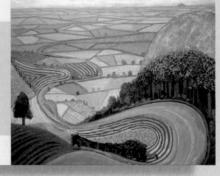

# **Student Gallery**

As you become fluent in the universal language of art, a wealth of studio opportunities will help you find your own voice.

The artworks on these four pages show how students just like you express their own unique insights and concerns.

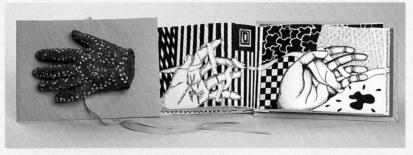

Page 5 Kristin Baker, Hand Book, 2000.

tempera, 6 <sup>1</sup>/<sub>2</sub> \* x 9 <sup>1</sup>/<sub>2</sub> \* (16.5 x 24 cm). Los Cerros Middle School, Danville, California.

Page 30 Matthew Howe, Falling Leaves, 2001.
Watercolor, construction paper, printmaking ink, 12" x 18" (30.5 x 46 cm)
Fred C. Wescott Junior High School, Westbrook, Maine.

Page 50 Hannah Parpart, Lines of Light, 2000.

Page 92 Rosie Perkins, The Magical Book, 2001. Magazine cutouts, construction paper, typed narrative, tempera paint, marker, handprinted paper, 12 ³/4\* x 19 ³/4\* 22 x 50 cm). Fred C. Wescott Junior High School, Westbrook, Maine.

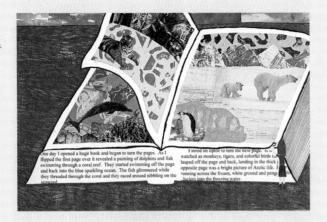

Page 107 **Christopher Berger,**"Who You Lookin' At?", 2000.
Marker, 9" x 11 ½" (21.5 x 29 cm). Penn View
Christian School, Souderton, Pennsylvania.

Page 144 **T. L. Tutor, Geometric** Silverware, 2000. Wood, wire, yarn, metal, clay 6\* To 7 \(^1/2^\*\) long (15 To 19 cm), Islesboro Central School, Islesboro, Maine.

# **Student Gallery**

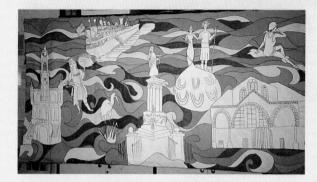

Page 170 Dennis McClanahan, Karina Ruiz, Rokeisha Joiner, Valarie Garcia, Iris Cuevas, Paul Brown, Shanna Nielsen, Views of Historic Galveston, 2000. Latex paint on canvas, 4'x8' (13 x 26.2 m). Central Middle School, Galveston, Texas.

Page 191 Wesley King,

The Fearless Monster, 2000.

Driftwood, paint, 18" x 1" (46 x 2.5 cm). JordanElbridge Middle School, Jordan, New York.

Page 219 Sunyoung Park, *Discrimination*, 2001. Linoleum block print, 3 <sup>3</sup>/<sub>2</sub>\* x 6 <sup>5</sup>/<sub>8</sub>\* (9 x 18 cm). Mount Nittany Middle School, State College, Pennsylvania.

Page 248 Sara Fischbacher, *Paper Mask*, 2001.
Paper, tagboard, glitter, 17" x 14" (43 x 35.5 cm). Smith Middle School, Fort Hood, Texas.

Page 269 Skye Lawrence, *Marble Run*, 2001.
Corrugated paper and cardboard, 18" x 17" x 11 <sup>1</sup>/<sub>2</sub>" (46 x 43 x 29 cm). Islesboro Central School, Islesboro, Maine.

Page 300 **Stephen Burrows**, *Keyboard Wiring*, **2001**. Keyboard, wire, rabbit's foot, copper foil,  $8^{1}/4^{\circ} \times 19^{\circ}$  (21 x 48 cm). Mount Nittany Middle School, State College, Pennsylvania.

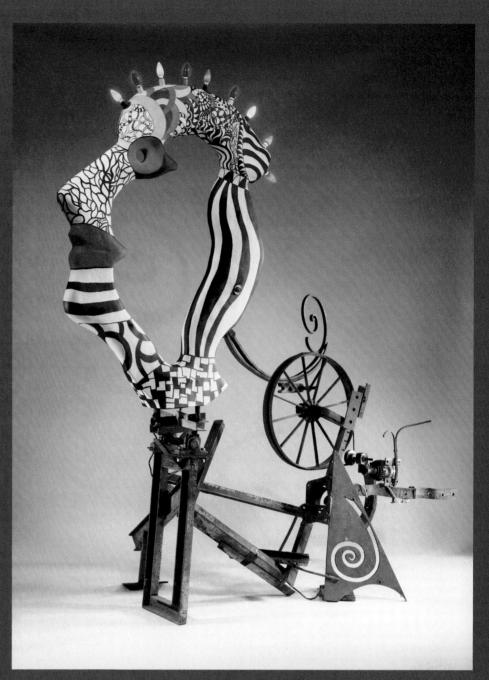

Page 40

## Foundations

# What Is Art?

If you ask three friends what art is, they probably won't give the same answer. Throughout history, art has meant different things to different people. And that remains true today.

Many art museums display beautiful objects from different cultures. Even though we call these objects works of art, the people who made them may not have thought of them as art. In fact, some cultures have no word for art. Yet they take great care in making beautiful pottery, jewelry, and masks.

Whether or not it is intended as art, an object made by a person shows that individual's creativity and skill. The artist, designer, or craftsperson must have thought about why he or she was making the object. Something he or she saw or imagined must have provided inspiration. Once the object is made, other people may see it as a work of art, or they may not. How they see and appreciate the object depends on their sensitivity and their own ideas about what art is.

Look carefully at some of the objects pictured in this book. Write down the names of the ones that interest you, including their page numbers. Which objects do you consider works of art? Why? Why do you feel that other objects are not art? Write down your answers. When you are finished with Part 1 of this book, look at the objects again. How have your opinions changed?

1

1

1

1

1

1

1

1

#### **Foundation Focus**

#### **Foundation 1** The Whys and Hows of Art

Foundation 1 Overview page 2-3

- Understand why humans produce art.
- 1.1 Practical, cultural, and personal functions of art.
- 1.2 Subjects and themes in art.
- 1.3 Expressionist, abstract, fantasy, and realistic styles of art.

#### **National Content Standards**

- Understand media, techniques, and processes.
- Choose and evaluate subject matter, symbols, and ideas.
- Assess own and others' work.
- Make connections between disciplines.

#### Objectives

#### Foundation 1.1 The Functions of Art

page 4 Pacing: One or two 45-minute periods

· Understand that art is created for practical,

cultural, and personal functions.

#### **National Standards**

- 3a Integrate visual, spatial, temporal concepts with content.
- 5a Compare multiple purposes for creating art.
- 5b Analyze contemporary, historical meaning through inquiry.

#### **Try This** Drawing, Painting, or Sculpture

· Create a drawing, painting, or sculpture that fulfills one of these functions.

3a Integrate visual, spatial, temporal concepts with content.

## page 5

#### **Objectives**

#### **National Standards**

#### Foundation 1.2 **Subjects and Themes** page 6 Pacing: One or two

45-minute periods

- · Understand and explain the difference between subject and theme in artworks.
- 3b Use subjects, themes, symbols that communicate meaning.
- 6a Compare characteristics of art forms.

## **Try This**

- · With other students, create a series of drawings based on the same theme.
- 1b Use media/techniques/processes to communicate experiences, ideas.

#### **Drawing** page 8

#### **Objectives**

#### **National Standards**

#### Foundation 1.3 Styles of Art page 10

Pacing: One to three 45-minute periods

- · Learn that artworks may be created in individual, cultural, or historical styles.
- Understand and identify the differences between expressionism, realism, abstraction, and fantasy art styles.
- 1a Select/analyze media, techniques, processes, reflect.

#### **Try This Drawing** page 12

- · Draw and paint a hand in two different art styles.
- 3b Use subjects, themes, symbols, that communicate meaning.

<sup>\*</sup> Assumes 4 classes per week for 36 weeks

#### **Featured Artists**

Tom Christopher M.C. Escher Keith Haring Käthe Kollwitz Leonardo da Vinci Maud Lewis

Robert McGill Mackall

Henry Moore Auguste Rodin Jamie Wyeth

#### Vocabulary

subject theme style

#### **Teaching Options**

Teaching Through Inquiry Using the Large Reproduction Using the Overhead Assessment Options

#### **Technology**

CD-ROM Connection e-Gallery

#### Resources

Teacher's Resource Binder A Closer Look: F1.1 Find Out More: F1.1 Assessment Master: F1.1

Large Reproduction 15 Overhead Transparency 1 Slides 1, 2, 3, 4, 16, 17

CD-ROM Connection Student Gallery Teacher's Resource Binder Thoughts About Art: F1.1

#### **Teaching Options**

Teaching Through Inquiry More About...Henry Moore Using the Large Reproduction Using the Overhead

#### **Technology**

CD-ROM Connection e-Gallery

#### Resources

Teacher's Resource Binder A Closer Look: F1.2 Find Out More: F1.2 Assessment Master: F1.2 Large Reproduction 3, 4 Overhead Transparency 3, 13 Slides 2, 4, 5, 7

Teaching Through Inquiry
Assessment Options
More About...Käthe Kollwitz
Using the Large Reproduction
Using the Overhead

CD-ROM Connection Student Gallery Teacher's Resource Binder Thoughts About Art: F1.2

#### **Teaching Options**

Meeting Individual Needs Teaching Through Inquiry Using the Large Reproduction Using the Overhead

#### Technology

CD-ROM Connection e-Gallery

#### Resources

Teacher's Resource Binder A Closer Look: F1.3 Find Out More: F1.3 Assessment Master: F1.3 Large Reproduction 13, 14 Overhead Transparency 17 Slides 6, 7, 8, 10, 12

Teaching Through Inquiry More About...Auguste Rodin Assessment Options Using the Large Reproduction CD-ROM Connection Student Gallery Computer Option Teacher's Resource Binder Thoughts About Art: F1.3 36 weeks

18 weeks

Connect to... page 14

#### **Objectives**

- · Identify and understand ways other disciplines are connected to and informed by the visual
- · Understand a visual arts career and how it relates to chapter content.

#### **National Standards**

6 Make connections between disciplines.

#### **Objectives**

- Portfolio/Review page 16
- Learn to look at and comment respectfully on artworks by peers.
- Demonstrate understanding of chapter content.

#### **National Standards**

5 Assess own and others' work.

#### **Teaching Options**

Museum Connection Interdisciplinary Planning

**Teaching Options** 

Advocacy Community Involvement Family Involvement

## Technology

Internet Connection Internet Resources Video Connection CD-ROM Connection e-Gallery

#### **Technology**

CD-ROM Connection Student Gallery

#### **Resources**

Teacher's Resource Binder Using the Web Interview with an Artist Teacher Letter

#### **Resources**

Teacher's Resource Binder
Chapter Review F1
Portfolio Tips
Write About Art
Understanding Your Artistic Process
Analyzing Your Studio Work

#### **Chapter Overview**

#### Foundation 1

By understanding why people create art, we can increase our understanding and appreciation of their art. By recognizing both cultural and individual styles in artists' shared themes and subjects, students will appreciate the uniqueness of individual artworks.

#### **Featured Artists**

Tom Christopher M. C. Escher Keith Haring Käthe Kollwitz Leonardo da Vinci Maud Lewis Robert McGill Mackall Henry Moore Auguste Rodin Jamie Wyeth

#### **Chapter Focus**

Throughout the world, artists produce works for practical, cultural, and personal uses. Beyond unique cultural and personal styles, artworks may be classified as expressionism, realism, abstraction, and fantasy.

#### **National Standards** Foundation 1 **Content Standards**

- 1. Understand media, techniques, and
- 3. Choose and evaluate subject matter, symbols, and ideas.
- 5. Assess own and others' work.
- 6. Make connections between disciplines.

# The Whys and Hows of Art

- Why do people all over the world create works of art?
- How do artists make their work unique?

Do you remember the first time you painted a picture?

You might have painted an animal or a scene from nature. Or perhaps you just painted swirling lines and shapes because you liked the way the colors looked **together.** No matter what the subject of the painting, there are many questions we can ask about how your first painting came to be. For example, what made you want to create it? How did you use paint to express your ideas? Why did you decide to paint the picture instead of draw it with crayons or a pencil? How was your painting similar to others you had seen?

These are questions we can ask about any work of art. whether it be your creation or someone else's. When artists work, they might not always think about these questions, but the answers are there. And while the answers might differ from one artist to the next, the

whys and hows of art can lead us to a world of wonder.

**Words to Know** 

subject theme style

## **Teaching Options**

#### **Teaching Through Inquiry**

Art History Have students use textbooks and library and Internet resources to investigate the original cultural contexts of the artworks on page 3, and to speculate about how these artworks might have been used. To prepare their findings, students could create images that show how each object appeared in its original surroundings, such as the hippo in an Egyptian setting, perhaps with a pyramid, and the ewer in use in a Japanese tea ceremony.

Fig. F1–1 The Huichol Indians of central Mexico cover objects with intricate patterns of brightly colored beads. What cat features can you locate? Native

American, Huichol Indian, Beaded Jaguar Head, 20th century.
Beads, pine pitch, and wax, 11\* x 12\* (28 x 30.5 cm). Courtest of Huicholartonline.com.

Fig. F1–2 This restored statue was discovered in a tomb. Three of its legs had been broken so that it would not harm the deceased in the afterlife. Egypt, Meir, Figure of Hippopotamus, Middle Kingdom

(1991–1786 BC).
Faience, height: 4 3/8\* x 7 7/8\* (11 x 20 cm). The Metropolitan Museum of Art,
Giff of Edward S. Harkness, 1917 (17.9.1). Photograph © 1997 The Metropolitan

Fig. F1–3 **How might the shape of a ewer affect its use?** [apan, Momoyama period (1568–1615), **Ewer for Use in Tea Ceremony**, early 17th century. Shino-Oribe ware. Stoneware with overglaze enamels, 7:1/a\* (19.7 cm) high. The Metropolitan Museum of Art, Purchase, Friends of Asian Art (fifts, 1988 (1988.156ab). Photograph © 2001 The Metropolitan Museum of Art.

Fig. F1–4 How would you describe the colors in this painting? What colors would you use to paint your hometown? Tom Christopher,

Broadway Steps, 1998.
Oil on canvas, 62" x 74" (157.5 x 188 cm). Courtesy the David Findlay Galleries (#C4288).

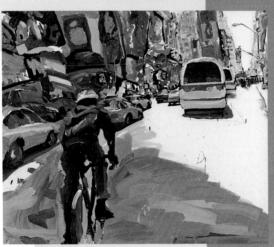

The Whys and Hows of

3

Art

#### **Chapter Warm-up**

Set out several diverse examples of art and designed objects—perhaps a drawing, a piece of jewelry or pottery, a shoe, and a photograph. **Ask:** Which pieces do you consider to be art. Why?

#### **Using the Text**

Aesthetics After students have read the text on page 2, ask them to describe a piece of art that they have made. Have volunteers answer the questions in the first paragraph.

#### **Using the Art**

Perception After students have studied the art images and read the captions on page 3, discuss their responses to the caption questions.

Art Production Lead students to imagine the movements of the artists' hands as they created their art. For the clay pieces, the artists' hands cupped and shaped the clay. Tom Christopher swept his hands and arms back and forth rapidly to make the brushstrokes. The Huichol Indian meticulously placed each little bead. Ask which work took longer to create. (probably the jaguar head, if not including drying time for the clay pieces)

Art History This Egyptian faience (clay containing ground quartz) hippopotamus was found in the shaft of a tomb chapel. Because Egyptians feared meeting a hippopotamus in their travels through the rivers of their afterlife, three of this hippo's legs were broken so that it would not harm the deceased.

#### More About...

Tom Christopher enjoys photographing the continuous parade of humanity in New York's Times Square. He transforms his city snapshots into slightly abstract, vibrantly colored acrylic paintings, which often include the unsettling qualities of urban life. Two of his paintings were printed as posters in the city's subways and another was made into a huge outdoor mural on the famous Times Square dance hall, Roseland.

#### The Functions of Art

#### **Prepare**

#### **Pacing**

One or two 45-minute periods, depending on the scope of Try This

#### **Objectives**

- Understand that art is created for practical, cultural, and personal functions.
- Create a three-dimensional paper artwork that serves two of the three art functions.

#### Teach

#### Engage

Aesthetics Have students show one another objects that they have with them, such as jewelry, school supplies, photographs, or combs. Ask: What is the function of each object? Do some objects have more than one use? Which would you consider to be art? Why?

#### **Using the Text**

Aesthetics After students have read pages 4 and 5, ask them to name several objects or artworks that fulfill each function.

#### **Using the Art**

Art History Ask: How might some of these artworks have served more than one function?

Art History Folk art, or "people's art," is usually created by self-taught artists who work outside academic art styles. It's sometimes described as primitive or naïve art. Discuss folk artists in the local community.

## National Standards Foundation 1.1

- **3a** Integrate visual, spatial, temporal concepts with content.
- **5a** Compare multiple purposes for creating art.
- **5b** Analyze contemporary, historical meaning through inquiry.

## **The Functions of Art**

Although people create art for many reasons, most artworks belong to one of three broad categories: practical, cultural, or personal. These categories describe the function, or role, of an artwork.

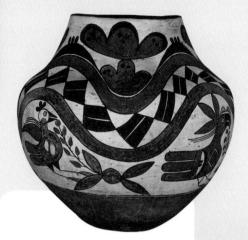

#### **Practical Functions**

Much of the world's art has been created to help people meet their daily needs. For example, architecture came from the need for shelter. People also needed clothing, furniture, tools, and containers for food. For thousands of years, artists and craftspeople carefully made these practical objects by hand. Today, almost all everyday objects that are designed by artists are mass-produced by machines.

Think about the clothes you wear and the items in your home and school. How do they compare to similar objects from earlier times or from other cultures? Which do you think are beautiful or interesting to look at? Why?

Fig. F1–5 Practical. The Acoma are Pueblo people of the semidry American Southwest. How has this artist included information about their homeland?

North American Indian, Acoma Polychrome Jar. Museum of Indian Arts and Culture/Laboratory of Anthropology, Museum of New Mexico. Photograph by Douglas Kahn. (18947/12).

Fig. F1–6 Cultural. Roman emperors built large triumphal arches to celebrate their greatest achievements. Roman, Arch of Constantine, 312–315 AD.
Located in Rome, Italy. Photo courtesy Davis Art Slifes.

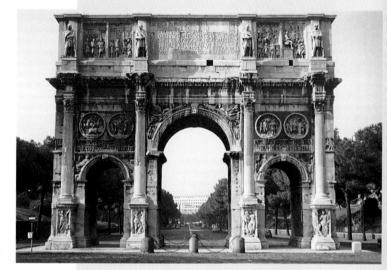

4

LESSON

FOUNDATION

## **Teaching Options**

#### Resources

Teacher's Resource Binder Thoughts About Art: F1.1 A Closer Look: F1.1 Find Out More: F1.1 Assessment Master: F1.1 Large Reproduction 15 Overhead Transparency 1 Slides 1, 2, 3, 4, 16, 17

#### **Teaching Through Inquiry**

Art Production Select a common object, such as a wastebasket. Ask students how they could design wastebaskets to serve practical, cultural, and personal functions. They may suggest trash bins painted with expressive designs to commemorate local holidays. Have students select from their pocketbook, pocket, or book bag, an object that they could redesign to serve the three art functions. Ask students to work in small groups to discuss their choices and designs and then report their most unusual solutions to the rest of the class.

#### **Cultural Functions**

We can learn a lot about different cultures by studying their art and architecture. Some buildings and artworks were made to honor leaders and heroes. Other works help teach religious and cultural beliefs. Sometimes art commemorates important historical events or identifies an important person or group.

Many artists continue to create artworks for cultural reasons. What examples can you think of in your community or state that serve a social, political, religious, or historical purpose? How are they different from artworks that have a practical function?

#### **Personal Functions**

An artist often creates a work of art to express his or her thoughts and feelings. The materials an artist chooses and the way he or she makes the artwork reflect the artist's personal style. The work might communicate an idea or an opinion that the artist has about the subject matter. Or it might simply record something that the artist finds particularly beautiful. Such personal works are created in many forms, including drawing, painting, sculpture, cartooning, and photography. What artworks do you know about that were created for personal expression or sheer beauty?

Fig. F1–8 Artists may use unusual materials to create personal meaning in their artworks. What did student artist Kristen Baker express in her artwork? Kristin Baker, Hand Book, 2000.
Construction paper, pen, ink, plaster gauze, tempera, 61/2\* x 91/2\* (16.5 x 24 cm). Los Cerros Middle School, Danville, California.

Fig. F1–7 Personal. Folk artist Maude Lewis brightened her home by painting colorful designs on the outside of her house. She also painted many of her household objects. How could you personalize your surroundings? Nova Scotian Folk Artist Maud Lewis in Front of Her House, 1965.

#### Try This

Create a three-dimensional paper artwork that meets two of the three art functions described in this section. You may decide to draw on your paper before folding, bending, and tearing it. Tape or glue it together. Write a description of your artwork that will help viewers understand its function.

#### Lesson Review

#### **Check Your Understanding**

- **1.** Select one artwork from page 3 that meets two of the three broad functions of art. Explain its possible uses.
- 2. Name and describe an object in your home or school that serves a practical function and could also be considered art.

#### **Try This**

Brainstorm a list of things students could make that would fulfill two of the art functions, such as an accordion-folded fan to commemorate a ball game or hero. Provide students with markers or pencils, tape, glue, and scissors. Display each artwork with a written description of its functions.

#### Assess

## **Check Your Understanding: Answers**

- 1. The hippo served a cultural/religious function of protecting the deceased in the afterlife; it likely had a personal function for the artist, who probably wished a good afterlife for the deceased. The ewer would have had the practical function of serving tea, and the cultural function of being part of the Japanese tea ceremony. Other answers possible.
- **2.** Encourage students to explain why they consider the useful object a work of art.

#### Close

Assign students to arrange a display of their artworks and descriptions. Encourage students to determine and explain how each piece could be used.

## 5

The Whys and Hows

of

Art

#### Using the Large Reproduction

Consider to what degree this architectural design serves practical, cultural, and personal functions.

#### 15

#### **Using the Overhead**

Lead a discussion of how this ancient sculpture may have served practical, cultural, and/or personal functions.

#### 1

#### **Assessment Options**

**Self** Ask students to consider one of their shoes. Have them de-

scribe its current function, which likely is practical. Challenge them to redesign their shoe so that it also serves a cultural and personal function. So that students demonstrate their understanding of the functions of art, direct them to write how this shoe can serve the three art functions.

## Prepare

#### **Pacing**

One or two 45-minute periods, depending on the scope of Try This

#### **Objectives**

- Understand and explain the difference between subject and theme in artworks.
- With other students, create a series of drawings based on the same theme.

#### Vocabulary

subject What you see in an artwork, including a topic, idea, or anything recognizable, such as a landscape or a figure.

theme The topic or idea that an artist can express and interpret in many ways with different subjects. For example, a work may reflect a theme of love, power, or discovery.

## National Standards Foundation 1.2

- **1b** Use media/techniques/processes to communicate experiences, ideas.
- **3b** Use subjects, themes, symbols that communicate meaning.
- 6a Compare characteristics of art forms.

# Subjects and Themes for Artworks

Artists are observers. They find subjects and themes for their work in almost everything they see and do. The **subject** of an artwork is what you see in the work. For example, the subject of a group portrait is the people shown in the portrait. Other familiar subjects for artworks include living and nonliving things, elements of a fantasy, historical events, places, and everyday activities.

You can usually recognize the subject of an artwork. Sometimes, however, an artist creates a work that shows only line, shape, color, or form. The artwork might suggest a mood or feeling, but there is no recognizable subject. This kind of artwork is called *nonobjective*.

Fig. F1-9 The subject of this sculpture is a four-armed elephant that represents the Hindu god Ganesha. India, Orissa, Seated Ganesha, 14th-15th centuries.

14th—15th centuries. Ivory, height: 71/4" x4 3/4" (18.4 x 12.1 cm). The Metropolitan Museum of Art, Gift of Mr. and Mrs. J. J. Klejman, 1964 (64.102). Photograph © 2001 The Metropolitan Museum of Art.

6

FOUNDATION

## **Teaching Options**

#### Resources

Teacher's Resource Binder
Thoughts About Art: F1.2
A Closer Look: F1.2
Find Out More: F1.2
Assessment Master: F1.2
Large Reproduction 3, 4
Overhead Transparency 3, 13
Slides 2, 4, 5, 7

#### **Teaching Through Inquiry**

Art Criticism Ask students each to select, from anywhere in this book, a piece of art that appeals to them. Have them identify the subject of the artwork to a group of four or five students. Challenge students to list the artworks from most realistic to most nonobjective. Have groups share their findings with the rest of the class.

#### **Using the Text**

Art Criticism After students have read the first paragraph, ask them to explain in their own words what the subject of an artwork is.

to cite examples of subjects and themes from stories they have read.

#### **Using the Art**

Art Criticism Have students identify the subject of each of the artworks on these pages. Ask: What was sculptor Henry Moore most interested in showing in Sheep Piece? (forms, the play of light on surfaces) Which piece of art on these pages is non-objective? (Moore's Sheep Piece)

Perception Ask students to describe the detailed carving in each sculpture. Then ask them how each surface would feel if they could run their fingers over it.

#### **Critical Thinking**

Ask students to compare the mood in Mackall's Circus Parade to that of Seated Ganesha. Discuss the role of elephants. (In the painting, elephants are novelties in a circus parade; in the statue, the elephant represents a god.)

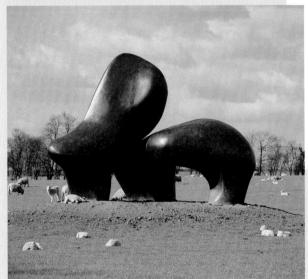

Fig. F1–10 Compare the subject of this painting to that of Seated Ganesha. How are they alike and different? Robert McGill Mackall. Circus Parade, n.d. Oil on canvas, 32" x 39 ½" (81.3 x 100.3 cm). Maryland Historical Society, Baltimore. Photo by

Fig. F1-11 This is a nonobjective sculpture. What mood does this work suggest? Henry Moore, Sheep Piece, 1971-72. Bronze edition of three, 18' 8" (5.7 m). Reproduced by permission of The Henry Moore Foundation.
Photograph by Michel Muller.

#### 7

0

Whys

#### More About...

English sculptor Henry Moore (1898-1986) was interested in direct carving and the emotional impact of form. During World War II, he drew people reclining in the London underground during bomb raids. For the rest of his life, he often used recliningfigure forms in his sculptures. Because he was so interested in natural forms, he carefully considered the landscape settings for his monumental outdoor sculptures.

#### **Using the Large Reproduction**

Lead a discussion about the subject and mood of this painting.

#### **Using the Overhead**

Compare the subiect and theme of this work with those of Fig. F1-10.

#### **Subjects and Themes**

#### **Using the Text**

Art Criticism After students have read the paragraphs, ask them to explain what an artwork's theme is.

Ask: What is the difference between theme and subject? What are the theme and subject of each of these artworks? How are the themes in Käthe Kollwitz's and Jamie Wyeth's artwork similar? (Both works are about protectiveness.)

#### Using the Art

Art Criticism Direct students to Portrait of Orca Bates, and ask them to write a detailed description of the subject. Discuss students' descriptions. Students should have noticed the boy's Hard Rock Café T-shirt, long hair, sturdy shoes, and the protective way that he is holding the seagull. From the landscape, they may infer something about his life.

#### **Try This**

Have students brainstorm possible themes for their drawing. Suggest different subjects that can express the same theme: for example, a galloping horse, a bicyclist, and an airplane could all be subjects for a theme about speed. Have small groups of students select a theme and decide on a subject for each member to draw. Distribute drawing media, such as pencils, markers, or crayons.

the theme.

## Computer Option Programs such as

WebWhacker, by storing preselected Websites, allow simulated online browsing. Students may copy and paste their chosen images into a slide program such as Hyper-Studio or Microsoft PowerPoint. As they show the slides, they could ask classmates to guess

Fig. F1–12 The landscape behind the boy is Monhegan Island, off the coast of Maine. What did Wyeth tell us about Orca Bates? Jamie Wyeth, *Portrait of Orca Bates*, 1989. Oll on panel, 50° x 40° (127 x 101.6 cm). The Farnesworth Art Gallery Giff of Mrs, John S. Ames by exchange.

The **theme** of an artwork is the topic or idea that the artist expresses through his or her subject. For example, the theme of the group portrait might be family togetherness or community support. Themes in art can be related to work, play, religion, nature, or just life in general. They can also be based on feelings, such as sadness, love, anger, and peace.

Artworks all over the world can reflect the same theme, but will still look entirely different. Why? Because the subjects used to express the theme probably won't be the same. For example, imagine that an artist in Australia and an artist in Canada each create a painting about natural beauty. Would the Canadian artist show a kangaroo? Probably not.

Look at the artworks in this lesson. What subjects do you see? What themes are suggested?

#### Try This

FOUNDATION LESSO

With a small group of students, create a series of drawings based on the same theme. Plan how each of you can use different subjects to show the same theme. Display your group's art together. Can other students guess the theme of your group?

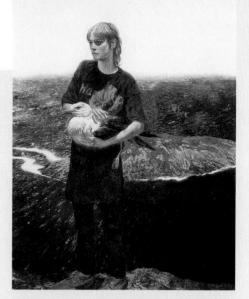

#### **Computer Option**

With a partner, browse art museum websites (virtual museums). Tour the sites, noting images that use similar

themes but feature different subjects. Try to find examples that differ not only in subject matter but also in the artist's nationality or geographic location. Discuss with your partner some ideas for developing a series of slides that are based on a theme but are created in different styles, featuring different subjects, media, and cultural influences.

Using the copy/paste command, create a slide show of five to ten slides to share and discuss with your classmates. The last slide can state the theme and the producers. You may wish to add special effects and sound.

0

## **Teaching Options**

#### Teaching Through Inquiry

Art Criticism Have students use the artwork they chose in Teaching Through Inquiry on page 6, or another artwork from this book. Make a master list of the chosen works, and have the class first arrange, in list form, the selected artworks by subject matter and then by theme. Have students work in small groups to discuss each arrangement and explain the difference between subject and theme.

#### More About...

German artist **Käthe Kollwitz** was a sculptor and printmaker who focused on death, war, and injustice in her artworks (her son was killed in World War I, and her grandson in World War II). During World War II, many artists fled Germany. However, even though the Nazis labeled Kollwitz a degenerate artist, she stayed in Berlin.

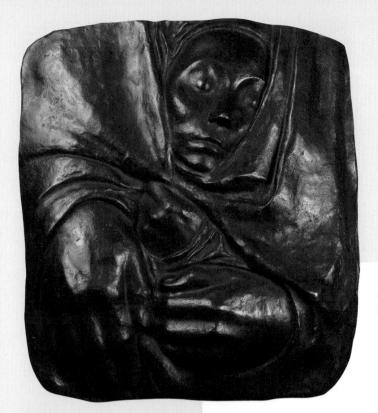

Fig. F1–13 What is the theme of this sculpture? How is it similar to the theme of Wyeth's portrait? Käthe Kollwitz, Rest in the Peace of His Hands, c. 1936. Bronze relief, 13·½° x 12·½° x 11·½° (3.3.7 x 31.8 x 2.7 cm). The National Museum of Women in the Arts, Gift of Wallace and Wilhelmina Holladay, © 2001 Artists Rights Society (ARS), New York/VG Bild-Kunst, Bonn.

Fig. F1–14 Each autumn, the landscape around this artist's home is covered with bright-colored leaves. If you created an artwork with a theme about nature near your home, what subject would you use? Amanda Winkler, The Leaf Mosaic, 2000.

#### Foundation Lesson 1.2

#### **Check Your Understanding**

**1.** What are the theme and subject of Fig. F1–12, *Portrait of Orca Bates* by Jamie Wyeth? How are they similar to Fig. F1–13, *Rest in His Hands* by Kāthe Kollwitz?

2. What do you think are the theme and subject of *Illumination*, shown on the Foundations chapter opener, page xx? Explain why you think this.

Extend

Allow each group to combine the individual drawings into large paintings to express the common theme. Groups may choose to enlarge their drawings, overlap images, and/or add a background to unify the painting.

#### Assess

#### Check Your Understanding: Answers

- 1. Wyeth's subject is Orca
  Bates. Students may also mention the bird he is holding and the landscape. Hands and a face form Kollwitz's subject. A theme of protectiveness is suggested in both artworks.
- 2. Illumination's subject is a head with light bulbs and a wheel. The theme (open to interpretation) could be "bright" ideas or the creation of energy to power lights.

#### Close

Discuss students' answers to Check Your Understanding. Encourage students to explain what clues in the artworks suggested each theme to them.

Display all the drawings, and ask nongroup members to name each group's theme. **Ask:** Did each group clearly express the theme? How might the group's members have made their themes even clearer?

9

of

Art

The Whys and Hows

#### **Assessment Options**

#### **Using the Large Reproduction**

Compare the subject and theme of this work with those of Fig. 1–12.

3

#### **Using the Overhead**

Lead a discussion about the subject and theme of this artwork.

13

#### **Prepare**

#### **Pacing**

One to three 45-minute periods, depending on the scope of Try This

#### **Objectives**

- Learn that artworks may be created in individual, cultural, or historical styles.
- Understand and identify the differences between expressionism, realism, abstraction, and fantasy art styles.
- Draw and paint a hand in two different art styles.

#### Vocabulary

style The result of an artist's means of expression—the use of materials, design qualities, methods of work, and choice of subject. In most cases, these choices show the unique qualities of an individual, culture, or time period. The style of an artwork helps you to know how it is different from other artworks.

## National Standards Foundation 1.3

1a Select/analyze media, techniques, processes, reflect.

**3b** Use subjects, themes, symbols, that communicate meaning.

## Styles of Art

A **style** is a similarity you can see in a group of artworks. The artworks might represent the style of one artist or that of an entire culture. Or they may reflect a style that was popular during a particular period in history.

You can recognize an artist's *individual* style in the way he or she uses art materials, such as paint or clay. An artist can adopt certain elements of design and expression that create a similar look in a group of his or her works. An artist might use the same kind of subject matter again and again.

Artworks that reflect *cultural* and *historical* styles have features that come from a certain place or time. For example, Japanese painters often use simple brushstrokes to depict scenes from nature. From a historical perspective, the columns used in ancient Greek architecture have characteristics that are immediately recognizable.

As explained in the following pages, there are also four *general* style categories that art experts use to describe artworks from very different times and cultures.

#### **Expressionism**

In an expressionist artwork, the mood or feeling the artist evokes in the viewer is more important than creating an accurate picture of a subject. The artist might use unexpected colors, bold lines, and unusual shapes to create the image. Expressionist artists sometimes leave out important details or exaggerate them. When you look at an expressionist work of art, you get a definite feeling about its subject or theme.

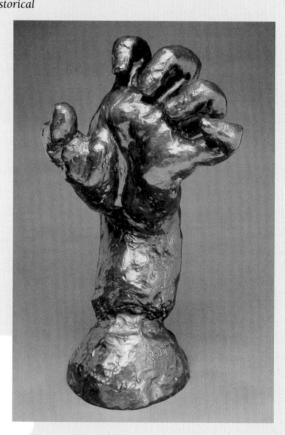

Fig. F1–15 Try holding your hand like this. What emotion does this hand seem to express? How does the texture of the sculpture add to this feeling? August Rodin, Large Tense Hand, 19th century.

10

FOUNDATION LESSO

## **Teaching Options**

#### Resources

Teacher's Resource Binder Thoughts About Art: F1.3 A Closer Look: F1.3 Find Out More: F1.3 Assessment Master: F1.3 Large Reproduction 13, 14 Overhead Transparency 17 Slides 6, 7, 8, 10, 12

#### **Meeting Individual Needs**

# Multiple Intelligences/Bodily-Kinesthetic Have students carefully imitate all the images of hands in the chapter. Tell them to close their eyes when taking each pose and to think about how the position makes them feel, such as calm, happy, or excited. Discuss how hand gestures, like facial features, can reveal a lot about people. Ask students each to develop a hand gesture to represent their present mood and to have a partner guess the emotion they are trying to communicate.

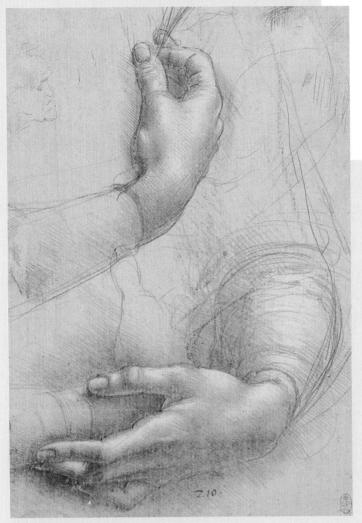

Fig. F1—16 Leonardo da Vinci filled his sketchbooks with detailed and lifelike drawings. He also drew ideas for his inventions. Notice how he experimented with several arrangements before shading these two hands. Leonardo da Vinci, *Study of Woman's Hands* (probably Ginerva de' Benci), c. 1474. Silverpoint, 8 ½° x 5 15/16° (21.5 x 15 cm). The Royal Collection © 2000. Her Majesty Queen Elizabeth II.

## Realism

Some artists want to show real life in fresh and memorable ways. They choose their subjects from everyday objects, people, places, and events. Then they choose details and colors that make the subjects look real.

A particular mood may be suggested in the artwork. Artists who work in this style often make ordinary things appear extraordinary. Some of their paintings and drawings look like photographs.

he Whys and Hows of

11

Art

#### Teach

#### Engage

Lead students in developing an awareness of architectural styles. Have students describe their school building. **Ask**: Is the roof flat or sloped? From what materials was it constructed? When was it built? Is it similar to other buildings constructed about the same time? How can you identify the age of buildings in your community? Explain that structures built about the same time in the same culture are often in the same style.

#### **Using the Text**

Art Criticism Have students read the text and then define style. Challenge them to explain the difference between realism and expressionism.

Ask: Why may an artist create an expressive work rather than a realistic work? (to suggest a mood or feeling)

#### **Using the Art**

Art Criticism Ask: Which hand is expressionist and which is realistic? (Rodin: expressionist; Leonardo: realistic) The rough surface texture of the sculpture suggests that what was important to the artist? (The unfinished surface suggests that the expression of a gesture or emotion was important.)

#### **Critical Thinking**

Have students hold their hands in the poses in the images. **Ask**: If someone had his or her hands in one of these positions, what might he or she be saying? Assign students to write a dialog for one of the images.

#### **Teaching Through Inquiry**

Art History So that they can prepare for a class conference titled "Rodin and Leonardo: Style-sharing Across the Centuries," challenge students to become experts on Rodin or Leonardo. Have students work in small groups, established according to which artist they have chosen. Groups should use library and Internet resources to find other examples of the artist's work. Ask students to prepare notes and written descriptions of the overall style of the artworks, and invite them to share their new expertise in the conference.

#### **Using the Large Reproduction**

Lead a discussion about the stylistic features of expressionism in this work.

13

#### **Using the Overhead**

Discuss the stylistic features of realism in this work.

17

#### **Using the Text**

Art Criticism Have students read about abstraction and fantasy. Ask: Is the style of the Keith Haring painting considered abstraction or realism? How did Haring make this hand an abstract artwork? (He simplified the shape and changed the colors.)

#### Using the Art

Art Criticism Ask students why the style of Escher's Drawing Hands is considered fantasy rather than realism. Point out that Haring's hand looks flat, whereas Escher's look as though they have depth. Discuss how each artist created these illusions. (with shading, or lack of it, and color)

#### **Try This**

Have students make several quick, experimental studies before drawing a more finished hand in pencil or charcoal. They could try a blind contour drawing, looking only at their hand as they sketch, and then some 30-second gesture drawings. Point out Leonardo's Study of Woman's Hands.

#### **Critical Thinking**

Have small groups categorize the style of images on pages 3-9. Discuss the group's classifications, having students identify why some works were classified as more than one style.

#### Extend

Have students form a clay sculpture of their hand or hands, perhaps using an expressionist style, as Rodin did. If the works are to be fired, students may need to hollow out any thick forms.

#### **Abstraction**

FOUNDATION LESSON

Artists who work in an abstract style arrange colors, lines, and shapes in fascinating ways. They find new ways to show common objects or ideas. Their artworks appeal to the mind and senses. For example, most people

see and feel flowing curved lines as graceful. Jagged lines remind people of sharp objects or sudden, unexpected events, such as lightning. Nonobjective artworks usually fall into this style category.

Fig. F1-17 Notice how Keith Haring abstracted his subject. Even though the image is simplified, how can you still tell that it is a hand? Keith Haring, Untitled (for Cy Twombly), 1988

## **Teaching Options**

#### Teaching Through Inquiry

Art History Have students work in small groups to answer this question: Why do styles of artworks change over time? Remind students that art historians use the idea of style to explain changes in art over time. Because clothing and hairstyles may change dramatically in a short time, guide their inquiry by asking students how they dressed and wore their hair a few years ago, and then have them compare those styles to their styles now. Ask: What accessories (bracelets, hair ornaments, hats, belts) were popular then? Which are popular now? What now seems old-fashioned? Guide student groups to explore the issue and prepare a presentation in which they use such visuals as diagrams and art reproductions to make their points.

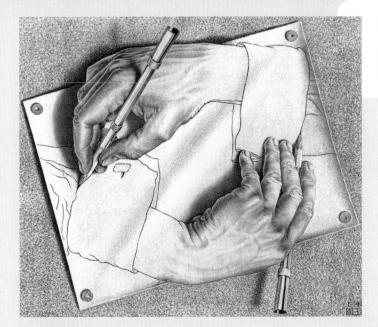

about this scene? M. C. Escher, *Drawing Hands*, 1948. Lithograph, 11 1/8\* (28.2 x 33.2 cm). © 2000 Cordon Art B.V. – Baar n – Holland. All rights reserved.

Fig. F1-18 What is unreal

#### **Fantasy**

The images you see in fantasy art often look as though they came from a dream. When fantasy artists put subjects and scenes together, they create images that appear unreal. While the subject might be familiar, the details in the artwork may not seem to make sense.

#### Try This

Draw your hand as realistically as you can. Before you begin, experiment holding your hand in different poses until you find an interesting one to sketch. Draw a second view of your hand in a style that is abstract or fantasy. Which drawing better expresses your personality?

#### **Sketchbook Connection**

Make several sketches of your hand. You may decide to hold an object in your hand. Begin sketching quickly and lightly

to find the shape of the hand. Then add darker lines. Add shading to one of your sketches to create the illusion of depth.

#### Foundation Lesson 1.3

#### **Check Your Understanding**

- **1.** How is realistic art different from fantasy art?
- **2.** Explain how the hands in the artworks on pages 10–13 express different themes.

Assess

## Check Your Understanding: Answers

- 1. Realistic art shows true-tolife subjects, whereas fantasy art shows dreamlike, unreal subjects.
- 2. Possible themes are tension and stress for Rodin, grace and beauty for Leonardo, excitement and agitation for Haring, and repetition and impossible situations for Escher. Ensure that students do not confuse the subjects (hands) with the themes.

#### Close

Discuss students' answers to Check Your Understanding. Have students arrange, by art style, a display of their drawings and paintings.

The Whys and Hows of Art

13

#### More About...

French sculptor **Auguste Rodin** (1840–1917) was influenced by Michelangelo's monumental and expressive sculptures. He worked at the time of the Impressionists and, like Impressionist paintings, his sculptures have a spontaneous feeling and an unfinished quality in their rough surfaces. This quality reflects his technique of forming the sculptures by hand in clay, plaster, or wax before casting them in bronze.

#### **Assessment Options**

**Teacher** Lead students each to imagine being a curator of a museum

that will display the images in lesson F1.2 (pages 6–9). In this museum are four galleries, each with works of a different style: expressionism, realism, abstraction, fantasy. Ask students in which gallery they would place each artwork. Have them write a sentence or two about each piece, explaining why it would fit well in the particular gallery.

#### **Using the Large Reproduction**

Of the four general style categories discussed in this chapter, consider where this work fits.

14

## Careers

Ask students to locate and conduct research on any public murals in the community, and then to choose one to "adopt" as a school project. Students may investigate the meaning and purpose of the mural and learn about its artist. If the artist is still living, students may be able to interview him or her by phone, through letters, or online. Have students publish the process and results of the project in the school's newspaper or on its Website.

#### **Daily Life**

Bring to class a number of handmade and mass-produced objects that would fit within a wide and inclusive view of art, and include such art forms as painting, graphics, collage, sculpture, ceramics, and jewelry. Set up a table with three signs: PRACTICAL, CULTURAL, PERSONAL. Have students work in small groups, and give each group several of the art objects. Ask the groups to categorize the purpose of each object as practical, cultural, or personal and then to place the objects with the appropriate sign. Discuss the results with the class, and ask students for their reflections

## Connect to...

#### **Careers**

Are there any large public paintings on the walls of buildings in your community? These paintings are called murals, and artists who make such works are **muralists** or **mural artists**. Muralists create art with a public audience in mind. They work with paint, clay, or other materials that can be applied to walls. Most often, murals are public works of art that are site-specific; that is, they are designed for a specific space or place. Muralists receive a commission from a patron to create their work. The patron may be a corporation, government agency, or individual who assigns and pays for the work. Muralists must be skilled in design

F1–19 Murals beautify public spaces and often reflect the people who live in a neighborhood. What are some things an artist would need to think about before painting the mural? Daniel Galvez, *Crosswinds*, 1992. and also must know how the weather will affect certain materials. Mural artists may major in fine arts in college or complete an apprenticeship with established mural artists.

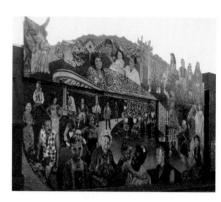

#### **Daily Life**

What does art mean to you? When you hear the term *art*, what images come to mind? Think of an object you see every day that you believe qualifies as a work of art. What are the **criteria** that are necessary for it **to be considered art**? Does the object have to be original and handmade? Or can it be a mass-produced item? Does it have to be a painting, or could it be a ceramic vase or quilt? Does it fill a practical, cultural, or personal function? Make a list of the artworks you encounter on a daily basis, and write down the artistic criteria they share.

F1–20 **What makes an object a work of art? Does displaying something in a museum mean that it is a work of art?** Native American, from California, *Karuk Spoons*, late 19th–early 20th centuries.

14

## **Teaching Options**

#### Resources

Teacher's Resource Binder:
Making Connections
Using the Web
Interview with an Artist
Teacher Letter

#### **Video Connection**

Show the Davis art careers video to give students a reallife look at the career highlighted above.

#### **Interdisciplinary Planning**

Show your art textbook to teachers of other subjects, and ask them which topics and artworks students study in their classes. Work together to develop interdisciplinary units.

## **Other Subjects**

#### Social Studies

Public memorials to great leaders serve a cultural function. For example, a recently dedicated memorial in Washington, D.C., honors Franklin D. Roosevelt, the 32nd president of the United States. Roosevelt is honored for leading the United States through the Great Depression and World War II. The life-sized bronze sculpture depicts Roosevelt in the wheelchair he designed himself. This sculpture replaces an earlier ten-foot bronze statue that showed the president in a straight chair with two tiny wheels on the back. A broad cape covered most of the chair. Although confined to a wheelchair, Roosevelt was almost never shown that way in photographs or newsreels of the time. Why would some contemporary groups be appreciative of the newer sculpture?

Language Arts

Think of a way that words can become art. Contemporary multimedia artists, such as Barbara Kruger and Jenny Holzer, use words and phrases as the subject and media of their artworks. They take words and pictures from mass media—advertisements, television, movies, newspapers, magazines—and display them in public places, such as on posters, billboards, theater and electronic signs, virtual

F1-21 One important feature of this statue is its placement. It is at ground level so that people in wheelchairs are able to touch it. FDR Memorial (detail),

2001.
Located in Washington, DC. Photo courtesy Brewster Thackeray, National Organization on Disability.

reality installations, and the Internet. The words themselves express social and political views and ideas. Why would an artist choose to use words? How can the use of words affect an artwork's meaning?

#### Mathematics

Do you think art can be found in mathematics? What mathematical ideas have interested both artists and mathematicians through time? The concepts of geometry may best connect the two subjects. These concepts include two-dimensional shapes, three-dimensional forms, the drawing system of perspective, symmetrical balance, and patterns made from repeating shapes. Many of these concepts may best be learned through experiences in art. Is it possible to learn about geometry without looking at any pictures or images, making any drawings, or handling any geometric forms?

## **Other Arts**

#### Music

People make and play music for many different reasons. Music has long been linked to religious ceremonies in cultures worldwide. The sounds and rhythms help people connect to the spiritual world. Music has also told stories through the ages. For example, folk songs from all cultures transmit lessons in history, values, and beliefs. People also create music simply for entertainment. Music is often an important element of social gatherings, festivals, and holidays.

#### **Internet Connection**

For more activities related to this chapter, go to the Davis Website at www.davis-art.com.

The Whys and Hows of

#### **Mathematics**

Have students bring their mathematics textbook to class, or borrow a set of texts from a math teacher. Ask students to work in pairs to study the texts and identify math concepts, especially those within geometry, that correlate with art. Challenge students to research and locate artworks that express the mathematical concepts.

#### Other Arts

So that students become increasingly aware of the variety of uses and contexts of music in their life, have them list the different ways music infiltrates their day. Ask students to categorize their list by purpose, such as for celebration, worship, commemoration, persuasion, or education. On the board, list all the categories, and have students bring in examples the next day. Play the recordings, and ask students to decide to which category each composition belongs, and then to vote on the best example in each category.

#### **Internet Resources**

#### **Keith Haring Kids**

http://www.haringkids.com/

This official Keith Haring Foundation site is designed for students.

#### The Huichol Center

http://www.huicholcenter.com/ Learn more about Huichol culture at this site.

#### Leonardo da Vinci: Scientist, Inventor, Artist

http://www.mos.org/leonardo/

This resource for teachers and students was developed by the Museum of Science, Boston, for the Science Learning Network.

#### **Museum Connection**

Develop a bulletin board about local museum and gallery exhibits, classes, and cultural events that will enrich students' art education. Display flyers, posters, schedules, and registration forms; and call students' attention to these special events. Encourage students to attend and then share their enriched art experiences with the class.

15

#### Portfolio & Review

#### **Talking About Student Art**

Teach students to discuss one another's art respectfully. Remind them that we learn from each other, and encourage them to consider why students created each of the artworks on this page. Help students decide if each work's function is practical, personal, or cultural. Then discuss the functions of the artworks that they created in this lesson.

#### Portfolio Tip

As students store their artwork in their portfolio, invite them to reflect on their

art. Help them understand that their portfolio becomes a chronicle of visible evidence of what they have learned in art class.

#### Sketchbook Tip

Students may create their own sketchbook by stapling or binding blank

pages together. Encourage them to design a cover that suggests their personality and interests.

## **Portfolio**

"When I made this drum, my idea was to create a Celtic-looking design on the outer part. Originally it was going to resemble the sea, and there were going to be starfish on it. That idea soon passed over and I ended up with the green drum." Kira Christensen

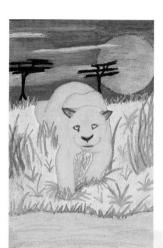

F1-22 How is this artwork a combination of practical, cultural, and personal functions? Kira

Christensen, Celtic Drum, 2001 PVC pipe, rawhide, leather, feather, acrylic paint,  $10^{1/2}$ " x  $6^{1/2}$ " x  $6^{1/2}$ " (26.5 x 16.5 x 16.5 cm). Les Bois Junior High School, Boise, Idaho.

"This piece of artwork I feel is sort of mysterious. What is going through this lion's head? Why is he all crouched up? The part I like best is the eves. It is almost as if there is some untold story in them." Veronica Schims

Oil pastel, 18" x 12" (46 x 30.5 cm). Fairhaven Middle School.

Bellingham, Washington

**CD-ROM Connection** 

To see more student art. view the Personal Journey Student Gallery.

F1-24 The class assignment was to begin with a flower close-up that could be viewed as abstract (or nonobjective) as well as realistic, and to work on a large scale. Note the size of the painting, listed in the credit information below. Ryan Brower, Flower Up-Close, 2000.

16

PORTFOLIO & REVIEW

## **Teaching Options**

#### Resources

Teacher's Resource Binder Chapter Review F1 Portfolio Tips Write About Art **Understanding Your Artistic Process** Analyzing Your Studio Work

For students' inspiration, for comparison, or for criticism exercises, use the additional student works related to studio activities in this chapter.

#### **Community Involvement**

Work with community officials to display student art regularly, in places other than the school, where others in the community can appreciate the artworks. Possibilities include the library, local government offices, store windows, malls, senior centers, district education buildings, or doctors' offices.

## **Foundation 1 Review**

#### Recall

List four general categories of art styles.

#### **Understand**

Explain the possible functions of a Japanese ewer. (*See example below.*)

#### Apply

Design a piece of art to serve a cultural function. Write a description of your artwork's subject, theme, and art style. Describe how it would serve its cultural function.

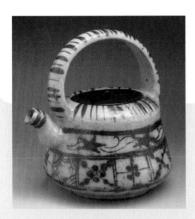

Page 3

#### Keeping a Portfolio

Artists keep their artworks in art portfolios. Some portfolios are folders of artists' actual artworks, whereas others are

digitized collections that can be viewed on a computer. Such a collection of artworks becomes a record of an artist's work. When artists apply for jobs, clients usually expect to see a portfolio of work so that they can see that artist's style. Begin a portfolio of your artworks. Store your art, as well as your art essays, reports, and statements in your portfolio.

#### Analyze

Compare and contrast the functions, art styles, subjects, and themes of the artworks on pages 6 and 7.

#### Synthesize

Suggest music that would go with each of the artworks on pages 10–13. How are the music and art styles of each work alike?

#### Evaluate

Imagine that you are on a committee to select a piece of art for your school's entrance area. What artwork from this chapter would you choose? Explain why this artwork's subject, theme, and style would make this an appropriate choice.

#### Keeping a Sketchbook

Artists keep sketchbooks, which they fill with drawings, sketches, doodles, plans, ideas, and notes. Begin your

own sketchbook by planning artworks that you may later store in your portfolio. Carry your sketchbook with you so that you can draw and record your thoughts any time. The more you sketch, the quicker you will build your drawing skills. Date your drawings to keep a record of your progress.

#### **For Your Portfolio**

As you complete each chapter, write a statement about what you learned. Store the statements in your portfolio

along with your artwork from that lesson. Review your art and writings to see how they change over time. You may notice that you begin to develop your own individual style. The Whys and Hows of Art

17

#### **Family Involvement**

Keep family members informed about upcoming art lessons and projects, and encourage them to share their culture and examples of its art, skills, and experiences with your classes.

#### **Advocacy**

To keep the rest of the school community aware of what students are learning in art, display students' artwork where it will be seen by students, faculty, and administration. With each piece, include a label (with the student's name and the artwork's title and medium) and a statement of educational goals for the group of works.

#### Foundation 1 Review Answers Recall

General style categories are expressionism, realism, abstraction, and fantasy.

#### **Understand**

The primary function of a Japanese ewer is to serve tea, but it could also function as the artist's means of self-expression, and as an object of beauty.

#### **Apply**

Students' designs might commemorate a leader, hero, or event, or teach about religious or cultural beliefs. Check students' writing for an explanation of how the design would serve a cultural function, and a description of the artwork's style, subject, and theme.

#### Analyze

Seated Ganesha serves a cultural function as a religious object, whereas Circus Parade and Sheep Piece serve personal functions as artists' self-expressions. Students might recognize Circus Parade as a cultural commemoration of a past community event. Seated Ganesha depicts a fantastical elephant with a religious theme. Circus Parade is a fairly realistic elephant in a circus parade, with a theme of a parade's spectacle and excitement. The subject of the abstract Sheep Piece is form; its theme is the beauty of form and texture.

#### **Synthesize**

Allow for a range of choices, but look for thoughtful complements and explanations for each piece. Students might select a classical piece with a flowing rhythm to go with Leonardo da Vinci's work, and a contemporary rap for Keith Haring's painting.

#### **Evaluate**

Students should justify their art choice in regard to its subject, theme, and style, as well as their own preferences.

#### Reteach

Have students work in small groups to analyze a piece of art from this chapter. After they have selected an artwork, ask them to decide why it was created (its function) and identify its subject, theme, and style. Have groups present their findings.

| F2 |  |  |  |
|----|--|--|--|
|    |  |  |  |
|    |  |  |  |

# Foundation Organizer

| 9 weeks | 18 weeks | 36 weeks | Touridation Organizer                                                                    |                                                                                                                                                                                                                                                                                                                                      |                                                                                                                                                             |  |
|---------|----------|----------|------------------------------------------------------------------------------------------|--------------------------------------------------------------------------------------------------------------------------------------------------------------------------------------------------------------------------------------------------------------------------------------------------------------------------------------|-------------------------------------------------------------------------------------------------------------------------------------------------------------|--|
|         |          |          |                                                                                          | Foundation Focus                                                                                                                                                                                                                                                                                                                     | National Content Standards                                                                                                                                  |  |
|         |          |          | Foundation 2 Forms and Media Foundation 2 Overview page 18–19                            | <ul> <li>Understand that art forms may be two-dimensional or three-dimensional.</li> <li>2.1 Two-dimensional Artworks</li> <li>2.2 Three-dimensional Artworks</li> </ul>                                                                                                                                                             | <ul> <li>1 Understand media, techniques, and processes.</li> <li>5 Assess own and others' work.</li> <li>6 Make connections between disciplines.</li> </ul> |  |
|         |          |          |                                                                                          | Objectives                                                                                                                                                                                                                                                                                                                           | National Standards                                                                                                                                          |  |
| 2       | 2        | 2        | Foundation 2.1 Two-dimensional Artworks page 20 Pacing: One or two 45-minute periods     | <ul> <li>Distinguish between two- and three-dimensional art forms and media.</li> <li>Explain the difference between art media and art forms.</li> </ul>                                                                                                                                                                             | <ul><li>1a Select/analyze media, techniques, processes, reflect.</li><li>5b Analyze contemporary, historical meaning through inquiry.</li></ul>             |  |
|         |          |          | Try This<br>Poster<br>page 22                                                            | Create a poster by using two different<br>two-dimensional art forms.                                                                                                                                                                                                                                                                 | <b>1a</b> Select/analyze media, techniques, processes, reflect.                                                                                             |  |
|         |          |          |                                                                                          | Objectives                                                                                                                                                                                                                                                                                                                           | National Standards                                                                                                                                          |  |
| 2       | 2        | 2        | Foundation 2.2 Three-dimensional Artworks page 24 Pacing: One to three 45-minute periods | <ul> <li>Understand that three-dimensional artworks<br/>have height, width, and depth.</li> <li>Know that sculpture, architecture, environmental design, and many industrial designs and crafts are three-dimensional art forms.</li> </ul>                                                                                          | <ul><li>1b Use media/techniques/processes to communicate experiences, ideas.</li><li>5b Analyze contemporary, historical meaning through inquiry.</li></ul> |  |
| •       | •        | •        | Try This<br>From 2-D to 3-D<br>page 26                                                   |                                                                                                                                                                                                                                                                                                                                      | <b>1b</b> Use media/techniques/processes to communicate experiences, ideas.                                                                                 |  |
|         |          |          |                                                                                          | Objectives                                                                                                                                                                                                                                                                                                                           | National Standards                                                                                                                                          |  |
| •       |          | •        | Connect to<br>page 28                                                                    | <ul> <li>Identify and understand ways other disciplines are connected to and informed by the visual arts.</li> <li>Understand a visual arts career and how it relates to chapter content.</li> <li>Learn to look at and comment respectfully on artworks by peers.</li> <li>Demonstrate understanding of chapter content.</li> </ul> | 6 Make connections between disciplines.                                                                                                                     |  |
|         |          |          |                                                                                          | Objectives                                                                                                                                                                                                                                                                                                                           | National Standards                                                                                                                                          |  |
| •       | •        | •        | Portfolio/Review<br>page 30                                                              | <ul> <li>Learn to look at and comment respectfully on<br/>artworks by peers.</li> <li>Demonstrate understanding of chapter content.</li> </ul>                                                                                                                                                                                       | 5 Assess own and others' work.                                                                                                                              |  |

#### **Featured Artists**

Robert Arneson Helmut Jahn Marvin Mattelson I. M. Pei Cindy Sherman

#### Vocabulary

ceramics fresco mobile montage mosaic relief sculpture

#### **Teaching Options**

More About...Bull-Leaping Teaching Through Inquiry Using the Large Reproduction Using the Overhead

#### **Technology**

CD-ROM Connection e-Gallery

#### Resources

Teacher's Resource Binder A Closer Look: F2.1 Find out More: F2.1 Assessment Master: F2.1 Large Reproduction 10 Overhead Transparency 10 Slides 2, 3, 4, 5, 7, 9, 10, 13, 14, 15, 16

Teaching Through Inquiry Meeting Individual Needs More About...Cindy Sherman Assessment Options CD-ROM Connection Student Gallery Computer Option Teacher's Resource Binder Thoughts About Art: **F2.2** 

#### **Teaching Options**

Teaching Through Inquiry More About...The Parthenon Using the Large Reproduction Using the Overhead

#### Technology

CD-ROM Connection e-Gallery

#### Resources

Teacher's Resource Binder A Closer Look: F2.2 Find Out More: F2.2 Assessment Master: F2.2 Large Reproduction 5, 16 Overhead Transparency 8, 18 Slides 1, 11, 12, 17, 18

Teaching Through Inquiry
More About...J Mays
Assessment Options
Using the Large Reproduction
Using the Overhead

CD-ROM Connection Student Gallery

#### **Teaching Options**

Interdisciplinary Planning Museum Connection

#### **Technology**

Internet Connection Internet Resources Video Connection CD-ROM Connection e-Gallery

#### Resources

Teacher's Resource Binder Using the Web Interview with an Artist Teacher Letter

#### **Teaching Options**

Family Involvement Community Involvement Advocacy

#### Technology

CD-ROM Connection Student Gallery

#### Resources

Teacher's Resource Binder
Chapter Review F2
Portfolio Tips
Write About Art
Understanding Your Artistic Process
Analyzing Your Studio Work
Home Connections Checklist

#### **Chapter Overview**

#### Foundation 2

Artists select either two-dimensional or three-dimensional art forms to express their messages or serve a function. In order to choose the most appropriate materials, artists should be familiar with and know how to use a wide variety of art media.

#### **Featured Artists**

Robert Arneson Marvin Mattelson I. M. Pei Cindy Sherman

#### **Chapter Focus**

Two-dimensional art forms have height and width, whereas threedimensional art forms have height. width, and depth. Based on their needs, artists choose to use either two-dimensional art media, such as drawing materials, paint, collage, printmaking, and photography materials; or three-dimensional media, such as sculptural, architectural, or crafts materials.

#### **National Standards** Foundation 2 **Content Standards**

- 1. Understand media, techniques, and
- 5. Assess own and others' work.
- 6. Make connections between disciplines.

# Forms and Media

- What are the differences between two-dimensional art forms and three-dimensional art forms?
- What materials do artists use to create two-dimensional and three-dimensional artworks?

When you tell someone that you have just created a painting or a sculpture,

you are naming the art form you used to express yourself. Art forms can be two-dimensional, as in painting, drawing, printmaking, and collage. Or they can be three-dimensional, as in sculpture, architecture, and even furniture.

When artists plan a work of art, they decide which art form will best express their idea. Then they work in that art form. For example, an artist who wants to express an opinion about nature might create a painting or a drawing. An artist who wants to honor an important person might create a sculpture.

The differences you see between artworks of any one form are vast. This is because artists use a wide variety of materials, or art media, to create their artworks. For example, a painter might choose to use oil paints or watercolor. He or she might paint on paper, canvas, or even glass. Similarly, a sculptor might work with clay, stone, or any object that best expresses his or her idea. Imagine seeing a sculpture made from a beach umbrella or a car!

The lessons in this chapter explore art forms and the media most commonly **Words to Know** used by artists.

art form art media fresco montage

mobile relief sculpture ceramics mosaic

## **Teaching Options**

#### **Teaching Through Inquiry**

**Art Production** Have students work in small groups to consider the expressive potential of different media. First have students view the four artworks of hands on pages 10-13 to note how different media can affect appearance and mood. Then have students create a list of feeling-related adjectives, such as calm, proud, energetic, nervous, busy, and bold. For each adjective, challenge students to choose a medium and imagine how an artwork could be made to convey the mood or feeling. Students may wish to record their ideas with sketches. Invite groups to share their ideas in a full-class discussion about art-making choices.

Fig. F2-1 What idea does this sculpture express? Robert Arneson, Pahlo Ruiz with Itch, 1980. ed earthenware, 87 1/2" (222.3 cm). Gift of the nds of Art (F82-38 a,b). The Nelson-Atkins Museum rt, Kansas City, Missouri. © Estate of Robert rson/Licensed by VAGA, New York, New York.

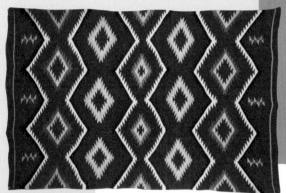

Fig. F2-2 What does this work tell you about the Navaio culture? North American Indian, Navajo, Arizona/New Mexico Blanket, Aniline dyes and wool,  $84\,^1\!/^2$ " x  $55\,^1\!/^2$ " (215 x 141 cm). Photo by R. Gray Gallery, Chicago, Illinois.

Fig. F2-3 The medium of this two-dimensional art is oil pastel. What is its art form? Nicole Dav-Bazhaw, Untitled, 1999.

**Chapter Warm-up** 

Use a sheet of paper to demonstrate that it has height and width, and, because it has so little depth, we consider it two-dimensional. Wad the paper into a ball to demonstrate that it now also has noticeable depth, making it clearly three-dimensional. Lead students in creating lists of twoand three-dimensional objects.

#### Vocabulary

art form A technique or method that is used to create an artwork, such as painting, photography, sculpture, or collage.

art media The materials used by the artist to produce a work of art.

#### **Using the Text**

Art Criticism Ask students to read about the difference between twoand three-dimensional art, and to explain this difference in their own words. Ask: Which artworks on page 19 are two-dimensional? Which are three-dimensional?

#### **Using the Art**

Art Criticism Ask: What media did Robert Arneson use to create Pablo Ruiz with Itch? (glazed earthenware, a type of clay) What do students think Arneson is saying about Spanish artist Pablo Ruiz y Picasso? Is Arneson honoring Picasso in this sculpture? Next, have students identify the media used to create the Navajo blanket and the student art. Discuss how they were made.

#### More About...

Traditionally, the Navajo wove wool leggings, belts, blankets, and some trade items. However, as they began to obtain goods at trading posts at the close of the nineteenth century, they became accustomed to manufactured clothing and weaving materials. Navajo artists began to weave blankets into designs that appealed to eastern customers, using bright-colored Germantown commercial yarns, named for the Pennsylvania city of their origin.

Drawing, painting, and other two-dimensional (2-D) art forms have height and width but no depth. To create 2-D artworks, such as those you see in this lesson, artists work with different types of art media.

#### **Drawing and Painting**

The most common media for drawing are pencil, pen and ink, crayon, charcoal, chalk, pastel, and computer software programs. Artists who draw choose from a wide range

of papers on which to create their images. Although many artists use drawing media to plan other artworks, drawings can also be finished works of art.

Oils, tempera, watercolor, and acrylics are common media used to create paintings. An artist might apply paint to a variety of surfaces, including paper, cardboard, wood, canvas, tile, and plaster. A fresco, for example, is a tempera painting created on a wet plaster surface.

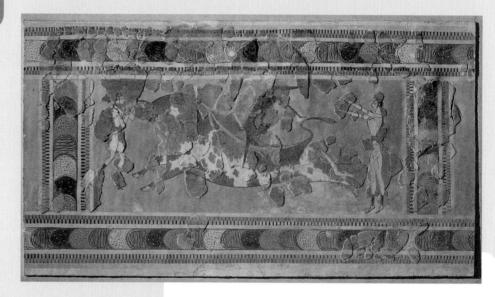

Fig. F2-4 Bulls were probably sacred animals to the ancient Minoans. This artwork shows two girls watching a boy vault over a bull. Minoan, from the palace at Knossos, Bull-Leaping (Toreador Fresco), c. 1450–1400 Bc. Fresco, height: 31 1/2\* (80 cm), including border. Archaeological Museum. Heraklion. Craft.

#### **Prepare**

#### **Pacing**

One or two 45-minute periods, depending on the scope of Try This

#### **Objectives**

- · Distinguish between two- and threedimensional art forms and media.
- · Explain the difference between art media and art forms.
- Create a poster by using two different two-dimensional art forms.

#### Vocabulary

fresco A technique of painting in which pigments are applied to a thin layer of wet plaster. The plaster absorbs the pigments, and the painting becomes part of the wall.

montage A special kind of collage that is made by combining pieces of photographs or other pictures.

#### **National Standards** Foundation 2.1

1a Select/analyze media, techniques, processes, reflect.

5b Analyze contemporary, historical meaning through inquiry.

## **Teaching Options**

#### Resources

Teacher's Resource Binder Thoughts About Art: F2.1 A Closer Look: F2.1 Find Out More: F2.1 Assessment Master: F2.1 Large Reproduction 10 Overhead Transparency 10 Slides 2, 3, 4, 5, 7, 9, 10, 13, 14, 15, 16

#### More About...

Bull-Leaping is the largest fresco recovered from the Minoan palace on the Greek island of Knossos. This restoration was based on the darker patches in the mural. Bull vaulting was probably part of a ritual game, which is alluded to in the Greek legend of the half-animal, half-human Minotaur.

#### Collage

To create a collage, an artist pastes flat materials, such as pieces of fabric and paper, onto a background. Some artists combine collage with drawing and painting. Others use unexpected materials, such as cellophane, foil, or bread wrappers. A collage made from photographs is called a **montage**.

#### **Printmaking**

This form of art can be broken down into several different kinds of processes. The main idea is the same for all: transferring an inked design from one surface to another. The design itself might be carved into wood or cut out of paper before it is inked. Then it is pressed by hand onto paper, fabric, or some other surface.

The most common printmaking processes

are gadget, stencil, relief, and monoprint. Other more complex processes include lithography, etching, and silkscreen. An artist can print a single image many times, using any printmaking process, except monoprinting; as the "mono" in its name suggests, an image can be printed only once.

Fig. F2–5 The student artist glued brilliant-colored tissue paper on an ink drawing to produce a mixed-media collage. Why do you think she added color to her portrait? Ileana Lopez, Untitled, 1998.
Pen, lik, Issue collage on paper, 16° x 11° (80, 8 x 28 cm), Gates Lane School, Worseste Mescriptstift

Forms and

Media

**Supplies for Engage** 

- empty cardboard boxes, such as packages for cereal, art supplies, or tissues. 1 box per 4 students
- scissors

#### Teach

#### Engage

Show students a box. Explain that it has three dimensions: height, width, and depth. Divide the class into small groups of students. Give each group a box and scissors, and tell groups to make the box two-dimensional. (They may flatten it or cut it into pieces.)

#### **Using the Text**

Art Production Have students work in small groups to develop lists of two-dimensional art forms and the media used to create each. Assign students to read pages 20–23 to learn about two-dimensional art forms and media.

Art Criticism Ask students to create a large class chart summarizing the group lists. Have students list the two-dimensional art forms as headings and, under each, provide a paragraph that describes the related art media.

#### **Using the Art**

Art Criticism Direct students' attention to Bull-Leaping. Ask: What art form is this? What media is it? Describe what you see in this painting. Do you know of a contemporary event involving bulls? (bull fights)

#### **Teaching Through Inquiry**

Art Production Have students work in small groups to investigate different ways to work with paint. For each painting in F1 and F2, have students note three things: the type of paint used, how the paint was applied (thickly, thinly, opaquely, transparently), and how paint was used for showing details (many details, some details, very few details). Next, have students work independently to create two small paintings of similar subjects. Suggest that they paint one in transparent watercolor and one in opaque tempera. Have students share their completed paintings within their group. Invite each group to plan an exhibit of their paintings, for which they arrange them to highlight how the use of media affects the look of artworks.

#### Using the Large Reproduction

Use this work as an example of printmaking. Discuss the technical aspects of making a woodblock print.

#### **Using the Overhead**

Use this work as an example of painting. Discuss the artist's use of brushstrokes.

10

#### **Using the Text**

Perception Ask: Where would you expect to find graphic designers' artwork? Have students list examples of graphic art that they can see in the artroom. (this textbook, labels on art supplies, designer logos on clothes) Aesthetics Discuss reasons why photography and movies are consid-

ered art.

#### Using the Art

Art Criticism Ask: How do the text and the illustration go together in the zebra poster? What is the poster's message? Why would a school of visual arts want to send this message?

Art Criticism Ask: What do you see in Cindy Sherman's photograph? Have you ever taken a photo of yourself? How did you do it? (with a timer or remote control) Challenge students to imagine a story to go with this photograph.

#### **Critical Thinking**

When commissioned to illustrate "To be good is not enough, when you dream of being great," Marvin Mattelson felt that the headline had been written for him. "I'm never satisfied with anything . . . I always want it to be better and greater. The classic zebra was a definition of myself." Challenge students to think of a good thing that they could make even better and then to draw it.

#### **Try This**

Review possible media that students could use (paints, pencils, ink, computer printouts, photographs, collage materials, printing), and discuss which would be most effective in communicating their message. Suggest that they plan their design with pencil before transferring it to a heavier piece of paper or posterboard.

#### **Graphic Design**

FOUNDATION LESSO

Graphic designers create original designs. Some of them print their designs by hand. They combine type and pictures to create posters, signs, corporate logos or symbols, advertisements, magazines, and books.

Most graphic designs are mass-produced on high-speed printing presses. Look around you. What examples of graphic design can you find in your classroom?

To be good is not enough. when you dream of being great.

Fig. F2-6 How does a rainbow zebra express "to be good is not enough"? Marvin Mattelson (illustrator), Subway Poster for School of Visual Arts.

## SCHOOL OF VISUAL ARTS

22

## **Teaching Options**

#### **Teaching Through Inquiry**

Art Criticism Explain that a film editor takes many hours' worth of film or tape and puts selected pieces together in a sequence. A film "cut" refers to a place in the film where pieces have been taken out or inserted. In the finished film, one cut ends and the next begins when, for example, the setting changes. Have students analyze a television commercial and count the number of film cuts they see. Ask them to write a description of the commercial and explain how the number of cuts affected the commercial's message.

#### **Meeting Individual Needs**

ESL and Multiple Intelligences/ Linguistic Ask students to imagine themselves as the swimmer in Cindy Sherman's photograph (Fig. F2-7) and to tell and/or write a story about what happened just before and just after this image.

## Photography, Film, and Computer Art

These 2-D art forms are fairly new in the history of art. The camera was invented in the 1830s, followed by moving pictures about sixty years later. Since their invention, photography and film have become two of the most popular media. Today, video cameras and computers offer even more media for artists working in the film or TV industry. Although individuals may use a single camera or computer to create art, feature films and television shows are usually created by a team of artists.

#### Try This

Create a poster for a school or community event. Use at least two of the two-dimensional media described in this section. As you design your poster, think about which art forms will catch people's attention and make your message understandable.

Fig. F2–7 Cindy Sherman uses photography and film to express her ideas. She often disguises herself with makeup and elaborate costumes. How could you use photography to express your ideas? Cindy Sherman, Untitled Film Still, 1979.

#### **Computer Option**

Design a poster about yourself. To begin, either create a selfportrait with a digital camera or scan an existing photograph

of yourself. Import your image into a program used for digital painting or drawing. Change the image in any way you wish. If you use a filter such as pointillism, charcoal, or embossing, consider how this will affect the poster's impact. Complete the poster by adding a large headline and, in smaller type, information about yourself.

#### **Sketchbook Connection**

Look at one of your favorite places from different angles and viewpoints. Using pencil, sketch an interesting view of

it. On another sheet of paper, recreate your scene in a different medium. You might choose to draw it with pastels or colored markers, paint it, or create a montage of cut paper and photos.

#### Lesson Review

#### **Check Your Understanding**

- **1.** List several media that can be used to create drawings and paintings.
- **2.** Explain the difference between a collage and a montage.

#### Computer Option Students may scan an

image into a program such as Adobe Photoshop. Encourage them to experiment with filters, and discuss the various effects. If the image-editing program does not support layout elements (borders, headlines, text), have students save the altered image and import it into a page-layout program. Students may base their layout on those of popular magazine covers.

#### Assess

## Check Your Understanding: Answers

- 1. Drawing media are pencil, pen and ink, crayon, charcoal, chalk, pastel, and computer software. Painting media are oils, tempera, watercolor, and acrylic.
- **2.** A montage is a collage created from photographs.

#### Close

Review students' answers to Check Your Understanding. Lead a discussion of how well their posters communicate their message about the event. **Ask:** Are you satisfied with the media? If you created a second poster, what media would you use? Display the posters in the school and community.

Forms and Media

23

#### More About...

Cindy Sherman began taking the 69 photographs in the *Untitled Film Stills* series soon after she graduated from State University of New York at Buffalo in 1977. After four years, she moved on to other subjects, explaining that she had run out of clichés. She continued to include herself in all of her photographs. *ARTnews* listed Sherman as one of the most important artists of the twentieth century.

#### **Assessment Options**

**Peer** Have students work in pairs to sort reproductions of two-dimensional artworks

according to their media. The images may be those from another chapter, the large reproductions, the overhead transparencies, postcards, calendars, or art magazines. Include at least one mixed-media image per group.

## **Prepare**

#### **Pacing**

One to three 45-minute periods, depending on the scope of Try This

#### **Objectives**

- Understand that three-dimensional artworks have height, width, and depth.
- Know that sculpture, architecture, environmental design, and many industrial designs and crafts are threedimensional art forms.

#### Vocabulary

mobile A hanging, balanced sculpture with parts that can be moved, especially by the flow of air.

relief sculpture A three-dimensional work designed to be viewed from one side, in which surfaces are raised from a background.

**ceramics** The art of making objects of fired clay. The clay is baked, or fired, at high temperatures in an oven called a *kiln*.

mosaic An artwork made by fitting together tiny pieces of colored glass, stones, paper, or other materials. The small pieces are called *tesserae*.

## National Standards Foundation 2.2

**1b** Use media/techniques/processes to communicate experiences, ideas.

**5b** Analyze contemporary, historical meaning through inquiry.

## **Three-Dimensional Artworks**

Architecture, sculpture, and other threedimensional (3-D) art forms have height, width, and depth. To create 3-D artworks, such as those you see in this lesson, artists work with different types of art media.

#### Architecture and Environmental Design

Architects design the buildings in which we live, work, and play. They think about what a building will be used for, how it will look, and the way it will relate to its surroundings. Architects combine materials such as wood,

steel, stone, glass, brick, and concrete to create the buildings they design. Then interior designers plan how spaces inside the buildings will look. They choose paint colors or wallpaper, carpeting, and upholstery fabrics. They also suggest how the furniture should be arranged.

Environmental and landscape designers plan parks, landscape streets, and design other outdoor spaces. They use trees, shrubs, flowers, grasses, lighting fixtures, and benches. They also use materials such as stone, brick, and concrete to create paths, sidewalks, and patios.

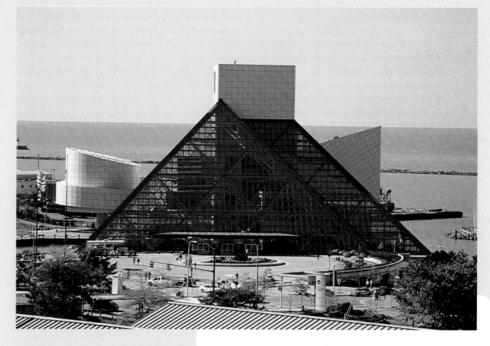

Fig. F2-8 The Rock and Roll Hall of Fame is located in Cleveland, Ohio. How does the design of this building suggest its use? I. M. Pei, Rock and Roll Hall of Fame and Museum, 1998.

24

LESSO

FOUNDATION

## **Teaching Options**

#### Resources

Teacher's Resource Binder
Thoughts About Art: F2.2
A Closer Look: F2.2
Find Out More: F2.2
Assessment Master: F2.2
Large Reproduction 5, 16
Overhead Transparency 8, 18
Slides 1, 11, 12, 17, 18

#### Teaching Through Inquiry

Aesthetics Ask: Do you consider architects and environmental designers to be artists? How are they different from builders? Are carpenters and brick masons artists? Lead students in discussing the fine differences among objects, and the way they are constructed that lead people to consider something a work of art. Note that people sometimes disagree about whether an object is or is not art.

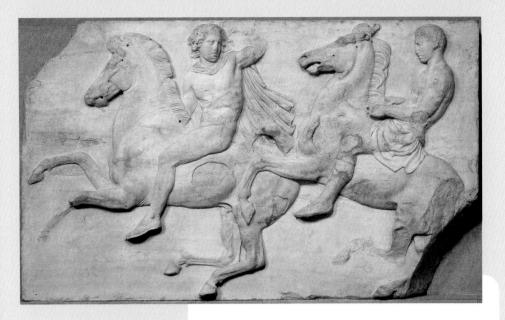

Fig. F2-9 These restless horses were once part of a larger sculpture of a procession. The procession was carved in marble relief near the top of the inner walls of the Parthenon, a Greek temple. Greek, Frieze of the Parthenon: Mounted Procession (detail, west II), 432 BC.

Marble, height: 42° (106cm). Courtesy the British Museum, © The British Museum, London, England.

#### **Sculpture**

Sculptures come in many forms. Most are designed to be viewed from all sides. You are probably most familiar with statues. A statue is a sculpture that stands alone, sometimes on a base. It can be life-size, as are the monuments you see in some parks. Or it can be small enough to place on a table or mantelpiece. A **mobile** is a hanging sculpture that has moving parts. The design on a **relief sculpture** is raised from a background surface and is intended to be viewed from only one side.

In addition to having many forms of sculpture to choose from, a sculptor can select from a great variety of media.

Traditional materials include wood, clay, various metals, and stone such as marble.

Sculptors also work with glass, plastic, wire, and even found objects.

Forms and Media

25

#### Teach

#### Engage

Have students describe a building in their community that is significant to them. Ask: How large is it? What materials is it made from? What shape are the windows and the roof? Describe any distinctive ornamentation. Tell students that, in this lesson, they will learn about three-dimensional art forms, including architecture.

#### **Using the Text**

Art Criticism Assign students to read page 24, and ask them to list the media used by architects, interior designers, and environmental designers.

Art Criticism After students have read page 25, ask them to explain what a mobile is. Challenge them to find other relief sculptures from previous chapters in this book. (Kollwitz's Rest in the Peace of His Hands, page 9) Have them locate sculpture examples on previous pages.

#### **Using the Art**

Art Criticism Direct students' attention to the Rock and Roll Hall of Fame. Tell students that the museum contains interactive exhibits, films, videos, and exhibits; and serves as a place for hosting concerts and lectures. Discuss students' answers to the caption question.

Art Criticism Explain that the
Parthenon frieze is a relief sculpture.
Ask: Which parts of this sculpture
are nearest to the viewer? Which
parts are farthest from the viewer?
How did the artist indicate these differences in depth? (by overlapping
and by using various carving depths)

#### More About...

The **Parthenon**, built between 448 and 432 BC, is a Doric temple perched atop the Acropolis, in Athens, Greece. Its interior frieze probably depicts a procession that was held every four years to honor the Greek goddess Athena. The horsemen in Fig. F2–9 are near the beginning of the parade. Originally, this frieze was brightly painted.

#### **Using the Large Reproduction**

Have students compare this building with the one in Fig. F2–8 and discuss use of materials and colors.

16

#### **Using the Overhead**

Have students compare this work with Fig. F2–9 and discuss features of sculpture in the round and bas-relief.

18

## 3-D Artworks

## **Using the Text**

Art Criticism After students have read the text, discuss the difference between crafts and industrial design. Ask students which medium is used in each of the artworks on these pages. Have them locate examples of industrial design within the artroom. (bottles, tools, desks, fire extinguisher, light fixtures, and so on)

## Using the Art

Perception Call students' attention to the patterns formed in the background of the stone mosaic. Have students trace these rows of stones with their fingers. Ask: How many different colors of stone were used in the bird's body?

Aesthetics As students consider the car design, lead them in discussing the various aspects of cars that affect the design. (safety, speed, gas mileage, sales appeal)

## **Try This**

Lead students in discussing how they could recreate one of the flat pieces of art in 3-D. Students may include themselves in the scene. Limit students' choice of 2-D art to those by professional artists.

#### **Computer Option** Three-dimensional simulation programs

range from the gamelike, such as SimCity, to those used by professional architects and designers. SimCity allows students to see the results of their design in a simulation of life in the environment. Such programs as The

Learning Company's Stagecast™ Creator allow students to create a simulated world with action animations. AutoCAD programs for interior-design and architectural rendering allow creation of sophisticated three-dimensional representations of structures.

## Crafts

LESSON

FOUNDATION

The term *crafts* applies to artworks made by hand that are both practical and beautiful. Among the many crafts are ceramics, fiber arts, mosaics, and jewelry making. Ceramics are objects that have been made from clay and then fired in a kiln. Fiber arts include objects that have been woven, stitched, or knotted from materials such as

wool, silk, cotton, and nylon. A mosaic is a design made of tiny pieces of colored glass, stone, or other materials. Artists who make crafts such as jewelry and other personal adornments might use gold, silver, wood, fabric, leather, and beads. Look at the clothing and jewelry your classmates are wearing. What materials are they made of?

Fig. F2-10 Do you think the artist placed the pebbles in the bird or the background first? Byzantine, Fragment with Bird, 6th century.

Fig. F2-11 Why was this car designed with this shape? What factors should industrial designers think about as they design cars? The New Volkswagen Beetle.

26

# **Teaching Options**

## **Teaching Through Inquiry**

Art History Have students work in groups to find ways that mosaics have been used in various cultures throughout the world and over time, including how mosaics are used today (as in commercial bathroom and flooring tiles). Ask groups each to create a posterboard display to illustrate their findings.

#### More About...

Oklahoman J Mays was the lead designer of the "new" VW Beetle, which was introduced in 1998. In college, he studied journalism until he realized he was spending most of his time drawing cars. He graduated from Art Center College of Design in Pasadena, California, and then worked for Volkswagen/Audi in Germany. While there, he learned to appreciate the spare Bauhaus design. Freeman Thomas, who collaborated with Mays in designing the Beetle, says: "The language of design is all about connecting with people."

## **Industrial Design**

Artists who design three-dimensional products for mass production are called industrial or product designers. They design everything from spoons and chairs to bicycles and cruise ships. Industrial designers pay great attention to a product's function and appearance. They use materials such as metal, plastic, rubber, fabric, glass, wood, and ceramics. The next time you're in a grocery or department store, note the many examples of industrial design all around you.

#### Try This

Choose a two-dimensional artwork shown in this book. Recreate it in three dimensions. For example, you might use clay to form a bull dance like the one shown on page 20 or cut and paste cardboard figures that stand up. Display your art near a reproduction of the original artwork.

#### **Computer Option**

Using the computer, create an environment. You may choose to show a place in nature, a building, or a

fantasy environment that exists only in your imagination. Try to include some sense of scale in your environment through the use of a reference such as a person or animal.

#### **Sketchbook Connection**

Sketch an object designed by an industrial designer. What materials were used to create the object? What function

does it serve? If you were to design a similar item for yourself, how would you change it? Draw your modified design.

#### Lesson Review

#### **Check Your Understanding**

**1.** What is the difference between two-dimensional and three-dimensional artworks? **2.** What are some crafts that are sometimes two-dimensional?

Fig. F2–12 This student artwork is similar to yarn paintings (nierika) made by the Huichol Indians of central Mexico. Ramon A. Gonzalez, Mexican Yarn Painting, 2000.

Yam, 10\* x 12\* (25.5 x 30.5 cm). Desert Sands Middle

#### Extend

Suggest to students that they research examples of Roman mosaics and then create their own mosaic from bits of colored paper or found stones, shells, gravel, or ceramic tiles glued to wood boards. Remind students to look again at the Byzantine mosaic to understand how tesserae may form a background pattern. Tell students that tesserae are bits of colored stone or glass used in making mosaics.

### Assess

# **Check Your Understanding: Answers**

- 1. Two-dimensional art has width and height, but three-dimensional art also has depth.
- 2. Mosaics and fiber arts are often 2-D. Students may be able to explain how other crafts could be 2-D.

## Close

Discuss students' answers to Check Your Understanding. Review which art forms are usually three-dimensional.

27

Media

## **Assessment Options**

**Self** Ask students to select several three-dimensional forms in their home or

school that serve a practical function and could be considered art. For each piece, have students draw and describe it, identify its media, and explain how the media and the function affect the design.

#### **Using the Large Reproduction**

Use this as an example of industrial design.

## **Using the Overhead**

Lead a discussion about the distinc-

tions often made between crafts and fine art.

#### Connect to . . .

#### Careers

Invite a local woodworker who is a fine artist or artisan to show his or her work and speak to your classes. Universities, community colleges, and area galleries are reliable sources for such artists. If you cannot find such an artist locally, have students search online-at the American Craft Museum: http://www. americancraftmuseum.org/; and the American Folk Art Museum: http://www.folkartmuseum.net/1.html -to find other artists who work in wood in forms as diverse as handcarved puppets or contemporary. hand-built furniture.

#### Other Arts

Play music from different eras: a grouping could include selections from swing, rock and roll, disco, and rap. Show film or video clips of dances that relate to each style, and encourage students to try each dance. Ask students to articulate the movement vocabulary, both physically and verbally. Ask: What movements, performed in what rhythms and/or patterns, characterize each form?

# Connect to...

## Careers

CONNECT TO

When you think of an artist, what image comes to mind? A painter wearing a beret and a smock, holding a paintbrush and a palette? Artists today have many more choices of art forms and media available to them. For example, woodworkers may be fine artists or artisans (skilled craftspeople), depending on the approach they take. Fine artists may work as sculptors or artists in three-dimensional design. An artisan may choose to use wood to make furniture, custom cabinetry, staircases, or practical household items. Each approach requires mastery of the techniques of cutting, joining, and finishing woods. Woodcarvers may earn a sculpture degree in college or learn their trade through apprenticeship programs.

F2-13 How is this lamp similar to and different from lamps you have seen? What makes it a work of art? Leah Woods, Lamp, 2000.

## **Other Arts**

#### Dance

Each dance form uses its own movement vocabulary, just as art styles rely on a visual vocabulary. The vocabulary is simply those movements that fit a particular dance. Many dance forms often borrow movements from earlier dances. For example, steps, rhythms, and movements of European folk dances became the basis for modern ballet. In the

early twentieth century, however, some choreographers (composers of dance) resisted the delicate, lighter-than-air movements of ballet. They created new movements that were close to the ground and had the body demonstrate weight, or heaviness. From boogie-woogie and disco to hip-hop and swing, each dance form contributes new movement vocabulary

#### **Internet Connection**

For more activities related to this chapter, go to the Davis Website at www.davis-art.com.

28

# **Teaching Options**

#### Resources

Teacher's Resource Binder: Making Connections Using the Web Interview with an Artist Teacher Letter

#### Video Connection

Show the Davis art careers video to give students a reallife look at the career highlighted above.

#### Interdisciplinary Planning

With other faculty, promote interdisciplinary field trips to museums or cultural events. Plan these well in advance so that students in all the subjects are introduced to the art prior to the tour.

F2-14 Architecture is one of the art forms we experience every day. From the buildings in which we live and are educated to office buildings and stores, architecture is an important part of our daily lives. Helmut Jahn, State of Illinois Center, 1985. Located in Chicago, Illinois, Courtesy Davis Art Siddes.

## **Daily Life**

What art forms and media do you come upon throughout your day? Make a list of them over the course of a day. Don't forget to look for a wide range of objects, such as posters, paintings, art photography, public sculpture, ceramics, quilts or weavings, and computer graphics. What other forms of art can you find? How many of these forms were available when your parents were teenagers?

## **Other Subjects**

#### Social Studies

Historians use different forms of primary and secondary sources for research and study. Primary sources are original materials, such as artworks, photographs, diaries, letters, and other artifacts. Secondary sources, such as your social studies textbook, are usually considered to be interpretations of primary sources. Look through your social studies textbook to see how many primary and secondary sources you can find. Which of these sources could be considered works of art?

#### Mathematics

What forms does art most often take in mathematics? In math, a figure is a geometric element. In art, two-dimensional figures are called shapes, and three-dimensional figures are called forms. In math, two-dimensional figures are known as plane figures, whereas three-dimensional figures are known as space, or solid, figures. Why would it be helpful for you to understand both sets of terms?

F2-15 The element neon is used to create the red color in bright signs like this one. Have you seen artworks created using neon?

#### Science

You may recall from science that an atom is the smallest particle of a chemical element that can exist and still retain its particular chemical properties. The **forms that chemical elements take** are determined by the way their atoms combine. For example, carbon atoms can become charcoal, pencil lead, or diamonds, depending on the way they join.

## **Daily Life**

Make and distribute a simple checklist of different art forms. Ask students to use it for keeping an account of the art forms that they encounter over just one day. The next time you meet with the class, tally and graph the results on the board or overhead projector, and discuss the findings.

Ask: What was the most common form? What conclusions can you draw from the results? Are any of the results unexpected? What did you learn from this activity? Did it change your thinking? If so, in what way?

#### **Social Studies**

Direct students' attention to a work of art and a reproduction of an artwork. Ask: Why is an actual artwork considered a primary source and a reproduction considered a secondary source? Why would a primary source be more valuable than a secondary source, especially where artworks are concerned? Can a secondary source, such as a reproduction, ever equal or replace its primary source? What aspects of an artwork are not always obvious in a reproduction? What art forms are most difficult to represent adequately in a reproduction?

Forms and Media

29

#### **Internet Resources**

#### The Art Car Museum

http://www.artcarmuseum.com/

View art cars by Larry Fuente and others.

#### **Art Kids Rule!**

http://artkidsrule.com/

Find art lessons, tutorials, quizzes, and links to various art forms.

#### Navajo Art: Weaving as a Way of Life

http://www.artsednet.getty.edu/ArtsEdNet/Resources/Navajo/Weav/index.html An instructional unit about Navajo weaving provides background information, questions, and activities for students and teachers.

#### **Museum Connection**

Develop a file of local museum contacts and their process for scheduling school tours. Schedule museum trips well in advance, and visit the museum prior to a tour, so as to select what students should see. Work with the museum's education staff to develop a tour geared to your classes.

#### **Portfolio & Review**

## **Talking About Student Art**

Have students identify the medium and the art form of the student examples. Instruct students in using the Expressive Word Cards in the Teacher's Resource Binder to describe these artworks and one another's works. Encourage students to look for the message and meaning in artworks.

## Portfolio Tip

Ensure that students understand how their portfolio will be used-if it will be

shared with family members and administrators, used for evaluation purposes, or kept as a personal record of growth.

## Sketchbook Tip

Discuss students' experiences using different media in their sketchbook.

Ask: Which media gave you the greatest sense of control? With which media were you able to cover the most area in a short time? Encourage students to write, in their sketchbook, a comparison of the media they used.

# **Portfolio**

REVIEW

PORTFOLIO

"I learned a lot, like how to sew. I really liked making my doll. The head gave it character and made it stand out." Titus L. Boehm

F2-17 Sometimes artforms and media overlap. This artwork combines aspects of printmaking, collage, and weaving. Matthew Howe, Falling Leaves, 2001. Watercolor, construction paper, printmaking ink, 12" x 18" (30.5 x 46 cm). Fred C. Wescott Junior High School, Westbrook, Maine.

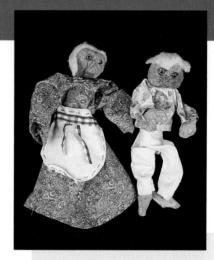

F2-16 Apple-head dolls are a traditional craft in western North Carolina. The head of each doll is carved from a dried apple. What crafts are popular in your hometown? Geneva Butler (left) and Titus L. Boehm (right), Apple-Head Dolls, 2001. Apple, wire, fabric, papier māché, paint, cotton, thread. Each doll is about 10° (25.5 cm) tall. C. D. Owen Middle School, Swannanoa, North Carolina.

#### **CD-ROM Connection**

To see more student art, view the Personal Journey Student Gallery.

"Our teacher told us to use the curves in our sculpture as pathways for blending color. I experimented with blues and purples. The effect reminded me of the colors of water and twilight. It took only one day to make the sculpture, but two weeks to paint it." James Chang

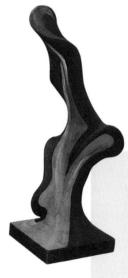

F2-18 Sculptures can be made from surprising materials. In this case, a section of pantyhose was stretched over a wire framework attached to a wooden base, then painted. James Chang, Evening Tide,

Pantyhose, wood, wire, tempera, height 11" (28 cm). Los Cerros Middle School, Danville, California.

30

# **Teaching Options**

#### Resources

Teacher's Resource Binder Chapter Review F2 Portfolio Tips Write About Art Understanding Your Artistic Process Analyzing Your Studio Work

## **CD-ROM Connection**

For students' inspiration, for comparison, or for criticism exercises, use the additional student works related to studio activities in this chapter.

# **Foundation 2 Review**

#### Recall

List two examples of two-dimensional media and two examples of three-dimensional media.

#### Understand

Explain the difference between two- and three-dimensional art forms.

#### Apply

Select a three-dimensional artwork from this chapter. Recreate your own version of this artwork in a two-dimensional media. Write a description of the artwork you selected. Explain what type of art form it is and the media it is made from. Describe the art form and media of your two-dimensional artwork.

#### Analyze

Compare and contrast the art forms and media of the *Bull-Leaping* fresco on page 20 and the mosaic on page 26 (Fig. F2–10, *shown at right*). How does the medium of each of these artworks influence its message?

#### For Your Sketchbook

Look carefully at a threedimensional object, and then draw it in your sketchbook. Draw the same object again,

but this time use a different medium. For example, if you drew it with pencil, try drawing it a second time with crayon, marker, or ink. With which medium were you able to draw the smallest details? Which medium would be better for large or fast sketches?

#### Synthesize

Select one artwork from Foundation 1 and one from Foundation 2 that are the same art form or medium. Write a description of both artworks' art form and medium.

#### Evaluate

From the chapter, select one artwork that you would like to hang on your bedroom wall. Explain why the medium, art form, subject, and theme would be appropriate for your room. Do you have a wall large enough for this art?

Page 26

#### **For Your Portfolio**

Select artwork to include in your portfolio. You might decide to choose pieces done in a variety of media and

techniques, or ones that show how your artistic skills are growing. Write your name and date on each artwork that you keep in your portfolio. Also write the assignment's purpose, what you learned, and why you selected the piece.

Forms and Media

31

#### **Family Involvement**

Develop a wish list of art-supply items that families might contribute to the art program. These may include found and recycled items, such as clean plastic cartons, yarn, sewing trims, magazines, newspapers, wood scraps, and Styrofoam trays. A complete list and form letter is in the Teacher's Resource Binder.

#### **Community Involvement**

Arrange for students to visit a local artist's studio. Before the visit, instruct students to note the materials and equipment the artist uses and how he or she stores and organizes them, and to try to identify any of the artist's inspirational objects in the studio.

#### **Advocacy**

Each time you send home an announcement of an art show, student exhibit, or field trip, include statements about the value of art in education and society.

## Foundation 2 Review Answers Recall

Examples of 2-D media include drawing media, such as pencil, ink, crayon, charcoal, chalk, pastel, and computer printouts; paint media, such as oils, tempera, and watercolor; collage media, including fabric, paper, and unexpected flat materials, such as cellophane or foil; printing media (inks); and photographic papers and films. Examples of 3-D media include wood, clay, metals, stone, plastic, glass, wire, and found objects.

#### **Understand**

Two-dimensional art forms have height and width, but not depth; three-dimensional art forms have height, width, and depth.

#### Apply

Students may draw, paint, or collage their interpretation of a 3-D artwork in this chapter. Look for thoughtful written descriptions.

#### **Analyze**

Bull-Leaping is a fresco (tempera paint on plaster), and Bird is made of pebbles. The fresco is smooth, whereas the bird has a slightly rough surface. Whereas the shapes of the mosaic pebbles somewhat determined the design of the bird, the plaster used by the artist of the fresco allowed for a freer use of line and color.

#### **Synthesize**

Each student's choices should share either the same medium or art form. Students should be able to differentiate between an art form (a classification or kind of art) and its media (materials it is made from).

#### **Evaluate**

Check that students correctly identify the medium, art form, subject, and theme in a relief or 2-D artwork and evaluate why these would be appropriate for their bedroom. Students should mention the artwork's size.

#### Reteach

Have students work in pairs to identify the art form and media of four artworks from Foundation 1, and to classify each as 2-D or 3-D. Have students present their findings to the rest of the class.

# 36 weeks 18 weeks 3 3

2

2

2

# **Foundation Organizer**

## **Foundation Focus**

#### · Understand that artists use the elements and principles of design to best express their ideas.

- 3.1 Elements of Design
- . 3.2 Principles of Design

## **National Content Standards**

- 2 Use knowledge of structures and functions.
- 6 Make connections between disciplines.

## **Objectives**

#### · Perceive and identify the art elements in artworks: line, shape, form, color, value, space, and texture.

#### **National Standards**

- 1b Use media/techniques/processes to communicate experiences, ideas.
- 2a Generalize about structures, functions.
- 2b Employ/analyze effectiveness of organizational structures.

# Try This

Foundation 3

**Elements and** 

Foundation 3 Overview

**Principles** 

page 32-33

Foundation 3.1:

page 34

**Elements of Design** 

Pacing: Three or four 45-minute periods

- · Create an illusion of depth in a landscape drawing.
- 1b Use media/techniques/processes to communicate experiences, ideas.
- 2c Select, use structures, functions.

## **Landscape Drawing** page 40

#### **Objectives**

#### **National Standards**

- Foundation 3.2 **Principles of Design** page 42
- Pacing: One or two 45-minute periods
- · Understand and perceive the principles of design in artworks.
- 2a Generalize about structures, functions.
- 2b Employ/analyze effectiveness of organizational structures.

#### **Try This** Collage page 44

- · Emphasize a center of interest in a collage.
- 2b Employ/analyze effectiveness of organizational structures.
- 2c Select, use structures, functions.

#### **Objectives**

- · Identify and understand ways other disciplines are connected to and informed by the visual
- Understand a visual arts career and how it relates to chapter content.

#### **National Standards**

6 Make connections between disciplines.

#### Connect to... page 48

## **Objectives**

## · Learn to look at and comment respectfully on

#### artworks by peers. Demonstrate understanding of chapter content.

## **National Standards**

5 Assess own and others' work.

#### Portfolio/Review page 50

#### **Featured Artists**

Omri Amrany and Julie Rotblatt-Amrany John Biggers Romaine Brooks Dale Chihuly Caryl Bryer Fallert Frances Hare David Hockney Hung Liu Yolanda Lopez
Deborah Oropallo
Niki de Saint Phalle and
Jean Tinguely
Charles Sheeler
Wayne Thiebaud
Doug Webb

#### Vocabulary

**Elements of Design** 

line shape form color value space texture Principles of Design
balance
unity
variety
emphasis
proportion
pattern
movement and
rhythm

#### **Teaching Options**

Teaching Through Inquiry
More About...Wayne Thiebaud
Using the Large Reproduction
Using the Overhead
More About...Charles Sheeler
More About...John Biggers

#### **Technology**

CD-ROM Connection e-Gallery

#### Resources

Teacher's Resource Binder A Closer Look: F3.1 Find Out More: F3.1 Assessment Master: F3.1

2, 9, 11, 18 Overhead Transparency 2, 9, 14 Slides 1, 5, 6, 7, 8, 9, 11, 12, 13, 14, 15, 18

Large Reproduction

Teaching Through Inquiry
More About...Niki de Saint Phalle & Jean Tinguely
Assessment Options
Using the Large Reproduction
Using the Overhead

Computer Option CD-ROM Connection Student Gallery

Teacher's Resource Binder Thoughts About Art: F3.1

## **Teaching Options**

Meeting Individual Needs Teaching Through Inquiry Using the Large Reproduction

## **Technology**

Computer Option CD-ROM Connection e-Gallery

#### Resources

Teacher's Resource Binder A Closer Look: F3.2 Find Out More: F3.2 Assessment Master: F3.2 Large Reproduction 8, 12 Overhead Transparency 5, 6 Slides 2, 3, 4, 5, 9, 11, 13, 14, 15, 16

More About...Yolanda Lopez
Using the Large Reproduction
Using the Overhead
Teaching Through Inquiry
More About...Omri Amrany & Julie Rotblatt-Amrany
Assessment Options

#### CD-ROM Connection Student Gallery

Teacher's Resource Binder Thoughts About Art: F3.2

## **Teaching Options**

Interdisciplinary Planning Museum Connection

#### Technology

Internet Connection Video Connection Internet Resources CD-ROM Connection e-Gallery

#### Resources

Teacher's Resource Binder Using the Web Interview with an Artist Teacher Letter

#### **Teaching Options**

Family Involvement Community Involvement Advocacy

#### Technology

CD-ROM Connection Student Gallery

#### Resources

Teacher's Resource Binder
Chapter Review F3
Portfolio Tips
Write About Art
Understanding Your Artistic Process
Analyzing Your Studio Work

## **Elements and Principles**

## **Chapter Overview**

#### Foundation 3

Artists use the elements and principles of design to create their art. To communicate effectively through art, artists must understand how the elements and principles interact.

#### **Featured Artists**

Omri Amrany and Julie Rotblatt-Amrany
John Biggers
Romaine Brooks
Dale Chihuly
Caryl Bryer Fallert
Frances Hare
David Hockney
Hung Liu
Yolanda Lopez
Deborah Oropallo
Niki de Saint Phalle and Jean Tinguely
Charles Sheeler
Wayne Thiebaud
Doug Webb

## **Chapter Focus**

The elements of design are line, shape, form, color, value, space, and texture. The principles of design are balance, unity, variety, emphasis, pattern, proportion, and movement and rhythm.

By understanding the characteristics of the design elements and how they work together as design principles, artists can choose and manipulate the elements and principles to best express their ideas.

## **Chapter Warm-up**

On the board, write: Design Elements: line, shape, form, color, value, space, texture. Have students use these words to describe the furnishings in the artroom. For example, the desks may have straight lines and square shapes and forms. They may be light brown with a smooth surface and a large, rectangular space between the legs.

# National Standards Foundation 3 Content Standards

- 2. Use knowledge of structures and functions.
- **6.** Make connections between disciplines.

OUNDATION

# Elements and Principles of Design

- What are the elements and principles of design?
- How do artists use the elements and principles of design in their artworks?

Artists use their imagination when they work. They experiment with ideas and art media,

**and invent new ways to create artworks.** But before they actually get down to making a work of art, they must have a plan, or design, in mind.

In art, the process of design is similar to putting a puzzle together. The basic pieces or components that an artist has to choose from are called the *elements of design*. Line, shape, form, color, value, space, and texture are the elements of design. The different ways that an artist can arrange the pieces to express his or her idea are called the *principles of design*. Balance, unity, variety, movement and rhythm, proportion, emphasis, and pattern are the principles of design. When an artist is happy with the arrangement, the design is complete.

As you learn about the elements and principles of design, think about how they can help you plan and create your own art. Soon you will see that they can also

color

help you understand and appreciate the artworks of others.

#### **Words to Know**

Elements of Design Princ line value balan shape space unity form texture varie

Principles of Design
balance pattern
unity proportion
variety movement
emphasis rhythm

32

# **Teaching Options**

#### **Teaching Through Inquiry**

Art Criticism Put students into three groups. Assign each group one of the artworks on page 33. Give each student a 3" x 5" card. Direct students to write the work's title on one side, and, on the other side, one word or phrase each for the shape, the lines, and the color. Collect and shuffle the cards. Give each student a card, with the descriptive words face-up. Challenge students to guess which work is described before they turn over the card. Tally and discuss the words used most often. Also discuss particularly poetic or appropriate descriptions.

Fig. F3-1 Dale Chihuly creates huge chandeliers from hundreds of colored blownglass shapes. How do you think light affects the look of this artwork? Dale Chihuly, Victoria and Albert Rotunda Chandelier, 1999.
Blown glass and steel, 18' x 8' x 8' (5.3 x 2.4 x 2.4 m

Fig. F3-3 The student artist arranged shapes around a central point to create a design with radial balance. How many radial patterns can you find? Adam Price,

Tessellating Figures, 2000.

Fig. F3-2 How did Deborah Oropallo create a sense of depth in some parts of this piece? Compare these lines to the lines of Chihuly's chandelier. Deborah Oropallo, Amusement, 1997 Oil on canvas, 120" x 52" (304.8 x 132.1cm). Collection of the San Jose Museum of Art, San Jose, CA. Museum purchase with funds from the Council of 100. Photo by Sue Tallon.

## **Using the Text**

Art Criticism Have students read the text and review the design elements from Chapter Warm-up. Next to the list of design elements on the board, write: Design Principles. Write the principles as volunteers name them. Discuss the difference between the elements and principles.

## Using the Art

Art Criticism Have students use design-element terms to describe Dale Chihuly's chandelier. Ask: What is the overall texture and the texture of individual pieces? What color is it? How does light affect the color? What adjectives describe the forms and lines? Point out that Chihuly created unity by repeating and overlapping similar forms. Have students compare their height to that of the chandelier.

Art Criticism Ask: What is the most important design element in Oropallo's Amusement? How do these lines compare to Chihuly's? Which seem geometric? Which seem organic? In which work is color more important? How did Oropallo create unity? (by repeating colors and the same kinds of lines)

## **Critical Thinking**

Challenge students to think of analogies, other than a puzzle with its pieces, to describe the relationship between the elements and principles. For example, the elements are ingredients for a cake; the principles are the recipe directions.

#### More About...

Maestro of molten glass, Seattle artist Dale Chihuly oversees a team of glassblowers to create his internationally exhibited, unconventional glass sculptures. Born in 1941, he studied interior design at the University of Washington, and glass at the University of Wisconsin and at the Rhode Island School of Design, where he also taught. Since losing vision in his left eve in a traffic accident and dislocating his shoulder while bodysurfing, he no longer is the head glassblower for his projects, but he creates drawings of his designs for his assistants.

## **Prepare**

## **Pacing**

Three or four 45-minute periods, depending on the scope of Try This

## **Objectives**

- Perceive and identify the art elements in artworks: line, shape, form, color, value, space, and texture.
- Create an illusion of depth in a landscape drawing.

## Vocabulary

elements of design The visual "tools" that artists use to create an artwork, such as line, color, value, texture, and shape.

# National Standards Foundation 3.1

- **1b** Use media/techniques/processes to communicate experiences, ideas.
- 2a Generalize about structures, functions.
- **2b** Employ/analyze effectiveness of organizational structures.
- 2c Select, use structures, functions.

# The Elements of Design

#### Line

LESSON

FOUNDATION

F 3

Many people think of a **line** as the shortest distance between two points. To artists, a line is a mark that has length and direction. Lines can have many different qualities that

Fig. F3-4 How did Wayne Thiebaud make the shapes of the numbers seem flat but indicate that the body is a threedimensional form? Wayne Thiebaud, Football Player, 1963.

Oli on carvas, 72° x 36° (183 x 91.5 cm). Virginia Museum of Fine Arts, Richmond, Gift of the Sydney and Frances Lewis Foundation. Photo: Katherine Wetzel. © Virginia Museum of Fine Arts. © Wayne Thiebaud/Licensed by VAGA, New York, New York.

help artists express their ideas. They can be thick or thin, wavy, straight, curly, or jagged. Artists use lines to outline shapes and forms or to suggest different kinds of movement. Sometimes artists use *implied* line. An implied line is not actually drawn, but is suggested by parts of an image or sculpture, such as a row of trees or a path of footprints.

If you look closely, you can find examples of line in every work of art you see. Notice how they affect the mood of an artwork. For example, how might a drawing with thick, zigzag lines be different from one with light, curved lines?

Fig. F3–5 Romaine Brooks used contour lines to draw a soldier, child, and dog. What kinds of shapes are formed by the lines? Romaine Brooks, The Soldier at Home, 1930. Pencil on paper, 97% \* x71% \* (24 x 18 cm). Gift of Romaine Brooks. Smithsonian American Art Museum, Washington, DC/Art Resource,

34

# **Teaching Options**

#### Resources

Teacher's Resource Binder
Thoughts About Art: F3.1
A Closer Look: F3.1
Find Out More: F3.1
Assessment Master: F3.1
Large Reproduction 2, 9, 11, 18
Overhead Transparency 2, 9, 14
Slides 1, 5, 6, 7, 8, 9, 11, 12, 13, 14, 15, 18

#### **Teaching Through Inquiry**

Art Production Have students make a collage that includes negative and positive shapes of letters. First have students draw their initials with thick lines on construction paper. Demonstrate how to cut out the letter shapes carefully with scissors. Depending on the size of the letters and the overall design, students may cut out several sets of their initials. Before students glue down the letters, encourage them to experiment with the arrangement of the letters and the negative shapes between them on a contrasting color of paper. Ask students to point out the negative and positive shapes in their design.

## **Shape and Form**

A line that surrounds a space or color creates a **shape**. Shapes are flat, or two-dimensional. A circle and a square are both shapes. A **form** is three-dimensional: It has height, width, and depth. A sphere and a cube are examples of forms.

Shapes and forms may be organic or geometric. *Organic* shapes and forms—such as leaves, clouds, people, ponds, and other natural objects—are often curved or irregular. *Geometric* shapes and forms—such as circles, spheres, triangles, and pyramids—are usually precise and regular.

Most two-dimensional and three-dimensional designs are made up of both positive shapes and negative shapes. The figure in a painted portrait is the painting's positive shape. The pieces of fruit in a still-life drawing are the positive shapes in the drawing. The background or areas surrounding these objects are the negative shapes. The dark, solid shape of a statue is a positive shape. The areas around and inside the forms of the statue make the negative shapes. Artists often plan their work so that the viewer's eyes move back and forth between positive and negative shapes.

Fig. F3-6 This vase is made of geometric forms. The artist carved a design into the surface. Are the lines and shapes in the surface design geometric or organic? Bryan Stauffer, Vase, 1999. Red earthenware, commercial glazes, 61/2\* x3\* x3\* (16.5 x7.5 x7.5 cm). Mount Nittany Middle School, State College, Pennsylvania.

Elements and Principles of Design

35

## **Supplies for Engage**

- paper
- crayons, oil pastels, or markers

## Teach

## Engage

Direct students to draw a line on a paper and then pass their page to another student. Have the second student add more lines to create a shape. Explain that both line and shape are art elements. You may choose to have students continue in this manner as you introduce each of the other art elements.

## **Using the Text**

Perception Assign students to read pages 34 and 35. Ask: What is an implied line? Where is an implied line in Romaine Brooks's drawing? (back of dog's front leg) What is the difference between shape and form? (Shapes are flat; forms have depth.) How do organic and geometric shapes and forms differ? (organic: curved, irregular; geometric: precise, regular)

## Using the Art

Perception Discuss students' answers to the caption questions for Wayne Thiebaud's painting and for Romaine Brooks's drawing. Ask students to locate organic and geometric shapes in the painting.

## More About...

Because he is known for his still-life paintings of commonplace objects, California artist **Wayne Thiebaud** is often identified with 1960s Pop Art. Before becoming a painter, he worked as a cartoonist, a commercial artist, and, for a short time, a Disney animator.

#### **Using the Large Reproduction**

Ask students to discuss positive, negative, organic, and geometric shapes in this work.

## **Using the Overhead**

Ask students to discuss qualities of line in this work.

## **Elements of Design**

# Supplies for Using the Text

- watercolor or tempera paint (for tempera: red, yellow, blue, black, white)
- brushes
- · white paper
- · water and containers
- palette or scrap paper for mixing paint

## **Using the Text**

Art Production After students have read the text, have them locate the primary colors on the color wheel. Demonstrate the mixing of the primaries to create the secondary colors: red and yellow to make orange, yellow and blue for green, and red and blue for violet. Teach students to make the intermediate hues by mixing a primary with an adjacent secondary. Have students each use only the primary colors to create their own color wheel.

Art Production Ask students to explain the meaning of value, shade, and tint. Call their attention to the value chart, and challenge them to mix black and white to make at least five different values. If students are using watercolors, they should just add more water to create tints.

## **Using the Art**

Art Criticism Discuss students' answers to the caption questions for Caryl Bryer Fallert's quilt. Direct students' attention to the range of values in Charles Sheeler's Rolling Power and the way that he created value contrast between shapes so as to distinguish one from another. Ask: What, do you think, was Sheeler most interested in showing?

## **Color and Value**

FOUNDATION LESSON

Without light, you cannot experience the wonderful world of **color**. The wavelengths of light that we can see are called the color spectrum. This spectrum occurs when white light, such as sunlight, shines through a prism and is split into bands of colors. These colors are red, orange, yellow, green, blue, and violet.

In art, the colors of the spectrum are recreated as dyes and paints. The three *primary hues* are red, yellow, and blue. *Primary* means "first" or "basic." *Hue* is another word for "color." You cannot create primary colors by mixing other colors. But you can use primary colors, along with black and white, to mix almost every other imaginable color.

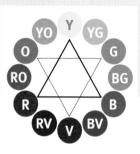

Fig. F3-7 The location of colors in a color wheel indicates their relationship to each other. Find the triangle with the primary colors on its points. Next, find the triangle with the secondary colors. Use this color wheel to help plan which colors to use in your artworks.

#### Key to the Color Wheel

Y = yellow V = violet
G = green R = red

G = green R = red B = blue O = orange

Fig. F3-8 How are these quilts like a color wheel? Where do you see the darkest shades of color? Caryl Bryer Fallert, Refraction #4-#7. Hand-dwidt criton fabric machine pieced and willed 88 y 88 (2) 24 x 23 cm) Contravor

36

# **Teaching Options**

## Teaching Through Inquiry

Art Production Demonstrate how to blend charcoal and white chalk on gray paper to create a value chart similar to the one on page 37, and then have students do likewise. Then set light-valued objects against a dark backdrop and shine a spotlight on them to create dramatic highlights and shadows. Have students use charcoal and white chalk to draw this still life on gray paper. Encourage them to create a range of values, as they did in the value chart.

Fig. F3-9 The values in this chart are arranged from black to white with ranges of gray in between. Hues may also be arranged according to their values, as in Caryl Bryer Fallert's quilt.

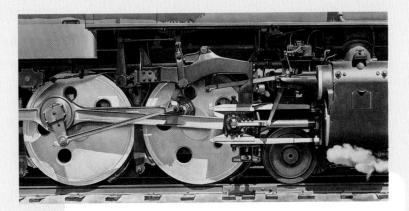

Fig. F3—10 How did American artist Charles Sheeler use value to show the forms and texture of a locomotive? Charles Sheeler, *Rolling Power*, 1939.

Oil on canvas, 15° x 30° (38.1 x 72.6 cm). Smith College Museum of Art, Northampton, Massachusetts. Purchased, Drayton Hillyer Fund. 1940.

The secondary hues are orange, green, and violet. You can create these by mixing two primary colors: red and yellow make orange; yellow and blue make green; red and blue make violet.

To create *intermediate* hues, you mix a primary color with a secondary color that is next to it on the color wheel. For example, mixing yellow and orange creates the intermediate color of yellow-orange.

**Value** refers to how light or dark a color is. A light value of a color is called a *tint*. A tint is made by adding white to a color. Pink, for example, is a tint made by adding white to red. Artworks made mostly with tints are usually seen as cheerful, bright, and sunny.

A dark value of a color is called a *shade*. A shade is made by adding black to a color. For example, navy blue is a shade made by adding black to blue. Artworks made mostly with dark values are usually thought of as mysterious or gloomy.

## **Critical Thinking**

Have students look back at Chihuly's glass chandelier on page 33 to discover the importance that light plays in perceiving color. Then turn off the artroom lights. **Ask**: What colors do you see? Is there color without light?

## **Teaching Tip**

Ask paint stores for any discarded paint-chip sample cards. Have students arrange them by values, color schemes, and color-wheel positions so as to create collages and paper mosaics.

## **Extend**

- Assign students each to paint a nonobjective or a representational composition with colors arranged as in the spectrum or color wheel.
- Have students paint a color wheel, cut it apart, and then use the color pieces to create a collage. Suggest the use of markers for drawing lines on the collage.

Elements and Principles of Design

37

## More About...

Philadelphia artist **Charles Sheeler** was also a photographer who used a range of values in his black-and-white compositions of American industry. His subjects included railroad yards, factory smokestacks, farms, and bridges.

#### **Using the Large Reproduction**

Have students discuss qualities of light, value, contrast, and color in this work.

## **Using the Text**

Perception Have students read the text and then, using the color wheel on page 36, identify the complements of the primary colors. Ask students to give other examples of analogous colors, split complements, and triads (such as blue, blue-green, and green for analogous colors). Encourage students to find examples of each scheme in their clothes, books, and artroom furnishings.

## Using the Art

Perception Direct student's attention to John Biggers's painting. Ask: What do you see? What is the main color in this painting? (red) Locate tints and shades of this color. What other colors did he use? (green, black, white) What type of color scheme is this? (complementary) Art Criticism Use the color-scheme chart to lead students in determining which color schemes Hung Liu used in her painting. (warm, analogous)

The intensity of a color refers to how bright or dull it is. Bright colors are similar to those in the spectrum. You can create dull colors by mixing complementary colors. Complementary colors are colors that are opposite each other on the color wheel. Blue and orange are complementary colors. If you mix a small amount of blue with orange, the orange looks duller. Many grays,

browns, and other muted colors can be mixed from complementary colors.

When artists plan an artwork, they often choose a color scheme—a specific group of colors—to work with. An artist might use a primary, secondary, intermediate, or complementary color scheme. Or the artist might choose any of the color schemes illustrated in the chart below.

secondary colors (orange, green, violet).

## Common Color Schemes warm: colors, such as red, orange, and yellow, that remind people of warm places, things, and feelings. cool: colors, such as violet, blue, and green, that remind people of cool places, things, and feelings. **neutral:** colors, such as black, white, gray, or brown, that are not associated with the spectrum. monochromatic: the range of values of one color (monochrome means "one color"). analogous: colors that are next to each other on the color wheel; the colors have a common hue, such as red, red-orange, and orange. **split complement:** a color and the two colors on each side of its complement, such as yellow with red-violet and blueviolet triad: any three colors spaced at an equal distance on the color wheel, such as the primary colors (red, yellow, blue) or the

38

LESSON

FOUNDATION

# **Teaching Options**

## Teaching Through Inquiry

Art Production Encourage students to experiment, using only primary colors and black and white tempera paint, to create the common color schemes. Demonstrate the mixing of small amounts of color on a palette to create various hues, tints, and shades. Ask students to list several subjects (scenes or objects) suggested by each color scheme. Then have students create a tempera painting of one of the subjects, using the color scheme that suggested it.

Art Production So that students see how color schemes can change a design, have them paint the same still life in two different color schemes. Encourage them to experiment with mixing colors before they begin. Ask students to write a description of the mood created by each set of colors.

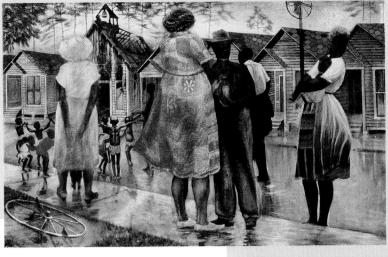

Fig. F3—11 African American artist John Biggers used a complementary color scheme in this scene. What effect do these colors create? John Biggers, Shotgun, Third Ward #1, 1966.

Michiganton, DC (Att Resource, New York

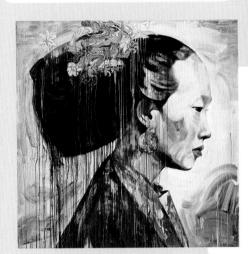

Fig. F3—13 The warm colors in the flower create a contrast with the cool blue background. Where do you see analogous colors in this design? Hannah MacDonald, Flower on Fire, 2000.
Tempera, 18" x 24" (46 x 61 cm). Chocksett Middle School, Sterling, Massachusetts.

Fig. F3—12 Match the color scheme in this painting to the color schemes in the chart on page 38. Hung Liu, Chinese Profile II, 1998.
Oil on carvas, 80° x 80° 203.2 x 203.2cm), Collection of San Jose Museum of Art, San Jose, California. Museum purchase with funds from the Council of 100. Photo by Sue Tailon.

## **Critical Thinking**

Ask students how color contributes to the mood in each artwork on page 39. Challenge students to explain how a change in the colors in each work would create a different feeling.

#### Extend

Have students create a series of three small nonobjective paper collages—one in a complementary scheme, one in a monochromatic scheme, and one in a triad scheme. Ask students to label, on the back of each, which scheme they used.

**Elements and Principles of Design** 

39

## More About...

John Biggers was born in North Carolina in 1942. Biggers was sent to boarding school and later entered Hampton Institute to study plumbing. While there, however, he studied art under Viktor Lowenfeld, an art educator who eventually became Biggers's mentor. Biggers later founded and became head of Texas Southern University's art department, from 1948 until 1983. While teaching, he continued to work as an artist—and continues so today.

## **Using the Large Reproduction**

Have students discuss the color scheme in this work.

11

## **Using the Overhead**

Have students discuss the color relationships in this work.

## **Elements of Design**

## **Using the Text**

Art Criticism Have students read page 40 and then explain, in their own words, the difference between negative and positive space.

Art Criticism After students have read page 41, ask them to define, in their own words, texture and implied texture.

## **Using the Art**

Perception Direct students to David Hockney's painting. Ask: How did Hockney create the illusion of depth? (The distant fields are higher on the page, smaller, with fewer details; and in lighter, duller, bluer colors than those closer to the viewer. Trees overlap areas behind them.) Have students trace the road back into the composition, noting how it becomes narrower as it recedes.

Perception Assign pairs of students to list the textures in the African mask. Create a class list of words describing texture, and add to it throughout the year.

**Perception** Ask students to point out the many implied textures in *Garrowby Hill* and to describe what they would feel if they were to run their fingers over the painting's surface.

## **Try This**

Before students begin the activity, review ways to indicate both space and depth. If possible, take students outdoors to sketch their landscapes. If students cannot complete their drawings in the allotted time, have them photograph their view for reference.

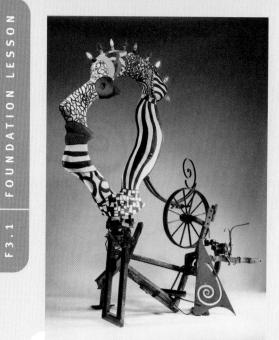

Fig. F3—14 Locate the negative spaces within this mobile sculpture. What do you think the lightbulbs and wheel represent? Niki de Saint Phalle and Jean Tinguely, *Illumination*, 1988.

Mobile sculpture, mixed media, height: 9' (2.75 m).

Courtesy Galerie Bonnier, Geneva. © 2001 Artists Rights Society (ASS, NewYork/ADAGE Paris.

Fig. F3–15 David Hockney used lighter, bluer colors to indicate distance in this painting of an English landscape. What techniques did he use to show depth? David Hockney, *Garrowby Hill*, 1998.

Space

Sculptors and architects work with actual **space**. Their designs occupy three dimensions: height, width, and depth. *Positive* space is filled by the sculpture or building itself. *Negative* space is the space that surrounds the sculpture or building.

In two-dimensional (2-D) art forms, artists can only show an illusion of depth. They have simple ways of creating this illusion. For example, in a drawing of three similar houses along a street, the one closest to the viewer appears larger than the middle one. The house farthest away appears smaller than the middle one. Artists can also create the illusion of depth by overlapping objects or placing distant objects higher in the picture.

Artists working in two dimensions also use linear perspective, a special technique in which lines meet at a specific point in the picture, and thus create the illusion of depth.

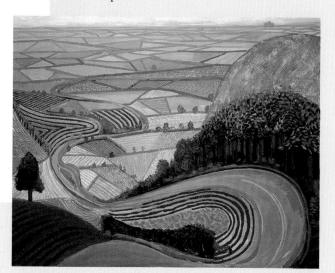

40

# **Teaching Options**

## **Teaching Through Inquiry**

Art Production To help students understand texture and the illusion of depth, have them create an abstract texture collage that indicates depth. Provide an assortment of beans, grains, rice, popcorn kernels, and seeds; white glue; pencils; and 8½" x 11" boards (corrugated cardboard or scrap lumber). Review the ways that Hockney created a sense of distance in his painting. Have students draw abstract shapes on their board and then fill them with textures so that some shapes appear near and others distant.

#### More About...

French-born American sculptor Niki de Saint Phalle (b. 1930) produces assemblages with feminist messages. She was married to the Swiss sculptor Jean Tinguely (1925-1991), who also used assembled objects in his kinetic artworks. Both saw the expressive potential of the materials they worked with. "Life is movement. Everything transforms itself," he said. When he created a robot that could draw, he noted that "anyone can make an abstract picture, even a machine."

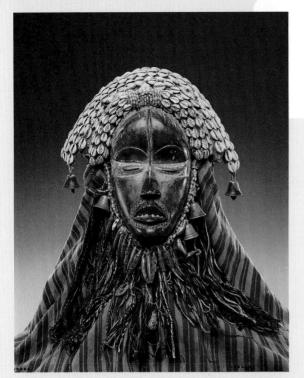

Fig. F3—16 Imagine running your fingers over this African mask and its attachments. What textures would you feel? Africa, Dan Culture (Liberia, Ivory Coast), Ga-Wree-Wre-Mask, 20th century.

Wood, metal, fiber, cowrie shells, glass beads, brass, bone, handwoven cloth, 47"× 16" x 22" (11)4 x 40.6 x 55.9 cm). Virginia Museum of Fine Arts, Richmond, The Addiph D. and Wilkins C. Williams Fund. Photo: Katherine Wetzel. © Virginia Museum of Fine Arts

#### **Texture**

**Texture** is the way a surface feels or looks, such as rough, sticky, or prickly. *Real* textures are those you actually feel when you touch things. Sculptors, architects, and craftspeople use a variety of materials to produce textures in their designs. These textures can range from the gritty feel of sand to the smooth feel of satin.

Artists who work in the two-dimensional art forms can create *implied* textures, or the illusion of texture. For example, when an artist paints a picture of a cat, he or she can create the look of soft fur by painting hundreds of tiny fine lines. What kinds of implied texture have you created in paintings or drawings of your own?

#### Try This

Draw a landscape with oil pastels. To create an illusion of space, make distant objects smaller and place them higher on the page. Use lighter values and cooler colors than objects in the foreground. Try using lines and dots to create textures.

#### Lesson Review

#### **Check Your Understanding**

- **1.** What are the elements and principles of design?
- **2.** Explain how David Hockney created an illusion of space in *Garrowby Hill*, Fig. F3–15.
- **3.** Describe the negative space found in *Illumination*, Fig. F3–14.
- **4.** Locate an artwork in this book that uses a warm color scheme. How do the colors add meaning to the art?

**Assess** 

# **Check Your Understanding: Answers**

- 1. elements of design: line, shape, form, color, value, space, texture; principles of design: balance, unity, variety, emphasis, proportion, pattern, movement and rhythm
- 2. Hockney located distant objects higher on the page, made them smaller than nearer ones, added fewer details, and painted them in lighter, duller, bluer colors.
- 3. The negative spaces are inside the head, inside the wheel, and under and between the head and wheel. The shapes of the spaces around the sculpture are also part of the negative space.
- 4. Check students' work for a selection that features a warm color scheme and for a thoughtful description of the meaning suggested by the colors.

## Close

Display students' landscape drawings. Ask students to identify close-up and distant objects in the works, and to explain the various techniques used to indicate distance and textures.

41

Elements and Principles of Design

#### **Assessment Options**

Peer Have students
work in small groups
to create radio broadcasts describing the theft of one
of the artworks in this chapter.
Direct students to use terms
from the text to describe the
work's line, shape, form, color,
value, space, and texture.

## **Using the Large Reproduction**

Ask students to consider and explain the importance of space and texture in this sculpture.

18

## **Using the Overhead**

Lead a discussion of how the artist used color and texture in creating this mask.

## **Prepare**

## **Pacing**

One or two 45-minute periods, depending on the scope of Try This

## **Objectives**

- Understand and perceive the principles of design in artworks.
- Emphasize a center of interest in a collage.

## Vocabulary

principles of design Guidelines that help artists to create designs and plan relationships among visual elements in an artwork. They include balance, unity, variety, pattern, emphasis, rhythm, and movement.

## Teach

## Engage

Have students stand with their arms stretched out from their shoulders. Point out that if you drew a line vertically through the center of their body, the sides would be mirror images and would form a symmetrical composition. Next, ask students to stand on one foot, lean to one side as far as they can, and note how they maintain their balance. Point out that even though they balanced themselves, both sides of their body were not arranged the same. This type of balance is asymmetrical.

# National Standards Foundation 3.2

**2a** Generalize about structures, functions.

**2b** Employ/analyze effectiveness of organizational structures.

2c Select, use structures, functions.

# **Principles of Design**

#### **Balance**

FOUNDATION LESSON

Artists use **balance** to give the parts of an artwork equal "visual weight" or interest. The three basic types of visual balance are symmetrical, asymmetrical, and radial. In *symmetrical* balance, the halves of a design are mirror images of each other. Symmetrical balance creates a look of stability and quiet in an artwork.

In asymmetrical balance, the halves of a design do not look alike, but they are balanced like a seesaw. For example, a single large shape on the left might balance two smaller shapes on the right. The two sides of the design have the same visual weight, but unlike symmetrical balance, the artwork has a look of action, variety, and change.

In radial balance, the parts of a design seem to "radiate" from a central point. The petals of a flower are an example of radial balance. Designs that show radial balance are often symmetrical.

Fig. F3−17 In this asymmetrical composition, space on the right balances the wall and bug on the left. The cat's gaze leads us to the insect. Japanese, Toko, Cat and Spider, 19th century.
Album leaf, colors and ink on silk, 14 3/4 \* x11\* (37.5 x 28 cm). The Metropolitan Museum of Art, Charles Stewart Smith, Collection, Gift of Mrs. Charles Stewart Smith, Charles Stewart Smith, pl. and Howard Caswell Smith, in memory of Charles Stewart Smith, 1914 (14.76.61.73). Photograph © 1981 The Metropolitan Museum of Art

#### Try This

Draw an asymmetrical picture of an animal. Make this drawing very unified by creating a single shape as the main part of the design and repeating shapes and textures. When you have completed your drawing, explain to other classmates how you created unity and balance in your drawing. How could you add variety to this drawing?

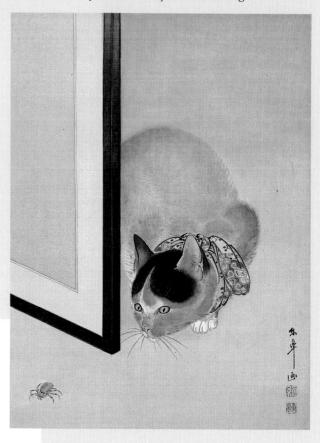

42

# **Teaching Options**

#### Resources

Teacher's Resource Binder
Thoughts About Art: F3.2
A Closer Look: F3.2
Find Out More: F3.2
Assessment Master: F3.2
Large Reproduction 8, 12
Overhead Transparency 5, 6
Slides 2, 3, 4, 5, 9, 11, 13, 14, 15, 16

#### **Meeting Individual Needs**

Gifted and Talented and Multiple Intelligences/Intrapersonal Ask students what personal insights Hare's materials could offer. Have students develop their own mixed-media self-portraits, focusing on one aspect of their life that is extremely important to them.

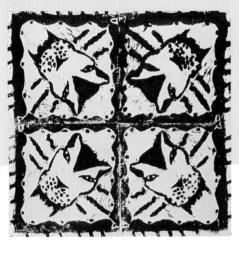

Fig. F3-18 Student artist Victoria Sample created a feeling of unity by repeating shapes and using limited color. Why could this also be considered a radial design?

Victoria Sample, *Untitled*, 1996. Linoleum block print, 18" x 18 ½" (46 x 47 cm). Grafton Middle School, Grafton, Massachusetts.

Fig. F3–19 Textile artist Frances Hare used a variety of materials, patterns, and textures to express her passion for dance. How did she also create a feeling of unity? Frances Hare, Sixteen Feet of Dance: A Celebration, A Self-Portrait, 1996. Cotton fabrics, beads, braided cloth, 69° x 56° (175.2 x 142.2 cm). Courtesy the artist.

## Unity

**Unity** is the feeling that all parts of a design belong together or work as a team. There are several ways that visual artists can create unity in a design.

- repetition: the use of a shape, color, or other visual element over and over
- dominance: the use of a single shape, color, or other visual element as a major part of the design
- harmony: the combination of colors, textures, or materials that are similar or related

Artists use unity to make a design seem whole. But if an artist uses unity alone, the artwork might be visually boring.

## **Variety**

Variety adds visual interest to a work of art. Artists create variety by combining elements that contrast, or are different from one another. For example, a painter might draw varying sizes of circles and squares and then paint them in contrasting colors such as violet, yellow, and black. A sculptor might combine metal and feathers in an artwork or simply vary the texture of one material. Architects create variety when they use materials as different as stone, glass, and concrete to create the architectural forms of a building.

Elements and Principles of Des

43

## **Using the Text**

Art Criticism Review with students the difference between the elements and the principles of design. If needed, refer students to page 32.

After students have read pages 42 and 43, ask them how artists create balance, unity, and variety in their artworks.

## **Using the Art**

Art Criticism Ask: What is happening in Cat and Spider? How did the artist create unity? Variety? Why, do you think, did Frances Hare call her quilt a self-portrait? Which is taller, you or the quilt?

## **Try This**

Ideally, as they draw, students will look at a live animal, perhaps a small pet brought into the artroom. Toy animals and nature videos or books offer alternatives. Students may want to draw their pet or an animal that they have studied in science. After students have done some trial sketches, discuss how they will arrange their animal to create an asymmetrical, balanced composition.

## **Teaching Through Inquiry**

Perception Provide small groups of students with postcard-size (or large) reproductions of artworks. Have students create a three-column chart to record their findings as they analyze the way the artist created unity and variety. In the first column, students write the name of the artwork. In the second column, they tell how the artist achieved unity (with the repetition of a color, shape, or other element; the use of a single visual element as the major part of the design; the combination of similar colors, textures, or materials; and so on). In the third column, students indicate how the artist achieved variety (with the addition of contrasting art elements or materials, and so on). Invite students to share their analysis of at least one of the artworks.

## **Using the Large Reproduction**

Use this artwork to discuss balance, unity, and variety.

## **Principles of Design**

## **Using the Text**

Art Criticism After students have read about emphasis and pattern, discuss what means artists use to emphasize their main subject. Ask: Why would artists want to create emphasis? (to make their message more understandable, to draw attention to their main subject) What is the difference between planned and random patterns?

## Using the Art

Art Criticism Ask students to describe the patterns in the artwork on these pages.

## **Try This**

Before students glue down their image, encourage them to experiment, by placing the image in various locations, with ways to create emphasis. Students may wish to use a contrasting color for the background, repeat photocopies of the image, or place the image at the center and draw lines and shapes leading to it.

Fig. F3–20 Yolanda
Lopez based her drawing on a traditional
religious icon from
her Mexican heritage.
How did she emphasize
her subject? Yolanda M.
Lopez, Portrait of the
Artist as the Virgin of
Guadalupe, 1978.
Oil pastel on paper, 22½ ½ " x 32½" (57 x 82.5 cm). Courtesy of the artist.

FOUNDATION LESSON

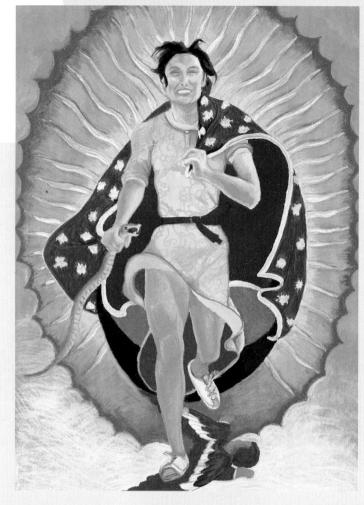

## **Emphasis**

Look at *Portrait of the Artist as the Virgin of Guadalupe* (Fig. F3–20). What is the first thing you see? Of course, you probably see the woman first. Now see if you can explain why you noticed her first. Here are some clues.

When artists design an artwork, they use emphasis to call attention to the main subject. The size of the subject and where it is placed in the image are two key factors of emphasis. You probably noticed the woman first because she is larger than most of the other objects in the painting. She is also placed in the middle of the work. Sometimes artists create emphasis by arranging other elements in a picture to lead the viewer's eyes to the subject. Or they group certain objects together in the design.

44

## **Teaching Options**

#### More About...

**Yolanda Lopez**, born in 1942 in San Diego, considers her art a tool for social and political change. In the 1960s, Lopez worked with Los Siete de las Raza, a group in San Francisco's Mission district, to organize a neighborhood health clinic and provide legal and social aid. At that time, her unsigned art appeared on the streets, and she was surprised that many people thought that the artist was male. Lopez has taught and lectured on contemporary Chicano art at the University of California at Berkeley and San Diego.

The Mexican religious icon on which Lopez based her painting was created only fifteen years after the Spanish conquest of Latin America. The artist has described it as a combination of Christian and Aztec religious figures. In the oil pastel, Lopez addressed women's rights, showing the modern Chicana striding out of her traditional halo and holding a snake, which represents wisdom.

#### **Pattern**

An artist creates a **pattern** by repeating lines, shapes, or colors in a design. He or she uses patterns to organize the design and to create visual interest. You see patterns every day on wallpaper, fabric, and in many other kinds of art.

Patterns are either planned or random. In a *planned* pattern, the element repeats in a regular or expected way. A *random* pattern is one that happened by chance, such as in a sky filled with small puffy clouds or in the freckles on a person's face. Random patterns are usually more exciting or energetic than planned ones.

Select a magazine photograph of an object that has special meaning to you. Carefully trim away the paper around the object. Glue the object onto a sheet of paper. Then create a design and emphasize the object by adding a background with either colored papers or by drawing. Before you begin, think about how you can emphasize your object. Will you locate the object near the center of the composition, use contrasting colors behind it, or draw lines leading to it? Explain how you emphasized the main object in your completed design.

Computer Option
Use a computer to create a

design with a strong center of interest. Either draw a shape or place a clip art object near the center of your page. Add textures, colors, and lines to draw the viewer's gaze to this part of your composition.

Fig. F3-21 What did the student artist repeat in her design to create a planned pattern? What might you cover with a pattern like this? Stacey Fong, *Pattern*, 1996.

Tom paper collage, 9" x12" (23 x 30.5 cm). Los Cerros

Elements and Principles of Design

45

Computer Option
Adobe Photoshop and
similar programs allow

users to work in multiple layers without disturbing the scanned image. A design may also be created in HyperStudio® or Microsoft PowerPoint, or a page-layout program such as PageMaker. Students could alter the size of the image and its placement on the page, as well as the composition of the created background. To create additional emphasis, students could use Microsoft PowerPoint and HyperStudio® to create animated presentations of their object.

## **Critical Thinking**

Ask students each to think of a hero (fictional or real) from their culture and then to create a drawing, painting, or collage of him or her. Challenge students to use emphasis to suggest the importance of their figure.

Teaching Through Inquiry

Art Production Have students work in groups of four or five to arrange themselves into compositions that illustrate emphasis. For example, one student could stand in the middle of the group, and the other members would point to him or her. If cameras are available, have students photograph their tableaux; otherwise, have students make sketches of their arrangements.

#### **Using the Large Reproduction**

Use this as an example of balance, unity, variety, emphasis,

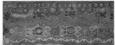

variety, emphasis, and pattern.

12

#### **Using the Overhead**

Use this artwork to discuss symmetrical balance, unity, variety, emphasis, and pattern.

## **Principles of Design**

## **Using the Text**

Perception After students have read page 46, have them compare the distance from the top of their skull to the center of their eyes to that from the middle of their eyes to the bottom of their chin. These distances should be about the same. Point out that their eyes are separated by the width of one eye. Ask: Where do the tips of your fingers fall when you hold your arms at your sides? How does the size of your hand compare to the size of your face?

**Perception** After students have read page 47, lead them in discussing the difference between movement and rhythm in artworks.

## Using the Art

Art Criticism Ask: How did Doug Webb use both human proportions and scale in *Kitchenetic Energy?* How does scale change the meaning of an ordinary kitchen sink?

Ask students to compare their height with that of the Michael Jordan figure and to explain the message expressed by the statue's larger-than-life size.

Explain that artists sometimes measure human proportions by how many heads tall a figure is. Challenge students to measure Jordan's head and compare this to his entire height.

Perception Have students describe the movement and rhythm in the statue of Michael Jordan and in *Kitchenetic Energy.* **Ask:** Which piece seems to have more movement?

## **Proportion**

FOUNDATION LESSON

**Proportion** is the relationship of size, location, or amount of one thing to another. In art, proportion is mainly associated with the human body. For example, even though your body might be larger, smaller, or shorter than your best friend's, you both share common proportions: Your hips are about halfway between the top of your head and your heels; your knees are halfway

between your hips and your feet; and your elbows are about even with your waist.

Scale is the size of one object compared to the size of something else. An artist sometimes uses scale to exaggerate something in an artwork. Look at *Kitchenetic Energy* (Fig. F3–22). How did Doug Webb manipulate scale to give a kitchen sink a new function?

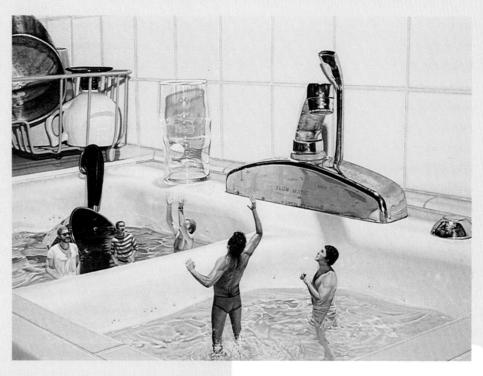

Fig. F3-22 How did the artist use scale in this painting? Why do you think he chose to change the scale of the people and the sink? What effect does this create? Doug Webb, Kitchenetic Energy, 1979.

46

# **Teaching Options**

## **Teaching Through Inquiry**

Perception Have students work in pairs to analyze the visual movement in paintings in this chapter. Assign each pair a painting, and have them answer: Where does the viewer look first? What is the center of interest or most important part of the painting? How did the artist direct our attention to this? Where does the eye move next? How did the artist create rhythm? Have students present their findings to the class.

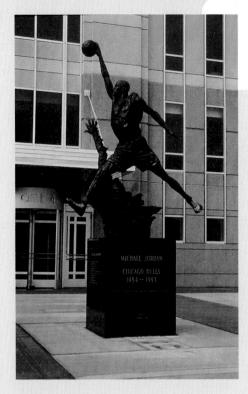

## **Movement and Rhythm**

**Rhythm** is related to both movement and pattern. Artists use rhythm, like pattern, to help organize a design or add visual interest. They create rhythm by repeating elements in a particular order. Rhythm may be simple and predictable, or it may be complex and unexpected.

For example, look at *The Spirit, Michael Jordan* (Fig. F3–23). How does your eye move across this sculpture? First your eye probably sweeps quickly from the ball down through his extended back leg. Notice how the artists created a rhythm by repeating this line in the shape of the opponent, and in Jordan's back arm. Find other repeated lines that create rhythms within this sculpture.

Fig. F3-23 This bronze statue is a tribute to basketball player Michael Jordan. Describe the movement in the sculpture. How did the artists emphasize this movement? Omri Amrany & Julie Rotblatt-Amrany, The Spirit, Michael Jordan, 1994.

#### **Sketchbook Connection**

Sketch people in motion in a sports event, physical education class, or dance. Try to capture their movement

with many quick sketches. Look for the stretch in their bodies and clothes. Experiment by drawing just a few lines in some figures and many quick lines in others.

#### Lesson Review

#### **Check Your Understanding**

**1.** How did Yolanda Lopez emphasize the main figure in *Portrait of the Artist as the Virgin of Guadalupe*, Fig. F3–20?

2. Is the balance in *The Spirit, Michael Jordan*, Fig. F3–23, symmetrical or asymmetrical? Why is balance so important in the design of this statue?

**3.** Describe the unity and variety in *Sixteen Feet of Dance: A Celebration, A Self-Portrait,* Fig. F3–19.

**4.** From this chapter, select an artwork that appeals to you. Describe the art elements and principles that are most important in this work's design.

#### **Assess**

# **Check Your Understanding: Answers**

- 1. Lopez made the figure large, centered her, and contrasted colors in the figure to those of the background.
- 2. The balance is asymmetrical. If the sculpture were not balanced, it would look as though it were tipping over.
- 3. Unity is created by a repeated pattern and by images of feet that are mostly the same shape and color. Variety is created by the different textures and the various orientations of the feet.
- **4.** Look for each student's understanding of the use of the elements and principles in the selected artwork.

## Close

Display the collages, and have students each write an explanation of how they emphasized their main subject and why they think they did or did not do so effectively. Discuss other art principles used in the collages.

Have students work in groups of three or four to compare their answers to Check Your Understanding. Direct groups to explain, to the rest of the class, the elements and principles in the artwork that one member chose for question 4.

# Elements and Principles of Design

47

#### More About...

**Omri Amrany and Julie Rotblatt-Amrany** were commissioned to create a statue of Michael Jordan for the front of Chicago's United Center. This tribute to the retired Bulls superstar was to be a realistic depiction of Jordan, show his spectacular skill, and create an illusion of flight. This husband-and-wife sculpture team insist that they are not sports sculptors, even though they have also created five statues of Tigers baseball players for Detroit's Commercial Park. Julie Rotblatt-Amrany equates sculpting an athlete to the capturing of a dancer's movement: "We've tried to eliminate gravity and [create] the motion of time."

#### **Assessment Options**

Teacher On the board, write: symmetrical balance, asymmetrical balance, radial balance, unity, variety, emphasis, proportion, pattern, movement and rhythm. Have students identify artworks, from this book or from a collection of postcards or reproductions, that demonstrate each of these. Discuss the reasons for their choices.

#### **Using the Overhead**

Have students consider and discuss the use of proportion in fashion design.

#### **Other Arts**

Have students compare the elements and principles in the waltz to those in hip-hop or another contemporary dance style. Ask in what ways the dances are similar and different in terms of shape and line (on the dance floor), form (of the body), rhythm and pattern (of steps), balance, unity, variety, and so on. Have students consider both the overall dance composition and individual performances.

#### **Social Studies**

A shotgun house is a form of folk architecture traditional to a specific place or region. Have students conduct research to discover and report if any forms of architecture are indigenous to your community or state. Saltbox houses in New England, Creole cabins in Louisiana, dogtrot houses in Texas, and adobe structures in the Southwest are all examples of indigenous architecture. Have students report on their findings through an exhibition of photographs at school or on the school's Website.

# Connect to...

## **Careers**

CONNECT TO

What well-designed Websites can you think of? Graphic design is most likely the first thing you notice when you visit a Website. This makes the role of the **computer graphic artist** quite important. Not long ago, graphic designers drew by hand, painted with airbrushes, used press-on type, and made "paste-ups" of art and text for a camera. Today, a successful graphic designer must be skilled not only in painting and drawing, but also in computer software

programs and photo manipulation. A graphic artist must come up with original ideas, and he or she must be able to translate a client's wishes into computer media. Computer graphic artists may create Web pages, computer animation or other special effects, illustrations, presentations, packaging, ads, newspapers, and books. Many colleges and universities offer degrees in computer graphics, often called communication design.

## Other Arts

#### Dance

Many of the elements and principles of the visual arts apply to dance as well. The bodies of dancers can create lines, shapes, and forms in space. Choreographers might have dancers twist and move their body into a tight ball or jump to form a starlike shape in space.

Several dancers might join together to create cubes or other forms. The choreographer might have all the dancers perform the same moves to create a sense of unity, or some dancers might perform contrasting movements to create variety or emphasis.

F3-24 A photograph is one way to capture a dance performance. What elements and principles of design do you see in this photograph? Barbara Morgan, Martha Graham: Letter to the World (Kick), 1940. Gelatin silver print. SuperStock. Underwood Photo Archives/SSI.

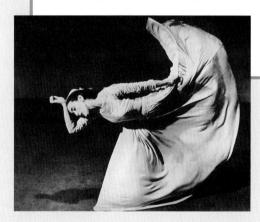

#### Internet Connection

For more activities related to this chapter, go to the Davis Website at www.davis-art.com.

48

# **Teaching Options**

#### **Resources**

Teacher's Resource Binder:
Making Connections
Using the Web
Interview with an Artist
Teacher Letter

#### **Video Connection**

Show the Davis art careers video to give students a reallife look at the career highlighted above.

#### **Interdisciplinary Planning**

To foster interdisciplinary planning, attend cultural events and workshops with faculty members from other disciplines. Such activities may provide the inspiration and motivation for innovative interdisciplinary programs.

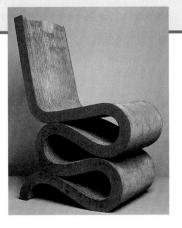

## **Daily Life**

What evidence of the elements and principles of design do you see in your daily life? Where do you see line, color, value, space, texture, balance, unity, variety, emphasis, and pattern? We often do not take the time to pay close attention to art in our surroundings. Can you identify at least one example of each of the elements and principles? Make a list of your findings.

F3—25 If you owned this chair, would you consider it a work of art or a functional piece of furniture? Why? Frank O. Gehry & Associates, Wiggle Side Chair, 1969—72. Compated cardbad Courtes Frank Osbry & Associates.

## **Other Subjects**

#### **Social Studies**

Artworks can give us visual clues about different cultures. We can learn much about the cultural roots of African American artist John Biggers from his paintings of "shotgun" houses. The houses were called such because people believed that a bullet fired through the front doorway would go straight out the back. This house style is now considered an important African American contribution to architecture. Biggers grew up in such a house and his paintings emphasize the geometric shapes on which the shotgun house is based. The artist also believes that the term shotgun is taken from shogun, a West African term for "king's house."

#### Language Arts

In art, pattern is a principle of design in which combinations of lines, colors, and shapes are used in a particular order to make a repeating image. In poetry, the rhythmical pattern of a poem is called its meter. The number and types of stresses or beats (weakly or strongly stressed syllables) in each line of a poem determines its meter. How could you use these similarities to write a poem about a work of art that depicts pattern?

F3–26 **What role do the shotgun houses play in this work?** John Biggers, *Shotguns, Fourth Ward*, 1987.
Acrylic and oil on board, 41 <sup>3</sup>/<sub>4</sub>" x 32" (106 x 81 cm). Hampton University Museum,

#### Science

Have you ever seen the rainbow of colors when white light passes through a prism? The individual colors separate within the prism while the different wavelengths of the rays of light are bent or refracted. To produce a rainbow, turn on a hose or sprinkler so that the water comes out as a fine spray. Stand so that you face the spray and have your back to the sun. Move about slightly until you find the right angle to see the rainbow.

# Language Arts

Have students each choose a detailed abstract or nonobjective artwork from this text and use it as the inspiration for a rhythmically patterned five-line poem, in which line 1 is one noun that tells about the work; line 2 is two adjectives that describe the work; line 3 is three action verbs; line 4 is a four-word phrase that expresses an idea or feeling about the work; and line 5 is either a synonym of the word in line 1 or another noun that tells about the work.

#### Science

Use a prism and a light source to demonstrate that white light is actually made up of the many colors in the visible spectrum. Lay a clear prism on one side, and shine a bright light through it onto a projector screen or white wall. Be sure the light hits one face of the prism at an angle. You may need to adjust the position of the light source until the spectrum is visible. Explain that the white light separates, as the rays of light are bent or refracted inside the prism, into bands of the colors (which always appear in the same order) in the visible spectrum.

49

Elements and Principles of Design

#### **Internet Resources**

#### **Dale Chihuly**

http://www.chihuly.com

Browse the official site of the artist, including his glass, drawings, and installations.

#### Crayola® Creativity Central

http://www.crayola.com/index.cfm

Log on to the crayon maker's site of activities for kids, parents, and educators.

#### Sanford: A Lifetime of Color

http://www.sanford-artedventures.com/study/study.html Direct students here to learn about the color wheel, the elements and principles of art, and much more.

#### **Museum Connection**

Before students tour your local museum, teach museum etiquette and the reasons for rules. Most museums discourage backpacks, food, flash photography, and chewing gum. Caution students not to touch objects (oils on the surface of the skin can damage fragile artworks).

#### Portfolio & Review

## **Talking About** Student Art

Encourage students to use the names of the art elements and principles to describe one another's artworks. Ask: What is the most important part of this artwork? How did the artist emphasize this area? How would you describe the rhythm, color, texture, or line in this artwork? In this piece, which art elements and principles are most important?

## Portfolio Tip

Have students begin a table of contents for their portfolio: instruct them to

number the back of each artwork and use that number to cite the work in the table of contents.

## Sketchbook Tip

Before students draw, suggest that they view their personal item from several

directions to find the most interesting view. Challenge students to draw their item again, but to change one of the elements.

# **Portfolio**

EVIE

ಹ

PORTFOLIO

patterns of shadow and light. Hannah Parpart, Lines of Light, 2000.

"I love butterflies, and I love to show things in motion. So I did a butterfly flying across the paper. My favorite thing about this picture is the colors. I wanted the colors to be bright and vivid." Vanessa Stassen

F3-29 A simple stencil print can be overlapped and repeated to create a sense of motion and rhythm. Vanessa Stassen, *Butterflies*, 2000. Compressed tempera, 12\* x18\* (30.5 x 46 cm). Northview Middle Indianapolis, Indiana.

"I took this photo when trying to find naturally occurring lines. Here the log overhang and bright sunlight creates distinct patterns of light and dark. The lines connect all parts of the photo together to make a normal scene abstract." Hannah Parpart

F3-28 Arms and legs were added to a simple conelike body shape, with wings for balance. How does the use of color bring harmony to the piece? Ashley Anderson, Wish Dragon, 2000. Clay, glaze, 8" x 10 ½" x 6 ½ High School, Boise Idaho. . 2" (20 x 26.5 x 16.5 cm). South Junior

#### **CD-ROM Connection**

To see more student art, view the Personal Journey Student Gallery.

# **Teaching Options**

#### Resources

Teacher's Resource Binder Chapter Review F3 Portfolio Tips Write About Art **Understanding Your Artistic Process** Analyzing Your Studio Work

#### **CD-ROM Connection**

to studio activities in this chapter.

For students' inspiration, for comparison, or for criticism exercises, use the additional student works related

#### **Family Involvement**

Encourage students to note how advertising billboards and signs in their community use the art elements and principles to focus the viewer's attention on their product. Ask: What types of color, lines, and movement do advertisers use to appeal to different groups of people? Assign students to share their observations with their families, and to record the family members' reactions to this information.

# Foundation 3 Review

#### Recall

Make a list of the elements of design and another of the design principles.

#### Understand

Explain the difference between the elements and principles of design.

#### Apply

Fold a sheet of paper into eight equal rectangles. In each rectangle, draw a diagram illustrating an art element and principle. For example, you might draw lines leading to the center of the design to show line and emphasis, or draw many different kinds of shapes for shape and variety. Because there are only seven art elements, repeat one of them. Label each drawing with the element and principle featured in it.

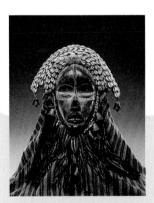

Page 41

#### For Your Portfolio

Select one of your artworks that demonstrates your understanding of one of the art elements or principles.

Write a description of this artwork, explaining how you emphasized that art element or principle.

#### Analyze

Write an analysis of the art elements and principles in *Ga-Wree-Wre Mask*, Fig. F3–16 (*see below*). Which element and principle seem to be most important in this piece? What type of lines, shapes, and forms did the artist use? Describe the textures, values, colors, and color schemes you see. What type of balance does it have? How did the artist create unity and variety? What did the artist emphasize?

#### Synthesize

Create an advertisement for your favorite sport or activity. Use color, line, texture, value, form, and shape to suggest the sport. Use these elements to emphasize your main subject. What type of balance will you use in your design?

#### **Evaluate**

Imagine that a children's museum has asked you to select one of the artworks from this chapter to purchase for their collection. The museum wants to use this artwork to teach young children about rhythm in art. For your choice, write a label that explains how the artist created rhythm in this work.

#### For Your Sketchbook

Sketch one of your personal belongings, such as a bag, book, shoe, or piece of sports equipment. Describe the art

elements and principles in your drawing. What type of shapes, forms, colors, lines, values, space, and textures does it have? Imagine how it would look if you changed one of these. Elements and Principles of Design

51

## Community Involvement

Challenge students to develop a project that will improve the community environment. For example, students might draw designs for a playground or garden. Work with a community group or parents club to implement the designs.

#### **Advocacy**

Display student art near the entrance of a performing-arts event so that family members and the community may view the art as they arrive or at intermission. Ensure that the art exhibit is publicly advertised and is mentioned in the performance's program notes.

## Foundation 3 Review Answers Recall

Elements: line, shape, form, color, value, space, texture; Principles: balance, unity, variety, emphasis, pattern, proportion, movement and rhythm.

#### **Understand**

The basic pieces or components that an artist arranges (line, shape, form color, value, space, texture) are the elements of design, whereas the principles of design have to do with the different ways artists arrange the elements.

#### Apply

Check students' work for designs that are clear examples of the elements and principles.

#### **Analyze**

Check each student's writing for a careful analysis of the selected artwork's elements and principles.

#### **Synthesize**

Students may draw, paint, or collage their advertisement. Check that each student effectively used the elements and principles to convey the sport or activity.

#### **Evaluate**

Within their explanation of how an artist created rhythm in an artwork, students should mention what elements the artist repeated and the type of movement the rhythm creates. Look for thoughtful reasons for selecting a piece for young children.

#### Reteach

Divide the class into seven collaborative-learning groups. Assign each group a different art element and principle (combine rhythm and movement as a principle for one group). Have each group select two artworks from another chapter—one that is a good example of their assigned art element and another that is a good example of their assigned art principle. Instruct groups each to plan and then teach a lesson about the assigned principle and element, using the artworks as examples.

|                      |               |               |               |                     | 四日日日日     |
|----------------------|---------------|---------------|---------------|---------------------|-----------|
| F4 A                 | 24.4          | A 100 V       | A VAV         | 38.27.98            | 1 8.23    |
| V VERENT CARREL TO A | alnis         | 82081         | Pl Lub        | THE R. P. HE        | 18 F m    |
|                      | refil telling | Spriffrutrity | adeliellestke | relifibreliseeliibr | (Blackd3) |

# Foundation Organizer

| 9 weeks | 18 weeks | 36 weeks | Foundation Focus National Content Standards                                |                                                                                                                                                                                                                         |                                                                                                                                                                                                                                                                                                                                            |  |
|---------|----------|----------|----------------------------------------------------------------------------|-------------------------------------------------------------------------------------------------------------------------------------------------------------------------------------------------------------------------|--------------------------------------------------------------------------------------------------------------------------------------------------------------------------------------------------------------------------------------------------------------------------------------------------------------------------------------------|--|
|         |          |          | Foundation 4 Approaches to Art Foundation 4 Overview pages 52–53           | <ul> <li>Understand that asking questions can guide us to better understand and appreciate artworks.</li> <li>4.1 Art History</li> <li>4.2 Art Criticism</li> <li>4.3 Art Production</li> <li>4.4 Aesthetics</li> </ul> | <ol> <li>Understand media, techniques, and processes.</li> <li>Use knowledge of structures and functions.</li> <li>Choose and evaluate subject matter, symbols, and ideas.</li> <li>Understand artist in relation to history and cultures.</li> <li>Assess own and others' work.</li> <li>Make connections between disciplines.</li> </ol> |  |
|         |          |          |                                                                            | Objectives                                                                                                                                                                                                              | National Standards                                                                                                                                                                                                                                                                                                                         |  |
| 2       | 2        | 2        | Foundation 4.1 Art History page 54 Pacing: One or two 45-minute periods    | Explain the role of art historians in art inquiry.                                                                                                                                                                      | <ul> <li>4b Place objects in historical, cultural contexts.</li> <li>4c Analyze, demonstrate how time and place influence visual characteristics.</li> <li>5b Analyze contemporary, historical meaning through inquiry.</li> </ul>                                                                                                         |  |
|         |          |          | Try This Art about a leader page 54                                        | Create a piece of art about a leader                                                                                                                                                                                    | <b>3b</b> Use subjects, themes, symbols that communicate meaning.                                                                                                                                                                                                                                                                          |  |
|         |          |          |                                                                            | Objectives                                                                                                                                                                                                              | National Standards                                                                                                                                                                                                                                                                                                                         |  |
| 2       | 2        | 2        | Foundation 4.2 Art Criticism page 56 Pacing: One or two 45-minute periods  | <ul> <li>Consider questions about the meaning of art.</li> <li>Explain the role of art critics in art inquiry.</li> </ul>                                                                                               | <ul> <li>4b Place objects in historical, cultural contexts.</li> <li>5c Describe, compare responses to own or other artworks.</li> </ul>                                                                                                                                                                                                   |  |
|         |          |          | Try This<br>Heritage<br>page 57                                            | Create an artwork based on family or community heritage.                                                                                                                                                                | <b>3b</b> Use subjects, themes, symbols that communicate meaning.                                                                                                                                                                                                                                                                          |  |
|         |          |          |                                                                            | Objectives                                                                                                                                                                                                              | National Standards                                                                                                                                                                                                                                                                                                                         |  |
| 2       | 2        | 2        | Foundation 4.3 Art Production page 58 Pacing: One or two 45-minute periods | <ul> <li>Consider questions about the production of artworks.</li> <li>Understand the role of artists in art inquiry.</li> </ul>                                                                                        | <b>1a</b> Select/analyze media, techniques, processes, reflect.                                                                                                                                                                                                                                                                            |  |
|         |          |          | Try This<br>Companion piece<br>page 59                                     | Create an artwork based on an artist from this chapter and then reflect on the experience.                                                                                                                              | <b>1a</b> Select/analyze media, techniques, processes, reflect.                                                                                                                                                                                                                                                                            |  |
|         |          |          |                                                                            |                                                                                                                                                                                                                         |                                                                                                                                                                                                                                                                                                                                            |  |

#### **Featured Artists**

Diana Bryer Willie Coin Hoang Vu Kcho Lawrence Leissner Bill Reid Norman Rockwell Jackson Pollock Robert Rauschenberg

## Vocabulary

art historian art critic artist aesthetician

## **Teaching Options**

Teaching Through Inquiry
More About...Marcus Aurelius
Assessment Options
Using the Large Reproduction
Using the Overhead

## Technology

CD-ROM Connection e-Gallery

CD-ROM Connection Student Gallery

#### Resources

Teacher's Resource Binder A Closer Look: F4.1 Find Out More: F4.1 Assessment Master: F4.1 Large Reproduction 4 Overhead Transparency 7 Slides 1, 13, 14, 17

Teacher's Resource Binder Thoughts About Art: F4.1

#### **Teaching Options**

Teaching Through Inquiry
More About...Norman Rockwell
Assessment Options
Using the Large Reproduction
Using the Overhead Transparency

## **Technology**

CD-ROM Connection e-Gallery

#### Resources

Teacher's Resource Binder A Closer Look: F4.2 Find out More F4.2 Assessment Master: F4.2 Large Reproduction 2 Overhead Transparency 11 Slides 18

CD-ROM Connection Student Gallery Teacher's Resource Binder Thoughts About Art: F4.2

#### **Teaching Options**

Teaching Through Inquiry More About...Hoang Vu Assessment Options Using the Large Reproduction Using the Overhead

## Technology

CD-ROM Connection e-Gallery

## Resources

Teacher's Resource Binder A Closer Look: F4.3 Find Out More: F4.3 Assessment Master: F4.3 Large Reproduction 7 Overhead Transparency 4 Slides 2, 3, 4, 5, 7, 9, 10, 12, 15, 17, 18

CD-ROM Connection Student Gallery Teacher's Resource Binder Thoughts About Art: F4.3

| 9 weeks | 18 weeks | 36 weeks | Foundation Organizer continued                                         |                                                                                                                                                                                                      |                                                                                                                                   |  |
|---------|----------|----------|------------------------------------------------------------------------|------------------------------------------------------------------------------------------------------------------------------------------------------------------------------------------------------|-----------------------------------------------------------------------------------------------------------------------------------|--|
|         |          |          |                                                                        | Objectives                                                                                                                                                                                           | National Standards                                                                                                                |  |
| 2       | 2        | 2        | Foundation 4.4 Aesthetics page 60 Pacing: One or two 45-minute periods | <ul> <li>Consider aesthetics questions about artworks.</li> <li>Explain the role of aestheticians in art inquiry.</li> </ul>                                                                         | <ul><li>5a Compare multiple purposes for creating art.</li><li>5c Describe, compare responses to own or other artworks.</li></ul> |  |
|         |          |          | Try This<br>Abstract artwork<br>page 60                                | Create an abstract or nonobjective artwork about a news event.                                                                                                                                       | 2c Select, use structures, functions.                                                                                             |  |
|         |          |          |                                                                        | Objectives                                                                                                                                                                                           | National Standards                                                                                                                |  |
| •       | •        | •        | Connect to<br>page 62                                                  | <ul> <li>Identify and understand ways other disciplines are connected to and informed by the visual arts.</li> <li>Understand a visual arts career and how it relates to chapter content.</li> </ul> | 6 Make connections between disciplines.                                                                                           |  |
|         |          |          |                                                                        | Objectives                                                                                                                                                                                           | National Standards                                                                                                                |  |
| •       | •        | •        | Portfolio/Review<br>page 64                                            | <ul> <li>Learn to look at and comment respectfully<br/>on artworks by peers.</li> <li>Demonstrate understanding of chapter<br/>content.</li> </ul>                                                   | 5 Assess own and others' work.                                                                                                    |  |
|         |          |          |                                                                        |                                                                                                                                                                                                      |                                                                                                                                   |  |

## **Teaching Options**

More About...Kcho Teaching Through Inquiry Using the Large Reproduction Using the Overhead Assessment Options

#### **Technology**

CD-ROM Connection e-Gallery

#### **Resources**

Teacher's Resource Binder A Closer Look: F4.4 Find Out More: F4.4 Assessment Master: F4.4 Large Reproduction 6 Overhead Transparency 15 Slides 18

Computer Option CD-ROM Connection Student Gallery Teacher's Resource Binder Thoughts About Art: F4.4

## **Teaching Options**

Community Involvement Museum Connection

#### **Technology**

Internet Connection Internet Resources Video Connection CD-ROM Connection e-Gallery

#### Resources

Teacher's Resource Binder Using the Web Interview with an Artist Teacher Letter

#### **Teaching Options**

Family Involvement Advocacy

## Technology

CD-ROM Connection Student Gallery

#### **Resources**

Teacher's Resource Binder
Chapter Review F4
Portfolio Tips
Write About Art
Understanding Your Artistic Process
Analyzing Your Studio Work

## **Chapter Overview**

#### Foundation 4

Asking questions from the disciplines of art history, art criticism, art production, and aesthetics can guide us in developing an appreciation and understanding of artworks.

#### **Featured Artists**

Diana Bryer Willie Coin Hoang Vu Kcho Lawrence Leissner Bill Reid Norman Rockwell Jackson Pollock Robert Rauschenberg

## **Chapter Focus**

As people study artworks, they become curious about them. The types of questions usually asked in the study of art may be categorized into art history, art criticism, art production, and aesthetics.

## **Preparation for Chapter** Warm-up

Have students work in small groups to collect five objects that they would put in a time capsule to help their grandchildren understand life in the first half of the twenty-first century.

## **National Standards** Foundation 4 Content Standards

- 1. Understand media, techniques, and processes.
- 2. Use knowledge of structures and functions.
- 3 Choose and evaluate subject matter, symbols, and ideas.
- 4. Understand arts in relation to history and cultures.
- 5. Assess own and others' work.
- 6. Make connections between disciplines.

# **Approaches** to Art

#### **Focus**

- What do people want to know about art?
- What kinds of questions do people ask about art?

Imagine finding an object that's unlike

anything you've ever seen before. You turn the object over in your hands and ask yourself, "What is this? Who made it? How was it made?" Suppose something about the object suggests that it was made a long time ago. You might wonder why the object was important to the people who lived at that time. What did they use it for? How is it different from objects that you normally see or use?

For thousands of years, people have wondered where objects and artworks come from and why they were made. It's human nature to be curious. We can be as curious about the function of an artwork as we are about its meaning. Asking questions about the artwork helps us understand it. The information we learn about the artwork can also teach us something about the times and cultures of our world and where we fit in.

This chapter will introduce you to the kinds of questions people ask about artworks. As you read the chapter, you will see that the questions fall into four categories: art history, art criticism, the making of art itself, and the

philosophy of art.

**Words to Know** 

art historian art critic

artist aesthetician

# **Teaching Options**

#### Teaching Through Inquiry

Aesthetics Have students work in small groups to discuss their initial reactions to each artwork. Direct groups to choose a recorder to document the members' comments. Have students review the comments. categorize them by their similarities, and then complete a chart with these headings: What We Know About the Ways People Respond to Artworks; What We Would Like to Know About the Ways People Respond to Artworks. Hold a class discussion in which groups share their questions and findings.

Fig. F4–1 Hopi people of the American Southwest use Kachina figures to teach children about their culture's beliefs and values. Willie Coin, Aholi Kachina, Hopi, 1952

Cottonwood, paint, corn husk, 11 ½ " x 2 ½" (28.6 x 6.4 cm).

Denver Art Museum Collection: Purchase from Alfred Whiting,

1948.336. © Denver Art Museum.

Fig. F4–2 We do not know exactly why prehistoric people painted huge animals on cave walls. Archaeologists and art historians are still fitting together clues. France, Périgord, Lascaux caves, Cave Painting (serigraph transcription): Horse, original paintings date from c. 15,000–13,000 BC.

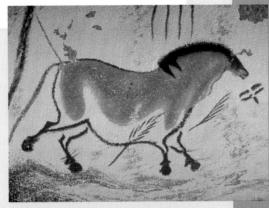

Fig. F4–4 Imagine how Jackson Pollock moved his arm as he drizzled and splattered paint across this huge canvas, dripping and slinging paint from sticks and brushes. Describe the rhythm in this piece. Jackson Pollock, Blue Poles, 1952. Enamel and aluminum paint with glass on canvas. 6 10 7/8 "x15 \*115/8" (212.09 x485.95 cm). Collection: National Gallery of Australia, Canberra (MGA Acx. No.7.46.4). © The Pollock-Krasner Foundation/Artists Rights Society (ARS), New York.

Approaches to A

## **Chapter Warm-up**

Display the collections of objects. Ask: Which of these objects will probably change most over the next few years? What do you think your grandchildren will want to know about these objects? Will they understand how they were used? Will they recognize references in our culture, such as singers, sports, and foods? In fifty years, how will these objects have changed? Do you think that your grandchildren will appreciate the way these things look and feel? Tell students that these are the types of questions people ask as they study art.

## **Using the Text**

Aesthetics Have students read the text to learn how people develop questions about art. Ask students into what four categories art questions are grouped.

## **Using the Art**

Aesthetics Divide the class into four groups. Have groups each write five questions that they would ask the artist of one of the artworks. Ask groups to report their questions to the rest of the class and look for similarities among the questions.

## **Teaching Tip**

Start a bulletin board about approaches to art. Post the questions that the groups developed in Using the Art.

Stamps, tissue paper, marker, 70° x 48° (178 x 122 cm).
Chocksett Middle School, Sterling, Massachusetts.

Fig. F4-3 Middle-school students

own version of Egyptian pharaoh

used canceled stamps to create their

Tutankhamun's gold coffin. How does the use of this unusual medium affect

the message of the artwork? Group Student Work, King Tut Stamp Mosaic,

#### More About...

Kachina dolls depict Pueblo kachinas—powerful spirits of ancestors, natural forces, plants, and animals—who come down from the mountains to visit a pueblo during religious ceremonies. These dolls are given to children both to bless them and to help them learn about the different kachinas.

## Prepare

## **Pacing**

One or two 45-minute periods, depending on the scope of Try This

## **Objectives**

- Explain the role of art historians in art inquiry.
- · Create a piece of art about a leader.

## Vocabulary

art historian A person who studies the history of artworks and the lives of artists.

## Teach

## **Engage**

Have the same groups from Chapter Warm-up each select one of their time-capsule objects to study in depth, by answering about it as many of the questions as possible under Looking at Art, Finding the Story, and Introducing the Artist. Explain that art historians ask these same questions about art.

## **Using the Text**

Art Careers Have students read page 54. Ask: In what fields could an art historian work? (curating, restoration, publishing, academia)

# National Standards Foundation 4.1

- **3b** Use subjects, themes, symbols that communicate meaning.
- **4b** Place objects in historical, cultural contexts
- **4c** Analyze, demonstrate how time and place influence visual characteristics.
- **5b** Analyze contemporary, historical meaning through inquiry.

# Art History

FOUNDATION LESSON

## The Stories Behind Art

Art history is just what you'd expect: the history of art. **Art historians**—people who study the history of art—want to know where artworks began. They research the cultures from which artworks spring. They learn about the people, the politics, and the economic conditions at the time and place where artworks were made. They try to figure out why artists created artworks and

how the artworks are different from others. And finally, when all of their research is done, they piece together the stories of art.

Do you ever wonder where artworks come from or what their story is? If you do, then you have begun investigating their history.

#### **Looking at Art**

There are certain basic questions that will get you started on the search for an artwork's story.

- **1.** What is the artwork? What is it about? What is its purpose?
- 2. When and where was it made?
- 3. Has the artwork always looked like this?

Or has it changed somehow over time?

## **Finding the Story**

The next set of questions will help you find out what an artwork meant to the artist and to the people who lived at the time it was made. By asking these questions, you can learn how the artwork reflects the cultural traditions of The time. Your answers will also help place the artwork in history.

1. What was happening in the world when the artwork was made? How is the world different now?

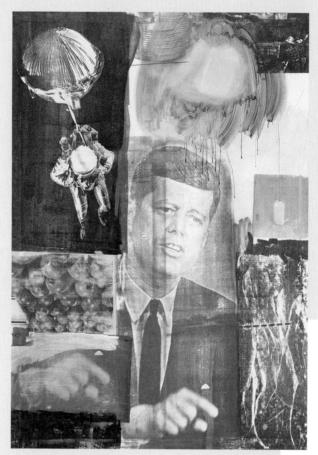

Fig. F4–5 Pop artist Robert Rauschenberg created Retroactive I soon after President John F. Kennedy was assassinated. From this painting, what can you discover about American culture in the 1960s? Robert Rauschenberg, Retroactive I, 1964.

Oil, silk-screen ink on canvas, 84° x 60° (213 x 152 cm).
Wadsworth Athreuum, Hartford. Gift of Susan Morse
Hilles (1964.30). © Robert Rauschenberg/Licensed by
VAGA, New York, New York.

54

# **Teaching Options**

#### Resources

Teacher's Resource Binder
Thoughts About Art: F4.1
A Closer Look: F4.1
Find Out More: F4.1
Assessment Master: F4.1
Large Reproduction 4
Overhead Transparency 7
Slides 1, 13, 14, 17

#### **Teaching Through Inquiry**

Art History Have students work in groups to create time lines of clothing styles through the ages. Ask groups to provide brief explanations on the time line that relate dress to living conditions and world events. In a class discussion, ask students to explain how and why clothing has changed over time.

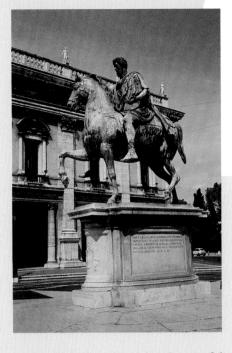

**2.** How do the customs and traditions of the artist's family or culture add to the meaning of the artwork?

**3.** What other kinds of art did people make at that time?

**Introducing the Artist** 

As the story of an artwork unfolds, questions about the artist begin to surface. Some art historians focus their investigations mainly on the life and work of a single artist. Imagine the accomplishment of having discovered something new and interesting about an artist!

- 1. Who made this artwork?
- **2.** What role did artists play in the community in which this work was made?
- **3.** How does this artist's style compare to the style of other artists during that time?
- **4.** What decisions was the artist faced with as he or she created this artwork?

Fig. F4-6 This statue of a Roman emperor is the only wellpreserved equestrian (horse and rider) statue to survive from antiquity. How did the artist show the importance of the emperor? Roman, Marcus Aurelius, Equestrian,

Bronze, over lifesize. Piazza del Campidoglio, Rome. SEF/Art Resource, New York.

Fig. F4–7 What is the story in this artwork? Where has the artist seen lions? Lisa Ball, Trapped Lion, 2000. Colored pencil, 9" x 9" (23 x 23 cm), Los Cerros Middle School, Danville, California.

You can ask any of these sample questions about a specific artwork or artist. You can also ask similar questions about an entire art period or about the value and use of artworks in general.

See if you can find out what art historians have said about artworks and artists that interest you or about when and where the artworks were created.

#### Try This

Create an artwork about a local or national leader from the past or present. Include information about the leader's culture to provide viewers with clues about who it is and when and where this person lived. What objects are associated with this person? How and where would most people have seen this person?

#### **Lesson Review**

#### Check Your Understanding

- **1.** How do art historians learn about the history of artworks?
- **2.** From this lesson, select a piece of artwork that appeals to you. Analyze it by answering one or two questions from each category in the lesson.

## **Using the Art**

Art History Have the same groups continue to work together to answer the caption questions for Robert Rauschenberg's *Retroactive I* and for the statue of Marcus Aurelius.

## **Try This**

Tell students that this artwork could be a collage, drawing, or painting, or a combination of these.

## Assess

# Check Your Understanding: Answers

- 1. Art historians research cultures; learn about the people, politics, and economic conditions of when and where art was made; figure out why art was made; and piece together art stories.
- 2. Student answers should indicate a careful study of the art.

## Close

Review students' answers to Check Your Understanding. Have student pairs exchange artworks and answer the art-historical questions about their partner's art. Ask students for a brief summary of what they have learned about art history.

#### 55

Art

Approaches to

#### More About...

Marcus Aurelius Antoninus served as a great Roman military leader and intellectual ruler from 161 to 180 AD. The statue of him is unusual in that it is one of the few remaining Roman equestrian statues: early Christians consciously destroyed such pagan images. However, this work was thought to be an image of Constantine, the first Christian emperor.

#### **Assessment Options**

Teacher Provide students with this scenario: Imagine that you find a piece of pottery half buried in the ground after a rainstorm. You do not recognize it, but it has some markings or drawings on it. You show it to your friends, but no one knows much about it. What questions could you ask about this piece of pottery? Who could help you learn its origin? Look for evidence that students understand the role of art historians and the nature of arthistorical questions.

#### **Using the Large Reproduction**

Have students discuss the art form, materials, and time period of this work, and consider its cultural context.

## **Using the Overhead**

Have students discuss the art form, materials, and time period of this fresco.

# Prepare

## **Pacing**

One or two 45-minute periods, depending on the scope of Try This

## **Objectives**

- Consider questions about the meaning of art.
- Explain the role of art critics in art inquiry.
- Create an artwork based on family or community heritage.

## Vocabulary

art critic A person who expresses a reasoned opinion on any matter concerning art. Art critics often judge the quality of artworks and suggest why they are valuable or important.

## **Supplies for Engage**

 movie advertisements from newspapers

## Teach

## Engage

Distribute the advertisements. **Ask:**Has anyone seen these movies?
What did you think about them?
Were they as good as these ads suggest? Explain that people take on the role of critic when they share their ideas about a movie they have seen.

## **Using the Text**

Have students read pages 56 and 57. **Ask:** What do art critics do? When would someone seek the advice of an art critic? (before purchasing art)

# National Standards Foundation 4.2

- **3b** Use subjects, themes, symbols that communicate meaning.
- **4b** Place objects in historical, cultural contexts.
- **5c** Describe, compare responses to own or other artworks.

# **Art Criticism**

## **Searching for Meaning**

Art critics want to know what artworks mean. They can help us learn about artworks by describing them and pointing out interesting things to look for. They judge the quality of artworks and suggest why they are valuable or important. Art critics often write about art in newspapers or magazines. Their views can influence the way we look at and think about artworks.

You have already asked questions like an art critic, perhaps without even realizing it. You may have looked at artworks in this book and wondered about their meaning. You have expressed your thoughts and opinions about objects and artworks around you. And you have compared them to other objects or artworks you're familiar with. Your views may have affected the way your classmates or others think about artworks.

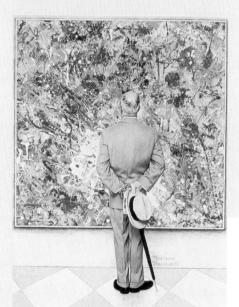

## **Finding Clues**

As an art critic, you need to observe certain things about an artwork before you can begin to think about its possible meaning. Here are some questions that will help get you started.

- 1. What does the artwork look like?
- 2. How was it made?
- **3.** How are the parts of the artwork arranged?
- **4.** Does it seem to suggest a mood or feeling? An idea or theme?

## **Making Connections**

Once you understand how the artwork is put together, you can focus more on its meaning and ask questions such as these:

- 1. What is the artwork about?
- **2.** What message does it send? How does it make me think, feel, or act when I see it?
- **3.** How is the artwork related to events in the artist's life? How is it related to events that happened at the time it was made?

## **Judging Importance**

Suppose you have learned enough about the artwork to decide that it is important. Next, you need to support your judgment. Ask yourself:

- **1.** What aspects of the artwork—such as artist, culture, message, or function—make it important? Why?
- **2.** What sets this artwork apart from similar artworks?
- **3.** How is my response to this artwork different from my response to similar artworks?

Fig. F4–8 When Connoisseur appeared as a magazine cover, art critics considered it just an illustration, whereas abstract paintings such as Pollock's (Fig. F4–3) were thought of as fine art. Do you agree with that judgment? Norman Rockwell, Connoisseur, 1962. Cover illustration for the Sotunday Evening Post, 13 January 1962. Printed by permission of the Norman Rockwell Family Trust. © 2001 The Norman Rockwell Expelled Family Trust. © 2001 The Norman Rockwell Expelled Family Trust.

56

FOUNDATION LESSO

# **Teaching Options**

## Resources

Teacher's Resource Binder Thoughts About Art: F4.2 A Closer Look: F4.2 Find Out More: F4.2 Assessment Master: F4.2 Large Reproduction 2 Overhead Transparency 11 Slides 18

## **Teaching Through Inquiry**

Art Criticism Art critic Clement Greenberg praised Jackson Pollock, saying Pollock "is not afraid to look ugly—all profoundly original art looks ugly at first." At about the same time, people were telling Norman Rockwell that even though they didn't know anything about art, they loved his paintings. Challenge students to write their ideas about Pollock's painting on page 53 and about Rockwell's painting, and to explain how their ideas compare with Clement Greenberg's and the people who loved Rockwell's work.

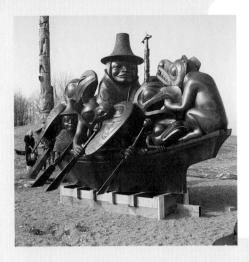

You can see the kinds of things art critics say about art when you read a review of an art exhibit in your local newspaper. Try to visit the exhibit yourself. Do you agree with what the critic says about it? Why or why not?

## Try This

Create an artwork about a journey or event that is part of your family's history or your community's heritage. Include symbols to help viewers identify your cultural history. These symbols might be landmarks, clothing, or an artistic style. Then write a description of the meaning and message of your artwork.

## **Sketchbook Connection**

Sketch a monument or building in your area. Then critique the structure by using the questions on these two pages

as a guide. Write your art criticism of the monument or building in your sketchbook.

Fig. F4–9 Canadian artist Bill Reid is often inspired by myths from his heritage. In this work, Bear faces the past while Raven steers the canoe. The wise Haida chief stands in the center as Beaver, Human Warrior, and Magical Dogfish Woman paddle. Bill Reid, The Spirit of Haida Gwaii, The Jade Canoe, 1994.

Fronze cast with jade green patina, 12' 9" x 11' 5" x 19' 10" (388.6 x 348 x 604.5 cm).
Collection of the Vancouver Airport Authority, Vancouver, Canada. Photo: Bill McLennan.

Fig. F4–10 What do you think this artwork is about?
To create this batik, the artist used wax to draw on cloth.
The wax blocks the color dyes from certain areas of the design. Lisa Hough, Indian Symbolism, 2000.

Batik, 18° x24° (66 x61 cm). Jaurel Nokomis School, Nokomis, Florida.

## **Lesson Review**

## **Check Your Understanding**

- **1.** What do art critics look for as they study artworks?
- **2.** Choose an artwork in this chapter. Write an art criticism about it by answering at least one question in each category on these two pages.

Using the Art

Art Criticism/Art History Explain that the meaning of connoisseur in the title of Norman Rockwell's painting is "someone who has studied and appreciates art," and that Rockwell painted Connoisseur when Abstract Expressionism was the popular style. Have students compare Rockwell's painting to Pollock's Abstract Expressionist painting on page 53. Ask students to explain the meaning of each work.

Art History Have students work in groups to use Bill Reid's The Spirit of Haida Gwaii in answering the questions on page 56.

## **Try This**

Lead students in discussing significant events in their family or community histories for use in creating a drawing, painting, or collage. Have student pairs use each other's art to answer the questions on page 56.

## Assess

# Check Your Understanding: Answers

- 1. Art critics look for meaning and for connections to other artworks and the artist's life.
- **2.** Answers will vary but should thoughtfully address one question from each category.

## Close

Have students write a description of their own artwork and its meaning. Display the artworks and descriptions.

## More About...

Norman Rockwell always wanted to be an artist. Born in New York City in 1894, he first studied at the New York School of Art and then the Art Students League. While in his teens, he became art director for Boys' Life; and, at 22, he painted his first cover for The Saturday Evening Post. Over the next 47 years, he painted over 300 covers about American life for the Post. Although not considered a fine artist during his lifetime, by the 1990s, he was described as "the Vermeer of this nation's domestic history."

## **Assessment Options**

**Teacher** Have students write an essay in which they

agree or disagree with the idea that anyone can be an art critic. Look for evidence that students understand the function of art criticism.

## **Using the Large Reproduction**

Approaches to

Art

57

Have students use this image to answer the questions in Finding Clues.

## **Using the Overhead**

Have students use this image to answer the questions in Judging Importance.

11

## Pacing

One or two 45-minute periods, depending on the scope of Try This

## **Objectives**

- Consider questions about the production of artworks.
- Understand the role of artists in art inquiry.
- Create an artwork based on an artist from this chapter and then reflect on the experience.

## Vocabulary

artist A person who creates art.

## Teach

## **Engage**

Ask: Have you ever made your own artwork just because you wanted to? Did you like this art because of the way it turned out or the fun you had making it?

# Supplies for Using the Text

 Students should each have an artwork that they have made recently.

## **Using the Text**

Art Criticism Have students each use their artwork to answer the art-production questions on these pages.

## **Using the Art**

Art Criticism Guide students to imagine how Hoang Vu's hands moved as he bent and twisted wire together, and to suggest what tools he used. (pliers)

# National Standards Foundation 4.3

**1a** Select/analyze media, techniques, processes, reflect.

# **Art Production**

## **Making Art**

FOUNDATION LESSON

Artists all over the world make artworks for decoration, to celebrate important events, and to communicate ideas or feelings. When artists plan a work of art, they think about its purpose and meaning. As they create the work, they explore their ideas and sometimes test the limits of the materials they use. In the end, they create a work that satisfies their personal and social needs, interests, values, or beliefs.

You think like an artist every time you explore the things you can do with pastels, a lump of clay, or any other art material. You might have an idea when you start, or your

exploration might lead you to one. When you are finished expressing your idea, you have a work of art that is all your own.

# Reflecting on Your Art and Yourself

As you create art, you will begin to realize what art and making art mean to you. Asking questions about your art-making experience will help you uncover that meaning.

- **1.** What artworks are important to me? How do they affect the way I make art?
- 2. What feelings or ideas do I like to express in my artwork? What does my art say about me?
- **3.** What process do I go through when I make art?

## Considering Your Art and the World

When you have a better understanding of your own art, you can think about how it fits into the big picture. Ask yourself:

- 1. What does my artwork tell others about the place and time in which I live? What special events, people, or things does it suggest?
- 2. What do my choices of materials and techniques tell others about my world?3. How is my artwork similar to or different from art that was made in other times and places?

Fig. F4–11 Vietnamese-American artist Hoang Vu is inspired by natural forms. He says he wants his sculptures to be fragile but strong, like leaves in wind. Hoang Vu, Nghe, 1998.

Wire, 16\* X10\* X14\* (A0.6 X 25.4 X 35.6 cm). Courtesy the Frunkin/Duval Callery. Santa Monica, California.

58

# **Teaching Options**

## Resources

Teacher's Resource Binder
Thoughts About Art: F4.3
A Closer Look: F4.3
Find Out More: F4.3
Assessment Master: F4.3
Large Reproduction 7
Overhead Transparency 4
Slides 2, 3, 4, 5, 7, 9, 10, 12, 15, 17, 18

## Teaching Through Inquiry

Art Criticism Assign students to research either the artist or art of the culture (such as Hopi or ancient Rome) of the piece they selected for Try This, and to make copies (hand, photocopy, or computer printouts) of other pieces created by the artist or within the culture. For a display of their artwork with the copies of other pieces, have students each include a written comparison/contrast of their own and the copied works. If students cannot locate more images, suggest that they find art of a similar style.

Fig. F4–12 Diana Bryer has an Eastern European Jewish heritage but lives in New Mexico. Can you locate symbols of both cultures within her artwork? Diana Bryer, The Jewish Fairy Blessing the Menorah of the Southwest, 1986.

Fig. F4–13 Imagine how this student artist went about creating this artwork. Have you ever made a portrait? How did you begin? David Yates, *Untitled*, 1999.
Mixed media, 18\*x12\*x3\* (46x30.5 x 7.5 cm). Chocksett Middle School, Sterling, Massachherster.

Comparing Your Art to Other Art

As an artist, you are probably aware of ideas and concerns that other artists have. When you compare your work to theirs, you might see a connection.

- **1.** How is my artwork similar to or different from artworks made by others? How has their work affected my work?
- **2.** If I could create an artwork with another artist, whom would I choose to work with? Why?
- **3.** What materials and techniques have other artists used that I would like to explore? Why?

The next time you create a work of art, ask yourself the questions in this lesson. See what answers you come up with. You'll probably learn something surprising about the artist in you!

## Try This

Choose one artwork in this chapter that most appeals to you. Create a similar piece of art, using the same theme or media or style. Do not copy the artwork. Instead, express something about your interests. When you have completed your work, reflect on it by answering some of the questions on these two pages.

## Lesson Review

## **Check Your Understanding**

- **1.** List some reasons that artists create art. Why have you made a specific piece of art in the past?
- 2. Select a piece of art that you have created. Explain how you feel about it. What does it say about your world? How does it compare to other art?

Approaches to

59

Art

## **Try This**

Discuss artworks in this chapter and how students could create companion pieces. Caution students to select a piece with which they can identify. Provide a limited choice of materials, such as clay, wire, or drawing and painting supplies.

## **Critical Thinking**

Ask students to name an artist in this chapter with whom they would they like to create a work of art, and to explain why.

## Assess

# **Check Your Understanding: Answers**

- 1. Artists create artworks for decoration, to celebrate important events, and to communicate ideas and feelings. Students' explanations will vary.
- 2. Students should describe how they feel about a piece of art that they have created, how it fits into the world, and how it compares to other art.

## Close

Discuss students' answers to Check Your Understanding. Display their artworks, and encourage students to explain the connection between their art and a piece in the book. Have volunteers share their reflections about creating their art.

## More About...

Hoang Vu was born in Saigon, now Ho Chi Minh City, in 1962. He has painful memories of unsuccessful, daring attempts to escape from Vietnam. As a young adult, he was finally able to flee by boat. He studied art at California State University Fullerton.

## **Assessment Options**

Teacher Ask students to imagine that they have been chosen to serve on a board to establish a new school—just for third graders. Some of the board members question whether the third graders should spend class time making art. Ask: Based on your understanding of art production, what would you say to convince the rest of the board members that creating art is important?

## **Using the Large Reproduction**

Use this image to speculate about how the artist might

respond to questions in Considering Your Art and the World.

## **Using the Overhead**

Use this image to speculate about how the artist might respond to questions in Comparing Your Art to Other Art.

## Pacing

One or two 45-minute periods, depending on the scope of Try This

## **Objectives**

- Consider aesthetics questions about artworks.
- Explain the role of aestheticians in art inquiry.
- Create an abstract or nonobjective artwork about a news event.

## Vocabulary

aesthetician A person who asks why art is made and how it fits into society. One who studies questions about art or beauty.

## Teach

## Engage

Ask: Do artworks have to be beautiful or pretty? Have students write a short answer by citing art examples from the text. Encourage students to debate their position, and then explain that this is an aesthetics question.

## **Using the Text**

Aesthetics Have students define aesthetics. Ask: What types of questions do aestheticians ask?

## **Using the Art**

Aesthetics Have students identify at least one question from the text that they would like to discuss in relation to one of the artworks in this lesson.

## **Try This**

Provide students with articles from newspapers and news magazines. To demonstrate how students should begin, read an article aloud and discuss which colors, lines, and shapes

# National Standards Foundation 4.4

- 2c Select, use structures, functions.
- **5a** Compare multiple purposes for creating art.
- **5c** Describe, compare responses to own or other artworks.

# **Aesthetics**

## **Investigating Art**

FOUNDATION LESSON

Aesthetics is the philosophy, or investigation, of art. **Aestheticians** can be called art philosophers. They ask questions about why art is made and how it fits into society. They're interested in how artworks came to be.

Every time you wonder about art or beauty, you think like an aesthetician. The questions that come to your mind about art are probably like the questions that aestheticians ask. All you need is a curious mind and probing questions to be an art philosopher yourself.

Thinking About Artworks

At some time or another, you have probably wondered what artworks are. Like an aesthetician, you can ask certain questions that will help you think more carefully.

1. Are all artworks about something?

- **2.** In what ways are artworks special? What makes some artworks better than others?
- **3.** Do artworks have to be beautiful or pretty? Why or why not?
- **4.** What makes one kind of artwork different from another?

## **Thinking About Artists**

As an aesthetician, you might wonder about the people who make art, why they make it,

and why some people, but not all, are called artists. You might ask:

- 1. What do artworks tell us about the people who made them? What do they tell us about the world in which they were made?
- 2. What do people express through making art? Do artworks always mean what the artist intends them to mean?
- **3.** Should there be rules that artists follow to make good artworks?

Fig. F4–14 What, do you think, was the artist most interested in as he created this painting? Lawrence Leissner, *The Second Trigram*, 1995.
Watercolor, 21\* x26\* (\$3.34.66 cm), Courtesy of the artist.

60

# **Teaching Options**

## Resources

Teacher's Resource Binder Thoughts About Art: F4.4 A Closer Look: F4.4 Find Out More: F4.4 Assessment Master: F4.4 Large Reproduction 6 Overhead Transparency 15 Slides 18

## **Assessment Options**

**Teacher** Ask students each to cut out three interesting images from recycled magazines. Shuffle the

images. Give each group of four students a dozen images to put into these categories: art, not art, could be art. Have students each write a short explanation of how they used aesthetics in this activity.

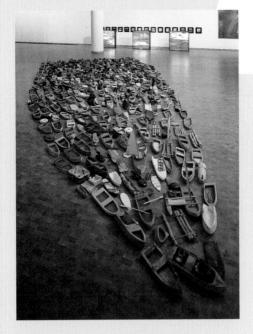

Fig. F4–15 The installation represents the large groups of people who leave Cuba by boat for Florida. What can this work tell you about this artist? Kcho, *The Regatta*, 1994.

Mixed media, dimensions variable. Stadt Köln, Rheinisches Bildarchiv Köln.

The questions that aestheticians ask do not necessarily investigate a specific artwork. Instead, they investigate the larger world of art in general.

## Try This

Create an artwork about a news event that concerns you. Try to use an abstract or nonobjective style to show the emotions surrounding this event and your feelings about it. Show your work to a partner. Does he or she understand the work in the way you wanted? Have your partner point to specific details in your work to support his or her interpretation. Why, do you think, people can have different reactions to the same work of art?

# Thinking About Experiences with Art

When you talk about art, you probably discuss whether or not you like an artwork. And you probably talk about how an artwork makes you feel. These questions will help you dig deeper into your experience with an artwork.

- **1.** How do people know what an artwork means?
- **2.** Is it possible to dislike an artwork and still think it is good?
- **3.** How is the experience of looking at an artwork like the experience of looking at a beautiful sunset? Or are these experiences completely different?
- **4.** How do beliefs about art affect the way people look at and explore artworks?

## **Computer Option**

Locate one of the artworks in this chapter on the Internet or a CD. Download the image into a file. Use

filters and drawing tools to transform it into your own artwork based on the famous piece. Using another's artwork in this way is called *appropriation*.

## **Lesson Review**

art historian?

## **Check Your Understanding**

What is another term for an aesthetician?
 How is an aesthetician different from an

would best express the emotions of the event. Students may use paint or oil pastels. Display students' art for visual reference as students answer the aesthetics questions.

# Computer Option To assist students,

you may wish to preselect Websites. Challenge students to attempt to give new meaning to the work by altering it to the point they feel they can claim it as their own. Discuss the new works and their meanings in comparison to those of the original works, and begin to establish criteria for what makes an artwork better or

more meaningful than another.

## Assess

## Check Your Understanding: Answers

- 1. art philosopher
- **2.** An art historian studies the history of art; an aesthetician asks why art is made.

## Close

Display students' artworks from Try This. Summarize students' discussions of the aesthetics questions in the text, and discuss their answers to Check Your Understanding.

proaches to Art

61

## Teaching Through Inquiry

Aesthetics To set the scene for a debate, display a found object on a pedestal. Include a label with the title and artist's name. Tell students that a museum is considering the purchase of this "artwork." Assign each of five collaborative-learning groups one of these positions to support:

- 1. Art should be beautiful.
- 2. Art should show artists' emotions.
- 3. Art should be made of traditional fine-art materials.
- 4. Art should be realistic.
- 5. Art should cause people to think.

Have groups each choose one student to present its position. Then open discussion to the full class to consider why several points of view would be important.

## Using the Large Reproduction

Use this image to discuss questions in Thinking About Artworks.

## Using the Overhead

Use this image to have students discuss what the house tells about the person who commissioned it.

## **Careers**

Ask students each to assume the role of museum educator and work in small groups to develop short programs, activities, or skits to present to younger students. The presentation might be guidelines on museum manners, interactive activities that use large or small reproductions as the artworks in their "museum," a dramatization of an artwork, poetry or writing based on artworks, or a written museum guide.

## Other Arts

Have students each critique a theatrical production on public television, or one you show in the classroom. Have them write four reviews, each from one of the different approaches to art. Have students share their reviews and identify the different perspectives.

# Connect to...

## **Careers**

Have you ever taken part in a guided tour in an art museum? Most likely, your guide was a museum educator. A museum educator may be a member of the museum's education department or a community volunteer called a docent. Most large museums have an education department. The staff works with public and private schools in the community and arranges visits and tour schedules. The department may also provide outreach programs, such as lectures, films, and other programs that travel outside the museum. Museum educators often plan and develop tours for special exhibitions or the permanent collection. Most museum educators approach the study of art through art history. This requires them to have a degree in art history or museum education.

F4–16 What guided tours have you been on? How did they help you understand a site or collection of objects?

Photo courtesy Eldon Katter

## **Other Arts**

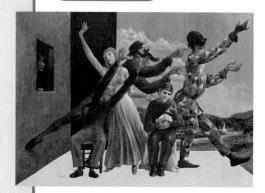

## Theater

There are different approaches to theater, just as there are approaches to the visual arts. For example, a theater historian examines a play within its context. When was it written? What other events were going on when the play was written? The theater critic searches for the performance's meaning. The critic describes the play and makes a value judgment—whether the piece was good or bad and why. Finally, a theater aesthetician examines the larger questions or issues: Why was the work made? What is its relationship to society and culture?

F4–17 The commedia dell'arte was a type of comedic play. It was first performed in Italy in the sixteenth and seventeenth centuries and reflected the lives of ordinary people of the time. André Rouillard, Commedia dell'Arte, 1991.

62

# **Teaching Options**

## Resources

Teacher's Resource Binder:
Making Connections
Using the Web
Interview with an Artist
Teacher Letter

## **Video Connection**

Show the Davis art careers video to give students a reallife look at the career highlighted above.

## **Community Involvement**

Invite local artists to visit your art classes to share their artwork and explain their profession, how they learned their skill, and why they create art. Before the visit, assign students to develop questions they would like to ask these artists.

## **Other Subjects**

## **Social Studies**

Do you know that different approaches towards certain artifacts can affect the kind of museum in which an object is placed? For example, an art historian and an anthropologist (a scientist who studies human culture) might differ on the kind of museum in which a Native American artwork should be placed. The art historian might say the work belongs in an art museum. The anthropologist might choose a museum of natural history or ethnography (the study of culture). Why, do you think, do different museums exist?

## Science

Sir Isaac Newton first proposed the **scientific** method, an approach to scientific study, in 1687. This step-by-step approach is now the standard used when conducting scientific

F4-18 Which would you choose as the most appropriate museum for a work such as the one pictured here? Why? Native American, Tlingit, Group of Three Baskets, early 20th century.

Peabody Museum – Harvard University. © Pres. and Fellows of Harvard College 1974. All rights Reserved. Photograph by Hillel Burger.

experiments. Researchers using the scientific method first ask a question based on observation. Next, they state a testable hypothesis or interpretation, design a study to answer the hypothesis, and collect data through observation and experiment. Last, they interpret the results and draw conclusions. Can you think of any way such an approach could be adapted to interpret a work of art?

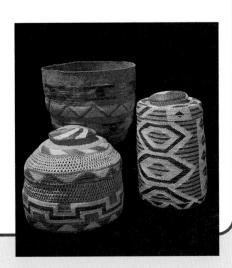

## Internet Connection For more activities related to this chapter, go to the

Davis Website at www.davis-art.com.

**Daily Life** 

When you recommend music, movies, computer games, or books to your friends, you are acting as a critic. Art critics approach art through a focus on interpretation and judgment. You are doing exactly that when you share your opinions with your friends. What are the guidelines or criteria you use in forming your opinions and judgments?

Approaches to Art

63

## **Daily Life**

Have students collect and bring in music and film reviews-from newspapers, magazines, or online publications—that are aimed specifically at preteens and teens. Ask students to work in small groups to answer these questions: Do you regularly read these kinds of reviews? If so, how do they influence what music you buy or movies you see? Do you find that you often agree with a review after you have heard the music or seen the movie? After the groups have answered the questions, hold a full-class discussion.

## Science

Make an outline of the steps of the scientific method, leaving writing lines under each step. Make copies of the outline. Have students gather in small groups, and provide one copy and a reproduction of a detailrich artwork for each group. Ask groups to apply the scientific method to the artwork, complete the outline, and report their findings to the rest of the class. Encourage students to discuss their success or difficulty with the activity.

## **Internet Resources**

## The Cave of Lascaux

http://www.culture.fr/culture/arcnat/lascaux/en/ Visit the official site of the prehistoric cave paintings in France.

## The Hopi Tribe

http://www.hopi.nsn.us/

This Website, maintained by the Hopi, contains a wealth of information on Hopi history, culture, government, and religion.

## Museum Connection

Challenge students to be docents for a museum tour. From your local museum's catalog, brochures, or Website, obtain images of and information about its artworks. Form the class into touring groups of four students each. Within each group, number students from 1 to 4. Have all the same-numbered students meet together to learn about two or three artworks and develop questions to help their original group view these artworks. Upon their actual visit to the museum, each student "expert" will guide his or her touring group's discussion about the artworks.

## Portfolio & Review

# Talking About Student Art

As students look at one another's artworks, ask them to describe what they see, what they think the artwork's meaning is, and how they know this. Ask the artist if this is what he or she intended for others to see and understand.

## **Portfolio Tip**

Have students each invite an adult to view their portfolio. The adult may be a

family member, teacher, administrator, or older friend. Send the portfolios home for the viewing, or invite the adults to the artroom for a portfolio day. After students each have explained their art to their adult viewer, ask the adults to share with students what they liked or found surprising about the art.

## **Sketchbook Tip**

Encourage students to get in the habit of using their sketchbook for both writing

and drawing. Guide students to record questions and comments that come to mind as they draw and as they observe possible art subjects.

# **Portfolio**

REVIEW

PORTFOLIO &

F4–19 This painting was inspired by an ancient art-form that involved painting on bark. Austin Pines, *Bark Painting*, 2001.

Watercolor, shoe polish, colored inks, and charcoal, framed with sticks and raffia, 12" x 15 1/4" (30.5 x 39 cm). Hillside Junior High School, Boise, Idaho.

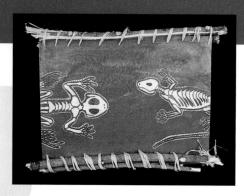

F4–20 What sets this artwork apart from other paintings of a house? Michael Baldwin, Photo Phantom Home, 2001.
Watercolor, marker, 10 1/4" x 14 1/4" (26 x 36 cm), Plymouth Middle School Phumputh Minneseta

"My structure is a space home for many kinds of people, old or young, big or small. Each home comes complete with a food, air, and water making machine to help you and your family live as long as possible. The roof is made purely of solar panels to make it run forever. The house can land on any surface or stay in space." Michael Baldwin

"When I made the piece, I was thinking mostly about detail. I wanted to add additional parts, like pictures or slippers, but my time was limited. I would have to say the hardest part was the floor. I had to measure each tile to get them to look somewhat the same."

Pat Chybowski

F4–21 What makes this artwork unusual? How has the artist's attention to detail made a difference? Pat Chybowski, *Porcelain Palace*, 2000. Clay glaze, 7" x 5 1/2" x 5 1/4" (18 x 14 x 13 cm). Antioch Upper Grade, Antioch, Illinos

64

# **Teaching Options**

## Resources

Teacher's Resource Binder
Chapter Review F4
Portfolio Tips
Write About Art
Understanding Your Artistic Process

Analyzing Your Studio Work

## **CD-ROM Connection**

For students' inspiration, for comparison, or for criticism exercises, use ional student works related

the additional student works related to studio activities in this chapter.

# Foundation 4 Review

## Recall

What does the term aesthetics mean?

## Understand

Explain how art critics can help people. What do art critics do in their jobs?

Make a list of questions that art historians might ask about Kachina, Fig. F4-1 (see below), and then try answering them.

Pretend that you are an art critic writing for your school newspaper. An art exhibit featuring the artworks on pages 60 and 61 has recently opened in your community. Describe and critique these artworks. (Use the questions in lesson F4.2 to guide your critique.) How strongly would you recommend that students see this show?

## Synthesize

Research prehistoric cave paintings from southern Europe, such as those in France near Lascaux (see Fig. F4-2) or the Ardèche region. Write an imaginary diary description about painting in these deep, dark caves. Include drawings like those of the early artists, and suggest why these artists might have painted such animals and figures.

## Evaluate

As an aesthetician, write an essay based on Niki de Saint Phalle and Jean Tinguely's Illumination on page 40. Discuss whether all art has to be beautiful. Use the questions on pages 60 and 61 to guide your discussion. Explain why you think Illumination was a good choice for the beginning of this book. Or, from the Foundation chapters, select another artwork that you feel would be a better choice, and explain why.

**For Your Portfolio** 

Select an artwork from your

art critic, or aesthetician might be interested in.

Write a description of your artwork from

this person's point of view. Use the questions

in the lesson about art history, art criticism,

or aesthetics to guide your discussion.

portfolio that an art historian,

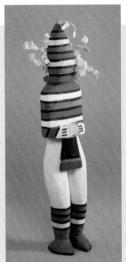

Page 53

## Family Involvement

Develop a Website for your art program. Either scan or use a digital camera to photograph student art. Post new contributions regularly so that students can share their work with distant friends and family. On the site, include the goals and objectives of your classes, links to other art sites, course syllabi, and class and homework assignments. Enlist students to help develop and maintain the site.

## **Advocacy**

Let local and school newspapers know about your students' artworks and projects. Get to know local entertainment and arts writers, and tell them about your program. Write press releases about what is happening in the art program.

## Foundation 4 **Review Answers** Recall

Aesthetics is the philosophy or investigation of art.

## **Understand**

Art critics can influence the way people look at art. By describing art and pointing out things to look for, usually in writing, critics help us learn about art. They also judge the quality of artworks.

## Apply

Art historians would be interested in the kachina's purpose, and when and where it was made; they might ask: How do the artist's culture and family customs add to the kachina's meaning? What other kinds of art do the Pueblo make? Who made this? What role did the artist play in his community? How does the artist's style compare to that of other artists in this culture? What decisions did the artist face as he created this kachina?

## Analyze

Look for thoughtful descriptions of Leissner's and Kcho's artworks, connections to their culture, and judging of the importance of these works.

## **Synthesize**

For their research, students may use the Internet, their social studies textbook, and encyclopedias and other reference books. Encourage students to consider how the artists might have studied animals, how they got through tight spaces to reach the caves, the natural materials they used, and the darkness of caves lit only by oil lamps and torches.

## **Evaluate**

Look for thoughtful discussion and explanations backed with reasons.

## Reteach

Have students analyze one of their artworks as an art historian, as an art critic, as an artist, and as an aesthetician. Guide students to use the questions from the respective sections in the text as an aid in their analysis. Ask students how this analysis of art from different points of view has changed how they feel about their own art.

Art

Approaches to

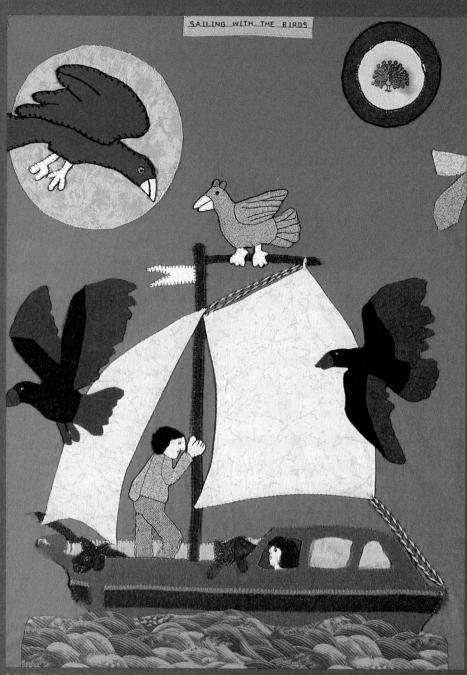

Rakhel Biller Klinger, Sailing with the Birds (detail), 1999.

Cloth, hand and machine appliqued with embroidery, 59° x 38° (147 x 97 cm). Courtesy of the artist.

# Art Is a Themes Personal Journey

Have you ever been on a journey? You probably take little journeys all the time: you go to school, to the grocery store. Maybe you walk down the block to play basketball. Or perhaps you wander from one side of a quiet forest to the other.

Long journeys—say, a trip to another state—can show you new things, make you think in a new way. But even short trips can change your point of view. On your walk to play basketball, you might see a new sign or a newly painted building. Spring rains might have flooded a stream in the forest. Suddenly, a familiar scene looks different to you.

An artist's first scribble is the start of a long journey. As young children, artists draw what they see around them. As they grow and change, their artwork changes. They meet people who make them think differently about what they see. They find new materials to work with. They explore new ideas and ask new questions. An artist's journey goes in many different directions.

In this part of this book, you'll learn about many artists and their journeys. You'll find out what they like and how they think. You'll read about people or places that have changed the way they work. And you'll meet artists who are storytellers or designers, artists who want to teach us, show us magic, or send us messages.

As you travel through these chapters, think about journeys you have taken. How have they changed you? How can you show those changes through your art? And how can the art around you help change the way you see?

4

5

3

3

# **Chapter Organizer**

## Chapter 1 Artists as **Storytellers**

Chapter 1 Overview pages 68-69

## **Chapter Focus**

- Core Learn how Jacob Lawrence and other artists use images to tell stories
- 1.1 Narrative Art
- . 1.2 Contour and Gesture Drawing
- . 1.3 The Kingdom of Dahomey
- · 1.4 Sculpting a Scene

## **Chapter National Standards**

- Understand media, techniques, and processes.
- Use knowledge of structures and functions.
- Choose and evaluate subject matter, symbols, and ideas
- Understand arts in relation to history and cultures.
- Assess own and others' work.
- Make connections between disciplines.

## **Objectives**

## **Core Lesson** An American Storyteller page 70 Pacing: Four or more

45-minute periods

- Describe purposes and methods used by artists to create storytelling artworks.
- · Explain the importance of developing a systematic approach to creating artworks in a series.

## **National Standards**

- 2a Generalize about structures, functions.
- 4c Analyze, demonstrate how time and place influence visual characteristics.
- 5b Analyze contemporary, historical meaning through inquiry.

## **Core Studio** Picture a Story page 74

- · Create a unified series of three paintings, using shape and other design elements, to tell a story.
- 1a Select/analyze media, techniques, processes, reflect.

## **Objectives**

## Then and Now Lesson 1.1 **Narrative Art**

page 76 Pacing: Three 45-minute periods

- · Define narrative art, and describe similarities between narrative art of the past and that of the present.
- Give examples of how today's narrative artists have been influenced by narrative artists of the past.

## **National Standards**

- 2b Employ/analyze effectiveness of organizational structures.
- 4a Compare artworks of various eras, cultures.
- 4c Analyze, demonstrate how time and place influence visual characteristics.

## **Studio Connection** page 78

- · Make a collage that tells a story.
- 1b Use media/techniques/processes to communicate experiences, ideas.
- 3b Use subjects, themes, symbols that communicate meaning.

## **Objectives**

## **Skills and Techniques** Lesson 1.2

Contour/Gesture Drawing • page 80 Pacing: Two or three

- · Explain the advantages of contour- and of gesture-drawing techniques.
  - Draw figures by using contour- and gesturedrawing techniques.

## **National Standards**

- 1a Select/analyze media, techniques, processes, reflect.
- 3a Integrate visual, spatial, temporal concepts with content.

## **Studio Connection**

45-minute periods

· Design and draw a comic strip.

## 1b Use media/techniques/processes to communicate experiences, ideas.

## **Featured Artists**

Apollodorus of Damascus Viola Frey Red Grooms Kuniyoshi Jacob Lawrence Roy Lichtenstein Roger Shimomura bas-relief contour drawing gesture drawing guild model narrative art

Chapter Vocabulary

series shape tapestry unity variety woodcut

## **Teaching Options**

Teaching Through Inquiry
Meeting Individual Needs
More About...The Great Migration
Teaching Through Inquiry
More About...Illuminated manuscripts
Using the Large Reproduction
Using the Overhead

**Technology** 

CD-ROM Connection e-Gallery Resources

Teacher's Resource Binder
Thoughts About Art:
1 Core
A Closer Look: 1 Core
Find Out More: 1 Core
Studio Master: 1 Core

Assessment Master: 1 Core Large Reproduction 1 Overhead Transparency 2 Slides 1a, 1b

Teaching Through Inquiry More About...Storytellers Assessment Options CD-ROM Connection Student Gallery Teacher's Resource Binder Studio Reflection: 1 Core

## **Teaching Options**

Meeting Individual Needs Teaching Through Inquiry More About...Kuniyoshi More About...Roy Lichtenstein Technology

CD-ROM Connection e-Gallery Resources

Teacher's Resource Binder Names to Know: 1.1 A Closer Look:1.1 Find Out More: 1.1 Assessment Master: 1.1 Overhead Transparency 1 Slides 1c

Teaching Through Inquiry More About...Internment camps Using the Overhead Assessment Options CD-ROM Connection Student Gallery Teacher's Resource Binder Check Your Work: 1.1

## **Teaching Options**

Teaching Through Inquiry More About...The comic strip Using the Overhead Assessment Options Technology

CD-ROM Connection e-Gallery

Resources

Teacher's Resource Binder Finder Cards: 1.2 A Closer Look: 1.2 Find Out More: 1.2 Assessment Master: 1.2 Overhead Transparency 2 Slides 1d

CD-ROM Connection Student Gallery Teacher's Resource Binder Check Your Work: 1.2

# 18 weeks 5 2 Lesson of your choice

## **National Standards**

- 1b Use media/techniques/processes to communicate experiences, ideas.
- 4b Place objects in historical, cultural contexts.
- 5b Analyze contemporary, historical meaning through inquiry.
- 2c Select, use structures, functions.
- **3b** Use subjects, themes, symbols, that communicate meaning.
- Reflect on one's own purpose and process of artmaking.

## **National Standards**

- 1a Select/analyze media, techniques, processes, reflect.
- 2b Employ/analyze effectiveness of organizational structures.
- 3b Use subjects, themes, symbols, that communicate meaning.
- 4c Analyze, demonstrate how time and place influence visual characteristics.

## **Objectives**

## Identify and understand ways other disciplines are connected to and informed by the visual arts.

Understand a visual arts career and how it relates to chapter content.

## **National Standards**

6 Make connections between disciplines.

## **Objectives**

## Portfolio/Review page 92

Connect to...

page 90

- · Learn to look at and comment respectfully on artworks by peers.
- Demonstrate understanding of chapter content.

## **National Standards**

5 Assess own and others' work.

| Teaching Options                                                                                                                                                   | Technology                                                                                      | Resources                                                                                                                                |
|--------------------------------------------------------------------------------------------------------------------------------------------------------------------|-------------------------------------------------------------------------------------------------|------------------------------------------------------------------------------------------------------------------------------------------|
| Teaching Through Inquiry Using the Large Reproduction                                                                                                              | CD-ROM Connection<br>e-Gallery                                                                  | Teacher's Resource Binder A Closer Look: 1.3 Find Out More: 1.3 Assessment Master: 1.3                                                   |
| Meeting Individual Needs<br>Teaching Through Inquiry<br>Assessment Options                                                                                         | CD-ROM Connection<br>Student Gallery                                                            | Teacher's Resource Binder<br>Check Your Work: 1.3                                                                                        |
| Teaching Options                                                                                                                                                   | Technology                                                                                      | Resources                                                                                                                                |
| Teaching Through Inquiry More AboutRed Grooms Using the Large Reproduction Studio Collaboration Teaching Through Inquiry More AboutTheater Sets Assessment Options | CD-ROM Connection<br>Student Gallery<br>Computer Option                                         | Teacher's Resource Binder Studio Master: 1.4 Studio Reflection: 1.4 A Closer Look: 1.4 Find Out More: 1.4                                |
| Teaching Options                                                                                                                                                   | Technology                                                                                      | Resources                                                                                                                                |
| Community Involvement<br>Interdisciplinary Planning                                                                                                                | Internet Connection<br>Internet Resources<br>Video Connection<br>CD-ROM Connection<br>e-Gallery | Teacher's Resource Binder Using the Web Interview with an Artist Teacher Letter                                                          |
| Teaching Options                                                                                                                                                   | Technology                                                                                      | Resources                                                                                                                                |
| Advocacy<br>Family Involvement                                                                                                                                     | CD-ROM Connection<br>Student Gallery                                                            | Teacher's Resource Binder Chapter Review 1 Portfolio Tips Write About Art Understanding Your Artistic Process Analyzing Your Studio Work |

## **Chapter Overview**

## Theme

People have always participated in the tradition of storytelling. Artists sometimes tell stories through their artworks, capturing and holding our attention with powerful images.

## **Featured Artists**

Apollodorus of Damascus Viola Frey Red Grooms Kuniyoshi Jacob Lawrence Roy Lichtenstein Roger Shimomura

## **Chapter Focus**

This chapter examines how Jacob Lawrence and other artists have approached narrative art, telling stories for different purposes and within historical and cultural traditions. Students see how Roger Shimomura creates stories from past events, and they explore gesture- and contourdrawing techniques to create their own pictorial stories. African storytelling traditions in appliqué are explored, and students create their own three-dimensional scene of a moment in a story.

# National Standards Chapter 1 Content Standards

- 1. Understand media, techniques, and processes.
- 2. Use knowledge of structures and functions.
- 3. Choose and evaluate subject matter, symbols, and ideas.
- **4.** Understand arts in relation to history and cultures.
- 5. Assess own and others' work.
- **6.** Make connections between disciplines.

1

# Artists as Storytellers

Fig. 1–1 Toussaint
L'Ouverture was a slave
who led a revolt and
founded the Republic of
Haiti. Lawrence, in his
first series, told the story
of this hero, Jacob
Lawrence, St. Marc
(Toussaint L'Ouverture),
1994.
Screenprint, 32 1/4" x 22 1/3"
(82 x 56.6 cm). Courtesy the Estate of
Jacob Lawrence and the Francine Seders
Gallery, Photo by Spike Mafford.

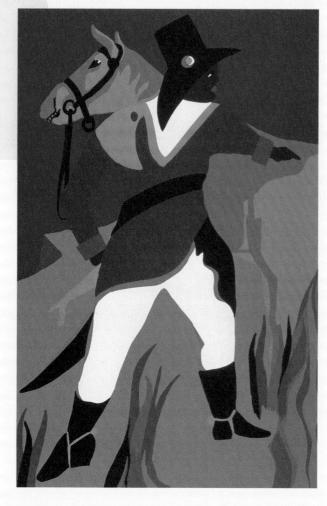

68

# **Teaching Options**

## Teaching Through Inquiry

Aesthetics From a collection of magazine or newspaper photographs, with any captions either covered or removed, give each small group of students one image. Ask members each to write a summary paragraph of the image's "story," share their summary with the group, and discuss these questions: Did all members summarize the same story? Should there be only one correct "reading" of an image's story? Why or why not? Have groups discuss their responses as a class.

## More About...

Though Jacob Lawrence told stories in drawings, prints, book illustrations, large murals, and even costume designs, he mostly made small tempera paintings of people's struggle to live good and honorable lives. The first African-American artist to have his work shown at a major New York City gallery, Lawrence was an art professor at the University of Washington in Seattle, where he taught drawing, painting, and design. He died in 2000, at the age of 82. Museums worldwide continue to hold major retrospective exhibitions of his work.

## **Focus**

- Why are stories important in our lives?
- How do artists tell stories?

Think about a time when you couldn't wait to get to school to tell a friend about something that happened to you, perhaps just the night before. Remember how you included the important parts of the story, adding as much detail as possible? You probably shared your story more than once. Each time, you may have changed the way you told it—even just a little bit—to make it a more exciting story.

People have been sharing stories with their friends and family for thousands of years. The very young, the very old, and all those between, love to hear stories. Stories allow us to visit faraway lands, meet fascinating characters, and imagine the way people lived in the past. When a storyteller tells a tale, we follow the words and create pictures in our mind.

Some storytellers create the actual pictures for us. Artist Jacob Lawrence, whose work is shown in Fig. 1–1, is known

for telling stories based on the lives of people who lived and worked in the past. In this chapter, you will learn about Jacob Lawrence and other artists who have discovered the power of images to continue the ancient art of storytelling.

lacob Lawrence

## **Meet the Artists**

Jacob Lawrence Roger Shimomura The Yemadje Family

## **Words to Know**

guild series tapestry bas-relief narrative art model shape woodcut contour unity drawing variety gesture

drawing

Materials for **Chapter Warm-up** 

· Children's picture books with large illustrations but little text.

## **Chapter Warm-up**

Have groups of students analyze a children's picture book, first by telling the story by looking only at the illustrations, and then discussing how the illustrations contribute to the text. Allow each group to share with the class, one illustration that effectively tells part of the story. Explain that this chapter focuses on ways that artists tell stories.

## **Using the Text**

Have students read page 69. Ask volunteers to tell a story that they heard today, and to describe a picture that could help people understand and remember the story.

## Using the Art

Perception Call students' attention to Jacob Lawrence's St. Marc. Ask: What details did the artist add to help viewers know more about this hero? How did the artist use shapes to compose his picture?

## Extend

Have students research Toussaint L'Ouverture so as to gain a better understanding of Lawrence's painting. Students could draw scenes from L'Ouverture's life. Ask: Why, do you think, did Lawrence choose to create a series of paintings about L'Ouverture?

69

# Chapter 1

## 1.1 Then and Now Lesson

Narrative Art page 76

## 1.2 Skills and **Techniques Lesson**

Contour and Gesture Drawing page 80

# **Graphic Organizer**

## Core Lesson

An American Storyteller

## **Core Studio**

Picture a Story page 74

## 1.3 Global Destinations Lesson

The Kingdom of Dahomey page 82

## 1.4 Studio Lesson

Sculpting a Scene page 86

## **CD-ROM Connection**

For more images relating to this theme, see the Personal Journey CD-ROM.

## **Prepare**

## **Pacing**

Four or more 45-minute periods: one to read text and plan art; one to draw designs; two or more to paint and evaluate

## **Objectives**

- Describe purposes and methods used by artists to create storytelling artworks.
- Explain the importance of developing a systematic approach to creating artworks in a series.
- Create a unified series of three paintings, using shape and other design elements, to tell a story.

## Vocabulary

series A group of related artworks, such as a group of sculptures, paintings, or prints.

# National Standards Core Lesson

- 1a Select/analyze media, techniques, processes, reflect.
- **2a** Generalize about structures, functions.
- **4c** Analyze, demonstrate how time and place influence visual characteristics.
- **5b** Analyze contemporary, historical meaning through inquiry.

# **An American Storyteller**

"I wanted to tell a story . . . so I did it in panels." Jacob Lawrence (1917–2000)

## Jacob Lawrence's Journey

CORE LESSON

Jacob Lawrence grew up during the Great Depression in Harlem, a neighborhood in New York City. As a teenager, he enrolled in after-school art classes. His teachers encouraged him to work hard as an artist.

Lawrence loved to visit the Metropolitan Museum of Art to see artworks from all over the world. He particularly liked the artworks that told stories.

The young artist spent many hours in the library. There, he read about the kingdoms of Africa and about heroic African Americans. He was always interested in people—what they cared about and what they accomplished. The more he learned, the more he wanted to find a way to tell the rest of us about their lives.

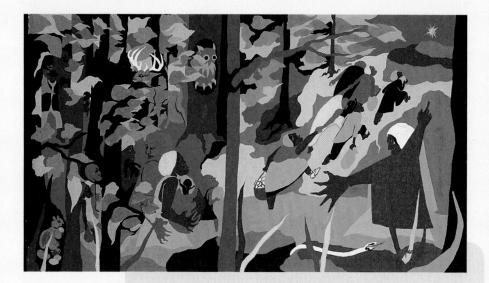

Fig. 1–2 The artist created two series of images about the work of Harriet Tubman. Tubman escaped slavery but returned repeatedly to the South to help others escape to the North. Jacob Lawrence, Through Forest, Through Rivers, Up Mountains, 1967. Tempera, gouache and pencil on paper, 1511/16" x 267/8" (40x 68 cm). Hirshhorn Museum and Sculpture Garden, Smithsonian Institution, The Joseph H. Hirshhorn Bequest, 1981. Photo: Lee Stalsworth.

70

# **Teaching Options**

## Resources

Slides 1a, 1b

Teacher's Resource Binder
Thoughts About Art: 1 Core
A Closer Look: 1 Core
Find Out More: 1 Core
Studio Master: 1 Core
Studio Reflection: 1 Core
Assessment Master: 1 Core
Large Reproduction 1
Overhead Transparency 2

## **Teaching Through Inquiry**

Art History Have students work in small groups to find out more about Jacob Lawrence's Harriet Tubman or Great Migration series. Invite students to explore the Internet and library resources to find the other images in each series and the accompanying text that Lawrence typically provided. Have groups each present a report of their findings.

# CORE LESSON

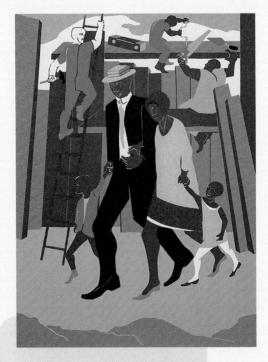

Fig. 1–3 Lawrence's paintings are small, but the message is monumental. His message in the *Builders* series is that people can live and work together to build a better world. Jacob Lawrence, *The Builders*, 1974.

Screenpint, 34° x 25 JA° (86.4 x 65.4 cm). Courtesy the Estate of Jacob Lawrence and Francies General College Photo by Snike Mafford.

Fig. 1–4 In his Migration series, Lawrence told about a time when many African Americans moved from the rural South to the industrial North. Jacob Lawrence, The Migration of the Negro, 1940–41.

Panel No. 1. Caselin tempera on hardboard, 12º x 18° (30.5 x 4.5 7 cm). Acquired 1942, The Phillips

Collection, Washington, DC

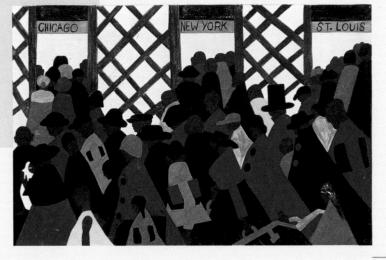

Artists as Storytellers

# Retelling History in Art

The challenge for any storyteller is to tell a story in such a way that an audience stays interested. Lawrence met this challenge by working with brightly colored paint to create pleasing shapes and patterns for the characters and settings in his paintings.

If a story had too many parts to tell in one image, Lawrence created a **series** of several paintings. The artworks on these pages—Figs. 1–2, 1–3, and 1–4—show you three examples from series he created. Before he began a series, Lawrence first had to decide how to attract his audience's attention. Then he decided what to show as the story continued, and how to bring it to an interesting end. The artist's paintings seem like little stages where action takes place, just as in a theater.

Teach

## Engage

Ask students to think of one of their favorite stories, and allow volunteers to tell their story to the class or small groups. **Ask:** If you were to illustrate this story in a book or a series of paintings, what main events would you include?

## Using the Text

Art History After students have read the text, review some of the highlights of Lawrence's life. Remind students that many people lost their jobs during the Great Depression.

## **Using the Art**

Perception After students have read the captions for Lawrence's paintings, have them focus on Fig. 1-2. Ask: What animals do you see? (squirrel, deer, owl) Which figure is Harriet? Why do you think so? (The figure is large and in red.) What shapes are repeated? (hands, leaves, trunks, human forms) Which shapes and lines are vertical; and which are diagonal? (trees; slanted human forms) How did Lawrence create movement? (by slanting the human shapes) Challenge students to locate repeated colors throughout the painting.

**Perception** Ask students to locate repeated shapes and colors in the images on page 71.

71

## Meeting Individual Needs

Multiple Intelligences/Linguistic and Intrapersonal Have students work in groups of seven, and have each member take the role of a different figure in Fig. 1–3. Ask students to write an inner monologue of what their character may be thinking, including thoughts about his or her relationship to others in the picture. Have each group use the monologues to create a skit that tells the painting's story. Direct students to ensure that each student character has a part. After the performances, have groups discuss how the activity has changed their understanding of Lawrence's work.

## More About...

Between 1915 and 1940, hundreds of thousands of African Americans made the difficult decision to move from the rural South to the North. In what is known as the **Great Migration**, many left family and friends to seek a better life. The migrants had to adjust to the technologies and cultures of the industrial North, and the northern population had to adjust to the influx of the migrants—and their customs and high hopes. Most people traveled by segregated trains to Chicago, Pittsburgh, New York, and other major cities.

## **Artists as Storytellers**

## **Using the Text**

Art Criticism Ask students to read Stories for Different Purposes and to list the three reasons for storytelling. (to tell what happened in the past, to teach a special message, to delight an audience) Challenge students to think of some famous stories and explain why they were told.

## **Using the Art**

Art History Explain that the column of Trajan is a huge, hollow marble cylinder that contains Trajan's ashes in its base. Like a giant comic strip, the story of two of Trajan's military campaigns spirals around the column. Challenge students to decipher what is happening in this scene.

Art Criticism Encourage students to describe what they think is happening in the Persian miniature. Ask them to compare the patterns and textures of the miniature to those of the film still, and to explain each artist's purpose in using the particular style.

Art Criticism Encourage students to describe the story in the film still. (The bulldog loves the kitty and wants the woman to feed it.) Ask: What did the artist make important in this illustration? How did the artist use shape to emphasize the main subject?

# **Stories for Different Purposes**

CORE LESSON

When Jacob Lawrence told stories about things that really happened in the past, he was following an ancient storytelling tradition. Much of what we know about the past has come to us in the form of stories, often told by older members of our family or community. Artists have always created visual stories to tell about the past. Look at the artworks in Figs. 1–5 and 1–6. How can you discover more about the stories these artworks tell?

Another reason for storytelling in art is to communicate a special message. Some

messages in art are meant to teach us how to behave or what to think. All over the world, stories with messages are carved in stone or painted on the walls of public buildings, where many people can see them.

Artists also tell stories for the simple purpose of delighting an audience. Such stories may be scary or funny tales of mystery or horror. They may take place in familiar settings or in places that exist only in our imagination. The characters in such stories might be people, or they might be animals or objects brought to life by the artist.

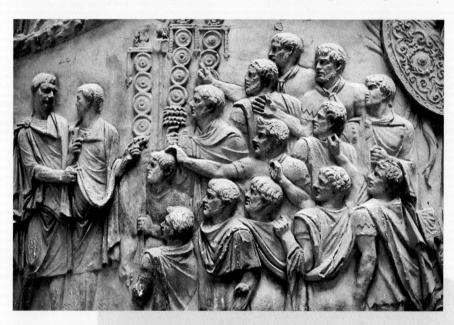

Fig. 1–5 This is a close-up look at a large column that celebrated how the emperor Trajan led his Roman soldiers to victory in battle. What might be happening in this part of the story? Apollodorus of Damascus, Column of Trajan (detail: Trajan addressing his troops), AD 113. Located in Rome, Italy, Marble, column height: 128 (39 m); each band: 36 (91 cm). Photo courtesy Davis AT Slides.

72

# **Teaching Options**

## **Teaching Through Inquiry**

Art Criticism Have students work in groups to practice their description skills. Provide each group with an object, perhaps a kitchen tool or a pinecone. Have students take turns offering and listing words to describe the object—from simple descriptors, such as "brown" or "oval"; to more lively ones, such as "prickly" or "metallic." Invite groups to use some of the descriptive words to write a story about the object—how it came to be, what it does from day to day, and so on. Have groups each share their story.

## More About...

Persian rulers loved fine books so much that they kept skilled calligraphers and artists in their courts to copy and create illuminated manuscripts. Even though orthodox Islamic rules prohibited depictions of human figures, the artists illustrated specific stories with scenes of hunts, battles, and feasts so as to capture the court's splendor. The artists, most interested in pattern and vivid color, drew the figures with delicately curved lines but without shading, so they appear flat.

# Stories in Many Forms

Artists use art forms such as drawing, printmaking, photography, and sculpture to tell stories. Artists who tell stories may do so in a series of images or in a single image. A single image may tell a complete story or show only one scene, leaving the viewer to imagine what happened before and what will occur after. Stories are told in visual form in movies, such as in Fig. 1–7, on television, and in magazines and newspapers. Look around your world for the many ways stories are told.

Fig. 1–6 This small, detailed painting is called a miniature. Many miniature paintings told stories about the lives of emperors in the Persian empire. Persian (Herat School), A Court Scene from the "Chahar Magaleh." c. 1431.

"Chahar Maqaleh," c. 1431.
Ink, colors, and gold on paper. The Minneapolis institute of Arts, Bequest of Margaret McMillan Weber in memory of her mother, Katherine Kittredge McMillan (51.37.30).

Artists as Storytellers

73

## **Critical Thinking**

Ask students to imagine that the Persian miniature is actually a film still from a movie. **Ask**: How do you think the change in art form (from miniature to film still) affects the impact of the story?

## Extend

Have students research the column of Trajan to find a detail of another episode from it, or show students the overhead transparency detail of Fig. 1–6. Lead students to note Roman structures in the backgrounds, and explain that the building of roads and bridges was an important part of Roman warfare. Have students each draw a Roman structure or soldier, using a figure from the column as their basis.

## **Using the Large Reproduction**

## Talk It Over

**Describe** Make a list of the important details in this work.

**Analyze** How did the artist arrange the parts of the artwork so as to attract attention?

**Interpret** What story does the artwork tell?

**Judge** How well does the story told by the artwork attract and hold the attention of the viewer?

## **Using the Overhead**

## Think It Through

**Ideas** From where, do you think, did the artist get the idea for the story told in this artwork?

Materials What materials did she use?

**Techniques** How did the artist use the materials to convey a sense of excitement?

**Audience** For the viewer to understand the story told here, what does he or she need to know before looking at the artwork?

2

## **Artists as Storytellers**

## **Supplies**

- sketch paper, 9" x 12"
- heavy drawing paper, 9" x 12", 3 sheets
- · pencil and eraser
- · tempera paint
- brushes
- water
- paper towels

## **Using the Text**

Art Production After students have read Studio Background, ask them the steps in Lawrence's process, and write them on the board. (learned about the story, sketched plot pictures, copied sketches onto paper or board, chose colors, painted one color at a time)

Art Production After students have read Picture a Story, demonstrate the process, referring to Lawrence's steps. Either assign students a social-studies or literature story, or brainstorm stories to illustrate. Encourage students to develop their own system of working to complete all three artworks.

## Using the Art

Perception Discuss students' answers to the caption questions. Ask: How many colors did Lawrence use in the finished painting?

Art Production Discuss possible advantages and disadvantages of Lawrence's system of painting the same color on all three panels before painting the next color. (would need to plan before beginning to paint; would have consistent color from one panel to the next; work may proceed more quickly because of not having to mix the same color many times and not having to clean brushes so often)

## Painting in the Studio

## Picture a Story

STUDIO

CORE

Have you ever thought about using only pictures to tell a story? What about creating a visual fantasy story that tells about people and places from

your imagination?

In this studio experience, you will paint a series of three pictures that tells a story. Think of a story that you want to tell in pictures. How will you show the beginning, middle, and end of your story? How will vou create pictures that look as though they belong together? Think about how to make your picture story interesting to viewers.

Studio Background

When Jacob Lawrence decided to paint a

series, he created the story's plot in pictures,

sketching each scene with a pencil on sketch

paper. After copying the sketches onto paper

or board, Lawrence chose all the colors. He

used one color at a time to paint the images. He painted the first color on all the boards.

Then he added the second color, then the

third, and so on, until he finished the images. By using many of the same colors in all the

boards, he created a series of images that look

as though they belong together. Lawrence

used this system of working whenever he

made a series of pictures.

**Plotting Pictures** 

## You Will Need

- · drawing paper, 3 sheets
- · pencil and eraser
- tempera paint
- brushes
- water
- paper towels

artwork different from the sketch? How is it different from the unfinished painting? Jacob Lawrence, In the Iowa Territory. panel 2 from the George Washington Bush series, 1973. Casein gouache on paperboard, 31 72 612 (80 x 49.5 cm). Washington State Historical Society, Tacoma. State Capital Museum Colle

Fig. 1-10 How is this finished

Fig. 1-9 (bottom) This image illustrates the artist's technique of painting a picture one color at a time. Jacob Lawrence, In the Iowa Territory (unfinished), 1973.

74

# **Teaching Options**

## **Teaching Through Inquiry**

Art Production Provide pairs of students with a roll of paper at least 30" long, or, alternatively, three or more sheets of 9" x 12" paper taped end to end. One student begins drawing a story, filling no more than 6" of drawing space. The second student picks up and continues the story, also filling no more than 6" of space. The two students take turns until they reach the end of the paper. Students may wish to begin with a preselected title or theme. Instruct students to draw the story so that all its parts fit together, and to create an interesting end.

## Try This

1. Decide what scene you will show for the beginning, middle, and end of your story. Create a pencil sketch of each scene on drawing paper. How can

you use shapes to express your ideas? How can you make your sketches look as though they belong together?

2. Think about the mood you want to create in your series. Choose paint colors that best express that mood. Which colors are joyful? Which are

serious? Will you use many colors or just a few? Remember: using many of the same colors in each scene will create unity in the series.

**3.** Carefully paint the shapes. Will you finish each scene before moving to the next? Or will you use Jacob Lawrence's system of adding colors one at a time to the whole series?

## Check Your Work

Discuss your work with your classmates. Take turns describing the stories you see. Discuss how each artist used shape and color to tell a story. Do the pictures in each series look as though they belong together? Why? What makes each story interesting?

## Lesson Review

## **Check Your Understanding**

- **1.** What kinds of stories did Jacob Lawrence tell in his artworks?
- **2.** Name three different purposes that artists may have for creating storytelling artworks.
- 3. How might an artist tell a story in one image?
- **4.** What is the importance of having a system for creating a storytelling series of images?

## Fig. 1–11 **How did this artist create unity in her series?** Heather Golding, *The Hill Town*, 2001. Tempera, each panel: 9 1/2" x 7" (24 x 18 cm). Thomas Prince School, Princeton, Massachusett.

Artists as Storytellers

75

## **Assess**

## **Check Your Work**

Encourage students to describe the stories they see in the artworks. **Ask:** How, do you think, does each series compare with the artist's intentions? How could the artist have made the message more understandable? Do all three pictures seem to go together? What system of working did the artist use?

# Check Your Understanding: Answers

- **1.** He most often told stories about events from the past.
- 2. Artists create storytelling artworks to: 1. Tell about the past, 2. Send a message, and 3. Entertain an audience.
- 3. The artist must include enough information: 1. to suggest action that has a beginning, middle, or end; or 2. for the viewer to imagine what happened before and after the scene shown.
- 4. It is important to have a system to make sure that the images in the series are connected to one another.

## Close

Review students' answers to Check Your Understanding. **Ask**: Why are stories important to us? How do artists tell stories? How did Lawrence tell his?

## More About...

Storytellers participate in an ancient art, and, like storywriters, use plot, setting, one or more characters, and one or more situations to structure a story. Storytellers who use the same plot, either from fantasy or real life, may tell the story in different ways. All good storytellers use vivid language to describe details of setting, characters, and events. Within the oral storytelling tradition, the storyteller changes the volume of his or her voice to capture the attention and interest of the listener. A good oral storyteller may also use periods of silence to create mystery or suspense. Whether telling a story orally, in words, or with pictures, a storyteller must plan the story's beginning, middle, and end.

## **Assessment Options**

**Self/Peer** Have students work independently to create a mock-up design of a bulletin board about artists as story-

tellers. Explain that the purpose of the bulletin board is to inform the school community about the methods used by artists to create storytelling artworks. Display and discuss all the mock-ups, and have students select one to complete as a display in the school. The final selection should best convey what students have learned about artists as storytellers.

## **Prepare**

## **Pacing**

Three 45-minute periods: one to consider text and images; one to cut and draw; one to arrange and paste

## **Objectives**

- Define narrative art, and describe similarities between narrative art of the past and that of the present.
- Give examples of how today's narrative artists have been influenced by narrative artists of the past.
- · Make a collage that tells a story.

## Vocabulary

narrative art Art that clearly depicts a story or idea.

tapestry A stitched or woven piece of cloth or fabric, often one that tells a story.

woodcut A relief print created by carving into a smooth block of wood, inking the wood, and pressing paper against the ink.

## Supplies for Engage

newspaper comics or comic books

## **Using the Time Line**

**Ask:** How long ago was the *Bayeux Tapestry* made? From looking at the technology depicted in the artworks, how would you compare eleventh-century warfare to that in Lichtenstein's twentieth-century *Whaam!*?

# National Standards 1.1 Then and Now Lesson

- **1b** Use media/techniques/processes to communicate experiences, ideas.
- **2b** Employ/analyze effectiveness of organizational structures.
- **3b** Use subjects, themes, symbols that communicate meaning.
- **4a** Compare artworks of various eras, cultures.
- **4c** Analyze, demonstrate how time and place influence visual characteristics.

# **Narrative Art**

LESSON

M O N

AND

ZHH

1828–29 Kuniyoshi, Tameijiro dan Shogo 1980 Shimomura, Diarv: Dec. 12, 1941

Middle Ages

19th-Century Japan

20th Century

11th century

Bayeux Tanestry

1963 Lichtenstein, Whaam! 1985 Shimomura, *Untitled* 

## **Travels in Time**

Throughout history, people have told stories with pictures. Long ago, people drew and painted stories on the walls of caves and tombs. They even carved stories in stone. In the Middle Ages, women used needles and thread to embroider a story on a very long piece of cloth (Fig. 1–12). The stitched cloth, called a **tapestry**, told the

story of a great battle of their time. The battle scenes were arranged in a series of connected pictures, or frames. This method of linking scenes together led to popular ways of telling stories in the twentieth century: the newspaper comic strip and comic books.

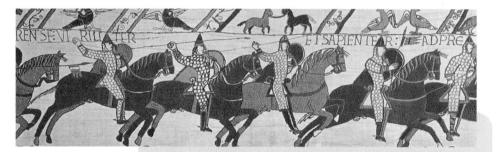

Fig. 1–12 This is just one scene in the *Bayeux Tapestry*. Notice how the shapes were repeated and overlapped in an orderly way. Is this scene at the beginning, middle, or end of the battle? Why do you think so? English, *Bayeux Tapestry* (detail: The Norman cavalry rushes into battle), 11th century.

Embroidered wool on linen, entire fabric: 20"x 230' (.51 x 70 m). Musée de la Tapisserie, Bayeux, France. Erich Lessing/Art Resource, New York.

76

# **Teaching Options**

## Resources

Teacher's Resource Binder

Names to Know: 1.1

A Closer Look: 1.1

Find Out More: 1.1

Check Your Work: 1.1

Assessment Master: 1.1

Overhead Transparency 1

Slides 1c

## **Meeting Individual Needs**

## English as a Second Language and Multiple Intelligences/Logical-Mathematical

Have students identify the repeated images in the *Bayeux Tapestry* (Fig. 1–12). (Have ESL students learn such words as *bird, horse, warrior, shield,* and *flower.*) Discuss how the visual repetition enhances the sense of forward narrative movement. Encourage students to use repeated motifs in a linear narrative drawing: have students use long, narrow paper to draw an event from their own life or from that of someone they are studying in history. Ask ESL students to share their story orally.

Fig. 1–13 What is the largest shape in this artwork? Which figure is Tameijiro dan Shogo? Do you think he is the hero in the visual story? Utagawa Kuniyoshi, *Tameijiro dan Shogo Grapples with His Enemy under Water*, 1828–29. Folio from The Heroes of Suikoden. Woodcut on paper. Private Collection. Courtesy

Fig. 1-14 This artwork is two separate paintings placed side by side. In the first frame, the pilot takes aim. What happens in the second frame? Note the shapes in each canvas. How would you describe the differences? Roy

Lichtenstein, Whaam! 1963.
Acrylic and oil on two canvases, 67 ½" x 158 ½" (170.2 x 402 cm). Courtesy The Tate Gallery, London, England. © Tate London, 2001.

# Stories of the Past and the Popular

Art that tells a story is called **narrative art**. These visual stories are a way to remain connected to the past. In the nineteenth century, the Japanese printmaker Kuniyoshi used the technique of **woodcut** to tell stories. Woodcuts are prints made by carving into a block of wood, inking the wood, and pressing paper against the wood.

The stories in Kuniyoshi's prints, such as the one shown in Fig. 1–13, were based on legends of great warriors. His images look like the superheroes of twentieth-century comic books. Kuniyoshi's popular woodcut prints were published both as illustrations in novels and as series.

In the twentieth century, American artist Roy Lichtenstein created a series of story-telling paintings based on the images and style of comic-book art (Fig. 1–14). His work is known as Pop Art, because it borrows from images that are widely popular. In what ways is his work *Whaam!* similar to and different from the cartoon characters shown in Fig. 1–7?

## Engage

Have students study several comic strips. **Ask**: How did artists make these interesting? Explain that even long ago, artists created sequential stories, such as those on the column of Trajan (Fig. 1–5).

## **Using the Text**

Art Criticism After students have read the text, ask them to define narrative art. Ask: What is an example of narrative art? (comic strips, the art on these pages) How are woodcut prints made? (by carving into a wood block, inking the wood, and pressing paper against the block) What art on these pages is a woodcut print? (Kuniyoshi's)

## **Using the Art**

Art Criticism Discuss students' answers to the caption questions for Kuniyoshi's print.

Artists as Storytellers

77

## **Teaching Through Inquiry**

**Perception** Have students choose an artwork from this lesson and write a description of it. Have them describe the lines, shapes, and colors in the artwork. **Ask:** How do they affect the mood of the story? Invite small groups to discuss ways to improve their descriptions.

## More About...

Kuniyoshi is considered to be one of the last printmakers to work in the Japanese tradition of *ukiyo-e* ("pictures of the floating world"). Initially, *ukiyo-e* prints depicted popular stories and visions of real life. They were published both as illustrations in novels and as separate picture sets. In sets of large prints, including triptychs, Kuniyoshi illustrated the stories of 108 samurai heroes engaged in battle with monsters. These images evoke the superhero images in some of today's comic books.

## More About...

Twentieth-century American artist **Roy Lichtenstein** created a series of paintings based on the images and style of comic-book art. He used mostly primary colors for large, outlined shapes. Because his work borrows from popular art forms and culture, it is considered Pop Art. In his narrative art, Lichtenstein sometimes showed just two story frames, in side-by-side canvases: the situation is introduced in the first frame; the conclusion, in the second.

# Using the Text

Art History Assign students to read the text to discover how Shimomura began his art career. Ask: On what themes has Shimomura's artworks focused? (events in his early life, social and political issues affecting Japanese Americans)

## **Using the Art**

Perception Ask: What parts of Diary: Dec. 12, 1941 seem Japanese? What parts seem American? Which shapes are organic? Which are geometric? Have students locate American cartoon characters, Japanese influences, and symbols of war in Fig. 1–16. Ask: How did Shimomura create unity? (by overlapping objects and repeating the grid pattern) How did he create variety? (by using different types of images; by contrasting organic shapes with a geometric grid)

## **Studio Connection**

Ask: What objects represent your life? What is on the walls of your bedroom?

What is in your locker and book bag? How could you represent your cultural heritage?

Provide magazine photographs, scissors, glue, markers, envelopes, drawing paper, and 11" x 14" heavy paper or posterboard; and direct students to use cutout magazine images of some objects and to draw other objects. Encourage students to try several arrangements on posterboard before gluing down the images.

Assess See Teacher's Resource Binder: Check Your Work 1.1.

## **Personal Stories**

"My interest in art started early. Art was always my first love, and my family and teachers reinforced that I was good in art. My grandmother kept my drawings from first through sixth grade." Roger Shimomura (born 1939)

their personal life. The stories may be based on their own experiences, on the lives of

people or ancestors who are important to them, or on events from their time.

Artists sometimes tell stories that relate to

Contemporary artist Roger Shimomura is a second-generation American of Japanese descent. He created many of his paintings, prints, and performance-art pieces about events in his early life and about social and political issues affecting Japanese Americans. Several of his artworks, such as the work shown in Fig. 1–15, are narratives inspired by diaries his immigrant grandmother wrote during her lifetime.

Fig. 1–15 **What geometric shape is repeated in this scene? What does the woman seem to be doing?** Roger Shimomura, *Diary: Dec. 12, 1941,* 1980.

Acrylic on carwas, 50° x 60° (127 x 152.4 cm). Smithsonian American Art Museum, Washington, DC/Art Resource, New York.

78

THEN AND NOW LESSON

# **Teaching Options**

## **Teaching Through Inquiry**

Art History To involve students in writing about similarities and differences in styles, use such prompts as "One way that the work of Roger Shimomura is like that of Kuniyoshi is . . . " and "One way that the work of Roger Shimomura is not like that of Kuniyoshi is . . . " To help students think about the influence that one artist may have had on another, use such prompts as "Shimomura may have been influenced by Kuniyoshi because . . . " and "Shimomura was probably influenced by Lichtenstein because  $\ldots$  " Write the prompts on the board or on chart paper, and record students' responses. Discuss the appropriateness and quality of the responses.

## More About...

In 1942, ten weeks after Pearl Harbor was attacked, Americans of Japanese descent were prohibited from living, working, or traveling along the west coast of the United States. Over 120,000 people, two-thirds of whom were American citizens of Japanese descent, were relocated to inland internment camps or to those in other states. Roger Shimomura was three years old when his family was first placed in an internment camp.

Fig. 1–16 Note how the artist used both large and small rectangles to unify his composition. Do you think the figure shapes add variety? Roger Shimomura, Untitled, 1985.

Acrylic on canwas, 60° x 72° (152.4 x 182.9 cm), Museum Purchase, Bumeta Adair Endowment Fund, Wichita Art Museum, Wichtla, Kansas

## Stories in a Personal Style

In elementary school, Shimomura made many drawings of comic-book characters, such as Donald Duck and Mickey Mouse. As a teenager, he collected comic books: Superman, Dick Tracy, and Wonder Woman were his favorites.

Shimomura has developed a style that is influenced by American comic books, Pop Art, and Japanese woodcut prints. His artwork *Untitled* (Fig. 1–16) is an example of his large, early canvases filled with the shapes of comic-book characters. Notice how he outlined the shapes of color in black. Shimomura's work shows not only the influence of such Pop artists as Roy Lichtenstein, but also the elegant lines and decorative details like those in Japanese woodcut prints.

## **Studio Connection**

How could you make a collage that tells a personal story? One way might be to collect or draw pictures of things

that really interest you. Your pictures might include your favorite food, clothing you like, people you admire, popular sports or television personalities, things that represent your cultural heritage, or something you do for fun.

## **Lesson Review**

## **Check Your Understanding**

- 1. What is narrative art?
- **2.** How is the *Bayeux Tapestry* like a twentieth-century comic strip?
- **3.** What kinds of art influenced Roger Shimomura's artistic style?
- **4.** How are the artworks by Roger Shimomura and Roy Lichtenstein similar? How are they different?

Extend

Have students compare Shimomura's Diary: Dec. 12, 1941 with Cat and Spider on page 42. Challenge them to create their own version of Cat and Spider, but to include something from their culture, as Shimomura did in his artworks.

## Assess

## Check Your Understanding: Answers

- 1. Narrative art tells a story.
- **2.** They both tell sequenced stories in strips.
- **3.** American comic books, Pop Art, and Japanese woodcut prints influenced Shimomura.
- **4.** Line, comic-book characters, and stories are important in both artists' art, but their themes are different.

## Close

Discuss students' answers to Check Your Understanding. Have students each write a paragraph that explains how the objects in their collage relate to their life. Display the collages with the explanations, and discuss how variety and unity were created in the collages.

79

Artists as Storytellers

## **Using the Overhead**

## **Investigating the Past**

**Describe** What do you see in this sculptural detail? **Attribute** What clues would help you identify when and where it was made?

**Interpret** Could people living when this was made identify what was represented?

**Explain** What do you think this meant to the people living at the time it was made?

## **Assessment Options**

**Teacher** Have students each write one paragraph that explains the similarities between narrative art of the past and comic

books of today, and a second paragraph that describes how comic-book art has influenced the work of contemporary artists.

**Peer** Have students work in pairs to interview each other about their understanding of the text in this lesson. Have students write three questions that their partner is to answer from information in the text. Ask students to rate each other on the quality of the questions and the correctness of the answers.

## **Contour/Gesture Drawing**

## **Prepare**

## **Pacing**

Two or three 45-minute periods: one to draw figures; one to draw comic strip; one to ink drawing (optional)

## **Objectives**

- Draw figures by using contour- and gesture-drawing techniques.
- · Design and draw a comic strip.
- Explain the advantages of contourand of gesture-drawing techniques.

## Vocabulary

contour drawing A drawing that shows only the edges (contours) of objects.

gesture drawing A drawing done quickly to capture movement.

## Teach

## **Using the Text**

Art Production Demonstrate slow drawing of the contours of a student model. Emphasize the importance of looking at the subject while drawing. Have students draw the contours of their own hand before attempting a full-figure contour of a student model.

Art Production After students have read Gesture Drawing, demonstrate making a quick gesture drawing. Have students make drawings, each in less than a minute, of classmates caught freeze-frame in several action poses.

## **Using the Art**

Perception Ask students to identify examples of contour and gesture drawings on these pages, and to write a list of adjectives describing each style. Compile a class list.

## National Standards 1.2 Skills and Techniques Lesson

- **1a** Select/analyze media, techniques, processes, reflect.
- **1b** Use media/techniques/processes to communicate experiences, ideas.
- **3a** Integrate visual, spatial, temporal concepts with content.

# **Contour and Gesture Drawing**

For hundreds of years, artists have relied on two basic approaches to drawing: contour drawing and gesture drawing. A **contour drawing** describes the shape of an object or figure. It also includes interior details. This kind of drawing is usually done slowly. A **gesture drawing** captures the movement or position of an object or figure. This kind of drawing is the opposite of contour drawing. It is done quickly, without any attention to details.

## **Contour Drawing**

Creating contour drawings can help you develop your ability to observe and record the world around you. Continued practice will also improve your eye-hand coordination. You may use contour drawing to create a sketch for a print or painting or to create a finished drawing. A drawing tool with a sharp point—such as a pencil, marker, or ballpoint pen—is a good choice for a contour drawing.

Ask a classmate to sit in a relaxed pose for you. Make a contour drawing that captures the pose. As you work, keep the following ideas in mind:

- Draw slowly and carefully. As you work, imagine that your drawing tool is touching and slowly moving along each edge of your subject.
- Concentrate on the edges and interior details of your subject, such as pockets or buttons on a shirt.
- Keep your eyes on your subject. Look at your paper only when you begin to draw a new edge.

Fig. 1–17 Notice how the artist incorporated her signature into the work.

Sarah Nixon, *Single Line Contour Drawing*, 2000. Pen, 6<sup>1</sup>/<sub>2</sub>\* x 9" (16.5 x 23 cm). Kamiakin Junior High School, Kirkland, Washington

Fig. 1–18 The artist chose to include only certain features of the subject. What features were left out? Cheng Lor, *Untitled*, *Single Line Contour Drawing*, 2000.

Pen, 7\* x9 1/2\* (18 x 24 cm), Kamiakin Junior High School, Kirkland,

80

SKILLS AND TECHNIQUES LESSON

# **Teaching Options**

## Resources

Teacher's Resource Binder

Finder Cards: 1.2

A Closer Look: 1.2

Find Out More: 1.2

Check Your Work: 1.2

Assessment Master: 1.2

Overhead Transparency 2

Slides 1d

## **Teaching Through Inquiry**

Challenge students to create continuous-line blind-contour drawings of nature objects and tools. You may choose to make this activity a contest that is won not by those who finish first, but by those who include details, do not look at their page as they are drawing, and never lift their drawing tool from the paper. If, in their sketchbook or portfolio, students have sketches of the same or similar objects, have them compare the sketches to their blind-contour drawings.

Fig. 1–19 In gesture drawings, artists can "stop" a figure's action.
What actions are taking place in these drawings?
Drawings courtesy of Kaye Passmore.

## **Gesture Drawing**

You can use gesture drawing as a way to quickly capture the main parts of a subject before something moves or changes. Most gesture drawings are thought of as sketches rather than as finished drawings. You may use them to help you plan a painting, sculpture, or print. Practice making gesture drawings by using a wide, soft pencil or the side of a crayon or piece of chalk.

Ask a classmate to strike and hold an action pose, such as jumping up to catch a ball or running. Make a gesture drawing that captures the movement of the pose. As you work, remember these points:

- Draw quickly. You can add details later, if you want.
- Take in the overall action of the scene and the position of your subject.
- Use large, swift strokes to help you capture shapes, angles, and positions.

## **Studio Connection**

Design and create a comic strip that tells a simple story. The strip should include a sequence of three or four

frames. You may ask classmates to pose for you or base your story on a scene from a television show or movie. Use contour drawings and gestures drawings, as appropriate, to help you plan each frame.

## **Lesson Review**

## **Check Your Understanding**

Define contour drawing. Name two subjects that would make good contour drawings.
 In what type of situation would you want to use gesture drawing instead of contour drawing?

Artists as Storytellers

81

## **Studio Connection**

Brainstorm possible stories to illustrate, and then have students take turns model-

ing poses from the stories. Direct students to create gesture drawings of freeze-frame action poses, as well as contour drawings of still poses. After students have drawn five or more poses, have them sketch their comic strip before darkening with pencil, marker, or ink.

**Assess** See Teacher's Resource Binder: Check Your Work 1.2.

## **Assess**

## Check Your Understanding: Answers

- 1. Contour drawings show an object's shape and include interior contour lines. Good subjects for contour drawings are objects, and people or animals in still positions.
- **2.** Gesture drawing lends itself to moving subjects, such as dancers and animals.

## Close

Display students' comic strips. Ask students to identify which figures were developed from contour drawings and which from gesture drawings, and to discuss their choice of technique for certain poses.

## **Using the Overhead**

## Write About It

**Describe** Describe the different ways the artist has shown horses.

Analyze In what ways might she have used contour

and gesture drawing in creating this painting?

## **Assessment Options**

**Self** Assign students to draw an object such as their shoe or book bag,

first as a quick gesture drawing and then as a contour drawing. Have students each write a comparison of their drawings, addressing which one seems more like the real object, and whether that drawing is necessarily the one that they like more.

## Prepare

## **Pacing**

Three or five 45-minute periods: one to consider text and images, and to plan; two to make paper banners, or four if working with appliqué

## **Objectives**

- Explain the traditional roles of artists in the kingdom of Dahomey.
- Describe how appliquéd banners are made.
- Use cutouts of animal shapes to make a banner that tells a story.

## Vocabulary

guild A group of skilled craftspeople. Each guild has a specialty, such as working with metal or carving stone. bas-relief A form of sculpture in which portions of the design stand out slightly from a flat background.

## **Using the Map**

Have students locate the Republic of Benin on this map and then on the world map. **Ask:** What countries surround the Republic of Benin? (*Togo, Niger, Nigeria, Burkina Faso*) What effect could Benin's climate have on its art?

## National Standards 1.3 Global Destinations Lesson

- **1b** Use media/techniques/processes to communicate experiences, ideas.
- 2c Select, use structures, functions.
- **3b** Use subjects, themes, symbols, that communicate meaning.
- 4b Place objects in historical, cultural contexts
- **5b** Analyze contemporary, historical meaning through inquiry.

# The Kingdom of Dahomey

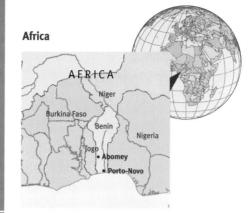

## **Places in Time**

In the late 1600s, the Fon people of West Africa formed the kingdom of Dahomey, which thrived for over 200 years. Abomey was the kingdom's capital city. The region is now part of the Republic of Benin.

# Stories in Memory of Kings

In Dahomey, the Fon royal court controlled the artists. Each artist belonged to a **guild**, a group of people in the same occupation. One Fon guild created life-size wood sculptures for the royal court, such as the one shown in Fig. 1–20. Another guild worked with metal. Still other guild artists decorated the palace walls with stories of historical events in bas-relief (Fig. 1–21). A **bas-relief** is a sculpture in which parts of the design stand out from the background.

The kingdom's most important arts were part of annual court ceremonies. People from every village came to see exhibits of the king's wealth and accomplishments. These displays were made even grander by the addition of colorful appliquéd tents, banners, umbrellas, and decorated hats made by the guild of royal tailors.

Fig. 1–20 This wood sculpture relates to a story of a king's power and greatness. The sculpture was made by joining many different carved shapes. Which shapes were added? Africa, Benin, Wooden Statue of Behanzin, King of Dahomey as the Figure of a Shark, 19th century.

82

GLOBAL DESTINATIONS LESSON

# **Teaching Options**

## Resources

Teacher's Resource Binder A Closer Look: 1.3 Find Out More: 1.3 Check Your Work: 1.3 Assessment Master: 1.3 Large Reproduction 2 Slides 1e

## **Teaching Through Inquiry**

Art Criticism Remind students that art critics, like detectives, pay careful attention to and describe details in artworks. Have students work in small groups so that each member, in turn, describes the details—such as subject matter, shapes, lines, colors, materials, and techniques—in one artwork in this lesson. The other students must identify the work being described. As a whole class, discuss the value of accurate description in getting to know an artwork.

# Storytelling Banners in Appliqué

Upon taking office, a king received a gift of imported cloth from his subjects. Royal tailors appliquéd the cloth with images that tell the stories of the king's power and great deeds. In the banner shown in Fig. 1–22, the lion represents one of the nineteenth-century kings of Dahomey. The tailors used templates to cut a variety of symbolic shapes. These were then hand-stitched to a background cloth.

In the more than 100 years since the French colonial powers brought an end to Dahomey, the art of appliqué has continued. The memory of the kings and

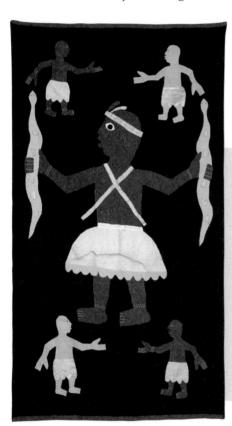

their influence on Fon culture is still strong. However, French colonists persuaded some artists to tell stories other than those about the former Fon kings. As a result, stories about daily life, farming, and hunting are now part of the new subjects in appliquéd cloths being made in Abomey and other cities in Benin.

Fig. 1–21 Bas-relief mud sculptures on the palace walls served as illustrations for storytellers who recited the history of the great kings of Dahomey. This relief symbolizes a call for unity by a king of Dahomey. Africa, Benin, Abomey, Earthen Relief #1, after conservation in March 1996. Musee Historique d'Abomey, Photograph: Susan Middleton.

Fig. 1–22 The shapes in this banner were cut from patterns and sewn to a background. What story do you think this banner tells? Africa, Benin, Fon kingdom, Wall Hanging Representing Da, A Symbol of Properity, in Human Form, 19–20th centuries.

Appliquéd cloth, height: 86 /s\* (220 cm.) @ Musee de l'homm? Photo D. Ponsard, Musée de l'homme, Paris, France.

Artists as Storytellers

## Teach

## Engage

Challenge students to think of influences from West African cultures. (musical traditions, textile design, carvings, masks) If possible, play some African music, and share pieces or images of African art.

## **Using the Text**

Art History Ask: What was Dahomey? (a country in present-day Republic of Benin) How did the king and the royal court influence Dahomey? (They controlled the artists and included arts in court ceremonies.) What type of art did Dahomey artists create? (wood sculptures, bas-relief sculptures, metalwork, appliqué) What is a guild?

## Using the Art

Perception Discuss the difference between the sculpture in Fig. 1–20 and the bas-relief in Fig. 1–21. (The three-dimensional wood sculpture can be viewed from all sides; the bas-relief, with figures that stand out from the background, is viewed from only one side.)

Perception Ask: What figure in Fig. 1–22 did the artist emphasize? How did the artist make the figure seem powerful?

83

## **Using the Large Reproduction**

## **Consider Context**

Describe What materials were used to make this?

**Attribute** What clues do you have about where or by whom this was made?

**Understand** How could you find out more about what these symbols mean?

**Explain** How do the symbols tell a story?

2

## The Kingdom of Dahomey

## **Using the Text**

Art History Have students read the text to learn how members of a family of contemporary Benin artists incorporate their culture's traditions into their art. Ask students to explain the process the Yemadje family uses to create appliqués.

## Using the Art

Art Criticism Ask: How did the artists emphasize certain parts of the design in the banner? What shapes and colors are repeated in this artwork?

## **Studio Connection**

Have students sketch their chosen animal. For a cloth appliqué, provide students

with felt and glue; or with fabric, needle and thread, thimbles, scissors, and pins or masking tape to hold the shapes in place. For a cutpaper banner, provide students with glue, colored paper, scissors, and markers (if students wish to add details).

**Assess** See Teacher's Resource Binder: Check Your Work 1.3.

## Extend

Assign students to research the arts and to find other examples of masks and sculpture created by artists of West Africa. Encourage students to create their own interpretation of one of the artworks.

## A Family of Storytellers

"We divide the work. One uses patterns to cut the shapes. Another does the tacking. Someone else does the final stitching. Then an apprentice attaches the border."

Yemadje family member

Joseph Yemadje and his family are descendants of the nineteenth-century Fon royal court artists. They continue the storytelling tradition in appliqué workshops in Abomey and other Benin cities. Although they still copy the old forms of royal symbols, the Yemadje artists combine some of the old images with new ones. However, for much of their work, they preserve a very pure form of appliqué by using traditional royal colors and symbols.

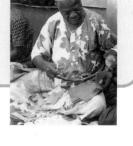

In creating appliquéd cloth, the Yemadje family of artists follow the basic Fon artistic principle of *nu ta do nu me*, which means "the highlighting of one thing by another." The artists highlight a background cloth with different colors of other cloth. Look at the banner in Fig. 1–23. What makes the shapes stand out against the background?

Fig. 1–23 Compare this banner to the one shown on page 83. What differences do you see? How are the two banners alike? Africa, Benin, Abomey, Fon Appliqué Cloth (detail), c. 1971. Photograph by Eliot Elisofon. Image no. H FON 10.1 (7021) Eliot Elisofon Photographic Archives, National Museum of African Art,

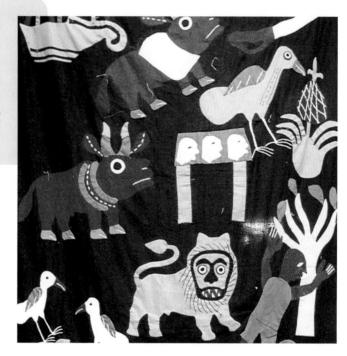

84

GLOBAL DESTINATIONS LESSON

# **Teaching Options**

## **Meeting Individual Needs**

English as a Second Language and Multiple Intelligences/
Interpersonal Have students work in small groups to study
Fig. 1–24, which shows people contributing to a single narrative piece similar to the Fon appliqué cloth. Ask groups
each to select a contemporary hero from sports, politics, or
school. For a group-produced "textile," have group members
sketch, on colored posterboard, shapes representative of
the hero. Encourage students to make their images work
together to convey an overall story about the hero. To place
next to their drawings, have students each write brief summaries, in English, of their portions of the narrative.

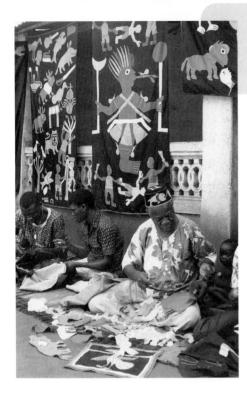

Fig. 1-24 Family members divide the work when they create banners. Some banners are made with new and different shapes created upon request. Benin, Abomey, Fon Men Making Appliqué Cloth, 1971.
Photograph by Eliot Elisofon, March 1971. Image no. H 2 FG

## **Studio Connection**

Characters are a part of almost every story. In Fon stories, a king is often represented by an animal. The kings of

Dahomey, who often identified themselves with wild animals because of their strength or wisdom, were represented by lions, elephants, sharks, and chameleons. What animal would you select to represent yourself in your life story? Choose an animal whose qualities you admire. Use the animal character to create a banner of part of your life story. If possible, use cloth, needle, and thread, and follow the traditional way of working with appliqué. You could also cut shapes from felt and then glue them to a background cloth, or you may make a cut-paper banner.

## **Creating Stories in Cloth**

The artists also follow the Fon principle of spreading the cutout patterns over the surface of the background cloth. Several steps are involved. The story's characters and images are pinned to the background to hold them in position. This temporary placement allows changes to be made. When the artist is satisfied with the composition, the cut edges of each shape are turned under and then carefully handstitched to the background. Because the borders of the whole cloth frame the entire story, an artist makes decisions about the color and width of the bands of cloth. Look closely at Fig. 1–24 to see some of the steps artists take when creating a Fon banner.

## Lesson Review

## **Check Your Understanding**

- 1. Name two examples of the kinds of guilds in the kingdom of Dahomey.
- 2. In the region that was once Dahomey, how has the making of appliqué banners changed over the past 300 years?
- **3.** What are the steps involved in making an appliqué?
- 4. How are the Dahomey banners similar to and different from the banners or flags that people hang from their homes or in the streets of your community today?

## Assess

## **Check Your Understanding: Answers**

- 1. wood, storytelling in bas-relief, and metal
- 2. Today's appliqué artists incorporate new images with the traditional royal colors and symbols.
- 3. The steps in appliqué are: cutting out images, pinning them to a background, and turning under their edges and stitching the images to the background.
- 4. Although both kinds of banners include cultural symbols, the symbols of each culture are different.

## Close

Discuss students' answers to Check Your Understanding. Allow students to tell their banner's story to one another.

Artists as Storytellers

## **Teaching Through Inquiry**

Aesthetics Many of the Fon banners made today are actually copies of ones made hundreds of years ago. Invite students to suggest reasons why, and under what circumstances, the copying of old artworks is appropriate. On the board, make a list of the reasons. Then ask for and make a list of reasons why copying should not be encouraged. Encourage students to understand how practices in other cultures may be understood differently in their own culture.

## **Assessment Options**

Peer Have pairs of students interview each other about the traditional roles of artists in the kingdom of Dahomey.

Self Ask students each to write an explanation of the ways that their banner tells a story, to include a statement about their use of shapes, and to comment on how their work meets the objectives of the assignment.

## **Pacing**

Four or more 45-minute periods: one to consider art and to plan; one to create setting; one to mold figures; one to create props and evaluate

## **Studio Preparation**

So that students will not have use for knives, cut off the top and two sides of sturdy cardboard boxes before class.

## **Objectives**

- Recognize the storytelling elements in the work of contemporary sculptors.
- Apply the elements of storytelling to the creation of a sculpture.
- Reflect on one's own purpose and process of artmaking.

## Vocabulary

**model** To shape clay, or another similar material, by pinching, pulling, or other manipulation with the hands.

**shape** A flat figure that is created when actual or implied lines meet and surround a space.

unity A principle of design, in which all parts of a design work together to create a feeling of wholeness.

variety The use of different lines, shapes, textures, colors, or other elements of design to create interest in an artwork.

## National Standards 1.4 Studio Lesson

- **1a** Select/analyze media, techniques, processes, reflect.
- **2b** Employ/analyze effectiveness of organizational structures.
- **3b** Use subjects, themes, symbols that communicate meaning.
- **4c** Analyze, demonstrate how time and place influence visual characteristics.

Sculpture in the Studio

# Sculpting a Scene

## **Story Under Construction**

LESSON

STUDIO

## **Studio Introduction**

For a storytelling artwork, artists first decide which special moment of the story to show—a moment from the story's

beginning, middle, or end. In this studio experience, you will construct a scene that shows a special moment from a story. Pages 88 and 89 will show you how to do it. How can you capture a moment and show it in a sculpture? First, decide what kind of story you want to show. Will you show a moment from a story that really happened?

Or will you show a moment from an imaginary story? Next, imagine stopping the action of the characters in that moment. What are they doing? How are they posed? What is the scene? Create simple sketches: they can guide the sculptural construction of your story.

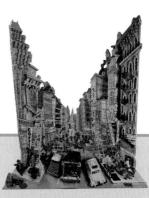

Fig. 1–25 How do you think the mood and feeling of this setting would change if the shapes were straight and regular? Red Grooms, Looking along Broadway towards Grace Church, 1981. Mixed media, height; 71\* (18.0.3 cm). © The Cleveland Museum of Art, 2001, Gift of Agenes Gund in honor of Edward Henning, 1991.27. © 2001 Red Grooms/Artists Rights Society (ARS), New York.

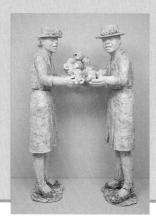

Fig. 1–26 If these sculpted figures were characters in a play or movie, what might they be saying to each other?
Viola Frey, Double Grandmother,
1978–79.
Glazed white clay, height: 61 1/6\* (156 cm). The Minneapolis institute of Arts, Gift of the Regis Corporation (Bl. 129.1.2).

# Studio Background

## **Three-Dimensional Freeze Frame**

Red Grooms and Viola Frey are two contemporary artists who have created storytelling sculptures. Although their stories are about everyday life, each artist's journey through telling the story has been different.

In his stories, Red Grooms emphasizes setting (Fig. 1–25). He often uses cardboard, wood, and foamcore to build his scenes. He is best known for constructing exaggerated environments—from city streets to subway cars—that viewers can actually walk through. Viola Frey focuses on characters and creates life-size clay figures (Fig. 1–26). Her work is influenced by the Japanese porcelain figurines she played with as a child.

Each artist's works seem frozen in time and thereby excite the viewer's imagination. You might imagine that, if you flipped a switch, everything would start moving and the story would go on.

86

# **Teaching Options**

## **Resources**

Teacher's Resource Binder Studio Master: 1.4 Studio Reflection: 1.4 A Closer Look: 1.4 Find Out More: 1.4 Overhead Transparency 1

Slides 1f

## **Teaching Through Inquiry**

Art Production Have students work in collaborative-learning groups to create a scene from a story with many characters. Give each student enough clay to model one character. Ask group members to divide up the job of researching the features and details that distinguish one character from another, to assign the creation of a different figure to each member, and to discuss and make decisions about the grouping of the figures in a setting or settings.

# Fig. 1–27 How has this student created unity and variety in his sculpture?

Michael Giancoli, Snowboarding, 2001. Clay figure with glaze, cut-paper and cardboard setting, 12" x 12" x 8" (30.5 x 30.5 x 20 cm). Colony Middle School, Palmer,

# Fig. 1–28 What modeling techniques do you think this artist used?

Emily Dougherty, Volley Ball,

Clay figure with glaze, cut-paper and card board setting, 12" x 8" x 17" (30.5 x 20 x 43 cm). Colony Middle School, Palmer, Alaska

Artists as Storytellers

87

## More About...

Red Grooms says his art has a "sort of comic strip feel for city life." His distinctive, bright colored, witty sculptures, which blend Pop Art and Expressionism, soften New York City's serious attitude. He calls his sculptural reliefs "stickouts" and his walkthrough sculptures "sculptopictoramas." Grooms is also a painter, printmaker, filmmaker, and performance artist.

## **Using the Overhead**

## Think It Through

**Ideas** How has the artist expressed his own ideas about a real-life story?

**Techniques** What does the comic-strip format allow the artist to do that would be difficult to achieve with a traditional sculpture format?

1

## **Supplies**

- corrugated cardboard boxes, top and 2 sides removed
- · clay, air-dry or modeling
- modeling tools (paperclips, toothpicks, utensils)
- construction paper, 12" x 18" sheets and scraps in a variety of colors
- white glue
- scissors
- found objects, tape, paint and brushes, hot glue and glue gun (optional)

## **Supplies Note**

Students may either use bright-colored modeling clays or paint their air-dried clay sculpture.

## Teach

## Engage

Show a clip from an animated movie with clay figures, such as *The Nightmare Before Christmas, Chicken Run,* or the Wallace and Gromit film *The Wrong Trousers;* and discuss how it was made. (In a scene, clay figures are moved slightly, then photographed to create a sense of motion.) Tell students that they will create a scene from a story.

## **Using the Text**

Art Production After students have read pages 86 and 87, discuss scenes they could recreate in sculpture.

## **Using the Art**

Art Criticism Ask: In the works on these pages, what did each artist emphasize? What is the story? How does color affect each sculpture's meaning?

# Sculpting a Scene

# **Studio Experience**

- 1. As students create the setting for their scene, remind them that they can repeat similar shapes to create unity, and use different kinds of shapes to create variety.
- 2. Demonstrate the shaping of figures. Encourage students to add details and to attach any added clay pieces securely so that they will not fall off as they dry. Discuss the size of the figures in relation to their setting.
- 3. Demonstrate how to construct props out of clay, cardboard, construction paper, or found objects.

### **Idea Generators**

Some students may wish to depict a scene from a fairytale. As a class, generate a list of fairytales, and have students identify each story's high points.

### **Extend**

- Have students photograph or sketch their sculpture. Encourage them to create a mood with highlights and shadows, by using spotlights or flashlights with colored cellophane or stage-light gels.
- Assign students to research "claymation" movie stills and then to sketch one of the stills, giving special attention to the scene's variety of shapes, colors, and textures.

# **Elements and Principles**

Have students work in small groups to choose artworks in the textbook that show strong examples of shape, unity, and variety. Invite a spokesperson from each group to explain to the class why the group chose the artworks.

### Sculpture in the Studio

# **Constructing Your Scene**

### You Will Need

- prepared cardboard box
- colored construction paper
- cardboard scraps
- scissors

STUDIO LESSON

- · white glue
- clay
- tools for creating surface textures

### Try This

1. Start by creating your background scene with the box and construction paper. Will you create an indoor scene or an outdoor one? How can you

use shapes and forms to create background details? Think of ways to cut, fold, curl, or crumple construction paper to make colorful shapes and forms. Carefully glue the details to the sides and floor of the box.

2. Make your characters out of a ball of clay. Create a five-point star by pulling out a point for the head, each arm, and each leg.

**3. Model**, or shape, the head and limbs by pinching and pulling the points. As you work, think about the pose you want each character to have. Do

any of your figures have to be bent or twisted at the waist? Do arms or legs have to be bent to create the desired pose?

**4.** Add details, such as facial features, hair, and clothing patterns. Will you carefully press tiny coils, balls, or other bits of clay

onto the figures? Or will you create details by pressing textures onto the surfaces?

- 5. When your characters are finished, decide whether you would like to create props for your scene. Does your indoor scene need simple furniture? Does your outdoor scene need trees or cars that aren't part of the background? Do your characters need to hold special objects, such as a broom or a baseball bat? Make props from scraps of cardboard or construction paper.
- **6.** Add whatever props are necessary to the characters. Then place the characters in the scene.

### Check Your Work

Discuss your completed sculpture with your classmates. What part of your story does your artwork tell? Ask your classmates what they think happened before and after this scene. How did you use shapes and forms in your artwork?

#### **Computer Option**

Use your constructed scene and clay characters to produce a short animation sequence. You can capture simple

motions and actions by taking a series of still pictures, so that a character appears slightly different in each frame. You may use any digital camera or stop-action video. Set up the scene and then gradually—one tiny movement at a time—capture the movements or actions of your character. Import the images into a multimedia software program to create a digital clip of your characters acting within the environment you have created. Finish your animation by adding title, credits, and sound effects.

88

# **Teaching Options**

### **Studio Collaboration**

By planning ahead and coordinating their work, students could combine their individual efforts to work on a series of scenes from the same story.

### **Teaching Through Inquiry**

**Perception** Assign students to research the art of Red Grooms or Viola Frey. Have them each choose one of the works and write a story about what is happening in the piece. Allow students to present their stories and the art that they selected.

Art Production Have students create a scene similar to that described in Try This, but to make it in the style of Red Grooms or Viola Frey. Before students begin, discuss each artist's style, and which style would best complement their scene.

Fig. 1-29 What story comes to mind when you look at this sculpture? Is this artist showing the beginning, middle, or end of the story? Krystina Hagen, Hobo Frighte, 2001.

# **Elements and Principles**

# Shape, Unity, and Variety

A line that surrounds a space or color in a drawing, painting, or other two-dimensional artwork creates a shape. Some shapes are geometric, such as a circle, square, or triangle. Leaves, seashells, or other objects found in

Geometric

nature have organic shapes. Organic shapes are irregular and often have curves. The shapes you notice first in an artwork are positive shapes. The area surrounding the positive shapes creates the negative shapes.

Artists can use

shape and other design elements to create unity and variety in an artwork. Unity is the feeling

that all parts of an artwork belong together. One way artists create unity is by repeating a shape, color, or other element. They can also use a dominant shape, color, or other element to unify the work. Similar colors, textures, or materials in an artwork also help create unity.

Variety adds visual excitement to an artwork. Artists create variety by including

shapes or other elements that contrast. Most artists combine unity and variety. Say, for example, you see a painting that shows circles and squares repeated throughout the canvas. The repetition of

shapes creates unity. But the different sizes and colors of the shapes create variety.

**Computer Option** This project may be

completed either by individuals or by small groups. Students may use digital cameras and most multimedia software to create high-quality clay animations. To make the animation action move smoothly, students may use the computer to repeat individual frames. Tech4Learning®'s Clay Animation Kit includes software, a clay-animation book, animation clay, and accessories. A stepby-step introduction to the art of clay animation is at http://www. animateclay.com

# Assess

# Check Your Work

Assign students to write the story from which their scene comes. Display the sculptures and stories, and have students explain how they used shapes and forms in their sculpture. Ask students to select sculptures that show, individually, unity, variety, organic shapes, and geometric shapes.

# Close

Review with students the steps involved in creating their sculptures. Ask: If you were to make another, similar sculpture, what would you do differently?

89

Artists as Storytellers

### More About...

Greeks of the fifth-century used semicircular theater sets that merely suggested locations mentioned in a play. During the Middle Ages, people built more realistic scenery for the Christian Bible stories performed on platform stages and movable pageant wagons. By the seventeenth century, painted backdrops (similar to huge murals) and rectangular stages were in use in Europe. Today, superrealism, hyperfantasy, and highly abstract minimalism each abound in theater design.

# **Assessment Options**

Teacher Display reproductions of sculptures that are obviously narrative works, and others that are not at

all narrative. Ask students to identify the works that tell a story and to give reasons why.

Self Have students write a statement in which they reflect on the process they used for their scene; what they like about the completed work; and what was the purpose of their artwork.

# Social Studies

Have students research early American quilts to discover the names and histories of traditional quilt-block patterns. Point out that the same pattern often had a different name or story in various parts of the country. For the historical patterns, challenge students to develop and share new names and stories that reflect contemporary life.

# **Language Arts**

Have students each choose a narrative image from this book and write a short story that interprets the artwork's story. Remind students to include an introduction, the development of a central idea, a climax, and a conclusion, along with details and elaboration. Ask students not to reveal the artwork. Have students take turns reading their story, and challenge the rest of the class to find its image.

# Connect to...

# Careers

CONNECT TO

Have you ever seen a painting that told a story? Did it make you want to know more about the artist? The old cliché "a picture is worth a thousand words" is especially true in narrative paintings that have realistic images. **Painters** develop their own individual style and may use different media and materials, such as oil, acrylic, or

water-based paints. They may paint on canvas, paper, or wood. Many painters receive master of fine arts degree from a college, university, or art school; others are self-taught. Some contemporary painters focus on nonobjective works, whereas others produce narrative art—art that tells a story.

Fig. 1–30 This artist is known for creating narrative artworks based on the lives of people he knew. What story does this painting tell? Romare Bearden, Serenade, c. 1940.

Gouache/casein on Kraft paper, 30" x 47" (78 x 119 cm). © Romare Bearden Foundation, Inc. Licensed by VAGA, New York, NY.

# **Other Arts**

#### Theater

Theater is an excellent way to experience the art of storytelling. The theater offers stories played out by live actors. Many cultures have developed unique forms of theater. In Japan, for example, the traditional dancedrama called *kabuki* has delighted audiences since about 1600. Kabuki performers act out dramatic stories of historical events and everyday life in an exaggerated style. Spectacular scenery, color costumes, and a large orchestra enhance the sensational tales.

Fig. 1–31 In traditional Kabuki theater, female roles are played by men. The male actors who play female characters are called *onnagata*. Utagawa Kunisada,

Scene from a Kabuki Play, c. 1842.
Published by Yamatoya Heikichi (Elkudo). Color woodblock print. Museum Collectio the Bayly Art Museum, University of Virginia.

90

# **Teaching Options**

### Resources

Teacher's Resource Binder:
Making Connections
Using the Web
Interview with an Artist
Teacher Letter

### **Video Connection**

Show the Davis art careers video to give students a real-life look at the career high-lighted above.

# **Other Subjects**

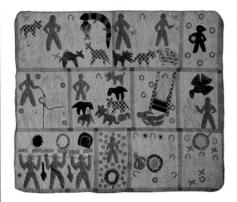

Fig. 1–32 Each panel in this quilt tells a story from the Christian Bible. Why is appliqué a useful technique for telling stories in cloth? Harriet Powers, Bible Quilt, c. 1886. Pieced and appliqued, plain and roller printed cotton, 75 \* x 89 \*)% \* (91 x 227 cm). Smithsonian Museum of American History, Giff of the and Mrs. H.M. Heckman.

### **Social Studies**

As cultural traditions pass through time, they may stay the same, adopt or adapt new characteristics, or undergo transformation into completely new forms. The traditions of storytelling often appear in artifacts and artworks. For example, Fon tailors in West

Africa made appliquéd banners about events in the history and daily life of their kingdom of Dahomey. The Fon techniques of using appliquéd designs to illustrate a story are closely related to similar practices in the United States. Harriet Powers, an African American woman born a slave in 1837, made story quilts that closely resemble Fon traditions. As in the Fon banners, Powers used large, simple cutouts of people and animals. Her quilts also recall the Fon techniques of contrasting foreground and background colors, balanced placement of figures across the background, and the addition of borders.

### Language Arts

Do you have a favorite book that tells a story? Do you prefer a storybook with illustrations, or would you rather visualize mental images on your own? **Reading stories is one way people develop an understanding of others.** Stories allow us to share the thoughts, feelings, hopes, and fears of others. Storytellers are respected in many communities because they preserve and pass on tales about real or imagined events in the past. If you were an author, what story would you tell? Would you want your story to have illustrations?

### Other Arts

Ask students to work as a class or in small groups to recreate narrative artworks through dramatic interpretations. Encourage students to choose an appropriate artwork and plan and present an interpretive performance that may include props, painted backdrops, costumes, spoken parts, music, and dance. Have students perform these "living paintings" for an audience of classmates, teachers, and parents.

# **Daily Life**

What stories do you come across throughout your day? You encounter different kinds of stories when you listen to the radio, pay attention in class, talk to your friends, read a book or magazine, watch television, surf the Internet, or go to a movie. Think of the stories you hear and the stories you tell in just one day. Are they more fiction than fact? Are you more likely to tell or hear stories?

**Internet Connection**For more activities related to this chapter, go to the

Davis Website at www.davis-art.com.

Artists as Storytellers

91

# **Internet Resources**

National Storytelling Network and Storytelling Foundation International

http://www.storynet.org/ http://www.storytellingfoundation.net

These two organizations advance the art of storytelling.

### **Community Involvement**

Make arrangements for students to interview residents at an assisted-living facility about their childhood experiences. Have students and/or interviewees write their stories and create a cut-paper mural as a collective visual record of the memories

### Interdisciplinary Planning

Share with other teachers the theme of this chapter and the ideas presented on these "Connect to..." pages. Discuss ways to work as a team to reinforce and integrate learning across the curriculum.

# **Talking About Student Art**

Engage students in the practice of good description of artworks. Display student works, and ask students, in turn, to select one work to describe to the rest of the class, who should listen carefully and look closely to guess which work is being described.

# **Portfolio Tip**

Remind students that the portfolio is an ongoing record of their perfor-

mance: it shows progress in their art-historical understanding, aesthetic awareness, use of descriptive language, and refinement of studio skills.

# Sketchbook Tip

Guide students to understand that a sketchbook is both a journal and a porta-

ble drawing board for working out ideas. Encourage students to reserve sections in their sketchbook for new vocabulary, important facts to remember, questions to think about, assignments, ideas about art, and so on.

# **Portfolio**

REVI

PORTFOLIO

"I got my idea from looking through animal picture books. I decided to make the book larger than life, and I had the animals come to life off the page." Rosie Perkins

"After my house burnt down I felt sad, but I knew we were going to start building right away. Everything would be fine again. It's just going to take time. I wanted to do something with a fire and my new house being built by a staple gun."

#### **Zachary Wilson**

Fig. 1-34 How does the outline of a staple gun change the focus of the story told in this picture? Zachary Wilson, *The Powerful Tool*, 2001. Tempera, 17<sup>3</sup>/4" x 23" (45 x 58.5 cm), Victor School, Victor, Montana.

thinking about my dog. His name is Pepper. I wanted to make a place in my art where Pepper could run and play without getting hurt by chasing cars." Michael Whatley

"I wanted to tell a story about a dog. I was

Fig. 1-33 This artwork tells a story in more

Magazine cutouts, construction paper, typed narrative, tempera parker, handprinted paper, 12  $^3/^4$  x 19  $^3/^4$  (32 x 50 cm). Fred C. Wescott Junior High School, Westbrook, Maine.

Book, 2001.

ways than one. Both words and pictures are

used in the design. Rosie Perkins, The Magical

Fig. 1-34 One thing that makes this collage exceptional is its size—it is five feet tall. Artwork like this can also be made from cut pieces of fabric and hung as a banner. Michael Whatley, Dog in the Country, 2001. Cut paper, 5' x 3' (16.4 x 9.8 m). Fletcher-Johnson Educational Center, Washington, DC.

**CD-ROM Connection** 

To see more student art, view the Personal Journey Student Gallery.

92

# **Teaching Options**

### Resources

Teacher's Resource Binder Chapter Review 1 Portfolio Tips Write About Art Understanding Your Artistic Process Analyzing Your Studio Work

# CD-ROM Connection

For students' inspiration, for comparison, or for criticism exercises, use the additional student works related to studio activities in this chapter.

# **Chapter 1 Review**

#### Recall

Define narrative art

#### (Understand)

Explain why stories are important to people.

### Apply

Give at least three examples of visual stories in your everyday life.

### Analyze

Consider the Fon banner shown below. Discuss how the artist used shapes to hold the interest of the viewer.

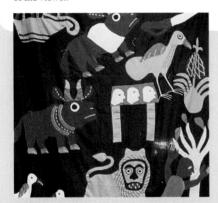

Page 84

### Synthesize

Create a list of "Things to Think About" for someone who wants to tell a story with images, but no words.

#### Evaluate

Focus on one aspect of a story—either character, situation, or setting. Find an artwork in this chapter in which the artist showed this aspect in an especially interesting way. Give reasons for your selection.

#### **For Your Portfolio**

You can use your portfolio to keep track of your personal journey in art by keeping your artworks, essays, and

other art-related work in it. Write one statement about what you wanted to say in an artwork that you made in this chapter. Write another statement that explains what you learned.

#### For Your Sketchbook

Your sketchbook is a good place to explore new ideas about art. For this chapter, explore different ways to tell

stories with shapes, colors, and lines.

Artists as Storytellers

93

# Advocacy )

Have students work with you to design a flyer, brochure, or series of posters about the values of art education. Help students identify the important skills and concepts that could help people in the workplace and community to live an art-filled life. Caution students to use easy-to-understand terms. Reproduce, distribute, and display these materials at school-board and parent meetings and throughout the community.

### **Family Involvement**

A simple bimonthly newsletter is an effective way to communicate with family members about what students are learning in art and about art events. Suggest ways that families could make an upcoming craft show or museum exhibition into an educational adventure. Provide questions to ask of exhibitors, or suggest things to look for. Keep the newsletter friendly, informative, and inviting.

# Chapter 1 Review Answers Recall

Narrative art is art that tells a story.

### **Understand**

Stories allow people to visit faraway places, meet fascinating characters, and learn about the way people lived in the past. Stories can also teach a special message and delight an audience.

### Apply

Answers will vary, but may include comics, television, and movies.

### **Analyze**

Answers will vary, but may include the fact that shapes are simple, brightly colored, and stand out against the background.

### **Synthesize**

Answers will vary, but may include the need to think about such things as situation, setting, plot, character, beginning, middle, and end in order to grab and hold the interest of the viewer.

### **Evaluate**

Answers will vary. Look for appropriate reasons.

### Reteach

Provide students with several examples of children's picture books. Have them review the illustrations to determine which of the illustrators has been able to tell the story through imagery. Suggest that they cover the text and view only the images. Hold a discussion to consider what the artist has included in the series of images to help tell about the characters, the situation, setting, and plot. Summarize by explaining that when artists tell stories with imagery, they must decide what to show and how to show it.

| , | <b>k</b> S |  |
|---|------------|--|
| 5 | ee         |  |
|   | š          |  |

3

3

3

# **Chapter Organizer**

36 weeks

# **Chapter Focus**

# **Chapter National Standards**

# Chapter 2 Artists as Recorders

Chapter 2 Overview pages 94-95

- Core Art is a means by which people record the events of daily life. Artists often function as recorders of daily life
- 2.1 Documenting Daily Life
- 2.2 Tonal Drawing and Shading
- 2.3 Art of Haiti
- 2.4 Still-Life Drawing

- 1 Understand media, techniques, and processes.
- 2 Use knowledge of structures and functions.
- 3 Choose and evaluate subject matter, symbols, and ideas.
- Understand arts in relation to history and cultures.
- Assess own and others' work.
- 6 Make connections between disciplines.

### **Objectives**

### **National Standards**

Core Lesson **Recorder of Daily Life** page 96

Pacing: Three 45-minute periods

- Explain how artists use a variety of media to record people's daily lives and feelings.
- Demonstrate an understanding of artists' selections of what daily-life feature to show and how to show it.
- 2a Generalize about structures, functions.
- 2b Employ/analyze effectiveness of organizational structures.
- 3a Integrate visual, spatial, temporal concepts with content.
- 4c Analyze, demonstrate how time and place influence visual characteristics.
- 5b Analyze contemporary, historical meaning through inquiry.

### Core Studio **Recording Daily Life** page 100

- Complete a final drawing, based on a series of sketches, to record a daily-life moment.
- 1b Use media/techniques/processes to communicate experiences, ideas.
- 2c Select, use structures, functions.
- 3b Use subjects, themes, symbols that communicate meaning.

# **Objectives**

### **National Standards**

Then and Now Lesson 2.1 **Documenting Daily Life** page 102

Pacing: Three or four 45-minute periods

- Provide examples of genre scenes as documents of daily life.
- Explain why photographs are important records of daily life.
- 4a Compare artworks of various eras, cultures.
- 4c Analyze, demonstrate how time and place influence visual characteristics.
- 5b Analyze contemporary, historical meaning through inquiry.

### **Studio Connection** page 104

· Use a range of values to create pencil drawings, enhanced by collage elements, to record a daily-life activity.

- 1b Use media/techniques/processes to communicate experiences, ideas.
- 3a Integrate visual, spatial, temporal concepts with content.

# **Objectives**

# **National Standards**

**Skills and Techniques** Lesson 2.2 **Tonal Drawing** and Shading

2

page 106 Pacing: Two 45-minute periods

- · Identify hatching, stippling, and blending and smudging techniques in tonal drawings.
- 1b Use media/techniques/processes to communicate experiences, ideas.

# **Studio Connection**

- · Use various shading techniques to draw a still life.
- 1b Use media/techniques/processes to communicate experiences, ideas.

### **Featured Artists**

Inatace Alphonse Castera Brazille Dorothea Lange Limbourg Brothers Whitfield Lovell Gabriel Metsu Philomé Obin Louverture Poisson James Rosenquist Ben Shahn Wayne Thiebaud James VanDerZee Carrie Mae Weems

# **Chapter Vocabulary**

contrast
crop
genre scene
Harlem Renaissance
installations
still life
tonal drawing
value

### **Teaching Options**

Teaching Through Inquiry
More About...Dorothea Lange
Using the Large Reproduction
Meeting Individual Needs
Teaching Through Inquiry
More About...Ben Shahn
More About...Book of hours

# Technology

CD-ROM Connection e-Gallery

### Resources

Teacher's Resource Binder Thoughts About Art: 2 Core A Closer Look: 2 Core Find Out More: 2 Core Studio Master: 2 Core Assessment Master: 2 Core Large Reproduction 3 Overhead Transparency 4 Slides 2a, 2b

Teaching Through Inquiry More About...Digital photographs Assessment Options CD-ROM Connection Student Gallery Teacher's Resource Binder Studio Reflection: 2 Core

# **Teaching Options**

Teaching Through Inquiry
More About...The Harlem Renaissance

### **Technology**

CD-ROM Connection e-Gallery

### Resources

Teacher's Resource Binder Names to Know 2.1 A Closer Look 2.1 Find Out More 2.1 Assessment Master 2.1 Overhead Transparency 3 Slides 2c

Meeting Individual Needs Teaching Through Inquiry Using the Overhead Assessment Options CD-ROM Connection Student Gallery Teacher's Resource Binder Check Your Work: 2.1

# **Teaching Options**

Teaching Through Inquiry More About...Pencils Using the Overhead Assessment Options

### **Technology**

CD-ROM Connection e-Gallery

### Resources

Teacher's Resource Binder Finder Cards 2.2 A Closer Look 2.2 Find Out More 2.2 Assessment Master 2.2

Overhead Transparency 4 Slides 2d

CD-ROM Connection Student Gallery Teacher's Resource Binder Check Your Work: 2.2

# Chapter Organizer continued

36 weeks 18 weeks 9 weeks **Objectives National Standards Global Destinations** · Explain various influences on Haitian art. 3a Integrate visual, spatial, temporal concepts Lesson 2.3 · Describe the subject matter of Haitian art. with content. Art of Haiti 4c Analyze, demonstrate page 108 how time and place influence visual Pacing: Four 45-minute characteristics. periods 5b Analyze contemporary, historical meaning through inquiry. **Studio Connection** · Use dark and light values in a painting of a 1b Use media/techniques/processes to page 110 daily-life activity. communicate experiences, ideas. 2c Select, use structures, functions. 3b Use subjects, themes, symbols that communicate meaning. **Objectives National Standards** 2 2 Studio Lesson 2.4 · Explain how objects provide information about 1b Use media/techniques/processes to communicate Still-Life Drawing people's lives and times. experiences, ideas. page 112 Understand that Pop artists used everyday 2b Employ/analyze effectiveness of organizational Pacing: One or more objects to make statements about structures. 45-minute periods contemporary life. 2c Select, use structures, functions. · Use a range of values in a still-life drawing. 3b Use subjects, themes, symbols that communicate 4c Analyze, demonstrate how time and place influence visual characteristics. 5b Analyze contemporary, historical meaning through inquiry. 5c Describe, compare responses to own or other artworks. **Objectives National Standards** Connect to... · Identify and understand ways other disciplines page 116 are connected to and informed by the visual Understand a visual arts career and how it relates to chapter content.

6 Make connections between disciplines.

### **Objectives**

- · Learn to look at and comment respectfully on artworks by peers.
- Demonstrate understanding of chapter content.

## **National Standards**

5 Assess own and others' work.

2 Lesson of your choice Portfolio/Review

page 118

### **Teaching Options**

Teaching Through Inquiry More About...Castera Brazille

### **Technology**

CD-ROM Connection e-Gallery

### Resources

Teacher's Resource Binder A Closer Look: 2.3 Find Out More: 2.3 Assessment Master: 2.3

Large Reproduction 4 Slides 2e

Meeting Individual Needs Teaching Through Inquiry Using the Large Reproduction Assessment Options CD-ROM Connection Student Gallery Teacher's Resource Binder Check Your Work 2.3

### **Teaching Options**

Teaching Through Inquiry More About...Pop Art Using the Overhead Teaching Through Inquiry More About...Pastels Assessment Options

### Technology

CD-ROM Connection Student Gallery Computer Option

### Resources

Teacher's Resource Binder Studio Master: 2.4 Studio Reflection: 2.4 A Closer Look: 2.4 Find Out More: 2.4 Overhead Transparency 3 Slides 2f

# **Teaching Options**

Community Involvement Interdisciplinary Planning

# Teaching Options

Advocacy Family Involvement

### **Technology**

Internet Connection Internet Resources Video Connection CD-ROM Connection e-Gallery

### **Technology**

CD-ROM Connection Student Gallery

### Resources

Teacher's Resource Binder Using the Web Interview with an Artist Teacher Letter Venn Diagram

### Resources

Teacher's Resource Binder
Chapter Review 2
Portfolio Tips
Write About Art
Understanding Your Artistic Process
Analyzing Your Studio Work

# **Chapter Overview**

### **Theme**

People have always been interested in recording the events of daily life. Artists sometimes function as recorders, selecting features of and choosing ways to depict daily life.

### **Featured Artists**

Inatace Alphonse
Castera Brazille
Dorothea Lange
Limbourg Brothers
Whitfield Lovell
Gabriel Metsu
Philomé Obin
Louverture Poisson
James Rosenquist
Ben Shahn
Wayne Thiebaud
James VanDerZee
Carrie Mae Weems

# **Chapter Focus**

This chapter examines how artists record daily-life events, particularly how photographer Dorothea Lange recorded people during the Great Depression. Students learn about genre scenes and other historical approaches to documentation, and study how artist Whitfield Lovell creates installations to record rural life of the past. Students explore drawing techniques and discover how Inatace Alphonse and other Haitian artists make records of their communities. Students each create a stilllife drawing to show something about themselves.

# National Standards Chapter 2 Content Standards

- 1. Understand media, techniques, and processes.
- 2. Use knowledge of structures and functions.
- **3.** Choose and evaluate subject matter, symbols, and ideas.
- 4. Understand arts in relation to history and cultures.
- 5. Assess own and others' work.
- **6.** Make connections between disciplines.

2

# Artists as Recorders

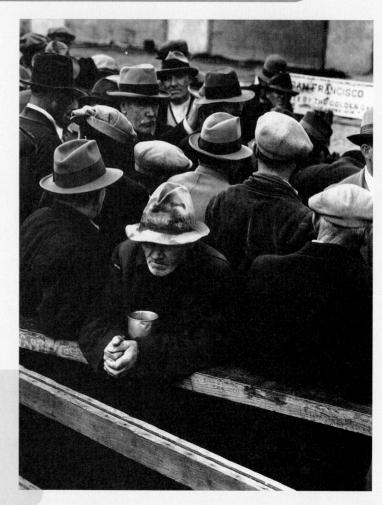

Fig. 2–1 How did the artist use lights and darks to direct the viewer's attention? Dorothea Lange, White Angel Breadline, San Francisco, 1933. Gelatin silver print. © The Dorothea Lange Collection, Oakland Museum of California. City of Oakland. Gift of California. City of Oakland.

94

# **Teaching Options**

# **Teaching Through Inquiry**

Art History Provide small groups of students each with a photocopy of Lange's photograph. Instruct groups to research the historical context of the photograph, particularly the role of breadlines during the Great Depression. Invite each group to make a poster of the image and their findings. Discuss each poster, and display all of them in a public space in the school.

### More About...

During the **Great Depression** of the 1930s, many people waited endless hours in lines for free bread, possibly the only food they would eat that day. The United States was in the midst of an economic crisis: the stock market crashed, banks failed, a drought struck ranchers and farmers in the Midwest, and unemployment ran high. In 1933, one out of four people didn't have a job.

### **Focus**

- Why are the events of daily life important
- · How do artists record the details of our daily lives?

Many people worldwide keep diaries to track the events of their day-to-day life. Historians may use diaries to learn how people lived and what they thought about in the past. When individuals write in their diary, they do not usually think that someone in the future will use what they've written. They don't think of themselves as recorders of their time.

Artworks, like diaries, also can tell us about times gone by. We can look at artworks for clues about how people lived and what they cared about. Although all artists don't create their artworks to be historical records, some are especially interested in documenting the people and events of their time.

Dorothea Lange used photography as a way to record what she saw in the world around her. She is known for her photographs of people who faced hardships in their daily life, like the unemployed men waiting in line for a free meal (Fig. 2–1). In this chapter, you will learn more about

Dorothea Lange and other artists who have recorded the way we live.

Dorothea Lange Whitfield Lovell Inatace Alphonse

### **Words to Know**

crop genre scene Harlem

tonal drawing still life value Renaissance contrast

installation

Artists as Recorders

# Supplies for Warm-up

· photographs from old yearbooks, magazines, newspapers, or photo albums

# **Chapter Warm-up**

Display the old photographs, and lead students to note how people and places have changed. Tell students that they will study how artists record their world.

# **Using the Text**

Aesthetics Ask: How can artworks be like diaries? Have you ever taken a photograph to remember a moment or sketched something so that you would know what it looked like later?

# **Using the Art**

Perception Ask: How did Dorothea Lange capture the emotion of the Great Depression? What do you see first? (foremost man's hat and hands) Why do these stand out? (lighter than the background) Besides value contrasts, how else did Lange emphasize this man? (placed him near the center of her design, led lines of the railing to him)

### Extend

Have students photograph a day in the life of their school or their own life. Ask them to record the time that each photo was taken and to write a caption for each. Make a chronological display of the photographs and captions.

**Dorothea Lange** 

# **Graphic Organizer** Chapter 2

# 2.1 Then and Now Lesson

Documenting Daily Life page 102

### 2.2 Skills and **Techniques Lesson**

**Tonal Drawing** and Shading page 106

# **Core Lesson**

Recorder of Daily Life

# **Core Studio**

**Recording Daily Life** page 100

### 2.3 Global **Destinations Lesson**

Art of Haiti page 108

### 2.4 Studio Lesson

Still-Life Drawing page 112

### **CD-ROM Connection**

For more images relating to this theme, see the Personal Journey CD-ROM.

### **Artists as Recorders**

# **Prepare**

# **Pacing**

Three 45-minute periods: one to consider text and images and begin figure sketches; two for drawing

# **Objectives**

- Explain how artists use a variety of media to record people's daily lives and feelings.
- Demonstrate an understanding of artists' selections of what daily-life feature to show and how to show it.
- Complete a final drawing, based on a series of sketches, to record a dailylife moment.

# Vocabulary

**crop** To frame an image by removing or cutting off the outer edges.

# National Standards Core Lesson

- **1b** Use media/techniques/processes to communicate experiences, ideas.
- 2a Generalize about structures, functions.
- **2b** Employ/analyze effectiveness of organizational structures.
- 2c Select, use structures, functions.
- **3a** Integrate visual, spatial, temporal concepts with content.
- **3b** Use subjects, themes, symbols, that communicate meaning.
- **4c** Analyze, demonstrate how time and place influence visual characteristics.
- **5b** Analyze contemporary, historical meaning through inquiry.

# **Recorder of Daily Life**

"You put your camera around your neck along with putting on your shoes, and there it is, an appendage of the body that shares your life with you. The camera is an instrument that teaches people how to see without a camera."

Dorothea Lange (1895-1965)

# **Dorothea Lange's Journey**

As a teenager, Dorothea Lange decided to be a photographer. She learned her craft as a helper in portrait-photography studios in New York. Eventually, she set out on a journey to see the world, selling her photographs along the way. When she ran out of money, she found a job and later opened her own

studio in San Francisco. However, after several years, Lange realized that she was no longer interested in photographing people who posed for their portrait. She was much more concerned with recording the people she saw on the streets. Many of these people were homeless and out of work.

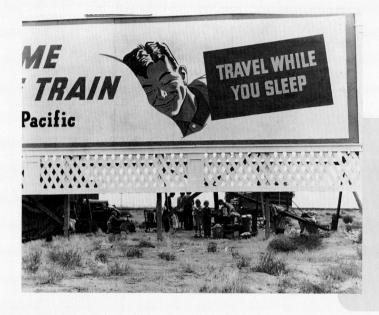

Fig. 2–2 During the depression, families lived as best as they could while they traveled throughout the country looking for work. The families shown here lived beneath a giant billboard. Why did Lange photograph the families from a distance? Dorothea Lange, Three Families, Fourteen Children on U.S. 99, San Joaquin Valley, California, 1938. Gelatin silver print, 9½% x7 ½° (24.5 x 19.1 cm). The St. Louis Art Museum. Purchase: Museum Shop Fund, 148:1987.

96

CORE LESSO

# **Teaching Options**

### Resources

Teacher's Resource Binder
Thoughts About Art: 2 Core
A Closer Look: 2 Core
Find Out More: 2 Core
Studio Master: 2 Core
Studio Reflection: 2 Core
Assessment Master: 2 Core
Large Reproduction 3
Overhead Transparency 4
Slides 2a, 2b

### **Teaching Through Inquiry**

Art Criticism Remind students that artists decide what to show and how to show it. Have small groups address either of Lange's photographs. Ask groups to list the important subject matter and details, and to interpret the artwork, answering such questions as What feeling did the artist convey?, What is the message?, and How did the artist use subject matter and details to convey feelings and ideas? As an aid, suggest to students that they imagine how the photograph would look without specific details. Hold a class discussion in which groups share their findings.

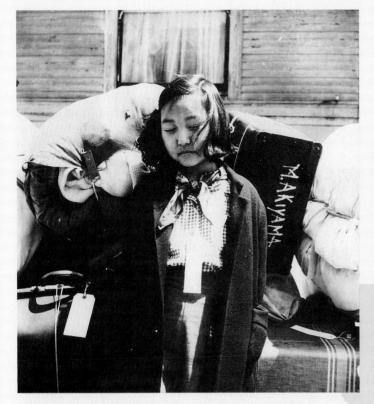

Fig. 2–3 Where do we usually find things with tags on them? Why do you think the artist chose to take this picture? Dorothea Lange, Tagged Girl, Oakland, 1942. Gelatin silver print. From the National Archive and Records Administration, taken for the War Relocation Authority. The Oakland (CA) Public Library.

# Recording the Human Spirit

Lange had much compassion for the people she recorded in her photographs. She used photography to document those whose lives were changed because of the Great Depression and a drought. Many were forced to move around the country in search of work. In such photographs as *Three Families*, *Fourteen Children* (Fig. 2–2), Lange helped show the government the urgent need to help Americans in distress. When World War II began, Lange photo-

graphed the Japanese Americans who were sent to live in camps until the end of the war (Fig. 2–3).

Throughout her life, Lange carefully observed people alone and with others. She watched them as they rested or moved about. She noticed little things, like their gestures or the way they held their head. She saw not only how they looked, but also how they felt. And she used her camera to record these feelings for the rest of us to see.

Artists as Recorders

97

# Teach

# Engage

Ask students to remember a time in their life when they felt hopeless or very sad. **Ask**: What was the position of your body then? Did your shoulders sink and your head droop? How about your hands? Encourage students to explain how they express emotion with their body. Explain that Dorothea Lange captured feelings in photographs.

# **Using the Text**

Art History Ask: Why did Dorothea Lange prefer not to photograph people in her studio? How, do you think, did Lange's photographs change people's thinking?

# **Using the Art**

Art Criticism Ask: Was Lange standing near or far away from her subject when she took each photograph on these pages? How, do you think, do the camera angles influence the message in these photographs?

Aesthetics Ask: Are these photographs art? Why or why not? Are all photographs art? Why or why not?

### Extend

Ask students to research a photographer who was a contemporary of Lange, such as Ansel Adams, Imogen Cunningham, or Edward Weston. Have students copy one of the artist's photographs and write a description of its values, identify the darkest and lightest values and the greatest value contrasts, and explain how the artist emphasized the main subject.

### More About...

Born in 1895, **Dorothea Lange** became a commercial portrait photographer in the 1920s. By the 1930s, she was photographing the oppressed and—as a Farm Security Administration (F.S.A.) photographer—farm families migrating West in search of work. Her photographs provided documentation for programs that assisted disadvantaged Americans. During WWII, Lange photographed Japanese-Americans in internment camps, and women and minority wartime-industry workers in California. Throughout her life, Lange recorded people in distress around the world.

### **Using the Large Reproduction**

### Talk It Over

**Describe** Name all the details you can see in this portrait.

**Analyze** How did the artist use dark and light areas to focus attention?

**Interpret** What, do you think, seemed important to record about this person?

**Judge** Is this kind of portrait a good way to record daily life? Why?

3

### **Artists as Recorders**

# **Using the Text**

Art History Have students read Records in Many Forms. Ask: From artworks, what we can learn about people's lives in the past? (how people dressed, games they played, their work, their food)

Art Production Have students read Selecting What to Show. Ask: How do artists remember what they have seen? (use camera, make mental note, sketch) What decisions do artists make about how to show their subject? (whether to be near or far, what part of a setting to show)

# **Records in Many Forms**

Dorothea Lange recorded life with a camera. Since its invention, over 150 years ago, the camera has provided us with photographic images of our world. In newspapers, magazines, and television, we see visual records of our life as we live it day to day.

Artists living today and in the past, working with materials ranging from paint to stone, have documented the way we live. We can look at artworks for clues about how people dressed for different occasions, what games they played, what work they did, and even what they liked to eat.

Fig. 2–4 This newsstand in Mexico City, like newsstands worldwide, displays magazines and newspapers filled with photographic records of daily-life events. In magazines that you enjoy, look for images of people working and playing.
Photocourtey Eldon Katter.

Fig. 2–5 The artist Ben Shahn is noted for his paintings and prints of people and events from his time. What does this image tell about the way people lived? Ben Shahn, Handball, 1939.

Tempera on paper over composition board, 22 3/4" x 31 1/4" (57.8 x 79.4 cm). The Museum of Modern Art, New York. Abby Aldrich Rockefeller Fund. Photograph © 2001 The Museum of Modern Art. New York

98

CORE LESSON

# **Teaching Options**

# **Meeting Individual Needs**

Gifted and Talented and Multiple Intelligences/Linguistic Ask students to examine the photographs by Dorothea Lange (Figs. 2-1 through 2-3) and to identify, in each, the visual clues (in clothing, poses, background, facial expressions, and so on) regarding the poverty and dire circumstances of her subjects. Then have students locate newspaper and magazine photographs that show people facing difficult times today. Ask: How do these images compare to those by Lange? Is either set more moving? More informative? More imaginative? Have students each defend their position in writing.

### **Teaching Through Inquiry**

Aesthetics Provide small groups of students with several strips of paper and a copy of an identical newspaper photograph and caption. Ask groups to use the strips to crop the image so as to change its meaning significantly, and to write a caption appropriate for the cropped image. Have groups share their revised image and caption with the rest of the class.

# **Selecting What to Show**

All artists must select what they want to record. Some artists focus on special events or important people. Others show ordinary people doing ordinary things, such as young men playing handball in Ben Shahn's artwork (Fig. 2–5). But how do artists who work without a camera remember what they have seen? Some artists train themselves to observe carefully. They keep the scene in their "mind's eye" and then later record what they remember. Other artists make quick sketches on the spot; later, they select what to feature in their final artwork.

After selecting a subject, an artist must decide how to show it. As Dorothea Lange did, an artist may choose to record close-up views of just a few people or views of a faraway crowd. Settings are also important. The addition of buildings, scenery, or objects helps put people and events into a recognizable world. To highlight certain features or draw attention to certain parts of an artwork, the artist can create contrast by experimenting with light and dark.

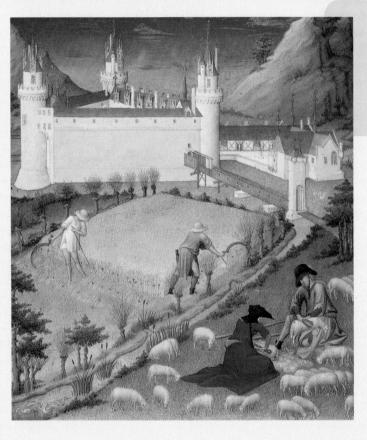

Fig. 2–6 What does this image, created in the 1400s, tell us about the way some people lived? Limbourg Brothers, Les Très Riches Heures du Duc de Berry (detail), 15th century.

Mauscript (Ms. 65/1284, fol.7v), approx.

81/12\* x5 1/2\* (21.6x 14 cm), Musée Condé, Chantilly, France. Giraudon/Art Resource,
New York.

# Using the Art

Perception Direct students' attention to Handball. Ask: What is going on in this painting? What is the mood of this painting? (Ionely, somber) Lead students to note how the large area of blank space in the center of the painting contributes to the mood. Tell students that Shahn painted this during the Great Depression; therefore, the image suggests that the young men, seemingly at play, are actually jobless.

Art History Have students compare the size of the Limbourg Brothers' Book of Hours to this book. Ask: What type of work are the people doing? (harvesting grain, shearing sheep) What tools are they using? (scythes, knives) What structure dominates the background? (castle) Have students describe the clothes that the figures are wearing.

# **Critical Thinking**

Assign students to find other examples of the Limbourg Brothers' illuminations. Then have them develop a chart to compare fifteenth-century European lifestyles to American lifestyles today, examining such factors as food, shelter, and means of transportation.

Artists as Recorders

99

### More About...

Ben Shahn (1898–1969) was known as a painter, printmaker, photographer, and calligrapher. As a leader of Social Realism, he used his art to criticize and comment on the judicial system, racial injustice, and the hardships of migratory workers and miners. In the 1930s he worked on WPA mural projects and photographed rural poverty. In his later works, he explored tragic themes with strong social commentary.

### More About...

For the Duc de Berry, the brother of the king of France, the Limbourg brothers illustrated a **book of hours**, a series of devotional prayers to be used for private worship. The calendar pages depict the seasonal tasks of the peasants and nobility; the lunette represents the sun chariot's move through the signs of the zodiac.

### **Using the Overhead**

#### Think It Through

**Ideas** What could have inspired the artist to record this moment?

Materials What materials did she use?

**Techniques** How did she use the materials to give the artwork its special look?

Audience What kind of audience would possibly

not understand the meaning of this artwork?

# **Artists as Recorders**

# **Supplies**

- · sketch paper
- pencil
- eraser
- drawing paper
- paper strips or L's for viewfinders

# **Using the Text**

Art Criticism/Art Production Have students read Studio Background.
Ask: How did Lange make different versions of the same subject? (shot close-up, stood back from her subject, cropped photos)

Art Production Go over the steps in Try This. Take the class to the lunchroom or another school location to make a series of quick sketches of people in everyday activities, or have students take turns modeling everyday activities. Have students select and crop one sketch and then darken the outline of the cropped image in pencil.

# **Studio Tip**

To make a viewfinder, cut two L shapes from a sheet of copy paper. These shapes may be moved together and apart to form larger or smaller rectangles to crop an image.

# **Using the Art**

Art History Discuss the plight of the people in Lange's photographs. Inform students that, within days of *Migrant Mother's* appearance in newspapers, food for starving families was rushed to Nipomo, California.

Art Criticism Have students compare the composition of the two scenes.

Ask: How did Lange focus attention on the mother's face in Migrant Mother?

### Drawing in the Studio

# **Recording Daily Life**

CORE STUDI

Dorothea Lange said that she lived a "visual life." As she went about her daily routine, she paid attention to what she saw happening around her.

What do you see happening when you go out into the world each day?

In this studio experience, you will create a drawing that records a moment from daily life around you. When you leave your home, look around. Notice people's activities, gestures, and body positions. Be aware of settings—the objects, buildings, or scenery surrounding the people. Think of ways to show these details in your drawing.

### You Will Need

- sketch paper
- pencil
- eraser
- drawing paper

### Try This

1. Make several sketches of your subject. Will you show many details or focus on the overall shapes and forms?

2. Decide whether you want to show your subject up close or from a distance. Experiment with ways to refine your sketches.

Try using strips of paper to frame, or crop, them. Cropping to the outside edges of a sketch can give you a distance view. Cropping to a smaller part of a sketch can give you a close-up view.

**3.** Look at all of your sketches and cropping ideas before selecting an image for your final drawing. As you work on your drawing, pay particular attention to *value*—light areas and dark areas. Where will you place shadows? Where will you place highlights?

# Studio Background

Dorothea Lange almost always had her camera with her, but she didn't photograph everything she saw. Known for her "compassionate eye," she carefully observed the world and selected scenes that she thought were important to record. She often shot more than one photograph of a scene. She sometimes stood back and shot from a distance, and then moved in for closer views. In the darkroom, she refined, or improved, the photographs she selected. To do this, she often cropped the images to eliminate some parts and emphasize others.

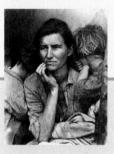

Fig. 2–7 When Lange came upon this family, the strong and determined mother had just sold her car tires to buy food. The artist took six photographs, moving closer for each image. Dorothea Lange, Migrant Mother, Nipomo, California, 1936. Gelatin silver print. Reproduced from the Collections of the Library of Congress.

Fig. 2–8 This photograph is one of the six that Lange took of this family. Why may viewers think this photograph is less dramatic than *Migrant Mother?* Dorothea Lange, *Migrant Agricultural Workers Family*, 1936. Gelatin silver print. Reproduced from the Collections of the Library of Congress.

100

# **Teaching Options**

# **Teaching Through Inquiry**

Art Production With a viewfinder, have students crop family or magazine photographs so as to record different aspects of living in today's world. Students may, for instance, crop a photo of a family having a meal, to focus on the food we eat, the relationships we have with others, or the clothes we wear. Ask students to create a title and a caption for each cropped image. Invite students to share their work within small groups.

Note how contrast, or big differences in value, can help direct the viewer to what you wish to give special attention in the drawing. Fill the page with your drawing.

#### Check Your Work

Share your finished drawing, along with your original sketches, with a group of classmates. Take turns telling why you chose to refine the particular sketch with which you worked. Talk about your subject-matter decisions. Make sure to tell about your decisions to include some parts or exclude others. Invite your classmates to share their ideas about your artwork.

#### **Lesson Review**

### **Check Your Understanding**

- 1. During what great event in American history did Dorothea Lange make many of her photographs?
- 2. Select an artwork in this lesson, and describe how the artist recorded the way people lived in the past and what they cared about.
- 3. What kinds of selections must a photographer make before completing an artwork? 4. If you wanted to make artworks that record the way people live their daily life, would you choose to be a painter or a photographer? What are the advantages and disadvantages of each?

Fig. 2-9 This student artist shows the unique view of sitting on the school bus. She commented, "The most difficult part . . . was making the view outside the window in the correct proportion. The houses . . . were so small, it seemed like the bus was 50 feet tall!" Notice how the highlight areas are closest to the windows. Anna Boch, A Backseat View, 2001.

Artists as Recorders

101

# Assess

### **Check Your Work**

Ask students to show some of their beginning sketches to explain how they chose and cropped images. Ask them to point out values in the drawings and to discuss whether value contrasts effectively emphasize the subjects. Have students keep their sketches and final drawing in their portfolio.

### **Check Your Understanding: Answers**

- 1. the Great Depression
- 2. Answers will vary. Look for careful descriptions of the artist's method and conveyance of ideas.
- 3. The photographer must select what to show and how to show it.
- 4. Answers will vary.

# Close

Discuss students' answers to Check Your Understanding, Display their completed drawings. As students view the exhibit, ask them what someone looking at this artwork in the year 2100 AD could learn about daily life at the start of this century.

### More About...

Unlike film-based photographs, such as those that Lange created, digital photographs are not processed in a darkroom; beyond the cost of a digital camera, such photographs can save money and time. Digital news photographs transmitted by telephone lines or wireless connections can arrive in distant newspaper offices within minutes. Special-occasion and family digital snapshots can be uploaded onto the Web so that more people may share such images more quickly. Digital photos, via radio signals from probes and orbiting instruments, have even been received from other planets, such as the images from the 1997 Mars Pathfinder mission.

### **Assessment Options**

**Teacher** Have groups of students create a dialogue between Dorothea Lange and another artist with whom they are familiar, in which the artists discuss their role as recorders, addressing such questions as What medium, if any, is the best to use when recording daily life?, What is important to think about when making an artwork to record the way people live and work?, and What kinds of subject matter should an artist include when recording daily life? Look for an understanding that the artworks, because the artists have selected what to show and how to show it, also reveal what the artist believes is important.

# **Documenting Daily Life**

# **Prepare**

# **Pacing**

Three or four 45-minute periods: one to consider text and images; one to sketch objects; one or two to create collage elements and final artwork

# **Objectives**

- Provide examples of genre scenes as documents of daily life.
- Explain why photographs are important records of daily life.
- Use a range of values to create pencil drawings, enhanced by collage elements, to record a daily-life activity.

# Vocabulary

genre scene A scene or subject from everyday life.

Harlem Renaissance 1920–1940.
A name of a period and a group of artists who lived and worked in Harlem, New York City. The members of the Harlem Renaissance used a variety of art forms to express their lives as African Americans.

installations Art that is created for temporary display in a particular site.

# **Using the Time Line**

Ask: How many years separate the artworks shown in this lesson? Point out that VanDerZee photographed Miss Suzie Porter during World War I; then ask students to connect a 1999 historical or personal event with Lovell's installation.

# National Standards 2.2 Then and Now Lesson

- **1b** Use media/techniques/processes to communicate experiences, ideas.
- **3a** Integrate visual, spatial, temporal concepts with content.
- **4a** Compare artworks of various eras, cultures.
- **4c** Analyze, demonstrate how time and place influence visual characteristics.
- **5b** Analyze contemporary, historical meaning through inquiry.

# **Documenting Daily Life**

1838 First permanent photographic image 1992 Weems,

17th-Century Holland

20th Century

1662–65 Metsu, Letter Reader

> 0 N

> 1915 VanDerZee, Miss Suzie Porter

1999 Lovell, Whispers from the Walls

### **Travels in Time**

We can learn a lot about the way people live, work, and play just by looking at artworks. Throughout history, artists have recorded the daily-life activities of the people around them. Art historians call such artworks genre scenes. From artworks, we know about work in ancient Egypt and games in ancient Greece. We also have some idea of what the interior of people's homes looked like in seventeenth-century Holland (Fig. 2-10). For some twentieth- and twentyfirst-century artists, photography has been a way of recording daily life.

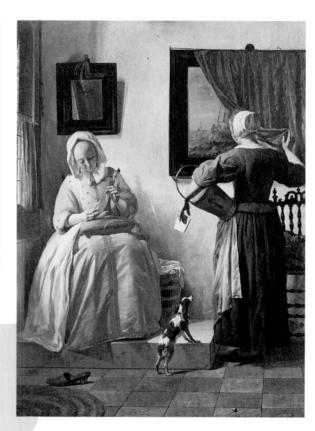

102

# **Teaching Options**

### Resources

Teacher's Resource Binder

Names to Know: 2.1

A Closer Look: 2.1

Find Out More: 2.1

Check Your Work: 2.1

Assessment Master: 2.1

Overhead Transparency 3

Slides 2c

# **Teaching Through Inquiry**

Art History Have students work in small groups to compose a letter from the woman in the Metsu painting to the woman in the VanDerZee photograph. Instruct students to include in their letters detailed descriptions of each woman's clothing and the décor of her home. Invite groups to read their letter aloud. Then discuss the importance of paying attention to small details when looking at a work of art and how they provide clues to the time and place where the artworks were made.

# **Recording Urban Life**

In the first half of the twentieth century, New York artist James VanDerZee looked at urban African American culture through the lens of a camera. His black-and-white photographs display a wide range of values, from dark to light (Fig. 2–11). VanDerZee's work records life in New York City during the 1920s and 1930s. This era is called the **Harlem Renaissance**, a renewal of the creative and intellectual contributions of African Americans.

Contemporary artist Carrie Mae Weems uses the camera to make documents, or records, of human situations. Since the 1970s, Weems has been using her camera to document the activities of political groups,

Fig. 2–11 What does this photograph tell you about city life in the early twentieth century? How does the contrast in values call attention to the textures and patterns? James VanDerZee, Miss Suzie Porter, Harlem, 1915.

Fig. 2–12 When developing a photograph, photographers can make areas lighter or darker than they really were. Why might the artist have wanted to make the bedcover lighter? Carrie Mae Weems, *Untitled*, from the *Sea Island* series, 1992.
Top panel of 2 sliver prints (edition of 10), 20° x 20° (51 x 51 cm). Courtesy P.P.O.W., New York.

families, and people on the street. She examines issues related to African American culture. She sometimes photographs objects, without people, to document an idea about culture. Her use of strong contrast between dark and light areas makes her images sharp and clear. Note the range of values in her photograph in Fig. 2–12. How does this photograph give you a sense of daily life?

# Teach

# Engage

Ask: What is on the walls, the floor, and the ceiling of your bedroom? If people 100 years from now were to see a photograph of your room, what could they decipher about your life?

# **Using the Text**

Art History What are genre scenes? Why is Carrie Mae Weems considered a contemporary genre artist?

# Using the Art

Art Criticism Ask: What do all three of these artworks have in common? What is the subject of each painting? What part of each artwork is most important? How did the artists emphasize their center of interest?

Perception Have students look carefully at the three artworks. Ask: Where do you see light and dark values in each artwork? Where, do you think, is the light source in each? How can you tell?

Artists as Recorders

103

# More About...

The Harlem Renaissance was a flowering of African-American literature and art during the 1920s and 1930s in New York City's Harlem area. As African Americans from the rural South migrated to the urban, industrial North between 1914 and 1918, many settled in Harlem. Artists Aaron Douglas, Palmer Hayden, William H. Johnson, Augusta Savage, and James VanDerZee were joined by jazz musicians, poets, and writers, including Langston Hughes and Jean Toomer. As the Great Depression began, the Harlem Renaissance faded.

# **Documenting Daily Life**

# **Using the Text**

Art History Ask: What does Whitfield Lovell document in his art? (rural life of the past) How is this different from VanDerZee's art? (VanDerZee documented city life.)

# Using the Art

Art Criticism Ask: What features in Whitfield Lovell's installations suggest that they document a rural rather than urban setting? Remind students that Lovell arranged the light in these installations. Ask: What did Lovell highlight in each installation?

Aesthetics Ask: Why are these rooms considered art? How are they different from furniture-store displays?

### **Studio Connection**

Provide students with recycled newspapers and magazines, drawing paper,

pencils, glue, and scissors. Photocopy any family photographs that students bring in.

Suggest to students that they create emphasis by using strong contrasts in value. Have students title their series and write a paragraph explaining its meaning.

Assess See Teacher's Resource Binder: Check Your Work 2.1.

### Extend

Take students to a local historical museum to sketch objects from the past, or bring old daily-life items into class for students to sketch. Have students arrange the sketches into a composition and create an oil pastel or tempera painting from them.

### **Creating Temporary Records**

"I enjoyed the fact that my father and I shared the trait of being particular about visual things." Whitfield Lovell (born 1959)

documents African American life. He creates records of daily life by constructing life-size environments. These stagelike settings are called **installations**. Two views of his installation Whispers from the Walls are shown in Figs. 2-13 and 2-14. Artists create installations with real objects in a section of a museum or gallery. Installations are usually temporary, which means they do not remain in one place for very long. A photograph of the installation becomes the permanent record of the artist's creation.

# Whitfield Lovell is another artist who

Records of the Past

Unlike James VanDerZee, who looked at city life, Lovell documents the rural life of the past. He uses old photographs of people as inspiration for his charcoal drawings in his installations.

Lovell's interest in photographs began at an early age. He learned about photography from his father, an amateur photographer. From his father, he also learned to pay

> attention to the way shapes, values, and colors work together. Study Lovell's use of value in Fig. 2-13. His control of the dark and light values makes the people in his drawings seem like ghosts coming through the walls. He also uses carefully placed spotlights to create contrast between highlights and shadows.

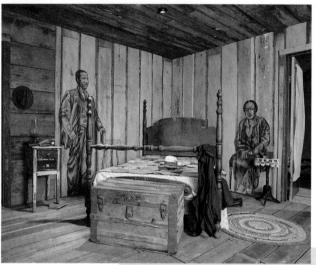

Fig. 2-13 What catches your eye in this bedroom scene? How does the contrast between the hat and the bedcover compare with that in the photograph by Carrie Mae Weems on page 103? Whitfield Lovell, Whispers from the Walls (bedroom installation view), 1999. orth Texas Press. Courtesy DC Moore Gallery, New York

104

THEN AND NOW LESSON

# **Teaching Options**

### **Meeting Individual Needs**

Multiple Intelligences/Spatial Have pairs of students discuss what each interior in this lesson could reveal about the person who either does or could inhabit it; and how the artists used value, contrast, composition, and the like to convey mood. Have each student think of his or her own room from the eye of an artist depicting a genre scene. Ask them to sketch the room—using color, value, composition, and so on-so as to communicate something about themselves. Have partners discuss each other's work, and allow time for students to make alterations afterwards.

### **Teaching Through Inquiry**

Art History Have students work in small groups to list questions that they would like to ask Whitfield Lovell in an e-mail. Students may wish to know about the meaning of his work or how he comes up with his ideas. Suggest that the whole class review the questions and decide which two are the most important.

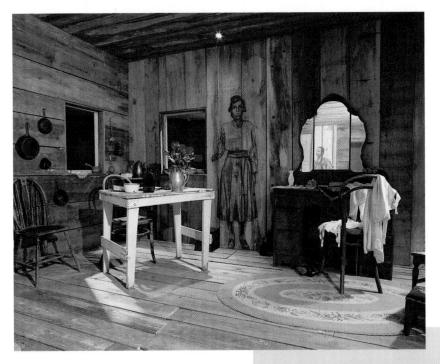

Lovell forms his scenes with objects collected from flea markets. Being selective and collecting visual things is important to the way Whitfield Lovell works. Examining the past is also important to him. The old photographs and objects he collects for his artworks are records of daily life of people in the past.

#### **Studio Connection**

What kinds of activities are part of daily life in your home or community? For a series of pencil drawings that record

daily life, what people and objects will you include? Can you find photographs of people to uses? If not, you may use pictures from magazines or newspapers. Will you make drawings from the pictures you collected? What kind of background setting will you draw? You may choose to cut out and arrange the drawings into a setting that you draw on a separate sheet of paper.

Fig. 2-14 The artist installed this scene in a museum gallery. Why might he have been interested in controlling the lighting to create highlights and shadows? Whitfield Lovell, Whispers from the Walls (table and vanity installation view), 1999.

### **Lesson Review**

#### **Check Your Understanding**

- 1. What are genre scenes? What are installations?
- 2. What and when was the Harlem Renaissance?
- **3.** How is the work of Whitfield Lovell similar to and different from the artwork of James VanDerZee, Carrie Mae Weems, and the genre scenes painted in seventeenthcentury Holland?
- 4. Why is photography a good way to document daily life?

Artists as Recorders

105

# Assess

### **Check Your Understanding: Answers**

- 1. Genre scenes are depictions of everyday life. Installations are life-size environments created in museum or gallery settings.
- 2. The Harlem Renaissance, which took place in the 1920s and 1930s, was a renewal of African-American artistic contributions.
- 3. Answers may vary. All are recorders of daily life; Van-DerZee and Weems took photographs, whereas Lovell uses or works from photographs; photographs and genre paintings are essentially 2-D, whereas Lovell's installations are 3-D.
- 4. Answers may vary. Photographs can be instant; they are accurate, do not "lie," last a long time, and may be scanned or transferred to CD-ROM.

# Close

Discuss students' answers to Check Your Understanding. Display their art and paragraphs. Have students select, from each series, the image that shows the most effective use of value. Discuss which series would provide the most information about daily life.

### **Using the Overhead**

### **Investigating the Past**

Describe In this tomb painting, what are the people doing? Attribute What clues could help you identify when and where this was made?

Interpret What does the painting tell you about the life of people at the time it was painted?

Explain Why, do you think, was this scene painted on the wall of a tomb?

### **Assessment Options**

**Teacher** Ask students each to make a list of at least five works of art in other chapters of the book, including the Foundations

chapters, that they consider to be records or documents of daily life. Have students give reasons for each choice.

Peer Display students' artworks. Have pairs of students work to provide written feedback on five of the artworks. (Ensure that each student's work receives at least one evaluation.) Instruct students to comment on the use of value, the choice of subject matter, and the overall quality of the drawing.

# **Tonal Drawing & Shading**

# **Prepare**

# **Pacing**

Two 45-minute periods

# **Objectives**

- · Identify hatching, stippling, and blending and smudging techniques in tonal drawings.
- · Use various shading techniques to draw a still life.

# Vocabulary

tonal drawing A drawing in which an artist uses value or various tones of color to create the illusion of threedimensional space.

# Teach

### Engage

Demonstrate shading techniques with pencil, charcoal, or felt-tip pen.

# **Using the Text**

Art Production Have students read about shading techniques. Point out that artists use these to suggest depth and form in their artworks.

# Using the Art

Art Production Ask: In Fig. 2-16, where is the light source?

After students have studied the techniques, have them use pencil or charcoal to illustrate each one.

### **Safety Note**

For preserving charcoal drawings, use

fixative or hair spray only in well-ventilated areas.

# **National Standards** 2.2 Skills and **Techniques Lesson**

1b Use media/techniques/processes to communicate experiences, ideas.

# **Tonal Drawing and Shading**

**Tonal drawing** is a method that artists use to create the illusion of three-dimensional form on a flat surface. They use value, or various tones of color, to create the illusion. In a black-and-white drawing, for example, black is the darkest value, and white is the lightest value. There are many values of gray between black and white. The principles of

value also apply to a color drawing. Every imaginable color has a darkest value, a lightest value, and a range of values between.

Shading is a gradual change in value. Where an artist places values in an artwork is determined by the actual or suggested source of light. Shading, highlights, shadows, and cast shadows are clues to the location of the light source.

Fig. 2-15 This value scale shows a range of values for purple. See also the gray scale on page 115.

Fig. 2-16 The highlight areas in this drawing suggest that the light source is on the right.

Fig. 2-17 This artist used hatching and crosshatching techniques to record animal fur. Molly D. Stewart, The Cat's Meow, 2000.
Pen, ink, 8 ½" x 11" (21.5 x 28 cm). Northview Middle School, Indianapolis, Indiana.

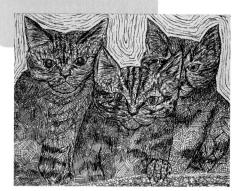

# **Tonal Drawing Techniques**

Tonal drawing techniques, such as linear hatching, stippling, and blending and smudging, allow artists to create gradual changes between light and dark areas. Some techniques work better with some drawing materials than others, so it's important to practice various techniques when using various drawing materials.

106

SKILLS AND TECHNIQUES LESSON

# **Teaching Options**

### Resources

Teacher's Resource Binder

Finder Cards: 2.2

A Closer Look: 2.2

Find Out More: 2.2

Check Your Work: 2.2

Assessment Master: 2.2

Overhead Transparency 4

Slides 2d

### **Teaching Through Inquiry**

Perception Renaissance masters employed hatching, crosshatching, stippling, and smudging and blending techniques in their drawings. Ask: What shading techniques did Leonardo da Vinci use in Study of Woman's Hands on page 11? Which did M. C. Escher use in Drawing Hands on page 13? Assign students to find other drawings by these artists so as to discover how they created value tones.

### **Linear Hatching**

You can use fine-tipped drawing tools, such as pencils, markers, and pen and

hatching

ink, to practice linear hatching techniques. Hatched lines go in one direction and usually follow an edge or contour of the object that the artist is drawing. The lines are parallel to one another. If placed close together, they

create a dark area. If placed farther apart, they create a lighter area.

Crosshatched lines go in two different directions. When crosshatching, an artist begins by creating hatched lines. Then

crosshatching

the artist crosses them with another set of lines. Look at the illustrations in this lesson, and practice using both linear hatching techniques to draw an object. Do you prefer one technique over the other? Why?

### Stippling

A stipple drawing is made of tiny dots. The closer the dots, the darker the tone. To prac-

stippling

tice stipple, use a fine tipped drawing tool. Begin with wide spaces between the dots. Then gradually add more dots. Now use the stipple technique to practice drawing an object.

### Blending and Smudging

To practice blending and smudging techniques, switch to a soft drawing tool, such as a soft lead pencil, charcoal, or colored chalk. Using one tool at a time, create an area of color on drawing paper.

smudging

Smudge or blend the area with your fingers, a tissue, or a cotton swab. Work from dark to light to show a

gradual change in value. Then choose one of the tools and create a practice drawing of an object. Try using an eraser to remove smudges and to create highlights.

#### **Studio Connection**

Create a still-life arrangement of your favorite snack foods.
Draw the arrangement by using any one of the

techniques described in this lesson. Choose the appropriate drawing tools for creating the tonal areas and illusion of three-dimensional form that are characteristic of the technique you selected. Do not worry about the details of package labels. Concentrate just on creating tonal areas. Try to achieve a full range of value in your drawing.

#### **Lesson Review**

#### **Check Your Understanding**

1. What drawing tools are most suitable for blending and smudging techniques? For hatching and stippling?

2. Which type of drawing do you think needs to be carefully protected from damage by an accidental swipe of the hand?

Fig. 2–18 How does the effect created by stippling compare to the effect created by hatching and crosshatching? Christopher Berger, "Who You Lookin' At?", 2000.

Marker, 9° N x 11 1/2" (23 x 29 cm). Penn View Christian School,

Artists as Recorders

107

### **Studio Connection**

Students will need still-life snack-food objects; sketch paper (12" x 18"); pencils,

charcoals, or fine-point felt-tip pens; erasers; and fixative (optional). Allow students to work in small groups to create still-life arrangements. Have students light one side of the arrangement with a spotlight, flashlight, or natural daylight.

With pencil or charcoal, have students lightly sketch the whole arrangement before adding details. Remind them to create a range of values.

**Assess** See Teacher's Resource Binder: Check Your Work 2.2.

# **Assess**

### Check Your Understanding: Answers

- 1. Blending and smudging: soft lead pencils, charcoals, colored chalks, oil pastels. Hatching and stippling: fine-tipped pencils, markers, pen and ink.
- 2. Pencil, charcoal, chalk.

# Close

Display students' drawings. **Ask:** Where is the light source in each drawing? Have students identify light, medium, and dark values, and various shading techniques in the artworks.

### More About...

Pencils as we know them—graphite encased in wood—were invented in England during the 1680s. A little over a hundred years later, Nicolas-Jacques Conté discovered that varying amounts of clay could be mixed with graphite and fired to create a range of hard and soft pencils. Today, pencils are measured from soft (dark, EE) to very hard (light, 9H).

### **Using the Overhead**

### Write About It

**Describe** Have students write two sentences to describe the subject matter and the details used to represent the figures.

**Analyze** Use the overlay, and have students explain how the artist used different tones and col-

### **Assessment Options**

**Teacher** Have students make four drawings of a simple

object, using a different shading technique (linear hatching, crosshatching, stippling, blending and smudging) in each. Direct students to label each drawing's technique.

# **Prepare**

# **Pacing**

Four 45-minute periods: one to consider text and images; one to draw; two to paint

# **Objectives**

- · Explain various influences on Haitian
- . Describe the subject matter of Haitian art.
- · Use dark and light values in a painting of a daily-life activity.

# Using the Map

Ask: What countries are close to Haiti? Since Haiti has a tropical climate, what type of plants would you expect to find on this island?

# **National Standards** 2.3 Global Destinations Lesson

- 1b Use media/techniques/processes to communicate experiences, ideas.
- 2c Select, use structures, functions.
- 3a Integrate visual, spatial, temporal concepts with content.
- 3b Use subjects, themes, symbols that communicate meaning.
- 4c Analyze, demonstrate how time and place influence visual characteristics.
- 5b Analyze contemporary, historical meaning through inquiry.

# **Art of Haiti**

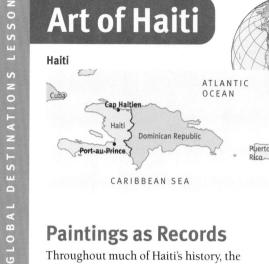

# **Paintings as Records**

Throughout much of Haiti's history, the people who worked in the fields did not have an opportunity to learn to read and write. If people do not have a history of reading and writing, making pictures is a way to keep records of daily life. This may explain why Haiti has been called a "nation of painters." Farmers paint. Cooks paint. Plumbers and mechanics paint. Painting, like any other

# **Places in Time**

Haiti is a small country in the Caribbean's West Indies. It covers the western third of the island of Hispaniola. Christopher Columbus started a Spanish colony there in 1492, but most of Haiti's people are descendants of Africans brought to the island as slaves in the sixteenth century. Haiti became a rich French colony but has been independent since 1804. Today, most of the people are farmers who grow such crops as coffee, corn, sugar cane, and sisal

work, is an important part of daily life. Sometimes, Haitian painters must choose between buying paint or buying bread.

Fig. 2-19 What does this picture show about daily life in a Haitian home? Louverture Poisson, The Lesson, c. 1946-47.

cm). Milwaukee Art Museum, Gift of Mrs. Richard B. Flagg (M1979.22).

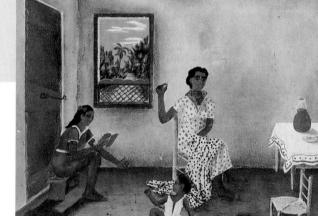

108

# **Teaching Options**

### Resources

Teacher's Resource Binder A Closer Look: 2.3 Find Out More: 2.3 Check Your Work: 2.3 Assessment Master: 2.3 Large Reproduction 4 Slides 2e

### Teaching Through Inquiry

Aesthetics Remind students that many of the artists who paint scenes of everyday life in Haiti are self-taught. Invite students to explain what they find appealing—and unappealing about the work of untrained artists. Invite students to discuss the advantages and disadvantages of trying to learn something on one's own.

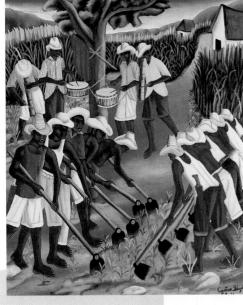

# **Visual Histories**

Haitian painters, most of whom are selftaught, are faithful recorders of events as they unfold. They look at the activity around them and fill their canvases with scenes of everyday life. Because their paintings are about what people have in common, the works speak to all the people.

Some painters use both humor and sadness to recreate the visual histories of faces and events. Generally, the paintings are portraits of people and families. Other paintings show farming and work, celebrations and carnivals, and crowded markets. Look at the daily-life activities shown in Figs. 2–19, 2–20, and 2–21. How did each artist show what life is like in Haiti?

Fig. 2–20 *Coumbite* is Haitian Creole for "communal activity." How did the artist place light and dark areas to give you a feeling of rhythmic movement? What else did the artist do to create a sense of rhythm and movement? Castera Brazille, *Coumbite Communal Fieldwork*, 1953.
Oil on masonite, 24° x 19<sup>1</sup>/<sub>4</sub>° (61 x 49 cm). Milwaukee Art Museum, Gift of Mr. and Mrs. Richard B. Flagg (M1991.106).

Fig. 2–21 Music and dancing are favorite pastimes in Haiti. Rhythm and movement can be shown in art by the use of repetition. What lines, shapes, and colors are repeated in this painting? Philomé Obin, Bal en Plein Air (Outdoor Dance),

Oil on masonite, 24" x 29 1/2" (61 x 75 cm). Milwaukee Art Museum, Gift of Mr. and Mrs. Richard B. Flagg (M1991.142).

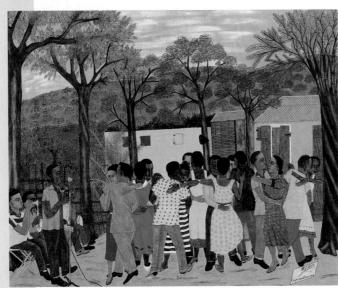

Artists as Recorders

109

# Teach

# Engage

If any students have visited or have relatives in Haiti, allow them to share their impressions of this country. Have students glance at the images in this lesson, and then write three words to describe their initial impression of Haitian art. Compile a class list.

# **Using the Text**

Art History Have students read page 108. Ask: Who were the ancestors of most Haitians? Why has Haiti been called a "nation of painters"?

# Using the Art

Perception As students study Louverture Poisson's *The Lesson*, have them discuss the scene. **Ask:** What is each person doing? What objects are in the room? What type of plants are located outside the window? **Art Criticism** Have students compare Brazille's painting with Obin's. **Ask:** Who is making the music in each artwork? Which piece do you think has more movement?

### Extend

Have students research Haiti in travel guides and other sources to learn about its customs and culture. Ask students to draw or paint a scene of Haitian life based on their research.

### More About...

Castera Brazille was born in Haiti in 1923. When he was 21, he became a stockman and maintenance worker for the Centre d'Art, a group that promoted Haitian artists. Within a short time, Brazille himself became a painter and created three murals in the Episcopal Cathedral of Sainte Trinite in Port-au-Prince. He died of tuberculosis in 1965.

# Using the Text

Art History Have students read the text to learn about Inatace Alphonse and his art. Ask: How old is Alphonse now? What did he do before he began painting? (He was a shoe maker, carpenter, and blacksmith.)

# **Using the Art**

Art Criticism Discuss the activity in each painting. Point out how Alphonse fills his compositions with figures, shapes, and colors, leaving very little negative space. Have students locate the light source and point out repeated shapes and colors in each painting.

### **Studio Connection**

Have students brainstorm a list of everyday activities in the community, such as grocery shopping, work in local industries, traffic moving through a busy intersection. After students draw a series of thumbnail sketches to plan their composition, have them draw their activity on a heavy piece of paper or board.

Demonstrate the mixing of paints to create a range of light and dark values to emphasize a subject. As students work, remind them to check the values in their painting. Guide students to consider the light source in their scene. Ask: Do you have enough contrast so as to distinguish objects? Do objects appear three-dimensional? Would darkening or lightening areas make your art more effective?

**Assess** See Teacher's Resource Binder: Check Your Work 2.3.

### A Recorder of Haitian Life

"I paint the Haiti of my childhood, everyone working together to help each other."

Inatace Alphonse (born 1943)

The subject matter of Haitian paintings today continues to be dominated by scenes of daily life. This art is popular with gallery owners, collectors, and tourists. That is why a talented artist like Inatace Alphonse can pursue art-making as a full-time career.

Alphonse was born in 1943 in Port-au-Prince, the capital of Haiti. Like many selftaught artists before him, Alphonse pursued another trade while he worked on his handpainted postcards of market scenes. He learned the trades of shoe maker, carpenter, and blacksmith.

Courtesy of the artist and the Haitian Art Collection
Del Ray Reach Florida

Fig. 2–22 Compare this painting of communal workers with the one by Castera Brazille on page 109. How is the sense of movement different in each work? Inatace Alphonse, *Harvest with Cows*, 1990s.

Actylic on canvas, 11° x 14° (28 x 35.6 cm). Courtesy of

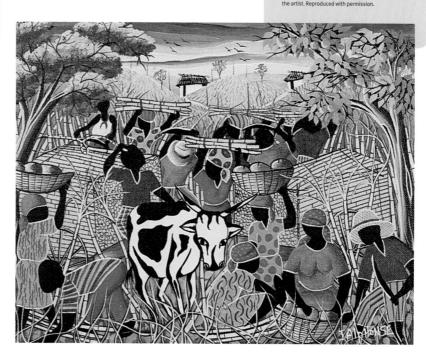

110

DESTINATIONS LESSON

# **Teaching Options**

### **Meeting Individual Needs**

Multiple Intelligences/Bodily-Kinesthetic Ask students to examine Coumbite Communal Fieldwork (Fig. 2–20) and identify what instrument the men are playing in the background. Have students use the artist's clues about rhythm (repetition of figures and their tools, alternating light and dark areas) to tap out the sound of the drum beat. After, discuss how the drum beat might have helped the workers. (coordinated their movements, provided incentive, sustained energy) Discuss activities that students do in which a drum beat could be helpful (consider sports, walking, and chores).

### **Teaching Through Inquiry**

Art Criticism On the board, make a column for each artwork in this lesson. At the top of each column, write the title and name of the artist. Down the left side of the first column, list: subject matter, color, line, shape, texture, value. For each artwork, have students generate descriptive words for each listed item. Write their responses on the board. Then ask students to select two of the artworks and write comparative statements about them. (for example: The colors in A are brighter and more varied than in B.)

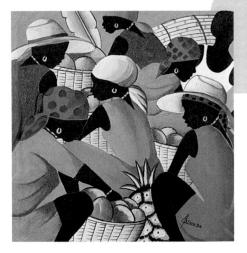

Fig. 2–23 Note how the figures fill the canvas. How did the artist use dark and light values to give the figures three-dimensional form? Inatace Alphonse, Market, 1990s.
Acylicon canvas, 12° x12° (31 x 31 cm). Courtesy of the artist. Reproduced with permission.

# 00

#### **Studio Connection**

Haitian artists are faithful recorders of daily life. They use dark and light values to make flat shapes look three-

dimensional. They also pay attention to the direction of light. If you were to paint a daily-life activity, what would you show? To begin, make sketches, and plan your composition in pencil. How will you make dark and light values? What will be the direction of the light? Where will you put shadows?

# **Colorful Records**

Alphonse used his background in black-smithing to advantage to create sheet-metal sculptures. However, he soon learned that his real talent was in capturing the movement and action of the human figure on canvas. He returned to painting colorful scenes of daily life. Before long, people in Europe, Africa, South America, and the United States were collecting his work. One critic has called Alphonse the Haitian Bruegel, referring to the European Renaissance artist Pieter Bruegel (whose work is shown in Fig. 2–28), a painter of daily-life scenes.

Alphonse's paintings are beautiful records of Haitian life. His paintings are also bright: the colors are high intensity with strong highlights and carefully blended values. In such works as *Harvest with Cows* and *Market* (Figs. 2–22 and 2–23), he captures the hustle and bustle of people going about their daily activities.

#### **Lesson Review**

### **Check Your Understanding**

- **1.** Use what you know about the history of Haiti to explain what cultures might have influenced Haitian art.
- **2.** Who are the painters in Haiti, and what do they usually paint?
- **3.** Describe how Haitian painters use dark and light values to create the illusion of three-dimensional forms in their daily-life scenes.
- **4.** Why, do you think, are scenes of Haitian life so popular with collectors in other countries?

## Assess

# **Check Your Understanding: Answers**

- 1. Answers will vary. Students should mention Spanish, French, and African influences.
- 2. Haitian painters, generally self-taught, are working people who paint scenes of everyday life, work, and play.
- 3. Haitian painters use placement of highlights and shadows to show direction of light and roundness of forms.
- 4. Answers will vary. Students may indicate that the colorful records of familiar scenes are appealing because they show people what life is like in another place.

# Close

Discuss students' answers to Check Your Understanding. Have students make a display of their paintings by arranging them according to what type of activity is depicted. Challenge students to locate the light source in each piece.

Artists as Recorders

111

# **Using the Large Reproduction**

#### **Consider Context**

Describe What do you see in this painting?

**Attribute** What clues do you have about where or by whom this was made?

**Understand** How could you find out more about what this image means? **Explain** How did the artist record an event?

### **Assessment Options**

Peer Have students work in pairs to discuss the answers to the caption questions for ork in the lesson. Ask them to

each artwork in the lesson. Ask them to write and answer additional questions about the artworks.

Self Have students each write a short description of their painting and comment on the light source and the decisions they made about placement of highlights and shadows. Ask students also to comment on what they think are the best features of their painting.

# **Prepare**

# **Pacing**

One or more 45-minute periods

# **Objectives**

- Explain how objects provide information about people's lives and times.
- Understand that Pop artists used everyday objects to make statements about contemporary life.
- Use a range of values in a still-life drawing.

# Vocabulary

still life An artwork that shows nonliving things, such as fruit, flowers, or books.

value The lightness or darkness of a color. Tints are light values of colors. Shades are dark values of colors. Value is an element of design.

contrast A great difference between two things. Contrast usually adds drama or interest to a composition.

# **Supplies**

- drawing paper
- · pencil and eraser
- markers, colored pencils, or pastels
- · variety of objects
- flashlight or other light source (optional)

# National Standards 2.4 Studio Lesson

- **1b** Use media/techniques/processes to communicate experiences, ideas.
- **2b** Employ/analyze effectiveness of organizational structures.
- 2c Select, use structures, functions.
- **3b** Use subjects, themes, symbols that communicate meaning.
- **4c** Analyze, demonstrate how time and place influence visual characteristics.
- **5b** Analyze contemporary, historical meaning through inquiry.
- **5c** Describe, compare responses to own or other artworks.

Drawing in the Studio

# Still-Life Drawing

# The Objects of My Life

STUDIO LESSON

### **Studio Introduction**

If someone found your book bag and emptied its contents, what clues to your life would those contents provide? We

rarely think about objects as historical records, but archeologists and historians often rely on them as they piece together evidence of how people once lived.

In this studio lesson, you will draw a still life that "says" something about you.

Pages 114 and 115 will tell you how to do it. A still life is an arrangement of objects that are not alive and cannot move. You will select and arrange objects that suggest who you are, how you live, and what you care about. You could choose items from home and school, such as knickknacks, a favorite cup, a book, photographs; or natural objects, such as shells, rocks, and twigs. Open up your imagination, and find things that really tell about you.

# Studio Background

#### A Record of Time

To record people, places, and events, artists usually include objects found in society at the time of their work. These objects provide clues to how people lived and what they cared about. Many artists have directed all of their attention to such objects.

Pop artists of the 1960s often focused on everyday popular objects. These artists sometimes expressed a point of view about how daily life is surrounded by an ever-increasing assortment of products to buy and use. Artist James Rosenquist sometimes layered his still-life objects. In other paintings, he painted objects individually around the canvas.

Fig. 2–24 Have you ever wanted to paint something as ordinary as dishes in a dish drainer? What does this painting tell us about life in the mid-1960s? James Rosenquist, *Dishes*, 1964.

112

# **Teaching Options**

### Resources

Teacher's Resource Binder

Studio Master: 2.4

Studio Reflection: 2.4

A Closer Look: 2.4

Find Out More: 2.4

Overhead Transparency 3

Slides 2f

### **Teaching Through Inquiry**

Art History Dishes was painted during the early 1960s and gives viewers clues about daily life at that time. Have students work in small groups to create a 5-minute presentation entitled, "How the 60s Are (and Are Not) Us!" Students should examine the artwork and look for clues about life in the 1960s. They might also do library or Internet research about the time period. For each of their findings, they should consider how life now is similar to and different from life in the 60s. Ask student groups to present what they have learned.

Fig. 2–25 Look carefully at this still-life drawing. What does it tell you about the artist? Eben Bein, *Lit by a Candle*, 2001. Colored pencil, 8 % 11 1/6" (22 × 29 cm). R. J. Grey union Filish School Arton Massachusetts

Fig. 2–26 How did the artist use color in her still-life drawing?

Maura Gordon Stuff | Like, 2001.

Colored pencil, 8 3/4" x 10" (22 x 25.5 cm). R. J.

Artists as Recorders

113

# **Pre-Studio Assignment**

For the next class, ask students to bring in a sandwich bag containing three or more items (at least two of which are clearly three-dimensional) that have special meaning to them.

# Teach

# Engage

Ask volunteers to tell what is in their book bags, pockets, and lockers. Discuss what these objects could reveal about their owner and his or her life.

# **Using the Text**

Art History Have students read The Objects of My Life and Studio Background. Ask: What subjects did Pop artists usually feature in their art? Why do you think they did this?

# **Using the Art**

Art History/Aesthetics Discuss students' answers to the caption questions for Rosenquist's Dishes. Ask: How has the artist created contrast? (created strong differences between colors, lines, shapes) What is the mood of this picture?

### Extend

Have students research Pop artists such as Andy Warhol, Jasper Johns, Roy Lichtenstein, Robert Rauschenberg, George Segal, and Claes Oldenburg to learn how they used everyday objects in their art. Have students create their own artwork of an ordinary item in the style of one of these artists.

### More About...

At the end of the 1950s, **Pop Art** began in Great Britain as a reaction to the seriousness of abstract expressionism. During the 1960s, the Pop Art movement reached its peak in New York. Artists combined the high art of museums and galleries with the popular-culture art of advertising. With its mass-produced images of everyday items—such as comic strips, soup cans, and Coke bottles—Pop Art was widely popular because most people could identify with its subjects.

### **Using the Overhead**

### Think It Through

**Ideas** What ideas, do you think, did the artist want to express in this painting?

**Techniques** How did the artist use the technique of fresco to record an everyday event?

3

# Still-Life Drawing

# **Studio Experience**

- 1. Encourage students to experiment with different arrangements, perhaps by tipping over some objects or turning some upside down. If students must move their objects before completing their drawing, have them arrange the objects on boxes or boards and mark each object's location so that the same arrangement may be set up later.
- 2. Before they draw, lead students to compare the relative sizes of their objects. Demonstrate quickly and lightly sketching the outlines of a whole still life before concentrating on the details of any one object.
- 3. Encourage students to use value contrasts to add drama to their still life and make their objects stand out from the background. Guide students to lightly indicate the main shadows before darkening them.

### **Idea Generators**

- · Students could draw objects they have with them, such as book bags, wallets, shoes, jewelry, books, key chains, or juice containers.
- . Challenge students to set the still life in front of a mirror and to draw the actual and the reflected image.

# **Studio Tip**

Ideally, each student will arrange and draw his or her own still life; however, if space or light sources are limited, students may work in small groups to set up objects contributed by each group member.

# **Critical Thinking**

Have students draw a still life with white chalk on black paper. When beginning artists draw on black paper, they often reverse the light and dark values, thereby creating an Xray effect. Challenge students not to do this but to create realistic values.

# **Computer Option**

**Encourage students** to emphasize the sym-

bolic aspects of their objects, as in the still lifes by William Harnett, Janet Fish, and Audrey Flack. Students could bring in items representative of their childhood.

### Drawing in the Studio

# **Drawing Your Still Life**

### You Will Need

STUDIO LESSON

- drawing paper
- pencil and eraser
- markers, colored pencils, or pastels
- variety of objects
- flashlight or other light source (optional)

### Try This

1. Begin by arranging your objects. As you decide where to place them, think about the parts of the arrangement

that you want to emphasize in your drawing. Try shining a light onto the arrangement from a particular direction, such as from above or one side. How can you use the light to create shadows and contrast? Experiment!

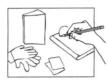

2. When you are satisfied with the arrangement and lighting, create a pencil sketch. Focus on the main shapes

and forms first. Lightly sketch the outlines. Then add smaller shapes and forms as needed. Don't worry about details at this point, as you will focus on those later. Fill the paper with your sketch.

3. Next, add color and detail. How can you use color to help emphasize the important parts of your drawing? How can you use value and

contrast to direct your viewer's eye? As you work, decide which details of the objects to show. Will you include all of the details or just the most obvious ones?

#### **Check Your Work**

Share your drawing with one classmate or more. Talk about the objects in your drawing and how you decided to show them. What do the objects say about you? What do they say about the time in which you live? Describe the way you used value and contrast to direct the attention of your viewer.

### **Computer Option**

A computer with a flatbed scanner can be used as a camera to "photograph" a still life. Select some personal

objects, such as a photo, jewelry, key ring, hair ribbon, wristwatch, book, or CD. Carefully lay your objects face-down on the scanner glass, overlapping them for a dynamic composition. You might lay a T-shirt or fabric on top, as a background. Scan your still life and save the file. Rearrange the objects and scan again. When you have a scan you are pleased with, use a special effect to change the lighting effects. How might you add contrast?

114

# **Teaching Options**

# **Teaching Through Inquiry**

Art Production Invite students to create different versions of their still life in any of the following ways:

- · Walk around the display of the objects to see the arrangement from different perspectives. Then create several different views.
- Use paint instead of drawing materials.
- · Use a resist technique, such as painting a thin coat over crayon drawings.
- · Work with collage elements, using shapes cut from magazines or newspapers as parts of the objects.

Guide students to create contrasts in value, regardless of the methods they try. After students have completed their different versions, have groups of three discuss the artworks.

### **Elements and Principles**

### Value and Contrast

#### Value Scale

**Value** is the range of light to dark in a color. Look at the value scale; you will see that the

lightest value is white. The darkest value is black. Notice the number of gray values that are between white and black. The number of values can vary

from one scale to another. Artists can create a value scale for any color. The color red, for example, may have a light value of pink and a dark value of maroon. Red itself may fall somewhere in the middle of its value scale.

Artists create value by the use of highlight and shadow areas in a drawing or painting.

The gradual change in color from light (highlight) to dark (shadow) helps make objects in the artwork look three-dimensional. To learn more about value, see Lesson 2.2, on page 106.

Contrast can add excitement and drama to an artwork. One way that artists create contrast is the use of strong differences between values. Artists also create contrast by using strong differences between colors, shapes, textures, and lines. Artists use contrast when they want certain parts of an artwork to be the first to catch the viewer's attention.

Look at your artwork and that of your classmates. Where do you see highlight areas? Shadow areas? Contrast?

Fig. 2–27 The things that interest the artist are clearly seen in this drawing. Notice how the red fabric helps create unity in the picture. Phillip Reynolds, *My Favorites*, 2000.
Colored pend., 12\* x18\* (30.5 x 46 cm). William Byrd Middle School, Vinton, Virginia.

# **Elements and Principles**

Challenge students each to create a value scale using the color of their choice. Provide a selection of colored pencils or pastels from which they can choose a color. Encourage students to add black or white to their color as needed to create the light and dark values.

# Assess

### **Check Your Work**

After students have shared their drawings and answered the questions, ask them how they would change their artwork if they were to do another version.

# Close

Display students' artworks. Have student pairs introduce each other's artwork, defend their partner's choice of objects, and describe the use of value and contrast. **Ask**: If a twenty-second-century art historian saw this display of artworks, what could he or she learn about life in the early twenty-first century?

Artists as Recorders

115

### More About...

Pastels, which are similar to colored chalks, are dry pigments in a kaolin binder. Soft pastels are easy to blend but create a fine dust that could be inhaled accidentally; harder pastel sticks are safer to use but cannot be blended as easily. Pastels may be either water-soluble or oil-based; oil-based pastels are similar to soft crayons.

Pastel artworks combine elements of both drawing and painting. Artists who work with pastels usually spray them with fixative or hairspray to prevent the medium from smudging. For works in progress, artists generally use workable fixative, which may be drawn on.

### **Assessment Options**

**Self** Have students use the questions in Check Your Work to guide their writing of an artist's statement. Ask

students also to include an explanation of which parts of their artwork are particularly successful and which parts they would do differently in a future still-life drawing. Display the statements with the artworks.

### **Careers**

Invite students to work in pairs to role-play art historians who work in an art museum. Ask pairs each to choose from the large art reproductions that accompany this text, an artwork they would like to purchase for their museum. For a display of the reproductions, have pairs write a gallery card, which should include the title, artist, date, and owner of the work; its provenance, or origin, and history; and a short interpretation or explanation of the work.

# **Daily Life**

Ask students to consider what they would most want to include in a visual record of their life. Have students make photocopies or photographs with a digital camera of objects or written materials that have special meaning, and encourage them to use and record these personal images in a collage or relief assemblage. You may wish to allow students to include actual photographs, written texts, or objects in their work.

# **Language Arts**

Writing has long been a method of recording events, people, and beliefs. For ancient Mesoamerican and South American people, writing was a way to record religious beliefs and keep track of time. They created books, called codices, whose pages were made from bark paper or deerskin arranged like a folding screen. They used signs and pictures, rather than words, to record what was important to them. When the Spanish conquistadors invaded the New World in the sixteenth century, they destroyed many of these books. Discuss possible reasons the conquistadors had for destroying such books.

# Connect to...

# **Careers**

What do you think art historians do? If you think they spend their days giving lectures about old paintings in dusty art museums, you need to update your thinking. As museums have increased in number and expanded their art collections, the career of art historian has also changed. Today's art historians may work as curators in museums or teach at colleges and universities. They may also write for journals, textbooks, and other books, as well as develop videotapes, video and laser discs, CD-ROMs, and other forms of interactive media. All are concerned with the history of art and its impact on our culture. Art historians usually earn a graduate degree in art history. Often, they become experts in a particular subject, style, culture, time period, art form, or media.

Fig. 2–28 Art historians can learn much from artworks such as this sixteenth-century painting. Compare this painting with the work of Inatace Alphonse (pages 110 and 111). What could an art historian learn from each work? Pieter Bruegel the Elder, The Wedding Dance, 1566.

# **Other Arts**

#### Music

Have you thought of music as a record of a specific time or place? Music often reflects a unique culture or moment in history. For example, the blues are an African American musical invention. Blues musicians used their music to record the life and culture of black America. The blues began in the South but eventually spread throughout the country during the Great Migration of the early twentieth century. The blues probably grew out of earlier field-work songs and ballads that told stories of life in the rural South.

# **Daily Life**

People keep many kinds of records. What kinds of records of *you* do you think your school and parents have? Your school probably has grade reports, test scores, school photos, and letters from your parents and teachers. Your parents most likely have your birth certificate, medical records, photographs, and special keepsakes from your childhood. What kinds of records do you keep for yourself?

#### **Internet Connection**

For more activities related to this chapter, go to the Davis Website at www.davis-art.com.

116

# **Teaching Options**

### Resources

Teacher's Resource Binder:
Making Connections
Using the Web
Interview with an Artist
Teacher Letter

### Video Connection

Show the Davis art careers video to give students a reallife look at the career highlighted above.

# **Other Subjects**

### Language Arts

Writing has long been a method of recording events, people, and beliefs. For ancient Mesoamerican and South American people, writing was a way to record religious beliefs and keep track of time. These people created books, called codices, whose pages were made from bark paper or deerskin arranged like a folding screen. They used signs and pictures, rather than words, to record what was important to them. When they arrived in the sixteenth century, the Spanish destroyed many of the books of the Mesoamerican and South American people. Why might the conquistadors have wanted to destroy such books?

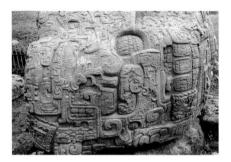

Fig. 2–29 Ancient peoples also carved their writing on statues and architectural features. Pre-Columbian Guatemala, Zoomorph P from Quiriga, c. 300–630.

### Science

Do you think a running horse ever has all four feet off the ground at once? Photographer Eadweard Muybridge (1830–1904) settled this

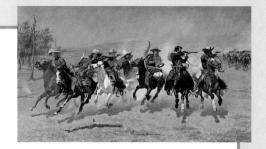

Fig. 2–30 Artist Frederic Remington probably knew of Muybridge's research. In this painting, Remington depicted galloping horses with all their hooves off the ground. Frederic Remington, *Dash for the Timber*, 1889.

debate when he recorded positive proof in the late 1800s. Using cameras with fast shutters, Muybridge took the first successful sequential photographs of a fast-moving horse. The resulting photo sequence was an international sensation that earned Muybridge a place in the history of photography. For the rest of his life he continued to record rapidly moving subjects through his unique photographic methods.

### Mathematics

How do we record numbers? What symbols do we use? The decimal place-value system used in much of the world needs only ten symbols: 0, 1, 2, 3, 4, 5, 6, 7, 8, and 9. The system is based on the concept that each symbol has a fixed value and, at the same time, an infinite number of values when placed in different positions. Do you think the origin of our counting system is derived from counting on our fingers? The word digit, used for the ten numerals 0–9, is from the Latin word for *finger*.

Challenge students each to develop a system of glyphs or picture writing and then create a page of a contemporary codex. Students may create visual symbols for each letter of the alphabet or for ideas and objects. Encourage students to think about what they want to record and their purpose for doing so. Have students share their completed codices, and invite the rest of the class to interpret them.

### Other Arts

Have students listen to early blues recordings, such as those by Bessie Smith or Billie Holiday. Ask: What images come to mind as you listen to the music? What do you think the artist was trying to convey? Explain that the blues influenced many later musical styles, including jazz and rhythm and blues. Play a selection from Miles Davis's Sketches in Spain or a selection from a Charlie Parker recording. Ask students to compare these selections with the blues selections. Ask: What similarities do you hear? What blues influences do you hear in jazz music?

Artists as Recorders

117

### **Internet Resources**

WPA: New Deal Art During the Great Depression.

http://www.wpamurals.com

### **Community Involvement**

Plan a community art day. Invite community artists to your classes to demonstrate and talk about their work.

### **Interdisciplinary Planning**

Work with your colleagues in the other disciplines to come up with ways to work together on common goals. Examine the textbooks in social studies, math, science, and language arts; make note of the artworks in those texts; suggest ways that those artworks can be approached and studied in each curriculum area.

# Talking About Student Art

Vary your approach to engaging students in discussion about their own art. One approach is to focus on the use of one or two art elements in each artwork. On the board, provide such prompts as "This artwork has mostly \_\_\_\_\_ lines. They create a feeling of . . ." Always encourage students to say more.

# Portfolio Tip

For each item in their portfolio, have students each create and maintain a record

that includes the item number, the date of completion, a description, and a comment or reason for inclusion.

# **Sketchbook Tip**

Suggest to students that they keep their sketchbook with them at least a part of

every day and contribute to it, either by sketching or by writing reflections about their work.

# **Portfolio**

REVI

PORTFOLIO

"I am a figure skater. When I painted this, I was thinking about getting back on the ice, practices, and competition. The most difficult part was painting the fingers, because I'm not that good at drawing hands. I had to be very careful because the fingers are very small." Justine Kirkeide

Fig. 2–32 Inspired by an old family photograph, this student artist made a drawing of her father as a toddler, walking with the help of a baby stroller or walker. What can you learn about the daily life of this child by looking at the environment around him? Jaime Farley, Happiness, 2001.

Fig. 2–31 How does this artist use simple details to make her picture look like a skating rink? Justine Kirkeide, *Skate Practice*, 2000. Tempera, 18" x 12" (46 x 30.5 cm). Plymouth Middle School, Plymouth, Minnesota.

"This artwork shows a picture of my dad when he was young. It shows the happiness of the person and that he would go in his stroller in the day time." Jaime Farley

of eating an apple is conveyed in a series of drawings. The use of shadow makes the object appear more three-dimensional. Sara Lawler, Apple Study, 2001.
Colored pencil, 5 3/4 x 24\* (14.5 x 61 cm). Camels Hump Middle School, Richmond, Vermont.

Fig. 2-33 The simple act

### **CD-ROM Connection**

To see more student art, view the Personal Journey Student Gallery.

118

# **Teaching Options**

### Resources

Teacher's Resource Binder
Chapter Review 2
Portfolio Tips
Write About Art
Understanding Your Artistic Process
Analyzing Your Studio Work

## **CD-ROM Connection**

For students' inspiration, for comparison, or for criticism exercises, use onal student works related

the additional student works related to studio activities in this chapter.

# **Chapter 2 Review**

### Recall

What are genre scenes?

#### **Understand**

Explain the importance of selection in recording scenes from daily life.

#### Apply

Use what you have learned about value and contrast to create a drawing of ordinary objects.

#### Analyze

Select one photograph by Dorothea Lange and compare it with photographs by James VanDerZee (Fig. 2–11, *shown below*) and Carrie Mae Weems. Consider what the artists selected to show and how they chose to show it. Also compare their use of dark and light values and contrast.

#### For Your Sketchbook

Make a section in your sketchbook where you keep a list of words and phrases that describe events and situations

in your daily life. Also include photographs of everyday life. You may use words and images as ideas for subject matter in future artworks.

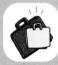

#### **For Your Portfolio**

From this book, choose an artwork that you think clearly records daily life. Write a detailed description of the

work. Tell what the artist selected to record and how he or she used value and contrast to emphasize certain parts. Date your report, and add it to your portfolio.

#### Synthesize

Plan a storyboard for a video production that records a week of activity in your school. Remember that you must select your subject matter. For example, you may choose to focus on the routine of a custodian, the third grade, your own classroom, or the school office. Your storyboard must also show what you think is most important to record about this activity.

#### Evaluate

From this chapter, choose two artworks that you think best record daily life in two different ways; for example, at work and at play. Give reasons to support your selections.

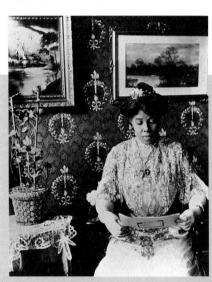

Page 103

# Artists as Recorders

119

# Advocacy

Assist students in composing a short but well-reasoned letter to school-board members that explains the importance of art in everyday life. Choose one or more students and family members to attend a board meeting, and ask one student to read the letter.

### **Family Involvement**

Encourage students to involve family members in recording or documenting a favorite family tradition, either with photographs or in a written description of the tradition. Create a "treasured traditions" display.

# Chapter 2 Review Answers Recall

Genre scenes are scenes from everyday life.

### **Understand**

It is important for an artist to select what to show and how to show it in order to convey the intended ideas and feelings.

### **Apply**

Look for evidence that student understands differences in value and contrast.

### **Analyze**

Answers will vary. Look for evidence that student can discriminate between what the artist shows and how the artist shows it. Look for evidence that student understands how artists use value and contrast.

### **Synthesize**

Artworks will vary. Look for evidence that student can make selections about subject matter and use of composition, as well as value and contrast, to highlight certain features.

#### valuate

Answers will vary. Look for appropriate reasons.

### Reteach

Have students create a storyboard for a series of photographs that would record the daily life of students in their school. They will need to decide what to show and how to show it; when to include a close-up shot and when to show a scene from a distance. Summarize by explaining that when artists record daily life they must select the most important aspects of their subject to show their viewers.

# **Chapter Organizer**

#### Chapter 3 Artists as Designers

Chapter 3 Overview pages 120-121

Core Lesson

page 122

periods

A Designer of Fashion

Pacing: Four 45-minute

#### **Chapter Focus**

- · Core Designers focus on how a product looks and feels as well as how well it works.
- . 3.1 Design for Living
- · 3.2 Human Proportions
- · 3.3 Art of Japan
- · 3.4 Package Design

#### **Chapter National Standards**

- 1 Understand media, techniques, and processes.
- 2 Use knowledge of structures and functions.
- 3 Choose and evaluate subject matter, symbols,
- 4 Understand arts in relation to history and cultures.
- 5 Assess own and others work.
- 6 Make connections between disciplines.

#### **Objectives**

· Identify various types of designers. Explain the importance of following the steps of the design process.

#### **National Standards**

5b Analyze contemporary, historical meaning through inquiry.

# **Core Studio**

- · Create a fashion design for a client.
- 3b Use subjects, themes, symbols that communicate meaning.

#### **Drawing on Fashion** page 126

**Objectives** 

#### **National Standards**

- Then and Now Lesson 3.1 **Design for Living** page 128 Pacing: Four 45-minute periods
- Explain the similarities and differences among Bauhaus, Memphis, and ergonomic designers.
- Identify major style characteristics of Michael Graves's product designs.
- 4a Compare artworks of various eras, cultures.
- 5b Analyze contemporary, historical meaning through inquiry.

#### **Studio Connection**

page 130

- · Demonstrate understanding of functional form and decorative form in the design of two ceramic containers.
- 1b Use media/techniques/processes to communicate experiences, ideas.

#### **Objectives**

#### **National Standards**

2 **Skills and Techniques** Lesson 3.2 **Human Proportions** 

page 132 Pacing: Two 45-minute periods

- · Define proportions and explain their importance to designers.
- 2a Generalize about structures, functions.

#### **Studio Connection** page 133

- Create drawings from a model, using proportion guidelines.
- 2b Employ/analyze effectiveness of organizational structures.

#### **Featured Artists**

Hugo Blomberg Marcel Breuer Michael Graves Toshiyuki Kita Ralph Lysell Issey Miyake

Pat Oleszko Peter Shire **Gosta Thames** 

#### **Chapter Vocabulary**

ergonomic form function graphic designer pattern proportion

#### **Teaching Options**

Teaching Through Inquiry More About...Fashion designers Using the Large Reproduction Meeting Individual Needs Teaching Through Inquiry More About...Industrial designers Using the Overhead

Teaching Through Inquiry More About...Costume designers

**Teaching Options** 

Teaching Through Inquiry

Meeting Individual Needs

Using the Overhead

Assessment Options

#### **Technology**

**CD-ROM Connection** e-Gallery

CD-ROM Connection

Student Gallery

#### **Technology**

**CD-ROM Connection** e-Gallery

**CD-ROM Connection** Student Gallery

**CD-ROM Connection** e-Gallery

#### Resources

Teacher's Resource Binder Thoughts About Art: 3 Core A Closer Look: 3 Core Find Out More: 3 Core Studio Master: 3 Core Assessment Master: 3 Core

Large Reproduction 5 Overhead Transparency 6 Slides 3a, 3b

Teacher's Resource Binder Studio Reflection: 3 Core

#### Resources

Teacher's Resource Binder Names to Know: 3.1 A Closer Look: 3.1 Map: 3.1 Find Out More: 3.1 Assessment Master: 3.1

Overhead Transparency 5 Slides 3c

Teacher's Resource Binder Check Your Work: 3.1

#### **Teaching Options**

Teaching Through Inquiry More About...Michael Graves

Assessment Options

**Teaching Through Inquiry** Using the Overhead Assessment Options

#### **Technology**

#### Resources

Teacher's Resource Binder Finder Cards: 3.2 A Closer Look: 3.2 Find Out More: 3.2 Assessment Master: 3.2

Overhead Transparency 6 Slides 3d

**CD-ROM Connection** Student Gallery

Teacher's Resource Binder Check Your Work: 3.2

# 36 weeks 18 weeks

3

3

2 **Global Destinations** Lesson 3.3 Art of Japan

page 134 Pacing: Two 45-minute class periods

#### **Objectives**

- · Explain basic rules of traditional Japanese
- · Identify qualities of both Japanese and European ideas about design in the work of Toshiyuki Kita.

#### **National Standards**

- 3a Integrate visual, spatial, temporal concepts with content.
- 4a Compare artworks of various eras, cultures.
- 5b Analyze contemporary, historical meaning through inquiry.

**Studio Connection** 

- · Use contour lines to plan for and draw several different views of a high-tech product for the
- 3b Use subjects, themes, symbols that communicate meaning.

page 136

Studio Lesson 3.4

Pacing: Two or more

45-minute periods

Package Design

page 138

future.

#### **Objectives**

- · Understand the importance for package designs to convey a message about a product.
- Understand the kinds of concerns a designer must address when creating a package design.
- · Design a package for a product or store.

#### **National Standards**

- 1a Select/analyze media, techniques, processes, reflect.
- 2a Generalize about structures, functions.
- 2b Employ/analyze effectiveness of organizational structures.
- 2c Select, use structures, functions.
- 3b Use subjects, themes, symbols that communicate meaning.
- 5c Describe, compare responses to own or other artworks.

#### **Objectives**

- · Identify and understand ways other disciplines are connected to and informed by the visual
- Understand a visual arts career and how it relates to chapter content.

#### **National Standards**

6 Make connections between disciplines.

#### **Objectives**

#### Portfolio/Review page 144

Connect to...

page 142

- · Learn to look at and comment respectfully on artworks by peers.
- Demonstrate understanding of chapter content.

#### **National Standards**

5 Assess own and others' work.

# 2 Lesson of your choice

#### **Teaching Options**

Teaching Through Inquiry More About...Nanbu iron kettles Using the Large Reproduction

#### **Technology**

**CD-ROM Connection** e-Gallery

#### Resources

Teacher's Resource Binder A Closer Look: 3.3 Find Out More: 3.3 Assessment Master: 3.3

Large Reproduction 6 Slides 3e

Meeting Individual Needs Teaching Through Inquiry More About...Toshiyuki Kita Studio Collaboration Assessment Options

**CD-ROM Connection** Student Gallery

Teacher's Resource Binder Check Your Work: 3.3

#### **Teaching Options**

Teaching Through Inquiry More About...Website designers Using the Overhead Teaching Through Inquiry More About...New-product design **Assessment Options** 

#### **Technology**

**CD-ROM Connection** Student Gallery Computer Option

#### Resources

Teacher's Resource Binder Studio Master: 3.4 Studio Reflection: 3.4 A Closer Look: 3.4 Find Out More: 3.4

Overhead Transparency 6 Slides: 3f

#### **Teaching Options**

Community Involvement Interdisciplinary Planning

#### **Technology**

Internet Connection Internet Resources Video Connection **CD-ROM Connection** e-Gallery

#### Resources

Teacher's Resource Binder Using the Web Interview with an Artist Teacher Letter Story Map

#### **Teaching Options**

Advocacy Family Involvement

#### **Technology**

**CD-ROM Connection** Student Gallery

#### Resources

Teacher's Resource Binder Chapter Review 3 Portfolio Tips Write About Art **Understanding Your Artistic Process** Analyzing Your Studio Work

#### **Chapter Overview**

#### Theme

People care not only about how well a product works, but also about how it looks and feels. Such matters are of concern to artists who design the things we use.

#### **Featured Artists**

Hugo Blomberg Marcel Breuer Michael Graves Toshiyuki Kita Ralph Lysell Issey Miyake Pat Oleszko Peter Shire Gosta Thames

#### **Chapter Focus**

This chapter looks at the role of artists in planning and creating everyday objects. Students see how fashion designer Issey Miyake gets ideas and creates trends. They also create fashion designs of their own. Students are introduced to various designers and design traditions. They learn about the importance of human proportion in design, and use proportion guidelines in their own drawings. After a study of Japanese product design, students create an original package design for a product or store.

#### National Standards Chapter 3 Content Standards

- 1. Understand media, techniques, and processes.
- 2. Use knowledge of structures and functions.
- **3.** Choose and evaluate subject matter, symbols, and ideas.
- 4. Understand arts in relation to history and cultures.
- 5. Assess own and others' work.
- **6.** Make connections between disciplines.

3

# Artists as Designers

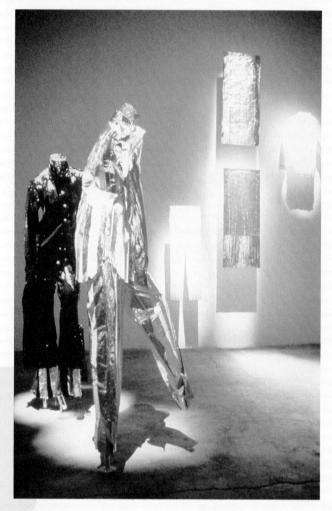

Fig. 3–1 In his creative designs, Issey Miyake thinks of new and creative ways to use fabrics. In designs such as these, he emphasizes the need to recycle. Issey Miyake, Laboratory Starburst, 1999–2000.

Photo by Yasuaki Yoshinaga. From "Issey Miyake, Making Things," 13 Nov. 1999–29 Feb. 2000. Ace Gallery, New York. © Issey Miyake Inc

120

# **Teaching Options**

#### **Teaching Through Inquiry**

Aesthetics Have students imagine planning an exhibition of fashion for a museum. Ask: What kinds of fashions will you include—and exclude? Casual? Formal? Contemporary? Vintage? How will you group the styles? Ask students each to explain, in a newspaper article, the purpose of the exhibition or the message it sends. Invite students to share their plan with the class. Have a discussion to address the question "When is clothing art?"

#### More About...

Issey Miyake—who calls himself a "clothes maker," not a fashion designer—wants people to experience the pleasure of wearing clothing in which aesthetics, craft, and everyday life come together. Working collaboratively not only with other artists and photographers, but also with the members of his studio, he gathers research on new themes and fabrics. Pattern makers then combine several ideas into an actual item. Miyake's inventive use of a single piece of cloth and his experiments with fabrics have found their way into popular styles.

#### **Focus**

- How do people show that they care about the look and use of objects?
- How do artists design the things we see and use?

Have you considered that most things you see and use every day were once ideas in someone's imagination?

Our school desks, cars, dinner plates, toys, and tools are all products designed by artists who started with a problem and some ideas about how to solve it.

Designers need to think about how a product will be used, as well as how it will look. The look may sometimes be the more important consideration. Take the clothes we wear. People want their clothes to keep them warm or cool, of course, but they also want to get just the right "look." They may shop for clothes that create a certain fashion statement. Fashion designers plan the clothes, shoes, and other items we wear. They sometimes design in familiar styles. Other times, they create designs that surprise, and even shock.

Clothing designer Issey Miyake experiments with new looks and fabrics. His clothing designs shown in Fig. 3–1 are examples of how his products not only cover the body, but also surprise and delight his audience. In this chapter, you

will learn more about Miyake and other designers who create products for us to use and enjoy.

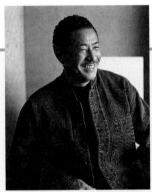

Issey Miyake

#### **Meet the Artists**

Issey Miyake Michael Graves Toshiyuki Kita

#### **Words to Know**

form function ergonomic proportion graphic designers pattern

Direct students each to list three classroom objects that were designed by an artist. Compile a class list to help make students more aware of the influence of art and design in their surroundings.

#### **Using the Text**

Aesthetics Ask: What do designers think about as they design a product? (how a product will be used. how it will look) What objects have you bought because you liked the design or how the object looked?

#### **Using the Art**

Aesthetics Have students study Miyake's clothing designs. Ask: Who would most likely wear these clothes? Where could you wear something like this? How are these clothes different from clothes that you usually wear?

#### Extend

- · Have students design a uniform for their school, a club, or a team. Ask: What features do you expect to find in clothes? What should clothes for this particular group do? Why do people wear uniforms?
- · Ask students to imagine that two people are wearing the Miyake designs and then to write a dialog that the pair could have. Guide students to think about how they would feel about themselves in these clothes.

# **Graphic Organizer**

3.1 Then and Now Lesson Design for Living page 128

> 3.2 Skills and **Techniques Lesson Human Proportions** page 132

Chapter 3

Core Lesson A Designer of Fashion

Core Studio

**Drawing on Fashion** page 126

3.3 Global **Destinations Lesson** Art of Japan page 134

3.4 Studio Lesson Creating a Package Design page 138

#### **CD-ROM Connection**

For more images relating to this theme, see the Personal Journey CD-ROM.

# Prepare

#### **Pacing**

Four 45-minute periods: one to consider text and images; one to draw a figure; one to design; one to color

#### **Objectives**

- · Identify various types of designers.
- Explain the importance of following the steps of the design process.
- · Create a fashion design for a client.

#### Vocabulary

form A general term that refers to the structure or design of a composition. function A general term that refers to how the structure or design of a composition works.

#### Teach

#### Engage

Read aloud Issey Miyake's statement. **Ask:** What does Miyake mean? Do you agree or disagree with this? When someone says "jeans and T-shirt," what does your imagination see? How would you design unusual jeans and T-shirts?

#### National Standards Core Lesson

**3b** Use subjects, themes, symbols that communicate meaning.

**5b** Analyze contemporary, historical meaning through inquiry.

# A Designer of Fashion

"If you take T-shirts or pairs of jeans, they can never cause any sort of surprise, since people always know what to expect from them. I prefer to surprise people, to cause emotion."

Issey Miyake (born 1938)

#### Issey Miyake's Journey

Issey Miyake was born in 1938 in Hiroshima, Japan. He was interested in clothing design at an early age. While studying graphic design in Tokyo, he presented his first collection of clothing. Miyake's work has taken him all over the world, where he has paid attention to the way people dress and the colors in the landscapes.

Like all designers, Miyake starts with a problem to solve. To him, clothing should be beautiful and always give pleasure to those who wear it and see it. His designs make people stop and think about clothing in new ways. Miyake wants to create clothing that not only covers the body, but also extends it, like a sculpture. In what ways does his *Flying-Saucer Dress* (Fig. 3–2) remind you of a sculpture? How do you think this dress moves when a person walks?

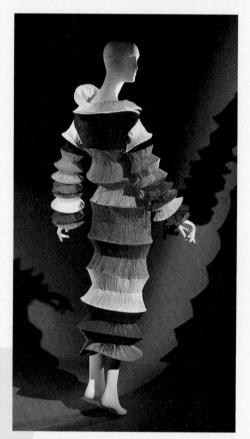

Fig. 3 – 2 Miyake often sets trends that eventually show up in mass-produced clothing. In what ways does this dress look like other dresses you have seen? Issey Miyake, Flying-Saucer Dress, 1994. Heat-set polyester. Philadelphia Museum of Art. Gift of Issey Miyake, Photo by Iym Rosenthland and Graydon Wood, 1997.

122

# **Teaching Options**

#### Resources

Teacher's Resource Binder
Thoughts About Art: 3 Core
A Closer Look: 3 Core
Find Out More: 3 Core
Studio Master: 3 Core
Studio Reflection: 3 Core
Assessment Master: 3 Core
Large Reproduction 5
Overhead Transparency 6
Slides 3a, 3b

#### **Teaching Through Inquiry**

Art Production Invite students to approach the design process as Miyake does, by crushing, pleating, and twisting an assortment of various fabric samples. Students may discover other ways to alter the fabric, such as by cutting, tearing, or piecing together. Invite students to imagine and make sketches of clothing they would make with the altered fabrics. Like Miyake, they may create titles for their designs. Ask students to present their sketches and fabrics in a large-group discussion.

# Exploring Fabrics and Forms

Issey Miyake likes to experiment with fabrics and ways to use them. He plays with the patterns created by crushing, pleating, twisting, shrinking, bleaching, and recycling textiles. His fabrics may be bright and cheerful or soft, natural, and quiet colors.

Early in his career, Miyake created a group of clothes called "A-POC" (Fig. 3–3). Each clothing item was produced mostly from a single piece of cloth—a square of material

with added sleeves. The result was clothing that seemed to flow around the body, much like the traditional Japanese kimono.

Miyake also collaborates with other creative people. He often invites artists to plan new fashions and shows with him. In his studio, he works with a team of designers to research ideas and make new creations. Today, Issey Miyake is taking advantage of the newest technologies for creating fabrics and designing clothing.

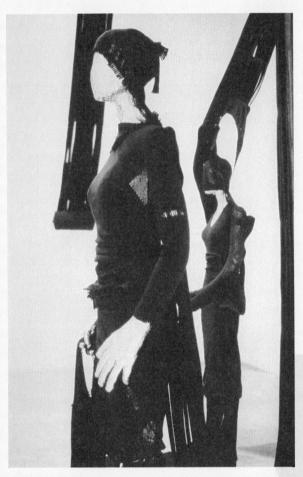

Fig. 3–3 A-POC stands for "a piece of cloth." People follow the designer's directions and cut a tube of knitted fabric into an entire outfit. Issey Miyake, A-POC "King" and "Queen," 1999–2000.
Photo by Yasuaki Yoshinaga. From "Issey Miyake, Making Things," 13 Nov. 1999–29 Feb. 2000.

Artists as

Designers

123

**Using the Text** 

Aesthetics Ask: What are Miyake's sources of ideas for his clothes? (how people dress, landscape colors, experiments with fabrics) What does Miyake want his clothing to do? (be beautiful, give pleasure to wearers and viewers, cover body, extend the body) What is A-POC? (clothing made from one piece of cloth, such as a kimono)

#### **Using the Art**

Aesthetics Have students describe Miyake's clothing designs. Ask: How is the Flying-Saucer Dress like a sculpture? If you could see a woman wearing this, how would the dress move as she walked? Where have you seen clothes like these? Why, do you think, have these clothes satisfied Miyake's criteria for being beautiful, providing pleasure to wearers and viewers, and covering and extending the body? Why is a clothing designer an artist?

#### **Extend**

Have students create costume designs for a theme party. As a class, select a theme, such as outer space, under the sea, or grocery-store items. Have students create costume designs from found objects, cardboard, Styrofoam<sup>TM</sup>, and fabric. Ask students each to sketch their costume, write a description of it, and critique its appearance and anticipated wearability.

#### More About...

Fashion designers design clothes and create patterns for mass production. To do so, they study fabric weights, colors, and textures; and also how people respond to different types of clothing. Fashion designers create new designs each year, some of which are widely copied. Products by leading fashion designers are identified by not only their style, but also their label. The trend of designers' labels on their products began in the early 1900s, when fashions, especially for wealthy women, were shown in popular magazines and newspapers.

#### **Using the Large Reproduction**

#### Talk It Over

**Analyze** Describe the shapes and color relationships that the designer used.

**Interpret** What message does the form send about the object?

**Judge** Is this a good design for a twenty-first-century forklift? Why?

#### **Artists as Designers**

#### **Using the Text**

Aesthetics/Art History Ask: What is the difference between form and function? (form: how something looks; function: how something works) How do we know that ancient people were interested in both form and function? (from their decorated tools) Lead students in analyzing the form and function of several ordinary objects in the classroom. Ask: What is the function of this wastebasket? What did an artist do to make this wastebasket look good?

Art Production After students have read page 125, ask if they know any designers. If any students have watched designers work, such as interior designers or landscape designers, allow them to share their knowledge with the class.

#### **Using the Art**

Aesthetics As students study Ericofon and the forklift, ask them to compare these to telephones and forklifts
that they have seen. Ask: Would you
like to use these products? Why?
What types of designers created
these designs? (industrial designers)
Ask: What makes the Website design exciting? What are some of the
things that Website designers must
consider? (ways to catch viewers'
attention, site navigation, users'
ability to understand information
presented) Do you think all Website
designers should be artists?

#### **Design Through Time**

People have always designed products to meet their special needs. Since the first time someone shaped a piece of stone to use as an ax, people have used available materials to make useful objects. They have also created new materials and developed techniques as they designed new objects to meet their needs.

Fig. 3–4 **How is your own telephone similar to and different from this one?** Hugo Blomberg, Ralph Lysell, Gosta Thames, *Ericofon*, 1949.

Fig. 3–5 Industrial designers must think about safety. This forklift allows the driver to move up with the lift instead of looking up from ground level. How does the look of this forklift compare to that of today's cars and other vehicles?

Over centuries, people have needed and wanted different things. Look at the telephone in Fig. 3–4. At one time, this design brought thoughts of a future world. Who could have known that people someday would want a fancy cover for a cellphone?

People have also cared about the way useful objects looked. Even in the ancient world, tools often had decorations that had no specific use. The decorations were added only to give pleasure to those who used the tools. This is an example of how designers have paid attention to the **form** (how it looks) as well as the **function** (how it works) of the objects they design. Like function, form undergoes change, depending on what appeals to people at different times.

124

# **Teaching Options**

#### **Meeting Individual Needs**

Multiple Intelligences/Spatial, Linguistic Ask students to imagine being hired by an environmentally concerned client to design next season's "hot" fashion. The clothes have to be made from recyclable "found" materials, such as junk mail, plastic wrap, aluminum foil, paper or plastic bags, and rubber bands. Have students each sketch a new fashion and attach material samples. Then ask students to create a magazine advertisement for their fashion.

#### **Teaching Through Inquiry**

Art Criticism Have students work in small groups to compare and contrast product designs from the past and present. Groups may wish to consider either the telephone or the forklift design. Invite students to list the characteristics of the product of the past and of its contemporary counterpart. Guide students to consider how the look of each object is appropriate for its purpose. Invite students to share their findings.

# Designers for Every Need

Many kinds of designers fill our needs. Product designers plan items such as appliances, tools, vehicles, toys, athletic equipment, and furniture. The forklift in Fig. 3–5 shows the work of an industrial designer. Fabric, jewelry, shoe, and accessory designers plan items we use to dress in comfort and style. Interior designers work with the spaces in which we live, work, and play. They may plan with lighting, furniture,

Fig. 3–6 The Internet is filled with work created by Website designers. What kinds of problems would a Website designer need to solve?

and floor and wall coverings. Landscape designers plan with trees, plants, and walkways. Theater designers plan sets, lighting, or costume design. Graphic designers plan all sorts of advertisements, posters, and brochures. And Web designers create what most of us see every time we use the Internet on a computer: Websites, home pages, and electronic ads (Fig. 3–6).

#### **Critical Thinking**

**Ask:** What is the function of Miyake's clothing? How do his clothes satisfy both form and function? Do the forms balance the function? How could the form or design of clothing interfere with its function? (could be uncomfortable, interfere with movement, be difficult to clean)

#### Extend

- Architect Louis Sullivan believed that form follows function. Have students explain what this means. Assign students to use Sullivan's directive to redesign their artroom chair.
- Either invite a designer into your classroom to explain his or her job, or show students several interviews with designers on the video series Art Careers! Talks with Working Professionals (Davis Publications, Inc.). Discuss the education needed to become a designer.

Artists as Designers

125

#### More About...

Industrial designers design objects that we use every day, such as stoves, telephones, furniture, and cars. Industrial design evolved around 1870, when businesspeople discovered that the design of a product could help sell it. The first designers for industry were often trained as painters, sculptors, or architects. Some designs, such as Michael Thonet's bentwood chair, become classics. Many industrial-design ideas can be traced to the Bauhaus.

#### **Using the Overhead**

#### Think It Through

**Ideas** From where do you think the designer got the idea for this design?

**Materials** What kinds of materials are important for this design?

**Audience** For what audience (age, gender, lifestyle) was this designed?

6

#### **Artists as Designers**

#### **Supplies**

- lightweight cardboard or tag board (9" x 12")
- scissors
- drawing paper (9" x 12")
- tracing paper, several sheets
- · pencil
- markers, crayons, colored pencils
- glue

#### **Supply Tip**

If you are able to obtain discarded pattern books from fabric stores, students may study them to understand how designers draw clothes.

#### Safety Note

Provide only markers that are labeled non-

toxic: many markers are toxic if used in poorly ventilated areas.

#### **Using the Text**

Art Production Assign students to read Studio Background. Review the design-process steps by listing on the board the key word of each. (identify, explore, brainstorm, plan, produce, evaluate)

Art Production Have students draw the figure of their chosen hero on cardboard (see Lesson 3.2). Encourage them to draw several clothing designs on tracing paper (see Step 3 of Studio Background). Demonstrate transferring a tissue sketch to drawing paper by blackening the back of the sketch with pencil, laying the sketch face-up on drawing paper, tracing over the lines, and checking that all lines were transferred to the drawing paper.

#### Using the Art

**Aesthetics Ask:** Is *Jazzmin* clothing or sculpture?

Art Production Have students study the student art to see how others have tackled a similar assignment.

#### Drawing in the Studio

#### **Drawing on Fashion**

Fashion designers create clothing and accessories for a wide variety of people and uses. They experiment with fabrics, colors, and patterns.

They also care about how clothing will look and feel to the person who wears it. Fashion designers often look to leaders in their field for their inspiration.

In this studio experience, you will design an outfit or uniform for someone you admire. For what will your outfit be used? What features does it need? Will you create a design that is entirely from your own imagination? Or will you borrow ideas from leading fashion designers?

#### You Will Need

- lightweight cardboard
- scissors
- drawing paper
- pencil
- markers, crayons, colored pencils
- white glue or cellophane tape (optional)

#### Try This

1. Choose the person for whom you would like to design an outfit. Will you choose an athlete, movie star, artist, or teacher?

**2.** Create a paper doll of that person. Draw the outline of the person on lightweight cardboard. Think about body proportions. How long should

the arms and legs be? How large should the head be? (To learn more about human proportion, see Lesson 3.2, on page 132.) Cut out the doll.

#### **Studio Background**

#### **The Design Process**

No matter what they are designing, all designers go through a similar series of steps. At each stage of the process, they ask important questions.

- 1. Identify the problem. What do the clients want and need? Which is more important: the product's look or the way it will be used?
- 2. Explore the problem. What designs of the product already exist? Who will use the product? What do the users like and dislike?
- **3. Brainstorm**. What are some possible solutions to the design problem? In this stage, designers make rough sketches or models.
- 4. Plan. Which idea needs more work? How should the idea be changed or improved? Several people usually are involved in choosing and developing one of the sketches.
- **5. Produce**. How can the product be made? In this stage, a prototype, or sample, is created and shown to the client.

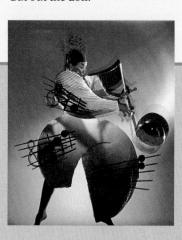

Fig. 3–7 The artist who made this design for clothing often creates wearable sculpture and performs in what she designs. Pat Oleszko, Jazzmin, 1994

Pat Oleszko, *Jazzmin*, 1994.

Mixed media, for ciothing design, 4' x 2' x 7' (122 x 61 x 213 cm). Courtesy of the artist.

Photo: Neil's Selkirk.

**6. Evaluate**. How well does the product solve the problem? What parts of the process worked well? How can the product and the process be improved?

126

# **Teaching Options**

#### **Teaching Through Inquiry**

Art History Refer students to the steps of the design process, and provide an object (such as a pencil sharpener, book bag, or desk lamp) to each group of students. Ask groups to answer the design-process questions as they think the designer of their object would have answered them. Have groups share their findings, and then hold a large-group discussion about the decisions that designers must make.

**3.** Lightly trace the doll on drawing paper. Sketch the features of the clothing on the trace. What features—such as puffy sleeves, a sash, or special

hat—do you need? Remember to create a front and back view of your design.

4. Color your design and create patterns. Will you create an all-over pattern, areas with different patterns, or simply a border design? Carefully erase any unwanted trace lines. If you want, cut out the clothing and attach it to your doll.

Fig. 3–8 Figuring out the body proportions for a figure in action creates a different kind of challenge. Brian Cole Plamondon, *Tony Hawk's Handprint*, 2000.

Tagboard, markers, 7\*x5\* (18 x 15 cm). Archie R. Cole Junior High School, East Greenwich, Rhode Island.

#### **Check Your Work**

Write a letter to the person for whom you have designed the outfit. Explain why you designed it the way you did. Tell the person how you used the six steps of the design process as you worked. Share your letter with a classmate.

#### **Lesson Review**

#### **Check Your Understanding**

- 1. Give examples of at least three different items that are designed by artists.
- **2.** What are the two things that designers must consider when designing items for our use?
- 3. Name at least three different kinds of
- 4. Why is it important for a designer to identify the problem that his or her design will solve?

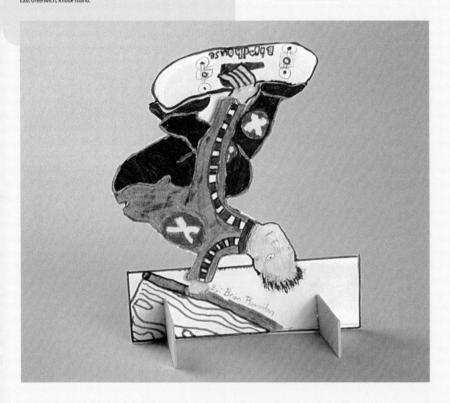

Artists as Designers

127

#### **Assess**

#### **Check Your Work**

Have students work in small groups to assess their art and read their letters to one another. **Ask**: Did your classmates understand your design? What part of the designing process did you find most difficult? Most enjoyable? If you were to repeat this project, what would you do differently?

## Check Your Understanding: Answers

- 1. Answers may include telephones, clothing, vehicles, posters, and greeting cards.
- 2. Designers must consider how the designed object will look (its form) and how it will work (its function).
- 3. Answers may include designers of fashion, costume, products, graphics, jewelry, shoes, stage sets, and lighting.
- 4. Answers may vary. Students should mention that designed items that do not address an identified problem may not be useful and, therefore, may not sell.

#### Close

Discuss students' answers to Check Your Understanding. Display students' letters with their paper dolls (some students may create bases to display their figure as sculpture). Review the role of designers.

#### More About...

Training for theatrical **costume designers** includes more than learning how to draw or knowing about historical clothing. Costume designers must be familiar with makeup, scenic design, and art and architectural history. To create a costume, the designer must consider such external factors as the character's environment; historical period; economic, social, and, sometimes, religious status; age; physical characteristics; and personality. The right costume may sometimes be as important as the lines the actor delivers.

#### **Assessment Options**

**Teacher** Have students each create a booklet for teaching younger children about different kinds of designers. As

students plan, remind them to consider not only the designers and their products, but also the way in which the designers work. Look for evidence that students understand the extent of design's impact, the work of different kinds of designers, and the design process. Make arrangements with a primary-grade classroom teacher to have students present their booklets to the younger students.

#### **Prepare**

#### **Pacing**

Four 45-minute periods: one to consider text and images; two to build containers; one to glaze or paint containers

#### **Objectives**

- Explain the similarities and differences among Bauhaus, Memphis, and ergonomic designers.
- Identify major style characteristics of Michael Graves's product designs.
- Demonstrate understanding of functional form and decorative form in the design of two ceramic containers.

#### Vocabulary

**ergonomic** A design that is built to increase the user's comfort and/or productivity.

#### Supplies for Engage

 various types of shoes (high heels, tennis shoes, sandals, etc.)

#### National Standards 3.1 Then and Now Lesson

**1b** Use media/techniques/processes to communicate experiences, ideas.

**4a** Compare artworks of various eras, cultures.

**5b** Analyze contemporary, historical meaning through inquiry.

# **Design for Living**

|     | 6th century вс<br>Hydria |            | 1932<br>Breuer,<br><i>Chair</i> | 1985<br>Graves<br>Tea Se |       |
|-----|--------------------------|------------|---------------------------------|--------------------------|-------|
| Anc | ient Greece              | Early 20th | Century                         | Late 20th Ce             | ntury |
|     |                          | 1919       |                                 | 1090                     | 1086  |

Bauhaus founded

#### Travels in Time

People have always designed functional objects to meet their basic needs. The urns and vases of the ancient Greeks, such as the one shown in Fig. 3–9, are excellent examples of well-designed

functional objects. The function, or use, of a vessel determined how it looked. This is also true today.

Peter Shire,

Peach Cun

Graves.

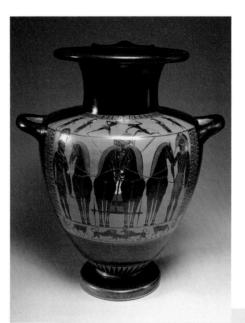

#### **Movements in Design**

The world changes rapidly. Many things we take for granted today were beyond people's imagination a century ago. The design of objects also changes rapidly.

Throughout the twentieth century, different movements, or schools of thought, influenced the design of objects. One such movement was De Stijl. (See Fig. 3–29 for an example of De Stijl.) De Stijl artists wanted to bring harmony to the design of objects through the use of basic geometric shapes and primary colors. Another school, the Bauhaus, was founded in 1919 by a group of artists, architects, and designers in Germany. Bauhaus designers used modern industrial materials and did not add any decoration. Look at the chair in Fig. 3–10. How does its function determine its form?

Fig. 3–9 Study this example of a functional, decorated design. Where do you see pattern? How did the artist create the pattern? Ancient Greece, Athens (attributed to the Antimenes painter), Hydria, c. 530–510 BC.
Black figure earthenware, height: 16 5/8" (42.2 cm). Cleveland Museum of Art, Purchase from the 1.4. Wade Fund. 1975.1.

128

### **Teaching Options**

#### **Resources**

Teacher's Resource Binder Names to Know: 3.1 A Closer Look: 3.1 Find Out More: 3.1 Check Your Work: 3.1 Assessment Master: 3.1 Overhead Transparency 5 Slides 3c

#### **Meeting Individual Needs**

English as a Second Language Have students look through catalogues and newspaper advertisements for examples of products similar to those shown in this chapter. Ask students to read the ads to learn about the products and then to select one ad that is particularly appealing. Have students describe in English what the product is designed to do. Next, have them sketch an ad, accompanied by English text, for their own invention of a similar product.

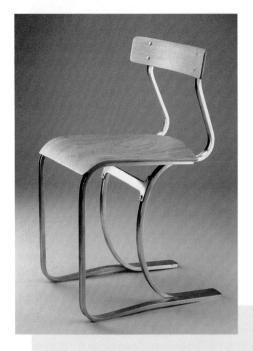

Fig. 3–10 At first glance, does this chair look as though it would support a lot of weight? What gives this chair its strength? Marcel Breuer, Side Chair, Wohnbedarf Model 301, 1932.

Manufactured by Embru. Aluminum and wood, 29" x 16 ½" x 18" (73 x 42 x 46 cm). Photo by Bruce White. The Mitchell Wolfson Jr. Collection, The Wolfsonian-Florida International University, Miami Beach, Florida.

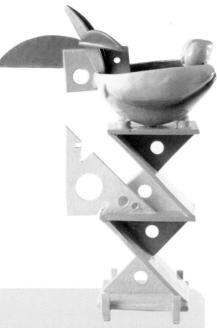

Fig. 3–11 How did the designer use pattern on this cup? What shapes are repeated? How would you drink from this cup? Peter Shire, "California Peach" Cup, Memphis, 1980.

Glazed earthenware. Cooper-Hewitt National Design Museum, Smithsonian Institution/Art Resource, NY. Gift of Denis Gallion and Daniel Morris, 1988-60-3.

#### Design in Your World

In 1981, the Memphis design group was founded. Their designs included commercially successful furniture, fabric, and ceramics, such as the cup in Fig. 3–11. Although they borrowed from many sources, including the architectural styles of ancient Greece and Rome, the group also used bold colors in new ways.

Since the eighties, many designers have become interested in "people friendly" creations. Their designs are **ergonomic**, built to increase the user's productivity and comfort, usually at work. Designers use their knowledge of the human body to create objects that people can use efficiently and safely. Look around your home and school for examples of ergonomic design.

#### Teach

#### **Using the Time Line**

Ask: Explain that the Bauhaus opened soon after World War I and closed in 1933 as the Nazi party gained control of Germany. Note that world events can influence art. List political and economic factors that could encourage arts either to flourish or decline.

#### Engage

Display the shoes. Discuss which shoe best shows the designer's interest in appearance, function, simplicity, complexity, and decoration.

#### **Using the Text**

Art History Ask: What did the De Stijl artists try to do in their designs? What were some goals of the Bauhaus designers? What was the focus of Memphis design? What is ergonomic design?

#### **Using the Art**

Art History Have students compare the Greek crater to "California Peach" Cup. Ask: How important were form and function to each artist?

Artists as Designers

129

#### **Teaching Through Inquiry**

Art History Have small groups each select a familiar product, such as an automobile, telephone, toaster, or washing machine. Assign each group to research the history of the design changes in the product. Ask each group to present an oral report and, if possible, to use visuals.

#### **Using the Overhead**

#### **Investigating the Past**

**Attribute** What clues could help you identify when and where this was made?

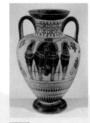

Interpret What does the shape of this vessel tell you about its use or purpose?

Explain Why was this designed to look this way?

5

#### **Using the Text**

Art History Ask: What did Michael Graves study in college? (architecture) What did he draw in his sketchbooks? (furniture, household object designs) Tell students that Michael Graves is famous today for his Post-Modern architectural designs.

#### **Using the Art**

Art Criticism Have students answer the caption questions. Ask: Why is Graves's kettle considered whimsical?

#### **Studio Connection**

Demonstrate slab, coil, and pinch methods.

- Pinch: Roll a clay ball. Press thumbs to within about ½" of bottom of ball. Slowly rotate the ball, pinching the walls between thumb and fingers.
- Slab: With a rolling pin on a heavy piece of cloth, roll clay 1/4" to 1/2" thick. Cut out clay shapes for sides and base, and join together.
- Coil: Flatten a clay ball between hands to form a base. Roll coils or clay snakes about ½" thick. Attach a coil around the perimeter of a base, and then layer coils on top of it.

Students will need clay (about 1 lb each; provide air-hardening clay if a kiln is not available), clay tools (paper clips, plastic knives, toothpicks, rolling pins, and burlap as a clayrolling surface), containers of water or slip (watered-down clay), and glaze or acrylic paint (optional). Teach students to score the clay and use water or slip to join the pieces. Have students glaze or paint their finished piece.

Assess See Teacher's Resource Binder: Check Your Work 3.1.

#### **Critical Thinking**

Ask students to consider Michael Graves's statement and then to imagine they are Graves's clients. Have students write answers to his questions. Ask: If Graves was to design a school for your community, what effect do you think your responses would have on his design?

#### **Designing with Humor**

"When I design for clients, I ask, 'What kind of things do you like? What kind of things do you hate?'" Michael Graves (born 1934)

Photo: Timothy Greenfield-Sander

Designers today also think about how their objects will fit into contemporary society. Designer Michael Graves has an educated eye and whimsy, a kind of humor. He designs objects that are both classic and fun.

As a child in Indiana, Michael Graves loved to draw. "The more I drew, the better I got," he says. As an architecture student, he experimented with product design. He filled his sketchbooks with designs for furniture and other household objects. His sketches were soon made into real products.

Name a product, and Graves has probably created his own special design for it. During the 1980s, he designed for the Memphis group. Today, his whimsical kettles (Fig. 3–12), utensils, and tableware are very popular.

Fig. 3–12 What visual elements were repeated in this set? Why did Graves put a bird on the spout of the kettle? Michael Graves, Whistling Bird Teakettle with Matching Sugar Bowl and Creamer for Alessi, 1985.

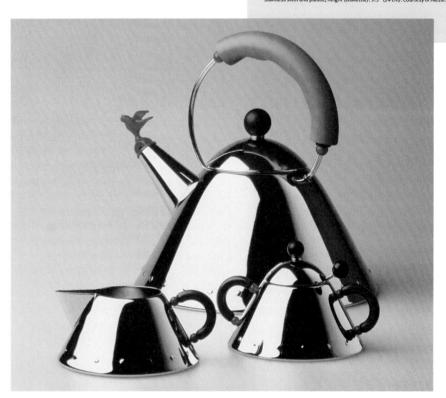

130

# **Teaching Options**

#### Teaching Through Inquiry

Aesthetics Assemble a large collection of cups, ranging from ornate china to decorated paper cups to clear plastic cups. Engage students in a discussion about what they like and dislike about the designs, and why. List the reasons on the board. Have students analyze the list to see if there are patterns in the way they tend to think about the design of objects.

Art History Assign students to research Post-Modern architecture and buildings designed by Michael Graves, such as the Walt Disney World Swan and Dolphin Hotels, the Public Services Building (Portland, Oregon), and the San Juan Capistrano Regional Library (California). Have them, using Graves's buildings as examples, create a poster about Post-Modern architecture.

### The Art of Design

Fig. 3-13 What classical Greek element do you think Graves had in mind when he designed this clock? Michael Graves, Mantel Clock for Alessi, 1986.

Ebonized wood, stained birdseye maple, green oxidized metal watch hands, 18i dot at center hand pivot, terra cotta numerals, off-white face, 18k gold pendulur satin finish. Photo by William Taylor, Courtesy of Ales

Michael Graves, who is also an architect, refers to classical traditions of architecture in many of his designs. The clock shown in Fig. 3–13 is an example of how Graves blends classical, simplified styles with his imagination. In this design, Graves created a clock that looks like a building. Many of his products feature symmetry and order, such as this clock. But Graves always adds an unexpected element to create a sense of fun and whimsy.

#### **Lesson Review**

#### **Check Your Understanding**

- 1. What does the design of a modern teapot and that of ancient Greek urns have in common? 2. What is one difference between Bauhaus and Memphis design? What is one similarity between Bauhaus and ergonomic design? 3. What qualities does Michael Graves bring
- together in his designs of products? 4. Usually, products designed by well-known artists are more expensive than products that do not have designer labels. Why do you think this is so? Do you think having well-designed objects is worth the extra money?

#### **Studio Connection**

Make two ceramic containers, such as two teacups, each for the same specific purpose. Use slab, coil, and pinch methods,

alone or in combination. As you design each container, consider both its function and the form you want it to have. Make one container as simple and functional as possible. In other words, let the function determine the form. Any decorative surface pattern should be functional. For example, a pattern of tea leaves would suggest the use of a teacup. Make the second container functional as well, but be more playful with its design and surface pattern. For example, you could use the slab method to make your teacup out of a threedimensional "T."

Artists as Designers

131

#### Assess

#### **Check Your Understanding: Answers**

- 1. Their function of pouring liquids is similar; their shapes, because they facilitate pouring, are also similar.
- 2. Bauhaus did not add decoration; Memphis used bold, decorative colors. Bauhaus and ergonomic design both emphasize functional form.
- 3. Graves uses classical, simplified styles; imagination; and a sense of fun.
- 4. Answers may vary. The power of big names can often command high prices. Welldesigned products usually last longer and are therefore cheaper over time. They may also increase in value.

#### Close

Have students exhibit their ceramic containers by grouping them by form and function. Encourage students to tell which grouping they prefer and to explain why. Discuss students' answers to Check Your Understanding. Review the difference between Bauhaus design and Graves's designs by asking students to explain the Bauhaus mantra "Less is more" and the Post-Modern response "More is a bore."

#### More About...

Michael Graves believes that what makes a domestic setting truly home is the infusion of beautiful, cultural things. His line of homecleaning supplies is proof that he wants people to use beautifullydesigned objects for even the most menial of tasks. The inspiration for his now-affordable collection of decorative, table-top, and personal accessories comes from a love of color, humor, and classical features.

#### **Assessment Options**

Teacher Assign students to do additional research on the major twentieth-century design movements identified in this lesson. Challenge students to find the names of two designers who are

associated with each movement but are not mentioned in the text. Ask students to identify similarities and differences between their own approach to designing projects and that of the designers they have named.

Self Ask students to reflect on, describe, and generalize about their own preferences for the design of three products they use every day. Products may include clothes, dishes, and furniture. Prepare a bulletin-board chart with the following (or other) pairs of words, each word on the opposite end of a continuum: simple/ornate, casual/dressy, expensive/inexpensive, plain/fancy, functional/decorative. Invite students to place an X at the point on each continuum where each of their three products best fits.

#### **Prepare**

#### **Pacing**

Two 45-minute periods: one to consider text and images; one to complete drawing

#### **Objectives**

- Define proportions and explain their importance to designers.
- Create drawings from a model, using proportion guidelines.

#### Vocabulary

**proportion** The relationship between one part of the human figure and another.

#### Teach.

#### Engage

Have students stand with their arms close to their sides. **Ask**: What part of your body do your elbows touch? (waist) How far down your leg do your fingertips extend? How does the size of your hand compare to that of your face?

#### **Using the Text**

Art Production Ask: How many heads tall are most adults? Explain that children's bodies are smaller in relation to their heads.

Art Production Have students check facial proportions on a classmate. Use a ruler to measure and compare proportions with the proportions explained in the lesson. Use these proportions to make a drawing.

#### National Standards 3.2 Skills and Techniques Lesson

- **2a** Generalize about structures, functions.
- **2b** Employ/analyze effectiveness of organizational structures.

# **Human Proportions**

People differ in many ways. Some may be tall or big-boned, while others may be petite. But most people are alike in their proportions, which are the relationship between one part of the body and another. When designers create a chair or a piece of clothing, they make decisions about size and shape based on the typical human proportions. Whether you are drawing a picture of a man, woman, or young child, the same general rules of proportion will help make your drawing seem right.

#### The Human Figure

Study the proportions shown in Fig. 3–14. Practice your understanding of these proportions by creating several sketches of the human figure. Use a full sheet of paper for each drawing. You might begin with eight very light horizontal lines, all the same distance apart. This will give you seven spaces. The head will fill the top space, and the feet will rest on the bottom line.

First, sketch a standing-up figure from the front. Then sketch a standing figure from the back and one from the side. Next, try sketching a seated figure from the side. Have a classmate pose for you, or work from a photograph. Each time, be careful to use the same proportions.

Fig. 3–15 Notice that the eyes are about halfway between the top of the head and chin. The space between eyes is about one eye width. The bottom of the nose is about halfway between eyes and chin. The mouth is slightly higher than halfway between chin and nose. Its corners are directly below the center of each eye. Ears are about parallel to the eyelids and bottom of the nose.

132

SKILLS AND TECHNIQUES

# **Teaching Options**

#### Resources

Fig. 3-14 Notice that the

of the head. The hips are about halfway between

the feet and the top of the

head. The elbows and

waist are just above the

hips. The shoulders are

about halfway between

the waist. The knees are

about halfway between

the feet and the hips.

height of most people age 12 and up is about seven or eight times the height

Teacher's Resource Binder

Finder Cards: 3.2

A Closer Look: 3.2

Find Out More: 3.2

Check Your Work: 3.2

Assessment Master: 3.2

Overhead Transparency 6

Slides 3d

#### **Teaching Through Inquiry**

Art Production Invite students to design a proportionally correct mode of transportation, such as a bicycle, scooter, motorcycle, or snowmobile. Then have them design the same object—but this time, playfully out of proportion. Have students share both designs with classmates.

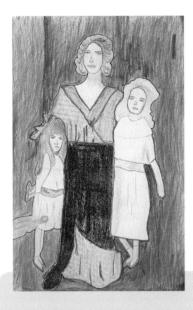

Fig. 3-16 When making a drawing that shows people of different sizes, what is important to remember when determining proportion? Rheannon J. Swinney, Sisters with Mother, 1999.

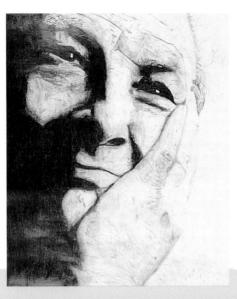

Fig. 3-17 Once you have an understanding of facial proportion, you can become more creative in your composition. This artist has tipped and turned the face slightly and added the hand. Christopher Johnson, Unknown, 2000

#### The Human Face

Study the proportions outlined in Fig. 3–15. Practice your understanding of these proportions by creating two sketches of the human face. First, sketch a face from the front. Have a classmate pose for you or work from a photograph. Instead, you could draw yourself while looking into a mirror.

Then sketch a face in profile. When creating a profile view, notice these additional proportions: the top of the ear is about halfway between the eye and the back of the head; and the bridge of the nose and front of the chin are nearly in a straight line, one above the other.

#### **Studio Connection**

Draw a detailed portrait of yourself or a classmate. One way to start is to draw an oval shape with light pencil guide-

lines for the eyes, nose, lips, and ears (as described in this lesson). After these general guidelines are in place, observe the specific characteristics of your subject. Is the face wide or thin? Does your subject have a long nose or a short one? Is the forehead high, or does the hair cover the forehead? Adjust your marks, if necessary, to show these differences.

#### Lesson Review

#### **Check Your Understanding**

- 1. Define *proportions* in your own words.
- 2. Why is knowledge of human proportions important to artists and designers?

Artists as Designers

133

#### Using the Art

Art Production Help students use a pencil to estimate body proportion. With an arm extended, align the top of a pencil with the top of a model's head. Place your thumb on the pencil to align with the base of the model's chin. Use this unit of measure to count how many heads high the body is. Then create a drawing of a human figure based on this unit of measure.

#### **Studio Connection**

Have students draw with pencil on 12" x 18" drawing paper. Guide students to note where the neck joins the head.

Assess See Teacher's Resource Binder: Check Your Work 3.2.

#### Assess

#### **Check Your Understanding: Answers**

- 1. Proportions are the size relationship between one body part and another.
- 2. Answers will vary but may include reference to how designers plan objects, such as chairs and eating utensils, that are to be used by people.

#### Close

Using the guidelines described in the Fig. 3-15 caption, have students check the proportions in their drawings. Review students' answers to Check Your Understanding.

#### **Using the Overhead**

#### Write About It

Describe Write a description of the design in this image.

Analyze Explain how the design addresses standard human proportions.

# **Assessment Options**

Peer Ask students to imagine that they have been asked to give a speech at a meeting of designers about the role of human proportion and design. Tell students that fashion, product, industrial, toy, jewelry, and costume designers will gather for this meeting; and that the speech must convince them all to see the importance of a clear understanding of proportion. Have students write their speeches and then present them in small groups. As each student presents a speech, have the other group members rank it as: 1very convincing; 2—adequately convincing; or 3—not at all convincing. Guide members to provide at least one reason for each of their rankings.

#### **Prepare**

#### **Pacing**

Two 45-minute periods: one to consider text and images; one to draw

#### **Objectives**

- Explain basic rules of traditional Japanese design.
- Identify qualities of both Japanese and European ideas about design in the work of Toshiyuki Kita.
- Use contour lines to plan for and draw several different views of a high-tech product for the future

#### **Using the Map**

Ask: What are Japan's latitudes? (roughly from 45° to 30° N) How does this compare with your community's latitude? Point out that the climate of Japan is moderated by the surrounding Sea of Japan and Pacific Ocean, and that the island nation is about the same size as Montana—but with many more people.

#### National Standards 3.3 Global Destinations Lesson

- **3a** Integrate visual, spatial, temporal concepts with content.
- **3b** Use subjects, themes, symbols that communicate meaning.
- **4a** Compare artworks of various eras, cultures.
- **5b** Analyze contemporary, historical meaning through inquiry.

# Art of Japan

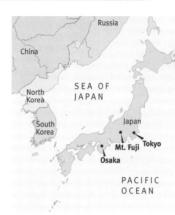

Japan

#### A Tradition of Design

The design of functional and beautiful everyday objects has a long tradition in Japan. Craftsworkers created by hand the many objects used in the tea ceremony and daily life. They worked with clay, wood, metal, paper, or cloth.

Many artists followed traditional rules and standards of design and beauty. One of these rules is *wabi*, which is the idea of finding beauty in simple, natural things. Wabi also means an appreciation of imperfect and irregular natural objects. Another rule is *sabi*. This refers to timelessness and simplicity. Following the rules of wabi and sabi, an artist would want an object to have uneven, simple shapes and a timeless look. Study the jar and teacup shown in Figs. 3–18 and 3–19. What evidence do you see that these artists followed the rules of wabi and sabi?

#### Places in Time

Japan is an island nation in the West Pacific. It has an ideal climate and geography for growing tea on steep, terraced hillsides. For centuries, the preparation of tea leaves and the serving of the drink have been performed in a ritual known as the tea ceremony. An important feature of the ceremony is the use of beautifully crafted utensils.

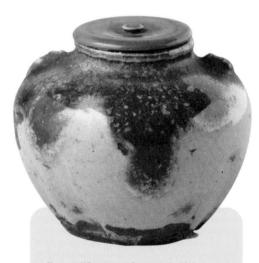

Fig. 3–18 What pattern do you see in this jar? What, in nature, does it remind you of? Japan, Owari province, *Tea Jar*, 19th century, Pottery, height: 1<sup>1</sup>/<sub>4</sub>\* (a.m.). Philadelphia Museum of Art: The Louis E. Stern Collection, Photo by £ric Mitchell, 1981.

134

### **Teaching Options**

#### Resources

Teacher's Resource Binder
A Closer Look: 3.3
Find Out More: 3.3
Check Your Work: 3.3
Assessment Master: 3.3
Large Reproduction 6
Slides 3e

#### **Teaching Through Inquiry**

Aesthetics Have students work in small groups to discuss the following: When does the desire for beauty get in the way of the practical use of an object? Can something like a cup or bowl ever be too perfectly beautiful to be of practical use? What are some examples? Ask groups each to list their thoughts and additional questions to share with the class.

Fig. 3–23 The use of lacquered wood for tableware is a strong tradition in Japan. What geometric shape did the artist repeat in the design? Toshiyuki Kita, *Urushi Tableware*, 1986.

acquered wood, height: 3 3/16" (8.1 cm), diameter: 5 1/8" (13 cm). Omukai Koshudo

#### **Designs for the Future**

When Kita designs things, he thinks of tools we use daily, and he sees the effect of new technologies on lifestyles and the environment. Because his primary interest is in the harmony of technology and people's lives, his work explores the relationship between people and materials.

Kita thinks about the look of objects from the past, the needs of the present, and meanings for the future. So, when he designs, he tries to hold on to the past while taking a giant step forward. In his designs, such as the tableware in Fig. 3–23, Kita looks to past traditions in Japan while creating products for the future. What is modern about this design?

#### **Studio Connection**

Plan for and draw several different views of a high-tech product for the future, such as a cellphone, timepiece,

computer, or pager. Use contour lines to show as many features as possible. Consider needs in communication, transportation, entertainment, the home, and so on. Think about efficiency. Who will use the product? How will it be used? How will your design be an improvement over something that now exists? How can pattern enhance the design?

#### Lesson Review

#### **Check Your Understanding**

- 1. What are two rules of traditional Japanese design?
- 2. What does the design of Japanese hightech products have in common with that of traditional everyday objects?
- 3. Give an example of how Toshiyuki Kita combines Japanese and Western ideas about design. What three things does Kita try to create in a well-designed product?
- 4. What products can you find in your home that are made in Japan? What distinguishes their design from other products?

**Assess** 

# **Check Your Understanding: Answers**

- 1. wabi (finding beauty in the imperfection and irregularities of natural things) and sabi (timelessness and simplicity)
- 2. beauty; a natural look; a preference for natural, organic forms
- 3. The Wink chairs combine the comfort and support of Western recliner chairs with the Japanese practice of sitting on the floor. Kita tries to create the look of the past, answers to the needs of the present, and meanings for the future.
- 4. Answers will vary.

#### Close

Display students' drawings with their paragraphs. Discuss how wabi and sabi were used in their designs. Discuss students' answers to Check Your Understanding.

137

Artists as Designers

#### More About...

Toshiyuki Kita studied industrial design in Naniwa College in Osaka, Japan. In 1969, Italian manufacturers began to produce his designs that were based in his Japanese heritage. In 1980, he gained international recognition for his Wink chair. Today, he bridges European and Japanese cultures by traveling between his offices in Milan and Osaka.

#### **Studio Collaboration**

Have students collaborate to design a set of clay dishes with a unifying theme. Encourage students to create guidelines to ensure that their designs will go together. Help them create displays of their completed designs.

#### **Assessment Options**

evaluate their findings.

Peer Have students work in groups to prepare a display of images of products (toys, household items, high-tech items, automobiles, and so on) designed in Japan. Encourage students to prepare labels that describe outstanding design features, such as lines, shapes, colors, and patterns. Have groups compare and

**Self** Invite students to reflect on the ideas for their drawing. Ask them each to write a short commentary of their intentions and the most successful qualities of their drawing.

#### **Package Design**

#### **Prepare**

#### **Pacing**

Two or more 45-minute periods: one to consider text and images; one or more to create package design

#### **Objectives**

- Understand the importance for package designs to convey a message about a product.
- Understand the kinds of concerns a designer must address when creating a package design.
- Design a package for a product or store.

#### Vocabulary

graphic designer An artist who plans the lettering and images for books, packages, posters, and other printed materials.

pattern A choice of lines, colors, or shapes that are repeated over and over, usually in a planned way. Pattern is a principle of design.

#### **Supplies for Engage**

 several shopping bags, shoeboxes, or cereal boxes

#### National Standards 3.4 Studio Lesson

- 1a Select/analyze media, techniques, processes, reflect.
- 2a Generalize about structures, functions.
- **2b** Employ/analyze effectiveness of organizational structures.
- 2c Select, use structures, functions.
- **3b** Use subjects, themes, symbols that communicate meaning.
- **5c** Describe, compare responses to own or other artworks.

Design in the Studio

# Creating a Package Design

# Marketing in Three Dimensions

STUDIO

#### Studio Introduction

As you walk down the cereal aisle of your grocery store, which packages catch your eye? Have you ever noticed

that the bright and colorful designs of some cereal boxes are directed toward young people? They seem to send a message that says "If you buy this cereal, you will have fun!" Other cereal box designs send messages about how healthy you can be if you eat the cereal inside.

Businesses depend on **graphic designers**—artists who plan the lettering and artwork for packages, posters, advertisements, and other printed material—to help market and sell their products. Many people will select one item over another because the package design appeals to them. With so much product competition, package designs must be as visually appealing as possible.

#### **Studio Background**

#### **Designers at Work**

In this day and age, there are millions of products and hundreds of stores from which to buy them. Graphic designers have the unique challenge of creating packages that will sell a specific product or promote a specific store. For example, they must try to make one kind of shampoo, one brand of cold medicine, or the corporate image of a particular store stand apart from all the rest. They often create designs to fit a standard container, such as a coffee can, perfume box, or shopping bag. They sometimes custom-design packages that have unusual forms.

Graphic designers need to answer several questions as they create a package design.

1. What size and shape should the package be?
What materials should be used? If the product is heavy, the designer must construct a package that will hold the weight.

**2.** What message should the design communicate? The designer must know the important characteristics of the product or store, and figure out a way to tell the buyer about them through the design.

**3.** Who is the buying audience? Some messages are aimed at the general public. Others are aimed at

Fig. 3–24 Why is this a successful example of graphic design? "Green Stripe" Fresh Produce Containers, 1980. Corugated cardboard. Designer: Jack Gemsheimer, Partners Design, Inc. Photography: Dennis Brubaker, Project Director CrossRoads Studios.

Fig. 3–25 Do you think the artist thought about the audience for this product? What makes you think so? Imaginarium KangarooHop! Package Design.
Art Director/illustrator/design, Earl Gee; photography, Sandra Frank. © 2001 Gee + Chung Design.

specific groups, such as teenagers, car drivers, or people who care about the environment.

4. What kind and style of graphics will best communicate the message? The style may be serious, fun, realistic, or abstract. Lettering styles can also help send messages. Creative use of the elements and principles of design can also attract attention and send the right message.

138

# **Teaching Options**

#### Resources

Teacher's Resource Binder Studio Master: 3.4

Studio Reflection: 3.4

A Closer Look: 3.4 Find Out More: 3.4

Overhead Transparency 6

Slides 3f

#### **Teaching Through Inquiry**

Art Criticism Ask students to imagine that they are agents for designers. They are to select one of the designs on these pages and "pitch" the design to a potential client, persuading him or her that this is the only design to choose. Guide students to describe the design so that the client will be able to imagine it, and to explain what the particular design will "say" about the product or store.

In this studio experience, you will create a package design for a product or store of your choice. Pages 140 and 141 will tell you how to do it. Choose a product or kind of store for which you would like to design a package. For example, you may want to design a case for a music CD, a shoe box, or a department store shopping bag. Use line, shape, color, and pattern to send a message about your product or store.

Fig. 3–26 This student artist used simple shapes and just a few colors to express his message.

Barry Knapp, *Barry's Pro Shop*, 2000.

Cut paper, pipe cleaners, height: 16 <sup>1</sup>/<sub>4</sub>° (41 cm), Jordan-Rubridge Middle School, Jordan New York

Artists as Designers

139

#### **Supplies**

- cardboard box or shopping bag
- construction paper
- markers
- scissors
- glue
- collage materials

#### Teach

#### Engage

Show students several shopping bags, shoeboxes, or cereal boxes. **Ask:** To what audience were the artists directing the design of these packages? What types of lettering, illustrations, and colors do you think appeal most to young children? How could designers change these so they are appropriate for serious adults?

#### **Using the Text**

Art Production Ask: What type of artist designs packages, advertising, and printed materials? (graphic designer) What are some questions that graphic designers must answer before creating a package design?

#### **Using the Art**

Perception As students study the illustrations, have them describe the type of customer that each package was designed for. Ask: What will catch the customer's attention? How did each artist use pattern and color? How is the type different from normal lettering? How does the type seem to go with the design?

#### More About...

Most forms of information, such as books, movies, and TV shows, are most easily understood if they are linear—taken in sequence. However, **Website designers** have to keep in mind that people using the Internet can "enter" a site from any "page"—not necessarily the home page. These designers, therefore, must ensure that the information and graphics make sense from any point of entry. They must also use images and text to make obvious the "navigation" to desired information, and possibly to entice visitors to investigate other pages as well.

#### **Using the Overhead**

#### Think It Through

**Ideas** From where do you think the designer got the idea for this design? What audience was this designed for?

**Techniques** What processes were used to create this design?

6

#### **Studio Experience**

Encourage students to consider the colors that seem to go with their product. Guide students to use type that suggests their message: they may hand-letter it, print it from a computer, or cut it from old magazines and newspapers. They may also wish to cut a few large letters from construction paper.

#### **Idea Generators**

Suggest to students that they design a package for a locally grown fruit or vegetable, a new breakfast cereal, a product from a country they are studying in social studies, or a shopping bag promoting the local food bank. **Ask**: How would you make your product appear healthful or serious? How would you make it look fun and exciting?

#### **Studio Tip**

Remind students that lettering is an integral part of their design: they should plan its style, color, and size when they design the rest of their package.

#### **Extend**

Assign student groups to create a video commercial for one of their packages. Lead them to determine what they will feature—the product, the package, how the consumer will use the product, or how much fun or help the product will be. Show some video clips of commercials, noting what was emphasized. Demonstrate making a storyboard and writing a script.

#### Design in the Studio

# Creating Your Package Design

#### You Will Need

- cardboard box or shopping bag
- construction paper
- markers

#### scissors

- glue
- collage materials

#### Try This

1. Think about the product or store you want to promote on your container. What images come to mind when you think of your subject? What name, brief saying, or other words can you include to attract the buyers' attention? Refer to the questions in the Studio Background (page 138) for ideas.

2. Notice the shapes and sizes of the front, back, and sides of your container. Remember that the design is seen on all sides of the package. How can you use these spaces to create an exciting design? Where can you use pattern?

**3.** To create a background, trace the sides of your container onto construction paper and cut out the panels. Choose

one or more paper colors that will best express your message.

**4.** Use markers and collage materials to create words and images for your package. Will you create a pattern in the background or in the

images and words? Will you create your own images or cut them from a magazine? Will you draw your words, or will you cut letters out of paper and glue them onto the panels?

**5.** Carefully glue the construction-paper panels to the sides of your box or bag.

#### **Check Your Work**

When designers complete a project for a client, they present their ideas and explain what they have done and why. Prepare a presentation about your package design. Get together with two of your classmates, and take turns playing the roles of presenter and clients. Be sure to explain how your design decisions fit the audience and your client's intended message.

#### **Computer Option**

Using the computer and a slide-presentation program (such as Powerpoint or Hyperstudio), make a brief

(3–5 slides) presentation that features your package design. Identify your product, talk about the package design, and share your overall design decisions. Include information about how the design is intended to appeal to the target audience (the people who will purchase the product).

140

### **Teaching Options**

#### **Teaching Through Inquiry**

Art Production Have students design a silly package for something small (such as a safety pin), large (a motorcycle), fragile (an egg), or squirmy (a gummy worm). Students may brainstorm for other ideas. Remind students that the package must both protect and send a message about the contents. You may wish to have students work in pairs or groups to complete this assignment.

#### More About...

New-product design is a long process for companies. First, designers brainstorm ideas, from the most sensible to the most outlandish. A focus group of individuals eliminates the ideas that don't work. Prototypes (models) of the remaining ideas are made and tested. The "winner" is then sent to a test market, a city in which the population is likely to use the product. If the item sells well, full production and delivery begins!

#### **Elements and Principles**

#### Pattern

Artists create **pattern** in a design when they repeat lines, shapes, or colors. A *planned pattern* is one in which the elements are repeated in rows or some other regular way. Many clothing

fabrics show a planned pattern. When the repeated elements appear scattered in the design, they create a random pattern. You can see random patterns in tie-dyed fabric

An overall pattern can help hold an artwork together visually. Small areas of pattern add interest to an artwork. Look at your own artwork

and the work of your classmates. Which ones show planned or random patterns? Are they overall patterns? Or were they created in certain areas to add interest to the artwork?

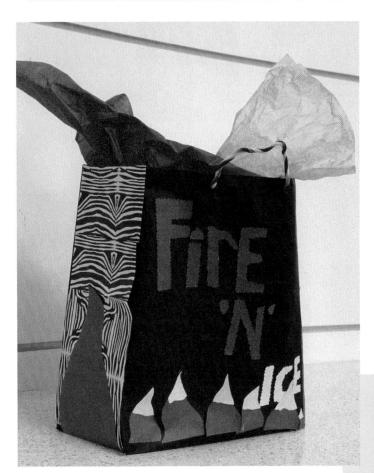

Fig. 3–27 How did the artist use pattern in her design? Tiffani Hendrie, Fire 'n' Ice, 2000. Cut paper, pipe cleaners, 17" x14" x5" (43 x 35.5 x 13 cm). Jordan-Elbridge Middle School, Jordan, New York.

Artists as Designers

141

#### Computer Option Students may use their package design

to accompany their presentation, or they may base the presentation on a design created on the computer. To launch a discussion about design considerations of actual products, have students bring in some of their favorite ads or products. Help students focus on the design elements used to attract attention and convey the intended message.

#### **Elements and Principles**

After students have read about pattern, have them identify random and repeated patterns in the classroom (in clothing, the ceiling, flooring, book covers, etc.).

#### Assess

#### **Check Your Work**

Before students present their packages, encourage them to explain how their design will satisfy the client's needs and what will attract customers to the product.

#### Close

Display students' packages. Ask students to describe how they used pattern in their design. Review the role of graphic designers.

**Assessment Options** 

**Peer** Have students collaborate to create a school bulletin-board display that features the importance of package design. As a class, col-

lect examples of package design. Have groups of four each work with one of the designs. Have students each write a statement about the item assigned to the group, addressing these questions: 1. What message does the design send about the contents or the store? 2. Why was it important for the designer to send this message? 3. What else did the designer have to consider when designing this package? Have students share their statements within their group, and then ask group members to judge which statement best addresses the questions. Display the winning statements, with the packages, on the school bulletin board.

Connect to...

#### **Daily Life**

Ask students to collect and bring in magazine ads and hard copies of Web pages that depict utilitarian objects developed by a designer or design team. Have students work in small groups to categorize by function the ads or other examples that group members have collected. Ask groups to share and discuss their findings as you record their responses on the board.

#### **Language Arts**

Make photocopies of the pages in Jules Verne's From the Earth to the Moon and 20,000 Leagues Under the Sea that describe his fantastic designs for spacecraft and submarines. Have students work independently to create drawings, paintings, or sculptures that illustrate the author's descriptions. Display the completed artworks next to the text that inspired them.

# Connect to...

#### Careers

Some **fashion designers** have become celebrities themselves through their creations for music and movie stars. Yet many lesser-known fashion designers work for clothing manufacturers that sell their work through department stores, specialty stores, and mail order or online catalogs. Students interested in a career in fashion design may earn degrees in fashion merchandising or fashion design through college or university art departments or fashion-design institutes.

Fig. 3–28 Fashion designers may specialize in women's, men's, or children's clothing or accessories. They may design casual, business, or formal clothing. Photo © Andres Aquino, FashionSyndicatePress. Or accessories.

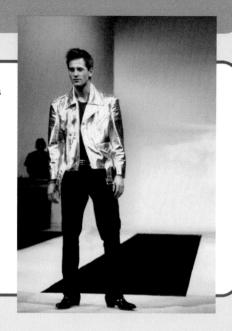

Fig. 3–29 **What elements and principles of design do you see in this chair?** Gerrit T. Rietveld, *Roodblauwe Stoel* (*Red*, *Yellow*, *and Blue Chair*), 1918.

(*Kea, Tellow, and Blue Charry,* 1918. Painted wood, 34 ½ \* x26\* x32 ½ \* (88 x 66 x 83 cm). G. van de Groenedkan, NL–Utrecht. Vitra Design Museum, Weil am Rhein.

#### **Daily Life**

Deliberately designed objects surround you, although you may not pay them much attention. The alarm clock that wakes you, the toothbrush you use, the clothes you wear, the cereal box on the breakfast table, and the car or bus in which you ride to school are all deliberately designed objects. They are designed for specific purposes: to work properly, to attract your attention, to make you comfortable, to fit your body, or to encourage you to buy. Take notice of such objects for one day; see how many you encounter.

142

# **Teaching Options**

#### Resources

Teacher's Resource Binder: Making Connections Using the Web Interview with an Artist Teacher Letter

#### **Video Connection**

Show the Davis art careers video to give students a reallife look at the career highlighted above.

#### **Other Subjects**

#### Language Arts

Do you like to read science fiction? Do you know who was the first person to write it? Though the term *science fiction* wasn't introduced until 1926, French writer Jules Verne introduced science fiction in the late 1800s. He called his books "novels of science." In *From the Earth to the Moon* and *Twenty Thousand Leagues Under the Sea*, Verne described and predicted **technological designs** that did not yet exist. Two of his most astonishing designs were a cannon-propelled spacecraft and a whale-shaped submarine called the *Nautilus*.

#### Mathematics

What do hot-air balloons, jellyfish, and umbrellas have in common? They all share a **mathematical concept called cylindrical symmetry**. The top and bottom of an object with cylindrical symmetry may be different, but all distances are the same from its vertical axis. You may remember a childhood toy that included a set of different-sized rings that you placed over a central rod. The rings were different sizes, but they shared a vertical axis, and thus were cylindrically symmetrical.

Fig. 3–30 What other objects can you think of that illustrate the concept of cylindrical symmetry? Photo courtesy Anette

#### Science

Have you ever heard the term "ergonomic design"? Ergonomics is an applied science in which objects are designed to work effectively with the human body. For this reason, ergonomics is sometimes called human engineering. One example you may have seen is the ergonomic computer keyboard, which has keys placed to fit the natural movements of the fingers and hands. What examples of ergonomics do you encounter in your daily life?

#### **Other Arts**

#### **Theater**

Theater requires special kinds of designers,

each with an area of expertise. The stage designer creates a set that communicates the mood of the show. Lighting designers decide which parts of the set and which actors to expose or to leave in shadows. The lighting (for example, a spotlight on characters delivering important dialogue) helps direct the audience's attention to what is important. The costume designer uses clothing to help convey the personalities of different characters. What other features do you think add to a theater performance?

Internet Connection
For more activities related to this chapter, go to the Davis Website at www.davis-art.com.

Artists as Designers

143

#### **Mathematics**

Bring to class a few bulbous fruits and vegetables, such as zucchini, squash, and pears. Slice them horizontally with a paring knife, and use them to demonstrate the concept of cylindrical symmetry. Fan out the slices to show students that each slice is radially symmetrical, even though the slices are different sizes. Challenge students to suggest other objects that have cylindrical symmetry.

#### Other Arts

Show students the first five minutes of a videotape or movie of a theatrical performance, but keep the sound off. Stop the tape, and ask students to describe what choices they think the stage, lighting, and costume designers made for the production. Then have students explain what information these choices convey.

Ask: What can you learn about the period and location of the story? By analyzing the theatrical designs, what can you learn about the relationships and the personalities and social status of the characters?

#### **Internet Resources**

# Cooper-Hewitt National Design Museum

http://www.si.edu/ndm/

This branch of the Smithsonian Institution houses industrial designs, textiles, and wall coverings from around the world.

#### The Museum of Modern Art

http://www.moma.org/

Browse through the world's first curatorial department devoted to architecture and design at The Museum of Modern Art in New York City.

#### **Community Involvement**

Invite reputable buyers, merchandisers, or retailers in your community to talk with students about "designer" merchandise and consumer issues of quality, status, best buys, and so on. Encourage guests to help make students more aware of quality design and consumer value.

#### **Interdisciplinary Planning**

Look realistically at the art program within the context of the whole school. Remember that your art program is a single thread running through the fabric of education. Keeping this in mind will help you and your colleagues to focus on the essential interdisciplinary connections. Keep asking "What's the point?"

#### **Talking About** Student Art

Whenever you lead a discussion on the relationship between the form and function of students' artworks. ask student artists first to listen to what others have to say. After the class has talked about the work, the artist can then respond to the comments and talk about the work's relationship between form and function.

#### Portfolio Tip

Encourage students to come up with several designs they think would be

appropriate for personalizing both the outside and inside of their portfolio. Students need not actually carry this out.

#### Sketchbook Tip

Have students design appropriate borders and title pages for different sections

of their sketchbook.

# **Portfolio**

"When I was making the birdhouse, I was thinking of a day and night theme. I have always liked suns and moons. The difficult part was making the clay the right width."

Marilyn Kane

Fig. 3-32 Product designers often do drawings or models of new design ideas. What does a model show that a drawing does not? T. L. Tutor,

Geometric Silverware, 2000. Wood, wire, yarn, metal, clay 6" to 7 1/2" long (15 to 19 cm). Islesbord Central School, Islesboro, Maine.

Fig. 3-31 How is the design of this artwork both decorative and functional? Marilyn Kane, Ceramic Birdhouse, 2001. Clay, glaze, 5 ½" x 5" x 5 ¾" (14 x 13 x 14.5 cm). Fred C. Wescott Junior High School, Westbrook, Maline.

"The knife took the longest to make because I did it first. The other ones were easier because I got better each time. I was trying to make them all relate to each other, so I got the idea to make them all have a shape at the end." T. L. Tutor

Fig. 3-33 Labeling certain items shows the level of planning in the mind of the artists. It also helps convince the viewer that this could be a design for a real invention. Aaron Burnett, Diego McCombs, Sub. Limo. 14, 2001. Pencil, markers, 9 1/2" x 13 1/2" (24 x 34 cm). Thomas Metcalf Laboratory School, Normal, Illinois.

#### **CD-ROM Connection**

To see more student art. view the Personal Journey Student Gallery.

144

# **Teaching Options**

#### Resources

Teacher's Resource Binder Chapter Review 3 Portfolio Tips Write About Art **Understanding Your Artistic Process** Analyzing Your Studio Work

For students' inspiration, for comparison, or for criticism exercises, use

the additional student works related to studio activities in this chapter.

# **Chapter 3 Review**

#### Recall

Name three different kinds of designers, and explain what they do.

#### Understand

Using the example of the tea jar shown in Fig. 3–18 and below, explain the basic rules of traditional design in Japan.

#### Apply

Draw a design for a new scooter. To plan your design, answer the questions about the design process on page 126.

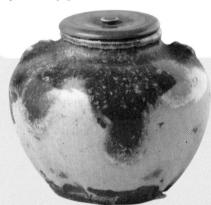

Page 134

#### Analyze

Choose a designed object and identify its function and decorative features.

#### Synthesize

Use your knowledge of standard human proportion to design a computer workstation for your classroom. Include the dimensions on your design.

#### Evaluate

Select a package design, and judge how well the size, shape, and materials hold the product. Also judge how well the design communicates a message about the product. Give reasons for your judgments.

#### **For Your Portfolio**

Use your portfolio as a place to store your artwork, essays, and other completed work. Whenever you include an

artwork, fill out an artist's statement form. Write your name and date, and what media and techniques you used. Identify your artwork's message. Write what you like about the artwork and what things you would change if you reworked the piece.

#### For Your Sketchbook

Your sketchbook is a place for collecting found images as well as creating your own. On a page in your sketchbook,

paste an envelope or pocket for keeping cutouts or clippings of designs that you like.

Artists as Designers

145

#### Advocacy

Ask students to honor the school administrators by thanking them for supporting the art program and for making art an essential part of student learning. Have students design an award with this message, and display it in the school lobby.

#### **Family Involvement**

Ensure that family members understand that their assistance is welcome in your classroom. Prepare a short, simple list of pointers to help them feel comfortable in assisting students who require individual attention.

#### Chapter 3 Review Answers Recall

Answers will vary, but may include fashion, clothing, product, fabric, jewelry, shoe, accessory, interior, landscape, theater, graphic, package, or Web designers.

#### **Understand**

The tea jar has uneven, simple shapes and a timeless look.

#### **Apply**

Students should identify the problem to be solved, explore the problem, brainstorm for ideas, make sketches and select one to refine, consider how the product might be made, and evaluate the extent to which the final design addresses the problem.

#### **Analyze**

Look for evidence that student understands the difference between decorative and functional features.

#### **Synthesize**

Designs will vary. Look for evidence that student has considered human proportion.

#### **Evaluate**

Look for appropriate reasons addressing the size, shape, materials and message of the package design.

#### Reteach

Provide students with pads of "stickies"—small squares of paper that can be easily placed and removed from objects. Have them label objects in the classroom, noting what kind of designer was involved in creating each object. They should review the text to find examples of different kinds of designers—fashion, product, graphic, and so on. Summarize by explaining that artists as designers play an important role in our society.

2

2

3

6

2

# **Chapter Organizer**

#### Chapter 4 Artists as Teachers

Chapter 4 Overview pages 146–147

#### **Chapter Focus**

- Core Artists create artworks that teach important lessons. Artworks are used to teach beliefs and values throughout history and around the world.
- 4.1 Art and Beliefs
- · 4.2 Lettering and Calligraphy
- . 4.3 Islamic Art of North Africa
- · 4.4 Designing a Poster

#### **Chapter National Standards**

- 1 Understand media, techniques, and processes.
- 2 Use knowledge of structures and functions.
- 3 Choose and evaluate subject matter, symbols, and ideas.
- 4 Understand arts in relation to history and cultures.
- 5 Assess own and others' work.
- 6 Make connections between disciplines.

#### **Objectives**

 Identify ways that artists use artworks for the purpose of teaching.
 Explain what artists as teachers must consider when creating their artworks.

#### **National Standards**

- **2b** Employ/analyze effectiveness of organizational structures.
- 4a Compare artworks of various eras, cultures.
- **5b** Analyze contemporary, historical meaning through inquiry.

#### Core Studio A Teaching Puppet page 152

**Core Lesson** 

Teacher

page 148

The Puppeteer as

Pacing: Two or more

45-minute periods

- Create a puppet to teach a lesson of their choosing.
- 1a Select/analyze media, techniques, processes, reflect.
- **3b** Use subjects, themes, symbols that communicate meaning.

#### **Objectives**

Then and Now Lesson 4.1 Art and Beliefs page 154

Page 154
Pacing: Five or more
45-minute periods

- Identify lessons that large-scale art forms can teach.
- Explain the appearance of Barbara Kruger's art and how it teaches important lessons.

#### **National Standards**

- 1a Select/analyze media, techniques, processes, reflect.
- 3a Integrate visual, spatial, temporal concepts with content.
- **4b** Place objects in historical, cultural contexts.
- **5b** Analyze contemporary, historical meaning through inquiry.

### Studio Connection page 156

- Paint a mural that teaches an important lesson.
- **3b** Use subjects, themes, symbols that communicate meaning.

Skills and Techniques Lesson 4.2 Lettering/Calligraphy

page 158
Pacing: One or more
45-minute periods

#### **Objectives**

· Understand uses of calligraphy.

#### **National Standards**

5c Describe, compare responses to own or other artworks.

#### Studio Connection

page 159

- Use calligraphy to letter a poem, quote, or message that teaches a lesson.
- **1b** Use media/techniques/processes to communicate experiences, ideas.

#### **Featured Artists**

Judy Chicago Lawrence Halprin Jim Henson Barbara Kruger Ambrogio Lorenzetti Diego Rivera Norman Rockwell Ben Shahn Osman Waqialla

#### **Chapter Vocabulary**

arabesques calligraphy poster proportion monument mural

#### **Teaching Options**

Teaching Through Inquiry
More About...Jim Henson
Using the Large Reproduction
Teaching Through Inquiry
More About...Kachinas
More About...Judy Chicago
Using the Overhead

#### Technology

CD-ROM Connection e-Gallery

#### Resources

Teacher's Resource Binder Thoughts About Art: 4 Core A Closer Look: 4 Core Find Out More: 4 Core Studio Master: 4 Core Assessment Master: 4 Core

Large Reproduction 7 Overhead Transparency 8 Slides 4a, 4b

Meeting Individual Needs More About...Bunraku Teaching Through Inquiry Assessment Options CD-ROM Connection Student Gallery Teacher's Resource Binder Studio Reflection: 4 Core

#### **Teaching Options**

Teaching Through Inquiry
More About...Ambrogio Lorenzetti
More About...Diego Rivera
Using the Overhead

#### Technology

CD-ROM Connection e-Gallery

#### Resources

Teacher's Resource Binder Names to Know: 4.1 A Closer Look: 4.1 Find Out More: 4.1 Assessment Master: 4.1 Overhead Transparency 7 Slides 4c

Meeting Individual Needs Advocacy Teaching Through Inquiry More About...Barbara Kruger Assessment Options CD-ROM Connection Student Gallery Teacher's Resource Binder Check Your Work: 4.1

#### **Teaching Options**

Teaching Through Inquiry Using the Overhead Assessment Options

#### **Technology**

CD-ROM Connection e-Gallery

#### Resources

Teacher's Resource Binder Finder Cards: 4.2 A Closer Look: 4.2 Find Out More: 4.2 Assessment Master: 4.2 Overhead Transparency 8 Slides 4d

CD-ROM Connection Student Gallery Teacher's Resource Binder Check Your Work: 4.2

# Chapter Organizer continued

18 weeks

36 weeks

2

#### **Objectives**

#### **National Standards**

- **Global Destinations** Lesson 4.3 **Art of North Africa** page 160 Pacing: Two 45-minute
- · Explain the difference between calligraphy and writing.
- Describe how calligraphy is used in Islamic artworks of North Africa.
- 3a Integrate visual, spatial, temporal concepts with
- 5b Analyze contemporary, historical meaning through inquiry.

- **Studio Connection**
- Create a wall plaque that teaches something
- 3a Integrate visual, spatial, temporal concepts with

#### page 162

periods

- important.
- content.

#### 3

#### 3 Studio Lesson 4.4 **Designing a Poster**

page 164 Pacing: Two or more 45-minute periods

#### **Objectives**

#### Use examples to explain how posters can be used to teach important lessons.

- Explain why proportion and scale are important considerations when creating a poster to teach an important lesson.
- Create a poster to teach a lesson.

#### **National Standards**

- 2c Select, use structures, functions.
- 3b Use subjects, themes, symbols that communicate meaning.
- 4c Analyze, demonstrate how time and place influence visual characteristics.
- 5b Analyze contemporary, historical meaning through inquiry.

#### **Objectives**

#### **National Standards**

Connect to... page 168

- Identify and understand ways other disciplines are connected to and informed by the visual
- Understand a visual arts career and how it relates to chapter content.
- 6 Make connections between disciplines.

#### **Objectives**

#### **National Standards**

Portfolio/Review page 170

- · Learn to look at and comment respectfully on artworks by peers.
- Demonstrate understanding of chapter content.
- 5 Assess own and others' work.

2 Lesson of your choice

#### **Teaching Options**

Teaching Through Inquiry More About...Sudan Using the Large Reproduction

#### Technology

CD-ROM Connection e-Gallery

#### Resources

Teacher's Resource Binder A Closer Look: 4.3 Find Out More: 4.3 Assessment Master: 4.3 Large Reproduction 8 Slides 4e

Meeting Individual Needs Teaching Through Inquiry More About...Mohammed Assessment Options

CD-ROM Connection Student Gallery Teacher's Resource Binder Check Your Work: 4.3

#### **Teaching Options**

Teaching Through Inquiry
More About...Four Freedoms
Using the Overhead
Teaching Through Inquiry
More About...Posters and billboards
Assessment Options
Studio Collaboration

#### Technology

CD-ROM Connection Student Gallery Computer Option

#### Resources

Teacher's Resource Binder Studio Master: 4.4 Studio Reflection: 4.4 A Closer Look: 4.4 Find Out More: 4.4 Overhead Transparency 8 Slides 4f

#### **Teaching Options**

Community Involvement Interdisciplinary Planning

#### **Technology**

Internet Connection Internet Resources Video Connection CD-ROM Connection e-Gallery

#### **Resources**

Teacher's Resource Binder Using the Web Interview with an Artist Teacher Letter

#### **Teaching Options**

Advocacy Family Involvement

#### Technology

CD-ROM Connection Student Gallery

#### Resources

Teacher's Resource Binder
Chapter Review 4
Portfolio Tips
Write About Art
Understanding Your Artistic Process
Analyzing Your Studio Work

#### **Chapter Overview**

#### Theme

We often rely on others to teach us what is important for us to know. Some artists make artworks to teach important ideas and values.

#### **Featured Artists**

Judy Chicago
Lawrence Halprin
Jim Henson
Barbara Kruger
Ambrogio Lorenzetti
Diego Rivera
Norman Rockwell
Ben Shahn
Osman Waqialla

#### **Chapter Focus**

This chapter features Jim Henson, Barbara Kruger, and other artists who make artworks to teach important lessons. Students learn how artworks have been used to teach beliefs and values throughout history and around the world. They discover that artworks that teach may include words as well as imagery. After studying the Islamic tradition of teaching through the use of calligraphy, students create their own calligraphy and other kinds of lettering to include in their artworks, and also create a poster to teach something.

#### National Standards Chapter 4 Content Standards

- 1. Understand media, techniques, and processes.
- 2. Use knowledge of structures and functions.
- 3. Choose and evaluate subject matter, symbols, and ideas.
- 4. Understand arts in relation to history and cultures
- 5. Assess own and others' work.
- **6.** Make connections between disciplines.

4

# Artists as Teachers

Fig. 4–1 Jim Henson could not have known that his character Kermit would be familiar to children and adults throughout the world. What lessons do you remember learning from Kermit? Kermit.

146

# **Teaching Options**

#### **Teaching Through Inquiry**

Aesthetics On the board, write: painting, drawing, printmaking, sculpture, puppets, jewelry, graphic design, photography, video, television. Have students work in groups to consider the pros and cons of selecting each art form as a way to teach. For example, although a painting may be carefully planned to teach an important belief, it is a single piece that can be seen by only a small number of people at one time. Have groups share their findings in a large-group discussion.

#### More About...

Sesame Street was created after a study showed that young children remember much of what they see in commercials. The show was designed to "sell" numbers and letters, much like commercial advertisers try to sell their products. The characters' creators are sculptors, woodworkers, painters, designers, costumers, prop makers, chemists, and engineers. The materials for making Muppets include Ping-Pong balls, feathers, Teflon tubing, fake fur, and foam sheeting.

#### **Focus**

- Who are the teachers in our world?
- How do artists use their artworks for teaching?

Our first teachers are our parents and siblings. They teach us how to do many things—tie our shoes, eat with utensils, ride a bike, and even to read. In school, we learn from our classmates and teachers. We learn, for example, about important people, events in history, and ideas in science and math. We also learn new skills. Some of the most important things we learn are good habits (such as studying hard) and values (such as the importance of being considerate and of caring for the environment). We also learn from our experiences outside of home and school. Grandparents, neighbors, and people we see on television or listen to on the radio are some of the teachers among us.

The artist Jim Henson created Kermit the Frog (Fig. 4–1) and other Muppets. For over thirty years, his *Sesame Street* characters have taught small children important lessons, such as to count and sound out words, and to be polite and responsible in daily life. In the lessons that follow, you will read about Jim Henson and other artists who have made

artworks for the purpose of teaching.

Jim Henson Barbara Kruger Osman Waqialla

monument mural calligraphy arabesque poster proportion

Artists as Teacher

147

#### Chapter Warm-up

Have volunteers sing and/or recite the lyrics to several TV advertisements. Ask the rest of the class to guess the product that the song advertises. **Ask:** What have you learned from television?

#### **Using the Text**

Art History Ask: Who are our teachers? Have students work in pairs to develop a list of people and things that they learn from. Combine their responses into a class list. Ask: What do you remember having learned from Kermit?

#### Using the Art

Perception Ask: From what materials is this puppet made? How, do you think, does he "move"? (Puppeteers below the view of TV monitors manipulate wires connected to his hands.)

Aesthetics Ask: Is Kermit a work of art? Why or why not?

#### Extend

Challenge students each to compose their own teaching song about something that they have studied in school. Encourage them to create a visual or prop to reinforce their lesson. Allow students to teach their lesson to their classmates or another class.

Jim Henson

Graphic Organizer Chapter 4

#### **Core Lesson**

The Puppeteer as Teacher

Core Studio
A Teaching Puppet
page 152

4.3 Global
Destinations Lesson
Islamic Art of North Africa

4.4 Studio Lesson

page 160

Designing a Poster

#### **CD-ROM Connection**

For more images relating to this theme, see the Personal Journey CD-ROM.

4.1 Then and Now Lesson
Art and Beliefs
page 154

# 4.2 Skills and Techniques Lesson

Lettering and Calligraphy page 158

147

#### **Prepare**

#### **Pacing**

Two or more 45-minute periods: one to consider text and images; one or more to plan and make puppets

#### **Objectives**

- · Identify ways that artists use artworks for teaching.
- · Explain what artists as teachers must consider when creating their artworks.
- · Create a puppet to teach a lesson.

#### Vocabulary

monument An artwork created for a public place that preserves the memory of a person, event, or action.

#### **Supplies for Engage**

· Sesame Street video clip featuring the Muppets

#### **National Standards** Core Lesson

- 1a Select/analyze media, techniques, processes, reflect.
- 2b Employ/analyze effectiveness of organizational structures.
- 3b Use subjects, themes, symbols that communicate meaning.
- 4a Compare artworks of various eras, cultures.
- 5b Analyze contemporary, historical meaning through inquiry.

# The Puppeteer as Teacher

"When I was young, my ambition was to be one of the people who made a difference in this world. My hope still is to leave the world a little bit better for my having been here."

Jim Henson (1936-1990)

LESSO

CORE

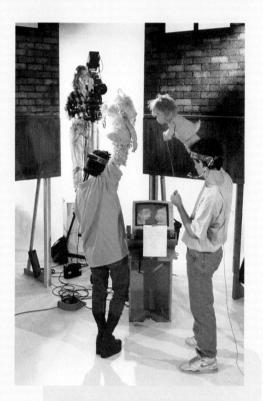

Fig. 4-2 The arms or hands of Muppets are attached to rods. The rods are controlled from below by puppeteers. Puppeteers Handling Muppets.

#### Jim Henson's Journey

When Jim Henson was a boy, he loved to use different art materials and techniques to make things. His grandmother was a painter, quilter, and needleworker. She encouraged her grandson to explore the world around him and always to use his imagination. He particularly liked his art classes and was very active in high-school theater productions. When he saw television for the first time, as a teenager, he knew that he would make a career working with this new and exciting medium.

Henson's interests in art, theater, and television all came together when he landed a job as a puppeteer on a local children's television show. He was only eighteen. One year later. Henson created Kermit, his most famous puppet.

148

# **Teaching Options**

#### Resources

Teacher's Resource Binder Thoughts About Art: 4 Core A Closer Look: 4 Core Find Out More: 4 Core Studio Master: 4 Core Studio Reflection: 4 Core Assessment Master: 4 Core Large Reproduction 7 Overhead Transparency 8 Slides 4a, 4b

#### Teaching Through Inquiry

Art Criticism Have students work in small groups to analyze the relationship between the form and function of the Muppets shown in this lesson. Ask students to create a chart with four columns: in the first column, they write the name of each Muppet; in the second, words and phrases that describe each Muppet's appearance; in the third, words and phrases that describe each Muppet's role on Sesame Street, noting especially what kinds of things the Muppet usually teaches; in the fourth, an explanation of how each Muppet's appearance supports its teaching role.

Fig. 4–3 Muppets are sof and flexible. This allows them to show different facial expressions. How could this be important for a teaching puppet?

Muppets.
© The lim Henson Company.

# Creativity Through Collaboration

From early on, Henson collaborated. He and Jane Nebel, whom he later married, brought in others to work with them. Eventually, Henson was asked to create a group of puppets for a new show, *Sesame Street*. Henson's work resulted in the "birth" of the Muppets: Ernie and Bert, Oscar the Grouch, Grover, Cookie Monster, and Big Bird. Collaboration is important because it takes many people to operate the Muppets

(Fig. 4–2). The puppeteers all must work together to make a successful show.

Over the years, Henson and his team created many more Muppets for Sesame Street and other television shows and movies (Fig. 4–3). Henson's great sense of humor helped his characters teach important information and good habits in a fun and entertaining way.

Artists as Teachers

149

#### Teach

#### Engage

Show the Sesame Street clip. Ask: How is this like a TV commercial? What would cause children to pay attention to this video? Discuss what young children can learn from this segment, and call students' attention to the repetition of information through both sound and sight.

#### **Using the Text**

Art Careers Ask: What is the meaning of collaboration?

#### **Using the Art**

Perception Have students study the photograph of Jim Henson and the Muppets on page 149. Ask: What do these puppets have in common? How are they different? Which features did the artists emphasize in each? How do the features suggest the personalities? How do the facial proportions differ from human proportions? Discuss the scale among the various Muppets, including Big Bird.

Perception Have students study Fig. 4–2. Ask: What is happening in this photograph? Why were the puppeteers looking at a TV monitor? What decisions do you think the camera operator had to make? What did viewers see on their home screens? Why should a TV director study art?

#### More About...

Jim Henson, born in Greenville, Mississippi, did eventually fulfill his ambition (see the artist's statement on page 148): he had a moving effect on folks worldwide.

Sesame Street has been broadcast in over 120 countries, and the Muppet Show reached 235 million viewers during its five-year run. Key to Henson's appeal was his mixture of education, innovation, and zany humor aimed at family audiences, not just children.

#### **Using the Large Reproduction**

#### Talk It Over

**Describe** Identify the subject matter and other details in this painting.

**Analyze** Explain how the artist organized the parts of the painting to attract and hold the viewer's attention.

**Interpret** Explain the lesson that this painting teaches about living and working in the rural Midwest during the early part of the twentieth century.

Evaluate Determine whether this lesson about life at an

earlier time still has relevance today.

#### **Artists as Teachers**

# **Using the Text**

Art History Ask: What decisions do artists make as they create a work to teach a lesson? (the scale of the artwork, what lesson to teach, how to help viewers learn the lesson, where and how art will be viewed) Why do the Hopi give their children kachina dolls? (to teach about the Hopi spirits and religious symbolism)

# Using the Art

Perception/Art History Have students compare these kachinas to each other. Ask: What type of headdress is each wearing? What are the colors and the textures of each? How did the artists suggest nature forms?

Perception/Art History Ask: How could a visit to the FDR Memorial suggest moving through time? How did the architect unify this work? (by having water flow through it; by repeating waterfalls and granite blocks)

Perception Ask: What do you see in Judy Chicago's The Dinner Party? (The feminist installation of thirtynine ceramic place settings commemorates great female historical, mythological, and cultural figures.) Why, do you think, did she choose this theme?

# The Teaching of Traditions

LESSON

CORE

Artists worldwide have created artworks to help people learn important traditions within their own culture. Artworks can also teach community values and facts about history. All teachers must make choices about how to teach. In art, this means that artists make choices about what lesson to teach and how to help their viewers learn that lesson. To do so, artists think about scale (the size of the artworks they will produce). They also think about where and how people will view their artworks.

Dolls and other small-scale objects are very useful for teaching. The Hopi of the American Southwest, for example, use small kachina figures (Fig. 4–4) to help teach children about the spirits and symbolism important to Hopi religious beliefs. Before traditional annual celebrations, Hopi fathers and uncles carve kachinas and present them to the children.

Fig. 4–4 Hopi children use figures such as these to help them remember each kachina's story and special religious function. Native American, Sio Hemis, Kachina, 19th–20th centuries.

Carved and painted wood. Fred Harvey Collection, Heard Museum, Phopolic Adriao.

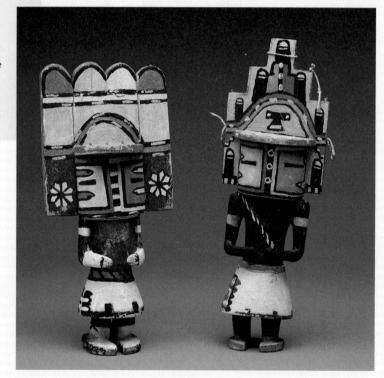

150

# **Teaching Options**

## **Teaching Through Inquiry**

Art Production Explain that each artwork on these pages was created to teach about special individuals. Ask students to plan an artwork to teach about one or more individuals whom they consider important, such as a president or hero, a group of artists from their state or community, or a character from a story. Students may wish to design a memorial park like the FDR Memorial, or a three-dimensional representation of a person, like the kachinas. To teach about a group of people, students could design a dinner plate to commemorate each member, like those created by Judy Chicago, and ask students to make sketches of their ideas and share them with their classmates.

#### More About...

Kachinas represent the benevolent spirit beings who visit the Hopi each year. During the winter solstice, costumed Hopi men assume the kachina's powers in ceremonies and dances. Kachinas represent sun, death, weather, human qualities, demons, plants, and animals. Traditionally, Hopi men carved kachinas in kivas (chambers, usually underground, where men hold meetings and ceremonies) and gave them to infants, young girls, and women during community ceremonies.

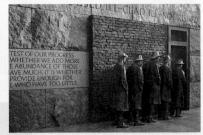

Fig. 4–5 The FDR Memorial covers more than 7 acres. As visitors move through a series of waterfalls and read inscriptions carved into granite, they go on a journey through time. George Segal, Bread Line (aerial view and closeup), 1997. Bronze. Room 2 from the Franklin Delano Roosevelt Memorial, Washington, DC. Photo by Lawrence Halprin.

Fig. 4–6 Judy Chicago gathered many people together to help her create this installation. When assembled, it fills an enormous room. Judy Chicago, *The Dinner Party*, 1979.

Mixed media, 48 × 42 × 3′ (15 × 13 × 1 m). Collection: The Dinner Part Trust, Photo: Donald Woodman. © 2001 Judy Chicago/Artists Rights Society (ARS), New York.

# Teaching for a Better World

Throughout history, artists have created artworks for the walls and other features of religious or public buildings. These artworks remind people of shared values and beliefs. Artists have also created public structures to teach about events and people from the past. One such public monument is the Franklin Delano Roosevelt Memorial (Fig. 4–5), in Washington, DC. Lawrence Halprin designed the memorial as a series of outdoor "rooms." Each room represents one of the four terms that Roosevelt served as president. The memorial allows visitors to learn about the important events of his presidency.

Individual artists sometimes use their artworks to teach people to think differently about things—to change their mind or attitudes. In recent times, artists have created artworks to teach us to think differently about issues facing our society. In her installation *The Dinner Party* (Fig. 4–6), artist Judy Chicago teaches about the artistic and other contributions of women throughout history. Each place setting at the table represents an important woman in history. Violence, poverty, the role of women, and racial tensions are some of the other topics addressed by artists as teachers.

Artists as Teachers

151

## **Critical Thinking**

Explain to students that, like most public memorials, the design for the FDR Memorial was heavily criticized: critics questioned its physical scale and its \$50 million cost; disability advocates wanted Neil Estern's sculpture within the memorial to show more of Roosevelt's wheelchair. Guide students in imagining that a civic group has proposed for the center of the community, a \$3 million memorial honoring a local hero. Have students mock-debate the pros and cons of this memorial to the city or town council.

#### **Extend**

Lead students in remembering national or community events—such as political inaugurations, destruction from storms or earthquakes, sportsvictory celebrations—that have affected either them or their family. Direct students each to design a sculpture for their community to commemorate one of the events. Have students build a small-scale model and suggest a site for the sculpture, and encourage them to consider how the location will affect their design.

#### More About...

Feminist artist **Judy Chicago** (born Judy Cohen, in 1939) enlisted women volunteers to help create her *Dinner Party* installation, which teaches about women's roles in fine arts and history. Craft techniques traditionally done by women, such as china painting and stitchery, depict women's historical roles. Thirty-nine place settings rest on a triangle, an ancient symbol for women. The table is on a white tile floor inscribed with 999 names of other women of achievement, thereby providing the "foundation" for the honored guests, which include Georgia O'Keeffe, Hatshepsut, Sacagawea, and Susan B. Anthony. Oversized ceramic plates (featuring stylized female designs), goblets, and utensils rest on long place mats. Each place mat is covered with symbols of its honored quest's achievements.

### **Using the Overhead**

#### Think It Through

**Ideas** What ideas seem important in this teaching artwork?

Materials What materials did the artist use?

**Techniques** What techniques did the artist use?

Audience Who could benefit from the lesson taught in this artwork?

# **Artists as Teachers**

# **Supplies**

- found objects, such as cardboard tubes, foam balls, socks, dowels, felt, fabric scraps, trimmings (ribbon, rickrack, and so on), and gloves
- scissors
- white glue (hot-glue gun and glue, optional)
- · markers (optional)
- tempera or acrylic paint and brushes (optional)

# **Using the Text**

Art Production Have groups create a puppet show that will teach a lesson. Lessons may be based on historical events, literature, science concepts, or moral issues. Ask: How will you use facial features and clothing to suggest your puppet's personality? What props will the puppets need? How large should these props be to fit the puppets' scale? Demonstrate constructing puppets.

# **Using the Art**

Art Criticism Using information in the caption, compare the size of the hand puppets to the size of the bunraku puppet. Discuss how puppeteers manipulate these. Ask: Can you see the puppeteers manipulating the bunraku puppet?

# **Assess**

# **Check Your Work**

Have students work with a partner who is from a group other than their own. Direct students each to write two descriptions: one of the personality of their own puppet and one of their partner's puppet, based only on each puppet's appearance. Ask: Do the two descriptions of each puppet agree? If partners find differences, ask them to suggest ways to make the personality of either or both puppets more understandable.

#### Sculpture in the Studio

# **A Teaching Puppet**

CORE STUDIO

When artists create artworks for the purpose of teaching, they must consider what they want to teach and how they will teach it. **In this studio** 

experience, you will create a puppet that will help you teach something important. Do you want to teach an event in history, the importance of good habits, or something about caring for the environment?

As you think of ideas for your puppet, reflect on your audience, what you want to teach, and the kind of puppet character that can help you. Write down your ideas. The character you create should have a personality especially suited for the teaching.

#### You Will Need

- puppetmaking materials
- scissors
- · white glue
- markers (optional)
- tempera paint and brushes (optional)

#### Try This

1. Decide what kind of puppet to make. Will you create a hand puppet or a finger puppet? Will you make an even larger puppet? The scale, or size, of your puppet will be important. A small puppet, for example, will work best with a small audience. A larger puppet might be best for a large audience.

# **Studio Background**

#### Puppet

For hundreds of years, people around the world have used puppets to tell stories and teach important lessons. In some cultures, puppet theater is almost as popular as television.

Puppets come in all shapes and sizes. Some of the largest puppets in the world can be found in Japan. *Bunraku* is a traditional form of Japanese puppetry used to tell stories about the past. A Japanese *bunraku* puppet is shown in Fig. 4–7. Because the puppets are so large, three people are needed to control each one.

On a smaller scale, hand puppets (Fig. 4–8) are another popular form of puppetry. Perhaps the smallest puppets are finger puppets. In ancient China, children played a game in which their fingers were painted. Today, finger and hand puppets are made from many different materials.

Fig. 4–7 The puppeters move the puppet's eyes, eyebrows, and sometimes its mouth, arms, and feet, while other artists play music and tell the story. Japan, Bunraku puppet, 20th century. Courtesy the Sheehan Gallery at Whitman College, Walla Walla, Washinston.

Fig. 4–8 Hand puppets are often used to tell fables and other stories that teach a lesson. Western Europe, Hand Puppets, late 19th–early 20th centuries. Painted wood, average height: 16' (41 cm), Girard Foundation Collection in the Museum of International Folk Art, a unit of the Museum of New Mexico, Santa Fe. Photo by Michel Monteaux.

152

# **Teaching Options**

#### **Meeting Individual Needs**

English as a Second Language,
Multiple Intelligences/Interpersonal and Linguistic Ask students to
choose one thing they would like to
teach that would make the world a
better place. Topics may be related
to social interactions, the environment, politics, the arts, and so on.
Work collaboratively on a skit that
conveys their message, using hand
puppets. Discuss reactions to the
process.

#### Teaching Through Inquiry

Art History Have students work in groups to investigate puppet traditions in various cultures. Direct students to use library and Internet sources to find the kinds of puppets created, how they are made, how they are used, and what purposes they serve in the culture. Encourage students to discover the extent to which puppets are used to teach important ideas and beliefs in the culture. Have groups contribute their findings to a class bulletin board.

**2.** Plan and assemble your puppet. What features will it have? What materials will you use to create the puppet? Choose materials that will suit

the size and purpose of your puppet.

**3.** When the main forms of your puppet are finished, glue on smaller items, such as sequins, yarn, buttons, and the like. How can you use details to

create a personality for your puppet? How can that personality help teach your lesson? Add other details as needed with paint or marker.

Fig. 4–9 "This scientist will teach you all you want to know about rainbows. He will teach you the colors of the rainbow, where you can see them, and what special treat waits for you at the end of a rainbow. I hope you enjoy the show." Maribeth Côtě, The Wacky Rainbow Scientist, 2000. Sock, pipe cleaners, buttons, height: 12" (30.5 cm). Thomas Prince School, Princeton, Massachusetts.

#### Check Your Work

Share your decision-making process with your classmates. Why did you decide to make your puppet the way you did? How did the lesson you wanted to teach and your intended audience affect your decisions? How did you use materials and details to create a personality that helped teach your lesson?

#### **Lesson Review**

#### **Check Your Understanding**

- **1.** What kinds of things do people often teach one another?
- **2.** How was Jim Henson's childhood important to his choice of a career?
- **3.** When artists plan to make artworks for the purpose of teaching, what must they think about?
- **4.** Can an artwork teach us something if the artist did not intend it to do so?

Artists as Teachers

153

# **Check Your Understanding: Answers**

- 1. People teach each other skills; ideas from history, science, math, and so on; good habits, and values.
- 2. Henson liked to make things with different art materials; his grandmother, who worked with fabric and paint, influenced him; he was active in theater productions; he was fascinated with television.
- 3. Artists as teachers need to think about what to teach and how to teach it. Students may also mention that artists need to think about scale.
- 4. Answers will vary. Students may indicate that because viewers bring their own ideas to their experiences with artworks, they may learn something that the artist did not intend to teach.

# Close

Allow students to present their puppet lessons to another class. Display students' puppets and personality descriptions.

#### More About...

Although the audience is aware of the puppeteers during a Japanese bunraku performance, the art form retains a seamless sense of magic. Because the puppets have movable joints, eyes, mouth, and brows, they appear highly realistic. An onstage narrator speaks, chants, whispers, and sobs, giving voice to each character. An onstage accompanist, in traditional dress, provides music and dramatic sounds, such as for rain or wind.

#### **Assessment Options**

**Teacher** Ask students to imagine being members of a group called The Community Connection, whose job is to create TV spots,

posters, flyers, and multimedia presentations that teach about the community's history, values, events, and so on. Have students each write a proposal to involve artists in the effort. The proposal must include a statement about the importance of artist involvement and a description of what artists can contribute. Look for evidence that each student understands ways that artists create artworks for teaching and what they must consider when they do.

# **Prepare**

# **Pacing**

Five or more 45-minute periods: one to consider text and images and to plan mural; one to sketch ideas; one to enlarge design; two or more to

# **Objectives**

- · Identify lessons that large-scale art forms can teach.
- Explain the appearance of Barbara Kruger's art and how it teaches important lessons.
- Paint a mural that teaches an important lesson.

# Vocabulary

mural A large painting or artwork, usually designed for and created on a wall or ceiling of a building.

# **Using the Time Line**

Consider the span of time separating Good Government and the Education Ministry mural. Point out that both frescoes are found on the walls of government buildings. Ask: Why, do you think, have the walls of civic buildings been important places to teach lessons? What kind of lessons would most likely be found there?

# **National Standards** 4.1 Then and Now Lesson

- 1a Select/analyze media, techniques, processes, reflect.
- 3a Integrate visual, spatial, temporal concepts with content.
- 3b Use subjects, themes, symbols that communicate meaning.
- 4b Place objects in historical, cultural contexts
- 5b Analyze contemporary, historical meaning through inquiry.

# **Art and Beliefs**

Rivera, Education Ministry mural

1987 Kruger, Hero

Italian Renaissance

LESSO

3

0 2

Z V

14th century Lorenzetti, Peaceful City

20th Century

1967

Wall of Respect

1990 Kruger. Think Twice

#### **Travels in Time**

Throughout history, one use of art has been to teach religious and political beliefs. In the Middle Ages, stained-glass windows and mosaics in churches were reminders of important religious lessons. In the Renaissance, artists used frescoes (Fig. 4-10) and sculptures in government

buildings and other public places to teach political beliefs. Today, murals and billboards can teach about social concerns and cultural identities. What all of these art forms have in common is their size: they are all large in scale.

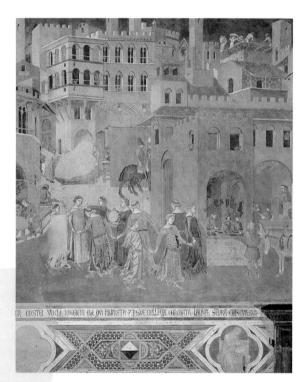

Fig. 4-10 What lesson do you think this image teaches? This is a detail of a fresco cycle that covers the walls of a large room. Ambrogio Lorenzetti, Peaceful City, from Effects of Good Government in the City and the Country Government in Green (detail), 14th century.

154

# **Teaching Options**

#### Resources

Teacher's Resource Binder

Names to Know: 4.1

A Closer Look: 4.1

Find Out More: 4.1

Check Your Work: 4.1

Assessment Master: 4.1

Overhead Transparency 7

Slides 4c

#### **Teaching Through Inquiry**

Art History Have small groups of students do research on murals that teach. Assign each group a specific time period. Ask groups to present their findings on a time line.

## **Murals That Teach**

A mural is a large artwork that is usually painted on the wall or ceiling of a public building. Murals are one way to remember the people and events that helped shape a nation. Some of the most beautiful murals are those created in the first half of the twentieth century in Mexico City. The large-scale murals by Diego Rivera (Fig. 4–11) are used to teach the Mexican people about their country's history. Rivera was one of a group of Mexican muralists that also included David Alfaro Siqueiros and José Clemente Orozco. These artists painted huge murals with larger-than-life figures.

The Wall of Respect in Chicago (Fig. 4–12) was an important teaching mural painted in the second half of the twentieth century. It showed a number of African-American political, historical, and popular-culture figures. Painted in 1967 on an abandoned building, the mural was destroyed along with the building in 1971. But it inspired hundreds of similar murals in neighbor-

Fig. 4-11 Diego Rivera's murals remind people of the past and give them hope for the future. How is a mural useful in teaching? Diego Rivera, The People Receive Books, 1923-28.

Fig. 4-12 How can a mural on the side of a building contribute to your personal journey in the place you live? The Original Wall of Respect, 1967; destroyed 1971. Originally at 43rd and Langley, Chi

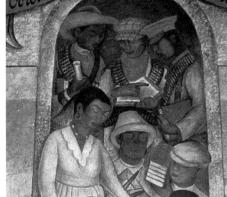

hoods across America. These murals, like so

many artworks before them, teach us about

the past and what should be remembered in

the future.

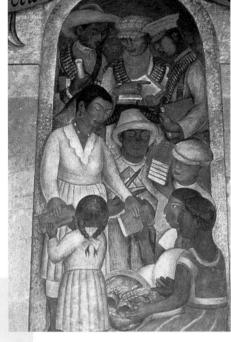

Artists as Teachers

155

Teach

### Engage

Ask students to describe the largest painting, photograph, or mosaic they have seen. Ask: What is the message of any murals or billboards in the community? Why, do you think, did artists make them so large?

# **Using the Text**

Art History Ask: What art form did artists of the Middle Ages use to teach religious messages? What art forms did Renaissance artists use to teach political beliefs? What was Diego Rivera teaching in his Education Ministry murals?

# Using the Art

Art History Ask students to describe the medieval Italian town and what activities the people are doing in Lorenzetti's fresco. Guide students to see the patterns created by the windows.

Art Criticism Have students compare Rivera's composition to Lorenzetti's. Ask: What was each artist interested in showing? What is the relative proportion in size of the people to the architecture in each work? How much space did each artist leave between the figures?

#### More About...

Muralist Diego Rivera (1886-1957) studied art in Mexico City and then in Europe. After returning to Mexico, however, he rejected European art as elitist. Instead, he felt that his political murals, which celebrated Mexico's heritage. were nonelitist—and therefore accessible to the masses. An active leader in the Communist party, Rivera often depicted Communist leaders symbolically in his murals. (Much to his consternation, however, he was expelled from the party in 1927.) His political sympathies were at times ambiguous: he accepted commissions from American capitalists, such as John D. Rockefeller.

# **Using the Overhead**

#### Investigating the Past

Describe What do you see in this picture?

Attribute Do you recognize it as a detail of a larger image in the book? If it were a different work, how would you know that it was probably painted by the same artist?

Interpret What lesson, do you think, was being taught in this portion of the mural?

**Explain** Why might this artwork have been important to the people at the time it was made?

# **Art and Beliefs**

# **Using the Text**

Art Criticism Ask: How does Barbara Kruger's art teach? What are some things that Kruger did before she began to create the type of art shown here? What are stereotypes? (oversimplified ideas or images) Clichés? (overused expressions) What is the stereotype of a football player? A rock-band member? An artist? Do all football players, rock-band members, and artists fit their stereotype?

# **Using the Art**

Art Criticism Ask: How does blackand-white photography emphasize Kruger's message? What stereotype about heroes is suggested here? How did Kruger challenge the stereotype?

#### **Studio Connection**

If possible, get school administration approval of an area for students either to

paint or display a mural. Have students elect a subject and discuss ways of depicting it. Assign each student an item or area to draw on 9" x 12" paper. Encourage students to draw their assignment from different viewpoints. Display the drawings, and guide the students in deciding how they can arrange these images for the mural. Ask: Which objects will you make large? What will be in the foreground and the background? Have students sketch possible layouts and then choose one sketch, draw a grid over it, and make copies of the design. Have a student team use pencil, charcoal, or chalk to draw a large grid on the wall or on mural paper. Ask students each to draw and paint their section or object on the mural surface. If students are working directly on a wall, provide latex house paints.

**Assess** See Teacher's Resource Binder: Check Your Work 4.1.

#### **Teaching Through Challenges**

"I just say I'm an artist who works with pictures and words."
Barbara Kruger (born 1945)

Photo: Timothy Greenfield-Sander

Not all artworks instruct you to follow certain rules or provide you with answers. Barbara Kruger does not say that her artworks teach. But they do teach because they challenge you to think about, and even to reject, a message or idea.

Growing up in New Jersey, Kruger took photographs of buildings and neighborhoods. But she lost interest in that when she started

working for magazines. As a graphic designer for a magazine, she learned to look carefully at photographs. She thought about making them larger or smaller, focusing in on one part, and placing type over them. This experience helped her as an artist and gave her the confidence to use "found" images to create her own art

Fig. 4–13 What lesson is introduced with this large-scale image? How would seeing this image as a billboard differ from seeing it as a small painting on a museum wall? Barbara Kruger, Untitled (Think Twice), 1992. Photographic silkscreen or winyl, 102\* x 82 1/2\* (259 x 205,5 cm). Courtesy of Mary

156

THEN AND NOW LESSON

# **Teaching Options**

# **Meeting Individual Needs**

Multiple Intelligences/Logical-Mathematical and Naturalistic Have student pairs each select one of the images by Barbara Kruger and then show their image to five males and five females outside the classroom. Have students ask and chart the answers to these questions: What was this image meant to teach us? Do you like the artwork? Have pairs present the results, and discuss any patterns in responses among males and females: for instance, whether more females than males think the message is pro-women, or whether fewer males than females liked the work. Have students debate whether artists who want their work to teach something have to consider in advance their audience's preferences.

### Advocacy

Make arrangements for billboard space in your community for Youth Arts Month (March). Have students design a billboard that will teach people in the community about the importance of art in the school curriculum. Have students discuss what other, smaller-scale items, such as badges or shopping bags, that they could design and distribute with the same message.

Fig. 4–14 What, do you think, was Barbara Kruger trying to say with this billboard? Barbara Kruger, *Untitled* (We Don't Need Another Hero), 1987. Photographic silkscreen on vinyl, 109° x210° (27.6) x533.4 cm). Courtesy Mary Boone Galler, New York. Emily Fisher Landau Collection, New York.

# Teaching with Pictures and Words

Kruger's artworks range from large scale to small. Some of her works, such as those in Figs. 4–13 and 4–14, are billboards. Her artworks are easy to recognize. She places bands of text over black-and-white photographic images to create artworks that look like pages from a magazine.

Kruger's work teaches because she shows stereotypes and clichés (overused sayings). The artist seems to be saying "Here's the issue and what it looks like to me; what do you think?"

#### **Studio Connection**

Paint a group mural to teach about your school—its history and goals, what makes it a special place, and so on. You

may paint the mural on large sheets of paper and display it in the school or community on a temporary basis. Or you may wish to create a mural that is more permanent. Think about where the mural should be: the hallway, cafeteria, gymnasium, a local public building, an outside wall, and so on. Think also about how to teach in visual form. With use of few or no words, how can you convey the important ideas?

#### Lesson Review

#### **Check Your Understanding**

- **1.** What do stained-glass windows, murals, and billboards have in common?
- **2.** What is one kind of lesson that murals can teach?
- **3.** How do Barbara Kruger's artworks teach?
- **4.** Explain what inspired the look of Barbara Kruger's artworks.

# Assess

concern them.

Extend

# Check Your Understanding: Answers

**1.** All are generally large in scale.

Have students create a collage that questions a stereotype or

cliché. They may combine magazine or newspaper images and type to challenge issues that

- 2. Murals can teach lessons about social concerns and cultural identities. Students may suggest other appropriate lessons.
- **3.** They challenge viewers to think about or rethink an idea.
- **4.** Kruger's experience in graphic design inspired the look of her art.

# Close

- Review the ways that large, twodimensional artworks can teach.
- Invite other classes to an unveiling ceremony of the group's mural. Have students explain their mural's lesson and their reasons for painting it.

Artists as Teachers

157

# **Teaching Through Inquiry**

Aesthetics Ask students to document the messages of several billboards and other "big" images in their community. Have students create a bulletin-board display of their findings, either with photographs or drawings. Ask: To what extent are the messages ones that teach? Attach a blank sheet of paper, and invite students to write comments about whether the billboards are visual pollution or important visual messages. Have small groups review the responses and discuss the aesthetics of billboards.

#### More About...

In her artworks, **Barbara Kruger** creates social awareness with a feminist twist. Before combining type with black-and-white photographs, she challenges massmedia stereotypes and clichés of identity, power, and sexuality. In billboards, posters, and magazine covers, she causes viewers to question their values and tastes in a material world.

#### **Assessment Options**

**Teacher** Present students with an image of a billboard and of a specific mural with which they are all

likely to be familiar. Ask students to record the works' similarities and differences in a Venn diagram.

**Peer** Have students work in small groups to develop important teaching messages in the style of Barbara Kruger. Photocopy and display the artworks, and ask groups each to report on reasons for their selections of words and images. Ask groups also to explain how their messages relate to Kruger's work.

# **Prepare**

## **Pacing**

One or more 45-minute periods

# **Objectives**

- Understand uses of calligraphy.
- Use calligraphy to letter a poem, quote, or message that teaches a lesson.

## Vocabulary

calligraphy Precise, beautiful handwriting.

# **Supplies for Engage**

 samples of greeting cards and invitations

# Teach

## Engage

Introduce the art of calligraphy by showing students some examples.

# **Using the Text**

Art History Ask: Who used calligraphy during the Middle Ages in Europe? What other cultures have developed calligraphy?

Art Production Ask: What is the first thing you should do when you begin to practice calligraphy? What enables you to make thick and thin lines in your lettering?

# **Using the Art**

Perception Ask students to identify strokes of thick, thin, and medium widths in the calligraphy diagram. Point out the arrows indicating stroke direction.

**Perception Ask:** How is mechanical lettering different from calligraphy?

# National Standards 4.2 Skills and Techniques Lesson

**1b** Use media/techniques/processes to communicate experiences, ideas.

**5c** Describe, compare responses to own or other artworks.

# **Lettering and Calligraphy**

Calligraphy is a form of beautiful lettering. Historically, people have used it to record important ideas in books, on scrolls, and in other important documents. During the Middle Ages in Europe, monks and nuns used calligraphy to make copies of religious books. In Japan, there is a long tradition of practicing calligraphy as a form of self-discipline and meditation. In Arab and other Asian cultures, the forms of written communication are so complex that people need calligraphy skills just to write simple sentences.

Today, people still use calligraphy to create special handwritten messages. It is a skill worth developing.

Fig. 4–16 **To help teach important lessons, many artists combine calligraphy with beautiful illustrations.**Jon Brelsford, *Psalm 24:1*, 2000.
Pen, ink, watercolor on paper, 111\* x 14\* (28x 35.5 cm). Penn View Christian School,

# abedefghijklm nopgrstuvwxyz ABCDEFGHIJKL MNOPQRSTUVW XYZ

Fig. 4–15 The numbers and arrows surrounding each letter indicate the number, order, and direction of strokes needed to make that letter. Also notice the relationship between one part of a letter and another. This relationship, which is called proportion, is important in calligraphy.

# **Calligraphy Practice**

Before you begin writing letters, first practice making rows of diagonal, vertical, horizontal, and curved strokes with a calligraphy pen. The pen should have a medium nib and chisel point. Use lined notebook paper or draw parallel lines to help guide your practice. Be sure to hold your pen at a constant angle and pull the nib toward you. This will result in the beautiful thick and thin lines that make calligraphy distinctive.

Now combine strokes to create letters. Look at the alphabet in Fig. 4–15. Practice writing each letter. Make the height of capital letters about seven times the width of the pen nib. The height of small lowercase letters, such as a, should be about five times the width of the nib. Tall lowercase letters, like h, are the same height as capital letters. The width of letters will vary slightly, but as a general rule, each should be similar to the height of a lowercase a.

158

LESSON

NIQUES

# **Teaching Options**

#### Resources

Teacher's Resource Binder Finder Cards: 4.2 A Closer Look: 4.2 Find Out More: 4.2 Check Your Work: 4.2 Assessment Master: 4.2 Overhead Transparency 8 Slides 4d

#### **Teaching Through Inquiry**

Art Production Ask students to create their own alphabet. First, have students collect examples of different types of lettering from magazines, word-processing software, or Websites. Then have students review their collection to select features to use in their own design. Invite students to be playful as they create their own unique letterforms. For example, they may wish to form letters out of cartoon figures or animal shapes.

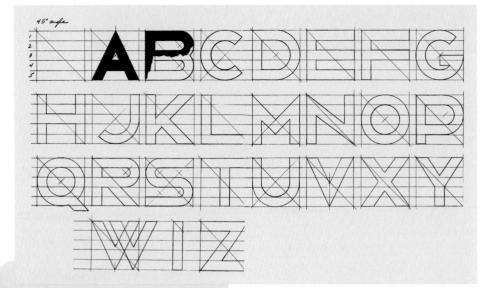

Fig. 4–17 Why might graphic designers use mechanical lettering in a poster design?

# **Mechanical Lettering**

Look at the letters in Fig. 4–17. This is called mechanical lettering, which is different from calligraphy. Graphic designers often use mechanical lettering on posters and billboards. The letters are all capitals. Notice also that each letter is a square—five spaces high and five spaces wide. Some of the parts of individual letters are created by drawing a 45-degree angle from one corner of the square to the other.

Practice writing your name with mechanical lettering. How do these letters compare to the letters used in calligraphy? The next time you plan a poster or design a bulletin-board message, refer to this diagram. You might paint the letters or draw them on construction paper and cut them out.

#### **Studio Connection**

Use your lettering skills to copy a short poem, quote, or message that teaches a lesson. With a pencil, draw light guidelines on

your work surface to create a layout for the words. Leave a little space between each letter and extra space between each word. Also, plan carefully for the spacing between lines. For example, make sure that lowercase letters like *p* and *y* don't touch any capital letters or letters like *l* or *b* in the line below. Be sure to check your spelling before you begin lettering.

#### **Lesson Review**

#### **Check Your Understanding**

**1.** Use your own words to describe calligraphy. **2.** If you were skilled in both calligraphy and mechanical lettering, which would you use to write a thank-you note to a friend? Why?

Artists as Teachers

159

### **Studio Connection**

Demonstrate calligraphy, emphasizing a constant pen angle, letter slant, and

use of guidelines. Explain that spaces between letters will vary. For example, the letters K and C will probably have less space between them and the next letter than letters such as D and B.

Have students practice lettering, on lined notebook paper, with a chiseled-point felt-tip pen or a lettering nib, holder, and ink. Before students plan their calligraphy, discuss margin widths and line spacing.

**Assess** See Teacher's Resource Binder: Check Your Work 4.2.

# Assess

#### Check Your Understanding: Answers

- **1.** Calligraphy means "beautiful writing."
- 2. Answers may vary. Look for evidence that students know the difference between calligraphy and mechanical lettering.

# Close

Display students' calligraphy. Ask students to identify well-shaped letters and pleasing spacing.

#### **Using the Overhead**

#### Write About It

**Describe** What kind of lettering did the artist use? Describe the way the artist used lettering to teach.

**Analyze** Explain the placement of the written message.

How do the other elements help focus attention on the written word?

#### **Assessment Options**

**Peer** Collect advertisements from magazines, and give one to each student. Ask students to

write a description of the lettering used. If calligraphy was used in their ad, have students write an explanation, with reasons, of whether mechanical lettering would have been a better choice; or vice versa. Have student pairs each review each other's work by rating, from 1 to 3 (best to worst), the clarity of the explanation and the level of support provided by the reasons. Have pairs discuss their evaluations.

# **Prepare**

# **Pacing**

Two 45-minute periods: one to consider text and images and to practice calligraphy; one to create plaque

# **Objectives**

- · Explain the difference between calligraphy and writing.
- · Describe how calligraphy is used in Islamic artworks of North Africa.
- Create a wall plaque that teaches something important.

# Vocabulary

arabesques Geometric designs and curves, often connected with calligraphic writing.

# **Using the Map**

Ask students to locate the Sahara, which covers a large portion of North Africa. Have students fingertrace the spread of Islam from Iran, across North Africa, and into Spain. Have students locate Khartoum, the capital of Sudan and home to calligrapher Osman Waqialla.

# **National Standards** 4.3 Global Destinations Lesson

- 3a Integrate visual, spatial, temporal concepts with content.
- 5b Analyze contemporary, historical meaning through inquiry.

# **Islamic Art of North Africa**

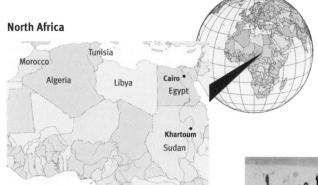

### **Places in Time**

The Islamic religion was started in 622 AD by the Arabian prophet Muhammad. Within a century, the religion had spread from Arabia (now Iran) to North Africa. The North African followers of Islam found their guidance in the text of the Quran (or Koran), a holy book (Fig. 4-18). The religion brought about an artistic and cultural unity in the vast desert regions of North Africa bordering the Mediterranean Sea.

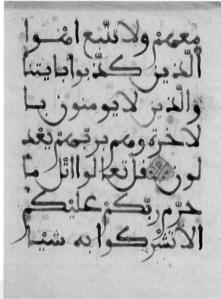

Fig. 4-18 What kinds of lessons, do you think, would be written in calligraphy in this holy book? North African (Egypt?), Two Text Pages from Sura 6 of the Koran, 12th century.

Ink, colors, and gold on paper, 5 1/4 x 6 1/4 (13 x 16 cm). Bequest of Mrs. Margaret McMillan

Webber in memory of her mother, Katherine Kittredge McMillan. The Minneapolis Institute of Arts.

160

LESS

S

20

DESTI

GLOBAL

# **Teaching Options**

#### **Resources**

Teacher's Resource Binder A Closer Look: 4.3 Find Out More: 4.3 Check Your Work: 4.3 Assessment Master: 4.3 Large Reproduction 8 Slides 4e

### **Teaching Through Inquiry**

Art Criticism Have students work in pairs: one student describes one of the artworks in the lesson, being careful to give clues only about the formal design elements (types of lines, shapes, colors, forms, textures, values); the other student identifies the image. Instruct students to take turns.

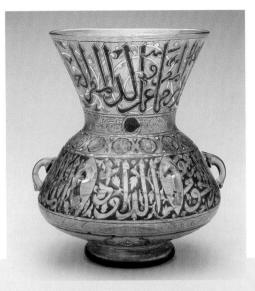

Fig. 4–19 Why would an artist want to add writing to such an object? Islamic, Egypt, Mosque Lamp, 1331–35.
Blown glass with enamel, gilded; height:

Fig. 4–20 What are the similarities and differences between this writing board and the boards in your classroom? Africa, Sudan, Omdurman city, Writing Board, 19th–20th century.
Wood and ink, 31 7/8" x 11" (81 x 28 cm). The Brooklyn Museum Expedition 1922, The Robert B.Woodward Fund (22.231).

# **Lessons in Calligraphy**

Calligraphy, the art of beautiful handwriting, is highly developed in Islamic art. It is one of Islam's important artistic contributions. The teachings of Islam are often written in calligraphic script. North African Islamic artists use calligraphy to decorate many kinds of handmade objects, such as the lamp in Fig. 4–19. Decorative writing often covers objects made by blacksmiths, leather workers, dyers, jewelers, and metal workers.

The writing board (Fig. 4–20) is also an important art form associated with Islam in

North Africa. Writing boards are made of wood and are used to teach children the sacred writings of Islam. Calligraphers write the lessons in precise, bold, and rounded Arabic script. The Arabic script on writing boards is often richly decorated with geometric designs and calligraphic curves known as **arabesques**.

Teach

# **Engage**

Remind students of permanent plaques, trophies, and decorative signs in their school, and have them describe the lettering on these. **Ask:** How is this lettering different from lettering in most books? How did artists arrange the lettering to fit the space? Tell students that they will study how North African artists use lettering to decorate objects.

# **Using the Text**

Art History Ask: In addition to holy books, what else did Islamic artists decorate with calligraphy? Why do artists make Islamic writing boards? In our culture, what type of "writing boards" have you learned from? (perhaps from wall plaques, chalkboards, overheads)

# Using the Art

Art History Discuss students' answers to the caption questions. Have students point out arabesques in the art. Explain that the Koran, Islam's sacred book, is written in Arabic, the language Allah used to reveal himself to Mohammed; and that writing boards and decorative script help Moslems memorize as much of the Koran as they can.

Artists as Teachers

161

### More About...

The northern part of **Sudan** was once the ancient kingdom of Nubia and has been under Egyptian rule for much of its history. During the first half of the twentieth century, Great Britain and Egypt jointly governed Sudan. Since 1956, the country has been self-governing. Sudan is the largest country in Africa, about one-fourth the size of the United States. The Red Sea borders it on the east and the Nile River runs through it from north to south. The northern part is desert; the southern part is fertile.

### **Using the Large Reproduction**

#### **Consider Context**

Describe What kind of script is this?

**Attribute** What clues indicate the culture that produced this work?

**Understand** How could you find out more about the intended message?

**Explain** What explanation can you give as to why there are only words and no images?

# **Using the Text**

Art History Discuss the effect that the joint British-Egyptian rule of Sudan had on artist Osman Waqialla's education. Ask: Why was it important for Waqialla to master traditional calligraphy skills before beginning to create his own, more expressive scripts?

# **Using the Art**

Art Criticism Ask: What did Waqialla emphasize in each piece? How did he make some letters more important than others? How do you think he decided which words to make large? Have students describe how the letters complement one another.

#### **Studio Connection**

Refer students to Lesson 4.2, and demonstrate calligraphy techniques. Have

students practice with either a felttip pen with a regular or chiseled tip, or with a lettering pen and ink.

With students, brainstorm some proverbs, sayings, and rules that they could letter. Encourage students to identify the most important words in their saying. **Ask**: How can you help viewers remember your lesson? How can you emphasize words? What type of lettering will suggest your message?

Have students plan their plaque on sketch paper before they transfer it to cardboard, foamcore, or wood. Guide students to consider how they will display the plaque (by hanging it, displaying it on a cardboard easel, and so on).

As students work, remind them several times to step back from their plaque to check that it is readable. Encourage students to suggest ways to make unclear messages more readable.

**Assess** See Teacher's Resource Binder: Check Your Work 4.3.

#### The Calligrapher as Teacher

"My art teaches about the sacred (religious) and the secular (non-religious)."

Osman Waqialla (born 1926)

Today, many North African artists continue the art of calligraphy. One such artist is Osman Waqialla. He is an artist, poet, journalist, and teacher.

Waqialla was born in Sudan, an African country just south of Egypt. He went to

school in Sudan, but under a British system of education. Waqialla's art education was based not only on European influences, but also on African traditions and use of local materials.

In the 1940s, Waqialla studied art in London and then studied in Egypt, at the School of Arabic Calligraphy and College of Applied Arts. Here, he explored Arabic calligraphy and developed his unique style.

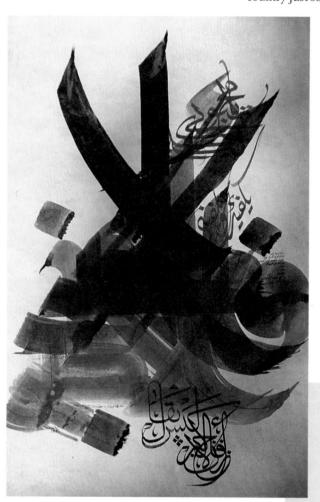

Fig. 4–21 What reason might the artist have had for making some letterforms much larger than others? Osman Waqialla, Calligraph: "Deep sorrow defies definition" (Arabic text from the poem "The Wandering Dervish" by Mohammed Alfeytoori), n.d. linkon paper, 16 ½" x 23 ½" (42 x 60 cm). Courtesy Osman Waqialia / Napata Graphics.

162

DESTINATIONS

GLOBAL

# **Teaching Options**

# **Meeting Individual Needs**

**Gifted and Talented** Ask students to study Fig. 4–20 and note as much as possible about the board. Discuss the way in which the object is not only a teaching tool, but also an item of beauty. What art elements help you appreciate this board as a work of art?

#### **Teaching Through Inquiry**

Aesthetics Have students work in groups to examine the images that are decorated with Arabic script, and to discuss the following questions and report their findings to the rest of the class: Even if you are unable to read the Arabic script on these objects, would you like to have them in your home? Why or why not? Can you appreciate the beauty of something, even if you don't know what it means?

# **Expressive Teachings**

Wagialla has mastered the skills of traditional calligraphy. This mastery allows him to be more expressive in his script. He often varies the size and shape of letterforms, and even overlaps letters to create decorative effects.

In addition to the scripting of sacred texts, Waqialla created a series of nonreligious works of modern poetry. He continues to work with both religious and nonreligious themes. His unique designs and emphasis on Arabic and Islamic identity have influenced a movement in calligraphic style known as the Khartoum School. Like the artists who have followed his lead, Osman Wagialla sees the letters of Arabic script as beautiful forms of artistic expression.

Fig. 4-22 How did the artist make some shapes stand out? Osman Waqialla, Calligraph (text from one of the gospels), 2001. Wood writing plaque, 16 ½ × 23 ¾ 8" (42 × 60 cm). Courtesy Osman Waqialla/Napata Graphic

Create a decorative board or plaque that teaches something important, such as a proverb, saying, or rule. Think of an

**Studio Connection** 

imaginative shape for the plaque. Practice calligraphy and decorative letterforms before applying them to the plaque. Your plaque can be of heavy cardboard, foamcore, or wood. Because the presentation of your written words is important, consider how the plaque will be displayed.

### **Check Your Understanding**

- 1. How are writing boards used in Islam?
- 2. How is calligraphy used by Islamic artists in North Africa?
- 3. How does Sudanese artist Osman Waqialla use calligraphy in his artwork?
- 4. What objects in your home are decorated with beautiful writing?

Extend

Show students greeting cards that feature lettering more than they do illustrations, and note how the type of calligraphy suggests the mood of the card. Ask students each to create a card for someone who has been helpful to them, and to design lettering to fit their card's message.

# Assess

### **Check Your Understanding: Answers**

- 1. Writing boards are used to teach children sacred Islamic writings.
- 2. They use calligraphy to decorate objects and create writing boards.
- 3. He letters religious texts and modern poetry in expressive
- 4. Answers will vary.

# Close

Discuss students' answers to Check Your Understanding. Display their calligraphy, and have students explain their choice of lettering to teach their lesson.

Artists as Teachers

163

#### More About...

The prophet Mohammed (c. 570-632 AD), born in Mecca, preached that he was the messenger of Allah, the only god. Believers in Islam (Arabic for "submission") are Moslems (Arabic for "those who submit to God"). Islam is one of the world's largest religions, widely practiced in the Middle East, North Africa, Pakistan, Indonesia, and parts of Eastern Europe. Human figures and animals are not to be depicted in Islamic sacred books or architecture; therefore, calligraphy, geometric designs, and plant forms decorate the religious artworks.

#### **Assessment Options**

Teacher Have students each prepare a small poster of a variety of calligraphy, handwriting, and lettering styles that

they think are beautiful. Ask students to attach a statement of reasons for their choices and what they see to be the major differences among the styles.

Self Ask students to comment in writing on the legibility of their writing and hand lettering. Have them comment on what they like about their style and how they could improve it.

# **Designing a Poster**

# **Prepare**

# **Pacing**

Two or more 45-minute periods: one to consider text and images and to plan; one or more to complete poster

# **Objectives**

- Use examples to explain how posters can be used to teach important lessons.
- Explain why proportion and scale are important considerations when creating a poster to teach an important lesson.
- · Create a poster to teach a lesson.

# Vocabulary

poster A large, printed sheet, usually made of paper or cardboard, that advertises, teaches, or announces something. A poster usually combines pictures and words.

**proportion** The relation of one object to another in size, amount, or number.

# Supplies for Engage

- drugstore or supermarket advertisement insert from Sunday newspaper
- full-page advertisement showing one product

# National Standards 4.4 Studio Lesson

- 2c Select, use structures, functions.
- **3b** Use subjects, themes, symbols that communicate meaning.
- **4c** Analyze, demonstrate how time and place influence visual characteristics.
- **5b** Analyze contemporary, historical meaning through inquiry.

Drawing in the Studio

# **Designing a Poster**

# **Teaching a Lesson**

LESSO

STUDIO

#### **Studio Introduction**

Think of the times you have seen a community-event flyer, a political poster, or a billboard. These are all examples

of posters. A **poster** is an artwork that combines one or more pictures with words to send a message or teach a lesson. Posters teach by making us aware of public concerns and events. If you make a list of the kinds of messages you see on posters, your list could include campaign messages, pleas to protect wildlife, advice to parents, warnings against smoking, or many other topics and themes.

In this studio experience, you will design a poster that will teach a lesson. Pages 166 and 167 will show you how to do it. Choose a topic that is important to you. Perhaps your poster will teach about the value of reading, eating well, or exercising. What other ideas come to mind? Think about your audience as you design the poster. Where will your audience see it? How large or small should it be to grab your audience's attention? How can you design the poster to best teach your lesson?

# **Studio Background**

#### **Teaching with Posters**

Artists began making posters as a way to communicate to a large audience. The posters you see here were designed for the purpose of teaching. The poster by illustrator Norman Rockwell (Fig. 4–24) reminds Americans about the importance of freedom. Ben Shahn, an artist known for his style and interest in lettering, created a poster to teach others about human rights (Fig. 4–23). The artists involved in the program combined their drawings with poetry to help educate people who rode on buses.

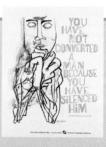

Fig. 4–23 What did the artist do to alter the proportions of the human figure in this poster? Ben Shahn, You Have Not Converted a Man Because You Have Silenced Him, 1968.

Offset lithograph, 45° x 30° (11 x 76 cm). National Museum of Art, Smithsonian institution, gift of the Container Corporation of America. © Estate of Ben Shahn/Lucensed by VAGA, New York, New York.

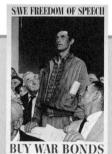

Fig. 4–24 This poster, from a series of four that Norman Rockwell designed, encouraged Americans to preserve their basic freedoms.

Norman Rockwell, Save Freedom of Speech, 1943.

Color lithograph, 40° x 28 ½° (102 x 72 university, Printed by permission of the Norman Rockwell Family Trust. Copyright © 2001 The Norman Rockwell Family Trust.

164

# **Teaching Options**

#### Resources

Teacher's Resource Binder Studio Master: 4.4 Studio Reflection: 4.4 A Closer Look: 4.4 Find Out More: 4.4 Overhead Transparency 8 Slides 4f

#### Teaching Through Inquiry

Art Criticism Have students work in small groups to compare and contrast the two posters on these pages. Provide each group with a copy of the Venn diagram in the Teacher's Resource Binder, and have students compare the posters on the basis of subject matter, the lesson being taught, the arrangement of the parts of the poster to attract and hold the viewer's attention, and the choice of materials and techniques used to create the poster. Have groups share their findings.

# SEATBELTS ARE FOR EVERYONE!

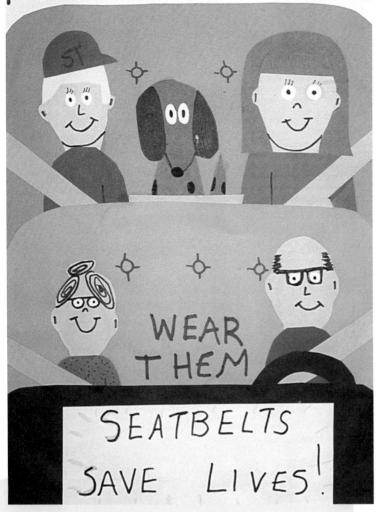

Fig. 4–25 "I used cut paper to make my poster. I used some comic things like putting my dog in the car, too. Sometimes the paper was hard to fit." Scott Skophammer, Seatbelts Work, 2000.

Cut paper, marker, 12" x 18" (30.5 x 46 cm), Saint Paul Lutheran School, Fort Dodge, Iowa.

# **Supplies**

- · sketch paper
- pencil and eraser
- ruler
- large drawing paper or posterboard
- colored pencils, markers, or crayons
- newspapers or magazines (optional)
- · scissors (optional)
- glue (optional)

# Teach

# Engage

Have students compare the ads listed in Supplies for Engage. **Ask:** Which kind of ad is more memorable?

# **Using the Text**

Aesthetics Ask: What billboards or posters have you seen that you think are examples of clever ads? What features caught your attention? What were the messages of the ads? What were they intended to get the viewers to do?

# **Using the Art**

Art Criticism Ask: What lesson is taught by each artwork in Studio Background? Which one has the greater ratio of lettering to illustration? Challenge students to describe the theme that is common to both artworks.

# Artists as Teachers

#### 165

#### More About...

President Franklin Roosevelt closed his 1941 State of the Union address by describing four essential human freedoms that the United States should fight to protect: freedom of speech and expression, freedom of worship, freedom from want, and freedom from fear. Illustrating these principles in *Four Freedoms* became a great challenge for Norman Rockwell. Initially, these four paintings were published as covers for *The Saturday Evening Post*, later, they were issued as posters in the war-bond campaign. In 1994, they were reproduced on postage stamps. (See More About on page 56.)

### **Using the Overhead**

#### Think It Through

**Ideas** What kinds of decisions did the artist need to make when exploring ideas for this artwork?

**Techniques** What techniques did the artist choose in making this artwork? What other techniques could have been effective?

8

# **Designing a Poster**

# **Studio Experience**

- 1. As students plan their design, remind them to use scale and proportion to emphasize their message and attract viewers' attention. Encourage students to try some designs with large lettering, and some with small, in relation to the illustration; and to experiment by arranging the lettering above, below, on the side of, and on the illustration. Guide students to consider what colors will best suggest their theme.
- 2. Have students lightly draw on drawing paper or posterboard, an enlargement of their favorite thumbnail design. Demonstrate lightly penciling in guidelines with a ruler, for lettering on a straight baseline.
- 3. As students work, encourage them to look at their poster from a distance to check that its words are readable. Suggest making some areas darker or lighter to improve readability.

#### **Idea Generators**

Suggest poster themes for school or community issues, or lead students in brainstorming possible messages to teach. Discuss different ways that students could illustrate the same topic.

# **Studio Tips**

- In addition to magazine and newspaper type, students may use computer fonts. They may print this type, copy it, modify it, and color it.
- Have students study print placement in magazine advertisements. Point out that artists usually leave a margin between the lettering and the edge of the page.

#### Extend

Have students work in groups to design a travel poster for Sudan. Ask groups to research the country's geography and history and to select colors and an illustration to suggest its culture.

# **Elements and Principles**

Display examples of student art that show a strong use of proportion. Have a class discussion in which students describe how the use of proportion helps make a statement or emphasizes the importance of objects in the artworks.

#### Drawing in the Studio

# **Creating Your Poster**

#### You Will Need

- sketch paper
- · pencil and eraser
- ruler

STUDIO LESSON

- large drawing paper
- colored pencils, markers, or crayons
- newspapers or magazines (optional)
- scissors (optional)
- glue (optional)

express it.

**4.** If you decided not to draw your words, cut letters or words from a magazine or newspaper. Arrange the words on the poster. Carefully glue

them in place when you are happy with the arrangement.

**3.** Choose the idea that you think works the best. With a pencil, lightly draw your design

on drawing paper. Then fill in areas with color. What colors will enhance your teaching? Think about the mood you want

to express and how you can use color to

**Check Your Work** 

**5.** When you are finished with your poster, carefully erase any unwanted lines.

#### Try This

- 1. Choose a topic for your poster. What do you want to teach about the topic? How can you use words and pictures to express your teaching? Will you choose two or three key words, or will you write a longer statement? Will you use one picture or more than one?
- **2.** Plan your design. Decide where you | want to place words and pictures. Will you

draw your letters by hand or

will you cut them out of a

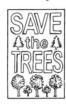

Save

the

Trees

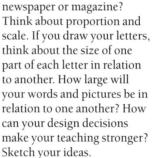

## ecide where you | Display your n

Display your poster with your classmates' posters. Group similar themes and topics, and discuss the designs. How do the words and pictures work together in each design? Talk about the size relationships between words and pictures. Which ideas work better than others to express the teaching? What improvements could be made?

#### **Computer Option**

Design your poster by using either an image-editing program like Photoshop, or a page layout program such

as Adobe PageMaker. You will create two versions of your poster using the same topic, text, and images but different designs and use of color. Experiment with size relationships, colors, and type styles. Which version is more effective in portraying the lesson you want to teach?

166

# **Teaching Options**

# **Teaching Through Inquiry**

Art Production Have students work in groups to design and create posters to teach important lessons to younger students. Suggest that a representative from each group solicit ideas from a classroom teacher in one of the primary or lower elementary grades. For example, students could create a series of posters to teach behaviors, such as listening carefully or being helpful; or such skills, as distinguishing between real and makebelieve or finding the main idea in reading passages. Guide students to consider appropriate content and format for teaching the lessons, and to make decisions about lettering and proportion.

#### More About...

Graphic artists design posters and billboards to attract viewers' attention and hold it long enough to deliver a message. For a freeway billboard, that span of attention may be just a few seconds. Bright colors, strong contrasts, oversized illustrations, unusual subjects, moving objects, and celebrity faces all will draw attention. The challenge for advertising writers is to express their message with as few words as possible.

#### **Elements and Principles**

## **Proportion**

**Proportion** is the relationship between a part of something and the whole. It compares the size or amount of the part to the whole. For instance, if you saw a sheep, you might say "Wow, for such a

big sheep, she sure has a small head!" By saying this, you have noted the size of the head in proportion to the size of the whole body. Or suppose you see

a painting that is almost entirely yellow and red, with just a small amount of white. You might say "A large proportion of this painting is yellow and red." (To learn about human proportion, see Lesson 3.2, pages 132 and 133.)

*Scale* is the size of one thing compared to the size of something else. In art, scale may be used

to exaggerate an object and thereby surprise viewers. Scale may also add humor to an artwork. Imagine seeing a painting in which an ant is

larger than a house!

Artists often use proportion and scale to make a statement, or to make some objects in an artwork more important than others. How have you used proportion and scale in your own artworks?

Fig. 4–26 "I made this because I live on a beautiful beach, and I think we should keep them clean so future generations can see their beauty." Jonathon Renuart, Save the Beaches, 2000. Colored pencil, marker, cut paper, 12° x18° (31 x46 cm). Laurel Nokomis, School, Nokomis, Florida.

Artists as Teachers

167

Computer Option
If students wish to

layer individual items, have them use Adobe Photoshop. If they wish to import headlines, text blocks, and images, have them use Adobe PageMaker. This program allows rotation of items and click and drag of individual items.

# **Assess**

#### **Check Your Work**

Ask students to write a description of their poster and to explain what they intended to teach and how they emphasized their message. Ask them to answer these questions: How did you use proportion and scale in your design? On a four-star scale, with four stars being the best, how would you rate the neatness, idea, lettering, and illustration? Is the message understandable? If you made another, similar poster, what would you do differently?

# Close

Arrange a display of students' posters in an area of the school where other students may view them. Allow students to explain orally how they emphasized their message.

# **Assessment Options**

**Teacher** In their science, math, or social studies textbooks, have students find a page that they think

could be made into a poster to teach something. Each student should explain why the particular page would make a good poster and how it should be changed to make one. Look for evidence that students understand how a poster should be organized to communicate a lesson. Each student's explanation should include reference to scale and proportion.

#### **Studio Collaboration**

Have students work in groups to develop an advertising campaign to teach their school or community about a political, social, or environmental issue. Ask groups to create posters and banners focusing on the different aspects of their issue. Suggest the use of a distinctive color scheme, lettering style, or illustration in their artworks so as to help viewers recognize their position on the issue.

# **Daily Life**

Ask students to work in small groups to develop an art lesson to present to another class at the same grade level or to a class of younger students. Encourage students to include several approaches to art and to artmaking. Suggest to students that their lesson include art images (postcards or large reproductions), group discussion or individual responses, demonstrations, and opportunities to ask questions. Have students present their lessons and then reflect on the experience.

## **Language Arts**

Help students understand and practice, in paint and print, the parallel concepts of self-portraiture and autobiography. Ask students each to create a self-portrait that includes or accompanies a short autobiographical passage. Encourage students to think of unusual approaches in paint and mixed media to complete the assignment. Display the artworks and passages.

# Connect to...

# Careers

CONNECT

What do you think an **art teacher** needs to know and be able to do? Teaching art requires familiarity with a wide range of art materials and media, art periods and styles, and historic and contemporary art. Art teachers may teach at different grade levels, from kindergarten to college, and in public or private schools. They may also be artists and experts in their art field of interest. For training and higher

education, art teachers usually pursue degrees in art education. They acquire certification to teach in public and private schools, and may obtain an advanced (doctorate) degree in order to teach in colleges or universities. If you enjoy learning about, making, and teaching through art, you might consider the profession of an art teacher. Ask your own art teacher to share his or her reasons for becoming a teacher.

# **Other Arts**

#### Theater

In many cultures, puppets enact stories that are meant to teach. Performances of famous tales, myths, legends, and reflections of daily living educate audiences about history, morals, values, and beliefs. One of the oldest storytelling traditions is the shadow-puppet theater known as wayang kulit, from the Indonesian island of Java. The puppetmaster is called dalang. The dalang is highly respected by the community, not just for his role as an actor, but also for his role as a historian and a teacher.

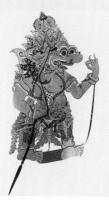

Fig. 4–27 The flat, cutout puppet is attached to rods that the puppeteer uses to move the puppet in front of a light. The audience, seated in front of a screen, sees only the puppet's shadow. Indonesia, Central Java, Wayang Kulit (Shadow Puppet), c. 1950.

Cut, painted leather, height: 31 ½° (79 cm). Museum of International Folk Art, a unit of the Museum of New Mexico, Santa Fe.

Internet
Connection
For more activities related to this chapter, go to the

Davis Website at www.davis-art.com.

168

# **Teaching Options**

#### Resources

Teacher's Resource Binder:
Making Connections
Using the Web
Interview with an Artist
Teacher Letter

#### **Video Connection**

Show the Davis art careers video to give students a reallife look at the career highlighted above.

# **Other Subjects**

#### Social Studies

Have you ever wondered if **beliefs and attitudes about learning and teaching differ among cultures**? Most Native American cultures hold the belief that knowledge must be earned rather than given. As a result, the asking of questions is considered rude, because learning is withheld until the right to know is earned. For example, at different stages in their life, Hopi children are given specific kachinas, and they learn the lessons the kachinas teach. The kachinas are not toys to be played with, but are reminders of the knowledge they carry.

#### Language Arts

Many similar concepts exist between art and language arts. These concepts may best be taught together. Related pairs of terms from art and language arts include meaning/main idea, detail/elaboration, sketch/rough draft, biography/portrait, and drawing/handwriting. Can you make comparisons between each pair of terms?

#### Science

Have you ever visited or read about the Grand Canyon? In the 1800s, many artists and photographers went on expeditions into the area. They captured the area's natural beauty in hundreds of paintings and photographs. **These artworks were often used to teach people in the East about the West.** They were also meant to encourage people to move into and settle the region.

Fig. 4–28 This painting was used to encourage the establishment of the first national parks, in order to preserve and protect the region's beauty and natural environment. Thomas Moran, Shin-Au-Av-Tu-Weap (God Land), Canyon of the Colorado, Utah, c. 1872–73.

Watercolor and pencil on paper, 4 1½16\* x 14 9½6\* (12.2 x 36.9 cm). Smithsonian American Art Museum, Gift of Dr. William Henry Holmes 1930.12.42. Courtesy Art Resource, New York.

# **Daily Life**

The word *teacher* means "one who instructs." There are **many people who serve the role of teacher in your life**. But do you serve that role for anyone else? No matter how young or how old you are, you can teach by example, by instruction, or by working with others. You may be a teacher to younger brothers and sisters, to children you babysit, to neighbors you help, or to friends at school or in clubs.

Fig. 4–29 What situations can you think of in which you act as a teacher?

Artists as Teachers

169

#### Science

Have students work in pairs to create a tourist educational brochure about a U.S. national park, in which they emphasize and encourage efforts to preserve the beauty and natural environment for future generations. Assign or allow each pair to choose a national park to research both online and offline. If possible, have students use photo-editing and publishing software to produce their brochure.

#### Other Arts

Ask students to watch an episode of *Sesame Street* or any other children's show with puppets, and to describe what lesson and/or information the puppets tried to convey. Discuss whether the values presented are important ones. Have students work in small groups to create a short sock-puppet performance that communicates an important lesson, value, or historical event.

#### **Internet Resources**

#### **Diego Web Museum**

http://www.diegorivera.com/index.html
This virtual museum is dedicated to Rivera.

#### **Jim Henson's Muppets**

http://www.muppets.com/ and http://www.henson.com/

Browse these sites for information on Jim Henson and his Muppets.

#### **Community Involvement**

Make arrangements for a field trip to area churches, temples, or synagogues that have narrative stained-glass windows. Ensure that someone will be available to explain the stories or lessons depicted.

#### **Interdisciplinary Planning**

Ask students to identify the ways that artworks are used for instructional purposes in textbooks for subjects other than art.

#### **Portfolio & Review**

# Talking About Student Art

Remind students to give reasons to support their interpretations of artworks. To get students started with an interpretation of a student's work, write the following prompts on the board: "I think this work is about..."
"I think this because...."

# **Portfolio Tip**

Whenever possible, photograph student artwork with a single-lens reflex cam-

era. Set the work against a plain background. For outdoors, use ISO 64 or ISO 100 film. For indoors, use ISO 400 film.

# **Sketchbook Tip**

Ask students to use their sketchbook as a place to collect a variety of new

and different alphabets and letterforms. Encourage students to use these as springboards for creating their own unique alphabet.

# **Portfolio**

REVI

ŏ

PORTFOLIO

"I chose a Giant Panda for my endangered species vest because I was in awe of such a majestic creature. The texture of the fur was hard to paint, but in the end my Panda vest turned out pretty much like I hoped it would." Kristin Bott

Fig. 4–30 **How does wearing a picture of endangered animals raise public awareness?** Kristin Bott, *Endangered Species Animal Vest*, 2000. Acrylic paint on fabric, 25° x 18° (63.5 x 46 cm). Kamiakin Junior High School, Kirkland, Washington.

Fig. 4–31 What does this license plate teach you about Idaho? Mariel Ryan, License Plate Design, 1999.

"I chose to put IMGMNST (I am gymnast) on my license plate because at the time I was taking gymnastic lessons and wanted very much to be a gymnast. The most difficult part was measuring the perimeter to make it all of the same measurements as a real license plate." Mariel Ryan

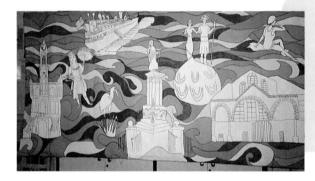

Fig. 4–32 Seven students worked together to paint a mural of scenes from their town's history. Each student chose a scene to represent. In order to teach others about history, the artists first had to learn about it themselves. Dennis McClanahan, Karina Ruiz, Rokeisha Joiner, Valarie Garcia, Iris Cuevas, Paul Brown, Shanna Nielsen, Views of Historic Galveston, 2000. Latex paint on canvas, 4\* 8\* (13 × 26.2 m). Central Middle School, Galveston, Texas.

#### **CD-ROM Connection**

To see more student art, view the Personal Journey Student Gallery.

170

# **Teaching Options**

#### Resources

Teacher's Resource Binder
Chapter Review 4
Portfolio Tips
Write About Art
Understanding Your Artistic Process
Analyzing Your Studio Work

#### **CD-ROM Connection**

For students' inspiration, for comparison, or for criticism exercises, use

the additional student works related to studio activities in this chapter.

# **Chapter 4 Review**

#### Recall

Name three artists who have made artworks to teach important lessons.

#### **Understand**

Give at least two examples of the kinds of lessons that artists might try to teach with their artworks.

#### Apply

Produce a series of six drawings that teach good habits. Consider, for example, safety, good grooming, and getting along with other people.

Page 149

#### Analyze

You have learned how artists use puppets, such as Jim Henson's Muppets (Fig. 4–3, *shown below*), to teach important lessons. Explain what makes a puppet an effective teacher.

#### Synthesize

Document examples of visual lessons in your community, and explain what is being to taught and to whom.

#### Evaluate

Imagine that you could choose Jim Henson, Barbara Kruger, or Diego Rivera to create an artwork for your school. State why you think this artist is the best choice to teach an important lesson to students in your school.

#### For Your Portfolio

From this chapter, choose one artwork. In writing, describe it, explain its meaning, and judge its merit as a visual

lesson. Remember that you need to use words that create an image in your reader's mind.

#### For Your Sketchbook

Select one letter of the alphabet. Fill a sketchbook page with variations (fonts) of the letterform. On another page,

match letterforms with a particular audience. For example, which of your fonts would be appropriate for an audience of third graders? Of adults?

Artists as Teachers

171

## Advocacy

Work with students to create a Microsoft PowerPoint® presentation about the value of art in their life, so as to educate family groups and civic organizations.

#### **Family Involvement**

Invite family members to assist you in developing resources by collecting art-related articles and cartoons that they come across in magazines and newspapers.

# Chapter 4 Review Answers Recall

Answers will vary but may include Jim Henson, Barbara Kruger, Judy Chicago, Kachina doll makers, Diego Rivera, Ambrogio Lorenzetti, Osman Waqialla, or Ben Shahn.

#### **Understand**

Answers will vary, but may include lessons about history, new skills, or good habits.

#### **Apply**

Artworks will vary, but look for evidence that students can design an artwork that will teach good habits.

#### **Analyze**

Answers will vary, but may include how puppets are non-threatening and can teach with humor.

#### **Synthesize**

Answers will vary, but look for evidence that students can discern the intended audience for a particular lesson.

#### **Evaluate**

Answers will vary, but look for appropriate reasons and an understanding of the selected artist's work.

#### Reteach

Have students review their social studies or science textbooks to find an idea that they believe is important to teach. Once they have decided on what they would like to teach, ask them to envision ways to teach it by creating small- and large-scale artworks. Ask: What kind of small-scale artwork could you make to teach the idea to a small number of people? What kind of large-scale artwork could you make that would teach the idea to a large number of people? Summarize by explaining that when artists function as teachers they must decide the best way to get their lesson across to their chosen audience.

3

3

3

3

# **Chapter Organizer**

# Chapter 5 Artists as **Interpreters**

Chapter 5 Overview pages 172-173

### **Chapter Focus**

- Core Artists interpret nature, conveying ways to think about our relationship with the natural world
- . 5.1 Landscapes as Art
- 5.2 Color Mixing
- 5.3 Art of China
- 5.4 Wood Constructions

#### **Chapter National Standards**

- 1 Understand media, techniques, and processes.
- Use knowledge of structures and functions.
- Choose and evaluate subject matter, symbols, and ideas.
- 4 Understand arts in relation to history and cultures.
- 5 Assess own and others' work.

#### **Objectives**

#### **Core Lesson** Landscape Interpreter page 174

Pacing: Three or more 45-minute periods

- Explain how artists select subject matter and use the elements of art to present their own interpretations of nature.
- Identify ways that color can be used to offer different interpretations of nature.

### **National Standards**

- 2b Employ/analyze effectiveness of organizational structures.
- 3b Use subjects, themes, symbols that communicate meaning.
- 4a Compare artworks of various eras, cultures.
- 5c Describe, compare responses to own or other artworks.

# Core Studio with Paint

- · Create a painted interpretation of an animal in natural surroundings.
- 1b Use media/techniques/processes to communicate experiences, ideas.

# **Creating Animals**

page 178

#### **Objectives**

Then and Now Lesson 5.1 Landscape as Art page 180

Pacing: Two or more 45-minute class periods

- Recognize similarities and differences among Romantic, Realist, and Luminist painters.
- Describe April Gornik's approach to landscape painting.

#### **National Standards**

- 3a Integrate visual, spatial, temporal concepts with content.
- 4a Compare artworks of various eras, cultures.
- 4c Analyze, demonstrate how time and place influence visual characteristics.
- 5b Analyze contemporary, historical meaning through inquiry.

#### **Studio Connection** page 182

- Interpret an outdoor scene by using pastels for blended color.
- 1b Use media/techniques/processes to communicate experiences, ideas.
- 2c Select, use structures, functions.

**National Standards** 

#### **Objectives**

#### 2 Skills and Techniques Lesson 5.2 **Color Mixing**

page 184 Pacing: Two or more 45-minute periods

- · Explain the process of creating tints and shades.
- 2a Generalize about structures, functions.

# Studio Connection

page 185

- Learn about the process of creating color intensity and how it differs from creating shades.
- 2c Select, use structures, functions.

#### **Featured Artists**

Wen Boren
Deborah Butterfield
Chao Shao-an
Gustave Courbet
Fuentes family
April Gornik
Martin J. Heade
Franz Marc

Jacob van Ruisdael

J. M. W. Turner Johannes Vermeer Theodore Waddell

### **Chapter Vocabulary**

complement dynasty expressive color intensity local color Luminism primary colors Realist Romantic shade spectrum tint

#### **Teaching Options**

Teaching Through Inquiry
More About...Impressionism
Using the Large Reproduction
Meeting Individual Needs
Teaching Through Inquiry
More About...Carved and painted carousel horses
Using the Overhead

# Technology

CD-ROM Connection e-Gallery

### Resources

Teacher's Resource Binder
Thoughts About Art:
5 Core
A Closer Look: 5 Core
Find Out More: 5 Core
Studio Master: 5 Core
Assessment Master:
5 Core

Large Reproduction 9 Overhead Transparency 10 Slides 5a, 5b

Teaching Through Inquiry More About...Franz Marc Assessment Options CD-ROM Connection Student Gallery Teacher's Resource Binder Studio Reflection: 5 Core

### **Teaching Options**

Meeting Individual Needs Teaching Through Inquiry Using the Overhead

#### Technology

CD-ROM Connection e-Gallery

#### Resources

Teacher's Resource Binder Names to Know: 5.1 A Closer Look: 5.1 Find Out More: 5.1 Assessment Master: 5.1 Overhead Transparency 9 Slides 5c

Teaching Through Inquiry More About...Johannes Vermeer Assessment Options CD-ROM Connection Student Gallery Teacher's Resource Binder Check Your Work: 5.1

### **Teaching Options**

Teaching Through Inquiry More About...Painting Assessment Options Using the Overhead

#### **Technology**

CD-ROM Connection e-Gallery

#### Resources

Teacher's Resource Binder Finder Cards: 5.2 A Closer Look: 5.2 Find Out More: 5.2 Assessment Master: 5.2 Overhead Transparency 10 Slides 5d

CD-ROM Connection Student Gallery Teacher's Resource Binder Check Your Work: 5.2

| 9 weeks | 18 weeks | 36 weeks | Chap                                                                                                    | ter Organizeı                                                                                                                                                                                                                                                                                | Continued                                                                                                                                                                                                                                                                                                                                                                                                                                |
|---------|----------|----------|---------------------------------------------------------------------------------------------------------|----------------------------------------------------------------------------------------------------------------------------------------------------------------------------------------------------------------------------------------------------------------------------------------------|------------------------------------------------------------------------------------------------------------------------------------------------------------------------------------------------------------------------------------------------------------------------------------------------------------------------------------------------------------------------------------------------------------------------------------------|
| J.      |          |          |                                                                                                         | Objectives                                                                                                                                                                                                                                                                                   | National Standards                                                                                                                                                                                                                                                                                                                                                                                                                       |
|         |          | 2        | Global Destinations<br>Lesson 5.3<br>Art of China<br>page 186<br>Pacing: Two 45-minute<br>class periods | <ul> <li>Explain why nature is a source of inspiration for Chinese artists.</li> <li>Describe Chao Shao-an's method of painting from nature.</li> </ul>                                                                                                                                      | <ul> <li>2b Employ/analyze effectiveness of organizational structures.</li> <li>3a Integrate visual, spatial, temporal concepts with content.</li> <li>4a Compare artworks of various eras, cultures.</li> <li>4b Place objects in historical, cultural contexts.</li> <li>4c Analyze, demonstrate how time and place influence visual characteristics.</li> <li>5b Analyze contemporary, historical meaning through inquiry.</li> </ul> |
|         |          |          | Studio Connection<br>page 188                                                                           | Use watercolors to paint a colorful floral arrangement.                                                                                                                                                                                                                                      | <b>1b</b> Use media/techniques/processes to communicate experiences, ideas.                                                                                                                                                                                                                                                                                                                                                              |
|         |          |          |                                                                                                         | Objectives                                                                                                                                                                                                                                                                                   | National Standards                                                                                                                                                                                                                                                                                                                                                                                                                       |
|         | 3        | 3        | Studio Lesson 5.4<br>Wood Constructions<br>page 190<br>Pacing: Two or more<br>45-minute class periods   | <ul> <li>Learn how artists may attend to the shapes, colors, and forms of materials when interpreting animals.</li> <li>Understand how artists work with colors and color schemes to express moods or ideas.</li> <li>Create a sculptural animal out of wood scraps and branches.</li> </ul> | <ul> <li>1b Use media/techniques/processes to communicate experiences, ideas.</li> <li>2b Employ/analyze effectiveness of organizational structures.</li> <li>3b Use subjects, themes, symbols that communicate meaning.</li> <li>4c Analyze, demonstrate how time and place influence visual characteristics.</li> <li>5c Describe, compare responses to own or other artworks.</li> </ul>                                              |
|         |          |          |                                                                                                         | Objectives                                                                                                                                                                                                                                                                                   | National Standards                                                                                                                                                                                                                                                                                                                                                                                                                       |
| •       | •        | •        | Connect to<br>page 194                                                                                  | <ul> <li>Identify and understand ways other disciplines<br/>are connected to and informed by the visual<br/>arts.</li> <li>Understand a visual arts career and how it<br/>relates to chapter content.</li> </ul>                                                                             | 6 Make connections between disciplines.                                                                                                                                                                                                                                                                                                                                                                                                  |
|         |          |          |                                                                                                         | Objectives                                                                                                                                                                                                                                                                                   | National Standards                                                                                                                                                                                                                                                                                                                                                                                                                       |
| •       | •        | •        | Portfolio/Review<br>page 196                                                                            | <ul> <li>Learn to look at and comment respectfully on<br/>artworks by peers.</li> <li>Demonstrate understanding of chapter content.</li> </ul>                                                                                                                                               | 5 Assess own and others' work.                                                                                                                                                                                                                                                                                                                                                                                                           |

Lesson of your choice

### **Teaching Options**

Teaching Through Inquiry More About...Ming dynasty Using the Large Reproduction

#### Technology

CD-ROM Connection e-Gallery

#### Resources

Teacher's Resource Binder A Closer Look: 5.3 Find Out More: 5.3 Assessment Master: 5.3 Large Reproduction 10 Slides 5e

Meeting Individual Needs Teaching Through Inquiry More About...Chao Shao-an Assessment Options CD-ROM Connection Student Gallery Teacher's Resource Binder Check Your Work: 5.3

# **Teaching Options**

Teaching Through Inquiry
More About...Woodcarvings from Oaxaca
Using the Overhead
Studio Collaboration
Teaching Through Inquiry
More About...Additive/subtractive color theory
Assessment Options

#### Technology

CD-ROM Connection Student Gallery Computer Option

#### Resources

Teacher's Resource Binder Studio Master: 5.4 Studio Reflection: 5.4 A Closer Look: 5.4 Find Out More: 5.4 Overhead Transparency 9 Slides 5f

# **Teaching Options**

Community Involvement Interdisciplinary Planning

### **Technology**

Internet Connection Internet Resources Video Connection CD-ROM Connection e-Gallery

#### Resources

Teacher's Resource Binder Using the Web Interview with an Artist Teacher Letter

## **Teaching Options**

Advocacy Family Involvement

#### Technology

CD-ROM Connection Student Gallery

#### Resources

Teacher's Resource Binder
Chapter Review 5
Portfolio tips
Write About Art
Understanding Your Artistic Process
Analyzing Your Studio Work

# **Chapter Overview**

#### Theme

We are all connected to nature, and we each think about this connection in different ways. In their artistic interpretations of nature, artists convey ways to think about our relationship with the natural world.

#### **Featured Artists**

Wen Boren
Deborah Butterfield
Chao Shao-an
Gustave Courbet
Fuentes family
April Gornik
Martin J. Heade
Franz Marc
Jacob van Ruisdael
J. M. W. Turner
Johannes Vermeer
Theodore Waddell

## **Chapter Focus**

This chapter looks at ways in which artists interpret nature. Contemporary artists Theodore Waddell and April Gornik, who work within the traditions of animal and landscape art, are featured. Students are introduced to basic color concepts and some techniques for mixing and blending color for expressive purposes. They also discover how traditional and contemporary Chinese artists have interpreted nature's beauty. Finally, students create an animal sculpture.

# National Standards Chapter 5 Content Standards

- 1. Understand media, techniques, and processes.
- 2. Use knowledge of structures and functions.
- 3. Choose and evaluate subject matter, symbols, and ideas.
- **4.** Understand arts in relation to history and cultures.
- 5. Assess own and others' work.
- Make connections between disciplines.

# Artists as Interpreters

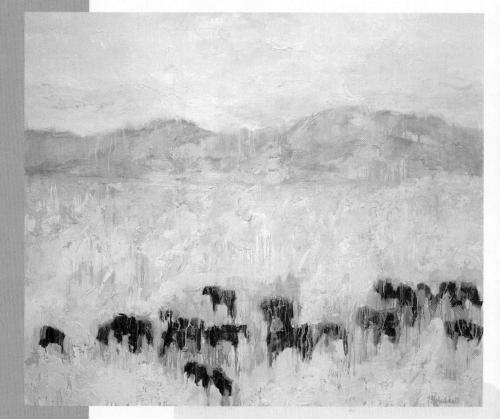

Fig. 5—1 As Theodore Waddell travels through the wide-open spaces of Montana, he notices how the grazing animals seem to blend into the landscape. How did the artist use paint to show this? Theodore Waddell, Monida Angus #7, 2000. 0il, encaustio cnawas, 60° x72° (15x 183° m), courtey Benice Steinbaum Galler, Maini, Florida.

172

# **Teaching Options**

# **Teaching Through Inquiry**

Art Production Have students imagine they are the author of the imaginary book Creating Art About Nature.

Discuss questions they would ask Theodore Waddell about his own artwork and how he would answer them. Questions might include: How did you come up with the idea? What did you do to begin painting? How did you use brushes or other tools to apply paint? How did you know when the painting was finished? and so on. You may wish to have students work in pairs to create and then role-play their dialogue for the class.

#### More About...

Best known for painting, **Theodore Waddell** also sculpts and makes
prints. As a child, he used potatoes
and erasers to make his first prints!
Much later, he tried to use his thickly
painted brushwork to create monoprints—but quickly learned that he
couldn't send such laden plates
through a printing press.

#### **Focus**

- How do people think about, or interpret, their connections to the natural world?
- In what ways do artists use color and art techniques to show their ideas about nature?

People react to nature. For example, when you come across a spiderweb, what is your reaction? Do you see it as a nuisance to get rid of immediately? As evidence that an interesting insect is nearby? As a beautiful pattern of lines? One person might exclaim that the web is creepy; another person might show it to friends and talk about its delicate design. The way we react to nature depends on how we think about and explain it—how we interpret it.

Artist Theodore Waddell often looks at animals in the environment. He notes how colors in nature change with the seasons and even with the time of day. Waddell shows how animals seem to merge with their surroundings. His painting *Monida Angus* #7 (Fig. 5–1) depicts the two as if they were one. In this chapter, you will learn more about Theodore

Waddell and other artists who give us new ways of thinking about what nature provides.

Theodore Waddell April Gornik Chao Shao-an

colors

tint shade intensity complement dynasty color spectrum

Theodore Waddell

Artists as Interpreter

Ask: What is the most beautiful natural scene you have ever seen? What was the most exciting natural scene you have ever visited? What was the scariest? Explain the ways in which we—and artists—react to nature depends on what we think and feel about it.

# **Using the Text**

Aesthetics Show students an actual or toy specimen of an insect. Have them write what their first reaction is to the insect, and then compare the responses.

# **Using the Art**

Perception Ask: What subjects does Theodore Waddell paint? What did he repeat in this painting? What are the painting's colors and textures? Do you mind that the painting is not realistic? Have students squint and look at the painting. Ask: How is the painting divided? What area is most important? How did Waddell emphasize this? (contrast, size, placement) How do you know that the cattle, not the mountains, are closer to the viewer?

### **Extend**

Develop a class list of plants and animals in the local environment. Have students select one to repeat and overlap in an oil or chalk pastel drawing similar to Waddell's. Encourage students to indicate landscape shapes in their composition.

176

#### 5.1 Then and Now Lesson Landscape as Art page 180

## 5.2 Skills and Techniques Lesson

Color Mixing page 184

# Graphic Organizer Chapter 5

# **Core Lesson**

Landscape Interpreter

#### Core Studio

Creating Animals with Paint page 178

#### 5.3 Global Destinations Lesson

Art of China page 186

#### 5.4 Studio Lesson

Wood Constructions page 190

#### **CD-ROM Connection**

For more images relating to this theme, see the Personal Journey CD-ROM.

# **Prepare**

# **Pacing**

Three or more 45-minute periods: one or more to consider text and images and to sketch; one to draw and to paint background; one to add texture

## **Objectives**

- Explain how artists select subject matter and use the elements of art to present their own interpretations of nature.
- Identify ways that color can be used to offer different interpretations of nature
- Create a painted interpretation of an animal in natural surroundings.

## Vocabulary

expressive color Color that communicates an artist's ideas or feelings.

local color The representation of colors as they appear in the natural world.

# National Standards Core Lesson

- **1b** Use media/techniques/processes to communicate experiences, ideas.
- **2b** Employ/analyze effectiveness of organizational structures.
- **3b** Use subjects, themes, symbols that communicate meaning.
- **4a** Compare artworks of various eras, cultures.
- **5c** Describe, compare responses to own or other artworks.

# **Landscape Interpreter**

"I spend a lot of time observing before I begin painting. How animals move on a plain of green and ochre, constantly changing and yet remaining the same. It is good to be in this place."

Theodore Waddell (born 1941)

Theodore Waddell's Journey

Theodore Waddell is an artist and a rancher who grew up and still lives in Montana. Montana is called the land of "big sky" because of its vast landscape. From a distance, Waddell sees creatures and an occasional tree dotting the horizon. From up close, he also observes them in his daily work on his ranch.

Waddell left home to study art in college and graduate school, where he was especially interested in making sculpture. When he returned and took up ranching, he turned to painting because he thought that would be the best medium to show the wide-open spaces of the landscape he loved.

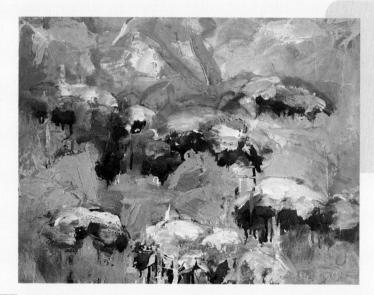

Fig. 5–2 Waddell has studied how artists throughout history have used paint to interpret the world of nature. The title of this painting refers to the Impressionist painter Claude Monet, who observed and painted the effects of sunlight. Theodore Waddell, Monet's Sheep #3, 1993.

Oil, encaustic on canvas, 18"x 24" (46 x 61 cm). Courtesy Bernice Steinbaur Gallery, Miami, Florida.

174

CORE

# **Teaching Options**

#### Resources

Teacher's Resource Binder
Thoughts About Art: 5 Core
A Closer Look: 5 Core
Find Out More: 5 Core
Studio Master: 5 Core
Studio Reflection: 5 Core
Assessment Master: 5 Core
Large Reproduction 9
Overhead Transparency 10
Slides 5a, 5b

# **Teaching Through Inquiry**

Art History Invite students to study Monet's Sheep #3 and then prepare a presentation called "The Monet Connection." Guide students to use library and Internet resources to find out about the work of Monet. Then have them describe connections between Monet and Waddell and explain their ideas about why Waddell titled the painting Monet's Sheep #3. Students may wish to create posters with diagrams or other visuals for presenting their findings to the class.

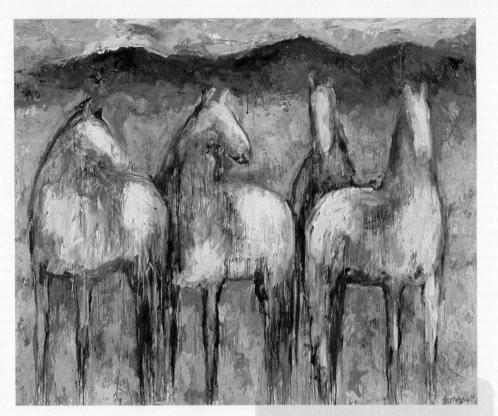

# **Interpreting the Land**

Waddell has experimented with ways to use paint. In his early paintings, he applied paint thickly. By doing so, he suggested the forms of animals. To create interesting effects and textures, he has applied paint with a brush, a rag, and the heel of his hand. In his more recent paintings, he uses thinned paint to create his animal forms with quick brushstrokes. He even allows the paint to drip.

Waddell begins slowly, carefully observing. He explores the land and makes notes about the sites he wants to include in his paintings. He notices that things appear differently as

Fig. 5-3 Horses, sheep, and cattle are common sights for the artist. He paints them in many different ways. How does this painting differ from his paintings of cattle and sheep shown on pages 172 and 174? Theodore Waddell.

rtesy Bernice Steinbaum Gallery, Miami, Florida

the seasons change. Summer light brings out colors not seen in the harsh Montana winters. Horses in the spring reflect the colors of the sky, the grass, and the vibrant sunlight. In winter, their forms emerge through snow that Waddell paints in purples, pinks-even black! Study the artworks in Figs. 5-2 and 5-3. These painted interpretations reveal Waddell's thinking about how, in nature, everything is connected.

Teach

# Engage

Suggest to students—in preparation for painting an animal in its environment—that they think about what animal they will paint and to research their animal and its environment.

Read aloud Theodore Waddell's statement. Ask: Why, do you think, is the observation of a subject before painting important to an artist?

# **Using the Text**

Art Production Ask: What are some of the ways that Waddell applies paint to canvases? How does Waddell begin a painting?

# **Using the Art**

Art Production Have students compare the techniques in the two paintings. Ask: In which is the paint thinner? (Monet's Sheep #3) What are the media for Ennis Horses? (oil paints, encaustic, graphite) Explain that the encaustic process involves the painting of liquid-hot colored wax (such as melted crayons) onto a surface. Ask: What are the colors in each painting? What seasons do these colors suggest? What did Waddell repeat in each painting? How did he create unity in each?

Artists as Interpreters

175

#### More About...

French artist Claude Monet (1840–1926) was a leader in the group that developed Impressionism during the second half of the nineteenth century. These artists used broken, visible brushstrokes to paint nature and life. Color and light in their works became more important than realistic depictions of subjects. Like Japanese prints, their paintings have asymmetrical, almost casual designs. During the last half of his life, Monet repeatedly painted the light and color in the gardens and lily pond that he designed for his Giverny home.

#### **Using the Large Reproduction**

#### Talk It Over

Describe Carefully describe the subject matter of this painting.

Analyze Explain how the artist used color and brushstrokes to attract and hold the viewer's attention.

Interpret What did the artist "say" about the subject of her painting?

Judge Was the artist's choice of color a good one for the subject of her painting?

# **Using the Text**

Aesthetics After students have read the text, have them point out nature designs on such everyday objects as dishes, jewelry, clothing, and tissue boxes. Ask: How, do you think, did each of the artists who created these objects feel about the natural object he or she chose? What idea was each artist expressing about nature?

# **Using the Art**

Art Criticism Have students compare the three horse sculptures. Ask: From what medium is each horse made? Are you surprised by any of these materials? How do the materials add to the expressive qualities of each horse?

## **Ideas About Nature**

Artists from cultures around the globe have found beauty in the natural world. Some artworks show nature as magnificent, dazzling, or grand; others, as peaceful or calm. Whereas one artist interprets nature as friendly, another may find it dangerous or threatening. What are your ideas about nature?

# **Images of Nature**

Artists interpret nature: they depict animals, insects, plants, and entire landscapes, bringing their own ideas about nature to their work. Each artist thinks about and interprets nature uniquely. When artists observe nature, they look for and see different features. Study the three artworks of horses shown here (Figs. 5–4, 5–5, and 5–6). What features did each artist emphasize? How is each work unique?

You can find interpretations of the natural world in paintings, sculptures, and other types of artworks. Many objects you encounter every day are decorated with artists' images of nature. Notice flowers, birds, bugs, and trees on greeting cards, fabric, and dishes. Whenever you see images of the natural world, try to determine how the artist showed it. Is nature presented as serious or silly? Delicate or bold? Some artists are very careful: they work almost like scientists, showing every detail of a plant or animal. Other artists want to express a general idea about nature. As you look at artworks, pay attention to the use of color and other art elements to express different moods, feelings, and ideas.

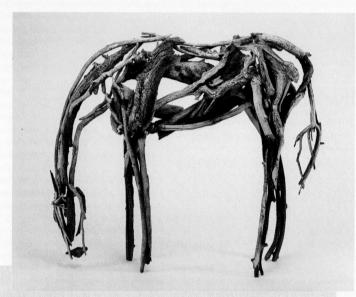

Fig. 5–4 Deborah Butterfield uses wood, metal, straw, and other materials to create life-size sculptures of horses. Each horse sculpture has a different "personality." What words can you use to describe how this artist interprets nature? Deborah Butterfield, Cottonwood Creek, 1995–96, 6.

176

# **Teaching Options**

### **Meeting Individual Needs**

Multiple Intelligences/Spatial-Naturalistic Tell students that Deborah Butterfield is best known for her skeletonlike horses made from scrap metal, wire, tree branches, twigs, and clay. Explain that although not made entirely from natural materials, the works appear to be at one with nature. Ask students to sketch plans for an animal sculpture. You may wish to have students use natural, found materials to create the sculptures.

#### More About...

Carved and painted carousel horses have roots in the grand tournaments of mid-sixteenth-century France. The French carousel allowed riders to try to spear gold rings with lances while the merry-go-round rotated. A 1799 carousel in Salem, Massachusetts, is the earliest known in the United States. Most steeds on the first American carousels were carved on just the out-facing side. The full-bodied horses were created in the 1900s.

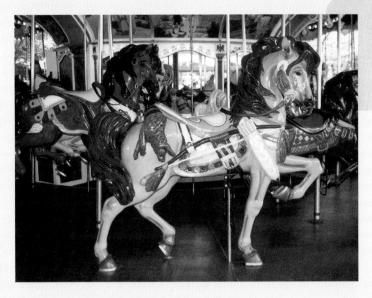

Fig. 5-5 We find brightly colored horses on carousels throughout the world. What feelings or ideas are expressed by such bright colors? Carousel Horse, 20th century.

Photo courters SchoolArts magazine.

Fig. 5–6 In China, the horse has always been an important part of culture. How does this sculpture show the artist's respect for the importance of the horse? China, Tang dynasty, Tomb Figure of a Saddle Horse, early 8th century.

Earthenware, three-color lead glazes, length: 31 ½7 (80.5 cm). Victoria & Albert Museum, London'Art Resource, New York.

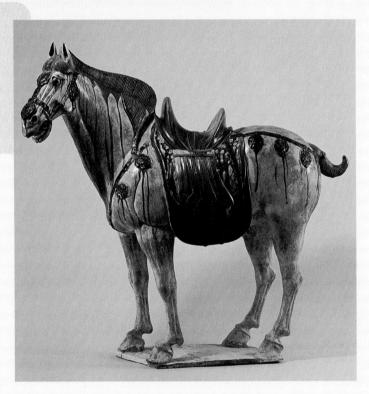

177

# **Critical Thinking**

Assign students to research horses by other artists, such as those by Rosa Bonheur, Edgar Degas, Charles Russell, and Frederic Remington; and by ancient Romans (page 55) and Greeks (page 25), and prehistoric artists (page 53). Have students describe one horse and explain what quality of the animal the artist emphasized.

#### Extend

Guide students to create their own three-dimensional figure of a horse or another animal by building a wire armature and adding clay or papier-mâché to it. Suggest to students that they paint their animal with colors that show its personality.

## **Teaching Through Inquiry**

Art Criticism Have students work in small groups to compare and contrast how the horse is interpreted in each of the three artworks. Guide students to create a word bank of expressive words, such as calm, powerful, shy, peaceful, bold, and so on; and then to use words from the word bank to complete, for each artwork, the sentence "The artist showed the horse as (calm, powerful, etc.)." Have students list, next to each sentence, the characteristics of the artwork that help convey the interpretation: for example, "The artist showed the horse as calm by depicting it in a restful position" or "The artist showed the horse as bold by the use of bright colors." Have groups share their findings.

## **Using the Overhead**

#### Think It Through

**Ideas** How do you think the artist got his idea for this painting?

Materials What materials did the artist use?

**Techniques** Use gestures to describe the way the artist worked with the materials.

**Audience** Who would probably enjoy seeing this artwork?

10

# **Supplies**

- · heavy drawing paper
- · pencil and eraser
- white construction paper, 2 sheets
- · tempera paint
- · variety of paintbrushes
- water
- · foam plastic plate

# **Using the Text**

Art Production Discuss each step in Try This. Ask: What are some reasons why artists usually draw more than one view of something before they begin a final artwork?

# **Using the Art**

Perception Invite students to discuss Marc's Two Cats. Ask: Did Marc use local color or expressive color? What mood do the colors suggest? What textures do you see? Where is a third animal in this artwork? (lower right)

## Assess

#### **Check Your Work**

Before students finish their painting, have them analyze their work from a distance to determine what fine details they should add, where they need more contrast, and where they should repeat a color.

Discuss students' answers to the questions. Guide students in writing a title that suggests how they feel about the animal.

#### Painting in the Studio

# Creating Animals with Paint

CORE STUDIO

Before interpreting nature in an artwork, an artist first looks carefully at the natural world. The artist probably has some ideas about nature, such

as whether it should be controlled or left alone. As a painter, the artist must decide which techniques and colors will best express those ideas.

In this studio experience, you will create a painting of an animal in natural surroundings. Choose an animal that interests you. What is its environment? How do you feel about the animal and its environment? As you plan, think of ways to show the animal. Do you want it to look powerful and strong or in need of protection? How can you express your feelings and ideas in a painting? As you work, remember that your painting will be viewed as your interpretation of the animal.

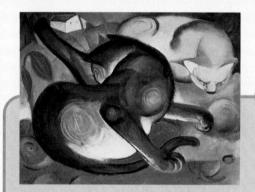

Fig. 5–7 When painting a scene or object from nature, artists sometimes use expressive colors. What feelings or ideas did Franz Marc express in this painting? Franz Marc, *Two Cats*, 1912.

1.712.

Oil on canvas, 74" x 98" (188 x 249 cm). Oeffentliche Kunstsammlung, Basel, Switzerland.

Art Resource, New York.

#### You Will Need

- · heavy drawing paper
- pencil and eraser
- white construction paper, 2 sheets
- tempera paint
- · variety of paintbrushes
- water
- · foam plastic plate

#### Try This

largest shapes first.
Think about where
you will place the
animal on the page.
Il you show the animal?

1. On drawing paper,

create a sketch of your

roundings. Sketch the

animal and its sur-

From what angle will you show the animal? Will it be doing something? What kind of background scenery will you include?

2. Experiment with mixing colors of paint on a plate. On a sheet of white construction paper, test the colors you mix. Which colors will best express your ideas? Will you use expressive color—color that expresses your feelings or ideas of the subject? Or will you use local color—color that you see in the natural world?

# **Studio Background**

#### **Painting Natural Forms**

To interpret the natural world in a painting, artists may use any of the elements of art. Painters may use lines that are sharp and clear or soft and blurred. They may decide to use many colors or just a few, and may have them range from light to very dark values. To create a mood, painters may create a work with dramatic lighting and shadows—or one with very little contrast. Painters may also use texture to create what looks to be a rough or smooth surface, or one of many different textures.

178

# **Teaching Options**

# **Teaching Through Inquiry**

Aesthetics Ask: Should artists always show animals realistically? Have students work in groups to respond, and to support their various answers with reference to the Marc image. Have groups record members' responses on a worksheet of two columns: one column with the heading "Yes, because . . . "; the other column with the heading "No, because . . . " Have groups share their responses in a class discussion.

3. On another sheet of construction paper, experiment making brushstrokes using a variety of paintbrushes. What textures and effects can you create? How can you use them

to create the forms and details of your scene?

**4.** When you have created colors and brush-strokes that you like, begin adding color to your sketch. Paint large areas of color first. When the paint is dry, add details.

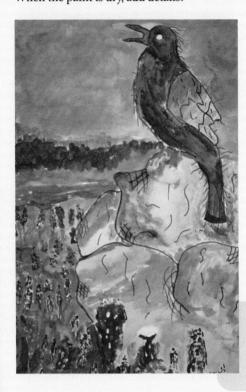

# Lesson Review

**Check Your Work** 

#### **Check Your Understanding**

**1.** Why may two paintings of the same scene painted by two separate artists look very different?

How did you use paint to create an animal in

natural surroundings? Did you experiment

with different brushstrokes? How did your

or feelings you have about the animal?

use of color and paint help you express ideas

- 2. Why did Theodore Waddell turn from sculpture to painting when he took up ranching in Montana?
- **3.** Provide two examples of objects that show an artist's interpretation of nature.
- 4. Why would an artist want to experiment with color when painting an interpretation of nature?

Fig. 5–8 This artist used local color to express her ideas about a bird in a field of flowers. Notice the variety of brushstrokes. Brittany Walker, *Bird Untitled*, 2000. Tempera paint, 12" x 18" (31 x 46 cm). Central Middle School, Galveston Texas

# Check Your Understanding: Answers

- 1. When observing nature, individual artists look for and see different features.
- 2. Waddell thought that paintings could best show the wideopen spaces of the landscape he loved.
- 3. Objects will vary.
- 4. Answers will vary but may include: to find out how best to express certain feelings or moods; to try to make the colors as realistic as possible; to make the animals complement the landscape; to provide the best expression of a general idea about nature.

# Close

Display students' paintings. Discuss students' answers to Check Your Understanding.

Artists as Interpreters

179

#### More About...

German artist **Franz Marc** (1880–1916), the son of a genre and landscape painter, studied theology before beginning his academic art training in Munich. When he studied van Gogh's works during visits to Paris in 1903 and 1907, he was impressed by the artist's brilliant, expressive color. He helped Kandinsky organize the first Blaue Reiter exhibition in Munich, in 1911. Both he and Kandinsky used color and content with a spiritual attitude in their paintings. Marc developed a theory of symbolic color by using flat areas of intense color. Two years after he was called into the German army to fight in World War I, he was killed at Verdun.

### **Assessment Options**

Peer Have pairs of students create a booklet of information about nature artworks, including what to look for and what questions to explore when considering any such artwork. Invite student pairs each to exchange booklets with another pair. Have pairs study the booklets and discuss them by offering positive comments and suggestions for improvement.

# Landscape as Art

# **Prepare**

# **Pacing**

Two or more 45-minute periods: one to consider text and images; one or more to draw

# **Objectives**

- Recognize similarities and differences among Romantic, Realist, and Luminist painters.
- Describe April Gornik's approach to landscape painting.
- Interpret an outdoor scene by using pastels for blended color.

# Vocabulary

Romantic A style of art whose themes focus on dramatic action, exotic settings, imaginary events, and strong feelings.

**Realist** A style of art that portrays subjects with lifelike colors, textures, and proportions.

Luminism A style of painting in which artists focused on the realistic depiction of light and its effects.

# **Using the Time Line**

Ask: How did the development of the steam engine, electricity, and steel change European rural landscapes between 1600 and 1991? In what ways did rural landscapes remain the same?

# National Standards 5.1 Then and Now Lesson

- **1b** Use media/techniques/processes to communicate experiences, ideas
- .2c Select, use structures, functions.
- **3a** Integrate visual, spatial, temporal concepts with content.
- **4a** Compare artworks of various eras, cultures.
- **4c** Analyze, demonstrate how time and place influence visual characteristics.
- **5b** Analyze contemporary, historical meaning through inquiry.

# Landscape as Art

16701854WheatfieldsCourbet,by van RuisdaelSeaside at Palavas

17th-Century Holland

19th-Century Romanticism and Realism

20th Centur

Gornik, Equator

1983

c. 1660–61 Vermeer's View of Delft

THEN AND NOW LESSON

1835
Turner,
Houses of Lords
and Commons

1863 Heade, Sunset 1991 Gornik, Divided S

#### **Travels in Time**

Throughout the history of art, artists have interpreted the land in many different ways. Some have shown the land as a decorative pattern; others, as a dreamlike vision. Dutch painters of the seventeenth century, such as Jacob van Ruisdael (Fig. 5–9), skillfully rearranged the various features of the land on their canvases. They were interested in the quality of light and open space and studied every color and detail. They captured the shifting shapes formed by clouds and the changing effects of sunlight on water. Their interpretations of the landscape were both dramatic (exciting) and natural.

# Interpreting Land and Sea

Many nineteenth-century European and North American artists continued to interpret the character of the landscape. Some **Romantic** artists, including Turner (Fig. 5–11), responded to nature's power and beauty, and painted dramatic, emotional interpretations. **Realist** artists, including Gustave Courbet (Fig. 5–10), concentrated on the realistic appearance of land, sea, and sky.

The study of light on the landscape was very important for a group of American

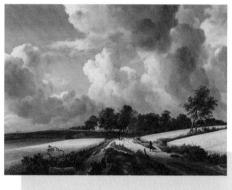

Fig. 5–9 Note the band of sunlight through the lower third of the painting. What happens to the colors of a landscape when clouds block the sun? Jacob van Ruisdael, Wheatfields, 1670.

Norsadet, Wiredifetta, 1070.

Jili on canvas, 39 3/s" x 51 1/4" (100 x 130 cm). Metropolitan Museum of Art, 
3equest of Benjamin Altman, 1913 (14.40.623). Photograph © 1994 The 
Metropolitan Museum of Art.

artists in the mid-nineteenth century. Art historians now refer to this interest in natural light as **luminism**. Sunset over the Marshes (Fig. 5–12) shows one artist's interpretation of the effects of light at sunset. The American luminist painters were concerned mostly with showing water and sky. Their works were realistic and had no sign of brushwork. Artists carefully blended colors. The artists were precise in showing different textures and the colors created by reflected and direct light.

180

# **Teaching Options**

#### Resources

Teacher's Resource Binder

Names to Know: 5.1

A Closer Look: 5.1

Find Out More: 5.1

Check Your Work: 5.1

Assessment Master: 5.1

Overhead Transparency 9

Slides 5c

# **Meeting Individual Needs**

Multiple Intelligences/Linguistic and English as a Second Language Explain to students that landscapes typically reveal more than the physical characteristics of a place: they can also conjure up the locale's mood or personality. Have students study images in this lesson and describe in English the mood or personality of each work. Ask students to create a landscape scene that communicates their emotions right now. After, ask students to discuss with a partner the way each other's work makes them feel and what about the landscape evokes that response.

Fig. 5–10 What is the dominant, or strongest, color in this painting? Gustave Courbet, Seaside at Palavas, 1854.
Oil on canvas, 10 5/8" x 18 1/8" (27 x 46 cm). Musée Fabre, Montpellier, France. Erich Lessing/Art Resource, New York

Fig. 5–11 Why is Turner called a Romantic painter? What colors did he use to show the elements of fire, water, and air? J. M. W. Turner, The Burning of the Houses of Lords and Commons, October 16, 1834, 1835.

Oli lon canwa, 36/2° x 48 1/2° (93 x 123 cm). Courtesy The Cleveland Museum of Art, Cleveland, Ohio. © The Cleveland Museum of Art, Bequest of John L. Severance, 1942.647.

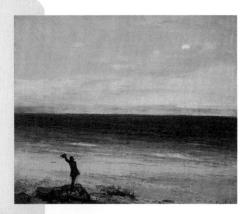

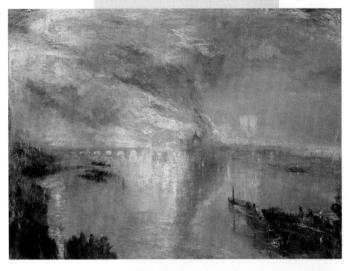

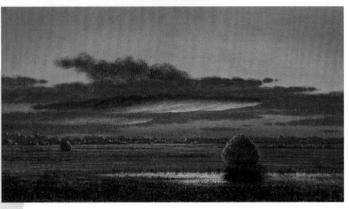

Artists as Interpreters

181

# Teach

# Engage

Have students view a landscape or scene near the school. **Ask:** How do you feel about this scene? Is it peaceful? Scary? Vast? Noisy? Why do you feel this way about the scene? How could you emphasize this feeling in a painting? What colors would suggest your feelings?

# **Using the Text**

Art History Ask: What were Dutch painters interested in showing? How were the Romantic artists' pictures different from the Realists'? (Romantics painted nature's power and beauty; Realists painted nature realistically.) What were the Luminists interested in showing?

# Using the Art

Art Criticism Ask: How are these four landscapes alike? How are they different? Which is the most realistic? How do the brushstrokes or texture of each compare?

# **Teaching Through Inquiry**

Art History Have groups of students identify and locate works by other nineteenth- and twentieth-century landscape artists. Assign each group a specific era for research. Have each group contribute a segment of a larger time line. (See the Time Line Template in the Teacher's Resource Binder.) If possible, have students use reproductions of artworks to make the time line visual. Have each group prepare a report of approaches to landscape painting in their assigned era.

### **Using the Overhead**

### Investigating the Past

**Describe** What natural features dominate this scene? What colors do you see?

**Attribute** What clues do the subject matter and composition give you as to what part of the country this depicts?

**Interpret** Is this a mere landscape, or does it express something more than a realistic view?

**Explain** This painting was made in 1935. How does it compare

to the work of other landscape artists of the 1930s? How does it compare to earlier works?

#### Landscape as Art

#### **Using the Text**

Art Criticism Ask: What quality does April Gornik want her landscapes to have? How does she want viewers to respond to her scenes? What painting was particularly influential in helping Gornik develop her painting style? (Vermeer's View of Delft)

#### **Using the Art**

Art Criticism Ask: What are the colors in Gornik's two paintings? How are Gornik's and Vermeer's paintings similar in their colors, composition, and use of space? How are they different? Where is the light source located in each? Encourage students to give a weather forecast for each painting.

#### **Critical Thinking**

Have students select one of the paintings from pages 180 and 181 that they think is most like April Gornik's art. Direct them to explain how the two paintings are similar.

#### **Studio Connection**

Before students begin drawing, discuss where they will place the horizon

line. Have students lightly sketch the whole scene with a pastel before they add large areas of color and details.

Have students mount or mat their drawing, title it, and write a label describing the artwork's color and light.

**Assess** See Teacher's Resource Binder: Check Your Work 5.1.

#### **Studio Tip**

- If students do not complete their drawing in one period, have them photograph the scene for reference.
- To make chalk pastels more permanent, spray them with fixative in a well-ventilated area.

#### **Landscapes to Experience**

"I really do love beauty." April Gornik (born 1953)

THEN AND NOW LESSON

The challenge facing today's landscape artists is finding a balance between observing and interpreting nature. American artist April Gornik achieves that balance by thinking of the outdoors as an inner space. She remembers that as a child in Ohio, she would go outside and look for storms. She saw the sky as a way

Photo: Timothy Greenfield-Sanders.

to reach beyond the limits of her world. As an artist, Gornik wants her landscapes to have a fictional, "other world" quality. She wants viewers to put themselves into her landscapes and experience the space.

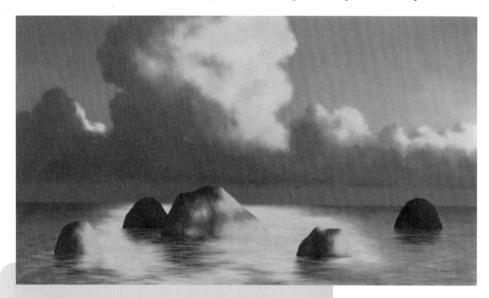

Fig. 5–13 The artist probably started this work with a series of small sketches. She then worked on one image and enlarged it, with pencil, on a canvas. April Gornik, Light at the Equator, 1991.

Oil on linen, 74\* x131\* (188 x 333 cm). Courtesy Edward Thorp Gallery, New York.

Fig. 5–14 In your opinion, why was April Gornik attracted to this painting? Jan Vermeer, View of Delft from the South, c. 1660–61.

Olion canvas, 38° x 45 1/2° (97 x 116 cm).
Courtey the Mauritshuis, The Hague,

182

### **Teaching Options**

#### **Teaching Through Inquiry**

Art Criticism Ask students to look in this book and in other books for images that focus on nature as the subject matter (landscapes, animals, flowers, and so on) and to identify the works by title and artist. Have students find at least two artworks for each of these interpretations of nature: plentiful, destructive, protective, peaceful, exciting, frightening. Suggest to students that they add synonyms and other descriptive words—such as powerful, giving, and forceful—to strengthen the interpretations. You may wish to extend the exercise by having students suggest the ways that lines, shapes, colors, and so on, contribute to the interpretations.

#### **Luminous Landscapes**

Once she finished school, Gornik traveled to Europe. In a small Dutch museum, she saw a seventeenth-century landscape painting, Ian Vermeer's View of Delft (Fig. 5–14). This was the only landscape Vermeer painted. When she returned to the United States, Gornik started painting landscapes. Years later, when she again viewed Vermeer's work, she realized that elements in View of Delft were what she was creating in her own landscapes.

Look closely at Gornik's paintings Light at the Equator and Divided Sky (Figs. 5–13, 5-15). Notice how her interpretations of nature focus on the pureness of light, color, and the structure of natural forms in the landscape. Her large drawings and paintings are luminous: light seems to shine through her colors. Although her work is often compared to the nineteenth-century American luminist painters, Gornik does not try to capture a specific place, time, or climate. Rather, she sets out to make something extraordinary-

#### **Studio Connection**

Using pastels on colored paper, interpret and draw an outdoor scene. What will you draw? How much of

your paper will you use for the sky? What colors will you use? How can you show the brightness or gloominess of the sky? How can you show things up close or far away? How can you show where the light comes from? What can you do to show how colors gradually change from light to dark or from one color to another?

#### **Lesson Review**

#### **Check Your Understanding**

- 1. How was a Romantic interpretation of nature different from a Realist interpretation?
- 2. What is luminism?
- 3. What are some similarities and differences between the work of April Gornik and the work of other artists in this lesson?
- 4. Why are the qualities of light and color important to landscape painters?

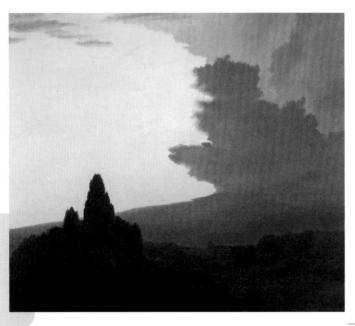

Artists as Interpreters

183

#### Assess

#### **Check Your Understanding: Answers**

- 1. Realist interpretations showed the actual appearance of scenes. Romantic interpretations, which were dramatic and emotional, showed nature's power and beauty.
- 2. Luminism is a realistic art style developed by mid-nineteenth-century American artists who studied light on landscapes.
- 3. Gornik and the other artists painted landscapes with open spaces and an abundance of sky. They were all interested in light in their scenes. Gornik's scenes are fantasy, but the other artists' are real places.
- 4. Answers will vary. Color and light suggest emotions, space. and form; and they can add drama to a landscape.

#### Close

Discuss students' answers to Check Your Understanding. Display their pastel drawings, and have students describe how the mood in each is suggested by color and light.

Fig. 5-15 Have you ever seen clouds like the ones in this painting? What did they make you think of? April Gornik, Divided Sky, 1983. is, 72" x 85" (183 x 216 cm ton Museum of Art. The University of Texas at Austin. Gift of Mr. and Mrs. Jack Herring, 1984.

a beautiful artwork.

#### More About...

Little is known about Dutch painter **Johannes** Vermeer (1632-1675). He was a respected master in the Delft painters' guild, but he probably had a source of income from work other than painting, perhaps as an art dealer. He likely painted View of Delft and many of his domestic interiors with the aid of a camera obscura, a primitive lens that focused an image into a box. He unified his serene compositions with pearly light. Upon his death, he left his wife and eleven children in poverty.

#### **Assessment Options**

Teacher Review the distinctive features of Romantic, Realist, and Luminist artworks. Arrange a representative display of such artworks, and assign a number to each one. Ask students to list the numbers and identify the movement of each work.

Self Ask students to write an evaluation of their own studio work, commenting on what they perceive as their strengths and weaknesses, their use of color to express a mood, and the degree to which their drawing could be considered a Realist or a Romantic work.

#### **Prepare**

#### **Pacing**

Two or more 45-minute periods: one to consider text and images and to mix colors; one or more to paint

#### **Objectives**

- Explain the process of creating tints and shades.
- Learn about the process of creating color intensity and how it differs from creating shades.

#### Vocabulary

**primary colors** The three colors from which other colors can be made: red, yellow, and blue.

tint A light value of a color.

shade A dark value of a color.

intensity The brightness or dullness of a color.

**complement** A color that is opposite another on the color wheel.

#### Teach

#### Engage

Demonstrate mixing secondary colors.

#### **Using the Text**

Art Production Have students use the primaries and black and white to create other colors, tints, shades, and intensities.

#### National Standards 5.2 Skills and Techniques Lesson

**2a** Generalize about structures, functions.

2c Select, use structures, functions.

### **Color Mixing**

This lesson is an introduction to the basic skills and techniques of color mixing. To review color basics: red, yellow, and blue are the three **primary colors**. All other colors are made from various combinations of these three pigments. Adding white makes a color lighter. A lighter value of a color is called a **tint**. Adding black makes a color darker. A darker value of a color is called a **shade**. In art, the word **intensity** refers to how bright or dull a color is.

#### **Practice Mixing**

To avoid unwanted colors and to get the colors you really want, you should practice mixing tempera paint. Begin by painting a

mixing primaries

SKILLS AND TECHNIQUES

small circle of each of the primary colors on a large sheet of manila paper. Then, on a paper plate, piece of cardboard, or disposable palette, mix one primary color with one other primary color. Paint another circle with this color, and label it with the names of the colors you mixed. Continue practicing until you have mixed a variety of combinations, including a mixture of all three colors. Remember to wash, wipe, and blot your brush between colors.

Then practice mixing tints. On manila paper, begin with three small circles of white paint. Add a drop of one color to one circle, and mix. Add two drops of the same color to the second circle, and mix. Add three drops of the same color to the third circle, and mix. Label each circle with the names and amounts of colors you mixed.

mixing tints mixing shades

To practice mixing shades, paint three small circles of one color. Add one drop of black to one circle, and mix. Add two drops of black to the second circle, and mix. Add three drops of black to the third circle, and mix. You may be surprised at the small amount of black needed to get a very dark shade. Again, label each circle with paint amounts and names.

184

### **Teaching Options**

#### Resources

Teacher's Resource Binder

Finder Cards: 5.2

A Closer Look: 5.2

Find Out More: 5.2

Check Your Work: 5.2

Assessment Master: 5.2

Overhead Transparency 10

Slides 5d

#### **Teaching Through Inquiry**

Art Production Have students work in groups to create a collection of paint chips like those from paint stores. Assign each group one of the primary or secondary colors, and have students create chips for tints, shades, and ranges of intensity of the assigned color. Provide 2" x 4" pieces of heavy paper for the chips, and have students record the "formula" on the reverse of each chip. Store the completed set for future reference.

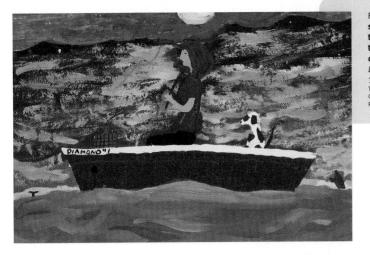

Fig. 5–16 Where do you see tints and shades in this artwork? Where did the artist mixed primary colors? Cherri Moultroup, Last Bits of Summer, mpera, 14" x 20" (35.5 x 61 cm).

#### **Changing Intensity**

Primary colors are bright colors. To make a color duller, you can add a small amount of its complement. A **complement** is the color opposite a color on the color wheel. For example, green is the complement of red. Adding a very small amount of green to red will make the red duller.

intensity scale

Practice changing the intensity of a color. First, paint three circles of yellow on manila paper. Leave the first circle alone. Add a drop of violet to the second circle, and mix. Add two drops of violet to the third circle, and mix. How do the three circles of yellow differ? Label each circle with colors and amounts of paint mixed. Try the same experiment with red and green, and orange and blue.

#### **Studio Connection**

Choose a subject for a small tempera painting on manila paper-for example, you might decide to create a still

life, a landscape, or a self-portrait. Mix your own colors. Be sure to include at least one primary color, one tint, and one shade in your composition

#### Lesson Review

#### **Check Your Understanding**

- 1. Why do you think it is usually best to begin with white paint when mixing a tint? Why would you not want to start with black to mix a shade?
- 2. How is the process of changing the intensity of a color different from the process of changing the value of a color?

#### **Using the Art**

Art Criticism Ask: What are the tints and shades in Last Bits of Summer? Where in her painting did Moultroup mix primary colors?

#### **Studio Connection**

Before students paint, have them lightly sketch their composition in pencil.

Assess See Teacher's Resource Binder: Check Your Work 5.2.

#### Assess

#### **Check Your Understanding: Answers**

- 1. If white is added to a color, a large amount of white would be needed to create the lightest tints. If a color is added to black to create a shade, a large amount of the color would be needed for it to be noticeable.
- 2. Complementary colors are mixed to change intensity; black is added to a color to change value. A dark color is not necessarily a dull color.

#### Close

Have students identify primary colors, tints, and shades in their paintings.

185

Artists as interpreters

#### More About...

Painting began with prehistoric peoples who used natural pigments on cave walls. Egyptians used watercolors on tomb walls. Renaissance artists used egg tempera to create frescoes. Oil paint eventually replaced egg tempera as the standard painting medium. Oil paints in tubes freed artists from making their own paints. Acrylic resins have been commercially manufactured since the 1930s but were not widely used until the 1960s.

#### **Assessment Options**

Teacher Provide each student with a reproduction of a painting

and a piece of layout or tracing paper. Ask students to trace the main parts of the painting and indicate how the artist used tints and shades and where the artist varied the intensity of one or more colors. Look for evidence that students understand the difference between tints and shades, as well as how colors can vary in intensity.

#### **Using the Overhead**

#### Write About It

**Describe** Tell about the artwork so that your reader can imagine its subject matter and other features.

Analyze Explain how the artist used color, line, and

other art elements to attract and hold the viewer's attention.

#### **Prepare**

#### **Pacing**

Two 45-minute periods: one to consider text and images; one to paint

#### **Objectives**

- Explain why nature is a source of inspiration for Chinese artists.
- Describe Chao Shao-an's method of painting from nature.
- Use watercolors to paint a colorful floral arrangement.

#### Vocabulary

dynasty A group of rulers from the same family or related in some other way.

#### **Using the Map**

Remind students that China is about the size of the United States (including Alaska). Point out that the Gobi Desert lies in the north; the south is moist and tropical; and much of the interior is mountainous.

The Ming dynasty marked the beginning of construction of the Imperial Palace in Beijing.

#### National Standards 5.3 Global Destinations Lesson

- **1b** Use media/techniques/processes to communicate experiences, ideas.
- **2b** Employ/analyze effectiveness of organizational structures.
- **4a** Compare artworks of various eras, cultures.
- **4c** Analyze, demonstrate how time and place influence visual characteristics.
- **5b** Analyze contemporary, historical meaning through inquiry.

### **Art of China**

#### **Places in Time**

For thousands of years, China was governed by **dynasties**, powerful family groups who ruled through many generations. Under the dynastic emperors, the arts in China grew. The change of powerful emperors from one dynasty to another often resulted in a change in the look of China's art. This was especially so during the Ming dynasty (1368–1644).

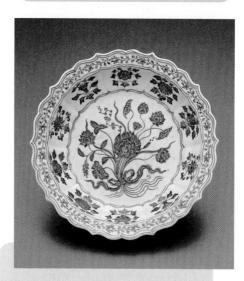

Fig. 5–17 What is the name of a color scheme that uses only tints and shades of one color? China, Ming dynasty, Xuande period, *Dish*, 1426–35.

Porcelain with underglaze blue decoration, height 2° (5.1 cm), 61th of Russell Tyson, 1955.1204. Photograph: Christopher Gallagher. The Art Institute of Chizago (Prize on Ullicolis).

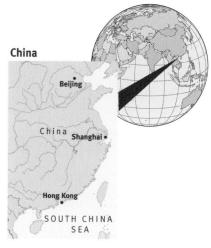

#### **Observing Nature**

At the beginning of Chinese culture, metal-workers and potters looked to nature for ideas. They decorated bronze and ceramic vessels with images of plants and animals. Professional craftsworkers during the Ming dynasty also studied the natural world to get ideas for decorating precious objects. They often covered objects, such as the dish and incense burner shown in Figs. 5–17 and 5–18, with images from nature.

Painters during the Ming and other dynasties were educated to be scholars. As educated people, they had special rights, led a comfortable life, and were expected to have elegant taste and a strong moral character. An important part of the artists' education was nature painting. The dynastic emperors stressed the importance of harmony between humans and nature. Artists helped by interpreting the beauty of the natural world in their paintings and writings.

186

GLOBAL DESTINATIONS

### **Teaching Options**

#### Resources

Teacher's Resource Binder A Closer Look: 5.3 Find Out More: 5.3 Check Your Work: 5.3 Assessment Master: 5.3 Large Reproduction 10 Slides 5e

#### **Teaching Through Inquiry**

Art Criticism Prepare a bulletin-board display of brushstrokes made with brushes ranging from large house paintbrushes to fine water-color brushes. Prepare labels on separate cards that students can tack into place. Use words such as bold, delicate, graceful, agitated, sweeping, hesitant, direct, nervous, broad, strong, weak, fine, and so on. Introduce the words, and invite students to match one or more labels with each brushstroke example. Challenge students to come up with other descriptors and to use any of them to describe line qualities of artworks in the book.

### Paintings of the Natural World

The Ming artistic rules were based on ideas and methods from a much earlier time. Chinese artists, always aware of the past, were educated to paint the natural world in the styles of the most famous artists of the previous dynasties. Thus, an artist such as Wen Boren (Fig. 5–19) could paint in at least six different styles and produce land-scapes ranging from dramatic and stormy to delicate and peaceful.

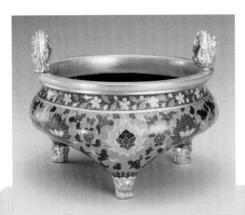

Fig. 5–18 The process of enameling on metal allows for rich and lively color effects. Do you think these are bright colors? China, Ming dynasty, *Incense Burner*, 16th century.

Fig. 5–19 What words would you use to describe this artist's interpretation of nature? Wen Boren, River Landscape with Towering Mountains, 1561.
Hanging scroll, ink and color on paper. Eugene Fuller Memorial collection. Scattle Act Museum.

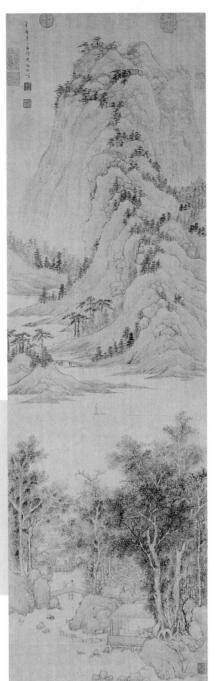

#### Teach

#### Engage

Discuss with students what they know about China. Explain that they will study the ways that Chinese artists depict nature.

#### **Using the Text**

Art History Ask: What is a dynasty? When was the Ming dynasty? (1368–1644) How were Ming painters educated? How did Ming emperors influence art?

#### **Using the Art**

Art Criticism Ask: What colors are on the Ming dish? (blue and white) What type of color scheme is this? (monochromatic) What are the colors and the nature design on the enameled incense burner? What is the path that would be taken by someone in Wen Boren's landscape? How did the artist indicate distance? (placed close objects at bottom of picture, middle-ground objects in middle, and distant objects at top)

Artists as Interpreters

187

#### More About...

Artists from the **Ming dynasty** (fourteenth through mid-seventeenth century) developed and perfected their skills in several art forms. Among them were blue and white porcelain, jade and ivory sculpture, and cloisonné enamelware. Artists also painted nature scenes on both hanging and hand scrolls of paper and silk.

#### **Using the Large Reproduction**

#### **Consider Context**

**Describe** What words describe the colors? **Attribute** What qualities in this artwork would lead

someone to believe that it is Chinese art?

**Understand** Why, do you think, does this work remind people about relationships in nature?

**Explain** What in this work, do you think, is appealing to viewers?

10

#### **Using the Text**

Art Criticism Ask: How did Chao Shao-an learn to paint? (drew from pictures and paintings, taught himself to paint in watercolors, studied with a master painter) How did he begin a painting? (made studies of natural subjects) Why do art critics praise his works? (He combined traditional Chinese art and modern art) What do you like about his art?

#### **Using the Art**

Art Criticism Ask: What are the colors in Chao's paintings? Where are areas of analogous color schemes in each painting? How many brushstrokes do you think he used in each leaf in Gladioli? Guide students to note that Chao filled the page with flowers and let them extend past the edge of the painting. Ask: Can you find any birds in Azaleas? Where? Point out the vertical calligraphy and the red squares, or chop marks, on each painting. Explain that Chinese artists and the artworks' owners traditionally stamp a painting with their mark.

#### **Studio Connection**

Set fresh or artificial flowers in vases where all students can have a close view of

them. Demonstrate using watercolors, with as few brushstrokes as possible, to indicate leaves, flowers, and branches. Before students begin, lead them to consider the design of their painting. Ask: What will you emphasize? Which will you make more prominent, the flowers or the vase? Encourage students to fill their page with their design. Provide students with watercolor brushes or pointed bamboo brushes.

**Assess** See Teacher's Resource Binder: Check Your Work 5.3.

#### Interpreter of Nature

"I recall fondly a life devoted to books." Chao Shao-an (1905–1998)

Like artists in the past, contemporary artists in China study the masterworks of Chinese art. Like many young Chinese, Chao Shao-an drew from pictures and old paintings. He was interested in art from an early age and taught himself to paint in watercolors. When he was fifteen, he studied with a master painter and continued to polish the techniques used by the old masters. He also learned new methods of drawing from life. He soon became known as a creative painter of birds, animals, and flowers.

Chao Shao-an's paintings clearly show his strong attachment to the natural world. Before beginning to paint, he made careful studies of subjects in nature. He interpreted

The Avery Brundage Collection, Chong-Moon L Center for Asian Art and Culture, Asian Art

his subjects according to his mood or feeling at a certain time. He also based his interpretations on his own ideas about color, light and shade, and perspective. Although most of his compositions appear to be very simple, Chao carefully planned them, arranging positive shapes and negative spaces.

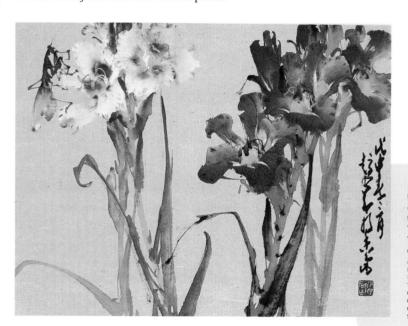

Fig. 5–20 Note how the artist used his colors. Where are the bright colors? The dult colors? The dark and light colors? Chao Shaoan, Gladioli, 1968. Ink and colors on paper, 13 1/8" x 18 1/2" (32.7 x 47 cm). The Aven Brundage Collection, Chong-Moon Lee Center for Asian Art and Culture, Asian Art and Culture, Asian Art and Culture, Asian Art and San Francisco (1992.248).

188

### **Teaching Options**

#### Meeting Individual Needs

Gifted and Talented and Multiple Intelligences/Naturalistic Have students use images in this lesson to illustrate how traditional Chinese artists represented the harmonious relationship between people and the natural world. Then ask students to create art that illustrates people's relationship to the environment in their own area today. Next, ask students to imagine being a modern botanist and to explain his or her aesthetic, scientific, and ecological reactions to the art.

#### **Teaching Through Inquiry**

Aesthetics Ask students to examine the artworks in this lesson. If possible, show them other Chinese paintings. Ask: What things distinguish these works from others in the book? What are the characteristics of a traditional Chinese artwork?

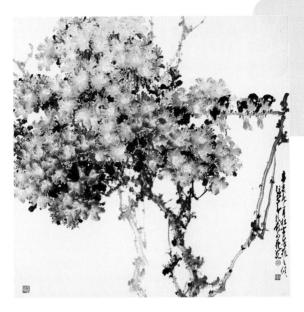

Fig. 5–21 Azaleas are at their most beautiful and colorful in the spring. Do you think the artist was responding to the warmth or the coolness of springtime? Why do you think this? Chao Shao-an,

Azaleas, 1971.

Ink and colors on paper, 38 3/8" x 37 3/4" (98 x 96 cm). The Avery Brundage Collection, Chong-Moon Lee Center for Asian Art and Culture, Asian Art Museum of San Francisco (1992.239).

# Traditional Landscapes in a Modern Style

Chao Shao-an has been praised for his ability to combine the traditional and the modern. In paintings such as *Gladioli* (Fig. 5–20) and *Azaleas* (Fig. 5–21), he used modern techniques to show traditional subjects. Art critics call attention to the modern look of his energetic and elaborate brushwork. Chao used dry and loose brushstrokes to create textures and catch the natural beauty that most people never notice. He skillfully built up layers of ink and color washes. Strong colors gradually fade into soft tones. His paintings are pleasant reminders of the friendly joining of humans with nature.

#### **Studio Connection**

Use the qualities and techniques of watercolor in your interpretation of flowers, leaves, and branches in a vase.

How will you arrange your composition to make a colorful interpretation of floral forms? Will your paper be vertical or horizontal? You may first make a light pencil sketch of the shapes and details of the arrangement, and then experiment with watercolor washes and ways to use thick and thin brushstrokes to make leaves, branches, and petals.

#### **Lesson Review**

#### **Check Your Understanding**

- **1.** Where did Chinese artists get ideas for decorating their pottery and metal vessels?
- **2.** What were artists during the Ming dynasty expected to be able to do?
- 3. What is at least one similarity and one difference between Chao's education and that of the artists of the Ming dynasty?
- **4.** Is Chao Shao-an a modern artist? Why or why not?

Artists as Interpreters

189

#### **Assess**

#### Check Your Understanding: Answers

- 1. from nature
- 2. Artists were to have elegant taste and a strong moral character, and were expected to interpret nature's beauty in their art.
- 3. Chao and Ming artists both studied past styles and were inspired by nature, but Chao creatively expressed his own feelings about nature with modern, energetic brushstrokes. The Ming artists were bound to traditional styles and techniques.
- **4.** Answers will vary. His work is modern in its free, expressive look, but he used a traditional Chinese approach to painting nature.

#### Close

Discuss students' answers to Check Your Understanding. Have students display their paintings according to color schemes, such as by cool or warm colors. If several of the paintings are of the same color, have students arrange them from light to dark.

#### More About...

Chao Shao-an (1905–1998) was trained in both classical Chinese and European art techniques by the founder of the Lingnan School in Guangzhou (Canton). In 1928, Chao exhibited his works publicly for the first time. He was known around the world as an artist and as an art educator, and eventually became leader of the Lingnan School. In 1937, when the Sino-Japanese War broke out, Chao fled to Hong Kong. He later moved the Lingnan School to Hong Kong. During his leadership, the school became an important link between traditional and contemporary Chinese art.

#### **Assessment Options**

**Teacher** Have students each summarize in their own words how Chao Shao-an

approached his work, and why Chinese artists in general look to nature for inspiration. Students may use their books to help them with their response.

**Self** Ask students to express their ideas about working with watercolor and to indicate what seems to work well for them and what is difficult. Ask them to identify one area of their skill that they would like to improve.

#### **Wood Constructions**

#### **Prepare**

#### Pacing

Two or more 45-minute periods: one to consider text and images; one or more to build and paint animal forms

#### **Objectives**

- · Learn how artists may attend to the shapes, colors, and forms of materials when interpreting animals.
- · Understand how artists work with colors and color schemes to express moods or ideas.
- · Create a sculptural animal out of wood scraps and branches.

#### Vocabulary

spectrum The complete range of color visible in a beam of light.

#### **National Standards** 5.4 Studio Lesson

- 1b Use media/techniques/processes to communicate experiences, ideas.
- 2b Employ/analyze effectiveness of organizational structures.
- 3b Use subjects, themes, symbols that communicate meaning.
- 4c Analyze, demonstrate how time and place influence visual characteristics.
- 5c Describe, compare responses to own or other artworks.

Sculpture in the Studio

### **Wood Constructions**

#### From Branches to Animals

STUDIO LESSON

#### Studio Introduction

Have you ever seen a cloud shaped like a walrus? How about tree branches in the shape of a horse? Shapes

and forms we see in nature can excite our imagination, and can inspire artists to make fanciful creations. Artists often respond to the qualities—such as shape, form, and color—that art materials offer.

In this studio lesson, you will build a sculptural animal out of wood scraps and branches. Pages 192 and 193 will tell you how to do it. Look carefully at collected scraps of wood. Find interesting wood forms or branches or twigs that have blown down or fallen from trees. Turn the wood pieces and look at all the sides and angles. Do any pieces look like animal shapes? Like the Oaxacan woodcarvers (see Studio Background), let the shapes and forms of the wood inspire you.

#### **Studio Background**

#### **Oaxacan Woodcarving**

Woodcarving from twisted tree branches is a popular art form among the Zapotec, of southern Mexico's Oaxaca valley. Artists carve animal sculptures, usually ones that show movement and expressive poses. The shapes of the branches help the artists decide what animals to make.

Oaxacans have carved toys and masks for hundreds of years. Today, over 200 Oaxacan families of woodcarvers produce sculptures, such as those in Figs. 5-22 and 5-23. The woodcarvers are mostly farmers. Usually, the men carve the sculptures, and the women paint them. Although the carvers sign the sculptures, the entire family plays a part in their production.

The decorating of the sculptures is as important as the carving. Instead of turning to nature for decoration ideas, the artists use colors and patterns that are brighter, bolder, and more fanciful than those in nature. Imagine seeing a bright-blue lizard with lavender and red flames, or a green-and-orangespotted antelope with pink hooves!

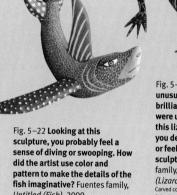

Untitled (Fish), 2000. Carved copal wood, 10" x 3" x 5" (25 x 8 x 13 cm). Photo courtesy Eldon Katter.

Fig. 5-23 Note the unusual patterns and brilliant colors that were used to decorate this lizard. How would you describe the mood or feeling of this sculpture? Fuentes family, Untitled (Lizard), 2000. Carved copal wood, 10" x 3" x 5" (25 x 8 x 13 cm). Photo courtesy Eldon Katter.

190

### **Teaching Options**

#### Resources

Teacher's Resource Binder Studio Master: 5.4 Studio Reflection: 5.4

A Closer Look: 5.4 Find Out More: 5.4

Overhead Transparency 9

Slides 5f

#### Teaching Through Inquiry

Art History Have the class create a bulletin board of animal interpretations. Have students work in pairs or in small groups to research examples of animal artworks from around the world and throughout history. Have students photocopy the images, write labels identifying the time and place in which the artworks were made, and create the bulletin-board display. Students may add three-dimensional animal artworks to the display, perhaps on a table in front of the bulletin board. Students may wish to organize the arrangement of images and three-dimensional pieces by animal type or major characteristic (calm, proud, threatening, and so on).

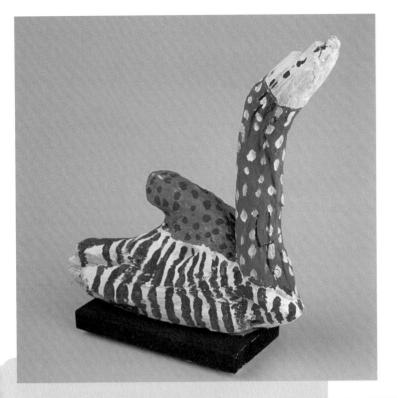

Fig. 5–24 "I picked up these two pieces of wood, and I saw the swan. So I started painting," said artist Anne Bertollini. What mood do her color choices suggest? Anne Bertollini, *The Swan*, 2000.

Fig. 5–25 This student changed an everyday stick into a snake-like monster. Would you describe the color choices as natural or fanciful? Why? Wesley King, The Fearless Monster, 2000. Driftwood, paint, length: 21° (53 cm.)

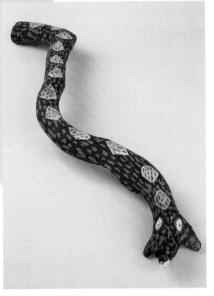

Artists as Interpreters

191

#### More About...

Woodcarvings from Oaxaca (wuh-HAH-kuh) have been carved as toys for hundreds of years. During the second half of the twentieth century, these carvings became popular tourist items: the tourist trade increased the carvings' prices—and the number of carvers creating them. The woodcarvings are usually made from copal, a soft Mexican wood, and are painted with acrylic paints. The finest details are added with the tip of a cactus needle.

#### **Using the Overhead**

#### Think It Through

Ideas What ideas about nature are important in this artwork?

**Techniques** How did the artist use materials to suggest these ideas?

9

#### **Supplies**

- prism
- wood scraps, assorted shapes
- small tree branches, twigs, or sticks
- woodworking tools such as rasps, files, coping saw, sandpaper
- wood glue
- · clamps (optional)
- tempera or acrylic paint (red, yellow, blue, black, white)
- paintbrushes
- disposable palette (scrap cardboard or foam or paper plate)
- water
- hot glue and gun (optional)
- small nails and hammer (optional)

#### Teach

#### Engage

Ask: Have you ever glanced at a tree branch or leaf and thought for a moment that it was an animal? Hold up a crooked branch, and ask students what animal it calls to mind.

#### **Using the Text**

Art History Ask: What animals have you "seen" in cloud shapes? Tell students that the Zapotec live in the Oaxaca valley and are descendants of a Mesoamerican Indian people.

Ask: Where is the Oaxaca valley? (in southern Mexico) What helps Oaxacan artists decide which animal to carve? (the shapes of branches)

#### **Using the Art**

Art Criticism Ask: What do you think were the shapes of the original tree branches used for the lizard and the fish? What suggests movement in the animals? (shape, painted design) What is the mood or feeling of each sculpture? How would the mood of each be different if the artists had used colors and patterns from nature?

#### **Wood Constructions**

#### **Studio Experience**

- 1. Demonstrate shaping wood pieces with sandpaper and woodworking tools, and then joining them with small nails or glue.
- 2. After students have read Elements and Principles, use a prism to separate white light, from a window or projector, into the spectrum colors.
- 3. Demonstrate mixing primary paint colors with black and with white to create other colors. Use the color wheel on page 308 to review complementary color schemes. Discuss the colors that can suggest such moods as anger and happiness.
- **4.** Encourage students to paint large areas on their animal before they add fine details.

#### Safety Note

Demonstrate the safe use of woodworking

tools. Caution students to protect work surfaces from sharp tools; and, if students use hot glue, to let it cool before touching it.

#### **Studio Tip**

As an optional construction technique, have students build animal skeletons or armatures from wire, pipe cleaners, or rolled heavy-duty aluminum foil. Have students wrap the armature with plaster cloth or papier-mâché and then paint.

#### **Extend**

Have students paint a picture of their animal in its habitat. **Ask**: Will your animal's environment show expressive or local colors? What will best suggest the mood or feature you want to emphasize in your animal? What other life forms will be in this environment? Will your animal blend into this environment or stand out?

Sculpture in the Studio

#### Building Your Sculptural Animal

#### You Will Need

- wood scraps
- small tree branches, twigs, or sticks
- rasps, files, coping saw, sandpaper
- wood glue
- tempera or acrylic paint
- paintbrushes

#### **Safety Note**

Rasps, files, and saws can be extremely dangerous when not used properly. If you have not used these

tools before, ask your teacher for help. To avoid injury, always handle all cutting tools with extreme care.

#### Try This

1. Decide whether you will use wood scraps or branches to create your animal. You may use both. Choose one or two pieces from which to

create the main form of the animal. How can you arrange and shape the pieces to create movement or an expressive pose? What small pieces can you add to create ears, legs, a tail, or other features?

2. Carefully shape the main form with a saw or other tools. If you use more than one piece of wood, glue the main forms together. Then add the smaller features.

**3.** After you have assembled your animal, decide whether you will decorate it. Will you leave your sculpture natural, with or without the tree bark? Or

will you paint it? If you decide to paint, think about color and pattern. Be as creative as you can! What mood do you want your colors to suggest? What colors can create a happy, scary, dangerous, gentle, or peaceful animal?

#### Check Your Work

Display and discuss your sculpture with your classmates. How did the shape of the wood add to the shape and pose of your animal? Do the paint colors you chose create the mood you wanted?

#### **Computer Option**

You may never have the chance to visit the Oaxaca valley in Mexico, but the Internet can bring the art-

works of this culture to you. Browse some Oaxacan sites selected by your teacher. Take special note of the sculptures and read about the artists and their culture. Select two or three images that you find especially interesting. Copy and paste these images, as well as information about them (title, locations, artist, etc.), into a document in a word-processing program. Include personal information, such as why you selected these images. Write four descriptive words that apply to the images you selected.

192

### **Teaching Options**

#### **Studio Collaboration**

Have student groups create a threedimensional environment for their animals. Students may use clay, found objects, papier-mâché, wire, paint, and plant materials to build a diorama. Encourage students to explain the features of their animals that allow them to thrive in this habitat.

#### **Teaching Through Inquiry**

Art Production Have students create paintings or colored-marker drawings of patterned animals. Invite students to look for ideas for patterns in books and other resources about animals. Students may, for example, stylize zebra stripes and leopard spots into overall patterns. Encourage students to be playful by asking them to think how, for example, a pig would look with zebra stripes. Suggest to students that they incorporate other patterns as background for the patterned animals. Remind students to be attentive to the use of colors and color schemes in creating their artworks.

#### **Elements and Principles**

#### Color

Our world is filled with color. Everywhere we turn, we see bright colors, dull colors, light colors, dark colors-every color you can imagine. You may wonder where color comes from. Color is a

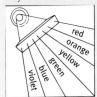

feature of light. When white light is separated into its colors by a prism, or even by a drop of water, a rainbow is created. The rainbow is the spectrum, or entire range of colors produced

from white light. When white light strikes an object, some of its colors are absorbed by the object and some of its colors are reflected. The object then appears to have color.

Artists can reproduce colors in the environment by using and mixing paints, dyes, or other color

pigments. They can use the three primary colors-red, blue, and yellow-plus black and white to create just about every color. When artists create a painting or drawing, they choose a color scheme, or plan for selecting colors. Color schemes can help artists express mood. An artist might choose a color scheme of bright colors or earth colors. Or an artist might choose a complementary color scheme. Complementary colors-such as red and green, blue and orange, and violet and yellow-are directly opposite each other on the color wheel. What mood do you think is created by a bright color scheme? An earth color scheme? A complementary color scheme?

Look at the artworks on pages 190 and 191. What color scheme was used on each sculpture? What mood does each create? Look at your own work or that of your classmates, and answer the same questions.

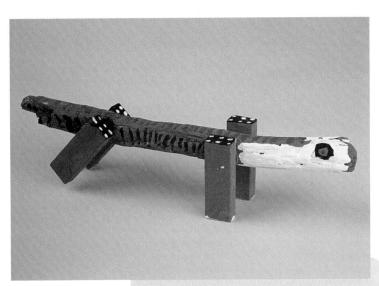

Fig. 5-26 This artist added wood pieces to the main form of his sculpture. This is known as an additive process. Brian Kinney, Domino the Dog, 2000.

Driftwood, paint, length: 14" (35.5 cm), Jordan -Elbridge Middle School, Jordan, New York

Artists as Interpreters

193

**Computer Option** To make their time on the Internet more pro-

ductive, preview and bookmark some sites for students. After students have gathered images and information and have written their descriptive words, have them share their findings with the class.

#### **Elements and Principles**

Have students look through the textbook for artworks that have a complementary color scheme; a bright color scheme; and an earth color scheme. Invite them to discuss the moods that each color scheme creates in the artworks they chose. Ask them to provide one or two reasons why they like or dislike each color scheme.

#### Assess

#### **Check Your Work**

Allow students each to explain to classmates how the shape of the wood influenced their animal's shape and pose. Challenge them to describe the mood suggested by colors in one another's sculptures, and then discuss whether the viewers and the artist perceive the same mood.

#### Close

Display the animal sculptures with their titles. Review with students what they have learned about Oaxacan woodcarvers and color.

#### More About...

Nearly every color in the visible spectrum can be made by mixing, or adding, three basic hues—typically, red, blue, and green. This additive theory of color is the basis for color TV and the color computer monitor. Other colors can be produced by using filters or colorants to remove a part of the spectrum of white light. This is the subtractive theory of color. Colors that we observe in nature—green grass, blue sky, yellow flowers—result from absorption of some of the light from the sun. This perception of color, part of our sense of sight, is subjective and therefore varies from individual to individual. However, to make color objective and universal, scientists, through measurement and experiment, have developed colorimetry. Objective color—which is measured in terms of brightness, hue, and saturation—permits a particular color to be reproduced anywhere in the world.

#### **Assessment Options**

your animal suggest its personality?

Self Encourage students to imagine how their animal would introduce itself to a partner's animal. Have students write their introduction and display it with their art. Ask: What features and colors in

#### Connect to. . .

#### **Social Studies**

Have students jointly develop and individually conduct a survey about cultural and personal interpretations of the meanings and emotional responses that colors evoke. For the sake of time, limit the list of color choices to black and white and the primary and secondary colors. Have students interview people from a range of ages and cultures. Ask them to compile and then discuss their findings in class.

#### Careers

Assemble a classroom art exhibit of the large reproductions of artworks. Tell students each to assume the role of an art critic, choose an image they particularly like, and write a persuasive review so as to encourage the reader to share their opinion. Have students share and discuss their reviews, and display them alongside the artworks.

### Connect to...

#### **Other Subjects**

#### **Social Studies**

Do you think all people interpret the meanings of colors in the same way? Or do you think colors have various meanings in different cultures? In many countries, including the United States, brides traditionally wear white. In China, however, white is the color worn for grieving. Chinese brides customarily wear red, a color that means happiness in their culture. In other cultures, the color red often symbolizes a warning, and it is used for stop signs, traffic lights, fire engines, and exit signs.

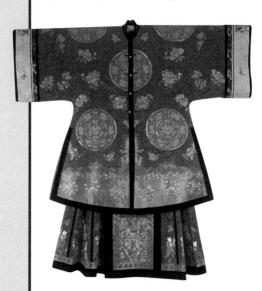

Fig. 5 – 28 In what ways is this wedding ensemble similar to and different from wedding dresses that you have seen?

China, Qing dynasty, Wedding Ensemble, c. 1860.

Slik with embroidery and couched gold threads; robe 43° x 8° (109 x 97 cm); skirt 39° x 46° (99 x 117 cm). Pacific Asia Museum Collection, Gift of Dr. and Mrs. Milton Bubble 109 & 140° Destrict Asia Museum Collection, Gift of Dr. and Mrs. Milton

Fig. 5–27 Champollion determined that each hieroglyph represented one or a group of sounds (letters).

Photo courtesy Helen Ronan.

#### Language Arts

How have researchers been able to translate ancient languages? One longtime challenge for them was the **interpretation of ancient Egyptian hieroglyphics**. In 1799, the discovery of the Rosetta Stone—a stone slab with writing carved in it—presented scholars with an opportunity to break the code. Carved into the stone was a passage written in three languages: hieroglyphics, demotic (a shorthand form of hieroglyphs), and Greek. Because scholars knew Greek, they were able to decipher words in the two unknown languages by comparison. French scholar Jean-François Champollion translated the full text on the stone in 1821.

#### Science

Have you ever made and glazed a ceramic object? Glazes produce a glasslike, waterproof surface on ceramics. In ancient China, potters used glazes to interpret the beauty of the natural world. They applied the glazes by dipping or painting. Early glazes were made from such natural chemicals as quartz, sand, iron, cobalt, and copper. The color of a glaze depended on the chemicals used to make it. For example, iron produced a yellow color, cobalt created blue, and copper produced green. Can you find examples of these colors in pictures of ceramics in this textbook?

194

### **Teaching Options**

#### Resources

Teacher's Resource Binder:
Making Connections
Using the Web
Interview with an Artist
Teacher Letter

#### Video Connection

Show the Davis art careers video to give students a reallife look at the career highlighted above.

#### **Careers**

Has your artwork ever been criticized? It may not have been a positive experience, yet art critics are typically more concerned with positive than negative views. Art critics are art experts who write reviews about contemporary art exhibitions for newspapers, radio, television, textbooks, scholarly journals, and Websites. Because they want to convince their readers to go look at the art, art critics generally write positive interpretations and articles. What do you think an art critic needs to know? Most art critics hold degrees in art history or fine-arts disciplines and are skilled at persuasive writing.

#### **Daily Life**

Do you have to **interpret popular culture** to your older family members? Do they know your favorite celebrities or musicians? Do they go to movies aimed at teenagers? What aspects of your life and your preferences would you most like your family members to understand?

#### **Other Arts**

#### Music

Musicians interpret nature in many different ways. Sometimes, nature itself has been used as part of the performance. In 1952, composer John Cage created quite a scandal with his work called 4'33". Rather than playing notes on the piano, Cage sat completely still during the performance, which lasted 4 minutes and 33 seconds. He allowed the silence to be filled with the "music" of the everyday world. Because the performance hall was open in back, nature's noises, along with rustling programs and audience coughs, became the musical score. Do you think this performance would be as shocking today as it was in 1952? Why or why not?

Fig. 5–29 Some composers have created music based upon the seasons. Can you imagine music inspired by this scene? How would it sound?

# Artists as Interpreters

#### **Daily Life**

Challenge students each to choose a favorite music CD or DVD and to write two reviews—one for their friends and one for their parents or another older family member. After both audiences have read the reviews, have students compare the responses and reflect on the process in a full-class discussion.

#### Other Arts

Play music that includes sounds from nature, and ask students to close their eyes and listen. Ask students how the music made them feel (calm, agitated, anxious, peaceful, and so on). Lead students to imagine that they have been hired by a large department store that wants to increase sales by calming shoppers with soothing, relaxing music so that they will not leave the store without making a purchase. Have small groups of students choose nature sounds, record them (they may wish to imitate the sounds with their voices or props), and share their compositions.

Internet Connection
For more activities related to this chapter, go to the Davis Website at www.davis-art.com.

195

#### **Internet Resources**

Georgia O'Keeffe Museum

http://www.okeeffemuseum.org/

Visit the only art museum devoted to the work of one woman.

#### **Community Involvement**

Arrange for a naturalist or local park official to talk to students about conservation and the preservation of natural resources. Ask the guest to comment on ways in which his or her work influences his or her interpretations of nature. Discuss how this is similar to or different from the way an artist may interpret or think about nature.

#### **Interdisciplinary Planning**

Work with colleagues in other disciplines to plan ways for students to explore the concept of color, such as the science of color, the psychological or therapeutic aspects of color, or the language of color.

#### Talking About Student Art

On the board, write a list of expressive words, such as *happy, sad,* and *energetic*. Ask students to study the display of student artworks. Call on students to select one artwork and to describe it with one or more words from the board. Discuss students' reasons for their choices.

#### Portfolio Tip

Suggest to students that they use descriptive and expressive words when

they write about the works in their portfolio or when they write peer reviews of their classmates' works. Encourage students to attach a word list to the inside cover of their portfolio and to add to it throughout the year.

#### **Sketchbook Tip**

Encourage students both to draw their observations from nature and to write

about what they see.

### **Portfolio**

"When I was painting the flowers, I was trying to capture the flowers as they were and to let the colors flow into the flowers." Fred Germer

"I tried to use colors that had lots of light so that it would seem welcoming." Garrett O'Keefe

Fig. 5–31 Using very simple lines, this artist creates a strong sense of the land surrounding his grandfather's home.

Garrett O'Keefe, Sundays at Grandpa's, 2001.

Oil pastel, 12" x 18" (30.5 x 46 cm). Fairhaven Middle School,

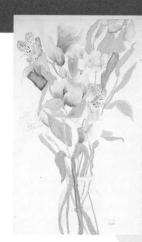

Fig. 5-30 How is this interpretation of flowers different from the flower interpretation in Fig. F2-3, on page 19? Frederic W. Germer, Flowers, 2001.

Flowers, 2001. Watercolor, 18" x 12" (46 x 30.5 cm). Smith Middle School, Fort

"My abstract garden is placed around a sidewalk in a park. It has multicolored paths and stands for plants. Also it has a lamp post near the front of the path for lighting." Seth Davis

Fig. 5–32 This garden model is similar to what a landscape architect might create when planning an actual park. Seth Davis, Abstract Garden, 2001. Cardboard, paper, tiles, found objects, 12" x 12" x 12" (30.5 x 30.5 x 30.5 cm). Thomas Metcalf Laboratory School, Normal, Illinois.

196

PORTFOLIO

### **Teaching Options**

#### Resources

Teacher's Resource Binder
Chapter Review 5
Portfolio Tips
Write About Art
Understanding Your Artistic Process
Analyzing Your Studio Work

#### **CD-ROM Connection**

For students' inspiration, for comparison, or for criticism exercises, use itional student works related

the additional student works related to studio activities in this chapter.

### **Chapter 5 Review**

#### Recall

List three artists who use animals as the subject matter in their artworks

#### Understand

Use examples to explain how artists have interpreted nature in different ways.

#### Apply

Find a color photograph of a nature scene. Draw or trace the scene, but change the colors to create a different interpretation. For example, use a scheme of complementary colors.

#### Analyze

Compare and contrast Oaxacan (see example below right) and Chinese interpretations of nature in the artworks in this chapter.

#### For Your Portfolio

and a scientific interpretation, or a realistic interpretation and a fanciful one. Title your artworks, add your name and date, and put them into your portfolio.

#### For Your Sketchbook

Use a nature motif to design a border on a sketchbook page. On the same page, write your ideas about nature.

#### Synthesize

Plan a series of posters or a bulletin-board display that shows opposite interpretations of nature: for example, nature as comforting and as dangerous; nature as wild and as tame.

#### Evaluate

From this chapter, select two artworks, one that is a good example of the use of local color, the other that is a good example of use of expressive color. Write reasons to support your selections.

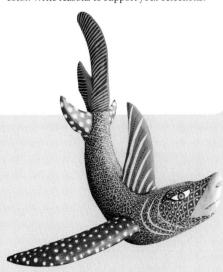

197

#### **Advocacy**

Have students each create a poster that calls attention to the natural beauty in the local community. Display the posters in local business establishments along with statements that highlight significant standards-based learning in art.

#### **Family Involvement**

Involve family members in helping you build a collection of natural forms (such as potted plants, seed pods, dried flowers, driftwood, unusual rocks, or crystal formations) for use in still lifes and for classroom display.

#### Chapter 5 **Review Answers** Recall

Theodore Waddell, Deborah Butterfield, Franz Marc

#### Understand

Answers may vary. Look for references to realistic interpretations, dramatic/emotional/expressive interpretations, decorative pattern, and the like.

#### **Apply**

Results may vary. Look for use of complementary colors (substituting red for green in the interpretation); or application of a specific color scheme, such as monochromatic, complementary, or split complementary.

#### **Analyze**

Answers may vary. Possible points to be made include: Use of controlled brushstrokes, repetition, and movement, but with different results. Both are close to, and carefully observe nature, but base interpretations on their own ideas about color.

#### **Synthesize**

Results may vary. Look for obvious contrasting qualities and themes.

#### **Evaluate**

Answers may vary. Possible reasons for selections might be that, in the example of local color, the colors look very much like you would really see them in nature; expressive colors look very different from anything you would see in the real world.

#### Reteach

Discuss ways that people are connected to nature and how we each think about nature in different ways. Suggested topics: those who depend on nature for earning a living (farmers, fishermen, etc.); those who use nature for sport and recreation (golfers, boaters, etc.); those who work to protect nature (animal rights activists, environmentalists, etc.). Have students identify artworks that make us think about nature from these different points of view. Discuss what the artist has done to make us think about our relationship to nature. Summarize that artists convey ways for us to think about our relationship with the natural world.

3

3

3

2

1

9 weeks

#### **Chapter Focus Chapter National Standards**

#### Chapter 6 Artists as Messengers

Chapter 6 Overview pages 198-199

- Core People discover many ways to communicate their ideas and feelings. Artists send visual messages in their artworks.
  - 6.1 Symbolism and Portraits

**Chapter Organizer** 

- **6.2** Monoprinting
- 6.3 Aboriginal Australia
- 6.4 A Linoleum Block Print

- 1 Understand media, techniques, and processes. Use knowledge of structures and functions.
- Choose and evaluate subject matter, symbols, and ideas.
- Understand arts in relation to history and cultures.
- Assess own and others' work.
- 6 Make connections between disciplines.

#### **Objectives**

Explain how people can communicate without Offer interpretations of artworks' messages.

#### **National Standards**

- 2c Select, use structures, functions.
- 4c Analyze, demonstrate how time and place influence visual characteristics.

#### **Core Studio Painting Symbols** page 204

**Core Lesson** 

a Message

page 200

periods

An Artist with

Pacing: Three 45-minute

- Create a set of symbol stamps for sending a visual message.
- 1b Use media/techniques/processes to communicate experiences, ideas.
- 3b Use subjects, themes, symbols that communicate meaning.

#### **Objectives**

#### Then and Now Lesson 6.1 **Symbolism in Portraits** page 206 Pacing: Two or more

45-minute periods

- · Compare the symbols in portraits by Chardin, Picasso, Kahlo, and Fonseca.
- Identify the symbolism in the work of Harry Fonseca.

#### **National Standards**

- 3b Use subjects, themes, symbols that communicate meaning.
- 4c Analyze, demonstrate how time and place influence visual characteristics.

#### **Studio Connection** page 208

- · Use colored pencils to create a symbolic selfportrait that sends a message.
- 1b Use media/techniques/processes to communicate experiences, ideas.

**National Standards** 

#### **Objectives**

#### **Skills and Techniques** Lesson 6.2 Monoprinting page 210

Pacing: One or more 45-minute periods

- · Understand three different methods of monoprinting.
- 1a Select/analyze media, techniques, processes, reflect.

### **Studio Connection**

· Identify the potential results from each monoprinting method.

1b Use media/techniques/processes to communicate experiences, ideas.

#### **Featured Artists**

Elizabeth Catlett
Jean-Baptiste-Simèon
Chardin
Harry Fonseca
Keith Haring
Hans Holbein
the Younger

Frida Kahlo Henri Matisse Clara Peeters Ada Bird Petyarre Rene Ronibson Bill Traylor

#### Chapter Vocabulary

emphasis line monoprint pictogram portrait relief print self-portrait symbol

#### **Teaching Options**

Meeting Individual Needs
Teaching Through Inquiry
More About...Marks of identity and ownership
Teaching Through Inquiry
More About...Bill Traylor
Using the Large Reproduction
Using the Overhead

#### **Technology**

CD-ROM Connection e-Gallery

#### Resources

Teacher's Resource Binder Thoughts About Art: 6 Core A Closer Look: 6 Core Find Out More: 6 Core Studio Master: 6 Core Assessment Master: 6 Core

Large Reproduction 11 Overhead Transparency 12 Slides 6a, 6b

Teaching Through Inquiry More About... Assessment Options CD-ROM Connection Student Gallery Teacher's Resource Binder Studio Reflection: 6 Core

#### **Teaching Options**

Teaching Through Inquiry More About...Frida Kahlo Using the Overhead

#### **Technology**

CD-ROM Connection e-Gallery

#### Resources

Teacher's Resource Binder Names to Know: 6.1 A Closer Look: 6.1 Find Out More: 6.1 Assessment Master: 6.1 Overhead Transparency 11 Slides 6c

Meeting Individual Needs Teaching Through Inquiry More About...Harry Fonseca Assessment Options CD-ROM Connection Student Gallery Teacher's Resource Binder Check Your Work: 6.1

#### **Teaching Options**

Teaching Through Inquiry Using the Overhead Assessment Options

#### **Technology**

CD-ROM Connection e-Gallery

#### Resources

Teacher's Resource Binder Finder Cards: 6.2 A Closer Look: 6.2 Find Out More: 6.2 Assessment Master: 6.2 Overhead Transparency 12 Slides 6d

CD-ROM Connection Student Gallery Teacher's Resource Binder Check Your Work: 6.2

| 18 weeks            | 36 weeks |                                                                                                                   | ter Organizer                                                                                                                                                                                                                                | National Standards                                                                                                                                                                                                                                                                                                                     |
|---------------------|----------|-------------------------------------------------------------------------------------------------------------------|----------------------------------------------------------------------------------------------------------------------------------------------------------------------------------------------------------------------------------------------|----------------------------------------------------------------------------------------------------------------------------------------------------------------------------------------------------------------------------------------------------------------------------------------------------------------------------------------|
|                     | 2        | Global Destinations<br>Lesson 6.3<br>Aboriginal Australia<br>page 212<br>Pacing: Two or more<br>45-minute periods | <ul> <li>Explain how symbols are used in Aborigine art.</li> <li>Compare the different meanings of similar symbols and patterns used in various parts of Australia.</li> </ul>                                                               | <ul> <li>1a Select/analyze media, techniques, processes, reflect.</li> <li>3a Integrate visual, spatial, temporal concepts with content.</li> <li>4c Analyze, demonstrate how time and place influence visual characteristics.</li> </ul>                                                                                              |
|                     |          | Studio Connection page 214                                                                                        | Create a pattern of symbols and lines that sends a message.                                                                                                                                                                                  | 2c Select, use structures, functions.                                                                                                                                                                                                                                                                                                  |
|                     |          |                                                                                                                   | Objectives                                                                                                                                                                                                                                   | National Standards                                                                                                                                                                                                                                                                                                                     |
| 4                   | 4        | Studio Lesson 6.4<br>A Linoleum Block Print<br>page 216<br>Pacing: Three or more<br>45-minute periods             | <ul> <li>Explain what relief printmaking is.</li> <li>Understand how artists use line and emphasis to communicate ideas, moods, and feelings in their artworks.</li> <li>Create a linoleum print that sends an important message.</li> </ul> | <ul> <li>1b Use media/techniques/processes to communicate experiences, ideas.</li> <li>2a Generalize about structures, functions.</li> <li>2b Employ/analyze effectiveness of organizations structures.</li> <li>2c Select, use structures, functions.</li> <li>3b Use subjects, themes, symbols, that communicate meaning.</li> </ul> |
|                     |          |                                                                                                                   | Objectives                                                                                                                                                                                                                                   | National Standards                                                                                                                                                                                                                                                                                                                     |
| •                   | •        | Connect to<br>page 220                                                                                            | <ul> <li>Identify and understand ways other disciplines<br/>are connected to and informed by the visual<br/>arts.</li> <li>Understand a visual arts career and how it<br/>relates to chapter content.</li> </ul>                             | 6 Make connections between disciplines.                                                                                                                                                                                                                                                                                                |
|                     |          |                                                                                                                   | Objectives                                                                                                                                                                                                                                   | National Standards                                                                                                                                                                                                                                                                                                                     |
| •                   | •        | Portfolio/Review<br>page 222                                                                                      | <ul> <li>Learn to look at and comment respectfully on<br/>artworks by peers.</li> <li>Demonstrate understanding of chapter content.</li> </ul>                                                                                               | 5 Assess own and others' work.                                                                                                                                                                                                                                                                                                         |
| 2 Lesson of your of |          |                                                                                                                   |                                                                                                                                                                                                                                              |                                                                                                                                                                                                                                                                                                                                        |

#### **Teaching Options**

Teaching Through Inquiry More About...Dreamtime Using the Large Reproduction

#### Technology

CD-ROM Connection e-Gallery

#### Resources

Teacher's Resource Binder A Closer Look: 6.3 Find Out More: 6.3 Assessment Master: 6.3 Large Reproduction 12 Slides 6e

Meeting Individual Needs Teaching Through Inquiry More About...Ada Bird Petyarre Assessment Options CD-ROM Connection Student Gallery Teacher's Resource Binder Check Your Work: 6.3

#### **Teaching Options**

Teaching Through Inquiry
More About...Elizabeth Catlett
Using the Overhead
Teaching Through Inquiry
Studio Collaboration
More About...Woodblock printing
Assessment Options

#### **Technology**

CD-ROM Connection Student Gallery Computer Option

#### Resources

Teacher's Resource Binder Studio Master: 6.4 Studio Reflection: 6.4 A Closer Look: 6.4 Find Out More: 6.4 Overhead Transparency 12 Slides 6f

#### **Teaching Options**

Community Involvement Interdisciplinary Planning

#### Technology

Internet Connection Resources Video Connection CD-ROM Connection e-Gallery

#### Resources

Teacher's Resource Binder Using the Web Interview with an Artist Teacher Letter

#### **Teaching Options**

Advocacy Family Involvement

#### **Technology**

CD-ROM Connection Student Gallery

#### Resources

Teacher's Resource Binder
Chapter Review 6
Portfolio Tips
Write About Art
Understanding Your Artistic Process
Analyzing Your Studio Work

#### **Chapter Overview**

#### Theme

People discover many ways to communicate their ideas and feelings.
Artists send visual messages in their artworks.

#### **Featured Artists**

Elizabeth Catlett
Jean-Baptiste-Siméon Chardin
Harry Fonseca
Keith Haring
Hans Holbein the Younger
Frida Kahlo
Henri Matisse
Clara Peeters
Ada Bird Petyarre
Rene Ronibson
Bill Traylor

#### **Chapter Focus**

Artists are messengers or communicators who often use symbols to help convey meaning. Students learn how Keith Haring developed a special set of symbols to create artworks with social messages. They explore the self-portrait as a way to send messages, and they encounter the selfportraits of Native American artist Harry Fonseca. In addition to a study of the skills and techniques of monoprinting, students are given the opportunity to explore stamp-pad, stencil, and linoleum-block printing. They also examine the use of symbols to send messages in traditional and contemporary Aboriginal art.

#### National Standards Chapter 6 Content Standards

- 1. Understand media, techniques, and processes.
- 2. Use knowledge of structures and functions
- 3. Choose and evaluate subject matter, symbols, and ideas.
- 4. Understand arts in relation to history and cultures.
- 5. Assess own and others' work.
- **6.** Make connections between disciplines.

6

# Artists as Messengers

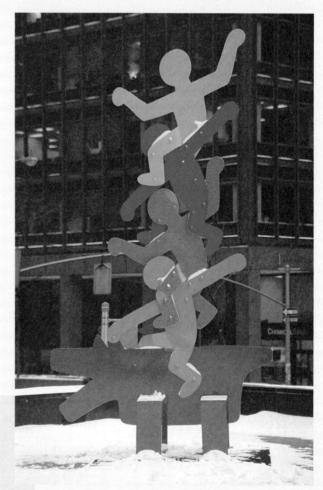

Fig. 6–1 How did the artist create a sense of energy in this sculpture? Keith Haring, *Untitled*, 1985.

Polyurethane paint on aluminum.
© The Estate of Keith Haring. Photo:
Ivan Dalla Tana.

198

### **Teaching Options**

#### **Teaching Through Inquiry**

Art Production Have students each create a small wire or cardboard sculpture of people performing dance moves that send a message. Have students create a label for their completed sculpture, in which they explain the type of dance portrayed and the message that the particular pose sends.

#### More About...

Keith Haring drew and painted on many different surfaces—walls, floors, sides of buildings, posterboard, paper scraps, discarded doors, vinyl tarpaulins, cars, surfboards, shoes—and even blimps! As the public came to know and love his drawings, he received many invitations to create them in such places as hospitals and playgrounds.

#### **Focus**

- What are the ways that people can communicate with one another?
- How do artists send messages?

Have you ever had a sore throat that made it impossible for you to talk? How did you communicate with family members? Did you write messages on a notepad, draw pictures, or make hand gestures? We rely so much on our ability to speak and write that we sometimes forget how many other ways we can communicate. Just a look will sometimes "speak" a hundred words.

Artists use visual ways to communicate. Throughout history, they have used images to tell stories, to persuade others to act in certain ways, and to tell about the beauty in the world. Like poets or writers, who use combinations of words, artists create combinations of visual imagery to send their messages to their audience.

Keith Haring made playful artworks with serious messages. In such artworks as the sculpture shown in Fig. 6–1, he used images of dancers to send a message about living an energetic and playful life. In this chapter, you will learn more about Keith Haring and other artists who have used

visual art to communicate their ideas.

**Meet the Artists** 

Keith Haring Harry Fonseca Ada Bird Petyarre

symbol pictogram portrait self-portrait

monoprint relief print line emphasis

#### Chapter Warm-up

Ask: What are the ways that people communicate? (speech, writing, music, drama, hand signs, body lanquage, paintings, logos, radio, TV) Tell students that in this lesson, they will learn how artists send messages.

#### **Using the Text**

After students have read the text, encourage them to share stories of occasions they tried to but could not communicate verbally because of a language barrier or laryngitis. Ask: How might pictures or symbols have helped?

#### **Using the Art**

Perception Ask: In Haring's sculpture, what are the figures doing? (dancing) How did the artist convey a sense of movement and playfulness? What do these figures remind you of?

#### Extend

Have students sketch, on several colors of posterboard, gesture drawings of student models in dance poses. Then have them cut out the figures and stick them vertically into a thick Styrofoam base, so as to create a sculpture similar to Haring's.

**Graphic Organizer** Chapter 6

Core Lesson

An Artist with a Message

**Core Studio Printing Symbols** page 204

6.3 Global **Destinations Lesson** Aboriginal Australia

page 212

6.4 Studio Lesson A Linoleum Block Print page 216

**CD-ROM Connection** 

For more images relating to this theme, see the Personal Journey CD-ROM.

**Keith Haring** 

6.1 Then and Now Lesson

Symbolism in Portraits

page 206

6.2 Skills and Techniques

Lesson

Monoprinting

page 210

199

#### **Artists as Messengers**

#### **Prepare**

#### **Pacing**

Three 45-minute periods: one to consider text and images; one to draw and glue; one to print

#### **Objectives**

- Explain how people can communicate without words.
- Offer interpretations of artworks' messages.
- Create a set of symbol stamps for sending a visual message.

#### Vocabulary

symbol Something that stands for something else, especially a letter, figure, or sign that represents a real object or an idea.

pictogram A picture that stands for a word or an idea.

#### **National Standards**

#### **Core Lesson**

- **1b** Use media/techniques/processes to communicate experiences, ideas.
- 2c Select, use structures, functions.
- **3b** Use subjects, themes, symbols that communicate meaning.
- **4c** Analyze, demonstrate how time and place influence visual characteristics.

### An Artist with a Message

"I am intrigued with the shapes people choose as symbols to create a language." Keith Haring (1958–1990)

9

LESSOI

CORE

#### **Keith Haring's Journey**

As a child, Keith Haring liked to draw with his father and his youngest sister. He also enjoyed looking at cartoons and illustrations. These inspired the simple cartoonlike forms in the drawings, paintings, murals, and sculptures that he made as an adult.

Throughout his life, Haring continued to draw. He often drew the same forms over and over. He used repeated forms as **symbols**, images that "stand for" and communicate certain ideas. One symbol,

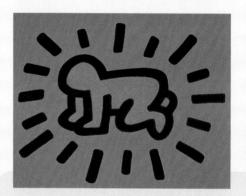

Fig. 6–2 What effect is created by the lines surrounding the figure? Keith Haring, *Icons* (Radiant Baby), 1990.
Silkscreen with embossing, 21° x 25° (53 x 63.5 cm). © The Estate of Keith Haring.

a glowing or "radiant" baby (Fig. 6–2), represents "how perfect people could be." The baby symbolizes a brighter future. Another of Haring's symbols, a barking dog (Fig. 6–3) represents the family dog, always there to watch what's going on and to protect us. Haring also combined his symbols in such artworks as the vase in Fig. 6–4. Each new combination sent a different message.

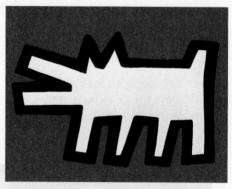

Fig. 6–3 How would combining the two symbols of a baby and a dog affect their meaning? Keith Haring, *Icons* (Barking Dog), 1990.

200

### **Teaching Options**

#### Resources

Teacher's Resource Binder
Thoughts About Art: 6 Core
A Closer Look: 6 Core
Find Out More: 6 Core
Studio Master: 6 Core
Studio Reflection: 6 Core
Assessment Master: 6 Core
Large Reproduction 11
Overhead Transparency 12
Slides 6a, 6b

#### **Meeting Individual Needs**

English as a Second Language and Multiple Intelligences/Linguistic Have pairs of students each select one of the Haring images, list all the symbols in the artwork, and, next to each, write what the symbol means to them. Then have pairs invent a story for the artwork, tying in the symbols and their meaning. Instruct students to use all the items on their list in the narrative. Have students share their stories and compare differences and similarities among the interpretations.

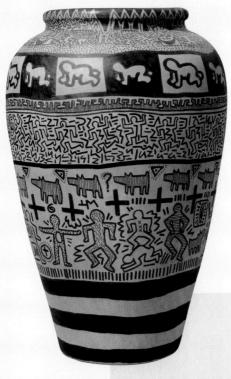

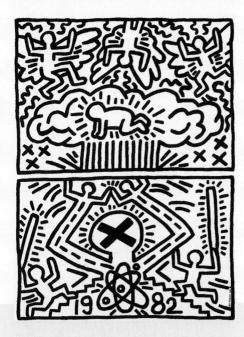

Fig. 6–5 What makes this a powerful message? What symbols do you see? What do you think they mean? Keith Haring, Untitled (Poster for antinuclear rally, New York), 1982.

Fig. 6–4 Haring studied artworks by the Egyptian, Greek, and other cultures.

What evidence of this do you see in his artwork? Keith Haring, Untitled, 1981.

# Messages for a Changing World

Haring used his visual symbols to comment on life in the later part of the twentieth century. He said: "I consider myself a perfect product of the space age not only because I was born in the year that the first man was launched into space, but also because I grew up with Walt Disney cartoons." He often drew Disney characters, but also included computers, spaceships, dolphins, and people at work and play. He sometimes surrounded the images with lines to show activity, or energy.

Like many people, Haring was worried about problems he saw. In such artworks as the poster in Fig. 6–5, he sent powerful messages about important issues. His messages were concerned with the environment, the cruelty of some people, and the negative impression that technology and the overbuying of products might have on us. He did not want us to forget about the really important things in life—family and other people we love.

Artists as Messengers

201

#### Teach

#### Engage

Read aloud Keith Haring's statement on page 200. **Ask**: In airports and bus and train stations, where many different languages are spoken, how do people learn where the restrooms, baggage claim, and transportation areas are? (by "reading" universal signage/symbols)

#### **Using the Text**

Art History Ask: What type of art inspired Keith Haring's symbolic art? (cartoons, illustrations) Why did Haring think he was a perfect product of the space age?

#### **Using the Art**

Art Criticism After students have discussed the meaning of Haring's radiant baby and barking dog, have them locate these symbols on the vase.

Ask: What meaning does the combination of the baby and dog suggest?

What art elements are most important in Haring's art? (line, shape)

What events are suggested by the symbols in the antinuclear poster?

#### **Critical Thinking**

Assign students to use the Internet, encyclopedias, or their social-studies text to do research on Greek vases. Ask students to explain how Haring's vase is similar to and different from a Greek vase. Challenge students to develop symbols for their life and use them to create a design for a vase.

#### **Teaching Through Inquiry**

Art Criticism Have students work in small groups to complete a Venn diagram that compares Keith Haring's poster and vase. (See the Teacher's Resource Binder, Graphic Organizers, for a blank Venn diagram.) Ask students to address the differences and similarities in the art forms, subject matter, use of art elements and principles, and messages. Have groups share their findings.

#### More About...

Marks of identity and ownership are most obvious in today's profusion of such corporate logos as McDonald's golden arches, the Nike swoop, and Apple Computer's apple with a bite missing. In the United States, cattle that grazed the open range were branded. Cattle brands were designed with symbols or initials such as the rocking h, the King Ranch's running w, and the four 6's. Farmers and truck drivers were among the first occupational groups to wear logos on their clothing in keeping with the kind of tractors or trucks they drove. Today every professional sports team and their fans proudly wear their logo.

#### **Artists as Messengers**

#### **Using the Text**

Art History Ask: What are pictograms? What symbols did Yorubans recognize in the king's headpiece?

#### Using the Art

Art Criticism Ask: Where is the animal in Bill Traylor's Figures, Construction? How are the figures in the image similar to and different from each other? What are they doing?

Perception As students study the Yoruba King's Crown, ask them to describe the birds, texture, and colors.

Ask: When the king wore this, what part covered his face? How high above his head, do you think, did the crown extend?

Art Criticism Ask: What part of Clara Peeters's Still Life seems most important? How did Peeters emphasize this center of interest? (with contrast of light and dark values; by placing these contrasts near the center of the composition)

Art History Ask: What do these three artworks have in common? (They are all symbolic.) Which piece is oldest? (Still Life of Fruit and Flowers) Most recent? (Figures, Construction)

### **Messages with Symbols**

People have long used images to communicate. The earliest forms of writing were actually simple pictures, or **pictograms**, which represented objects. Pictograms were easily recognized and "read" by community members. Many artists throughout history have developed their own personal sets of simple symbols. The painting in Fig. 6–7 shows some of the symbols that artist Bill Traylor created to represent people, houses, and all kinds of animals.

People also learn and read the meaning of pictures. Think about how very young children name objects in picture books. As we develop, we become better able to understand the meanings of images. We know that a certain shape is a symbol for, say, a ball or a cat. We also understand that an image of two people holding hands probably means that they have a caring relationship.

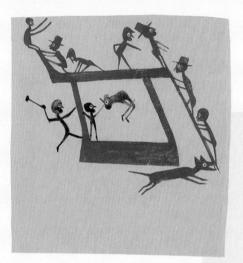

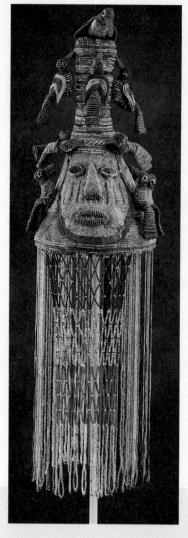

Fig. 6—6 In nineteenth-century Yoruban culture, the use of beaded objects was limited to only the most important officials. African, Nigeria (Yoruba), King's Crown, 19th century. Beads, leather, canvas, and wicker, height: 30° (76 cm). The Minneapolis Institute of Arts (The Fithel Morrico Van Putilis Mary 45-29).

Fig. 6-7 Bill Traylor was a self-taught artist. He used simple materials to make thousands of drawings. What message about living together does this image send? Bill Traylor,

Figures, Construction, c. 1940–42.
Watercolor, pencil on cardboard, 12 11/16" x 11 5/8" (32 x 30 cm). Montgomery Museum of Fine Arts, Montgomery, Alabama. Gift of Charles and Eugenia Shannon. (1982.4.16).

202

### **Teaching Options**

#### **Teaching Through Inquiry**

Aesthetics Have students work in groups to discuss the following: "You have learned that artworks, such as the Peeters painting and the Yoruban mask, sometimes contain symbols that are understood only by people living in a certain time and place. If you are not a member of the group who understands the symbols, can you understand the artwork's message? What value or significance can an artwork have for people who do not understand its symbols?" Invite students to record their ideas and share them in a large-group discussion.

#### More About...

Bill Traylor (1856–1947) worked the land most of his life—first as a slave and then as a plantation laborer. In his eighties—not having had any schooling in art, math, or reading—Traylor unexpectedly took pencil to scrap cardboard. He typically created geometric images, shaped them with pencil, and then filled in the drawings or added color. Until his death, Traylor worked as an artist on the streets of Montgomery, Alabama.

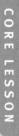

Fig. 6–8 This painting is an example of a vanitas painting, a kind of still-life painting. The message of such paintings is that, like flowers and fruit, people don't live forever. Clara Peeters, Still Life of Fruit and Flowers, after 1620.

Oil on copper, signed on knife handle, 25° x 35° (64 x 89 cm). Ashmolean Museum, Oxford. Bequeathed by Daisy Linda Ward, 1939.

@ Ashmolean Museum, Oxford.

# Understanding the Message

When we study artworks from the past or from cultures other than our own, we do not always understand the artists' symbolism. By looking at the seventeenth-century Dutch painting in Fig. 6–8, you may understand its message to be only "Look at these beautiful things." However, if you had lived in the Netherlands during the time the work was created, you would have known that the artist was sending a different message. Her painting is actually a reminder to viewers that time passes quickly and that life is short.

In the 1800s, an artist in the African kingdom of Yoruba covered a king's headpiece with symbols to send a message about the king's power (Fig. 6–6). The vertical lines on the face symbolize the ruler's family, and the birds refer to his ability to deal with the forces of evil. When the Yoruban people saw the crown, they understood its messages. Whenever artists wish to communicate, they must use symbols or images that others will understand.

Artists as Messengers

203

#### **Critical Thinking**

Challenge students to think of symbols, such as the school mascot, that people in their community or country would understand but that outsiders would probably interpret incorrectly.

#### Extend

Allow students to create their own still-life collage with magazine photographs of objects. Encourage students to choose images that have symbolic meaning to their life. After students have completed their collage, have them write what each object symbolizes.

#### **Using the Large Reproduction**

#### Talk It Over

**Describe** Carefully describe the subject matter, materials, and techniques used in this artwork.

**Analyze** How did the artist use art elements and principles to attract and hold the viewer's attention?

Interpret What message does this artwork send?

**Judge** Why, do you think, is this artwork considered valuable or significant?

#### **Using the Overhead**

#### Think It Through

**Ideas** What ideas are important in this artwork? What is its message?

**Materials** What materials did the artist use to send the message?

**Techniques** How did the artist create this artwork? What steps did the artist take?

**Audience** Who could benefit from understanding this artwork's message?

12

#### **Artists as Messengers**

#### Supplies

- sketch paper
- pencil and eraser
- black marker (optional)
- stiff cardboard, six 4" x 4" pieces per student
- · string, rubber bands, lightweight cardboard, sponges, Styrofoam
- scissors
- glue
- newsprint paper
- · drawing paper
- · stamp pad
- · tempera paint
- · damp paper towels

#### **Using the Text**

Art Production Discuss students' social concerns. Select an issue that many of them are interested in, and lead them in listing words associated with the issue and what symbols could represent these words.

Discuss each step in Try This.

Demonstrate gluing varn, rubber bands, cardboard, or sponges to the cardboard squares to make relief stamps. Caution students to allow the glue to dry before printing with the stamps.

Demonstrate inking the pads by spreading tempera paint on a damp sponge or a folded paper towel. Then demonstrate pressing a stamp onto the inking pad and then onto paper.

#### Using the Art

Art Criticism Ask: What do you think the symbols in Toboggan stand for? How did Matisse emphasize his main subject? What shapes and lines did he repeat?

#### Printmaking in the Studio

#### **Printing Symbols**

STUDI

Do you ever fill notebook pages with playful scribbles or drawings? The shapes and patterns that come into your mind as you doodle can

become part of your own set of symbols. Like Keith Haring, you can combine your symbols to send messages.

In this studio experience, you will make a set of symbol stamps and use them to create a print. Without using words in your print, express a message about a social issue. What issues concern you? Develop at least six different symbols that you can use to express your concern. Create a stamp for each one.

#### You Will Need

- sketch paper
- · pencil and eraser
- black marker
- (optional) stiff cardboard
- string, lightweight cardboard,
  - sponges
- scissors
- glue
- newsprint paper
- drawing paper
- stamp pad
- tempera paint
- damp paper towels

#### Try This

1. Fill a page with doodles. Focus your ideas on your chosen social issue. Choose six doodles that you will improve for your symbols. Create neater drawings of them. What kinds of lines will make the symbols more effective? What positive and negative shapes can you create? You will use your drawings to make your stamps.

#### **Studio Background**

#### Symbolic Messages

Every day, we come upon hundreds, perhaps even thousands, of symbols: words formed by the 26 symbols of the alphabet; mathematics symbols at the grocery store or bank; and traffic lights and other roadway symbols

But what is the one thing that all symbols have in common? They all send messages. Anyone can create a symbol for any reason. During the Great Depression, jobless workers, who traveled by train from town to town, created symbols (Fig. 6-10) to communicate with one another. For Toboggan (Fig. 6-9), artist Henri Matisse expressed his ideas by cutting symbols out of paper and transferring them to his paintings

Dangerous

Neighborhood

Good Place to

Catch a Train

Hit the Road **Ouick!** 

Fig. 6-9 What could the symbolic shapes mean? How did the artist create emphasis? Henri Matisse, Toboggan (plate XX

from /azz), published 1947.

Pochoir, printed in color, double sheet, 16 ½° x 25 ½° (42.2 x 65 cm). The Museum of Modern Art, New York. The Louise. Estern Collection. Photograph © 2001 The Museum of Modern Art, New York. © 2001 Succession H. Matisse, Paris/Artists Rights Society (ARS), New York.

Fig. 6-10 Jobless workers, one at a time, drew symbols such as these on sidewalks or carved them into trees. Each of the symbols represents a particular direction or warning.

204

### **Teaching Options**

#### **Teaching Through Inquiry**

Art History Have students work in pairs or in small groups to gather examples of symbols used now or in the past. You may wish to guide students to find traffic symbols used locally, nationally, or worldwide; or symbols used by various groups and organizations, such as the Girl Scouts or Boy Scouts. Have groups discuss their findings in a large-group discussion.

**2.** Decide which materials you will use. Will you glue string, cardboard pieces, or sponge onto the cardboard? What sizes will your stamps be?

- **3.** Place about a teaspoon of paint on a stamp pad. Practice stamping on newsprint. Carefully wipe off the stamps between colors.
- **4.** Create your final print on drawing paper. How will you use the size, shape, color, and arrangement of your stamps to create emphasis? How will you use the stamps to best express your message?

#### Check Your Work

Display your print with classmates' prints. Explain the meaning of your symbols and the message you are sending. How do your symbols compare to your classmates' symbols? Discuss the different ways that you and your classmates used line and shape to create emphasis.

#### **Lesson Review**

#### **Check Your Understanding**

- **1.** What are some ways that people can communicate without words?
- 2. What is a symbol?
- **3.** Name two of Keith Haring's symbols, and identify the message that each sends.
- **4.** Why is it sometimes difficult to interpret symbols from other times and places?

Fig. 6-11 How did this artist use shape and line to send her message? Candy Collins, Too Much Technology, 2001.

Ink on paper, 9" x 12" (23 x 30.5 cm) Holy Name Central Catholic Middle School, Worcester, Massachusetts. Artists as Messengers

205

#### Assess

#### **Check Your Work**

Before students explain their symbols and messages, allow partners to decode each other's message. Have students identify thick, thin, straight, curved, wavy, and zigzag lines in their classmate's print. Discuss the ways that students created emphasis in their art.

### Check Your Understanding: Answers

- 1. Without words, people can communicate with facial expressions, gestures, and images.
- **2.** A symbol is an image that "stands for" and communicates a particular idea.
- **3.** Answers may vary. The radiant baby stands for a hopeful future, and the barking dog stands for protection and attracting attention.
- 4. Answers will vary. Look for evidence that students understand that symbols are usually understood by only a limited number of people—those who live at a certain time and place.

#### Close

Discuss students' answers to Check Your Understanding. Review what students have learned about Haring's and other artists' symbols.

#### More About...

When many people were jobless during the Great Depression, some traveled from town to town on railroad cars. They often slept in makeshift camps on the edges of town and went into town to do assorted jobs for the community's residents. When they found someone in the community who provided a meal in exchange for work, they shared this information with other wanderers. They also shared information about places of safety or danger. These wanderers communicated with symbols drawn on sidewalks, carved into trees, or placed on doors, fences, or walls.

#### **Assessment Options**

**Teacher** Have students write a letter to a friend or family member, telling what

they have learned about artists as messengers. Instruct students to discuss at least one artwork in their letter. Look for evidence that students understand art as a visual form of communication, that they know how to interpret an artwork's message, and that they understand how artists sometimes use symbols to help convey their message.

#### **Prepare**

#### **Pacing**

Two or more 45-minute periods: one to consider text and images; one or more to create self-portrait

#### **Objectives**

- · Compare the symbols in portraits by Chardin, Picasso, Kahlo, and Fonseca.
- · Identify the symbolism in the work of Harry Fonseca.
- · Use colored pencils to create a symbolic self-portrait that sends a message.

#### Vocabulary

portrait An artwork that shows the likeness of a real person. self-portrait A work of art in which an artist shows himself or herself.

#### **Using the Time Line**

Ask: What have been some major changes in men's clothing over the last 500 years? Look at the images in this lesson in chronological order. as indicated on the time line, and discuss changes in clothing styles.

#### **National Standards** 6.1 Then and Now Lesson

- 1b Use media/techniques/processes to communicate experiences, ideas,
- 3b Use subjects, themes, symbols that communicate meaning
- 4c Analyze, demonstrate how time and place influence visual characteristics

### **Symbolism in Portraits**

Holbein, The Ambassadors Kahlo, The Little Deer Fonseca, Rose an Reservation Siste 16th-Century Germany **18th-Century France** 20th Century 1981 Fonseca, Covote Chardin, The Monkey-Painter

Travels in Time

A portrait, an artist's likeness of a person, is a way to remember someone. From ancient Egypt to today, portrait artists have used different ways to represent the special qualities of a person. Portrait artists from the fifteenth through the nineteenth century used objects as symbols to tell about a person. The Renaissance portrait The Ambassadors

(Fig. 6-12) shows how individuals were placed in settings with objects that represented their interests, greatness, or character. In the twentieth century, artists continued to use symbols to portray themselves and others, as well as their culture and their life

the Reservation

#### **Portraits as Messages**

What can you tell about a person by looking at a portrait? What can a portrait communicate? Happiness? Shyness? Portraits—whether painted, drawn, photographed, or in another art form-send messages. Portrait artists usually show more than what a person looks like. They create symbols to send messages about the subjects-what they enjoy, what they do for a living, or what they think.

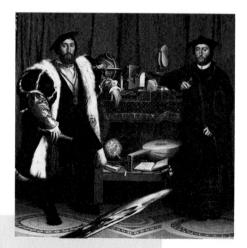

 $Fig.\,6-12\,\hbox{This painting shows two wealthy French ambass adors}$ in sixteenth-century England. Why do you think the artist showed them surrounded by books, a globe, and other instruments? Hans Holbein the Younger, The Ambassadors, 1533.

206

E S S O

3 0

2

z V

### **Teaching Options**

#### Resources

Teacher's Resource Binder Names to Know: 6.1 A Closer Look: 6.1 Find Out More: 6.1 Check Your Work: 6.1 Assessment Master: 6.1 Overhead Transparency 11 Slides 6c

#### **Teaching Through Inquiry**

Art History Have students work in groups to develop a time line of an artist and his or her self-portraits. Assign a different artist to each group. Possibilities include Picasso, Kahlo, van Gogh, and Rembrandt. Ask students to use the theme "Messages About Self over Time" as a way both to interpret temporal changes in the portraits and to present their time line.

#### The Message of Symbols

In the eighteenth century, the French artist Jean-Baptiste-Siméon Chardin painted a **self-portrait**, or a picture of himself (Fig. 6–13). He used a monkey to symbolize someone trained to perform in a certain way and to repeat the same actions. What message was Chardin trying to send?

The Mexican artist Frida Kahlo used plant and animal symbols to tell about her personal life. In her self-portraits and portraits, Kahlo used symbolism to express feelings and emotions. Study *Little Deer* (Fig. 6–14), a self-portrait from 1946. Notice how the artist painted her own face on the body of a deer. What message do you think she was trying to give to viewers?

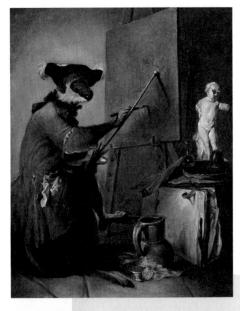

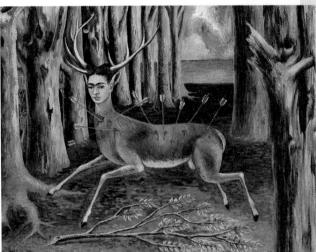

Fig. 6–13 Chardin was a still-life painter. What clues can you find to tell you that this could be the artist's self-portrait? Jean-Baptiste-Siméon Chardin, *The Monkey-Painter*, c. 1740. Oil on canwas, 28 ½\* ×23 ½\* (73 × 59.5 cm). Erich lessing /Art Resource, New York.

Fig. 6-14 How does this artwork communicate the idea of pain and suffering? What makes this such a powerful message? Frida Kahlo,

The Little Deer, 1946.
Oil on carwas, 8/4" x 111/4" (2.5 x 29.9 cm). Private
Collection, Photo: Hayden Herrera. Courtesy of MaryAnne Martin/Fine Art. © 2001 Banco de México, Diego
Rivera & Frida Kahlo Museums Trust, Av. Cinco de Mayo
No. 2, Col. Centro, De. Cuauhtémoc 60559, México, D.F.

Teach

#### Engage

Have student volunteers show any photographs—of their family, friends, and heroes—that they carry, perhaps in their wallet or book bag.

Ask: What are these people wearing and holding? What do their clothes and possessions indicate about their personality and life?

#### **Using the Text**

Aesthetics/Art History Ask: What is a portrait? (an artist's likeness of a person) Why might an artist choose not to depict a realistic image of his or her subject? (so as to symbolize something about the person) Why did Chardin paint a monkey in his self-portrait? (Like monkeys, artists were trained to repeat actions in a certain way.)

#### Using the Art

Perception Have students identify objects in Holbein's double portrait. Direct them to hold their book upright and look at the image from the lower left or upper right. Ask: What do you see near the bottom of the painting? (skull) Tell students that the painting may have been designed to be hung above a door or in a stairwell.

Art Criticism Ask: What objects in The Monkey-Painter suggest an artist's studio? Ask: What, do you think, is the symbolism of a deer downed by many arrows in a dense forest?

Artists as Messengers

207

#### More About...

As a teenager, Mexican painter **Frida Kahlo** (1907–1954) was injured in a bus accident that left her unable to have children and in pain for the rest of her life. While still in high school, she watched her future husband, Diego Rivera, paint a mural. In 1929, they entered a tumultuous marriage. Although she is often identified as a Surrealist, Kahlo—who based her small symbolic self-portraits on her Mexican art heritage—considered herself a Mexican realist.

#### **Using the Overhead**

#### **Investigating the Past**

**Describe** Name all of the things that you recognize in this picture.

**Attribute** Do the animals and vegetation suggest any particular geographical region?

**Interpret** What could be some possible messages of this human face between two animal heads?

**Explain** Why, do you think, might this message have been important to the artist?

11

#### **Symbolism in Portraits**

#### **Using the Text**

Aesthetics Have students read pages 208 and 209. Ask: What does Fonseca's statement mean? How does Fonseca combine new and old? (uses traditional symbols to send humorous messages about contemporary Native Americans) What did Fonseca do in order to create his personal style? (studied fine arts, developed some of his own techniques, researched his Native American background) Why did Fonseca select a coyote as a symbol in his art? (Coyote is a trickster in Fonseca's Nisenan Maidu culture.)

#### **Using the Art**

Art Perception Ask: What stereotype was Fonseca poking fun at in Rose and the Reservation Sisters? In Coyote Leaves the Reservation, what does Coyote's clothing say about his character and attitude? Why does Coyote have so many zippers on his jacket? Challenge students to make up another title for this painting, one that suggests Coyote's personality.

#### **Studio Connection**

Explain to students that they will create a symbolic self-portrait. Ask: What

animal suggests your personality? What clothing and objects could you include to symbolize your interests and moods? Provide students with mirrors to facilitate drawing themselves, and with animal picture books for reference.

Suggest to students that they make several quick experimental sketches before beginning their final colored-pencil drawing. Encourage students to include a background that adds meaning to their self-portrait.

**Assess** See Teacher's Resource Binder: Check Your Work 6.1.

#### **Personal Messages**

LESSO

N O N

0

"My work is of the old, transformed into a contemporary vision." Harry Fonseca (born 1946)

You have seen how artists of the past used symbols to comment on their personal experiences and society. Contemporary artist Harry Fonseca uses traditional symbols to send humorous messages about modern-day Native Americans.

Fonseca always loved to draw and paint. But it was his high-school art teacher who

introduced him to the great masterworks of art history. Although Fonseca studied fine arts in college, he held on to some of the selftaught techniques he developed in his youth. He also researched his Native American background. The combination of his professional training, self-training, and personal interests has resulted in a body of work that is rich in personal and cultural symbolism.

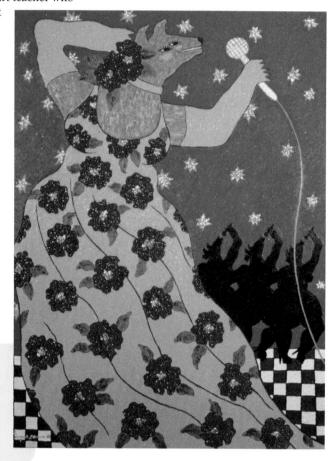

Fig. 6–15 Here, Coyote is dressed as a singer. Why do artists use humor to send messages about important issues? Harry Fonseca, Rose and the Reservation Sisters, 1981. 0ll and gitter on carvas, 30° x 40° (76 x 102 cm). Courtesy of the artist.

208

### **Teaching Options**

#### **Meeting Individual Needs**

Multiple Intelligences/Spatial-Intrapersonal Have students examine portraits of family members. Ask: Could any objects, clothing, or poses symbolize something? What might the subject have wanted others to think, feel, or understand? Next, have students create a self-portrait with just objects—symbols that represent themselves. Discuss with students what objects they could use to symbolize their feelings, thoughts, or important issues. Encourage students to "say" as much as possible in their symbolic self-portrait.

#### **Teaching Through Inquiry**

Aesthetics Ask: What is a portrait? For their answer, have students create a display case to show the many different types of portraits. (Students might contribute postcards, baseball cards, coins, stamps, photographs, cartoons, newspaper photos, magazine covers, pop-icon dolls, old driver's licenses, and so on.) For the display, have students create labels in the form of questions that could help viewers think more clearly about portraits, such as What is the function of a portrait?, Can a portrait be a symbol?, and Can a symbol be a portrait?

#### **Cultural Symbols**

The symbols in Fonseca's paintings are influenced by his mixed cultural background: he is of Portuguese, Hawaiian, and Nisenan Maidu descent. One of Fonseca's favorite symbols is Covote, a trickster in many Native American cultures. To teach safe and responsible behavior, the Nisenan Maidu of northern California tell stories of Coyote's tricks. Fonseca made Coyote's image a humorous symbol of a survivor who knows how to fit in, understand, and even outsmart the non-Native cultures in America. In such artworks as those shown in Figs. 6-15 and 6-16, Fonseca uses the trickster symbol to question and poke fun at cultural stereotypes, or overused images. His artworks send messages about himself and about Native Americans in society.

#### **Studio Connection**

Think about the ways that artists, including Harry Fonseca, have used animal images to symbolize them-

selves or their culture in self-portraits. Use colored pencils to create a character, possibly an animal, that sends a message about you, your culture, and what you care about. Include other symbols, such as objects that reflect your interests, feelings, and experiences. To create emphasis, experiment with different types and directions of lines.

#### **Lesson Review**

#### **Check Your Understanding**

- 1. What kinds of messages do portraits send? 2. What animals did Chardin and Kahlo each use to symbolize him- or herself?
- 3. How does Harry Fonseca use traditional symbols in his artwork?
- 4. Would you want to hang a portrait of yourself as an animal in your home? Why or why not?

Fig. 6-16 Do you think this is a self-portrait of the artist? Why or why not? Harry Fonseca, Covote Leaves the Reservation, 1981. Oil on canvas, 72" x 60° (183 x 152 cm). Courtesy of the artist.

Assess

#### **Check Your Understanding: Answers**

- 1. Portraits can send messages about what the subjects enjoy, what they think, what their work is, and so on.
- 2. Chardin used a monkey: Kahlo, a wounded deer.
- 3. Fonseca uses the coyote, a traditional Native American symbol, to show ways for Native Americans to fit into non-Native culture.
- 4. Answers will vary.

#### Close

Display students' self-portraits. Ask students to explain the symbolism in their drawing and the way in which their animal is a self-portrayal. Have students point out different types of lines within their portraits. Ask: What do you think is particularly effective in your drawing? What would you do differently in creating another selfportrait? Discuss students' answers to Check Your Understanding.

209

Artists as Messengers

#### More About...

Although Harry Fonseca had little exposure to art as a child, he knew by the age of eleven that he was going to be an artist. He studied art at Sacramento City College and Cal State University, yet he was reluctant to become an academic artist, because he wanted to pursue his own vision. During college, when he discovered Abstract Expressionism, he began to paint in a freer style. As he became more in touch with his Native American heritage, he participated in traditional dances and pursued his interest in ancient petroglyphs and basketry designs, which he included in his art.

#### **Assessment Options**

Peer Have students work in small groups to create questions they would like to ask the artists in the text about their views of symbolism, messages, meaning, and the function of portraits in society.

Self For their self-portrait, have students create a mat or frame that further develops the symbolic message of the portrait.

#### **Prepare**

#### **Pacing**

One or more 45-minute periods to consider images and text and to create prints.

#### **Objectives**

- Understand three different methods of monoprinting.
- Identify the potential results from each monoprinting method.

#### Vocabulary

monoprint A method of printmaking in which an edition of only one print is created.

#### **Teach**

#### **Engage**

Show students the media that they will use to create their monoprint.

#### **Using the Text**

Art Production Ask: What is a monoprint? Demonstrate the monoprint methods, and have students follow the steps in the text.

#### **Using the Art**

Art Production As students study the images, discuss how each one was made. Discuss possible subjects that students could use with each method.

#### National Standards 6.2 Skills and Techniques Lesson

1a Select/analyze media, techniques, processes, reflect.

**1b** Use media/techniques/processes to communicate experiences, ideas.

### Monoprinting

LESSON

TECHNIQUES

SKILLS AND

The prefix *mono-* means "one," and a monoprint is just that—an edition of only one print. Monoprinting is unlike other methods of printmaking, in which you can make many prints from the same plate. When you create a monoprint, you can prepare the plate in several ways. But the preparations you make on the plate usually do not survive after the first print.

Monoprints allow an artist to experiment and create works that are loose and free. They are also a good way to explore the use of various materials and contrasts, such as the relationship between thick and thin lines or between areas of dark and light.

# Methods of Making a Monoprint

You can practice the following three simple methods of creating a monoprint. For the smooth, nonabsorbent surface, you might use a piece of plastic or formica or even a cookie sheet. And remember: your print will be the reverse of the drawing or painting you create on the plate.

# 90

#### **Studio Connection**

Create a monoprint by using one of the methods discussed in this lesson. Choose a method that works well with

your subject. For example, method 1 works well for portraits. Method 2 works well for still lifes or abstract designs. Use copy paper or drawing paper to pull the print.

#### Method 1

Roll out a thin, even layer of ink on a smooth, nonabsorbent surface. Draw directly into the ink with a tool such as a toothpick,

pencil eraser, cotton swab, facial tissue, or old comb. Place a sheet of paper over the design, and rub it evenly but lightly with your hand. Then pull the print by lifting the paper away from the surface.

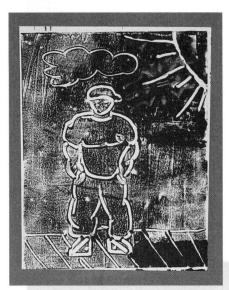

Fig. 6–17 The act of pulling the print will sometimes create interesting textures in the image. In what other ways might you create textures when using the printmaking technique described in method 1? Clifton Islar, A Boy in the Hood, 2001.

Tempera monoprint, 12° x8° (50.5 x 20 cm). Amidon School, Washington, DC.

210

### **Teaching Options**

#### Resources

Finder Cards: 6.2 A Closer Look: 6.2 Find Out More: 6.2 Check Your Work: 6.2 Assessment Master: 6.2 Overhead Transparency 12 Slides 6d

Teacher's Resource Binder

#### **Teaching Through Inquiry**

**Art Production** Have students keep a record of their experiences with monoprinting methods. Ask students to describe the process and the results of each method, and to make notes about what they like and do not like about each.

#### Method 2

Paint an image with tempera paint on a smooth, nonabsorbent surface. Work quickly so that the entire painted area stays wet.

Place a sheet of paper over the painted image, and rub it evenly but lightly with your hand. Then pull the print by lifting the paper away from the surface.

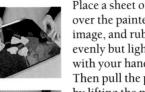

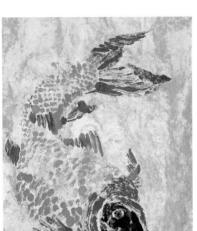

Fig. 6-18 This artist used method 2 to create his print. How does the mottled sheet of paper add to the impression of a print? Mike Tordé, *Untitled*, 2001. Printer's ink on colored paper, 10° x 8" (25.5 x 20 cm). Camels Hump Middle School, Richmond, Vermont.

#### Method 3

Roll out a thin, even laver of ink on a smooth, nonabsorbent surface. Place a sheet of paper over the inked surface, but do not

rub it. Using a pencil, draw an image on the paper. Then pull the print by lifting the paper away from the surface.

Fig. 6-19 Notice how this artist used four colors to create her print. When you try this method of printing (method 3) for the first time, however, use only one color. Katherine Leary, Flower, 1998.

#### **Lesson Review**

#### **Check Your Understanding**

- **1.** How is monoprinting different from other types of printmaking?
- 2. What are the differences in the results that you get with each method of monoprinting?

Artists as Messengers

211

#### **Studio Connection**

Encourage students to try each of the methods and create one print from each.

Assess See Teacher's Resource Binder: Check Your Work 6.2.

#### Assess

#### **Check Your Understanding:** Answers

- 1. In monoprinting, artists are able to create only one print from the plate. In other methods of printmaking, artists can create many prints from the same plate.
- 2. Answers will vary.

#### Close

Have students mount and display their prints. Discuss which techniques and subjects they found to be particularly successful.

#### **Using the Overhead**

#### Write About It

**Describe** Carefully describe the subject matter of this artwork.

Analyze Explain how the artist used lines and other elements to attract and hold the viewer's attention.

#### **Assessment Options**

Peer Have students work in groups of three, and assign each member a different one of the three methods of monoprinting. Instruct students each, in turn, to teach the other members the techniques of their assigned method and to explain the potential results. Have the two "students" ask clarifying questions and then practice the method according to the "teacher's" directions. Encourage students to discuss what they have learned and indicate how they could

use the methods in future artworks.

#### **Prepare**

#### **Pacing**

Two or more 45-minute periods: one or more to consider text and images and to cut stencils; one to print

#### **Objectives**

- Explain how symbols are used in Aborigine art.
- Compare the different meanings of similar symbols and patterns used in various parts of Australia.
- Create a pattern of symbols and lines that sends a message.

#### **Using the Map**

Ask: What can this map tell us about where most of the Australian population might be located? Remind students that Australia's interior is the largest desert outside of the Sahara, and tropical rainforests cover the northern coastal regions. Therefore, today's population clusters around the wetter south and east coasts.

#### National Standards 6.3 Global Destinations Lesson

- 1a Select/analyze media, techniques, processes, reflect.
- 2c Select, use structures, functions.
- **3a** Integrate visual, spatial, temporal concepts with content.
- **4c** Analyze, demonstrate how time and place influence visual characteristics.

### **Aboriginal Australia**

#### **Places in Time**

The first inhabitants of Australia probably arrived on the continent many thousands of years ago. The Aborigines spread across the land and settled in many different areas. They formed communities in the tropical regions of the north, the temperate climates of the south, the fertile river lands, and the harsh deserts. Because the vast geography separated the groups, each developed a distinct language and artistic style. However, a common characteristic of Aboriginal art is its importance to Aboriginal life.

#### Australia

Statements of Power

In Australian Aboriginal culture, knowledge determines a person's authority in the community. For Aboriginal groups, art is an expression of knowledge, and artworks are statements of authority.

In their artworks, Aboriginal artists use symbols and designs inherited from their ancestors. They use the symbols in order to examine the relationships between individuals and groups, people and the land, and people and their ancestors. Aboriginal symbols and designs usually vary from one family group to another. The paintings in Figs. 6–20 and 6–21 show some of the symbolic designs that are passed down from one generation to the next. These patterns of crosshatched lines identify family groups and ancestors.

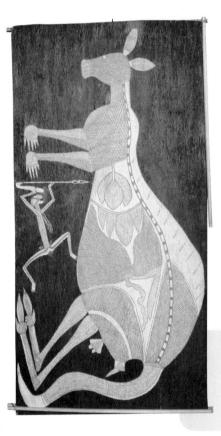

Fig. 6–20 Why might outsiders refer to this way of painting as "X-ray" style? Why would the artists want to show the internal organs of the animals in their region? Australian Aboriginal, Western Arnhem Land, Kangaroo and Hunter, 20th century.

X-ray style painting on bark. Private Collection, Prague, Czech Republic. Werner

212

GLOBAL DESTINATIONS

### **Teaching Options**

#### Resources

Teacher's Resource Binder A Closer Look: 6.3 Find Out More: 6.3 Check Your Work: 6.3 Assessment Master: 6.3 Large Reproduction 12 Slides 6e

#### **Teaching Through Inquiry**

Art Criticism Ask students to study the artworks in this lesson and then to analyze the ways that lines are arranged to create different patterns. Direct students to divide a sheet of drawing paper into eight sections and to use paint, markers, or crayons to fill each with a line pattern found in the artworks. Students may need more than one sheet of paper. Ask students to cut the sections apart and to write the name of the artwork and the artist on the back of each pattern. Then have students exchange patterns and match them to the artworks in the book, without looking at the information on the back.

#### Messages About the Land

Symbols and designs also vary from one geographical area to another in Australia. A symbol's meaning may depend on where the artist lives. Artists of the Northern Territory, for example, often use dot-andline designs, such as those in Fig. 6–22. The designs are symbols for special places in the artist's region, such as settlements, hills, or waterholes. A field of dots can symbolize clouds, rain, or fire. Curving lines may indicate the path of a river or animal tracks, whereas zigzag lines may symbolize lightning in the sky. Artists often combine many designs in their artworks in order to communicate a special message that is known only to their Aboriginal group.

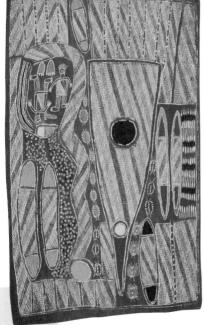

Fig. 6–21 Note the pattern of crosshatched lines, which symbolizes an ancestor of the artist. What different crosshatched patterns could you make to represent some of your ancestors? Australian Aboriginal, Painted Tree Bark with Crosshatching Pattern, 20th century. Courtesy the Archivo Fotografico del Museo Preistorico de Etnografico L. Pigorini, Roma. Photo by Damiano Rosa.

Fig. 6–22 Do you see dots or lines? Dotted lines often symbolize certain landforms, paths, or trails. The lines may also be decorative. Rene Ronibson, Snake

Ronibson, *Snake Dreaming*, 20th century.
Acrylic on canvas. Jennifer Steele/Art
Resource, New York.

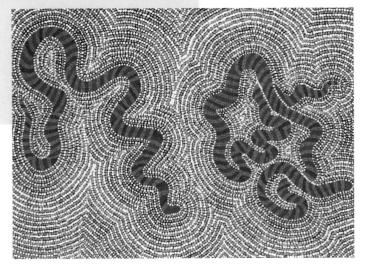

Artists as Messengers

213

#### Teach

#### Engage

Discuss what students know about Australia and its peoples. Explain that the Aborigines have inhabited this continent for more than 40,000 years.

#### **Using the Text**

Art History Ask: What determines a person's authority in our culture? (popularity, wealth, social status, career) What determines a person's authority in Aborigine groups? (knowledge) From whom do Aborigine artists find their symbols? (ancestors)

#### **Using the Art**

Art History Ask: What is happening in Kangaroo and Hunter? (hunter stabbing kangaroo) Why, do you think, did the artist show the kangaroo's internal organs?

**Perception Ask**: How is *Snake Dreaming* like a map or a memory of a journey? What patterns are formed by the dots and lines?

#### More About...

The Aborigine oral traditions that describe Australia's origin are known as **Dreamtime** or "time before time." Although many of these creation stories are dramatic and tell of amazing events and beings, they do contain the essence of truth. They tell of Ancestor Spirits, in human and other forms, who shaped the land before changing into animals, stars, hills, and other landmarks. Although each tribe has its own Dreamtime, most all of Dreamtime legends begin with Giant Dog or Giant Snake.

#### **Using the Large Reproduction**

#### **Consider Context**

**Describe** Describe the types and qualities of the lines. **Attribute** What clues in the lines, shapes, and patterns provide information about where this was made?

**Understand** Do you think the people who made this artwork were close to nature? Why or why not?

**Explain** Why do you think this artwork looks the way it does?

12

# Aboriginal Australia

# **Using the Text**

Art History After students have read the text, have them locate the southern part of Australia's Northern Territory on the map on page 212. Tell students that this arid region is Ada Bird Petyarre's homeland. Ask: What is a major responsibility of Petyarre and her sisters? (preserving and passing on their ancestors' symbols)

# Using the Art

Art Criticism Ask: What plant forms in Sacred Grasses can you identify? How are the patterns and textures in Sacred Grasses similar to and different from those in Mountain Devil Lizard? Which painting do you think took longer to create? Why? Upon what is the design of Mountain Devil Lizard based? (ancient ceremonial body painting)

#### **Studio Connection**

Encourage students first to sketch ideas for stencil shapes on scratch paper

and then to draw them onto tag board or waxed cardboard from paper milk cartons. Have students use scissors to cut out the insides of the shapes; for smaller details, closely supervise their cutting with an X-acto knife. Demonstrate stenciling a shape onto construction paper with tempera paint and a sponge or stiff brush. Guide students to repeat their shapes in various colors to create patterns and emphasis.

Assess See Teacher's Resource Binder: Check Your Work 6.3.

#### **Messages About Family**

"I draw from designs that I understand from my own background." Ada Bird Petvarre (born 1930)

Artist Ada Bird Petyarre is a spokesperson for her native Aboriginal group. She knows very well the land of her birththe desert part of Australia's Northern Territory. Petvarre was born in 1930 and is the oldest of five sisters, who are each well-known artists too. Petyarre and her sisters have a common knowledge of stories, dances. songs, and ceremonies. They also share the responsibility of preserving and passing on the symbols of their ancestors.

# The Meaning of Patterns

Ada Petyarre has worked in batik, watercolor, woodblock prints, and sculpture. Her most recent works are acrylic paintings on canvas. Each canvas is a pattern of repeated elements dots, lines, circles. The patterns often have important meaning for her family group. Petyarre also uses plantlike symbols that represent sacred desert plants and grasses or the large number

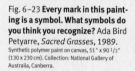

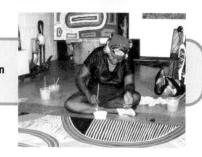

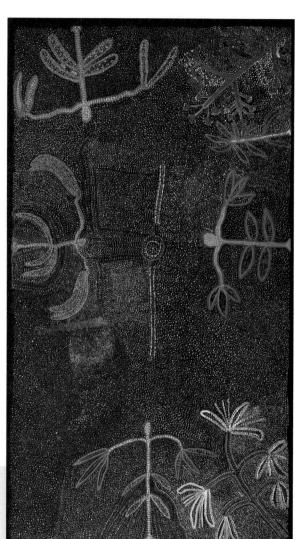

214

GLOBAL DESTINATIONS

# **Teaching Options**

#### **Meeting Individual Needs**

Multiple Intelligences/Bodily-Kinesthetic Have students quietly examine one of the images on these pages for three minutes. Remind students that the artwork's symbols may represent the artist's relationship to a group or the people's relationship to the land and their ancestors; and that we may find the work to be quite stirring even though we may not be able to understand specifically what the composition symbolizes. Ask: How do you feel as your eyes travel over the art's patterns and symbols? How do the colors, unity, balance, and rhythm contribute to this sensation? Ask students to sit for a few minutes to develop physical gestures to describe the feeling they had. Have students each present their gestures, and ask the rest of the class to determine what image is being described.

of wildflowers after a good rain. The painted patterns are her personal statements about her world. In *Sacred Grasses* (Fig. 6–23), the symbols are easy to recognize as plant forms. For her work *Mountain Devil Lizard* (Fig. 6–24), she repeated lines to create patterns. These patterns represent designs that are painted on the bodies of dancers in special ceremonies.

#### **Studio Connection**

Make and use stencils to create repeated shapes on one piece of paper. Use the stencils to create a pattern that sends a

personal message. Before you create your stencil pattern, practice with a sponge or stiff bristle brush to stipple paint around or through the openings in the stencil shape itself. Consider overlapping the stencils and using different colors for emphasis.

**Lesson Review** 

#### **Check Your Understanding**

- **1.** What symbols are used in Aboriginal art? What do they represent?
- 2. What are two reasons that the meaning of symbols and patterns differ from one part of Australia to another?
- **3.** What are some symbols that Ada Bird Petyarre repeats in her work? What do they represent?
- **4.** Why is Petyarre's work important to her Aboriginal group?

Fig. 6–24 How would you describe the lines in this painting? Ada Bird Petyarre, Mountain Devil Lizard, 1992.

Acrylic on canyas. Courtesy of the artist and linta Desert Art,

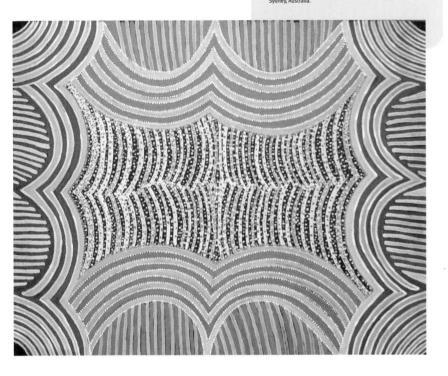

Artists as Messengers

## Assess

# Check Your Understanding: Answers

- 1. Plant symbols represent sacred plants; dot-and-line images may symbolize landmarks, plants, and trees.
- 2. Symbols and patterns may be passed down through the generations in one family, so their meaning would be understood only by that family. Chance use of the same symbols elsewhere, therefore, would not have the same meaning. Similarly, symbols and patterns used in specific regions may represent local landforms and landmarks, such as hills and paths.
- 3. Petyarre uses plant symbols to represent sacred plants, dot-and-line images to symbolize landforms and landmarks, and line patterns to symbolize ceremonial designs.
- **4.** Petyarre's work preserves and passes on her ancestors' symbols.

# Close

Discuss students' answers to Check Your Understanding. Display students' stencil prints, and allow them to explain the meaning of their patterns.

#### **Teaching Through Inquiry**

Aesthetics Have groups of students explore these questions: How do lines express feelings? Do people have similar feelings about certain kinds of lines? Ask students to prepare a set of visuals with different types of lines, conduct a small survey of both children and adults, and record each person's responses to each type of line. Have groups share their findings and create a display of lines labeled with the feelings most commonly associated with them.

#### More About...

Ada Bird Petyarre is a senior Aborigine woman in Utopia, a former Australian cattle station northeast of Alice Springs. In the 1970s, she became involved with the Utopia Women's Batik group, and she began painting in 1988. She paints "dreamings" of the Mountain Devil Lizard, Bean, Emu, Yam, and Grass Seeds.

#### **Assessment Options**

**Peer** Have students work in small groups. Instruct group members each to write one

question that could be answered by anyone who had read and understood the text. Then have students test one another with their question.

**Self** Ask students to describe the pattern they created in their print, comment on what they especially like about it, and tell what they would change if they made another print.

215

#### A Linoleum Block Print

# **Prepare**

#### **Pacing**

Three or more 45-minute periods: one to consider text and images and to draw; one to carve block; one to print

# **Objectives**

- · Explain what relief printmaking is.
- Understand how artists use line and emphasis to communicate ideas, moods, and feelings in their artworks.
- Create a linoleum print that sends an important message.

#### Vocabulary

relief print A print made from a design that is raised from a flat background, such as a woodcut.

**line** A mark with length and direction, created by a point that moved across a surface.

emphasis A principle of design in which some visual elements are given more importance than others to catch and hold the viewer's attention.

# **Supplies for Engage**

 photographs from news magazines or newspapers

## National Standards 6.4 Studio Lesson

- **1b** Use media/techniques/processes to communicate experiences, ideas.
- **2a** Generalize about structures, functions.
- **2b** Employ/analyze effectiveness of organizational structures.
- 2c Select, use structures, functions.
- **3b** Use subjects, themes, symbols, that communicate meaning.

Printmaking in the Studio

# A Linoleum Block Print

# Send a Message Without Words

LESSON

STUDIO

#### **Studio Introduction**

Most messages that we get are written, spoken, broadcast, or sent by codes and symbols. But messages can also be

expressed by artworks. Think of a drawing, painting, or newspaper photograph that caught your eye recently. How did it make you feel? What do you think it means? Your answers likely suggest the message that the artist wanted to express.

In this studio experience, you will create a linoleum print that sends an important message. Pages 218 and 219 will tell you how to do it. First, choose a topic for your message, such as pollution, animal rights, or school dress codes. What kind of image will best express the seriousness, humor, or concern you feel about your topic? How will you get people to notice and understand your message? How will you use lines and shapes to create emphasis? Will you outline the positive and negative shapes? Will you use lines to create patterns and visual texture?

Fig. 6-25 Elizabeth Catlett is noted for her sculptures and prints that send messages about the strength of African American women. How did she use shape and line to create emphasis in this print? Elizabeth Catlett.

Elizabeth Catlett,

Sharecropper, 1968.

Woodcut, 18" x 16 1/2" (46.5 x 42 cm).
Spencer Museum of Art: Gift of the Friends
of the Art Museum. © Elizabeth Catlett/
Licensed by VAGA, New York, NY.

Fig. 6–26 How did the artist show the heroism and strength of Harriet Tubman? How did she use contrast to emphasize her message? Elizabeth Catlett, *Harriet*, 1975.

1975. Linocut, 12 ½" x 10 ½" (32 x 26 cm). Courtesy Sragow Gallery, New York. © Elizabeth Catlett/Licensed by VAGA, New York, NY.

## **Studio Background**

#### **Relief Prints**

So that many people will see their messages, some artists make prints. Printmaking allows artists to create more than one copy of their artwork. Relief printmaking is one of several basic printmaking processes. A **relief print** is made from a design that is raised from a flat background. Two traditional relief-printmaking processes are woodcuts and linoleum, or lino, cuts. Both involve carving the surface of a block to create an image. The raised areas will create the lines and positive shapes in the print. The areas that are cut away will create the negative shapes.

On the carved block, the artist coats the raised areas with ink and then places a sheet of paper or other material on the inked surface. When he or she presses down on the paper or material, the inked image is transferred to it. The artist then "pulls the print" by carefully peeling the paper or material away from the block.

216

# **Teaching Options**

#### Resources

Teacher's Resource Binder Studio Master: 6.4 Studio Reflection: 6.4 A Closer Look: 6.4 Find Out More: 6.4 Overhead Transparency 12 Slides 6f

#### **Teaching Through Inquiry**

Art Criticism Ask students to imagine that they are responsible for selecting one of the two Elizabeth Catlett images for the cover of a book on heroic women. Explain that the purpose of the book is to highlight the accomplishments of women throughout history. Remind students that heroes may be individuals, such as Marie Curie, who have performed particular deeds; or may be a group, such as mail carriers, that has consistently contributed to the health and well-being of others. Explain to students that they are to support their selection with reasons, including the way that Catlett conveyed ideas, moods, and feelings in the artwork.

Fig. 6–27 Describe the artist's use of positive and negative spaces and shapes. Wil Johnson III, *Broken Home*, 2001.

Linoleum block print, 6 3/4" x 7 1/4" (17 x 18.5 cm). Mount Nittany Middle School, State College, Pennsylvania.

Fig. 6–28 How did the artist create pattern and texture in this print? Mathew Wolfgang, *The Countryside*, 2001

inoleum block print, 3 1/2" x 7" (9 x 18 m). Mount Nittany Middle School, State

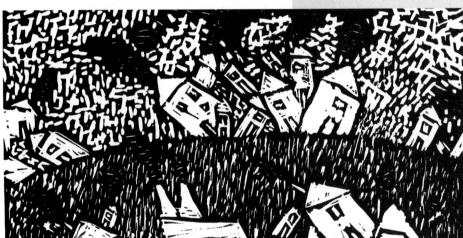

Artists as Messengers

217

# More About...

Sculptor, graphic artist, and teacher Elizabeth Catlett was born in Washington, D.C., in 1919. Her grandparents had been slaves, but her father was a mathematics professor, musician, and sculptor. Through her art, Elizabeth Catlett has fought against injustice and oppression.

#### **Using the Overhead**

#### Think It Through

**Ideas** How, do you suppose, did the artist arrive at the idea for this?

**Techniques** Explain how the artist used materials and techniques to communicate ideas, moods, and feelings.

12

# **Supplies**

- sketch paper
- pencil (#2 or Ebony)
- linoleum block (or softer printmaking material)
- · carving tools
- · bench hook
- water-soluble printing ink
- brayer
- inking plate (pie pan or cookie sheet)
- construction paper
- newspapers
- spoon (optional)

# Teach

#### Engage

Show students the photographs. **Ask:** How do you feel when you look at these photos? Do you think this was what the photographer intended you to feel?

## **Using the Text**

Art Production Ask: What is a relief print? What are two traditional relief-printmaking processes? What are some topics you could choose from for your print? What kinds of images would be appropriate for each of these topics? On the chalkboard, write a list of students' responses.

# **Using the Art**

Art Criticism Ask: What is the center of interest in each of Elizabeth Catlett's prints? How did Catlett emphasize one part of each print? (with contrast in value; by enlarging the subject) What parts did she carve away? (white parts) Have students finger-trace the movement through Harriet, from the left leg to the pointing finger. Ask: From studying Sharecropper, what do you know about the woman depicted? How, do you think, did Catlett feel about her?

#### A Linoleum Block Print

# **Studio Experience**

- 1. Demonstrate tracing around a linoleum block with pencil and drawing a design inside the shape. Guide students to make their design dark enough to transfer to the linoleum.
- 2. Demonstrate safe cutting techniques.
- 3. Demonstrate inking the block. Encourage students to use more than one color on their block, make multiple prints on a sheet of paper, and print on different kinds of papers.

#### **Idea Generators**

Direct students to select a topic from the list developed in Using the Text, page 217. Have them sketch thumbnails of different arrangements of their subject, such as by reversing light and dark values, adding patterns, making the subject larger or smaller, and using various line widths.

## **Safety Notes**

- Provide soft printmaking materials such as Soft-Kut® or E-Z Cut, which are easier to carve than battleship linoleum.
- Remind students to cut away from their fingers when they use cutting tools.

#### Extend

Have students use pencil to write their title, sign their name, and number their print just beneath the lower edge of their print. Explain that the number indicates the print's sequence in a limited print edition; for example, the third of ten prints printed from a block print would be numbered 3/10.

#### Printmaking in the Studio

# **Creating Your Print**

#### You Will Need

- sketch paper
- pencil

STUDIO LESSON

- linoleum block
- carving tools
- bench hook
- ink
- brayer
- construction paper

# 20 3

#### **Safety Note**

Linoleum-carving tools are extremely sharp! To avoid cuts and other injuries, use them with extreme caution. If

you are unsure about how to use the carving tools, ask your teacher for help.

#### Try This

1. On sketch paper, trace the edges of your block. Use a soft-leaded (#2) pencil to draw your design inside the lines of the trace. How will you use lines and shapes to best express your message? What part of the image will you emphasize? Think about which areas will print and which will be the color of the paper. With your pencil, fill in the areas that will print.

2. Carefully lay your design face-down on the linoleum side of the block. Make sure that the edges of the trace line up with the

edges of the block. With your hand, rub the back of the paper to transfer your design onto the block. Check the darkness of the image that is now on the block. Darken any lines that you think are too light.

**3.** Place the block on a bench hook. Carefully carve away the areas of your design that will not print.

**4.** Use a brayer to roll a thin, even layer of ink onto the raised surfaces of your block.

**5.** Carefully place your printing paper over the block. Gently rub the back of the paper. When you see the faint impression of your design on the back of the sheet, slowly

pull the print away from the block.

#### Check Your Work

Display your artwork. Can your classmates "read" the message of your print? Discuss the ways that you and your classmates used lines and shapes to emphasize your message. What kinds of lines did you use? How did you use lines to create pattern and texture? Where do you see positive and negative shapes?

#### **Computer Option**

By using computers, artists can quickly create different versions of the same design. They can also simulate some

printmaking characteristics. Using a program with drawing tools, create a line drawing. Vary the thickness of the lines to create a more interesting result. If necessary, reduce the size of the image. Then copy and paste the image four times onto one page—two on the top and two on the bottom—to create a composition of fourths. Change the copies—alter the color and value of each—to create four different versions of your drawing.

218

# **Teaching Options**

#### **Teaching Through Inquiry**

Art Production Provide students with two sheets of tracing paper or clear acetate, along with small reproductions of artworks (or use artworks in the textbook) so that they may analyze how the artist used line, such as by outlining the subject and/or by creating shape, pattern, space, or movement. First, have students trace, on one sheet of paper, the lines that they believe are significant. Then have them use the second sheet to identify the way the artist created emphasis or a center of interest. You may wish to have students work in groups and then share their findings as a class.

#### **Studio Collaboration**

Have students work in groups of twelve to create a calendar. Instruct groups to have each member design a print for a different month and then make twelve prints, one for each member.

#### **Elements and Principles**

## **Line and Emphasis**

In simplest terms, a **line** is a mark that has length and direction. Line is the most basic element of art, yet it is the foundation from which artists can create shape, pattern, texture, space, movement, form, or emphasis in their artworks. A line may start at one point and bend, wiggle, zigzag, wave,

loop, or move straight across an artwork. It can be fat, thin, light, heavy, broken, calm, or energetic. Indeed, line can be used to express any number of moods and ideas in art.

Artists create **emphasis** in artworks by making something—such as an object, shape, or simply white space—more noticeable than other things.

For example, an artist may make the main subject of the artwork the largest thing in an image. An artist may also place the subject in a certain spot. He or she may then use lines or other elements of art to lead the viewer's eye to the subject.

An artist may also use contrast, or strong differences between elements, to create emphasis. With any of these techniques, artists create a *center of interest* in the artwork.

Look at some of your own works of art. What kinds of lines did you use? In what ways did you create emphasis?

Fig. 6–29 What makes this a powerful image? What message do you think the artist was trying to send? Sunyoung Park, *Discrimination*, 2001. Linoleum block print, 31/2° x 63/8° (9 x 18 cm). Mount Nittany Middle School,

Artists as Messengers

219

Computer Option
Guide students to use
computer drawing

tools to produce a design with a message. Alternatively, have students draw on paper and then scan their image. Adobe Photoshop® and similar programs effectively simulate some printmaking qualities by mimicking textures, engraving, and embossing. Ask: What were the effects of your choices about color? Texture? Any special effects? What was successful? Why? What would you do differently next time?

## **Elements and Principles**

Invite students to identify a variety of line types in artworks you have displayed around the room or in artworks in their textbook. Have them choose from their own artworks the one that shows the strongest use of emphasis. Allow them to explain how they created it and why they feel the example is a good one.

#### Assess

#### **Check Your Work**

Have students answer the questions and then discuss their art as a class. Encourage students to explain the message in their print.

# Close

Guide students in matting, mounting, and labeling their print. Display the prints in a public place.

#### More About...

Egyptian and Chinese artists were the first to use woodblock printing to decorate textiles. By the early fourteenth century, the practice had spread to Europe. In the late 1300s, with the development of paper manufacturing in France and Germany, artists expanded their woodblock-printing techniques to this now-accessible printing surface. The first woodcuts printed in quantity on paper were playing cards. During the Renaissance, woodcuts became affordable art for the growing middle class. Japanese Edo woodcuts, from the seventeenth through nineteenth centuries, featured colored genre scenes of Japanese life. Their color and asymmetrical composition inspired the French Impressionists. Early-twentieth-century German Expressionists exploited the creative potential of woodblock printing.

#### **Assessment Options**

Peer Have students write an artist's statement to accompany their print. Ask students to explain (a) the process they used to create the print; (b) the way they used line to create shapes, pattern, space, and/or movement; and (c) how they created emphasis or a center of interest. Have student pairs exchange statements and prints. The peer reviewer should comment on how well the statement explains (a), (b), and (c). Then have peers meet to discuss their comments with each other.

#### Careers

Challenge students to find past or current newspaper articles that detail controversies, concerns, or aesthetic considerations about public art in the community or elsewhere. Instruct students that the articles may address whether a historical memorial should be removed because of contemporary interpretations, if a nonobjective sculpture is appropriate for its intended site, or whether a public sculpture can be considered a work of art. In a fullclass discussion, have students share their articles and aesthetic insights about the issues.

#### Other Arts

Have students select a passage from a book they are reading for language arts. Ask them to work in small groups, each on a different scene. to decide how to communicate what occurs, solely through pantomime. Encourage students to help one another during rehearsal in making their actions clear and understandable, and to discover physical gestures that will also help define their characters and express details in the text. Have groups perform their scene, and ask the viewing groups to discuss what they think occurred in the scene.

# Connect to...

# Careers

Have you ever visited an art museum and found an object that puzzled you? Did you admire it, even if you didn't know what it was supposed to be? If so, you were thinking philosophically about art. **Aestheticians** are philosophers who think about and question the nature and purposes of art. They are concerned with how people think about art, and the messages people send and receive about art. Most aestheticians receive a doctoral degree in philosophy from a college or university. An aesthetician may teach, write, and lecture about art in colleges and universities.

Fig. 6–30 Thinking like an aesthetician, what questions would you ask about this outdoor sculpture? What message do you think it sends? Henry Moore, *Nuclear Energy*, 1964–67.

Pronze, height: 23' (3.7 m). Located in Chicago, Illinois, Courtesy Davis Art Slides

# **Other Arts**

#### Theater

**Specialists in mime communicate without words:** they act out scenes without speaking. The word *pantomime* comes from Greek words meaning "all mimic." The art form began in ancient Rome: a single dancer mimed the actions of several characters while a chorus narrated a short version of a Greek or Roman heroic tale. Today, pantomime has become part of many circus clown acts.

Fig. 6-31 The character of a clown first appeared in early European pantomime plays that mixed music, song, dance, and acrobatic tricks.

220

# **Teaching Options**

#### Resources

Teacher's Resource Binder:
Making Connections
Using the Web
Interview with an Artist
Teacher Letter

#### Video Connection

Show the Davis art careers video to give students a reallife look at the career highlighted above.

#### **Interdisciplinary Planning**

Encourage teachers in other disciplines to use the theme of symbols that send messages as a springboard to explore symbol systems and forms of communication.

**Social Studies** 

ized design.

Ask students to research and collect

symbols of America that are known

worldwide, and then to create new

symbols for American culture today.

Possibilities for expression include

students write a press release that

explains the reasons for the modern-

a design for a new flag, postage

stamp, or public sculpture. Have

# **Other Subjects**

#### Social Studies

Since the beginning of history, people have used banners and flags to identify friend and enemy, to show allegiance, or to foster pride. The colors, designs, and shapes on the flag or banner often send a message. George Washington explained the message of the first American flag in these words: "We take the stars from heaven, the red from our mother country, separating it by white stripes, thus showing that we have separated from her, and the white stripes shall go down to posterity representing liberty.'

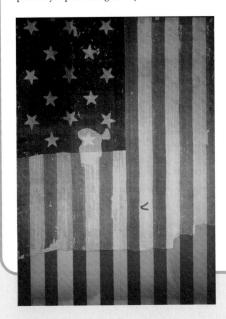

#### Language Arts

Why are secret messages necessary in times of war? During World War II, an unbreakable code was needed against the Japanese, who were then known for their skill at breaking codes. Because the Navajo language (a complex oral language with no alphabet or other symbols) was spoken by few non-Navajo, agents chose it as their code to send secret messages. During the war, around 400 Navajo served as code talkers; the Japanese never broke the code. Not until 1992 did the United States government publicly recognize the Navajo nation for this significant contribution.

#### Science

Morse code is a signaling system that uses dots and dashes to signify the letters of the alphabet. The code's best-known message—SOS—does not really mean "save our ship." It was just an easy signal to remember and recognize, even under bad weather conditions. Invented by Samuel Morse in 1838, Morse code was last used in 1999. In that year, the Global Maritime Distress and Safety System (GMDSS) began operation. GMDSS uses radio beacons and orbiting satellites that can pick up signals from anywhere on earth.

Fig. 6-32 How has the American flag changed over time? What does the flag mean to people today? Mrs. Mary Pickersgill, Baltimore, Star-Spangled Banner, 1813.
Cotton, wool bunting, Irish linen, 30' x 34' (originally 30' x 42').
Courtesy Smithsonian Institution.

# **Daily Life**

When older family members were your age, they probably received personal messages through the telephone and the mail. How do you communicate with your friends? The mass-production of computer technology has made available communication gadgets such as cellphones, pagers, personal digital assistants, and e-mail. What devices might people use to communicate in 2050?

Artists as Messengers

221

Internet Connection For more activities related to this chapter, go to the

Davis Website at www.davis-art.com.

#### **Internet Resources**

# **Aboriginal Art and Culture Center**

http://www.aboriginalart.com.au/didgeridoo/ Investigate Aboriginal music of the Southern Arrernte Aboriginal tribal group.

#### Interview with a Yoruba Artist

http://shop.metmuseum.org/explore/YORUBA/HTM/txt\_7a.htm Read the interview at the site of The Metropolitan Museum of Art.

#### **Community Involvement**

- · Ask students to explore their community and neighborhood and to document, with photographs or sketches, the ways that symbols on signs are used to communicate important messages. Have students create a display with the messages organized by type, such as for instruction, inspiration, corporate identity, and so on.
- · Challenge students to design a symbol for community or neighborhood banners that could hang from streetlights along a main thoroughfare. Help students submit their designs to community officials for consideration.

# **Talking About Student Art**

Following a discussion about the meaning of a student artwork, summarize the different interpretations proposed by students. On one side of the board, list and number the interpretations. Make a continuum, with "most plausible interpretation" at one end, and "least plausible interpretation" at the other end. Invite students to place the number of each interpretation along the continuum, and to give reasons for the placement.

## Portfolio Tip

Encourage students to include the following points in written reports for their

portfolio: 1. an introduction that captures the reader's attention and tells what will follow; 2. an elaboration of ideas with vivid, descriptive details: 3. a conclusion or summary statement.

## Sketchbook Tip

Encourage students to use a section of their sketchbook for collecting symbols,

logos, and trademarks that are part of our visual culture. Guide students to paste in the symbols or put them into an envelope glued to the back cover. Challenge students to explore ways to modify and incorporate these popular symbols into their own artwork.

# **Portfolio**

REVIE

ŏ

PORTFOLIO

9

"We had made cartouches in art using hieroglyphic symbols, and I decided to use the same method to tell my message. I decided to make the symbols symmetrical, with both sides the same." Alana McConnell

Fig. 6-34 What do the symbols and images in this artwork tell you about the artist? Ryan Johnson, Untitled, 2001.

Fig. 6-33 Using the title of this artwork as a guide. can you "read" the symbols the artist uses in place of letters? Alana McConnell, I Can Reach My Goals, 2001.

Tempera paint, tagboard, stencil print, 16" x 22" (40.5 x 56 cm). Amidor Elementary School, Washington, DC.

"I had to think about what I was doing and put it on paper. The best thing I like about my art is that it was very personal. Each part of my artwork explained my feelings and my life." Ryan Johnson

"When I was assigned to create a drawing combining the features of an animal with myself, I knew immediatedly that I wanted to somehow transform myself into a panda. I went through this process by thinking of what physical features a panda and I have in common." Cassie Rogg

#### **CD-ROM Connection**

To see more student art, view the Personal Journey Student Gallery.

Fig. 6-35 To send a message about yourself, what animal would you choose? Cassie Rogg, The Panda in Me, 2001. olored pencil, 18" x 24" (46 x 61 cm), Archie R. Cole lunior High School East Greenwich, Rhode Island.

222

# **Teaching Options**

#### Resources

Teacher's Resource Binder Chapter Review 6 Portfolio Tips Write About Art **Understanding Your Artistic Process** Analyzing Your Studio Work

# CD-ROM Connection

For students' inspiration, for comparison, or for criticism exercises, use

the additional student works related to studio activities in this chapter.

# **Chapter 6 Review**

#### Recall

What is a symbol?

#### Understand

Explain how portraits may send messages.

#### Apply

Use pictures as symbols for words in a message to a friend.

#### Analyze

Make a collection of logos, and explain how each one represents a product, service, or company.

#### **For Your Portfolio**

Create a symbolic portrait of someone you know well, such as a family member, a television star, or a neighbor-

hood shop owner. Write an artist's statement to explain the meaning of your symbols.

#### For Your Sketchbook

Fill a sketchbook page with many different kinds of lines. Identify those lines that might be used to

symbolize or express different moods and feelings, such as energy, calm, or joy.

#### **Synthesize**

Develop a list of three questions that a viewer should ask in order to understand an artist's message.

#### Evaluate

Review the artworks in this chapter (*see example below*). Select one that sends a message in a clear and understandable way. Give reasons for your selection.

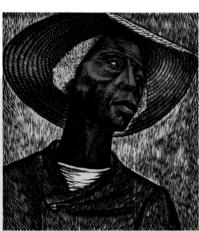

Page 216

# Artists as Messengers

223

# **Advocacy**

Have students design a logo for and write a short statement about the value of art in society. Ask students to select one logo and statement to include on all printed programs for school events.

#### **Family Involvement**

For effective communication between school and family, send home newsletters with reminders of upcoming assignments and specific information about what students are learning in art. Focus on the important aspects of what students are learning—include more than a listing of the projects.

# Chapter 6 Review Answers Recall

A symbol is an image that stands for and communicates certain ideas.

#### **Understand**

Portraits send messages about what people look like and sometimes what they enjoy, the kind of work they do, or what they think.

#### **Apply**

Results will vary. Look for clear understanding of symbols and their use.

#### **Synthesize**

Answers may vary. Students might ask questions like: What things do I recognize in this artwork? How do all of these things fit together? What do these things remind me of, what associations do they bring to mind, or how does it make me feel? What do all of these things mean, what's going on here, or what do I believe about this artwork?

#### **Evaluate**

Answers may vary. Look for reasons that make reference to things seen in the artwork. Also try to distinguish between supportable reasons and personal opinions.

#### Reteach

Discuss ways that people communicate their ideas and feelings. Suggested topics: facial expressions, body language, sounds, images, signs, symbols, and words, etc. Help students identify artworks in the textbook or in other resources that send messages through the means listed above. Discuss how these are good examples of ways that art communicates. Summarize by reminding students that artists send visual messages in their artworks.

3

3

3

3

# **Chapter Organizer**

#### **Chapter Focus**

# Chapter 7 Artists as Inventors

Chapter 7 Overview pages 224-225

- · Core People imagine strange worlds through dreams and fantasy. Artists explore fantasy by inventing optical illusions and magical worlds.
- 7.1 Fantasy in Art
- 7.2 Perspective
- 7.3 Art of Puerto Rico
- . 7.4 Building a Wire Sculpture

#### **Chapter National Standards**

- 1 Understand media, techniques, and processes.
- Use knowledge of structures and functions.
- 3 Choose and evaluate subject matter, symbols, and ideas.
- Understand arts in relation to history and cultures.
- Assess own and others' work.
- 6 Make connections between disciplines.

#### **Core Lesson An Inventive Artist** page 226

Pacing: Three 45-minute periods

#### **Objectives**

- Explain why artists are sometimes considered inventors.
- Identify methods to create the illusion of depth on a two-dimensional surface.

#### **National Standards**

- 2a Generalize about structures, functions.
- 3a Integrate visual, spatial, temporal concepts with content.
- 4a Compare artworks of various eras, cultures.
- 5c Describe, compare responses to own or other artworks.

# **Core Studio** Drawing a

· Create an invented world out of wire.

- 1b Use media/techniques/processes to communicate experiences, ideas.
- 2c Select, use structures, functions.

# **Fantasy World** page 230

Then and Now

Lesson 7.1 **Fantasy in Art** 

page 232

#### **Objectives**

- · Recognize characteristics of Surrealist art.
- Justify the interpretation of Ellen Lanyon's work as inventive and surreal.

#### **National Standards**

- 1a Select/analyze media, techniques, processes,
  - 2b Employ/analyze effectiveness of organizational structures.
  - 4b Place objects in historical, cultural contexts.
  - 5b Analyze contemporary, historical meaning through inquiry.

# **Studio Connection**

Pacing: Three or more 45-minute periods

page 234

- · Use perspective and a combination of media to create a fantasy environment for ordinary objects.
- 3b Use subjects, themes, symbols that communicate meaning.

#### **Objectives**

· Understand the difference between one- and two-point perspective.

#### **National Standards**

2b Employ/analyze effectiveness of organizational structures.

#### 2 **Skills and Techniques** Lesson 7.2 **Perspective**

page 236 Pacing: Two or more 45-minute class period

- · Practice perspective drawing.
- 1b Use media/techniques/processes to communicate experiences, ideas.

#### **Featured Artists**

Giuseppe Arcimboldo Hieronymus Bosch Alexander Calder Salvador Dalí M.C. Escher Ellen Lanyon René Magritte Lillian Méndez Meret Oppenheim Roland Penrose Remedios Varo

#### **Chapter Vocabulary**

horizon line linear perspective movement perspective rhythm

santos space Surrealist vanishing point

#### **Teaching Options**

Meeting Individual Needs
Teaching Through Inquiry
More About...Giuseppe Arcimboldo
Teaching Through Inquiry
Using the Large Reproduction
Using the Overhead

#### **Technology**

CD-ROM Connection e-Gallery

#### Resources

Teacher's Resource Binder Thoughts About Art: 7 Core A Closer Look: 7 Core Find Out More: 7 Core Studio Master: 7 Core Assessment Master: 7 Core

Large Reproduction 13 Overhead Transparency 14 Slides 7a, 7b

Teaching Through Inquiry More About...Salvador Dalí Assessment Option CD-ROM Connection Student Gallery Teacher's Resource Binder Studio Reflection: 7 Core

#### **Teaching Options**

Teaching Through Inquiry
More About...The Surrealist art movement
More About...René Magritte
Using the Overhead

#### **Technology**

CD-ROM Connection e-Gallery

#### Resources

Teacher's Resource Binder Names to Know: 7.1 A Closer Look: 7.1 Find Out More: 7.1 Assessment Master: 7.1 Overhead Transparency 13 Slides 7c

Meeting Individual Needs Teaching Through Inquiry More About...Ellen Lanyon Assessment Options CD-ROM Connection Student Gallery Teacher's Resource Binder Check Your Work: 7.1

#### **Teaching Options**

Teaching Through Inquiry More About...Depth Using the Overhead Assessment Options

#### **Technology**

CD-ROM Connection e-Gallery

#### Resources

Teacher's Resource Binder Finder Cards: 7.2 A Closer Look: 7.2 Find Out More: 7.2 Assessment Master: 7.2 Overhead Transparency 14 Slides 7d

CD-ROM Connection Student Gallery Teacher's Resource Binder Check Your Work: 7.2

# Chapter Organizer continued

| S        | ks |  |
|----------|----|--|
| 2        | a  |  |
| d)       | ee |  |
| <b>~</b> | 5  |  |
| wee      | >  |  |
| <        |    |  |

2

2

# 36 weeks 18

2

# **Objectives**

#### **National Standards**

#### **Global Destinations** Lesson 7.3 **Art of Puerto Rico**

page 238 Pacing: One or More 45-minute class periods

- Give examples of traditional Puerto Rican art
- Identify materials and techniques used by maskmakers in Puerto Rico.

4c Analyze, demonstrate how time and place influence visual characteristics.

# **Studio Connection**

- · Use paper-sculpture techniques to create
- 1b Use media/techniques/processes to communicate experiences, ideas.
- 3b Use subjects, themes, symbols that communicate meaning.

# page 240

rhythm and movement in a mask.

#### **Objectives**

#### **National Standards**

- Studio Lesson 7.4 **Building a Wire** Sculpture
- page 242 Pacing: One or more 45-minute periods
- · Learn about the wire creations of Alexander
- Understand how artists use the element of space and the principles of movement and
- Create an invented world out of wire.
- 1a Select/analyze media, techniques, processes,
- 2a Generalize about structures, functions.
- 2b Employ/analyze effectiveness of organizational structures.
- **5c** Describe, compare responses to own or other artworks.

#### **Objectives**

## **National Standards**

Connect to... page 246

Portfolio/Review

page 248

- Identify and understand ways other disciplines are connected to and informed by the visual
- Understand a visual arts career and how it relates to chapter content.
- 6 Make connections between disciplines.

#### **Objectives**

- · Learn to look at and comment respectfully on artworks by peers.
- Demonstrate understanding of chapter content.

#### **National Standards**

5 Assess own and others' work.

Lesson of your choice

#### **Teaching Options**

Teaching Through Inquiry More About...Santos Using the Large Reproduction

#### Technology

CD-ROM Connection e-Gallery

#### Resources

Teacher's Resource Binder A Closer Look: 7.3 Find Out More: 7.3 Assessment Master: 7.3 Large Reproduction 14 Slides 7e

Meeting Individual Needs Studio Collaboration Teaching Through Inquiry More About...Carnival Assessment Options CD-ROM Connection Student Gallery Teacher's Resource Binder Check Your Work: 7.3

#### **Teaching Options**

Teaching Through Inquiry
More About...Alexander Calder
Teaching Through Inquiry
Assessment Options

#### **Technology**

CD-ROM Connection Student Gallery Computer Option

#### Resources

Teacher's Resource Binder Studio Master: 7.4 Studio Reflection: 7.4 A Closer Look: 7.4 Find Out More: 7.4 Slides 7f

#### **Teaching Options**

Community Involvement Interdisciplinary Planning

#### Technology

Internet Connection Internet Resources Video Connection CD-ROM Connection e-Gallery

#### Resources

Teacher's Resource Binder Using the Web Interview with an Artist Teacher Letter

#### **Teaching Options**

Advocacy Family Involvement

#### **Technology**

CD-ROM Connection Student Gallery

#### Resources

Teacher's Resource Binder
Chapter Review 7
Portfolio Tips
Write About Art
Understanding Your Artistic Process
Analyzing Your Studio Work

# **Chapter Overview**

#### Theme

People have long imagined impossible worlds, often prompted by their dreams and fantasies. Some artists invent magical and mysterious worlds.

#### **Featured Artists**

Giuseppe Arcimboldo Hieronymus Bosch Alexander Calder Salvador Dalí M. C. Escher Ellen Lanvon René Magritte Lillian Méndez Meret Oppenheim Roland Penrose Remedios Varo

#### **Chapter Focus**

This chapter features artists who explore their interest in fantasy by inventing optical illusions and magical worlds. Students learn about Remedios Varo, who created exquisitely rendered mysterious settings, as well as other artists fascinated by transformations and strange combinations of imagery. After learning about Surrealism and the work of contemporary artist Ellen Lanyon, students practice the use of perspective and other methods of creating the illusion of space on a two-dimensional surface. In their study of Puerto Rican art, students discover how invention and fantasy enter into Puerto Rican cultural life. Using Alexander Calder as an entry point, they create their own invented world out of wire.

# **National Standards** Chapter 7 **Content Standards**

- 1. Understand media, techniques, and processes.
- 2. Use knowledge of structures and
- 3. Choose and evaluate subject matter, symbols, and ideas.
- 4. Understand arts in relation to history and cultures.
- 5. Assess own and others' work.
- 6. Make connections between disciplines.

# Artists as Inventors

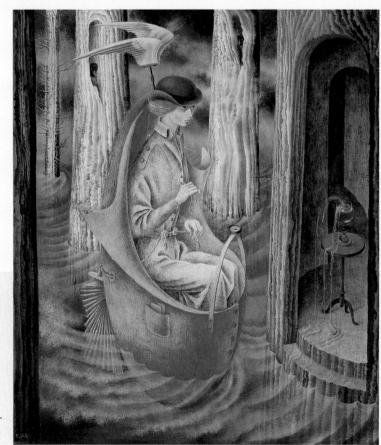

Fig. 7-1 Remedios Varo often showed imaginary journeys in her paintings. What ordinary item of clothing did she transform into a boat? Remedios Varo, Exploration of the Sources of the Orinoco River, 1959

Oil on canvas, 17 ½" x 15 ½" (44 x 39.5 cm). Private Collection. Courtesy Anna Alexandra and Walter Gruen.

# **Teaching Options**

# Teaching Through Inquiry

Aesthetics Have students work in small groups to explore the ways in which artworks include invented worlds. Have groups complete a twocolumn chart: in the first column, students brainstorm a list of words they associate with invented worlds, such as mysterious, impossible, illusion, transformation, and fantasy, in the second column, students use each word in the first column to complete the sentence "Artworks include invented worlds when . . . " Invite groups to share their findings in a full-class discussion.

#### More About...

As a young girl, Remedios Varo, who was born in 1908 in Spain, liked to copy her engineer father's mechanical drawings and site diagrams. While studying at an art academy for seven years, Varo developed her interest in Surrealism, psychology, alchemy, and astrology. When the Nazis occupied Paris, she fled to Mexico. Although her work has only recently become known in the United States, she has long been one of Mexico's best-loved artists.

#### **Focus**

- How do people use their dreams in order to imagine possible worlds?
- In what ways do artists create the worlds they dream and imagine?

Have you ever played a game in which you created imaginary worlds where things happened in strange or unusual ways? Perhaps you invented a place where weird animals or other creatures roamed the land. Or maybe you pretended to live on a faraway planet, where everything is upside-down or topsy-turvy.

Even in our own world, we may see things that seem both real and unreal. What we see as a wet and slick road may actually be dry. What we have "seen" is a mirage. Our life may sometimes seem bizarre, as if it were fantasy.

Mysterious worlds are often subjects of artworks. Artists, like most of us, are interested in what appears not to be of this world. By focusing on dreams and fantasies, artists may invent imaginative worlds for us to consider. In such artworks as *Exploration of the Sources* (Fig. 7–1), artist Remedios Varo seems to go to secret, dreamlike worlds. They are worlds where objects come alive, people become plants, and nothing is as we expect it to be. In this chapter, you will learn more about Remedios Varo and other artists who invent worlds in which what we know is transformed into what we

can only imagine.

Remedios Varo Ellen Lanyon Lillian Méndez

#### **Words to Know**

Surrealist perspective linear perspective horizon line

vanishing point

space movement rhythm

emedios Var

**Chapter Warm-up** 

Invite students to remember imaginary worlds they built in sand, with construction sets, and from found materials. Explain that artists, too, use their imagination to invent strange, new places.

## **Using the Text**

Aesthetics Discuss possible answers to the Focus questions.
Encourage students to describe dreams they have had that happened in unusual places. Ask: What subjects did Remedios Varo paint?

# **Using the Art**

Art Criticism Ask: What do you see in Exploration of the Sources of the Orinoco River? What forms the boat? (a jacket) What is the setting? What is unusual about the woman's proportions? (She is elongated.) How did Varo create a sense of depth? (by making background trees higher than foreground trees; water ripples closer together in foreground.) What is the source of the river? (glass on right) Have students finger-trace the movement through the composition.

#### **Extend**

Invite students to write an imaginary story about how the woman in Varo's painting came to be in this scene and why she is seeking the river source.

s inventors

Graphic Organizer Chapter 7

7.1 Then and Now Lesson Fantasy in Art page 232

> 7.2 Skills and Techniques Lesson Perspective page 236

Core Lesson

An Inventive Artist

Core Studio
Drawing a Fantasy World

page 230

7.3 Global
Destinations Lesson
Art of Puerto Rico
page 238

7.4 Studio Lesson
Building a Wire Sculpture
page 242

225

# **Prepare**

## **Pacing**

Three 45-minute periods: one to consider text and images; one to draw; one to add color

## **Objectives**

- · Explain why artists are sometimes considered inventors.
- · Identify methods to create the illusion of depth on a two-dimensional surface.
- · Create an invented world out of wire.

## Vocabulary

Surrealist A style of art in which dreams, fantasy, and the human mind are sources of ideas for artists. perspective A group of techniques for creating a look of depth on a twodimensional surface.

#### Teach

## Engage

Make some outrageous "What if?" statements, such as "What if this desk were a time machine?" or "What if my watch were the door to a secret world?" Encourage students to make up their own "What if?" questions about objects in the room.

## **National Standards Core Lesson**

- 1b Use media/techniques/processes to communicate experiences, ideas.
- 2a Generalize about structures, functions.
- 2c Select, use structures, functions.
- 3a Integrate visual, spatial, temporal concepts with content.
- 4a Compare artworks of various eras, cultures.
- 5c Describe, compare responses to own or other artworks.

# **An Inventive Artist**

"I took advantage of all that I learned, in painting the things that interested me on my own, which could be called, together with technique, the beginning of my personality." Remedios Varo (1908-1963)

# Remedios Varo's Journey

As a child in her native Spain, Remedios Varo (1908–1963) often copied her engineer father's detailed mechanical drawings and plans. She also loved fairy tales and magic stories. These stories inspired her to add fantasy-like elements to her drawings.

Varo studied at an art academy for seven years, developing her drawing talent and studying art history. She later journeyed to Paris, where she became familiar with and

felt a connection to the Surrealists. These artists were interested in dreams and the workings of the subconscious. In the 1940s, Varo fled Paris because of World War II. She moved to Mexico, where she developed her personal artistic style and pursued her interests in magic, fantasy, and science.

Fig. 7-2 In this artwork, travelers in tiny vehicles make their way through winding waterways. What parts of the scene look invented?

Remedios Varo, Spiral Transit, 1962. Oil on masonite, 39 3/8" x 45 1/4" (100 x 115 cm). Private collection. Courtesy Anna Alexandra and Wal Gruen. Photo by Javier Hinojosa.

226

CORE LESSON

# **Teaching Options**

#### Resources

Teacher's Resource Binder Thoughts About Art: 7 Core A Closer Look: 7 Core Find Out More: 7 Core Studio Master: 7 Core Studio Reflection: 7 Core Assessment Master: 7 Core Large Reproduction 13 Overhead Transparency 14 Slides 7a, 7b

#### **Meeting Individual Needs**

Multiple Intelligences and Gifted and Talented/ Naturalistic Have students invent a "What if" question that Remedios Varo might have asked before painting one of her works. Ask students to write the question and then describe the way Varo's painting "answered" it. Have students identify what aspects of the composition appear real or possible, and where Varo created pure fantasy.

# **Paintings from Questions**

Varo was fascinated with the way things worked. Like a scientist, she focused on mechanical objects, and also insects, plants, birds, and other things in nature. She observed and made detailed drawings of

what she saw. In *Spiral Transit* (Fig. 7–2), Varo carefully painted a walled city like those of the Middle Ages. But then she used her imagination to invent a scene that looks real but could not actually exist.

To create the invented worlds of her paintings, Varo asked questions and then explored possible answers. She would ask, for example, what the moon would look like if someone could capture it and put it into a cage. With her "What if?" questions, she allowed herself to ignore science's explanations of our world. In such artworks as *Creation of the Birds* and *Mimesis* (Figs. 7–3 and 7–4), she created imaginative solutions to her questions. Her paintings provide us with invented worlds to enter and ponder.

Fig. 7–3 What question do you think Remedios Varo was trying to answer with this painting? Remedios Varo, Creation of the Birds, 1957.

Oil on masonite, 21 1/4" x 25 1/4" (54 x 64 cm). Courtesy Anna Alexandra and Walter

Fig. 7–4 Here, the artist twisted reality around. Chairs and other ordinary objects seem to come to life. Remedios Varo, *Mimesis*, 1960.

Oil on masonite, 19" x 19 1/2" (48 x 50 cm). Courtesy Anna Alexandra and Walter Gruen.

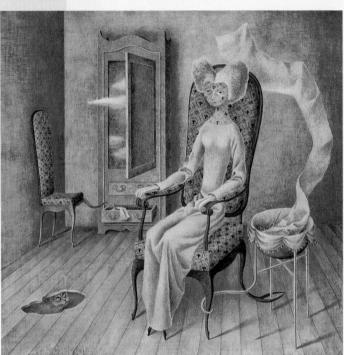

Artists as Inventors

227

**Using the Text** 

Art History Where was Remedios Varo born? (Spain) Why did she move to Mexico? (She fled WWII.) What are Surrealist artists interested in? (dreams, the subconscious) What type of training and life experiences helped Varo develop her art style? (She copied her father's mechanical drawings, loved fairy tales and magic stories, and studied art and Surrealism.) What type of question did Varo ask as she began to create a fantasy world? (What if?)

## **Using the Art**

Art Criticism Ask: What path would a boat travel to the center of the village in Spiral Transit? How did Varo indicate depth in this painting? (by making background buildings smaller and higher, with fewer details) How is Mimesis both real and unreal? What is happening to the woman? How did Varo create an illusion of depth? Point out that the lines on the floor are smaller in the distance and would meet at a point if they were extended back.

#### **Critical Thinking**

Ask: How would you describe Remedios Varo's art style? What similarities do you see in the subjects, themes, colors, and depth of her paintings in this lesson?

#### Teaching Through Inquiry

Art Criticism Have students work in small groups to compare and contrast the subjects and the way they are depicted in the three images on pages 226 and 227. For each artwork, have students record their answers to the questions "What looks real?" and "What looks unreal?"

#### **CD-ROM Connection**

For more images relating to this theme, see the Personal Journey CD-ROM.

#### **Artists as Inventors**

## **Using the Text**

Art History Ask: What kinds of subjects did Hieronymus Bosch paint? (fantasy creatures in imaginative worlds, people transformed into creatures, objects with human qualities) Which sixteenth-century artist combined fruits and vegetables to create portraits? (Giuseppe Arcimboldo) What is perspective? (a technique for creating an illusion of depth on a two-dimensional surface) How did M. C. Escher make unreal scenes look real? (by using several vanishing points within an artwork)

## **Using the Art**

Art Criticism Ask: How would you describe the warriors and their transportation in *The Temptation of St. Anthony*? What else do you see in this painting? How is Bosch's painting similar to Varo's artworks?

Art Criticism Ask students to identify the fruits and vegetables, and to describe the textures in *Vertumnus*.

Ask: Where did Arcimboldo contrast texture and colors? How was

Arcimboldo like a Surrealist artist?

Art Criticism From where would a viewer of Another World be able to see each bird? Have students contrast Bosch's and Escher's methods of creating depth.

# Art from the Imagination

Remedios Varo was not the first to explore "What if?" questions. Centuries before science would explain much of our universe, people used their imagination to explain what they could not understand. They wondered about the origin of fire or how the sun "moved" across the sky. As they wondered, they asked questions to help them find solutions to the puzzles. They asked "What if all the fire in the world came from a fire-breathing dragon?" or "What if a chariot pulled by a team of horses moved

the sun across the sky?" Their artworks showed what they imagined when they asked these questions.

Even after many puzzles in the world were explained by science, some artists continued to invent fantasy creatures in imaginative worlds. These worlds were often based upon dreams. Such artists as Hieronymus Bosch (Fig. 7–5), who lived in the second half of the 1400s, transformed people into creatures and gave humanlike qualities to objects.

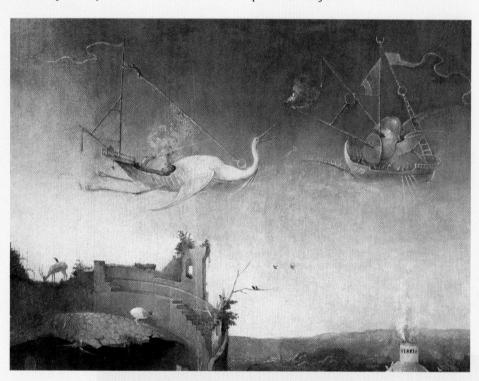

Fig. 7–5 Look closely at this image, a detail of a much larger painting. Note how the artist invented travel machines that could exist only in dreams or nightmares. How are these fantasy vehicles like those invented by Remedios Varo? Hieronymus Bosch, *The Temptation of St. Anthony* (detail), c. 1500. Oil on panel, central panel: 51 3/4\* x 47\* (131.5 x 119 cm). Museu Nacional de Arte Antiga, Lisbon, Portugal. Nicolas Sapieha/Art Resource, New York.

228

# **Teaching Options**

#### **Teaching Through Inquiry**

Art History Ask students to consider which artist—Bosch, Arcimboldo, or Escher—they would choose if they could interview him. Have students work in groups to compile questions they would like to have "answered." Direct groups to use library and Internet resources to find plausible answers, and then to present a panel interview (with one group member as the artist, and the other members as the panelists, who ask the questions) to the rest of the class.

#### More About...

Giuseppe Arcimboldo (1530–93), a Mannerist artist from Milan, worked with his father on the Milan cathedral's stained-glass windows before becoming a court painter in Prague. He is best remembered for his fantastic Mannerist human faces made from books, fruit, flowers, and fish. Some of these were allegories, whereas others, such as a librarian portrait made of books, are personifications.

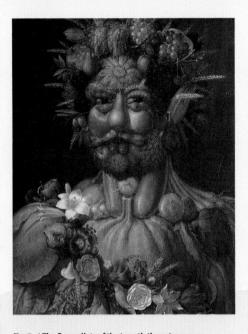

Fig. 7-6 The Surrealists of the twentieth century were fascinated with earlier imaginative paintings. What things from nature can you find here? Giuseppe Arcimboldo,

**Vertumnus**, c. 1590. Oil on wood,  $27^3/4^* \times 22^{-1/2^*}$  (70.5 x 57.5 cm). Slott, Skokloster, Sweden. Erich Lessing/Art Resource, New York.

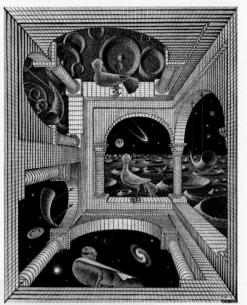

Fig. 7–7 How did this artist use perspective to create an optical illusion?
M. C. Escher, Another World II, 1947.
Wood engraving printed from three blocks, 12 ½ x 101¼ "31.5 x 26 cm). © Ordon Art B.V.-Baam-Holland. All rights reserved.

# **Artistic Tricks**

Some artists seem to love to fool us with optical tricks. In the mid-1500s, artist Giuseppe Arcimboldo invented a unique approach to fool the eye. The painting *Vertumnus* (Fig. 7–6) shows the technique he developed. Arcimboldo created fantasy portraits by combining images of different fruits, vegetables, and other natural objects.

Artists also may use mathematical and scientific approaches to make their unreal

worlds appear real. They create optical tricks through the use of **perspective**, a technique for creating the illusion of depth on a two-dimensional surface. Artist M. C. Escher, for example, distorted perspective and worked with several vanishing points in order to make impossible scenes look real. In his artwork *Another World II* (Fig. 7–7), how many different ways to look into space did the artist create?

Artists as Inventors

229

#### **Extend**

Ask students to create a self-portrait collage in the style of Arcimboldo. Have students each use magazine photographs of objects that have meaning to them: sports enthusiasts may wish to use photos from sports magazines; fashion enthusiasts, fashion magazines; and artists, artsupply catalogs.

#### **Using the Large Reproduction**

#### Talk It Over

**Describe** List what you see that you could find in the real world. List what you would probably never see in the real world.

**Analyze** How did the artist use the elements of art to attract and hold the viewer's attention? What is the center of interest?

**Interpret** How is this artwork an example of an invented world?

**Judge** For what purpose would this artwork be appropriate?

## **Using the Overhead**

#### Think It Through

**Ideas** From where, do you think, did the artist get the idea for this artwork?

**Materials** What materials did the artist use to create this artwork?

**Techniques** Describe the process that you think the artist

used to create this painting.

**Audience** Describe an audience that would probably enjoy this artwork. Tell why you think this.

13

#### **Artists as Inventors**

# **Supplies**

- · drawing paper
- · pencil and eraser
- ruler
- · colored pencils

# **Using the Text**

Art Production Have students read the introductory paragraphs, and tell them that they will be drawing a fantasy scene with a sense of depth or space. After students have read Studio Background, discuss different ways to indicate depth. Encourage students to ask "What if?" questions to begin planning their drawing.

As you go over the steps in Try This, demonstrate how to lightly sketch in a background that suggests space, and then add objects. Encourage students to create movement through their picture, perhaps by leading the viewer's eye along a road or by repeating objects and colors.

## **Using the Art**

Art Criticism Ask: What do you see in Salvador Dalí's *Mae West*? How did Dalí show perspective? Notice the difference in width between a floor square in the foreground and one in the background. Ask: Which is larger? Where would the lines of the floor tiles converge?

#### Extend

Encourage students each to draw a scene that they see every day, such as a view on their way to school or from a window in their home. Ask students how they could change the view or what could they add to transform it into a fantasy.

#### Drawing in the Studio

# **Drawing a Fantasy World**

CORE STUDIO

You have seen how Remedios Varo and other artists use their imagination to create invented worlds. Now it's your turn to create a fantasy

world, where unexpected things occur.

In this studio experience, you will use colored pencils to create an invented scene from a world where fantasy is combined with reality. As you make your detailed drawing, ask some "What if?" questions: What if people looked like plants? What if birds grew from seeds? Think of ways to draw and arrange lines and shapes to create rhythm and movement. Consider how you could use perspective to create the illusion of both deep and crowded spaces in your scene.

#### You Will Need

- · drawing paper
  - pencil
- eraser
- colored pencils or markers

ruler

#### **Try This**

1. Before you begin drawing, make some decisions about how you will create the illusion of deep space in your scene: will you use linear

perspective, placement, overlap, size, and/or color? How will you combine methods of perspective to get the look of space you want? If you use linear perspective, lightly draw your guides with a pencil and ruler (see page 236).

Fig. 7–8 **Salvador Dalí was a Surrealist. How did he use perspective to create the illusion of depth?** Salvador Dalí, *Mae West*, c. 1934.

Gouache, with graphite, on commercially printed magazine page, 11" x 7" (28.3 x 17.8 cm). Gift of Mrs. Gilbert W. Chapman, 1949-517. Photograph © 2001, The Art Institute of Chicago, All Rights Reserved. © 2001 Kingdom of Spain, Gala-Salvador Dalf Foundation Artists Rights Society (ARS), New York.

# **Studio Background**

#### Creating the Illusion of Depth

Renaissance artists discovered that parallel lines seem to recede, or move back in space, to a vanishing point. An artist's use of lines to create depth is called linear perspective. (To learn more about linear perspective, see Lesson 7.2, pages 236 and 237.)

Artists may use techniques other than perspective to create the illusion of depth. They may place shapes high on a paper or canvas so that they appear to be far away. Artists may also overlap shapes. By doing so, the topmost shape will appear to be in front of other shapes. The drawing of similar shapes in different sizes is another way that artists create depth. The smaller shapes will seem farther away than the larger ones. Artists also use color and value to give the illusion of depth. Bright colors appear to move forward; light shades and dull colors appear to recede.

230

# **Teaching Options**

# **Teaching Through Inquiry**

Art Production Show students Overhead Transparency 14 (Beverly Doolittle, *Pintos*). Point out that Doolittle's camouflage painting is based on the similarity of the pintos' patterns and colors with those in their environment. Have students select an animal and use colored pencils to draw and camouflage it in a similarly patterned and/or colored environment. Tell students that the environment may be real or imaginary.

2. Sketch the main features of your scene. What buildings, objects, and life forms will vou include? Which elements will be from the real world?

Which will be from an invented world? Think of ways to draw and arrange lines and shapes to create rhythm and movement. Will your shapes swirl or float in rhythmic patterns? Will they collide and create jerky or jagged patterns?

3. Fill in color and add details with colored pencil. Remember that shapes in the distance have less detail than those close up. How could you use value, or light and dark colors, to add to the illusion of depth?

Fig. 7–9 How did the artist create a sense of deep space in this artwork? Anthony Smith, Atlantis, 2000.
Colored pencil, 12" x 18" (30.5 x 46 cm). Laurel Central Middle Scho

#### Check Your Work

Pair up with a classmate to talk about your completed drawings. Which "What if?" question did each of you explore? What parts of your drawing show things from the real world? What parts are from a fantasy world? How did you create the illusion of space? Where did you create rhythm and movement?

#### Lesson Review

#### **Check Your Understanding**

- 1. What purpose did Remedios Varo's "What if?" questions serve?
- 2. Why do we sometimes think of artists as inventors?
- 3. Explain two ways to create the illusion of depth in a drawing or painting.
- 4. Why are some people curious about their

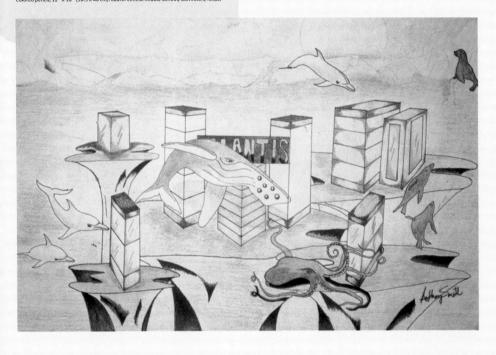

Artists as inventors

231

#### Assess

#### **Check Your Work**

Ask students to write their answers to the questions and to identify the best features in a partner's drawing. Have students title their art and write a descriptive label for it.

#### **Check Your Understanding: Answers**

- 1. Remedios Varo used "What if?" questions as a way of finding ideas for the subject matter in her artworks.
- 2. Artists are sometimes thought of as inventors because they imagine and then show new kinds of worlds.
- 3. Answers may include use of perspective, placement of shapes high on the page, overlapping, making similar shapes in different sizes, and use of differences in color and value.
- 4. Answers will vary.

# Close

Display students' artworks and labels. Have students describe the fantasy and some of the best features in their partner's drawing. Discuss students' answers to Check Your Understanding.

#### More About...

Salvador Dalí (1904-89) was a Spanish painter who studied art in Madrid before visiting Paris. Although he became associated with the Surrealist artists, he invented his own form of Surrealism. Dalí included his own paranoia and delusions in his artworks. Although his style was precisely realistic, his subjects were dreams and nightmares that often featured his homeland's Catalonian landscape and his wife, Gala.

#### **Assessment Options**

Self Have students each create a written essay or a visual one (such as a series of cartoons) in which they consider their own involvement with art-making so as to tell why they do or do not regard themselves as an inventor. Ask students to reflect upon the content and examples in 7 Core Lesson, and to pay particular attention to the different reasons we sometimes think of artists as inventors. Suggest to students that they store their completed work in their portfolio.

# **Prepare**

# **Pacing**

Three or more 45-minute periods: one to consider text and images; one to paint; one or more to cut and paste

# **Objectives**

- Recognize characteristics of Surrealist art.
- Justify the interpretation of Ellen Lanyon's work as inventive and surreal.
- Use perspective and a combination of media to create a fantasy environment for ordinary objects.

## **Using the Time Line**

During the 1930s, as the world moved towards war, artists and scientists dreamed of other, better worlds. By 1952, World War II had ended; within the decade, the United States and the Soviet Union began to explore space. As men stepped onto the moon in 1969, the world saw a whole new landscape. Encourage students to imagine their future world.

## National Standards 7.1 Then and Now Lesson

- **1a** Select/analyze media, techniques, processes, reflect.
- **2b** Employ/analyze effectiveness of organizational structures.
- **3b** Use subjects, themes, symbols that communicate meaning.
- **4b** Place objects in historical, cultural contexts.
- **5b** Analyze contemporary, historical meaning through inquiry.

# Fantasy in Art

**1936** Oppenheim, *Lunch in Fur* 

1958 Magritte, Listenina Room **1975** Lanyon, *The Disguise* 

**20th Century** 

Late 20th Century

1938

THEN AND NOW LESSON

Penrose, Winged Domino 1970 Lanyon,

Lanyon, Chemistry Versus Magic 1999 Lanyon, Dominoes and Dragons

#### **Travels in Time**

The invention of stories and special creatures has always been important to people. These inventions often help people to "explain the unexplained." Throughout history, artists have depicted invented scenes in different ways. In the Middle Ages, for instance, European artists

carved grotesque creatures in stone and painted pictures of dragons, even though these creatures did not exist. In the twentieth century, artists made things seem unreal by putting real things in invented, dreamlike settings.

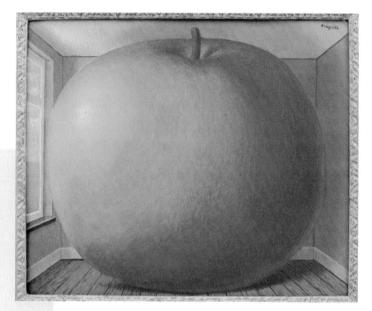

Fig. 7–10 By changing the usual scale of the object in relation to its setting, the artist invented a dreamlike space. Do you get the feeling that something is about to happen? René Magritte, *The Listening* 

Room, c. 1958. Oil on canvas, 15" x 18" (38 x 46 cm). Kunsthaus, Zurich, donated by Walter Haefner, Photo AKG London. © 2001 C. Herscovici, Brussels/Artists Rights Society (ARS), New York.

232

# **Teaching Options**

#### Resources

Teacher's Resource Binder Names to Know: 7.1

A Closer Look: 7.1

Find Out More: 7.1

Check Your Work: 7.1

Assessment Master: 7.1

Overhead Transparency 13

Slides 7c

#### **Teaching Through Inquiry**

**Art History** Ask students to select a Surrealist artist they would like to know more about. Provide guidelines for preparing a biography of the artist, and have students research and write a one-page report on the subject's personal journey as an artist.

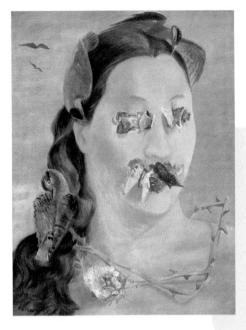

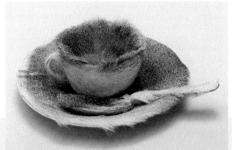

Fig. 7–11 Can you imagine trying to drink from this cup? Why does this cup seem to be something from a dream? Meret Oppenheim, Object (Lunch in Fur), 1936. Fur-covered cup, saucer, spoon; cup, diameter:  $49^{\rm th}$  (11 cm); saucer, diameter:  $93/8^{\rm th}$  (23.7 cm); spoon, length:  $8^{\rm th}$  (20.2 cm). The Museum of Modern Art, New York, Purchase, Photograph @2001 The Museum of Modern Art, New York, © 2001 Artists Rights Society (ARS), New York/ProLitteris, Zürich.

Fig. 7–12 The title of this portrait is *Winged Domino*. A *domino* is a type of mask. Do you see a mask in this work? Roland Penrose, *Winged Domino*—A *Portrait of Valentine*, 1938.

# More Real than Life

Surrealist artworks are based on the idea that dreams and fantasies often seem "more real" than real life. Surrealist artists in the first half of the twentieth century were interested in shocking their viewers. The Surrealists would mix up everyday objects with invented settings. Some artists carefully arranged their odd combinations. Others allowed chance or coincidence to create such surprises.

# **Visual Tricks**

The paintings of René Magritte are like dreams. In such artworks as *The Listening Room* (Fig. 7–10), he made familiar objects seem strange. The objects look real, but what the viewer sees could not possibly be. To play such visual tricks on viewers, Magritte placed objects in invented places or depicted objects in unreal sizes.

Surrealist Roland Penrose also seemed to play tricks on viewers. In a portrait of his wife (Fig. 7–12), he showed her covered with butterflies and birds. He covered normally recognizable features—eyes and lips—with winged creatures.

Other Surrealist artists were inspired to invent new methods by combining materials in unusual ways. For instance, for her artwork shown in Fig. 7–11, artist Meret Oppenheim covered a cup, saucer, and spoon with fur!

# Teach

# Engage

Place a miniature replica with an everyday object (for example, an apple placed in a dollhouse). **Ask:** If you could see only these objects, how would you know which was normal-sized? Explain that artists sometimes combine objects in ways that we do not expect, and that changing an object's scale is one way to create surprise in an artwork.

# **Using the Text**

**Art History Ask:** How did Surrealist artists shock their viewers?

## **Using the Art**

Art Criticism Ask: What surprises you in Magritte's *The Listening Room*? Is the room small, or is the apple large? What mood is suggested in Penrose's *Winged Domino*? How does it make you feel?

Artists as Inventors

233

#### More About...

The **Surrealist art movement**, which developed from the meaninglessness of Dada art, saw young European artists express their disillusionment with life following World War I.

Surrealist artists and writers, who derived many of their theories from those of Freud, were interested in unlocking their unconscious through their dreams and chance. During the 1920s and 1930s, Max Ernst, Giorgio de Chirico, Joan Miró, René Magritte, Man Ray, and Meret Oppenheim were some of the leading European Surrealist artists.

#### More About...

After studying at the Brussels Academy of Fine Arts, Belgian painter **René Magritte** (1898–1967) designed wallpaper, posters, and advertisements. In 1927, he moved to Paris, where he became part of the Surrealist art movement. In his paintings, Magritte changed the scale of everyday objects and caused viewers to question assumptions about the world.

#### **Using the Overhead**

#### **Investigating the Past**

**Describe** What do you see in this picture? **Attribute** When, where, and by whom was this work created?

**Interpret** Do the things in this picture seem real? What do you think this is about?

**Explain** What earlier artworks are similar to this one? Why do you think so?

13

# **Fantasy in Art**

# **Using the Text**

Art History/Art Production Ask:
What childhood memory influenced
Ellen Lanyon's art? (visiting a miniature village at the 1934 Chicago
World's Fair) Why does Lanyon
collect postcards and souvenirs?
(for ideas for her paintings)

# **Using the Art**

Art Criticism Ask: Where are the dominoes and the dragons in Dominoes and Dragons? What different shapes and colors are repeated in Lanyon's three paintings. What animals can you identify in The Disguise? How is this painting both real and unreal?

#### **Studio Connection**

Discuss the ways in which putting different objects together can suggest new

meanings for the objects. Then have students cut out magazine photographs of several objects that would not normally be found together. Encourage students to consider how much depth they want in the background, and have them draw or paint the background on heavy paper. Have students glue their objects on the background. After students have completed their collage, ask them to write a paragraph to explain its meaning.

Assess See Teacher's Resource Binder: Check Your Work 7.1.

#### Extend

Have students each create a sculpture by combining found objects, so as to add new meaning to the objects. Have students arrange and glue their composition in a box, and then perhaps add paint to their sculpture.

#### **Inventing Illusions**

NOW LESSON

AND

2 W "I wanted to make magic on a two-dimensional surface." Ellen Lanyon (born 1926)

When she was eight, Ellen Lanyon went to the 1934 Chicago World's Fair, where she played in a miniature village that her grandfather had built. She remembers the village as a storybook setting—so very real, yet so very magical. Her memories of that childhood experience influence her work today.

Lanyon taught herself to draw by working from photographs. As a teen, she worked part-time in a company's drafting department, enlarging designs for machine parts. These early experiences helped her to be inventive as a mature artist.

Photo courtesy the artis

# **Fantasy Inventions**

As part of her artistic process, Lanyon is always on the lookout for postcards and souvenirs. She often copies parts of postcard scenes and puts them into her own paintings. She also draws from a huge collection of found objects, carefully observing their details.

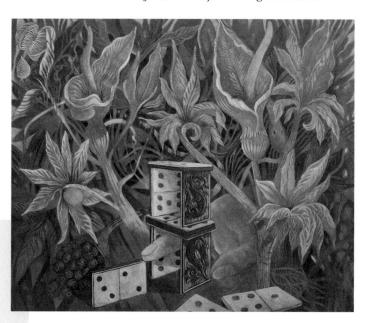

Fig. 7–13 What did the artist do to make the space seem crowded? Ellen Lanyon, Dragons and Dominoes, 1999.
Acrylic on canvas, 45\* x52\* (114 x 132 cm). Courtesy of the artist and Jean Albano Gallery, Chicago, Illinois.

234

# **Teaching Options**

#### **Meeting Individual Needs**

#### Multiple Intelligences/Musical

Have students select an image in this lesson and develop a song that conveys something about the artwork and its mood. Ask student pairs to share their songs, and have each listener, in turn, try to determine which painting was the inspiration, offering support with elements in both the song and the image.

#### **Teaching Through Inquiry**

Art Production Challenge students to work in the tradition of the Surrealists and put together two or more objects that are not usually thought of as belonging together. Suggest they explore collage techniques. Begin by carefully cutting out a wide range of objects and scenes from magazines. Be playful, always asking, "What would happen if...?" or "What if...?" Consider trying to connect the same images in a humorous way and then in a nightmarish or scary way. Have students comment on the way small changes can make big differences in the meaning of things.

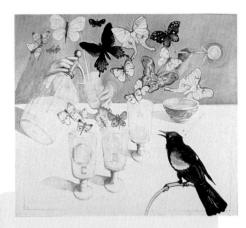

Fig. 7-14 Compare this work to Creation of the Birds on page 227. How are the two works alike? How are they different? Ellen Lanyon, Chemistry Versus Magic, 1970.
Acrylic on canvas, 60° x 60° (152 x 152 cm). The Letitia and Richard Kruger Collectic

Although her drawings and paintings are realistic, Lanyon often combines images of animals, plants, and found objects into fantasy inventions. Many of her artworks show objects used by people interacting with nature. In such paintings as Dragons and Dominoes and Chemistry Versus Magic (Figs. 7–13 and 7–14), Lanyon seems to want us to think about our relationship to the natural world.

Lanyon also likes to show transformations in her artworks. By transforming, or changing, things, she created an illusionthings look real, yet they are not real.

#### **Studio Connection**

Use crayons, pastels, watercolors, markers, and collage materials to invent a fantasy environment filled with

ordinary objects. You may use crayon resist to create a background for cutouts of your objects. Give them meaning by combining several things that are not always thought of as belonging together. Be playful in the arrangement of your selected objects.

Fig. 7–15 How would the effect of this picture be different had the artist not overlapped the shapes, but had left more open space between them? Ellen Lanvon, The Disquise, 1975.

#### **Lesson Review**

#### Check Your Understanding

- 1. Explain how some artists seem like inventors
- 2. Give some examples of what Surrealist artists have done
- 3. How are Ellen Lanyon's depictions both real and unreal?
- 4. What are some things you could do as an artist to create a fantasy environment?

Artists as Inventors

235

#### Assess

#### **Check Your Understanding:** Answers

- 1. have a belief in and a desire to create illusions and to make unreal things seem real
- 2. Surrealist artists have put everyday objects in unusual settings, and have allowed chance and coincidence to cause surprise.
- 3. Lanyon renders objects in accurate detail, but she combines them in unreal situations.
- 4. Answers will vary but may include being playful, putting together things that usually don't go together, and distorting the size and placement of objects.

# Close

Discuss students' answers to Check Your Understanding, Display the collages, and encourage students to explain how they suggested new meanings for objects, how they created an illusion of depth, and why their collage is surreal.

#### More About...

Ellen Lanyon creates fantastic and realistic images that question nature's mysteries and how humans affect natural habitats. Since a 1970s visit to Florida's Everglades, she has created artworks that advocate ecological balance. Lanyon has an extensive collection of everyday objects and taxidermy specimens that she depicts in her artworks, along with birds and fish in their natural environments.

#### **Assessment Options**

Teacher Review the characteristics of Surrealist art. Show students an assortment of ten artworks, four of which are obviously Surrealist. Ask students to identify the Surrealist works and to explain what makes them so.

Peer Ask students to discuss the inventive and surreal qualities of Ellen Lanyon's work. Guide students to keep Lanyon's style in mind and try to achieve similar qualities in this exercise. Have students each create a one-minute tracing of a pair of scissors in any position they wish. Have student pairs exchange drawings and work for one minute to add something to their partner's drawing. Encourage partners not only to be responsive to each other's initiatives, but also to push each other in slightly new directions. Have students continue the exchange at least ten times. Allow another period for students to complete the drawing that they started. Have students each comment on the degree to which their partner pushed them to create more inventive and surreal qualities.

# **Prepare**

## **Pacing**

Two or more 45-minute periods: one to consider images and text and to practice drawing; one or more to create a perspective drawing

#### **Objectives**

- Understand the difference between one- and two-point perspective.
- · Practice perspective drawing.

## Vocabulary

linear perspective A technique that uses guidelines to create the illusion of three-dimensional space on a two-dimensional surface.

horizon line The line where water or land seems to end and the sky begins. vanishing point The point on the horizon line where the edges, lines, or shapes appear to meet in the distance.

# **Teach**

# Engage

Have the class view real-life linear perspective, such as a view down a street or long corridor. Hold acetate, Lucite, or glass in front of the scene, and use a marker to trace the perspective lines of what you see. Help students identify lines that recede to the vanishing point.

# **Using the Text**

Art Production Demonstrate drawing a box in one-point perspective. Allow students to practice drawing boxes on, above, and below the horizon line. Next, demonstrate drawing a box in two-point perspective, and have students draw several boxes in two-point perspective.

#### National Standards 7.2 Skills and Techniques Lesson

**1b** Use media/techniques/processes to communicate experiences, ideas.

**2b** Employ/analyze effectiveness of organizational structures.

# Perspective

LESSON

AND TECHNIQUES

SKILLS

**Linear perspective** is a system of using lines to create the illusion of three-dimensional space. Artists use this system to create a sense of depth in a painting or drawing.

Look at the one-point perspective diagram. The **horizon line** represents the eye level of a viewer and is usually located where the earth appears to meet the sky. The **vanishing point** is the place where parallel lines seem to meet in the distance. Notice that the vanishing point is located on the horizon line.

Now look at the two-point perspective diagram. Artists use this system of linear perspective when they view an object or building from an angle or corner. Notice that in two-point perspective there are two vanishing points on the horizon line.

# Practice One-Point Perspective

Refer to the one-point perspective diagram for help in setting up your drawing. Use a yardstick to lightly draw a straight line across a sheet of paper. This represents the horizon line. Add a vanishing point at or near the center of the horizon line. Next,

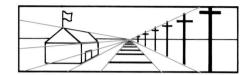

draw a row of buildings, houses, or other boxlike objects that seem to recede—go back into space and get smaller—as they approach the vanishing point. Be sure that all vertical lines remain parallel to the side of the paper. All horizontal lines should remain parallel to the top and bottom of the paper. You may wish to add diagonal guides for lines that recede to the vanishing point.

Fig. 7–16 Notice the feeling of deep space that is created by the use of one-point perspective. Where do you think the vanishing point is located? Steven Hudson, The Final Frontier, 2001. Colored pencil on paper, 9" x 12" (23 x 30.5 cm). Samford Middle School, Alburn, Albabam.

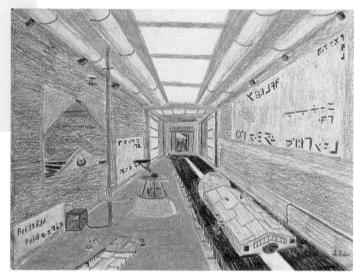

236

# **Teaching Options**

#### Resources

Teacher's Resource Binder Finder Cards: 7.2 A Closer Look: 7.2 Find Out More: 7.2 Check Your Work: 7.2 Assessment Master: 7.2 Overhead Transparency 14 Slides 7d

#### **Teaching Through Inquiry**

Art Criticism Have students work in small groups. Provide each group with photocopies of two illustrated pages from In the Night Kitchen by Maurice Sendak, Jumanji by Chris Van Allsburg, or another children's book in which the author-illustrator invented a world and created the illusion of depth. Have students compare and contrast the two images by noting how the artist used linear perspective and other methods to create the illusion of depth. Have groups share their findings in a full-class discussion about the contribution of the illusion of depth to the meaning and impact of the book illustrations.

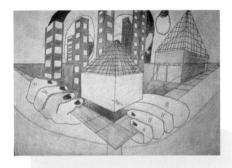

Fig. 7–17 This artist has used two-point perspective to create this drawing. What other methods of creating space did he use? Elmo Peterson, *Two-Point Perspective*, 2000. Colored pencil on paper, 12" x 18" (30.5 x 46 cm). Central Middle School, Galveston, Evas.

# Practice Two-Point Perspective

Study the two-point perspective diagram for help in setting up your drawing. Use a yardstick to lightly draw a horizon line across a sheet of paper. Add two vanishing points to the horizon line. These should each be about the same distance from the left and right edges of the paper. If the vanishing points have to be placed off the edges of the paper, you can tape your

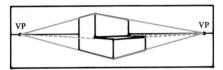

drawing onto a larger sheet. Then extend the horizon line onto the larger sheet and locate the vanishing points.

Next, draw a single building, house, or other boxlike object at the center of the paper. As in one-point perspective, lines above the horizon line slant downward, and lines below the horizon line slant upward. Your subject should be turned so that one corner is closer to the viewer.

# Other ways to create the illusion of three-dimensional space include

**3.** placement—objects near the top seem more

1. overlapping

seem more distant

5. color and value—

5. color and value light values and cool, dull colors suggest distance

**6.** focus—sharp detail suggests nearness

Artists have found inventive ways to combine these methods with one- and two-point perspective.

#### **Studio Connection**

Use a yardstick to help you create a perspective drawing, such as a street scene, a cityscape, or a still life that

includes boxlike forms (such as milk cartons, blocks, wrapped gifts, or books). You also could choose to draw an imaginary collection of boxes of different sizes as though they were flying in the air, all above the horizon line. Use one-point or two-point perspective as necessary to create the illusion of depth in your drawing. Include other ways of creating the illusion of three-dimensional space where needed.

#### Lesson Review

#### **Check Your Understanding**

1. In your own words, explain the differences between one-point and two-point perspective.2. Why is a yardstick—rather than a ruler—helpful in making a perspective drawing?

Artists as Inventors

237

# **Using the Art**

Art Production Discuss ways other than one- and two-point perspective to create the illusion of three-dimensional space. Ask: How do artists create the look of three-dimensional space? Which methods have you used in your own art? How did the students artists create an illusion of depth?

#### **Studio Connection**

Have students draw a perspective scene that they see every day, such as the

corner of a room, a building, or a street scene.

**Assess** See Teacher's Resource Binder: Check Your Work 7.2.

## Assess

#### Check Your Understanding: Answers

- 1. One-point perspective shows a view leading to one vanishing point; two-point perspective shows an object or scene from a corner or angle, and leads to two vanishing points.
- 2. A yardstick allows for a single, continuous straight line when the two vanishing points are far apart and/or off the page.

# Close

Display students' artworks, and have them explain how they showed depth in their drawing.

#### More About...

Because traditional Western representational paintings use perspective, space seems "real." However, artworks may convey a sense of depth by other means. Paths that wander through Chinese landscape paintings take the viewer from what is perceived to be near to far. In Persian miniatures, "stacked" figures indicate depth: the higher up the image appears in the composition, the deeper it is perceived to move into space. Some Western artworks, including many by Pablo Picasso and David Hockney, seem to have "shattered" the picture plane, and show the rearranged shards in a new and intriguing composition.

#### **Using the Overhead**

#### Write About It

**Describe** Describe the subject matter in this painting.

**Analyze** Explain how the artist created the illusion of three-dimensional space, or

depth, on the twodimensional surface.

## Assessment Options

**Peer** Have students work in groups to create a poster-

board display—for students in grades 3 through 5 to use in creating their own artworks—of ways to create spatial illusion. Have group members make sketches and then select examples that best demonstrate the methods of perspective.

# **Prepare**

## **Pacing**

One or more 45-minute periods, depending on the complexity of the mask

## **Objectives**

- Give examples of traditional Puerto Rican art forms.
- Identify materials and techniques used by maskmakers in Puerto Rico.
- Use paper-sculpture techniques to create rhythm and movement in a mask.

## Vocabulary

santos Carved, religious figures, usually made using clay, stone, or wood.

# Supplies for Engage

• travel video of the Caribbean

# **Using the Map**

Ask: What countries are close to Puerto Rico? What U.S. state is closest to it? (Florida) What, do you think, is the climate in Puerto Rico? (tropical) What is the capital of Puerto Rico? (San Juan) Tell students that Puerto Rico is mountainous and is only 100 miles wide and 35 miles long.

## National Standards 7.3 Global Destinations Lesson

- **1b** Use media/techniques/processes to communicate experiences, ideas.
- **3b** Use subjects, themes, symbols that communicate meaning.
- **4c** Analyze, demonstrate how time and place influence visual characteristics.

# **Art of Puerto Rico**

#### **Puerto Rico**

LESSON

GLOBAL DESTINATIONS

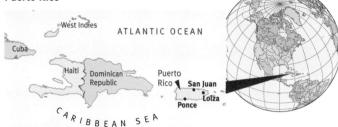

#### **Places in Time**

Puerto Rico—a beautiful, fertile island about a thousand miles southeast of Florida—has a diverse history. Its first inhabitants were the South American Arawak Indians. In the sixteenth century, Spanish colonists established large plantations. They brought Africans to the island to work in the fields and gold mines. In 1898, Puerto Rico became a commonwealth of the United States. Because of their rich heritage, Puerto Ricans celebrate many holidays and festive occasions.

# 500

# **Fantasy in Art**

Since the seventeenth century, Puerto Ricans have used colorful masks in their celebrations. The masks add a fantasy-like element to the festivals and parades.

Maskmakers use the traditional materials of papier-mâché and coconut shells to form the masks. Maskmakers in the town of Ponce typically produce masks with long, pointed teeth and tall horns (Fig. 7–18). The masks made in Loiza, however, usually have square mouths, triangular noses, and round eyes. Masks from both areas are colorful and have repeated elements that create visual rhythm and movement.

The addition of costumes to a Puerto Rican celebration is another element of fantasy in the festive events. Costumes (Fig. 7–19) play an important role in carnival, celebrated in February and July. Both masks and costumes help create a feeling of an unreal, dreamlike world.

Fig. 7–18 This mask is made from the traditional material of papier-mâché. It is decorated with the bright colors and patterns that are typical of masks from the town of Ponce. Puerto Rico, Ponce Mask, 21st century. Courtesy the Smithsonian Institution, National Museum of American History, Teodoro Vidal Collection.

238

# **Teaching Options**

#### Resources

Teacher's Resource Binder
A Closer Look: 7.3
Find Out More: 7.3
Check Your Work: 7.3
Assessment Master: 7.3
Large Reproduction 14
Slides 7e

#### **Teaching Through Inquiry**

Art Production Help students plan a papier-mâché mask that they could make at home. Ask students to identify the materials they would need, research papier-mâché techniques, select one technique, and write in their own words the step-by-step procedure they would follow. Have student pairs critique each other's plans. Ask students to make several sketches for masks of fantasy characters, and guide students to combine features with decorative elements to create rhythmic patterns. (The actual making of the mask is optional.)

Fig. 7–19 **Why do people wear costumes during celebrations?** Puerto Rico, *Vejigante Celebrant in a Loiza-style Costume and Mask*, 21st century.

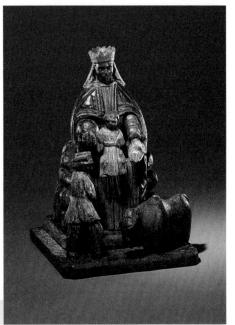

Fig. 7–20 Carved wooden images such as this are often placed in boxes called niches. Puerto Rico, Santos Figure: Virgen de Hormigueros, c. 19th century. Carved wood. Smithsonian Institution, National Museum of American History, Teodoro Vidal

# **Creative Traditions**

Art-making in Puerto Rico has long been a product of the island's racial, ethnic, and cultural mix. This mix has produced a variety of artworks. The elaborate carnival masks and costumes on these pages are examples of fantasy artworks. Artists also create practical artworks, such as musical instruments and delicate lace.

In addition to these artistic expressions, many artists produce spiritual artworks. Since the 1500s, artists have carved religious

figures called **santos** (Fig. 7–20). The artists who make such figures are called *santeros*. Because they do not usually have pictures of the saints, who lived long ago, the santeros have invented ways to represent them. They often use symbols to stand for saints and other holy figures from the Catholic religion. The santos have deep religious meaning and are popular in many Puerto Rican homes.

Artists as Inventors

239

# Teach

#### Engage

Invite students who know about or who have visited Puerto Rico to describe the country. Show the travel video.

Ask students to describe masks and costumes that they have worn. Discuss why they wore them, and ask if any were part of cultural celebrations.

## **Using the Text**

Art History Ask: What traditional materials do Puerto Rican maskmakers use? (papier-mâché and coconut shells) When do Puerto Ricans wear masks and costumes? (during carnival, in February and July) What are santos? (religious figures)

# Using the Art

Art Criticism Challenge students to identify each mask's features to determine where it was made. Ponce masks have long, pointed teeth and tall horns. Loiza masks feature square mouths, triangular noses, and round eyes. Ask: Which art elements are most important in the masks? Have students describe the figures in the santos.

#### More About...

Puerto Rican **santos**, anywhere from 8" to 20" tall, stand guard in homes and towns. Although Spanish colonizers brought the sculpture tradition with them in the 1500s, the original Taíno people had long carved small spiritual figures called *cemi*. Both the early, elaborate santos and the simpler ones of later times typically include items that identify the figure, such as St. Anthony with the infant Jesus and a book. Today, skilled Puerto Rican men and women keep this spiritual sculptural tradition very much alive.

#### **Using the Large Reproduction**

#### **Consider Context**

**Describe** How are the lines, shapes, and colors arranged? What mood or feeling is conveyed by this mask?

**Attribute** What about this mask suggests where it is from? For example, does it look like masks you have seen from Africa? China? Canada? Mexico? The Caribbean?

**Understand** What can you find out about the function of this mask? When, where, and for what reasons would it be worn?

**Explain** Why would knowing more about the origins of maskmaking in Puerto Rico help you explain why this mask is important to Puerto Ricans?

14

#### Art of Puerto Rico

## **Using the Text**

Art History Ask: Where did Lillian Méndez grow up, and where does she live now? (Puerto Rico; the United States) How does she share her Puerto Rican heritage with others? Why does Méndez feel that knowing about one's culture and ancestors is important?

#### **Using the Art**

Art Criticism Ask: Where are the rice bags and labels in *Goya Rice Bags*? Do you find this sculpture humorous? How did Méndez suggest a festival in this art? Show students a Puerto Rican flag, and then have them locate the flags in *Vejigante*. Ask: What materials would you use to create a costume symbolic of your culture or heritage?

#### **Studio Connection**

Demonstrate paper-sculpture techniques:

- Scoring—Press hard enough with a scissors point to indent a line in the paper; do not cut through the paper. Crease the paper along the scored line.
- Curling—Curl a strip of paper, place the strip against a pencil or the edge of a scissors blade, and gently pull the tool along the strip.

See page 262 for other paper-folding techniques.

Provide construction paper or bright-colored copy paper in assorted sizes, scissors, pencils, and white glue. Have students draw and cut out an oval on 9" x 12" paper, form the mask base by cutting a 1" slit at the top and bottom of the oval, and overlap and glue the edges of each slit (the oval should stand out slightly). Point out that human eyes are roughly at the middle of the head. Encourage students to use colored paper to add a variety of shapes, textures, and patterns to their mask.

**Assess** See Teacher's Resource Binder: Check Your Work 7.3.

#### **Reinventing Past Traditions**

"When you know where you came from, you have a much better understanding of where you are going."

Lillian Méndez (born 1957)

Today, many artists in Puerto Rico continue to use folk-art traditions as inspiration for their artworks. Such artists as Lillian Méndez often balance these traditions with present-day cultural influences.

As an artist, Méndez wears three hats: maker of objects, inventor, and storyteller. The biographical stories of her art describe her personal journey as a Latina raised in Puerto Rico and now living in the United States. Her childhood experiences are what add the colorful and inventive qualities to the objects she makes. Her use of the folkart tradition of papier-mâché gives her artworks their elaborate form.

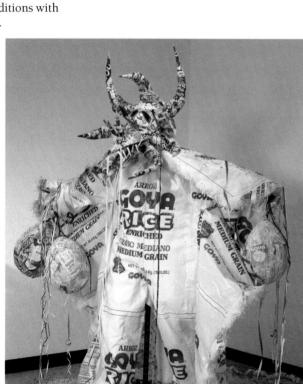

Fig. 7–21 This sculpture is part of a larger installation. The installation included masks and carnival costumes, as well as drawings and paintings on the theme of carnival. Lillian Méndez, Vejigante Made from Goya Rice Bags, 1999–2000.

1999–2000. Mixed media, 84" x 48" x 24" (213 x 122 x 61

240

GLOBAL DESTINATIONS LESSO

# **Teaching Options**

#### **Meeting Individual Needs**

Multiple Intelligences/Logical-Mathematical and Linguistic Have students examine the masks in this lesson or those in costume and celebration catalogs or on Websites. Ask students to create a chart of all the different types of masks they have seen or know about. Next to each entry, have students write the characteristic that a person would assume when wearing the mask. Ask students to select from their chart the type of mask they would most want to wear and to create a sketch for it. Have students each explain, in writing, the reason for their selection and how they think the mask would transform them.

#### Studio Collaboration

Have student groups use their masks in a skit or dance. Encourage students to select music that reflects their mask's festive nature.

240

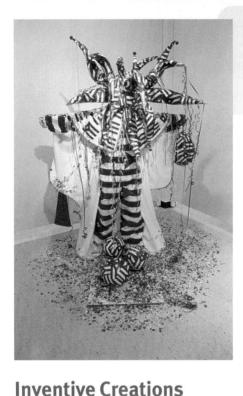

In her childhood, Méndez lived by the ocean

She was an inventor at an early age and used

to catch crabs with traps that she designed

herself. As an adult artist, Méndez is still

inventing. She makes inventive use of

or packages for Hispanic foods.

materials, such as the decoration of her

costumed figures with Puerto Rican flags

Through her art, Lillian Méndez shares her Puerto Rican heritage with others. She

has a keen interest in developing awareness of Hispanic/Latino art and culture. Méndez

stresses the importance of young people's

ground when they make art. She says: "It's

important to educate yourself about your

culture. The path that your ancestors have

traveled is fertile ground for your own imagination to develop and prosper."

consideration of their own ethnic back-

in the southeastern part of Puerto Rico.

Fig. 7–22 Do you think the artist meant this sculpture to be humorous? Why or why not? Lillian Méndez, Vejigante Made from Puerto Rican Flags, 1999–2000.

# O Try

#### **Studio Connection**

Try your hand at maskmaking! Make an elaborate paper mask that is decorative and festive. Use construction paper, and

explore a variety of paper sculpture techniques. Be inventive in creating facial features with three-dimensional paper forms and cut-paper shapes. Use staples and/or glue to assemble the parts of your mask.

#### **Lesson Review**

#### **Check Your Understanding**

- **1.** What are santos, and what role do they play in the lives of Puerto Rican families?
- 2. What materials are traditionally used by Puerto Rican maskmakers? What are the similarities and differences between the masks of Ponce and the masks of Loiza?
- 3. What evidence of Puerto Rican artistic traditions do you see in the work of Lillian Méndez?
- **4.** In what way is Lillian Méndez both a storyteller and an inventor?

rtists as Inventors

241

#### **Extend**

Assign students to research and write a report about their culture's symbols. Guide them in creating a paper, clay, or papier-mâché mask featuring their heritage's symbolism.

#### Assess

# Check Your Understanding: Answers

- 1. Santos are carved figures of saints; they have deep religious meaning and are kept in the house to protect the family.
- 2. Papier-mâché and coconut shells. Ponce masks have long, pointed teeth and tall horns. Loiza masks feature square mouths, triangular noses, and round eyes.
- **3.** use of papier-mâché; colorful forms with tall horns
- **4.** Méndez's art tells biographical stories; in her masks, she is inventive in her selection and use of such materials as flags and food packages.

# Close

Discuss students' answers to Check Your Understanding. Display the masks, and encourage students to identify effective paper-sculpture techniques in one another's masks.

#### **Teaching Through Inquiry**

Art History Have students work in collaborative-learning groups to write a one-page report on the origins and development of a specific Puerto Rican artmaking tradition. Suggest lacemaking, santos carving, musical instruments, maskmaking, painting, animal carving, and carnival costumes. Have each group present their report to the rest of the class.

#### More About...

Various threads of Puerto Rico's heritage mingle in the island's celebration of **carnival**, whose feasting, dance, and music, often with masks and costumes, have ancient origins. Spanish colonizers brought a strong Roman Catholic influence, such as the use of papier-mâché masks and the association of carnival with celebrating the last days before the start of the somber period of Lent. African and Native American customs weave throughout the joyous festivities as well, aptly symbolizing the island's cultural diversity.

#### **Assessment Options**

**Peer** Have student pairs ask each other questions about the materials and techniques used

to create the artworks shown in this lesson. Have students rate each other as knowledgeable, very knowledgeable, or needs to learn more about Puerto Rican art traditions.

# **Prepare**

#### **Pacing**

One or more 45-minute periods

## **Objectives**

- Learn about the wire creations of Alexander Calder.
- Understand how artists use the element of space and the principles of movement and rhythm.
- · Create an invented world out of wire.

## Vocabulary

**space** The empty or open area between, around, above, below, or within objects.

movement A principle of design, in which visual elements are combined to produce a sense of action.

rhythm A principle of design, in which repeating elements create visual or actual movement in an artwork.

# **Supplies**

- · variety of wire
- found materials, such as beads, buttons, fabric scraps
- · wood or Styrofoam for base
- stapler or tacks
- wire cutters (one pair per 4 students)
- hammer
- · needle-nose pliers (optional)
- · scissors (optional)

# National Standards 7.4 Studio Lesson

- **1a** Select/analyze media, techniques, processes, reflect.
- **2a** Generalize about structures, functions.
- **2b** Employ/analyze effectiveness of organizational structures.
- **5c** Describe, compare responses to own or other artworks.

Sculpture in the Studio

# Building a Wire Sculpture

#### The Whole Wired World

Studio Introduction In this studio experience, you will work with your classmates to create a make-

believe world out of wire.

Pages 244 and 245 will tell you how to do it. You have seen how artists can transform ordinary materials into imaginative or dreamlike objects and images. What kind of magical world can you create? With your

classmates, discuss possibilities. Will you create a magical jungle or a colorful, weird world at the bottom of an ocean? Will you change an ordinary scene at a shopping mall, amusement park, or your school into one where things are not exactly the way you would expect? Perhaps your imagination will lead your discussion to outer space and the creation of a strange planet full of bizarre forms and peculiar creatures.

## **Studio Background**

#### The Wire World of Alexander Calder

Alexander Calder was born into a family of artists: his mother was a painter, and his father and grandfathers were sculptors. He once said: "I think best in wire." In 1926, Calder began to work his magic with wire and other materials when he created and conducted performances of a miniature circus. He twisted and wrapped wires to make clowns, highwire performers, and animals he had sketched while at a live circus.

To capture the spirit of the circus, Calder included just enough detail in his wire sculptures. He was fascinated with movement and, throughout his life, developed ways to balance and move shapes in space. For many of his later sculptures, he welded giant sheets of metal together with heavy rods. Some sculptures, hung from ceilings, were *mobiles*. Others, fastened to the ground, were *stabiles*.

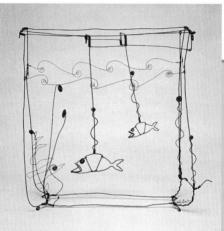

Fig. 7–23 Note how the artist used wire to suggest the threedimensional space of a fishbowl. Within this space, he suspended fish, waves of water, and other objects. What techniques did he use to connect the wires in this sculpture? Alexander Calder, Goldfish Bowl, 1929.

242

# **Teaching Options**

#### Resources

Teacher's Resource Binder Studio Master: 7.4

Studio Reflection: 7.4

A Closer Look: 7.4

Find Out More: 7.4

Slides 7f

#### **Teaching Through Inquiry**

Art Criticism Refer students to the text on page 245, which discusses the use of space, movement, and rhythm. Have students work in small groups to compare Calder's *Goldfish Bowl* to Remedios Varo's *Spiral Transit* (Fig. 7–2, page 226) by analyzing how the two artists used space, movement, and rhythm. Invite groups to share their findings in a full-class discussion about how these art concepts have been used in both two- and three-dimensional artworks.

Calder mean by "I think best in wire"? What is the subject of some of Calder's earliest wire sculptures? (the circus) What is a mobile? (a sculpture that moves and is hung from a ceiling) What is a stabile? (a sculpture that resembles a mobile but that rests on the ground and

Art Criticism Ask: What parts of Goldfish Bowl do you think move? Is wrapped them together) Where are did Calder create actual movement and a sense of movement? (The fish actually swing; Calder repeated swirls in the waves and created a

Fig. 7-24 Student artists used colored wire to help create their circus world. Notice the clever use of corks. Jayni Butta, Nicole Moss, Adam Harris, Joe Starmer, Jeff Patten, The Circus, 2001.

Fig. 7-25 Notice the use of found materials in this work. What is the theme of this sculpture? Deana Rotti, Sarah Scannell, Arianne DelGuidice, Fun Things to Do After School, 2001. Wire, pipe cleaners, coat hanger, 18" x 18" (46 x 46 cm). Chocksett Middle School, Sterling. Massachusetts

Artists as Inventors

# More About...

Although Alexander Calder (1898–1976) was born into a family of artists, he chose to earn a degree in mechanical engineering before studying painting at the New York Art Students League. He became fascinated with the circus when he created illustrations of Barnum and Bailey's Circus for a New York journal. In 1926, he created a miniature wire circus, which included articulated tightrope walkers, weight lifters, acrobats, and a ringmaster.

# **Using the Text**

Engage

subjects.

Art History Ask: What did Alexander does not have moving parts)

# **Using the Art**

this a mobile or a stabile? How do you think Calder created the swirls in the water and plants? How did he join pieces of wire? (bent and the positive and the negative spaces in this sculpture? How, do you think, visual path of movement.)

# A Wire Sculpture

## **Studio Experience**

- 1. Demonstrate building a wire figure. Show students how to cut and join wire by wrapping pieces around each other. Point out that a single wrap of two wires is not enough to make a secure connection.
- 2. Have students work in collaborative-learning groups to select a theme for their group sculpture and to assign tasks for creating each part of the sculpture. Provide each group with the supplies.
- 3. Guide students to turn out a flat foot or tab if they are to staple their sculptures to a wood base. Provide, if necessary, assistance with the staple gun. Hammer in any staples that do not go all the way into the wood.

#### **Idea Generators**

- Ask: What will your make-believe world look like? What would people play, do, and eat? How would they travel?
- · Ask students to imagine exotic worlds in outer space or undersea.
- Assign students scenes from literature, history, and science lessons.

#### **Safety Note**

Have students work far enough apart from

one another so as to avoid injury from the wires. Have students wear safety goggles.

#### Extend

Have students each sketch their group's sculpture. Discuss ways to show objects both near and far, and challenge students to create an illusion of space in their drawing.

#### Sculpture in the Studio

# **Making Your Wire Sculpture**

#### You Will Need

- · variety of wire
- wood for base
- · found materials stapler or tacks

#### Try This

STUDIO LESSON

1. With your classmates, choose a theme for your wire world. Discuss the features that the world will have. Will it have people, animals, or imaginary creatures?

Will you include other features, such as buildings, mountains, plants, or trees? Which parts will be realistic, and which parts will be fantasy?

2. Decide who will make which features of the make-believe world.

**3.** Make your sculpture for the make-believe world. Bend and twist lengths of wire into people, plants, animals, or imaginary

forms. You may decide to add beads, buttons, pieces of fabric, or other found materials to get the effects you want.

4. With a stapler or tacks, attach your sculpture to a wood base.

5. With classmates, arrange the completed sculptures in a tabletop display. How can the placement of the sculptures help create an overall sense of space in the scene?

How can they work together to create rhythm and expressive movement?

#### **Check Your Work**

Have a class discussion about the completed wire world. What parts of it are realistic? What parts are purely imaginary? How does the placement of the figures help create a sense of space, movement, and rhythm? Next, discuss what you learned from working with classmates on this project.

#### **Computer Option**

Artists can create threedimensional worlds in a computer's "virtual space." These worlds may be seen

from many points of view. Using a 3-D rendering program, create an environment or a creature (person, animal, insect, etc.). Allow your creation to be viewed from two different perspectives. Computer 3-D rendering is a lot like creating with wire, because to achieve the completed rendering you must first create what is called a wire frame. Then add color and texture to the surface of the environment or creature. This is how many animated movies and cartoons are created.

244

# **Teaching Options**

#### **Teaching Through Inquiry**

Art Production Provide small groups of students with 12" pieces of different types of wire (copper, steel, thick, thin). Have each group investigate different methods of working with the wire (such as coiling, twisting, wrapping, and joining) and share their findings with the rest of the class.

#### **Elements and Principles**

# Space, Movement, and Rhythm

In art, **space** is the empty or open area between, around, and within objects. *Positive space* is the area filled by a three-dimensional form. *Negative space* is the area surrounding a form. Sculptures

positive negative space space

and architecture fill actual space. For a painting or other two-dimensional artwork, artists create the illusion of actual space. To do this, they can choose from several methods of perspective. To learn more about perspective, see Lesson 7.2, pages 236 and 237.

Artists use the principle of **movement** to create the look of action in an artwork. Certain kinds of artwork, such as mobiles, actually move. Artworks can also show movement through the poses of people or animals, or in the way other subject matter is designed. For example, an artist may include bending trees in a painting to suggest a strong wind. Artists can also create *paths of movement* in their compositions. By carefully arranging lines, shapes, or other elements, they can lead the viewer's eye around the artwork.

**Rhythm** is a kind of movement that is related to pattern. Lines, shapes, and colors that are

pes, and colors that are repeated in an organized way can create a sense of rhythm. Rhythm can be simple and predictable, such as footprints in the sand. Or it can be complex, such as the grain of wood.

Fig. 7–26 **Student artists took their wire world a step further and added a painted background. Notice how they incorporated pipe-cleaner fireworks into the scene.**Lindsay Howard and Melissa McCarthy, *Fireworks*, 2001.

Pipe deaners, foamcore, cardboard, tempera, 12<sup>1</sup>/2<sup>\*</sup> x 18<sup>\*</sup> x 12<sup>\*</sup> (32 x 46 x 31 cm). Chocksett Middle School, Sterling, Massachusetts

Artists as Inventors

245

# **Assessment Options**

**Self** Provide each student with "Understanding Your Own Artistic Process" from the Teacher's

Resource Binder, and have students each evaluate the extent to which they incorporated space, movement, and rhythm to create their make-believe world.

Computer Option Some 3-D rendering programs, such as

Poser by Curious Labs, are designed just for manipulation of a figure. Others, such as 3D StudioVIZ by Autodesk, allow an entire environment to be rendered into a virtual world. You may wish first to have students create a simple wireframe object, and then allow those who are interested to develop this technique.

# **Elements and Principles**

Have students read and discuss Elements and Principles before they begin the wire sculptures. Encourage students to consider negative and positive spaces within their individual figures, as well as in their group's arrangement. Ask: How can you show movement within your wire sculptures? (by actual movement, visual movement within the figures, movement paths through the group sculpture)

# Assess

#### **Check Your Work**

Have the groups answer the questions and print descriptive labels for their art. Invite groups to present their sculpture and to explain how they created a sense of space, movement, and rhythm.

# Close

Display the sculptures and labels, and review with students what they have learned about Alexander Calder and space, movement, and rhythm.

Connect to...

## Other Arts

Have students listen to favorite music videos or CDs and identify the different sounds made by the electric guitar. Then have them listen to a classical acoustic guitar composition, such as "Recuerdos do la Alhambra" by Tarrega. Discuss the differences they detect in the sounds of the two instruments. Have student pairs conduct a debate in which one student argues that the acoustic guitar is better because it produces a pure musical form, and the other student argues that the electric guitar is better because it has pioneered new sounds.

## Social Studies

Have students each research, both different and diverse cultures. Chalstudents use the format of an illumi-

## Connect to...

## **Careers**

CONNECT

Do you have any jewelry you wear every day or only on special occasions? Does wearing jewelry make you feel special? In many cultures, jewelry has been worn for its protective properties, and has been used for adornment or to indicate royalty, status, or wealth. The success of a maker or designer of jewelry is based on the artist's imagination and skill. Jewelry designers may learn their trade through several sources: they may pursue a fine-arts degree, attend a trade school, learn through an apprenticeship with a designer or jewelry-making company, or be self-taught. Skill in drawing and an interest in working on a small scale are needed for a rewarding career as a jewelry designer and maker.

## **Daily Life**

It is possible that a person who was born in 1870 lived long enough to witness the invention of electric lighting, the automobile, and the airplane. In your life, you have already witnessed rapid technological advances in cellphones, pagers, and the Internet. The inventors of all of these aspects of technology shared the belief that society would benefit from their discoveries. What other kinds of technological advances do you think you may witness in your lifetime?

online and offline, invention myths in lenge students to select an invention myth and create an illustration that depicts its story. Alternatively, have nated manuscript, which combines written words with an illustration.

## **Other Arts**

#### Music

Do you know when the electric guitar was invented? The first experiments with electricity and the guitar began in the 1920s, when inventors and musicians collaborated to create guitar sounds that would be louder than the background orchestra. In an electric guitar, the vibrations of the strings are captured by "pickups," magnetic devices that turn the vibrations into electric signals. These signals then pass through an amplifier, an electronic device that increases the sounds of the strings. How do musicians today experiment with new sounds?

Fig. 7-27 Using the electric guitar in new and inventive ways has allowed musicians to produce fresh sounds in jazz, rock, and other forms of contemporary music, United States Electric Guitar (Flying V model), 1967. Mahogany, rosewood, plastic.
Manufactured by Gibson, Inc.
Smithsonian Institution, National Museum of American History Division of Cultural History.

246

## **Teaching Options**

## Resources

Teacher's Resource Binder: Making Connections Using the Web Interview with an Artist Teacher Letter

## **Internet Resources**

## Giuseppe Arcimboldo

http://www.agroart.org/arcimboldo/ See inventive portraits by this Italian Mannerist painter.

## **Video Connection**

Show the Davis art careers video to give students a reallife look at the career highlighted above.

## **Other Subjects**

#### Social Studies

Many cultures have myths and legends that explain inventions or the passing on of knowledge. For example, the Navajo people have a story that explains how they were given the knowledge of weaving. In the story, Spider Woman taught the Navajo how to weave on a loom that Spider Man showed them how to make. What similar tales can you think of that reflect the receiving of knowledge?

#### Mathematics

Can you think of any mathematical connections with art that might have seemed inventive to its earliest viewers? Artists have used mathematical concepts to invent systems for creating the illusion of depth on a flat surface. In linear perspective, for example, sets of implied lines move closer together in the distance until they. Two-point perspective uses lines that lead to two different vanishing points.

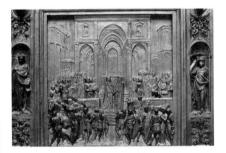

Fig. 7-29 In the early fifteenth century, Renaissance artists invented a system of drawing called linear perspective. Lorenzo Ghiberti, Gates of Paradise (detail), 1425-52.

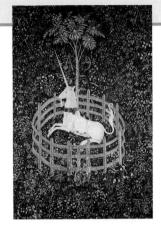

Fig. 7-28 The unicorn was supposedly a pure white horse with a horn in the middle of its forehead. What other fabled creatures can you think of? South Netherlandish,

The Unicorn in Captivity, c. 1495–1505.
Wool warp, wood, silk, silver, and gilt wefts, 12'1"x99" (368 x 251.5 cm). The Metropolitan Museum of Art, Gift of John D. Rockefeller Jr., 1937 (37.80.6).
Photograph © 1993 The Metropolitan Museum of Art.

#### Science

Do you think the invented creature the unicorn ever existed? Though the unicorn was only an imaginary creature, stories about it were based on a real animal called the narwhal. The narwhal is a small whale found only in northern Arctic waters. It has a body about fifteen feet long, a rounded forehead, small eyes, and grav skin. Male narwhals have a long spiraled tusk that is actually a tooth, rather than a horn. During medieval times, traders brought the tusks back to Europe and sold or traded them as unicorn horns, adding to the belief in the mythical creature.

## **Mathematics**

Show and discuss the National Gallery of Art video Masters of Illusion, available at http://www.nga.gov/shop/ multmult.htm#Video, which examines perspective drawing and other Renaissance artistic and scientific discoveries that led to the extraordinary special effects in today's movies and computer games. Afterwards, have students each make perspective drawings of interior or exterior views of the school.

## Science

Show and discuss with students other artworks that depict mythical beasts, such as dragons, centaurs, or the Minotaur. Have students each invent an imaginary creature that is a combination of three different living forms. Instruct students to draw the head, upper body, and lower body of three different animals and combine them to make one fantastic beast. Challenge students to write an accompanying short story about their creature's imaginary origin.

## **Internet Connection** For more activities related to this chapter, go to the

Davis Website at

www.davis-art.com

Artists as inventors

247

## **Community Involvement**

Ask students to consider the ways that people in residential areas transform their homes and that shopkeepers create displays so as to create different moods and feelings at various times of the year. Have students document, with photographs or sketches, the way communities are transformed during certain holiday seasons or festivals.

## **Interdisciplinary Planning**

Work with colleagues in the sciences, social studies, and language arts to explore the theme of illusion. Consider how we use language to create a mental image of a space, and how the mechanics of perspective, the physiology of perception, and the psychology of space and color contribute to illusions and affect human behavior.

## Portfolio & Review

## Talking About Student Art

For discussion of an artwork, ask students to consider its details, expressive characteristics, and theme. Remind students that their judgments about artworks are informed opinions, and that they should take all of these aspects into consideration.

## Portfolio Tip

As students replace works in their portfolio, suggest that they save the removed

artworks and recycle them in mixed-media paintings and collages.

## **Sketchbook Tip**

Remind students that their sketchbook is a good place to practice drawing facial

expressions. Encourage students to emphasize moods and feelings by experimenting with exaggeration and distortion. You may wish to have students transform sketches of faces into sketches for masks.

## **Portfolio**

"As I created this mask, I was thinking of a way to express my individuality, as well as my love for art. Each little detail shows how unique I am."

Sara Fischbacher

PORTFOLIO

Fig. 7–31 A blend of realistic and abstract images adds interest to this fantasy world. Jim Hunt, Under the Sea, 2000.

Colored pencil, pencil, marker, 9° x 12° (23 x 30.5 cm). Samford Middle

"We were drawing fantasy scenes, and the first thing I thought of was underwater fantasy. I thought my use of color and shading worked well together to create an interesting picture." Jim Hunt

#### CD-ROM Connection

To see more student art, view the Personal Journey Student Gallery.

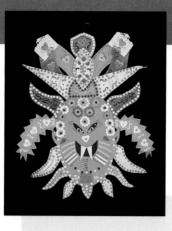

Fig. 7–30 The shapes, lines, and colors used by the artist makes this mask appear lively and vibrant. Sara Fischbacher, *Paper Mask*, 2001.

Paper, tagboard, glitter, 17" x 14" (43 x 35.5 cm). Smith Middle School, Fath Hood Taxes.

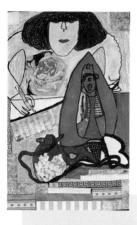

Fig. 7–32 The use of mysterious shapes and bands of colors makes the viewer wonder what the artist was imagining. Cristina Jane Houston, *Wall to Wall*, 2001.

Marker, chalk pastel, fabric, wallpaper, 17" x 11" (43 x 28 cm). Victor School, Victor, Montana.

"It started out as a still life, then I began to fill all the space with wall paper and chalk pastels. It is special because it is like a piece of my mind." Christina Houston

248

## **Teaching Options**

## Resources

Teacher's Resource Binder

Chapter Review 7

Portfolio Tips

Write About Art

Understanding Your Artistic Process

Analyzing Your Studio Work

## **CD-ROM Connection**

For students' inspiration, for comparison, or for criticism exercises, use

the additional student works related to studio activities in this chapter.

## **Chapter 7 Review**

## Recall

Name two ways to create the illusion of depth in a drawing or painting.

#### Understand

Explain why we sometimes think of artists as inventors.

## Apply

Produce an artwork that tricks the viewer's eye. (*See example below.*)

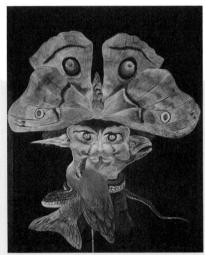

Page 235

#### Analyze

Select one work by Ellen Lanyon and one by Remedios Varo. Compare and contrast the way each artist used both realistic and imaginary features.

## Synthesize

Write directions or instructions for how to turn a realistic scene, such as a view of a farm or city, into a surrealistic drawing.

#### Evaluate

Select five artworks from this chapter, and write their titles. Decide what kind of work each is, and label each as fantasy, surreal, dreamlike, or real. Give reasons to support each decision.

#### For Your Portfolio

Look through this chapter to select one artwork that especially appeals to you. Write a two-part essay. In the

first part, write a detailed description of the work. In the second part, explain how this artwork suggests a world of fantasy. Write your name and the date on your essay, and put your essay into your portfolio.

#### For Your Sketchbook

Use a page of your sketchbook to transform one object into another in a sequence of six sketches. For example,

you might change a flower into a butterfly.

Artists as Inventors

249

## Advocacy

Invite school-board members and school administrators to accompany students—not as chaperones, but as participants—on a field trip to a local museum or artist's studio.

## **Family Involvement**

Invite family members to assist you in collecting artwork reproductions (post-cards, old calendars, or images found in magazines).

# Chapter 7 Review Answers Recall

Linear perspective and overlapping are two possible answers. Changes in size, position, color, or value are other possibilities.

## **Understand**

Answers may vary. Look for comparisons between artists and inventors, such as both seek to find new ways of doing things; both create solutions to problems; both bring into existence things that did not exist before.

## **Apply**

Results will vary. Look for use of optical illusions, contrasting/vibrating colors, unusual proportions, distorted perspective, etc.

## **Analyze**

Answers will vary. Possible points might include: Both artists include objects/things that are easily recognizable. Both combine objects in imaginative ways. Lanyon makes each thing look real. Varo exaggerates proportions and uses distortion.

## **Synthesize**

Answers will vary. Look for references to exaggeration, distortion, putting objects together that don't belong together, transformation.

## **Evaluate**

Answers will vary and more than one label might be used for the same artwork. Look for reasons that make sense and that are not just wild guesses or personal opinions. Look for evidence that demonstrates reasonable distinctions among the words used for labels.

## Reteach

Discuss how people go about transforming or changing their physical appearance or environment on a daily basis (make-up, wardrobe, jewelry, lighting for mood, flowers, decorations, etc.). Then discuss more dramatic transformations like those found in children's literature (Cinderella, Snow White, Superman, The Frog Prince, etc.). Find children's books that illustrate these transformations of people or environments. Discuss what the artist has done to show these dramatic changes. Summarize that artists sometimes invent magical and mysterious worlds.

3

3

3

2

# **Chapter Organizer**

## Chapter 8 Artists as **Planners**

Chapter 8 Overview pages 250-251

## **Chapter Focus**

- Core People plan living and working spaces. Architects and other artists design structures and spaces for us to use and enjoy.
- 8.1 Architecture for Living
- 8.2 Three-dimensional Models
- · 8.3 Art of Mexico
- 8.4 Corrugated Constructions

## **Chapter National Standards**

- 1 Understand media, techniques, and processes.
- 2 Use knowledge of structures and functions.
- 3 Choose and evaluate subject matter, symbols, and ideas.
- Understand arts in relation to history and cultures.
- 6 Make connections between disciplines.

## Core Lesson A Planner from the Start

page 252 Pacing: Three 45-minute periods

## **Objectives**

- Understand what architecture is.
- Explain what architects and city planners must consider when they plan buildings and cities.

## **National Standards**

- 2b Employ/analyze effectiveness of organizational structures.
- 3a Integrate visual, spatial, temporal concepts with content.
- 4c Analyze, demonstrate how time and place influence visual characteristics.

## **Core Studio Building** an

Create an architectural model for a setting.

1a Select/analyze media, techniques, processes, reflect.

## Architectural Model page 256

Then and Now

Architecture for Living

Pacing: One or more

45-minute periods

Lesson 8.1

page 258

## **Objectives**

- · Recognize both symmetrical and asymmetrical balance in architecture.
- Describe Melinda Gray's approach to architecture.

## **National Standards**

- 3a Integrate visual, spatial, temporal concepts with content.
- 4a Compare artworks of various eras, cultures.
- 4c Analyze, demonstrate how time and place influence visual characteristics.

## **Studio Connection**

· Use ruler and compass to render an architectural drawing of a dream house.

## page 260

## **Objectives**

## **National Standards**

#### 2 Skills and Techniques Lesson 8.2 Three-dimensional Models

page 262

Pacing: Two or more 45-minute periods

· Understand why architects make models.

1b Use media/techniques/processes to communicate experiences, ideas.

## **Studio Connection**

page 263

- Make three-dimensional geometric forms.
- 1b Use media/techniques/processes to communicate experiences, ideas.
- 2c Select, use structures, functions.

## **Featured Artists**

Luis Barragan Peter Cook Frank Gehry Melinda Gray Iktinos Kallikrates Ricardo Legorreta Paolo Soleri Pedro Ramírez Vázquez Robert Venturi Philip Webb Frank Lloyd Wright

## **Chapter Vocabulary**

architectural model architecture architects balance

cantilever form hacienda

## **Teaching Options**

Teaching Through Inquiry
More About...Frank Gehry
Using the Large Reproduction
Meeting Individual Needs
Teaching Through Inquiry
More About...Frank Lloyd Wright

## Technology

CD-ROM Connection e-Gallery

## Resources

Teacher's Resource Binder
Thoughts About Art:
8 Core
A Closer Look: 8 Core
Find Out More: 8 Core
Studio Master: 8 Core
Assessment Master:
8 Core

Large Reproduction 15 Overhead Transparency 16 Slides 8a, 8b

Teaching Through Inquiry More About...The Parthenon Assessment Options CD-ROM Connection Student Gallery Teacher's Resource Binder Studio Reflection: 8 Core

## **Teaching Options**

Teaching Through Inquiry More About...Fallingwater Using the Overhead

## **Technology**

CD-ROM Connection e-Gallery

## Resources

Teacher's Resource Binder Names to Know: 8.1 A Closer Look: 8.1 Find Out More: 8.1 Assessment Master: 8.1 Overhead Transparency 15 Slides 8c

Meeting Individual Needs Teaching Through Inquiry More About...The home of Jennifer Clark Assessment Options CD-ROM Connection Student Gallery Teacher's Resource Binder Check Your Work: 8.1

## **Teaching Options**

More About...Mechanical drawings Teaching Through Inquiry Using the Overhead Assessment Options

## Technology

CD-ROM Connection e-Gallery

## Resources

Teacher's Resource Binder Finder Cards: 8.2 A Closer Look: 8.2 Find Out More: 8.2 Assessment Master: 8.2 Overhead Transparency 16 Slides 8d

CD-ROM Connection Student Gallery Teacher's Resource Binder Check Your Work: 8.2

# 36 weeks

3

#### 2 **Global Destinations** Lesson 8.3 Art of Mexico

page 264 Pacing: Two 45-minute periods

## **Objectives**

- Distinguish between the type of architectural structures built by early civilizations and those built by the Spanish in Mexico
- Identify influences of pre-Hispanic and early Spanish architecture in the work of Ricardo Legorreta.

## **National Standards**

- 4a Compare artworks of various eras, cultures.
- 4c Analyze, demonstrate how time and place influence visual characteristics.

## **Studio Connection**

- · Draw a plan or aerial view of a public gathering
- 2b Employ/analyze effectiveness of organizational

## page 266

Studio Lesson 8.4

Pacing: Two or more

45-minute periods

Connect to...

page 272

Corrugated

page 268

Constructions

place.

## structures.

## **Objectives**

- Understand how sculptures and architectural works are made of one or more forms.
- Understand how artists create balance in their artworks.
- Use knowledge of form and balance to plan and construct a roller-coaster track for marbles.

## **National Standards**

- 1b Use media/techniques/processes to communicate experiences, ideas.
- 2a Generalize about structures, functions.
- 2b Employ/analyze effectiveness of organizational structures.

## **Objectives**

- · Identify and understand ways other disciplines are connected to and informed by the visual
- Understand a visual arts career and how it relates to chapter content.

## **National Standards**

6 Make connections between disciplines.

## **Objectives**

## Portfolio/Review page 274

- · Learn to look at and comment respectfully on artworks by peers.
- · Demonstrate understanding of chapter content.

## **National Standards**

5 Assess own and others' work.

# Lesson of your choice

## **Teaching Options**

Teaching Through Inquiry More About...Teotihuacán Using the Large Reproduction

## Technology

CD-ROM Connection e-Gallery

## Resources

Teacher's Resource Binder A Closer Look: 8.3 Find Out More: 8.3 Assessment Master: 8.3 Large Reproduction 16 Slides 8e

Meeting Individual Needs Teaching Through Inquiry More About...Ricardo Legorreta Assessment Options

CD-ROM Connection Student Gallery Teacher's Resource Binder Check Your Work: 8.3

## **Teaching Options**

Teaching Through Inquiry
More About...Roller coasters
Using the Overhead
Teaching Through Inquiry
More About...Pinball machines
Assessment Options

## **Technology**

CD-ROM Connection Student Gallery Computer Option

## Resources

Teacher's Resource Binder Studio Master: 8.4 Studio Reflection: 8.4 A Closer Look: 8.4 Find Out More: 8.4 Overhead Transparency 16 Slides 8f

## **Teaching Options**

Community Involvement Interdisciplinary Planning

## **Technology**

Internet Connection Internet Resources Video Connection CD-ROM Connection e-Gallery

## Resources

Teacher's Resource Binder Using the Web Interview with an Artist Teacher Letter

## **Teaching Options**

Advocacy Family Involvement

## **Technology**

CD-ROM Connection Student Gallery

## Resources

Teacher's Resource Binder
Chapter Review 8
Portfolio Tips
Write About Art
Understanding Your Artistic Process
Analyzing Your Studio Work

## **Chapter Overview**

## **Theme**

People plan ways to organize their living and working spaces. Architects and other artists create designs for structures and spaces for us to use and enjoy.

## **Featured Artists**

Luis Barragan
Peter Cook
Frank Gehry
Melinda Gray
Iktinos
Kallikrates
Ricardo Legorreta
Paolo Soleri
Pedro Ramírez Vázquez
Robert Venturi
Philip Webb
Frank Lloyd Wright

## **Chapter Focus**

This chapter features the role of artists in planning buildings and spaces for living, working, and playing. Students learn about contemporary architect Frank Gehry and his work, and explore some of the issues that planners must consider. Students create their own architectural model for a public building, explore historical traditions in architecture. and learn about the residential architecture designed by Melinda Gray. Along with constructing simple three-dimensional forms, students are introduced to Mexican traditions. Using what they have learned about artists as planners, students design a roller-coaster track for marbles.

# National Standards Chapter 8 Content Standards

- 1. Understand media, techniques, and processes.
- 2. Use knowledge of structures and functions
- **3.** Choose and evaluate subject matter, symbols, and ideas.
- 4. Understand arts in relation to history and cultures.
- **6.** Make connections between disciplines.

8

# Artists as Planners

Fig.~8-1~Gehry~is~known~for~creating~dramatic~forms~and~using~materials~in~new~and~unusual~ways.~How~does~this~museum's~design~compare~with~that~of~other~museums~you~have~seen?~Frank~Gehry,~Guggenheim~Museum,~Bilbao,~1997.

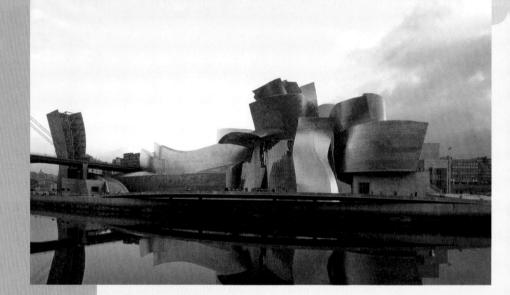

Fig. 8-2 Many of Gehry's buildings begin as gesture drawings, such as the one shown here. How is drawing helpful in working out ideas? Frank Gehry, Guggenheim Museum, Bilbao, Design Sketch.

Courtesy Frank O. Gehry and Associates, Santa Monica, California.

250

## **Teaching Options**

## **Teaching Through Inquiry**

Art Production Provide groups of students with Descriptive Word Cards and Expressive Word Cards from the Teacher's Resource Binder. They will use the cards to get ideas for sketches of architectural designs. Have students "deal" the cards and make sketches for a building. Encourage them to make gesture drawings and to note what words helped them get ideas. Ask group members to share their work.

## More About...

The Guggenheim Museum Bilbao opened in October 1997. The exterior is a mix of stone, titanium, and glass. Some of the museum's galleries are traditional rectangular spaces; others are of unusual proportions and forms.

- How do people plan their living environment?
- How do artists help us plan the spaces and places we use?

**People have always planned for ways to use the spaces around them.** They may plan temporary spaces like campsites. For permanent shelters, people plan ways to organize interiors and exteriors with places for cooking, washing, sleeping, working, and relaxing. They also plan ways to organize appliances, furniture, and other belongings.

**Architecture** is the art of planning buildings and spaces for people. The architecture of a street or neighborhood is often designed and built through the collaboration of a group of experts. These include city planners, engineers, builders, and architects. **Architects** are artists who design buildings. They also develop neighborhood, town, and city spaces, such as stores, hospitals, and government and other public buildings. Because many people living close to one another must have places to shop, work, and relax, planners must consider the best use of available spaces for businesses, parks, and roads.

Architect Frank Gehry designed the museum shown here (Fig. 8–1). The structure, in the industrial city of Bilbao, Spain, creates a gateway to an area that was once a busy shipyard. In this chapter, you will learn more about the

work of Frank Gehry and other architects who plan the spaces and places we inhabit.

Frank Gehry

8.1 Then and Now Lesson

Architecture for Living

page 258

8.2 Skills and

**Techniques Lesson** 

## **Meet the Artists**

Frank Gehry Melinda Gray Ricardo Legorreta

## **Words to Know**

architecture architect cantilever Post-Modernism architectural model hacienda form balance

Planners

## **Chapter Warm-up**

Discuss the school's architecture.
Tell students when the school was built and, if possible, who the architect was. **Ask**: What activities take place here? How did the architect plan for these functions? How would you change this plan?

## **Using the Text**

Art History Ask: What places are planned? (campsites, students' rooms) What is architecture? (the art of planning buildings and spaces for people) What is an architect? (an artist who designs buildings) Who designed the Guggenheim Museum Bilbao? (Frank Gehry)

## **Using the Art**

Perception Ask: How is the Bilbao museum different from most other buildings? How would you describe the forms in this building? How is the gesture drawing like the final building? Why would a gesture drawing be a good way to begin a building design?

## Extend

Invite a local architect to your class to describe his or her job. Ask the architect to bring photographs or models of structures he or she has designed. Have the architect describe the training for this profession. Alternatively, show a video interview of an architect, such as that on Volume 1 of Art Careers! Talks with Working Professionals (Davis).

Graphic Organizer Chapter 8

## **Core Lesson**

A Planner from the Start

Core Studio
Building an
Architectural Model

page 256

8.3 Global
Destinations Lesson
Art of Mexico
page 264

8.4 Studio Lesson
Corrugated Constructions
page 268

## **CD-ROM Connection**

For more images relating to this theme, see the Personal Journey CD-ROM.

Three-dimensional Models
page 262

251

## **Prepare**

## **Pacing**

Three 45-minute periods: one to consider text and images; one to plan; one to build model

## **Objectives**

- · Understand what architecture is.
- Explain what architects and city planners must consider when they plan buildings and cities.
- Create an architectural model for a setting.

## Vocabulary

architecture Buildings and other large structures. Also the art and science of planning and constructing such buildings.

**architects** Artists who design the construction of buildings or large structures.

## Teach

## Engage

Tell students that many architects remember that as children, they built with such materials as wooden blocks and sand. **Ask**: What materials did you build with when you were younger? Why might such early construction experiences as these be useful to an architect?

## **Using the Text**

Art Production Have students read pages 252 and 253. Ask: What were some of Frank Gehry's early building experiences? (made "little cities" from wood scraps, expanded his own home) What are some of

## National Standards Core Lesson

- **1a** Select/analyze media, techniques, processes, reflect.
- **2b** Employ/analyze effectiveness of organizational structures.
- **3a** Integrate visual, spatial, temporal concepts with content.
- **4c** Analyze, demonstrate how time and place influence visual characteristics.

## A Planner from the Start

"I approach each building as a sculptural object, a spatial container, a space with light and air." Frank Gehry (born 1929)

## Frank Gehry's Journey

Frank Gehry grew up in Toronto, Canada. He remembers when, as a child, he made "little cities" out of wood scraps with his grandmother. At 18, he and his family moved to California, where he still lives and works. As an architect, Gehry has produced shopping malls, houses, parks, museums, banks, restaurants—even furniture!

Gehry is noted for his experiments with forms, materials, and construction techniques. He first received national attention for the unusual design of his own home in California (Fig. 8–3). For this structure, he used inexpensive materials, such as plywood, tar paper, chain-link fence, concrete blocks, and corrugated metal. He started with a

pink, two-story house. Planning the use of space from inside to outside, he expanded the house upward and sideways. He even wrapped parts with metal and wood.

Gehry wants people to be comfortable in the buildings and spaces he plans. He thinks about how his buildings will be used daily, by ordinary people. He also pays attention to the community in which his buildings will be constructed. This was an important concern when he designed the Bilbao museum (Fig. 8–1), which is part of a newly developed riverfront area. The building's metal surface and free-flowing design suggest both the community's industrial past and its eye to the future.

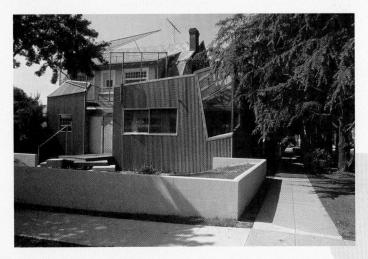

Fig. 8–3 Gehry's use of inexpensive materials has influenced the plans of many other architects today. Frank Gehry, *Gehry Residence*, 1978. Santa Monica, California. Photo ♥ Tim Street-Porter/Esto. All rights reserved.

252

## **Teaching Options**

## Resources

Teacher's Resource Binder
Thoughts About Art: 8 Core
A Closer Look: 8 Core
Find Out More: 8 Core
Studio Master: 8 Core
Studio Reflection: 8 Core
Assessment Master: 8 Core
Large Reproduction 15
Overhead Transparency 16
Slides 8a, 8b

## **Teaching Through Inquiry**

Art Criticism Have students work in small groups to use the Descriptive Word Cards and Expressive Word Cards (from the Teacher's Resource Binder) in comparing and contrasting the three Gehry designs. Guide students to note the architect's use of new materials, dramatic designs, and sense of humor.

Fig. 8–4 This building is like a three-dimensional collage. What different forms and materials can you identify? Frank Gehry, Vitra Headquarters, 1994.
Birsfelden, Switzerland. Photo: Tim Griffith/Esto.

Fig. 8–5 Many people say that some of Gehry's designs are humorous. How does this museum design include humor? Frank Gehry, Aerospace Museum, 1984.

## **The Planning Process**

For Gehry, the planning process is very important. He begins with wild gesture drawings, such as the one shown in Fig. 8–2. Then he creates three-dimensional models of different scales. As he constructs his models, he thinks about them as both sculpture and as a place for people to live or work. Gehry and a team of more than 120 people work to plan and create imaginative spaces for clients.

Like many architects working today, Gehry uses the computer to assist in design. He works with a computer program used in the aerospace industry. The program has allowed him to create surprising-looking buildings whose surfaces bend and ripple. Gehry asks: "How wiggly can you get and still make a building?" Some have called his space-age buildings "biomorphic," suggesting that they seem alive, constantly moving and changing.

Artists as Planners

253

Gehry's primary concerns as he begins to plan a building? (people's comfort, the building's use, the community around the building) How does Gehry design his buildings? (begins with gesture drawings, uses a computer, constructs models)

## **Using the Art**

Art Criticism As students study Gehry's designs, ask them to list the different kinds of building materials on the exteriors. Ask: Why do some people call these buildings "biomorphic"? How are these buildings different from those in your community?

Aesthetics How are these structures like sculpture? How did Gehry suggest the function of the Aerospace Museum in its form?

## **Critical Thinking**

Ask students to write an essay about one of these issues: why architecture should, or should not, be considered an art form; ways in which a builder is similar to and different from an architect; or why an architect should study art.

## **Extend**

Assign students to design a museum for a collection such as baseball cards, dolls, CDs, or photographs.

Ask: How would you make the outside of the museum suggest what is inside? Encourage students to consider not only the activities that would occur in this building, but also the ways in which people would move inside it.

## More About...

Frank Gehry thinks of his architecture as sculpture. Always open to experimentation, he creates biomorphic, sensuous, and curving forms through a process of drawing and model building. He pioneered the use of CATIA—a three-dimensional computermodeling program originally developed for the aerospace industry—to supplement the use of the two-dimensional CAD (computeraided design) programs once used by most architects. Gehry is also known for his exploration of such unassuming materials as chain-link fencing and concrete blocks. The process of planning is important to him, as is collaboration with the members of his architectural firm and his clients.

## **Using the Overhead**

## Think It Through

**Ideas** The artist of this work is one of Frank Gehry's favorite architects. How are the ideas for this structure similar to and different from Gehry's artworks?

**Materials** What materials do you recognize in this architectural form? **Techniques** Were the materials used in traditional or untraditional ways? Give reasons for your answer.

**Audience** What audience, do you think, did the architect have in mind when he planned this structure?

16

## **Artists as Planners**

## **Using the Text**

Aesthetics Have students read pages 254 and 255. Discuss design and architecture in the community. Ask: Does the architecture all go together, or is there a variety of designs and styles? Where do people work, play, and live? What other activities take place in your community? Have any landscape or environmental features shaped its design? What changes would you make to improve your community?

**Art Production Have students work** in small groups to design an environmentally friendly community. Ask: How did Paolo Soleri design Arcosanti so that it would not destroy the environment? (small enough that cars are not necessary; sun and wind provide energy) To guide them as they plan their communities, have students answer the questions in the first paragraph. Allow students to present their ideas to the class.

## **Using the Art**

Art Criticism Ask: How is Frank Lloyd Wright's Guggenheim Museum different from the buildings around it? Explain that the museum's main gallery spirals around an open central lobby capped by a skylight. Encourage students to imagine the routes people would travel from one area to the next in Soleri's Arcosanti. Ask: Why, do you think, was Plug-In City never built?

## **Planning Forms** for the Future

Imagine that you are asked to plan a new city. What would you include? What kinds of spaces would people need? Where would they live, work, and play? How would they get from place to place? How would you plan for them to get food and other items they need?

The idea of planning a new place from scratch has appealed to people throughout history. For example, such artists as

Hieronymus Bosch (Fig. 7-5) have created images of fantasy worlds or cities of the future. Architects and other artists often get ideas for the future from science-fiction stories, futuristic comic books, and children's drawings. They also dream of ways for new technology to meet people's needs in years to come. As cities develop, these visions sometimes become reality.

Fig. 8-6 American architect Frank Lloyd Wright created a new plan for viewing artworks in a museum: people walk a spiraling interior ramp that echoes the building's exterior shape. Frank Lloyd Wright, Solomon R. Guggenheim Museum, 1956-59.

Fig. 8-7 A group of British architects created the magazine Archiaram to show their ideas for a new kind of architecture that was not meant to be permanent. In Plug-In City, separate living units were to be plugged in to a central structure that provided power and water Why, do you think, was this kind of structure never built? Archigram-Peter Cook, Plug-In City, 1964.

254

## **Teaching Options**

## **Meeting Individual Needs**

Multiple Intelligences/Spatial and **Bodily-Kinesthetic** Have students work in groups of five or six to "build" the Guggenheim Museum Bilbao (Fig. 8-1) with their bodies. As they hold their poses, encourage students to close their eyes and sense their relationship to the space around them. After the demonstrations, ask students to write what this experience taught them about architecture and its interaction with the surrounding space.

## More About...

Early in his career, American architect Frank Lloyd Wright (1869–1959) developed his Prairie-style houses. which featured the horizontal lines of the Midwest's flat landscape. After seeing the Japanese pavilion at Chicago's 1893 World's Columbian Exposition, he became interested in Japanese architecture and incorporated the simplicity of Japanese forms and sensitivity to nature into his designs. In 1943, Solomon R. Guggenheim commissioned Wright to build a museum for the American industrialist's contemporary art collection.

## **Planning Decisions**

Most professional planners, however, do not have the opportunity to plan cities from scratch. Instead, they must plan buildings, parks, and other spaces within neighborhoods that already exist (Fig. 8–6). When architects plan, they consider how the new site will fit what is already there. A new structure may look similar to the other structures, wildly different, or somewhere in between. Planners also consider how the people who currently live or work in the area will be affected by the new plans.

Whether designing whole neighborhoods or just one building, planners must consider future needs. Some planners have created

Fig. 8-8 This plan for a city combines architecture with ecology. The architect has given the name arcology to his ideas. An arcology complex contains apartments, businesses, entertainment, and open spaces. Paolo Soleri, Arcosanti, 2001.

buildings and cities that have contributed to pollution and other environmental problems. Others, though, have sought ways to create new places while also saving the earth's resources. Architect Paolo Soleri has designed a city plan called *Arcosanti* (Fig. 8–8), in which the automobile would not be necessary. All services would be within walking distance of one another. Renewable resources, such as the sun and wind, would provide the city's energy supply.

## **Critical Thinking**

Get permission, and then have students interview local zoning-board members, building inspectors, or city planners so as to learn what community concerns these people address in their jobs. Ask students to consider whether a master plan exists for their community. Have students present their findings to the class.

## Extend

Have small groups of students design a playground for younger children. Suggest to students that they begin by listing the types of playground activities in which people will participate. Ask: What type of building materials will you use? As students work, guide them to consider safety and the ways in which children play. Have groups either draw their plan or construct a model of it.

Artists as Planners

255

## **Teaching Through Inquiry**

Aesthetics Invite students to create a list of "rules" they would want an architect to follow when designing a new school building to replace their present one. Guide students to consider such factors as the purposes for the school, construction materials, the "message" the building should convey, and the surrounding structures and space. Have students complete their lists in small groups and then share them in a large-group discussion.

## **Using the Large Reproduction**

## Talk It Over

**Describe** Carefully describe the architectural forms you see.

**Analyze** How did the planner use color and other art elements and principles to create interest in this piazza?

Interpret What moods or feelings does this

architectural form suggest to you?

**Judge** Is this a place most people would like to visit? Why or why not?

## **Artists as Planners**

## **Supplies**

- construction materials
   (Styrofoam, foamcore board, cardboard, cardboard tubes, wood scraps, boxes, construction paper, tagboard)
- scissors
- white glue or glue gun (optional)
- staples, tape (optional)
- tempera paint (optional)
- · brushes (optional)
- water (optional)
- · markers (optional)
- utility knives (optional)

## **Using the Text**

Art Production Review the factors that architects consider when they begin to design a building. Lead students in deciding where their building will be located, what its use will be, and how its use will affect its design.

Demonstrate folding and cutting cardboard and foamcore board to create a variety of forms. Encourage students to imagine how the forms they make can suggest building shapes.

## **Using the Art**

Art Criticism Discuss how student artist Jonathan Richards created symmetrical balance in his model, and how the exterior of his building suggests its use.

Art Criticism Ask: What type of balance does the Parthenon have? (symmetrical) Point out that very few perfectly straight lines exist within its design: even the columns taper slightly at the top. (See page 25 for a relief from the Parthenon's interior frieze.)

## **Critical Thinking**

"Form follows function" was a credo of twentieth-century architects.
Challenge students to explain what this means. **Ask:** Should the function or use of a building always be more important than how it looks?

## Sculpture in the Studio

## Building an Architectural Model

Before architects plan a building, sketch ideas, and make models, they first analyze what will be the building's use. They ask what activities

will take place in it, and what needs it must meet. They think about the building's heating and cooling systems, lights, walls, windows, and so on. They think about how the building will look on the inside and outside. They ask what the building will evoke, or call to mind, about its use. For example, a courthouse could have architectural features that evoke solemnity and justice, such as a broad stairway leading to high-ceiling, vast interior spaces.

In this studio experience, you will build an architectural model for a particular setting. Decide what kind of public building your model will represent. Think about your building's use, appearance, and what it will evoke, or call to mind, about its use. Make decisions about types of forms, such as cylinders, cubes, cones, or pyramids. How will you assemble them to create a sense of balance? Consider how the building's overall form will fit into its setting.

## You Will Need

- construction materials, such as Styrofoam<sup>™</sup>, foamcore board, cardboard, and wood scraps
- scissors
- white glue
- tempera paint (optional)
- brushes (optional)
- water (optional)

## Try This

1. Decide what kind of building model you will create. Will you build a model for a skyscraper or a community building that calls to mind what its use

will be? For what setting—city, village, forest, ocean, or outer space—will you create your model? How will you use forms to express your ideas? Sketch your plan.

**2.** Choose the forms you need to construct your model. Will you cut or bend any materials to create forms? Experiment with the

arrangement of the forms. How will you create balance in your arrangement?

Fig. 8–9 Because the Greeks thought of beauty as based on perfect proportions and balance, they planned each part of a building to harmonize with the other parts. What buildings in your town show the influence of Greek planning? Iktinos and Kallikrates (Ancient Greek), *The Parthenon* (northwest view), 448–432 BC.
The Acropolis, Athens, Greece. Art Resource, New York.

## **Studio Background**

#### **Learning from Ancient Planners**

For centuries, city and building planners in the Western world have been influenced by ancient Greek and Roman ideas.

The Greeks developed innovative ways to build temples and outdoor theaters. The Romans invented concrete and combined it with stone to build huge domed meeting halls and stadiums. Their city plans included the construction of roads, bridges, and aqueducts (channels that transport water) throughout their vast empire.

256

## **Teaching Options**

## **Teaching Through Inquiry**

Art History With the whole class, generate a list of kinds of public buildings and spaces (courthouses, libraries, sports arenas or stadiums, theaters, museums, gardens, amusement parks), and have students each select one kind to investigate. Invite students to form groups according to their interest, and instruct groups to use library and Internet resources to find at least three examples of their chosen kind of architecture, each from a different period and/or culture. Ask students to compare and contrast the examples and present their findings to the class.

**3.** When you are satisfied with your arrangement, carefully glue the forms together. Will you paint your finished model? Or will an unpainted model better express your ideas?

## Check Your Work

Display your architectural model with your classmates' models. Talk about the purpose and meaning of each model. How did you and your classmates create balance? Discuss the way that each model would fit in with other buildings that could be planned for the same setting.

Fig. 8–10 Look at the title of this image. See if you can identify the features of this building that suggest its use. Jonathan Richards, Aeronautics Museum, 2000.

Carthoard tabe. tempera, adhesive-backed paper, 19\* x21\* x6\* (48 x 53 x 15 cm). Thomas

rince School, Princeton, Massachusetts.

Fig. 8–11 What forms did the artist use to create his design? How did he create balance? Matt Hager, The Olive Hotel with a Mushroom, 2000. Cardboard, Styrofoam, masking tape, paper plates, 38 ½° x 12° x 12° (98 x 30.5 x 30.5 cm). Thomas Prince School, Princeton, Macrachinetts

#### **Lesson Review**

#### **Check Your Understanding**

- 1. What is architecture?
- **2.** Identify two or more ideas about architecture for which Frank Gehry is known.
- **3.** Name two or more things that architects and city planners consider when they plan buildings and cities.
- 4. When planning a building, do you think it is more important for the architect to consider the way the building will function or the way it will look? Why?

Artists as Planners

257

## **Assess**

## **Check Your Work**

Allow students to arrange their models into communities. Encourage students each to explain their model's purpose, meaning, and visual balance.

## Check Your Understanding: Answers

- 1. Architecture is the art of planning buildings and space for private and public use.
- 2. Answers may vary. Gehry is known for creating sculptural forms, and spaces with light and air; and using materials in new and unusual ways.
- 3. Answers may vary. Architects consider how a new site will fit with what is already there, and the purposes that the building or designed space will serve.
- **4.** Answers may vary. Look for reasons that support the response.

## Close

Have students summarize their process for designing and constructing their models. Did they make changes in their original idea? Why? Ask them why architects create models of their buildings before they begin construction.

## More About...

Greek architects Iktinos and Kallikrates designed the **Parthenon** as a temple for the goddess Athena. It sits atop the Acropolis, a rocky outcrop in Athens. Because the Greeks were concerned with harmony and proportion in their architecture, they organized their public buildings into orderly arrangements of parts. The Parthenon, with its columns topped by a molding and square blocks, is one of the best examples of Doric architecture.

## **Assessment Options**

**Teacher** Have students create an original way to teach younger children about artists as planners. Instruct students that

they must find a way to tell about architecture and what architects do, factors that architects must consider, what challenges they face, and what they can be proud of. For example, students—alone or in groups—may create a poem, a story, a TV show, or new lyrics to a popular song. Encourage students to use examples to help make their points. Look for evidence that students understand the range of planning that architects engage in and their considerations when designing a structure or space.

## **Architecture for Living**

## **Prepare**

## **Pacing**

One or more 45-minute periods to consider text and images and to draw the elevation

## Objectives

- · Recognize both symmetrical and asymmetrical balance in architecture.
- Describe Melinda Gray's approach to architecture.
- Use ruler and compass to render an architectural drawing of a dream house.

## Vocabulary

cantilever A structure, such as a beam or roof, that is supported at one end only.

Post-Modernism A style that reacts against earlier modernist styles. Post-Modern architecture often combines some styles from the past with more decoration, line, and/or

## **Using the Time Line**

Tell students that in the pre-Civil War era of The Red House, architects based their designs on earlier, traditional styles. By the 1930s, architects had adopted the international style developed by Bauhaus architects, who pared their designs down to the essentials. In the 1980s, Post-Modern architects reintroduced classical elements into architecture. Ask students to think of buildings in their community. Ask: When were they built? Where would they be positioned on this time line?

## **National Standards** 8.1 Then and Now Lesson

3a Integrate visual, spatial, temporal concepts with content.

4a Compare artworks of various eras, cultures

4c Analyze, demonstrate how time and place influence visual characteristics.

## **Architecture for Living**

The Red House, Webb

Venturi Vanna Venturi House

1992 Gray, Gluelam House

19th Century

THEN AND NOW LESSON

20th Century

1936-39 Wright, **Fallinawater** 

The 13° House

## **Travels in Time**

The first true builders were the Paleolithic hunter-gatherers of 750,000 years ago. Because their source of food was often far from their natural shelters of caves and rock ledges, they needed to find-or buildshelters that were close to lakes and rivers, where food was plentiful. The hunter-gatherers developed ways to construct simple wooden shelters. Over time, as new materials and techniques were discovered, people changed the design of their dwellings. Architects have tried to plan for more than just the shelter and comfort provided by a dwelling. Their designs show their concern for the way a house looks and what it says about the person who inhabits it.

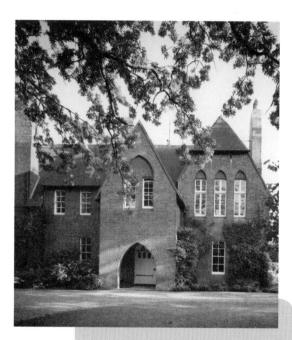

castles from the Middle Ages? Philip Webb, The Red House, 1859.

## **Planning Houses**

Of all the kinds of buildings ever built, perhaps none is more interesting than the house. British architect Philip Webb was well known for his plans for private homes in the nineteenth century. One of his best known is the Red House (Fig. 8-12), built

for William Morris, who was also a designer. Their goal was to create a contemporary look but also to use architectural features from older styles of buildings.

258

## **Teaching Options**

## Resources

Teacher's Resource Binder

Names to Know: 8.1

A Closer Look: 8.1

Find Out More: 8.1

Check Your Work: 8.1

Assessment Master: 8.1

Overhead Transparency 15

Slides 8c

## **Teaching Through Inquiry**

Art History Ask students to make an architectural survey of their community. Guide them to identify homes and other buildings that have had a long life, find the date when each structure was constructed, and identify the stylistic features that could be clues to when it was built. Ask: What is the condition of each building? If the building is in good repair, what was done to preserve or change it? If the building has been neglected, what could be done to give it a new life?

## **Creating Form**

Architects have always created balanced forms. However, in the early twentieth century, architects were able to use such recently developed materials as steel and iron to create new kinds of balanced forms.

In 1939. Frank Lloyd Wright designed the home Fallingwater (Fig. 8–13) with a modern look. He used steel to create cantilevered terraces to connect the home with its natural surroundings. (A cantilever is a projected beam supported at one end and freestanding

at the other end.) The cantilevers allow parts of the building to project over the water and rocks. Wright's use of cantilevers was an exercise in asymmetrical balance.

In the mid-twentieth century, some architects began to plan structures that looked back to the symmetry of traditional architecture. Architect Robert Venturi and others wanted to return to the formal design of carefully organized and symmetrical façades. This new trend in architecture was

called Post-Modernism, because it broke away from the modern look of earlier decades. In such structures as the Vanna Venturi House (Fig. 8–14), Venturi's designs create a playful mix of symmetry and asymmetry.

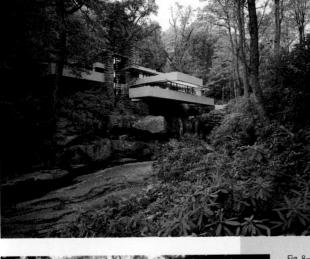

## **Engage**

Use a ruler and a small stack of books to create a cantilever atop a desk. Discuss how architects could use a cantilever in a building design.

## **Using the Text**

Art History Read the text and describe structures built by Paleolithic hunter-gathers. Ask: What were Philip Webb and William Morris trying to create in their house designs? (a contemporary look with features from older designs) How do Post-Modern architects share Webb and Morris's goals? How are their designs different? (Although they create balanced forms, as did past architects, Post-Modern architects do so in new ways, as with the use of cantilevers.)

## Using the Art

Aesthetics Have students locate the waterfall and the cantilevered terraces in the Kaufmann house. Ask: How does this home fit in with the landscape?

Artists as Planners

259

## More About...

When the Kaufmann family, wealthy owners of a Pittsburgh department store, commissioned Frank Lloyd Wright to design a summer home at their favorite camping spot on Bear Run, they envisioned a house with a view of the waterfall. However, Wright built Fallingwater over the waterfall, making it part of the design. The house is now a museum.

## **Using the Overhead**

## Investigating the Past

Describe What materials were used? What basic forms do you see? What details do you notice?

Attribute Why, do you think, would someone knowledgeable about styles of architecture be able to tell, just by looking at this house, approximately when it was built?

Interpret What does this home suggest to you about how the people who lived there wanted other people to think about them?

Explain What features of this building seem to be borrowed from earlier forms of architecture in England?

## Architecture for Living

## **Using the Text**

Aesthetics Read aloud Melinda Gray's statement, and then encourage students to restate this in their own words. Ask: How are you affected by order in your surroundings?

Art Criticism Ask: How does Melinda Gray use geometry in her designs? (bases her plans on geometric shapes and forms) How does Gray unify her designs? (uses grid patterns)

## **Using the Art**

Art Criticism Ask: How are Gray's houses similar to and different from homes in your neighborhood? Have students locate repeated grid patterns in the exterior view, and discuss how these unify the design.

Ask: What other features were repeated in these designs?

## **Critical Thinking**

Challenge students to develop a list of subjects that they think would be useful for architects to study. Have students check their lists against architecture-degree curricula, summaries of which students may find in university catalogs or on the Internet.

## **Studio Connection**

Ask: What type of house would you like to live in? How would it be different

from where you live now?

After students have completed their drawing, have them write a description of the special features of their dream house.

**Assess** See Teacher's Resource Binder: Check Your Work 8.1.

## Extend

Show students either some actual architectural drawings of floor plans or some from the Internet. Assign students to draw their dream house's floor plan. Discuss how various spaces will be used and how people will move from one area to another.

## **A Logical Planner**

"I'm really into order. It affects people even if they don't perceive it." Melinda Gray (born 1952)

Melinda Gray was born in 1952 in Chicago, Illinois. Like many of today's architects, she continues the tradition of creating new spaces for homes. After college, Gray studied architecture at the University of California in Los Angeles and apprenticed with a designer of commercial structures.

Gray's approach to architecture is a mix of craftsmanship, logical planning, and experimentation. Because her interest in

Photo by Grey Crawford. Courtesy Gray Matter Architectu

architecture grew out of a love of geometry, Gray bases her complex plans on geometric principles. She plans her buildings by using geometric shapes and forms that collide and intersect in dynamic ways.

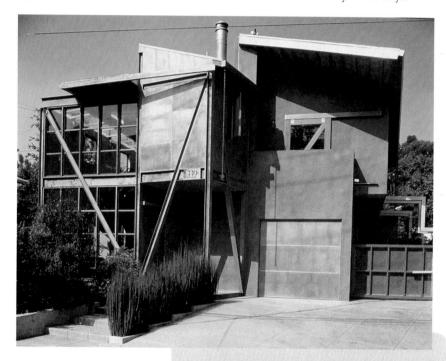

Fig. 8–15 Melinda Gray plans houses that are full of contrasts, such as curved and straight lines, open and closed spaces, and formal and informal balance. Melinda Gray, The 13° House (exterior), 1996.

Santa Monica Canyon, California, Photo by Grey Cardyord, Courtesy Gray Matter Architecture

260

HEN AND NOW LESSO

## **Teaching Options**

## **Meeting Individual Needs**

English as a Second Language and Multiple Intelligences/Linguistic and Spatial Help pairs of students read and understand the captions for all the images on these pages. Next, ask students to tell, in written or spoken English, which house they would like to live in and to explain how the architecture and use of space attracts them. After, have students draw their own design for a dream home of the future on a distance planet. Encourage students to consider how their architecture will relate to the "space" in space.

## **Teaching Through Inquiry**

Art Production Have students each make a drawing or a construction model of a house that makes no sense at all. Challenge them to be playful and imaginative. Caution students, however, that regardless of how strange the house looks, it should have enough practical features to make it functional. For example, if the door is on the roof, there should be access to it.

## The Order of Architecture

Gray especially likes to experiment with materials, and she mixes them in fun, unexpected ways. For example, she will contrast the warmth of natural wood with the coolness of steel or glass. She also designs carefully placed courtyards, gardens, balconies, and other outdoor spaces. These spaces visually extend the house and help people move around easily.

To unify her designs, Gray uses grid patterns. For the exterior of homes such as the 13° House (Fig. 8-15), she repeated patterns of squares and grouped square windows in a variety of sizes. She contrasted the strong vertical and horizontal lines with a curved, vaulted roof. The interiors of the homes she designs are based on cubes and other forms that intersect to create wide, open spaces. When she plans a room, Gray sometimes thinks about ways that two or more rooms can share space but also maintain privacy. Look at an interior view of one of Melinda Gray's homes (Fig. 8-16). What are some possible ways that space could be shared by two rooms?

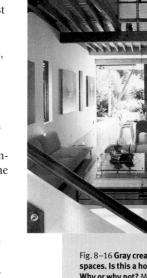

Fig. 8–16 Gray creates light-filled interior spaces. Is this a home you would like to live in? Why or why not? Melinda Gray, *The Gluelam House* (interior), 1992.

Santa Monica Canyon, California. Photo by Richard Cheatte. Courtesy Graw Matter Arthitecture.

#### **Studio Connection**

Draw an elevation plan or a façade of your dream house. Many architectural drawings are done with tools, like a ruler

and compass, that help make even lines and shapes. Make decisions about whether you want the front of your dream house to have a formal, symmetrically balanced look or a more informal, asymmetrical look. Before finalizing plans, do some research, and study some architectural floor plans and elevation drawings. Make sketches with pencil before rendering the final drawing with a fine-tip marker.

## Lesson Review

## **Check Your Understanding**

- 1. What do architects do?
- **2.** What architectural feature did Frank Lloyd Wright use to achieve asymmetrical balance?
- 3. Why did Melinda Gray become interested in architecture?
- **4.** Describe Melinda Gray's approach to architecture.

## **Assess**

## Check Your Understanding: Answers

- **1.** Architects design buildings and spaces for people.
- 2. cantilevers
- 3. She loved geometry.
- **4.** Gray mixes craft, logical planning, and experimentation.

## Close

Display students' drawings and written descriptions. Allow students to describe their house to their classmates, and have them identify the type of balance in their design.

Artists as Planners

261

## More About...

Melinda Gray describes the home of Jennifer Clark (Fig. 8–15) as an "honest house" because the structural elements of beams and pipes are exposed, not hidden behind a façade. Because she designed the home soon after the 1994 Northridge, California, earthquake, she used steel for part of the structural framework. Though steel is more expensive than wood, it is stronger and it allowed her to enclose large spaces.

## **Assessment Options**

**Peer** Have students work in small groups to explore the symmetrical and asymmetrical

balance of potential building forms, such as tennis balls, paper-towel tubes, tissue boxes, and ice-cream cones. Provide a variety of these found or constructed forms. Ask students to comment on the contributions of others in their group.

**Self** Ask students to reflect on their personal preference between a formally and symmetrically balanced building façade and one that has informal or asymmetrical balance.

## Prepare

## **Pacing**

Two or more 45-minute periods: one to consider images and text and to plan model; one to construct model

## **Objectives**

- Understand why architects make models
- Make three-dimensional geometric forms.

## Vocabulary

architectural model A small, threedimensional representation of a building, often made of paper, cardboard, wood, or plastic. Architects usually create such a model during the process of designing a building.

## Teach

## Engage

Ask: Where are there spheres, pyramids, cubes, rectangular solids, or cylinders in our school's architecture? What structures in the community were made from forms other than rectangles?

## **Using the Text**

Art Production Ask: Why, do you think, do architects construct models of their buildings? Demonstrate forming a cube, cylinder, cone, pyramid, arch, and geodesic dome from construction paper.

## **Using the Art**

Art Criticism Ask: What geometric forms do you see in the model? What type of structure might this become? What does the color suggest about the building? Where would you add windows or doors?

## National Standards 8.2 Skills and Techniques Lesson

**1b** Use media/techniques/processes to communicate experiences, ideas.

2c Select, use structures, functions.

## **Three-Dimensional Models**

Architects work with many other professionals to plan a building, but they are responsible for deciding how the final building will look. They sometimes plan a building using only a few basic geometric forms, such as a cube for the central space, cylinders for columns, and a pyramid for the roof. In other cases, an architect might decide to combine a great number of forms and shapes, including towers, domes, arches, spheres, barrel vaults, or cones. Look at the drawing of the building. It offers one example of how basic geometric forms can be combined.

During the process of designing a building, architects often create an **architectural model**—a small, three-dimensional representation of the building—from paper, cardboard, wood, or other materials. Some of the techniques they use are similar to the ones illustrated on these pages.

When you make a three-dimensional model, you may decide to use some readymade boxes, tubes, or spheres, if necessary.

#### **Architectural forms**

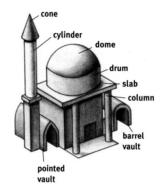

## **Practice Creating Forms**

Use construction paper, scissors, and glue to make a series of three-dimensional forms: a cube, a cylinder, a cone, a pyramid, and an arch. Use a ruler and compass when necessary. Be sure to measure carefully before you cut. Make crisp folds and use glue neatly. For additional guidance, study the diagrams provided on these pages.

## Paper-folding techniques

#### How to create and assemble a barrel vault

262

SKILLS AND TECHNIQUES LESSON

## **Teaching Options**

## Resources

Finder Cards: 8.2
A Closer Look: 8.2
Find Out More: 8.2
Check Your Work: 8.2
Assessment Master: 8.2
Overhead Transparency 16
Slides 8d

Teacher's Resource Binder

## More About...

Mechanical drawings are minutely detailed architectural "recipes." Text and sketches provide specific information about scale, angles, measurement, surface quality, and materials, along with detailed instructions on how to manufacture the building or object. Artists known as drafters create third-angle projections, revealing the top, front, and side views of the item simultaneously. Drafters sometimes still use traditional tools—such as compasses, curves, protractors, and T-squares—to produce drawings by hand. Most, however, work with CADD—computeraided design and drafting—which allows easy and speedy storage and sharing of images.

Note: Spheres and domes are not easy to make with construction paper and glue. However, you might try using the diagram below to help you construct a "geodesic dome" by folding and gluing together several circles. To make the dome, fold a circle on three sides to make a triangle with three flaps. Join many of these forms to make a dome.

#### Folding for geodesic dome

#### **Studio Connection**

Work with a small group of classmates to construct a three-dimensional model of a building or even a model of

a group of buildings. First, look at pictures of various buildings. Which basic forms did the architect combine in each one? Then discuss what you might create. Make some sketches to show how your building(s) can be created from basic forms. Then use construction paper to create a three-dimensional model of your plan.

#### **Lesson Review**

## **Check Your Understanding**

- 1. What is an architectural model?
- 2. Why do you think architects usually make three-dimensional models when they design a building?

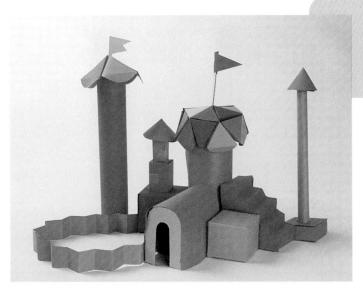

Fig. 8-17 What paper forms make up this architectural model? Group Student Work, A Model Village, 2001.

263

Artists as Planners

## Studio Connection

Have students work in groups of three or four to sketch ideas and then in-

corporate the individual ideas into one model. Provide groups with assorted colors and sizes of construction paper, scissors, glue, and staplers or tape. You may wish to have students use markers and paper shapes to add details, and to arrange their forms on a piece of cardboard.

Assess See Teacher's Resource Binder: Check Your Work 8.2.

## **Studio Tip**

To help students construct the basic geometric forms, provide varioussized enlargements of the diagrams in this lesson. Students may lay the diagram on construction paper and then cut out the paper and the diagram together.

## Assess

## **Check Your Understanding: Answers**

- 1. Answers will vary.
- 2. Models help architects revise their plans; architects use models to show clients how a finished building will look.

## Close

Have groups present their model to the class and identify its geometric forms and special features.

## Teaching Through Inquiry

Art Criticism Provide magazine photographs of buildings, and ask students to examine the buildings for evidence of three-dimensional geometric forms. Have students place tracing paper or clear acetate over the photographs and indicate the forms. Have students share their findings.

Art Production Have students create a series of sketches of their building from different views. Ask: Are you satisfied with the overall design? How could you improve it?

## **Using the Overhead**

#### Write About It

Analyze How did the architect combine these forms to attract and hold the viewer's interest?

Describe Describe

in this building.

the geometric forms

## **Assessment Options**

Peer Have pairs of students share their completed geomet-

ric forms, discuss the processes they used, and assist each other in identifying the forms that were produced well and those that could be improved.

## **Prepare**

## **Pacing**

Two 45-minute periods: one to consider text and images; one to draw

## **Objectives**

- Distinguish between the type of architectural structures built by early civilizations and those built by the Spanish in Mexico
- Identify influences of pre-Hispanic and early Spanish architecture in the work of Ricardo Legorreta.
- Draw a plan or aerial view of a public gathering place.

## Vocabulary

hacienda A Spanish word used to describe a large plantation or residence.

## **Using the Map**

Ask: On what continent is Mexico? (North America) What countries border Mexico? (United States, Guatemala, Belize) Mexico is about one-fifth the size of the United States. Look at the map. Notice that two mountain ranges run the length of the country, with the third highest peak in North America, Pico de Orizaba (Citlaltépetl), in the eastern range. Mexico's capital, Mexico City, sits on a high, central plateau surrounded by snow-capped volcanoes and is one of the most populous cities in the world. Mexico is a land of contrasts —from the dry northern deserts to the tropical Yucatan peninsula jungles to the thousands of miles of seacoasts.

## National Standards 8.3 Global Destinations Lesson

- **2b** Employ/analyze effectiveness of organizational structures.
- **4a** Compare artworks of various eras, cultures.
- **4c** Analyze, demonstrate how time and place influence visual characteristics.

## **Art of Mexico**

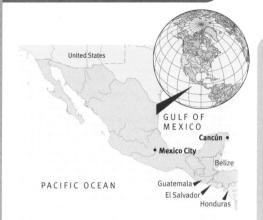

Mexico

## **Urban Architecture**

Urban architecture in pre-Hispanic Mesoamerica began with the rise of carefully planned ceremonial centers. In these urban centers, large groups of people could watch and take part in rituals and other events, both civic and religious. Early

Mexican planners developed an architecture of gently sloping walls, as well as plazas, platforms, ramps, and stairs (Fig. 8–18). Builders used local resources and raw materials for the building of stucco-covered stone walls.

The styles and structures of pre-Hispanic archaeological sites often have inspired modern architects, including Pedro

**Places in Time** 

Mexico, which is part of the North American continent, borders the United States. Most of the country's natural landscape is marked by hills or mountain ranges broken by plateaus. Deep valleys and canyons lie in contrast to the high mountains. The dramatic contrast that exists in the natural landscape can also be found in the human-made landscape: buildings. Structures range from simple adobe homes to complex stone temples. Mexico has always been a nation of planners and builders. The ruins of pyramids and temples are evidence of the architectural achievements of such early civilizations as the Olmec, Maya, Toltec, and Aztec cultures.

Ramírez Vázquez. For the National Museum of Anthropology (Fig. 8–19), Vázquez wanted a place where Mexican people could honor their heritage. He designed the museum around a large central plaza that was protected, yet open, and where people could come and go as they pleased.

Fig. 8-18 What is the overall plan of the placement of these structures? What evidence do you see that shows that the planners were thinking about having large groups of people moving about? Mexico,  $Teotihuac\acute{an}$ , 1st century AD. Photo courteys Karen Durlach.

264

## **Teaching Options**

## Resources

Teacher's Resource Binder
A Closer Look: 8.3
Find Out More: 8.3
Check Your Work: 8.3
Assessment Master: 8.3
Large Reproduction 16
Slides 8e

## **Teaching Through Inquiry**

Aesthetics Remind students that early and colonial Mexican cities and farms were well planned. Explain that a good working relationship between people and the built environment, whether in the city or the country, is based on careful planning of the space. Encourage students to "experience" the buildings and spaces in their city, town, or farm in a new way. Ask students to describe how they feel when they are standing or sitting in specific places; how the size of each space makes them feel; and how they respond to colors, lighting, sounds, and textures. Have students compare and discuss their reactions to the built environments.

Fig. 8–19 Why does the overall plan of this space seem balanced? Pedro Ramírez Vázquez, The National Museum of Anthropology, 1964.

Fig. 8–20 Barragan was known for the simple style of his buildings. Notice his use of color and asymmetrical balance. Luis Barragan, *Casa Antonio Galvez*, 1954.

## **Rural Architecture**

In the sixteenth century, Spanish settlers in Mexico began to build large agricultural estates called **haciendas**. The buildings and the spaces around them were planned on a grand scale to house hundreds of workers on the plantation. Today, the hacienda continues to be a popular style for homes in Mexico. Architect Luis Barragan planned buildings (Fig. 8–20) in a style that recalls the hacienda's simple, boxlike exteriors. His use of bright colors and such materials as water, stone, and plants resulted in architecture that was in harmony with its natural surroundings.

## Teach

## Engage

Encourage students who are familiar with Mexican and southwestern United States architecture to describe typical building features, such as tile roofs, stucco or adobe walls, courtyards, and rounded arches.

## **Using the Text**

Art History Ask: What were some early Mexican civilizations? (Olmec, Maya, Toltec, Aztec) How do we know about the architecture of these civilizations? (from their pyramids and temple ruins) Ask students to describe pre-Hispanic architecture styles. Explain that pre-Hispanic (pre-Columbian) refers to the period before the Spanish conquest of Mexico, in 1519.

## **Using the Art**

Art Criticism Ask: What in Figs. 8–18 and 8–19 are alike? (Both have spaces to accommodate large numbers of people.) How did architect Luis Barragan suggest a hacienda in Casa Luis Barragan? (with simple boxlike exteriors)

Artists as Planners

265

## More About...

**Teotihuacán**, Mesoamerica's first metropolis, was ascending at about the time that the Roman Empire was crumbling. By 500 AD, this symmetrically planned city of nearly 200,000 covered 9 square miles. The Aztec believed that Teotihuacán was the "place where gods were born." Today, sacrificial altars, some grand houses, and three rough stone pyramids remain. Originally, all had stuccoed exteriors that were adorned with frescoes.

## **Using the Large Reproduction**

## **Consider Context**

**Describe** Tell about the colors and how they make you feel. Describe the lines and angles of the building.

**Attribute** What in this structure reminds you of the pyramid structures of ancient Mexico? Explain.

**Understand** Do you think this building has a Mexican look about it? Why do you think this?

**Explain** Where, do you think, did the architect get his inspiration for this building?

## Using the Text

Art History Discuss Ricardo Legorreta's early experiences with architecture. Ask: What type of Mexican structures have inspired Legorreta's architectural designs? (Spanish haciendas, pre-Hispanic ceremonial centers) What are some "chain-restaurant and Hollywood set-design stereotypes"?

## **Using the Art**

Aesthetics Ask: How does Legorreta's design for the Camino Real Hotel take advantage of its site and view? What are the basic geometric forms in its design? What ancient Mexican structure does this resemble? (pre-Hispanic pyramids) How do Legorreta's buildings support his statement on page 266?

## **Studio Connection**

Discuss a shopping mall or town center familiar to students. Have them describe

how people move from one area to the next within it. **Ask**: Are there any bottlenecks? How could you improve on the area's plan? Encourage students to research architectural drawings on the Internet so as to see how artists indicate changes in elevations.

Ask: What activities will occur within your chosen gathering place? How will traffic flow through your site? What would be the advantages of a symmetrical design over an asymmetrical one? Which type of balance would work better for your site? Ask students to draw their plan lightly in pencil on a large sheet of paper and then to use pencil or a fine-tip marker to finish their drawing. Students may wish to add color with pencils or markers. Have students neatly print the names of buildings and areas on their plan.

**Assess** See Teacher's Resource Binder: Check Your Work 8.3.

## **Becoming an Architect**

"You have to go to the roots, to the culture, and design for a place. The challenge is to create architecture that everyone feels good in." Ricardo Legorreta (born 1931)

Ricardo Legorreta doesn't remember when or how he decided to be an architect. He says that it just happened. His interest in architecture came about in a natural way, from his visits to towns, haciendas, convents, churches, and the Mesoamerican pyramids. Born in Mexico City, Legorreta worked as a draftsman while studying for his degree in architecture at the University of Mexico.

Early in his career, Legorreta looked to the traditional architectural styles of Mexico. He worked with elements from both the Spanish haciendas and the pre-Hispanic ceremonial centers. However, he wanted to avoid the chain-restaurant and Hollywood set-design stereotypes of Mexican buildings. His buildings, therefore, combine the look of historical Mexico with the feel of the modern age.

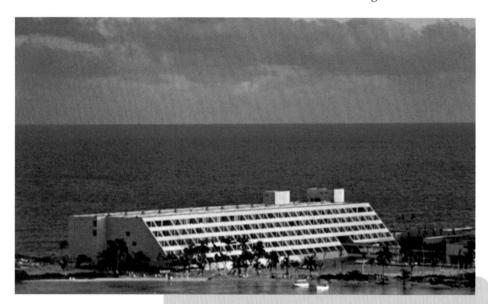

Fig. 8–21 What features of this structure remind you of the pyramids at Teotihuacán, pictured on page 264? Ricardo Legorreta, Camino Real Hotel, 1981.

Cancun, Mexico. Photo courtesy Legorreta Arquitectos.

266

## **Teaching Options**

## **Meeting Individual Needs**

Gifted and Talented Help students find images of pre-Hispanic architecture online and/or in art books, magazines, and encyclopedias. Have student pairs locate in these examples, architectural elements that Ricardo Legorreta has incorporated into or suggested in his architecture (such as the receding, ascending steps in many sacred or ceremonial buildings). Have students discuss how Legorreta calls on his ancestral roots—especially in materials, style, and function—in his distinctly modern buildings.

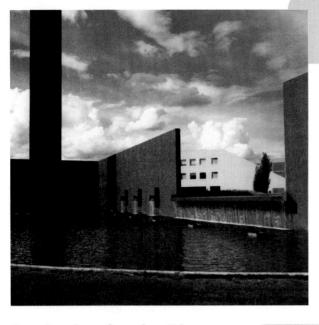

Fig. 8–22 How did the architect achieve informal balance in the plan for this site? Ricardo Legorreta, *Solana Complex*, 1992. Solana Texas Photo by Jourdes Legorreta.

## **Designing for the Place**

Legorreta's many hotels, like the one in Fig. 8-21, are planned to take advantage of the view and terrain. As in ancient Mexican ceremonial centers, they include open, public gathering spaces. But Legorreta also plans for enclosed and private spaces, following the tradition of convents, haciendas, and smaller Mexican houses. He plans other kinds of buildings, such as the corporate complex in Fig. 8-22, with walls of different size and scale. All of Legorreta's buildings are similar in their blending of simple forms, open spaces, natural light, and carefully planned color schemes. His architecture combines monumentality with simplicity.

#### **Studio Connection**

Draw a plan or aerial view for a public gathering place, such as a shopping mall or town center. Consider how people

and traffic will move through this space. Will there be places for people to sit? Will there be different levels? How could you show this? You may wish to make a 3-D model of your public space.

#### **Lesson Review**

#### **Check Your Understanding**

- 1. What kinds of structures were built by the early civilizations in Mexico?
- **2.** What type of agricultural structure was built by the Spanish in Mexico?
- **3.** Describe features that are similar in many of Legorreta's buildings.
- 4. If you were to plan a building that shows features from both traditional and contemporary Mexican architecture, what are some things you might include?

Artists as Planners

## **Extend**

Ask students each to research pre-Hispanic Olmec, Maya, or Aztec architecture and then to make a poster of its characteristic features.

## **Assess**

## Check Your Understanding: Answers

- **1.** Early civilizations built pyramids and temples.
- 2. hacienda
- 3. Legorreta includes simple forms, open spaces, natural light, and carefully planned color schemes.
- 4. Answers will vary.

## Close

Discuss students' answers to Check Your Understanding. Have students work in small groups to present their plan, identify special features, and trace the traffic flow through the design.

267

## **Teaching Through Inquiry**

Art Criticism Ask students each to choose a building in the community, but instruct them not to reveal their choice. Have students write a detailed description of the building, encouraging them to use architecture books to identify terms that describe certain types of windows, doorways, roofs, and so on. Guide students to tell about the size, materials, construction method, colors, and so on, but to be careful not to identify the building by name or location. Have students each read their description aloud, and have the rest of the class identify the building.

## More About...

In 2000, **Ricardo Legorreta** was awarded the prestigious American Institute of Architects gold medal, recognizing him as an architect whose work has had a lasting influence on the theory and practice of architecture. Legorreta bases his designs on traditional Mexican architecture—which features thick walls, bright colors, and enclosed patios—and on the South American preference for privacy.

## **Assessment Options**

**Peer** Ask student groups of five to write critiques of one another's drawing

of a public gathering place, and to complete and include these two statements: "I like this (particular feature) because . . ." and "I don't care for this (particular feature) because . . ." Each student should receive five critiques.

## **Corrugated Constructions**

## **Prepare**

## **Pacing**

Two or more 45-minute periods: one to consider text and images and to plan the construction; one or more to construct the roller-coaster track

## **Objectives**

- Understand how sculptures and architectural works are made of one or more forms.
- Understand how artists create balance in their artworks.
- Use knowledge of form and balance to plan and construct a rollercoaster track for marbles.

## Vocabulary

form An element of design; any three-dimensional object such as a cube, sphere, or cylinder.

balance A principle of design that describes how parts of an artwork are arranged to create a sense of equal weight or interest. Types of balance are symmetrical, asymmetrical, and radial.

## **Supplies for Engage**

 a game that requires the players to manipulate a marble or ball by tilting a board back and forth

## National Standards 8.4 Studio Lesson

**1b** Use media/techniques/processes to communicate experiences, ideas.

- **2a** Generalize about structures, functions.
- **2b** Employ/analyze effectiveness of organizational structures.

Sculpture in the Studio

## **Corrugated Constructions**

# Planning Architecture for Thrills

Studio Introduction

For many people, one of life's greatest thrills is the roller coaster, or some variation of it. While riding on a roller

coaster, you cannot admire its complex details. But if you look at this ride from the ground, you can see its graceful form and delicate balance.

In this studio experience, you will plan and construct a track for marbles. Pages 270 and 271 will tell you how to do it. How can you build a structure that will direct rolling marbles on a thrilling ride? How will you use form and balance to create a graceful ride for the marbles? Think about curves, gentle and steep rises, and spirals. Think about the kind of motion and speed that these features create.

## **Studio Background**

## Coasting, Anyone?

What do you get when you cross a cylinder with a spiral? An exciting, roller-coaster runway for marbles! Even though real roller-coaster tracks are made from wood or steel, you will plan and build your own from corrugated paper or any other flexible, sturdy paper, such as lightweight cardboard.

Corrugated paper can be made of two or three layers of paper. One layer is pressed to form ribs. The other one or two layers are smooth and cover one or both sides of the ribbed layer. You can easily roll corrugated paper into hollow or solid cylinders. To construct square or triangular forms for mazes, tunnels, and platforms, bend the paper across its ribs, which makes it rigid.

You can make a variety of runway forms by cutting corrugated paper into strips and gluing them together. Vary the lengths and widths of the strips to create several exciting features for your ride. Think of the tunnels, loop-the-loops, and spirals of most roller coasters. Now imagine how you can make them for the marbles' ultimate thrill!

Fig. 8–23 (top) In what ways do you think corrugated pape can imitate the characteristics of a roller-coaster ride?

Fig. 8–24 (bottom) By using the right kind of paper and simple construction techniques, you can create a roller-coaster track for marbles. A well-thought plan is the key to creating a thrilling ride.

268

## **Teaching Options**

## Resources

Teacher's Resource Binder Studio Master: 8.4 Studio Reflection: 8.4 A Closer Look: 8.4 Find Out More: 8.4 Overhead Transparency 16 Slides 8f

## **Teaching Through Inquiry**

Art History Have students create a list of places designed for people to use in their leisure time, such as parks, playgrounds, water slides, golf courses, zoos, amusement-park rides, and public gardens. Ask students to work in groups, according to their interest, to find out more about one of these places. Have groups formulate questions that they have about how and by whom the place is designed, use library and Internet resources to find answers to their questions, and then share their findings with the rest of the class.

## **Construction Tips and Ideas**

· Glue strips of corrugated paper together. The length of the strips will depend on the desired length of your runway. The runway's width will depend on the size of the marbles.

 For a runway that curves left and right, use the edges of the

glued strips as the track surface. For a runway that curves up and down, use the width of the strips as the track surface.

Create guides to keep the marbles on

track. For a left-and-rightcurving runway, cut additional strips to add as walls on each side. For an up-and-downcurving runway, create a

groove in the center of the track surface. Add a very narrow strip of corrugated paper along each edge of the surface. The gap between the narrow strips becomes the groove.

· If your runway has many rises or includes a loop-theloop, make sure the beginning of the track is steep enough to keep the marbles' momentum going!

#### Spirals and Circular Runways

• Create a sturdy cylinder from a sheet of corrugated paper. Then wrap a left-and-right-

curving runway, in corkscrew fashion, along the length of the cylinder.

Attach with glue. To prevent the marbles from falling off the spiral, include a wall on the outside of the runway.

· Tightly coil a long strip of corrugated paper into a large spiral disk. Glue the last

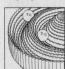

coil directly onto the coil preceding it. Gently push the center of the disk up

from the bottom to create a small mound. To make a spiral or circular runway, create banks and tracks by pushing each side of the disk alternately.

#### Mazes, Tunnels, and **Platforms**

Use a sheet of corrugated paper as the "floor" of a maze.

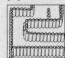

Create vertical walls by gluing the edges of strips to the floor.

- · To create free-swinging "gates" for the marbles, leave some ends of the walls unglued.
- · To create a tunnel, simply glue a strip of corrugated paper

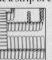

over the top of any squarewalled runway.

· To create a platform, glue several pieces of corrugated paper together. The number of pieces will depend on how high you want the platform. You can also roll and glue strips of corrugated paper. Or you can bend corrugated paper into square or triangular forms.

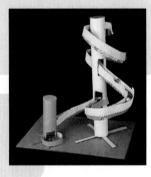

Artists as Planners

## Construction Tips and Ideas. Skye Lawrence, Marble Run, 2001. Corrugated paper and cardboard, 18" x 17" x 11 ½" (46 x 43 x 29 cm). Islesboro Central School, Islesboro, Maine.

Fig. 8-25 This spiral runway is a variation

of the standard type described in

269

## More About...

The earliest roller coasters, in eighteenth-century Russia, were sleds, made of wood or ice, ridden down large ice "slides." These led to the development of all-weather wooden slides and sleds with wheels. In the United States, roller coasters developed from coal-mine transports. In 1884, the Switchback Railway opened at Coney Island, New York. The railway, which cost a nickel a ride, paid for itself within one week!

## **Using the Overhead**

#### Think It Through

Ideas How, do you think, did the architect come up with the idea for this building?

Techniques How do you think a building like this could be constructed?

## **Supplies**

- sketch paper
- pencils
- corrugated paper in several colors or other flexible, sturdy paper
- cardboard tubes (optional)
- scissors
- glue
- · hot glue and gun (optional)
- · staples (optional)
- tape (optional)
- rubber bands or glue clamps (optional)
- · paint and brushes (optional)

## Teach

## Engage

Show students the game, and discuss some considerations in its design. Ask: How is this game like a roller coaster?

## **Using the Text**

Art Production Demonstrate constructing a variety of runways, tunnels, and platforms from corrugated paper or other sturdy paper. Roll marbles down the demonstration runways so that students see how steep the runways must be to keep the marble moving through successive rises, yet not moving so fast that it flies off the track. Ask: How is this construction like a sculpture? How does balance affect the design's appearance and how the marble moves? As students work, remind them to consider the look of the entire structure.

## Using the Art

Perception As students study the photographs of the roller coasters, ask them to identify the positive and negative spaces within the forms. Suggest that they follow the movement along several of the tracks.

## **Corrugated Constructions**

## **Studio Experience**

- 1. Discuss how form and balance will play an important role in the design of the roller-coaster track for marbles.
- 2. As students construct their rollercoaster track, demonstrate using rubber bands or clamps to hold glued structures together as they dry.
- 3. After students have conducted test runs, encourage them to improve the design to rid of any flaws, and to add paint and decoration to some parts of their structure.

## **Idea Generators**

Discuss roller coasters that students have ridden. **Ask:** Where in the ride was the fastest point? The slowest? Where did you feel like as though you were falling through space? What were the features that made the ride exciting? How can you create these features for your roller-coaster track?

## **Studio Tip**

Have students work together to link their constructions to form a giant roller-coaster track. Students may need to place some of the structures on lower levels so that the marbles will drop into the next run.

## **Extend**

Challenge students to create a larger track, one for Ping-Pong or tennis balls. Encourage students to be creative in their design, suggesting that they include chutes, drops, slides, levers, and sound effects. For construction materials, students might use carpet tubes, rulers, dryer-vent ducting, and plastic tubing.

## Sculpture in the Studio

## Making Your Corrugated Construction

## You Will Need

- · sketch paper
- · pencil

STUDIO LESSON

- corrugated paper or other flexible, sturdy paper
- scissors
- glue

## Try This

- 1. Come up with a plan for your marble track. How many features will your ride have? Will you focus on one feature, such as a spiral or a maze? Or will you also include tunnels, gently curved runways, or loop-the-loops? Think of ways to create balance in your work. Sketch your ideas.
- **2.** Construct your runways and other features. See Construction Tips and Ideas on page 269. Do you need to make any platforms to support rises in the track? Remember that your track forms must be sturdy enough to hold marbles.

**3.** If you have made more than one feature, assemble your forms. Arrange them to create the balance you desire. Attach the parts with glue, or simply lay them end to end. When you are finished, send some marbles on a test run!

## **Check Your Work**

Demonstrate how your ride works. Explain how you came up with your ideas. What kinds of forms did you include? How did you create balance? What would change if you made another marble track?

#### **Computer Option**

Using a 3-D design or a drawing program, create a full roller-coaster design or another ride of your choice.

Show both the inner structure (skeleton) and the outer façade of your design. You may also add color and texture to the outer layers of your ride. Show how your ride would look in an amusement park. Give your ride a creative name.

270

## **Teaching Options**

## **Teaching Through Inquiry**

Art Production Have students work in groups to make a two-dimensional plan for an amusement park. Guide students to make a list of what they would like to include in their park, such as rides, places to rest, and eating areas. You may wish to have students develop their plan around a theme such as animals, cartoon characters, outer space, or farm life. Instruct students to make sketches of special features and to create an aerial view of the park. Invite groups to share their ideas with the rest of the class.

## **Elements and Principles**

## Form and Balance

Sculptures and architectural works, such as buildings, bridges, and even roller coasters, are

made of one or more forms. A form has height, width, and depth. If you could add depth to the height and width of a square, you would create a cube. Like shapes, forms can be geometric or organic.

Forms are solid and fill space. The space that a sculpture or building fills is the positive space. The space surrounding the inside and outside edges of a sculpture or building is the negative space.

Look at a sculpture that is familiar to you. Let your eyes wander over its forms. How would you describe the positive space? Where do you see negative space?

Artists create balance by giving the parts of an artwork equal visual weight. Choose any artwork in this book, and imagine drawing a line through its center. If the two halves are mirror images, the artwork has symmetrical balance. If the two halves are not mirror images but still look visually

symmetrical asymmetrical balanced, the artwork has asymmetrical balance. The third kind of balance is radial balance in which the parts of the design seem to radiate, or spread out from the center of the artwork.

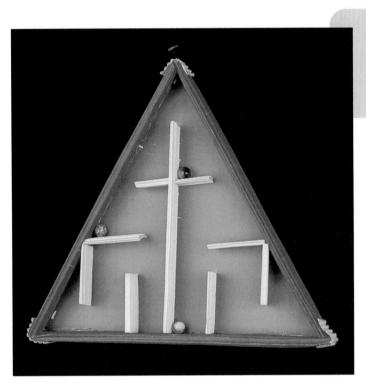

Fig. 8-26 How would you describe the form and halance in this maze? Eric Benson, Marble Maze, 2001. Corrugated cardboard, height: 10" (25.4 cm). Fred C. Wescott Junior High, Westbrook, Maine.

Artists as Planners

271

**Computer Option** Demo versions of programs used by archi-

tects, land developers, mechanical designers, and interior designers (such as 3D StudioVIZ by Autodesk) are often available to educators. Also, many professional firms have outreach programs to demonstrate workplace skills in the classroom. These community contacts may offer students a computer design experience that mirrors such an experience in the workplace.

## **Elements and Principles**

Have students identify artworks in this book that have symmetrical, asymmetrical, or radial balance.

## Assess

## **Check Your Work**

Have students work in small groups to complete Check Your Work.

## Close

Display students' roller-coaster tracks, and ask volunteers to point out special features and to identify negative and positive spaces in the designs.

## More About...

Modern pinball machines, which at first sat on countertops, originated in the 1930s. Pinball machines were wildly popular in the penny arcade, a gallery of games and attractions, which thrived during the depression era as a form of low-cost entertainment. Because high scorers won prizes, inventors installed tilt mechanisms to prevent cheating from lifting and shaking the game. Manufacturers introduced mechanical "flippers" during pinball's golden age, from 1948 to 1958.

## **Assessment Options**

Peer Invite students to create a list of standards that their roller-coaster tracks

should meet in order to be successful. Have students gather in groups of two or three to present their constructions and discuss the extent to which their tracks met each standard.

## **Careers**

Have students each create a print by using commercial scratch-foamboard as a printing plate. Available from any art-supply catalog, this material is easily cut with scissors and impressed with simple tools such as dull pencils, ballpoint pens, or wooden sticks. Have students use water-based printing inks, and encourage them to experiment with different kinds of papers for the printing surface.

## **Daily Life**

Ask students each to choose a major international city and plan a sevenday itinerary for visiting art museums and public artworks there. Encourage students to conduct research online and then use the information they discover to plan their trip. Challenge students to make the best use of their week's "stay" by planning each day around sites that are in the same neighborhood or section of town.

## Connect to...

## **Daily Life**

What would you need to do to **plan a trip**, especially to view artwork in another country? You might start by conducting online research about the country and its museums. You might need to obtain a guidebook or phrasebook, depending on the language of the country you plan to visit. Of course, you also would want to apply for a passport and make airplane reservations. What are the advantages to careful planning?

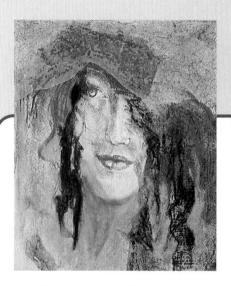

Fig. 8–27 Printmakers often combine techniques and processes in their work. This artist combined intaglio, collage, and pastel to produce this portrait. Mary Ellen Wilson, L'Autre, 1996.

Ink and nastel on paper, 8\* x 10\* (20.3 x 25.4 cm). Courtesy the artist.

## **Other Arts**

## **Dance**

Dancers, like three-dimensional artworks, interact with the space around them. Dancers move through space and create a dynamic relationship between themselves and the surrounding area. The person who plans and arranges the different steps and movements of a dance is called a choreographer.

Choreographers may be inspired by a piece of music to create an abstract design. Or they may be inspired by a dramatic idea and create a dance whose movements tell a story. Choreographers work with or without music, and either use traditional steps (from ballet or folk dances) or create new steps and movements.

## Careers

Have you ever watched a **printmaker** transfer an image onto a shirt? Although this is an example of commercial printing, it still involves processes used by fine-art printmakers. Printmakers use different techniques to produce prints that are original, usually limited in number, printed by hand, numbered, and signed. They may use such age-old techniques as intaglio (etching), relief printing, and lithography, or newer processes like screen or stencil printing, collagraphs, or photoetching. Many universities offer a fine-arts degree in printmaking. Graduates of such programs may teach in a college or university.

272

## **Teaching Options**

## Resources

Teacher's Resource Binder:
Making Connections
Using the Web
Interview with an Artist
Teacher Letter

## **Video Connection**

Show the Davis art careers video to give students a real-life look at the career high-lighted above.

## Interdisciplinary Planning

Team up with colleagues in math, science, industrial arts, and computer technology to explore ways to coordinate a unit on architects and city planners. For each discipline, identify content and skill areas that architects and city planners use.

## **Other Subjects**

## **Social Studies**

What kind of careful planning is needed to conduct an archaeological dig? First,

researchers must recognize and locate an archaeological site and learn about it through additional research. Next, they use special techniques to uncover objects and make a detailed site survey. They preserve their discoveries through record keeping and carefully pack the recovered artifacts. Why is each of these steps important to a successful dig?

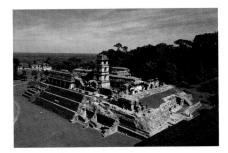

Fig. 8-28 Careful archaeology has uncovered and preserved many sites of the ancient Mesoamerican and South American cultures. Precolumbian Mexico, Palenque (Maya), Palace (general view), c. 720–783 AD.

Fig. 8-29 What are the similarities between planning a work of prose (writing) and planning an artwork?

## Language Arts

What steps do you follow to **plan a written** work, such as a piece of persuasive writing? You probably choose a topic, and then generate ideas through such writing strategies as brainstorming or graphic organizers (webs and mind maps). Next, you may develop a draft by categorizing your ideas and organizing them into paragraphs. Last, you complete a final draft by revising, elaborating on, combining, and rearranging the text.

## Mathematics

Carpenters use the expression "measure twice, cut once" as a reminder of the importance of measurement in planning. Do you know the source of the units of measurement we use? Originally, the measurement of a foot was the length of a man's foot from the heel to the big toe. This length was divided into 12 inches. In 1305, English king Edward I ordered that 1 yard equaled 3 feet. This measurement was the distance from the tip of his nose to the end of his outstretched hand.

Internet Connection For more activities related to this chapter, go to the Davis Website at www.davis-art.com.

273

Planners

## Language Arts

Challenge students each to choose an art process and write a detailed "how to" explanation of each step of its planning and execution. Before they begin their final draft, have students work in pairs to review and critique each other's first draft. If possible, display students' explanations beside representative art reproductions.

## Other Arts

When choreographers want dancers onstage to make their gestures and steps quite large, they instruct the dancers to "cover a lot of space!" However, dancers sometimes work in spaces that have limitations that change the dynamics of a dance. Ask students to invent a simple dance that covers a lot of space, about the size of the entire classroom. Then measure off a 3' x 3' space, and have students try to perform their sequence within it. Finally, put a stack of books into the small space, and have students make accommodations so that they do not hit the stack when they execute their dance again. Ask viewers to discuss how the space changed each of the three performances.

## **Internet Resources**

## Guggenheim Museum Bilbao

http://www.quggenheim-bilbao.es/ingles/home.htm Tour some of the museum's collection.

## **Leonardo Home Page**

http://www.mos.org/sln/Leonardo/

Explore this Leonardo da Vinci resource developed for teachers and students by the Museum of Science, Boston, for the Science Learning Network.

## **Welcome to Arcosanti**

http://www.arcosanti.org/

Visit this model of arcology (architecture + ecology).

## Community Involvement

- Invite a local landscape designer, architect, or city planner to your classroom to describe his or her work.
- · Have students design a time line, and illustrate it with photographs and small drawings, to show the architectural history of their community.

## Talking About Student Art

When students judge the merits of their own or another's artworks, remind them to use appropriate criteria and to support their judgments with reasons. As a class, establish the criteria, and ask whether the use of the same criteria for every artwork is appropriate. Guide students in making decisions about what criteria to use.

## **Portfolio Tip**

Encourage students to look through their portfolio and make notes and comments

about the materials and techniques they have used, especially about the ways that they achieved certain effects. Encourage students to keep a separate sheet in the portfolio for recording thoughts just about materials and techniques.

## **Sketchbook Tip**

Have students study the human landscape around them and then draw both

simple and complex geometric and organic shapes and forms that make up architectural structures.

## **Portfolio**

"I've always liked to draw buildings. These particular buildings were harder than my others because of the amount of detail I put into them, but I liked this piece because it was a nice mix of colors." Emil Harry

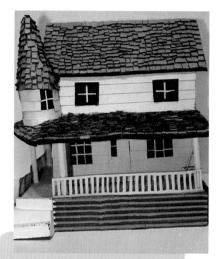

Fig. 8–31 How is building a model house different from drawing one? Ed Birkey, Grandma's Front Porch, 2001.
Corrugated candboard, mat board, paper, 13" x 17" x 15" (33 x 43 x 38 cm). Manson Northwest Webster Community School,

"I like the hovercraft spaceship and the mushroom-shaped buildings. I used yelloworange because it looks like a fiery planet with a lot of things happening, kind of like the sun, always glowing." Keane Warren

#### **CD-ROM Connection**

To see more student art, view the Personal Journey Student Gallery.

Fig. 8–30 An aerial viewpoint and careful use of one-point perspective gives this drawing a strong sense of depth. Emil C. Harry, Cityscape, 2001. Colored pencil, pencil, 81/2° x11" (21.5 x28 cm). Hillside Junior High School, Boise, Idaho.

"This took lots of planning, drawing 'blueprints' and then figuring out scale. I decided which materials would work best. I looked for textures that worked well together. I had a blast doing this project and was pleased with my sculpture from all sides." Ed Birkey

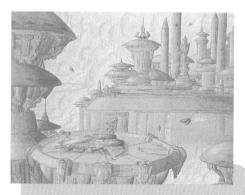

Fig. 8-32 A science-fiction drawing needs realisticlooking architectural forms to be convincing. A sense of perspective and depth strengthens the illusion. Keane Warren, Cloud: A City in Orange, 2001. Colored pencil, 9" x 12" (22.8.30.5 cm). Samford Middle School, Auburn, Alabama.

274

## **Teaching Options**

## Resources

Teacher's Resource Binder Chapter Review 8

Portfolio Tips

Write About Art

Understanding Your Artistic Process Analyzing Your Studio Work

## **CD-ROM Connection**

For students' inspiration, for comparison, or for criticism exercises, use

the additional student works related to studio activities in this chapter.

## **Chapter 8 Review**

#### Recall

Name two different kinds of architectural structures in Mexico, one pre-Hispanic and the other built during Spanish settlement.

#### Understand

Explain ways that an architect can plan for a new building to fit in with existing buildings in a neighborhood.

## Apply

Draw two different plans for the façade of a house. Create one plan with symmetrical balance and the other with asymmetrical balance.

## Analyze

Make a diagram by looking at a sketch or photograph of a building in your community or a photocopy of a building depicted in a magazine or book. Your diagram should show how the building is composed of basic geometric forms.

## For Your Sketchbook

Consider what buildings mean to their owners or users. Fill a page in your sketchbook with designs

of buildings that evoke an important quality, such as security, wisdom, strength, courage, peace, honesty, or creativity. For example, you could evoke security with a building that has features of a combination lock. Be playful in your designs, and have some fun!

## **Synthesize**

Imagine that you are the head of a design team charged with planning a new city from scratch. Develop a list of issues that you would have to consider.

## Evaluate

Of Frank Gehry, Melinda Gray (Fig. 8-15, shown below), and Ricardo Legorreta, whose buildings are shown in this chapter, recommend one architect as the best choice for designing your family's dream home. Explain your choice.

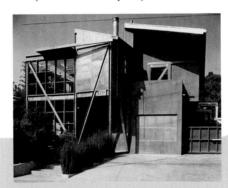

Page 260

## **For Your Portfolio**

Keep your portfolio organized. Always date and clearly identify each item in your portfolio, and place a sheet of tissue

paper or newsprint between each piece. On a regular basis, check the contents, and decide what to remove and what to keep.

28

275

## **Advocacy**

Have students design bumper stickers on the theme "Art Builds Bridges." Select one or more to have printed and distributed to members of the school and local community.

## **Family Involvement**

Encourage family members to work with students to create short video presentations about the visual aspects of their community, the countryside, or national and international travel that they think would be of interest and value to art classes. Video topics may range from "the doors on main street" and "diners on Route 66" to "colors of autumn" or "a spider's web."

## Chapter 8 **Review Answers** Recall

Pyramids or ceremonial centers and haciendas or agricultural estates.

#### **Understand**

Consider existing forms, styles, and materials, Consider how people who currently live or work in the area will be affected by the new plans.

Results will vary. Look for a clear distinction between symmetrical and asymmetrical balance.

## **Analyze**

Results will vary. Look for recognition of geometric forms.

## **Synthesize**

Answers will vary. Possible areas to consider: spaces for living, learning, working, playing; movement from place to place; access to and types of transportation; sources of food and water; climate and geographical location; potential for natural disasters; etc.

## **Evaluate**

Answers will vary. Look for reasons based on reference to the qualities of the artworks being discussed.

## Reteach

Discuss how people plan and organize their living and working spaces.

Help students locate house plans and landscape plans in newspapers and magazines. Perhaps bring in a book of house plans from a building supply company. Create a display of floor plans and elevation drawings, and discuss the special skills needed to make these designs. Brainstorm a list of things planners need to consider when designing a space for living, working, or playing. Summarize that architects and other artists create designs for structures and spaces for us to use and enjoy.

3

3

2

1

3

# **Chapter Organizer**

36 weeks

## Chapter 9 Artists as **Pioneers**

Chapter 9 Overview pages 276-277

## **Chapter Focus**

- · Core People are explorers in search of new ideas and experiences. Some artists are also explorers, pioneering new techniques, materials and ideas in their artwork.
- . 9.1 Traditions of Sculpture
- 9.2 Casting a Relief Sculpture
- 9.3 Art of Israel
- · 9.4 Recycling for Sculpture

## **Chapter National Standards**

- 1 Understand media, techniques, and processes.
- 2 Use knowledge of structures and functions.
- Understand arts in relation to history and cultures.
- 5 Assess own and others' work.
- 6 Make connections between disciplines.

## **Objectives**

## **Core Lesson** A Pioneer in Art

page 278 Pacing: Three or more 45-minute periods

- Understand why an artist can be considered a pioneer.
- Explain why Jaune Quick-to-See Smith is a pioneer.

## **National Standards**

- 1b Use media/techniques/processes to communicate experiences, ideas.
- 4a Compare artworks of various eras, cultures.
- 5b Analyze contemporary, historical meaning through inquiry.

## **Core Studio** Pioneering the Collagraph page 282

- · Create a collagraph by experimenting with unusual combinations of materials and textures.
- 1b Use media/techniques/processes to communicate experiences, ideas.
- 2c Select, use structures, functions.

## Then and Now Lesson 9.1 **Traditions of Sculpture**

page 284 Pacing: Two 45-minute periods

## **Objectives**

- · Explain how twentieth-century sculptors pursued change.
- Justify the classification of Jes's Moroles as a pioneer in sculpture.

## **National Standards**

- 4b Place objects in historical, cultural contexts.
- 4c Analyze, demonstrate how time and place influence visual characteristics.

## **Studio Connection** page 286

- Create a clay sculpture to challenge someone to think about a natural form in a new way.
- 1b Use media/techniques/processes to communicate experiences, ideas.

## **Objectives**

## **Skills and Techniques** Lesson 9.2 Casting a Relief Sculpture

page 288 Pacing: One 45-minute class period

· Understand the concepts and techniques involved in creating a cast relief sculpture.

## **National Standards**

- 1b Use media/techniques/processes to communicate experiences, ideas.
- 2b Employ/analyze effectiveness of organizational structures.

## **Studio Connection**

page 289

- · Create a cast relief sculpture with a variety of surface textures.
- 1b Use media/techniques/processes to communicate experiences, ideas.

## **Featured Artists**

Romare Bearden Sokari Douglas Camp Daniel Dancer Arthur Dove Marcel Duchamp Barbara Hepworth Jeff Koons Jesús Bautista Moroles Louise Nevelson John Outterbridge Pablo Picasso Jaune Quick-to-See Smith Nomi Wind

## **Chapter Vocabulary**

artisan assemblage casting collage collagraph

petroglyph pictogram relief sculpture site-specific sculpture texture

## **Teaching Options**

Teaching Through Inquiry
More About...Native American artists
Using the Large Reproduction
Using the Overhead
Meeting Individual Needs
Teaching Through Inquiry
More About...Romare Bearden

## Technology

CD-ROM Connection e-Gallery

## Resources

Teacher's Resource Binder
Thoughts About Art:
9 Core
A Closer Look: 9 Core
Find Out More: 9 Core
Studio Master: 9 Core
Assessment Master:
9 Core

Large Reproduction 17 Overhead Transparency 18 Slides 9a, 9b

Teaching Through Inquiry More About...Collage Assessment Options CD-ROM Connection Student Gallery Teacher's Resource Binder Studio Reflection: 9 Core

## **Teaching Options**

Meeting Individual Needs Using the Overhead More About...Daniel Dancer Teaching Through Inquiry

## **Technology**

CD-ROM Connection e-Gallery

## Resources

Teacher's Resource Binder Names to Know: 9.1 A Closer Look: 9.1 Find Out More: 9.1 Assessment Master: 9.1 Overhead Transparency 17 Slides 9c

Teaching Through Inquiry More About...Jesús Moroles Assessment Options CD-ROM Connection Student Gallery Teacher's Resource Binder Check Your Work: 9.1

## **Teaching Options**

Teaching Through Inquiry Assessment Options Using the Overhead

## **Technology**

CD-ROM Connection e-Gallery

## Resources

Teacher's Resource Binder Finder Cards: 9.2 A Closer Look: 9.2 Find Out More: 9.2 Assessment Master: 9.2 Overhead Transparency 18 Slides 9d

CD-ROM Connection Student Gallery Teacher's Resource Binder Check Your Work: 9.2

| 9 weeks | 18 weeks              | 36 weeks | Chap                                                                                                       | ter Organizei                                                                                                                                                                                                                                           | Continued                                                                                                                                                                                                                              |  |
|---------|-----------------------|----------|------------------------------------------------------------------------------------------------------------|---------------------------------------------------------------------------------------------------------------------------------------------------------------------------------------------------------------------------------------------------------|----------------------------------------------------------------------------------------------------------------------------------------------------------------------------------------------------------------------------------------|--|
|         |                       |          |                                                                                                            | Objectives                                                                                                                                                                                                                                              | National Standards                                                                                                                                                                                                                     |  |
|         |                       | 2        | Global Destinations<br>Lesson 9.3<br>Art of Israel<br>page 290<br>Pacing: One or more<br>45-minute periods | <ul> <li>Identify areas of artistic production in which<br/>Israelites were pioneers.</li> <li>Understand influences on the work of Nomi<br/>Wind's art.</li> </ul>                                                                                     | <ul> <li>1b Use media/techniques/processes to communicate experiences, ideas.</li> <li>4a Compare artworks of various eras, cultures.</li> <li>4c Analyze, demonstrate how time and place influence visual characteristics.</li> </ul> |  |
|         |                       |          | Studio Connection<br>page 291                                                                              | Make an experimental weaving that combines<br>traditional weaving techniques with other fiber<br>processes, such as knotting and braiding.                                                                                                              | <b>1b</b> Use media/techniques/processes to communicate experiences, ideas.                                                                                                                                                            |  |
|         |                       |          |                                                                                                            | Objectives                                                                                                                                                                                                                                              | National Standards                                                                                                                                                                                                                     |  |
|         | 2                     | 1        | Studio Lesson 9.4 Recycling for Sculpture page 294 Pacing: One or more 45-minute periods                   | <ul> <li>Learn how some artists have pioneered the use of recycled materials in their artworks.</li> <li>Understand how artists incorporate real and implied texture in their artworks.</li> <li>Create a sculpture from recycled materials.</li> </ul> | <ul> <li>1a Select/analyze media, techniques, processes, reflect.</li> <li>2a Generalize about structures, functions.</li> <li>5c Describe, compare responses to own or other artworks.</li> </ul>                                     |  |
|         |                       |          |                                                                                                            | Objectives                                                                                                                                                                                                                                              | National Standards                                                                                                                                                                                                                     |  |
| •       | •                     | •        | Connect to<br>page 298                                                                                     | <ul> <li>Identify and understand ways other disciplines are connected to and informed by the visual arts.</li> <li>Understand a visual arts career and how it relates to chapter content.</li> </ul>                                                    | lines 6 Make connections between disciplines.                                                                                                                                                                                          |  |
|         |                       |          |                                                                                                            | Objectives                                                                                                                                                                                                                                              |                                                                                                                                                                                                                                        |  |
| •       | •                     | •        | Portfolio/Review<br>page 300                                                                               | <ul> <li>Learn to look at and comment respectfully on<br/>artworks by peers.</li> <li>Demonstrate understanding of chapter content.</li> </ul>                                                                                                          | 5 Assess own and others' work.                                                                                                                                                                                                         |  |
|         | 2                     |          |                                                                                                            |                                                                                                                                                                                                                                                         |                                                                                                                                                                                                                                        |  |
|         | Lesson of your choice |          |                                                                                                            |                                                                                                                                                                                                                                                         |                                                                                                                                                                                                                                        |  |
|         |                       |          |                                                                                                            |                                                                                                                                                                                                                                                         |                                                                                                                                                                                                                                        |  |

### **Teaching Options**

Teaching Through Inquiry More About...The core-forming method Using the Large Reproduction

### **Technology**

**CD-ROM Connection** e-Gallery

### Resources

Teacher's Resource Binder A Closer Look: 9.3 Find Out More: 9.3 Assessment Master: 9.3

Large Reproduction: 18 Slides: 9e

Meeting Individual Needs **Teaching Through Inquiry** More About...The Bedouin Assessment Options

**CD-ROM Connection** Student Gallery

Teacher's Resource Binder Check Your Work: 9.3

### **Teaching Options**

**Teaching Through Inquiry** More About...John Outterbridge Using the Overhead **Teaching Through Inquiry** More About...Assemblages Assessment Options

### **Technology**

**CD-ROM Connection** Student Gallery **Computer Option** 

### Resources

Teacher's Resource Binder Studio Master: 9.4 Studio Reflection: 9.4 A Closer Look: 9.4 Find Out More: 9.4

Overhead Transparency 18 Slides: 9f

### **Teaching Options**

**Community Involvement** 

### Technology

Internet Connection Internet Resources **Video Connection CD-ROM Connection** e-Gallery

### Resources

Teacher's Resource Binder Using the Web Interview with an Artist Teacher Letter

### **Teaching Options**

Advocacy Family Involvement

### **Technology**

**CD-ROM Connection** Student Gallery

### Resources

Teacher's Resource Binder Chapter Review 9 Portfolio Tips Write About Art **Understanding Your Artistic Process** Analyzing Your Studio Work

# **Chapter Overview**

### Theme

Most people are explorers at some time, in search of adventure and new experiences. Some artists too are explorers—when they pioneer new ideas about art.

### **Featured Artists**

Romare Bearden
Sokari Douglas Camp
Daniel Dancer
Arthur Dove
Marcel Duchamp
Barbara Hepworth
Jeff Koons
Jesús Bautista Moroles
Louise Nevelson
John Outterbridge
Pablo Picasso
Jaune Quick-to-See Smith
Nomi Wind

### **Chapter Focus**

This chapter features artists who have pioneered art-making techniques and materials and have explored new ideas to present messages. Students are introduced to the art of Jaune Quick-to-See Smith and other artists whose works urge viewers to think about art and important issues. Through the creation of a collagraph, students explore new directions in their own art-making, and also learn how Jesús Moroles and other sculptors have led the way in making new sculptural forms. Students experiment in making a relief sculpture and discover how contemporary fiber artist Nomi Wind takes traditional Israeli techniques of weaving to new directions. After looking at the potential of recycled materials for creating art, students find new uses for old things by creating their own sculpture.

# National Standards Chapter 9 Content Standards

- 1. Understand media, techniques, and processes.
- 2. Use knowledge of structures and functions.
- 4. Understand arts in relation to history and cultures.
- 5. Assess own and others' work.
- Make connections between disciplines.

# **Artists as Pioneers**

Fig. 9–1 In this work, the artist included only the state names that are Native, or indigenous, words. For example, *Kansas* is a Sioux word meaning "south wind people.' Some words are also the names of tribes. How does this information change the way you view this map? Jaune Quick-to-See Smith, *State Names #2*, 2000.

Oil and collage on canvas, 48° x7° (127 x 183 cm). Courtesy Bernice Steinbaum Gallery, Mlami, Florida.

276

# **Teaching Options**

### Teaching Through Inquiry

Aesthetics Invite students to list words and phrases they associate with *pioneer* and then to review their portfolio to determine if they could be considered artistic pioneers. Discuss situations in which the following of the artistic lead of others is a good idea, and those in which charting new territory makes more sense.

### More About...

Jaune Quick-to-See Smith, an American artist with a Salish, French-Cree, and Shoshone heritage, views her work as a bridge between Native American culture and European traditions. She has achieved national recognition as both a painter and activist. In both roles, she seeks to affirm Native peoples, their heritage, and values.

### **Focus**

- · How do people explore new directions?
- In what ways are artists pioneers?

Imagine traveling to a new "territory," perhaps as far away and as fictional as a new galaxy — or as close and as real as a problem in math class today. Many scientists are pioneers: they can never be sure where their exploration may lead. Consider scientists Watson and Crick, who determined the structure of DNA and pioneered the route to the mapping of the human genome. To move into new territories, scientists take risks. They think about what they know and then experiment in new directions. Scientists—and others enthusiastically go forward and chart new territory for others to follow: they have a "pioneering spirit."

Many artists have also been pioneers. As each age sees developments in technology, artists explore new materials and techniques for making art. Some of their experiments have even resulted in new art forms. Pioneering artists also explore new ideas and present them as messages in their artworks. In doing so, they have encouraged us to think about, see, and experience the world in new ways.

Jaune Quick-to-See Smith is an art pioneer. In such works as State Names #2 (Fig. 9–1), the artist challenges how some people have thought about Native Americans. Many of her works also remind us that our natural environment is fragile. Smith asks that we think about our behavior in the past and how we could live in the future. In this chapter, you will learn

more about Jaune Quick-to-See Smith and other artists with a pioneering spirit.

Jaune Quick-to-See Smith

### **Meet the Artists**

Jaune Quick-to-See-Smith Jesús Bautista Moroles Nomi Wind

### **Words to Know**

pictogram petroglyph assemblage collage collagraph

site-specific sculpture casting relief sculpture artisan texture

### **Chapter Warm-up**

Ask: What is a pioneer? Challenge students to move beyond pioneer stereotypes such as people in covered wagons, and to name people who are pioneers because they have explored new ideas.

# **Using the Text**

Art History Ask: What are some ways that artists can be pioneers? (by exploring new materials, techniques, and ideas) Why is Jaune Quick-to-See Smith an art pioneer? (Through her art, she challenges how some people think about Native Americans.)

# **Using the Art**

Perception Ask: Which state names are not on Smith's State Names? What do the state names on the map have in common? (All come from Native American words.) What is Smith's message?

Art Criticism Ask: What colors are in this painting? Where did Smith repeat colors? How did she make this look like a painting? What is the texture? Have students compare the size of States Names (4' x 6') to that of something in the room, such as the board.

### **CD-ROM Connection**

For more images relating to this theme, see the Personal Journey CD-ROM.

### **Graphic Organizer** Chapter 9

9.1 Then and Now Lesson Traditions of Sculpture page 284

9.2 Skills and **Techniques Lesson** Casting a Relief Sculpture page 288

Core Lesson A Pioneer in Art

**Core Studio** Pioneering the Collagraph page 282

9.3 Global **Destinations Lesson** Art of Israel page 290

9.4 Studio Lesson Recycling for Sculpture page 294

# **Prepare**

# **Pacing**

Three or more 45-minute periods: one to consider text and images; one to make collage; one or more to print

# **Objectives**

- · Understand why an artist can be considered a pioneer.
- Explain why Jaune Quick-to-See Smith is a pioneer.
- Create a collagraph by experimenting with unusual combinations of materials and textures.

# Vocabulary

pictogram A picture that stands for a word or an idea.

petroglyph A line drawing or carving made on a rock or rock surface, often created by prehistoric people. assemblage A three-dimensional artwork made by joining together objects or parts of objects.

collage A work of art created by gluing pieces of paper, fabric, photographs, or other materials onto a flat surface.

collagraph A print made from a collage with raised areas on its surface.

# **National Standards Core Lesson**

- 1b Use media/techniques/processes to communicate experiences, ideas.
- 2c Select, use structures, functions.
- 4a Compare artworks of various eras, cultures.
- 5b Analyze contemporary, historical meaning through inquiry.

# **A Pioneer in Art**

"I go from one community with messages to the other and I try to teach and enlighten people."

Jaune Quick-to-See-Smith (born 1940)

# Jaune Quick-to-See Smith's Journey

Born in Montana in 1940, Jaune Quickto-See Smith spent much of her youth traveling. She lived with her father, a rodeo rider and trader, and moved on and off various reservations in the Northwest. She often worked as a farmhand and used her earnings from work to enroll in a correspondence art course.

Smith earned a college degree, something few Native Americans of her generation had done. Her artworks today show the influence of twentieth-century artists, including Robert Rauschenberg (see page 54), who looked to and commented on popular culture. In addition to making and exhibiting her own artworks, Smith has organized exhibitions of the artworks of other Native American artists. Her pioneering spirit has helped her create ways for us to see and appreciate their artworks.

Fig. 9-2 Smith often points to the ways that Native Americans have been depicted. What stereotypes did she explore here? Jaune Quick-to-See Smith. Trade (Gifts for Trading Land with White People), 1992. with objects, triptych: 60" x 70" (152 x 178 cm). Courtesy Bernice Steinbaum Gallery, Miami, Florida.

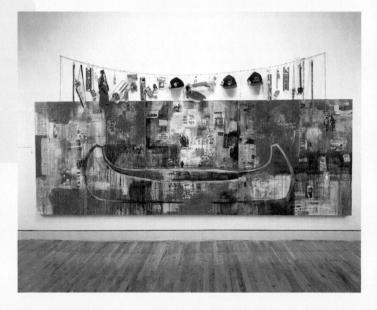

278

CORE LESSON

# **Teaching Options**

### Resources

Teacher's Resource Binder Thoughts About Art: 9 Core A Closer Look: 9 Core Find Out More: 9 Core Studio Master: 9 Core Studio Reflection: 9 Core Assessment Master: 9 Core Large Reproduction 17 Overhead Transparency 18 Slides 9a, 9b

### Teaching Through Inquiry

Art Production Refer students to the three artworks on these pages, and discuss how, in each artwork, the artist added nontraditional materials to reinforce the message. Invite students to create their own artwork to prompt viewers to think differently about an important issue. Suggest the use of both traditional and nontraditional materials. Have student pairs share their completed artworks and discuss the way the nontraditional materials reinforce the intended message.

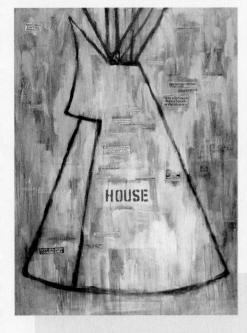

Fig. 9–3 In this painting, Smith used a pictogram of a tepee and labeled it "House." What message does this artwork send? Jaune Quick-to-See Smith,

House, 1995.

Acrylic, mixed media on canvas, diptych: 80" x 60" (203 x 152 cm). Courtesy

Bernice Steinhaum Gallery Miami, Florida.

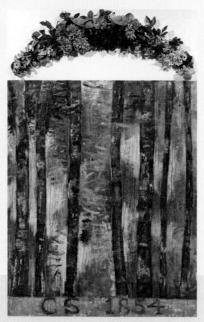

Fig. 9-4 Smith placed a funeral spray of flowers above her painting. How does this highlight the slow death of our environment? Jaune Quick-to-See Smith,

Requiem, 1990.

Oil and beeswax on canvas, silk flower wreath, 60" x 50" (152 x 127 cm). Courtesy

Remice Steinbaum Gallory Minmi Elocida.

# Changing the Way We Think

Smith believes that most children learn about Native Americans as if they lived only in the past. As a pioneer of new ways to think about her people, Smith says, "We are very much alive." She challenges oversimplified beliefs called stereotypes, such as those that all Native Americans live in tepees, wear feathered headdresses, or travel in canoes. Some of her artworks show how Hollywood movies, television, textbooks, and tourist shops fail to depict Native Americans as they really lived in the past and are living today.

Like her ancestors, Smith has deep ties to nature. Her paintings often send a message that all things, including humans, belong to the earth. Many of her paintings, such as *House* (Fig. 9–3), include **pictograms**—symbols of plants, animals, humans, and objects. These simple line drawings look like **petroglyphs**, the rock carvings created by Native Americans hundreds of years ago. Smith also layers paint with pictures and words from magazines and newspapers. She says that the use of familiar images and words creates a way for viewers to see what they already know—but in different ways.

Artists as Pioneers

279

# Teach

# Engage

Ask volunteers what their family's heritage is, and discuss any symbols of the culture.

# **Using the Text**

Art History Ask: What is Jaune Quick-to-See Smith's cultural heritage? What are stereotypes? (overused images; oversimplified beliefs) What stereotypes about Native Americans does Smith challenge in her artworks? How are Smith's pictograms like petroglyphs? What does Smith's opening statement mean?

### **Using the Art**

Art Criticism Ask: What materials did Smith use to create Trade? (commercial trinkets, newspaper clippings, photographs, oil paint, canvas) What do the trinkets hanging from the chain have in common? What does the canoe represent? Why, do you think, did she drip the red paint?

Art Criticism Ask: How are the three paintings on these pages alike?

### Extend

Have students use mixed media (newspaper or magazine clippings, photographs, paint, found objects) to create an artwork with a message about environmental issues or about stereotypes of their own cultural heritage.

### More About...

Native peoples throughout the Americas traditionally made art by using nature's resources—bark as canvas; plant and animal by-products for pigments; and rocks, hides, and bone. Each of the hundreds of nations developed its own distinct style. Today, some contemporary Native American artists work without reference to their heritage; others use modern media to express political, social, and spiritual concerns.

### **Using the Large Reproduction**

#### Talk It Over

**Describe** Make a list of words to describe this sculpture's features.

**Analyze** How did the artist use art elements and principles to attract and hold the viewer's attention?

Interpret What is this artwork about?

**Judge** How does this artwork reflect a pioneering spirit?

### **Using the Overhead**

#### Think It Through

**Ideas** What ideas were probably important to the sculptor?

**Materials** What different materials did he use?

**Techniques** How was this sculpture made?

**Audience** Who, do you think, was the intended audience of this artwork?

1

# **Using the Text**

Art History Ask: In what way was each artist a pioneer? (Duchamp was one of first to present ordinary objects as art; Nevelson was one of the first women to create large-scale sculptures; Bearden pioneered powerful messages about African Americans.) What is an assemblage? (a sculpture of combined objects)

# **Using the Art**

Aesthetics Ask: Which of these artworks are assemblages? (Bicycle Wheel, Royal Tide IV) Do you consider all of these pieces to be art? Why or why not? Why would artists present such objects as art?

Art Criticism Ask: Why, do you think, did Louise Nevelson paint Royal Tide IV a solid color? What is the most important art element in the sculpture?

Art Production/Art Criticism Ask:
What is Bearden's Jazz Village made from? (magazine clippings) What type of artwork is this? (collage) What is the subject? (four jazz musicians) What are the four instruments? (bass, trumpet, drums, saxophone) How did Bearden create the eyes and the hands? What textures, patterns, and colors did he repeat in this collage?

# Pioneering Questions About Art

Jaune Quick-to-See Smith, like many pioneers, looked around, thought about what she saw, and experimented with new ways to think, work, and act. Other artists have also been pioneers. Marcel Duchamp was among many early-twentieth-century artists who wanted to present new thinking about art. In artworks such as *Bicycle Wheel* (Fig. 9–5), Duchamp took ordinary objects, or a group of objects, and presented them as art. At first, people were shocked by art made from everyday things. But Duchamp's ideas made people think differently about what art is. Today, many artworks, including

assemblages, combine found materials. An **assemblage** is a sculpture of combined objects, such as boxes, pieces of wood, and parts of old machines.

# Pioneering Materials and Scale

In the second half of the twentieth century, artists continued to experiment with materials and the scale of their artworks. In the 1960s, Louise Nevelson began to make large-scale assemblages (Fig. 9–6). Because few women at that time were making large-

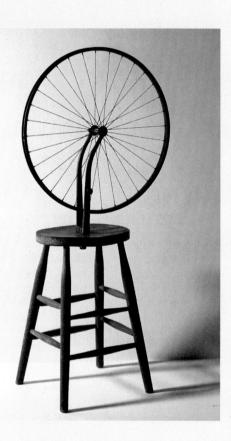

Fig. 9–5 Why, do you think, have some people referred to Duchamp's work as junk sculpture? Marcel Duchamp, *Bicycle Wheel*, 1963. Readymade: metal wheel mounted on painted wood stool, height: 49 1/4" (125 cm). Collettion of Richard Hamilton, Henley-on-Thames, Greet Britain. Cameraphoto/Art Resource, New York. © 2001 Artists Rights Society (ARS), New York/ADAGP, Paris/Estate of Marcel Duchamp.

280

# **Teaching Options**

### **Meeting Individual Needs**

#### Multiple Intelligences/Linguistic and Interpersonal

Pioneering artists—those at the forefront of a new style, medium, or way of thinking—often face great challenges because new ideas are sometimes neither quickly nor easily embraced. Have students describe the difficulties that any artists in this lesson might have faced when first trying to get others interested in their work. As a prompt, ask students in what ways the artists' pioneering use of materials and/or ideas might have initially made audiences uncomfortable. Then have small groups of students each write and perform a skit in which one of the artists tries to sell his or her work to a gallery owner.

scale sculpture, Nevelson was a pioneer for other women artists. She was also a pioneer because, whereas other sculptors were making sculptures out of welded metal, Nevelson turned to wood. But rather than carving wood, as so many artists had done in the past, Nevelson combined pieces that had been used in furniture and other objects. She built dramatic, huge walls and free-

standing structures from found wood scraps. Viewers were amazed by her artworks and felt small in their presence. One critic said: "Her sculpture changed the way we look at things."

Romare Bearden was another twentiethcentury artist who made artworks by combining found materials. He combined cut and torn images to create his collage

paintings. In Jazz Village (Fig. 9–7), for example, he combined images from magazines and other sources. An African American, Bearden pioneered powerful messages about his people. He often showed both the good and bad parts about being African American and living in the city.

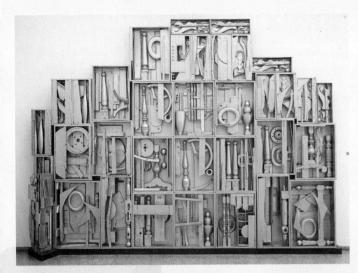

Fig. 9–6 The artist often assembled found wooden objects and painted them all one color — black, white, or gold. Louise Nevelson, Royal Tide IV, 1960.
Wood painted gold, 132" × 166" × 10"
335 × 427 × 25 < cm). Stadt Köln, Rheinisches Bildarchiv. O 2001 Estate of Louise Nevelson/Artist Rights Society (ARS), New York.

Fig. 9–7 This artist often celebrated the importance of music, especially jazz, in African American culture. How do the shapes, colors, and textures connect with the musical form of jazz? Romare Bearden, Jazz Village 1967.

Mixed media and collage, 30" x 40" (76 x 101.6 cm). © Romare Bearden Foundation/Licensed by VAGA, New York, New York.

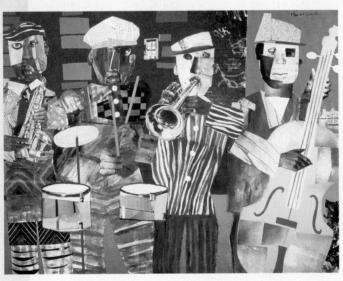

Artists as Pioneers

281

# **Teaching Through Inquiry**

Art History Have students work in small groups to focus on the work of Duchamp, Nevelson, or Bearden. Invite students to use library and Internet resources to investigate the way in which the artist worked, what he or she cared about, and what other artworks he or she created. Have students create a display that shows why the artist is considered an artistic pioneer.

### More About...

Romare Bearden (1912–1988) was born in Charlotte, North Carolina, but grew up in Harlem. His father was a city sanitation inspector, and his mother was a community activist. Bearden studied art at Boston University and then returned to New York to earn a degree in mathematics at Columbia University. After graduating, he studied at the Art Students League in New York and then served in the military in World War II. After the war, he worked as social worker and painted in the evenings. In 1964, when he began to create collages, he gained fame for his art. Bearden often incorporated his love for jazz in his art.

### **Critical Thinking**

Ask students to select, from this book, another artwork that they consider pioneering in its message, use of materials, or presentation of its subject. Have students write a paragraph defending their choice.

### Extend

Have students create a magazine collage about one of their favorite group activities. Encourage them to use a style similar to Bearden's.

### **Artists as Pioneers**

# **Supplies**

- · corrugated cardboard
- collage materials—variety of cardboard, burlap, buttons, screen
- glue
- · acrylic gel medium
- paintbrushes
- drawing or construction paper, 3 or 4 sheets

# **Using the Text**

Art Production Have students read Studio Background. Ask: What is the meaning of the French word from which *collage* comes? ("to glue") How does a montage differ from a collage?

Demonstrate making a collagraph; cutting shapes from textured materials and arranging them several ways; exposing the corrugated ridges in cardboard and adding flat objects, such as buttons; and experimenting with the arrangement of a design before gluing it. Tell students that they will cover their collage with acrylic gel medium and allow it to dry before printing.

Demonstrate coating a collage with ink and then pressing paper to it. Also demonstrate the method of using rags or paper towels to rub off the ink before printing. Encourage students to print with several colors of ink, use a variety of paper colors, and press more than one print on a sheet of paper. Have students sign their prints in pencil near the lower edge.

# **Using the Art**

Art Criticism Focus on Pablo Picasso's Glass and Bottle of Suze.

Ask: What are the objects in the still life on the table? What are the textures? Lead students to note the contrasts among textures and among values. Explain that Picasso shaded the newspapers with charcoal but they have darkened with age. Ask: How is Picasso's collage like the artworks on pages 280 and 281?

Printmaking in the Studio

# Pioneering the Collagraph

Some artists become pioneers by changing art processes that already exist. Say, for example, that you had made a **collage**, an artwork of bits of paper,

fabric, photographs, or other flat materials glued to a flat surface. Then you did something different: instead of gluing *flat* materials, you built up layers of paper and added cardboard, bottle caps, and other found objects. When you finished, you looked at your work and thought, "Hmm. This would make a really cool print." So you made a **collagraph**, a print made from a collage with raised areas.

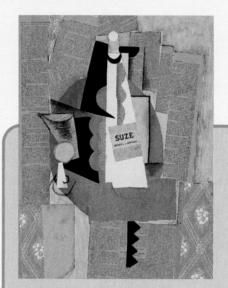

Fig. 9–8 This is one of the first collages ever made.

Soon after this experiment, Picasso made many different collages by using scraps of things he found.

Pablo Picasso, Glass and Bottle of Suze, 1912.

Pasted papers, gouach, and charcoal, 25 ½ x x 19 ½ x (65 x 36 cm). Washington university Gallery of Art, Saint Louis University Puthase, Kende Sale Fund, 1946.

© 2001 Estate of Pablo Picasso/Artists Rights Society (ARS), New York.

In this studio experience, you will create a collagraph from a mixed-media collage. Collect materials and objects that have interesting shapes and textures. Think of yourself as a pioneer. Like all pioneers, the collagraph artist never knows exactly what lies ahead!

#### You Will Need

- corrugated cardboard
- · collage materials
- glue
- acrylic gel medium
- paintbrushes
- printing ink
- drawing paper,
   3 or 4 sheets

### Try This

**1.** To make your printing plate, arrange your collage materials on a piece of corrugated cardboard. Think about texture placement and the message your artwork will send.

# **Studio Background**

### **Creative Combinations**

When most European artists were using traditional materials for sculptures and paintings, Pablo Picasso—and a few others with a pioneering spirit—did some experimentation. They pasted paper and other flat objects to their paintings and invented the collage (from a French word meaning "to glue").

Picasso and the other collage artists paved the way for more experiments with the combining of materials. Such experiments produced the *montage* (a special kind of collage made from pieces of photographs or other kinds of pictures) and the collagraph. Artists who create collagraphs often experiment by adding textures to a collage before printing. After pulling the first print, the artist may add different objects before printing again.

282

# **Teaching Options**

# **Teaching Through Inquiry**

Art Criticism Have students write an essay in which they describe what they see in the artwork on this page; analyze how the artist used art elements and principles to attract and hold the viewer's attention; and discuss the moods, feelings, and ideas conveyed by the artwork. Remind students that the artist combined traditional and nontraditional materials, and explain that the essay should address how this combination reinforces the moods, feelings, or ideas conveyed. Invite student pairs to share their essays.

2. When you are pleased with the arrangement, glue the materials in place. Then coat the plate with acrylic gel medium.

**3.** Brush ink onto the surface of the plate. Then experiment with printing. Place paper on the inked plate, and gently rub the paper with your hand. Remove the paper by lifting

the corners and carefully peeling the print away from the plate.

- **4.** Ink the plate again. Then wipe the ink off the plate surface, but leave the ink in the crevices. Place another sheet of paper on the plate, and gently rub the paper with your hand. Then peel away the print as before.
- **5.** Check the results from each method. Which is more interesting? Which better shows a variety of textures? Experiment with different printing colors.

Display your collagraph printing plate and one of your completed prints with those of your classmates. Make judgments about the prints and the plates. In what ways are they pleasing? Which of the two is more pleasing or interesting? Discuss your experiments.

#### **Lesson Review**

### **Check Your Understanding**

- 1. What is a pictogram?
- **2.** Explain why Jaune Quick-to-See Smith is a pioneer.
- 3. Identify an artist pioneer other than Smith, and explain how the artist's work showed a pioneering spirit.
- **4.** Why is a pioneering spirit important in making a collagraph?

Fig. 9–9 Notice the variety of textures on this collagraph plate. How, do you think, did the artist create them? Ryan Glick, Floral Fantasy Bouquet, 2001.
Cardboard collagraphic plate, textured wall-

Cardboard collagraphic plate, textured wallpaper, spray paint, 9 3/4" x 8 5/8" (25 x 22 cm) Springhouse Middle School, Allentown,

Artists as Pioneers

283

### **Assess**

### **Check Your Work**

Assist students in selecting one of their prints to display with their collagraph printing plate. Ask if they find their print or their plate more interesting or pleasing, and have them explain why.

### Check Your Understanding: Answers

- 1. A pictogram is a symbol of plants, animals, humans, and objects.
- 2. Jaune Quick-to-See Smith is considered a pioneer because she shows new ways to think about Native Americans, as well as our relationship to the natural world.
- **3.** Answers will vary. Look for reasons based on the way the artist explored new directions.
- **4.** The creation of a collagraph requires experimentation, an important component of the pioneering spirit.

# Close

Discuss students' answers to Check Your Understanding. Display their prints and collagraph printing plates. Ask students to select, from this chapter, the artist with the most pioneering spirit, and to explain why.

### More About...

With Georges Braque, Spanish artist Pablo Picasso developed Cubism and the art of **collage** in Paris. In 1908, Picasso pasted a small paper shape on a drawing to make what was probably the first collage, or papier collé. Later, as they explored their concern with what is illusion and what is reality, Picasso and Braque added words, letters, and realistic wood-grain and wallpaper effects to their paintings. By 1912, Picasso began layering found objects and paint in integrated collages.

### **Assessment Options**

**Teacher** Have students create a list of what they think are the top ten ways to become an art

pioneer. The lists will vary, but look for evidence that students understand that an art pioneer is willing to experiment and think about what he or she has created, chart new directions for use of materials or techniques, and provide new ways of thinking about important issues.

# **Traditions of Sculpture**

# **Prepare**

# **Pacing**

Two 45-minute periods: one to consider text and images; one to sculpt clay

# **Objectives**

- Explain how twentieth-century sculptors pursued change.
- Justify the classification of Jesús Moroles as a pioneer in sculpture.
- Create a clay sculpture to challenge someone to think about a natural form in a new way.

# Vocabulary

site-specific sculpture A sculpture created for a particular space, usually outdoors. They may be permanent, but site-specific sculptures are often temporary.

# **Using the Time Line**

Explain that during the first half of the twentieth century, European artists questioned the meaning of art, what art is, and what is real and unreal. They pioneered new ways of considering art and art materials. By the 1990s, concerns about protecting the environment and artists' search for their cultural heritage led them to explore natural materials and their ancestors' art.

Have students to locate their birthday on the time line. **Ask:** What do you think has been the most meaningful art or image produced during your lifetime?

# National Standards 9.1 Then and Now Lesson

- **1b** Use media/techniques/processes to communicate experiences, ideas.
- **4b** Place objects in historical, cultural contexts.
- **4c** Analyze, demonstrate how time and place influence visual characteristics.

# **Traditions of Sculpture**

| 1943<br>Hepworth, <i>Oval Sculpture</i> |                                      | Dancer, 2000<br>Fern Hope Hoop Moroles, Round Wafer |        |
|-----------------------------------------|--------------------------------------|-----------------------------------------------------|--------|
| Mid-20th Century                        | Late 20th Century Early 21st Century |                                                     |        |
|                                         | <b>1992</b><br>Koons, <i>Puppy</i>   | 1999<br>Moroles, <i>Granite We</i>                  | eaving |

### **Travels in Time**

LESSON

MON

AND

The tradition of sculpture as an art form has existed since prehistoric times. Small carved and modeled forms of both human and animal figures, dating from about 30,000 BC, have been found in caves. Large stone sculptures of ancient Egyptian kings still stand in the deserts. Some

of the centuries-old techniques of sculpting in stone, wood, and clay continue to be popular today. Modern sculptors, however, often experiment with new media and surface textures, creating new traditions in sculpture.

# **Pioneering the Modern**

In the early 1900s, many artists wanted to break with existing styles, to create truly "modern" art. They experimented with new, human-made industrial materials

and embraced advancements in technology. Other artists preferred traditional materials, such as wood, plaster, or stone. They experimented by exploring the texture and

surface qualities of these materials. Barbara Hepworth was one of the leading artists in this movement. Her *Oval Sculpture* (Fig. 9–10) is an example of her experiments with different surfaces and textures possible with plaster.

Fig. 9–10 Hepworth often found inspiration in the natural forms and landscapes of beaches. How does the form of this sculpture look as though it might have been smoothed by sand and ocean waves? Barbara Hepworth, Oval Sculpture Number Two, 1943.

Plaster, 11½\* x 16½\* x 10° (28.5 x 41.5 x 25.5 cm). The Tate Gallery, London. © Tate, London 2021.

284

# **Teaching Options**

### Resources

Teacher's Resource Binder Names to Know: 9.1 A Closer Look: 9.1 Find Out More: 9.1 Check Your Work: 9.1 Assessment Master: 9.1 Overhead Transparency 17 Slides 9c

# **Meeting Individual Needs**

Multiple Intelligences/Naturalistic and Spatial Challenge students to be artistic pioneers. Ask students to select an environment in which art is not typically displayed (the middle of a desert, high up in a rain forest, the middle of a bridge), make sketches for a sculpture that occupies the unusual space, and then design the art out of common, modern goods (rubber bands, old sneakers, take-out containers, discarded CDs, soda cans, and so on). Have students show and discuss their ideas with one another and then make changes in their own work.

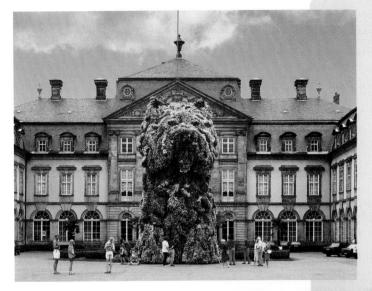

Fig. 9–11 This 40-foot puppy is made from 17,000 fresh flowering plants. How would you describe its texture, or the way the surface looks? Jeff Koons, Puppy, 1992. Stainless steel, soil, geotextile fabric, internal irrigation system and live flowering plants, 40° 6° x 40° 6° x 21° 3° (12.3 x 12.3 x 6.5 m). Located at Arolsen Castle, Kassel, Germany, © Jeff Koons.

Fig. 9–12 If you came upon this view while on a walk in the forest, what would be your reaction? Daniel Dancer, *The Fern Hope Hoop*, 1999.
Fern fronds and redwood tree, hoop: 24° x24° (61 x61 cm). Courtesy the artist.

# New Materials and Places for Art

In recent decades, sculptors have purposely set out to explore the possibilities of new media and spaces for art. Many artists have started to experiment with materials and surface qualities that are part of everyday life. This approach has turned the attention of some sculptors, including Jeff Koons (Fig. 9–11), from the technical skills of carving and casting to a focus on ideas.

Sculptor Daniel Dancer is part of a group of pioneering artists who create sculpture for a particular outdoor space. Many sculptors in history have looked to nature for inspiration. But Dancer chooses to work directly with his natural surroundings. For his **site-specific sculptures** (Fig. 9–12), Dancer must first consider the site, or location. The site helps determine the form and

meaning of the sculpture. In some cases, the artist's purpose is to make viewers more aware of the environment and the textures of natural objects. Although site-specific sculptures can be permanent, many are temporary installations, either outdoors or in museums or other interior spaces. The installations exist, for the long term, only in the form of photographs.

Artists as Pioneers

285

# Teach

# Engage

Ask: What do you think of when you hear the term "sculpture"? What sculpture on pages 284 and 285 is most like your idea of a typical sculpture? Have students select, from this book, another work that fits their idea of a typical sculpture.

# **Using the Text**

Art History Discuss ways that artists tried to create modern art in the early 1900s. Ask: How are today's artists experimenting with materials? What are site-specific sculptures? Why are many of these sculptures temporary?

# **Using the Art**

Art Criticism Explain that Hepworth visited artists in Paris in the 1930s.

Ask: How is Hepworth's art similar to Picasso's collage? What materials were used in each of the sculptures on pages 284 and 285? Which are site-specific? Which would be most appropriate for the entry lobby of your school? Why?

### **Teaching Through Inquiry**

Art History Involve students in creating a time line—from early civilizations through the twentieth century—of sculptures of the human figure. Have students work in groups to generalize about the changes in style, materials, and technique over time. Help students by identifying when various materials used for sculpture first came into use.

### More About...

Similar to the Navajo who create sand paintings to encourage healing, **Daniel Dancer** creates artworks of found materials to help restore and heal damaged land. He sees his sculptures, which are gradually reshaped and claimed by the earth, as prayers in the wild. Dancer, who is also an environmental photographer, tries to balance nature's beauty with its threatened destruction.

### **Using the Overhead**

### **Investigating the Past**

**Describe** Describe the textures and surface qualities in this work.

**Attribute** What qualities in this work could lead you to believe that the artist was seeing-impaired and had to depend on his sense of touch?

**Interpret** What mood and feeling is expressed in this work?

**Explain** In what way could this work be considered that of a pioneer in sculpture?

# **Traditions of Sculpture**

# **Using the Text**

Art History Ask: What does Jesús Moroles do that is new or different? (takes risks by cutting and working very hard stone with high-tech tools to create new sculptural forms and textures) What early work experiences helped Moroles develop as an artist? (carpentry, masonry)

# **Using the Art**

Art Criticism Ask: What medium does Moroles use for his sculptures? (granite) Discuss the difficulties of working with granite, and call attention to the sculptures' dimensions. Have students compare these to their height. Ask: What textures do you see in the sculptures? How is Granite Weaving like a textile weaving? What artwork on pages 284 and 285 is most similar to Moroles's sculptures? Why?

### **Studio Connection**

After students have read Studio Connection, ask them to list natural closed

forms—such as acorns, apples, oranges, and snail shells—and to imagine how these would look if they were opened. Then ask students to list natural open forms—such as leaves, starfish, sand dollars, and butterflies—and to imagine how these would look if they became more spherelike or closed.

Demonstrate flattening clay between your hands and then cupping the clay into a closed form. Also show students how to shape a ball. If the clay will be fired, make the ball hollow by forming and then joining two pinch pots. Demonstrate making a variety of surface textures by indenting the clay with objects such as paper clips.

Give students each about 1 pound of clay. Encourage students to somewhat open up a normally closed form, and to somewhat close up a normally open form. Guide students to consider the surface and then to smooth it or add indented textures.

Assess See Teacher's Resource Binder: Check Your Work 9.1.

### A Pioneer in Sculpture

LESSO

N O N

HEN

"I'm trying to just keep going on my own ideas." Jesús Bautista Moroles (born 1950)

ae s. of

Artists in the twenty-first century continue to pioneer ways of working with materials. They often challenge our understanding of what traditional materials can do. Sculptor Jesús Bautista Moroles tests the limits of stone, often working on a massive scale.

Moroles was born in Corpus Christi, Texas. Growing up, he worked for his uncle, a bricklayer, and he learned carpentry skills by helping his father renovate their home. Moroles credits these early work experiences in carpentry and masonry for his development as a mature artist.

Fig. 9–13 Notice the over-and-under pattern of a weaving. Compare this sculpture with the Navajo weaving on page 19. Why, do you think, did the artist create a stone sculpture that looks like a weaving? Jesús Bautista Moroles, Granite Weaving, 1999. Fredericksburg granite, 38 ° x 38 ° x 61/4° 06.5 x 9.5.5 x 16 cm). Courtesy the artist, Photos. Ann. C. Shermike artist, Photos. Ann. C. Shermike

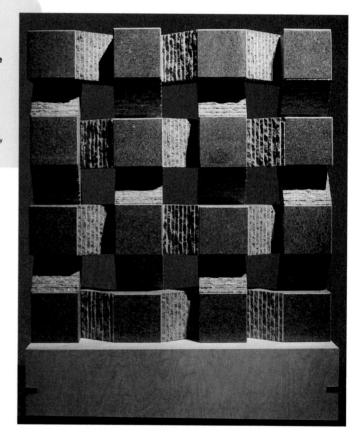

286

# **Teaching Options**

# **Teaching Through Inquiry**

Art Criticism Involve parents and community businesses in providing a variety of types of wood, metal, stone, glass, plastic, and textiles that are used in sculpture. Have students prepare a display titled "Materials of Sculpture." For each medium in the display, have students describe the physical properties and surface qualities, as well as the feelings or meanings that are usually associated with it. For example, glass is hard but breakable, smooth, transparent, revealing, fragile, delicate, and reflective. Ask students each to select one material and match its qualities with a subject for a sculpture.

Fig. 9–14 How would you describe the surface of this sculpture? In what ways does this work push the boundaries of sculpture? Jesús Bautista Moroles, *Round Wafer*, 2000. Black galaxy granite, 66° x 66° x 3/4° (167.6 x 167.6 x 2 cm). Courtesy the artist. Photo: Ann Sherman.

# **Pushing Boundaries**

Moroles constantly pushes the boundaries of traditional sculpture. He takes risks and uses his excellent technical skills to discover new sculptural forms and textures. To create his large-scale sculptures, Moroles works with traditional hand tools, such as picks, chisels, and mallets. To cut hard stone and create unusual forms (Fig. 9–13), he also uses nontraditional tools: diamond saws, drills, and grinders.

With the high-tech tools, Moroles can slice, split, chip, grind, or polish the granite to produce sculptures with razor-sharp edges and precise forms. He creates surfaces that are smooth and reflective, or rough and uneven. For his sculpture *Round Wafer* (Fig. 9–14), he pierced a block of stone with many large and small circles. This effect required careful and precise cutting of the stone.

### **Studio Connection**

Create a clay sculpture that will challenge someone to think about a natural form in a new way. Choose a natural form

and observe it closely. If you've chosen a closed form, such as an acorn, your sculpture could open it up. If you've chosen a flat, open form, such as a leaf, you could close it up. Focus on surface and texture.

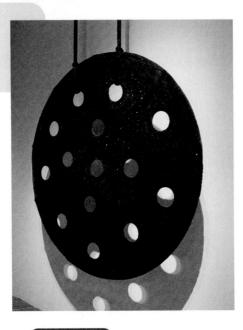

### Lesson Review

### **Check Your Understanding**

- **1.** Identify three ways that twentieth-century sculptors pioneered change in sculpture.
- **2.** What is site-specific sculpture?
- **3.** In what way is Jesús Bautista Moroles a pioneer in sculpture?
- 4. Considering the new things happening in sculpture today, what do you think an artist would need to do to be a pioneer in sculpture in the late twenty-first century?

# **Assess**

### Check Your Understanding: Answers

- 1. They experimented with new media and materials, embraced advancements in technology, explored new texture and surface qualities of traditional materials, and created art for different types of spaces.
- **2.** A site-specific sculpture is created for a certain, particular location.
- 3. Moroles takes risks and uses his technical skills to discover new sculptural forms and textures. He also uses high-tech tools.
- 4. Answers will vary.

# Close

Discuss students' answers to Check Your Understanding. Display their sculptures. Ask students to identify the nature form that inspired their sculpture, to describe their artwork's texture, and to explain why they consider their sculpture an opened or a closed form. Discuss how the claymolding process is different from the process Moroles uses to construct his sculptures.

Artists as Pioneers

287

### More About...

While growing up in a Dallas public-housing project, **Jesús Moroles** developed his interest in art at dollar art classes at the YWCA. In a college stone-carving course, Moroles discovered that he loved working with granite, which was so hard to carve that he "got lost in it." He gets his ideas for sculptures from the stone that he selects from quarries worldwide.

### **Assessment Options**

**Teacher** Review the lesson, and ask students to write a one-page essay that explains how sculpture changed in the twentieth century and the ways in which Jesús

Moroles was a part of that change.

**Peer** Have student pairs use simple paper-sculpture techniques of cutting, folding, bending, curling, and gluing to create a sculpture from one sheet of paper. Direct students to use scissors to make cuts in the paper, but not to cut the paper into smaller pieces. Instruct student pairs to have one student assume the role of technician, and the other, the role of decision maker, who tells the technician where and how to cut the paper. Then have students write comments about the helpfulness of their partner in the process. If possible, do this exercise twice, and have students change roles.

# Prepare

# **Pacing**

One 45-minute period

# **Objectives**

- Understand the concepts and techniques involved in creating a cast relief sculpture.
- Create a cast relief sculpture with a variety of surface textures.

### Vocabulary

casting A multistep process for creating sculptures in bronze, concrete, plaster, plastic, or other materials. Some casting techniques allow an artist to create several sculptures from a single mold.

relief sculpture A three-dimensional work designed to be viewed from one side, in which surfaces are raised from a background.

# **Studio Preparation**

If students are to use milk cartons, cut the tops off the boxes.

# Teach.

### Engage

Have students feel the surface of coins. Explain that these are reliefs.

# **Using the Text**

Art Production Have students read about the casting process. As you demonstrate making a relief, ask students to direct you through the steps.

# **Using the Art**

Art Production Ask: What are the shapes in the sculptures? What everyday objects did students use to make these forms? Which areas were indented in the mold?

# National Standards 9.2 Skills and Techniques Lesson

**1b** Use media/techniques/processes to communicate experiences, ideas.

**2b** Employ/analyze effectiveness of organizational structures.

# **Casting a Relief Sculpture**

Many of the sculptures that you see in parks, museums, and galleries are probably made by casting. **Casting** is a multistep process for creating sculptures in bronze or other materials, such as concrete, plaster, or plastic. Some casting techniques allow an artist to create several identical sculptures from a single mold.

# **Practice Casting**

AND TECHNIQUES

SKILLS

A **relief sculpture** is a sculpture that is meant to be viewed from one side, like a wall plaque. You can cast a relief sculpture by using wet sand or oil-based clay for the mold. Your final sculpture will be plaster.

First, cut off the bottom of a milk carton or other small box. When it is cut, the box

should be about 3" deep. Reinforce the sides of the box by applying a strip of masking tape around the outside. Then place about 1" of

fine, damp sand or oil-based clay into the bottom of the container.

Next, gather one or more textured objects—such as a large seashell, two acorns or unshelled nuts, a small stone, or a piece of thick rope—to make impressions into the

clay or sand. Press the objects into the clay or sand and lift them straight out again. This will create a mold, or negative design, for your

sculpture: whatever you press into the clay will appear raised up in the final sculpture.

When your design is ready, mix the plaster. Gently and slowly pour the plaster into the

box, as directed by your teacher. If you are pouring into sand, be careful that the plaster does not wash away the sand—you want the

plaster to flow over the surface. Pour the plaster to a depth of about 1". (If you would like to hang your small relief sculpture, press a loop of thick string firmly into the wet plaster before it hardens.)

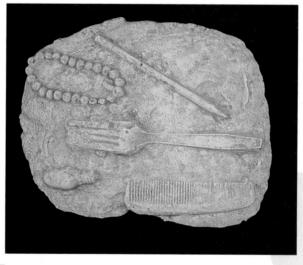

Fig. 9–15 You can use just about any object to create an interesting relief sculpture. How can you use objects and this method of casting to pioneer new ideas in art? Mary Hankin, Sandcast, 2001.
Sand, plaster, found objects, 8° x 10° (20 x 25.5 cm). Jordan-

288

# **Teaching Options**

### Resources

Teacher's Resource Binder Finder Cards: 9.2 A Closer Look: 9.2 Find Out More: 9.2 Check Your Work: 9.2 Assessment Master: 9.2 Overhead Transparency 18 Slides 9d

### **Teaching Through Inquiry**

Art Production To emphasize ways to find ideas for artworks, have students work independently or in small groups to look for examples and/or create a list of natural and human-made forms that could serve as "molds" for relief sculptures. Students might consider animal or human footprints, carved architectural moldings, impressions in Styrofoam, textured seashells, and decaying logs. Have students share their findings with the rest of the class.

Fig. 9–16 The round forms that this artist used help create a theme for the sculpture. How could you create a theme in your sculpture? Eric Bullard, My Universe, 2001.

After the plaster dries, peel away the box. (If you used sand, place the box inside a

larger box to catch the sand.) Remove the clay, or brush away any sand that sticks to the plaster.

# 0

#### **Studio Connection**

Make a larger casting by using a variety of textured objects. For the container, use a disposable aluminum pan

or a shoe box lined with a plastic bag and reinforced with masking tape. You could try pushing pebbles, shells, buttons, or beads about halfway down into the clay or sand. Leave them there when you pour the plaster. When it sets, the objects will be embedded in the finished relief sculpture.

### Lesson Review

### **Check Your Understanding**

- **1.** Explain why the depressions in the mold come out as elevations in the relief sculpture.
- 2. Why is this method of casting a good way to create a sculpture with a variety of textures?

Artists as Pioneers

289

# Assessment Options

**Peer** Have students each write or create a visual record of

the process they followed to create their relief sculpture. Invite small groups of students to share their records and discuss the extent to which each record would be clear for someone who has never been involved in the process.

### **Using the Overhead**

#### Write About It

**Describe** Carefully describe the surface textures of this sculpture.

Analyze How did the artist arrange forms and textures to attract and hold the viewer's attention?

18

### **Studio Connection**

Have students follow the directions to create a relief. In addition to using the sug-

gested textured natural objects, students may press small found objects into wet sand or clay. Encourage students to create a variety of textures.

**Assess** See Teacher's Resource Binder: Check Your Work 9.2.

### **Studio Tip**

Have students use a paper towel to wipe plaster from tools before rinsing them: plaster will harden and clog sink drains.

### Safety Tip

If students work with powdered plaster,

have them wear a paper breathing mask. Caution students that plaster in contact with skin for more than a few minutes may sometimes burn.

# **Assess**

### Check Your Understanding: Answers

- 1. The plaster is poured into the mold, which includes the depressions. When the plaster hardens and is removed from the mold, the areas that were depressed have been filled and are therefore in relief in the completed sculpture.
- 2. Answers will vary. Students may mention the use of a variety of tools and objects to create impressions that will appear in the cast relief sculpture.

# Close

Review students' answers to Check Your Understanding. Display their reliefs. Ask students to identify textures in the reliefs and to discuss which textures are most interesting.

# **Prepare**

### **Pacing**

One or more 45-minute periods, depending on the complexity of the weaving

### **Objectives**

- Identify areas of artistic production in which Israelites were pioneers.
- Understand influences on the work of Nomi Wind's art.
- Make an experimental weaving that combines traditional weaving techniques with other fiber processes, such as knotting and braiding.

# Vocabulary

artisan A person skilled in creating handmade objects.

# **Using the Map**

Ask: If you were to travel on land from Africa to Asia or Europe, what countries would you travel through? Tell students that if they followed the coast of the Mediterranean Sea, they would go through Israel, a small nation that has had a turbulent history, in part due to its strategic location.

Ask: What countries border Israel? (Egypt, Syria, Jordan, Lebanon)

# National Standards 9.3 Global Destinations Lesson

- **1b** Use media/techniques/processes to communicate experiences, ideas.
- 4a Compare artworks of various eras, cultures.
- **4c** Analyze, demonstrate how time and place influence visual characteristics.

# **Art of Israel**

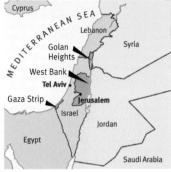

Israel

GLOBAL DESTINATIONS LESSON

### Places in Time

The nation of Israel, on the eastern shore of the Mediterranean Sea, was founded in 1948. For centuries, however, many cultures have existed in the region. The land has been known as Canaan, Palestine, and the Holy Land (because it is the site of many ancient holy places of the Jewish, Christian, and Moslem religions). Diverse ethnic groups, belief systems, sects, and cultures continue to populate Israel.

# Pioneers of the Ancient World

The artistic traditions of Israel and the rest of the Middle East have existed since ancient times, even before the civilizations of Egypt, Greece, and Rome. Ancient Israelite artisans became pioneers in many art forms, including the art of making glass.

It is believed that glassmaking may have been discovered by accident. The earliest glass vessels appeared in the ancient region known as Mesopotamia (present-day Iraq). The Israelite artisans learned to create colorful and complex glass objects and beads (Figs. 9–17, 9–18). Later, when they moved from their homeland, the Israelite artisans carried the craft to other parts of the world.

Fig. 9–17 Glass vessels were produced in Eretz Israel, "the land of Israel," for many centuries before the Greeks and Romans had even acquired a word for glass. What can you find out about how glass is made? Eastern Mediterranean (possibly Cyprus), Amphoriskos, 2nd–1st centuries BC. Almost opaque yeliow-green glass; core-formed, trail decorated, and tooled, height: 10°

290

# **Teaching Options**

### Resources

Teacher's Resource Binder A Closer Look: 9.3 Find Out More: 9.3 Check Your Work: 9.3 Assessment Master: 9.3 Large Reproduction 18 Slides 9e

### Teaching Through Inquiry

Art History Challenge students to contribute to a visual display about pioneering developments in art. Assign students to research the origins of art materials and art-making processes and record their findings on both a time line and a world map. Explain to students that some art-making traditions have multiple origins. Encourage students to include technologies (the making of glass, beads, paper, and so on), materials (oil paint, acrylics, tube watercolors, crayons, and so on) and artists who pioneered a particular style or use of materials and techniques.

# **Preserving Traditions**

In ancient times, Israeli artists were also pioneers in the textile arts. They were masters in the production of fine linen and wool cloth, embroidered fabrics, stitched garments, and carpets. Artists wove colorful designs of plants, flowers, and other natural objects. The designs sometimes included scenes and stories from the Bible. The carpets had both domestic and religious functions. They covered floors and furniture, and served as hanging screens in homes and in synagogues.

Fig. 9–18 These are typical of the beads used as trade goods for over 3,000 years. Do you think beads such as these, which perhaps no one other than the Israelites knew how to make, were valuable for trade? Eastern Mediterranean or Persia,

Were Valuable for Gauds, 6th-3rd centuries BC.
Translucent bluish-green, deep blue, and opaque white glass; core-formed, trail decorated, and tooled, diameter: 1/8 - 1/2 '(9 mm - 1.3 cm). © The Corning Museum of Glass. Corning Museum of Glass, Corning, New York.

Fig. 9–19 Carpets were and continue to be valued possessions of Israeli homeowners. Israel, Bezalel School, Marvadia Workshop, "Song of Songs" Carpet, 1920s. Wool, 68" x 39 1/3" (173 x 100 cm). The Israel Museum, Jerusalem. Photo © The Israel Museum Jerusalem.

Artisans today continue the ancient traditions of creating colorful carpets with complex designs (Fig. 9–19). They use traditional materials, such as silk, wool, goat hair, camel hair, cotton, linen, hemp, and jute. As in the past, the carpets can be found in many Israeli homes and religious buildings.

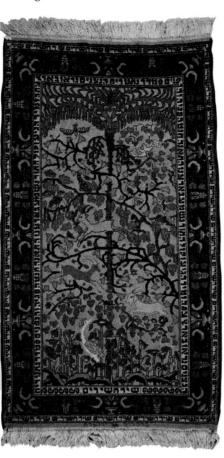

Teach

# **Engage**

Discuss recent events in Israel, and ask volunteers to tell what they know about this country and its history.

# **Using the Text**

Art History Ask: When and where was glass believed to have been discovered? (2400 BC in Mesopotamia) What materials did ancient and contemporary Israeli artisans weave? (silk, wool, goat hair, camel hair, cotton, linen, hemp, jute) What subjects did they include in their weavings? (plants, flowers, natural objects, Bible scenes and stories) How did they use these weavings? (as floor and furniture coverings, as hanging screens in homes and synagogues)

# Using the Art

Art Criticism Ask: What are the colors, textures, and patterns in the vase and beads? How do the patterns and shape suggest that these glassworks were made from liquid or molten quartz? Why would the beads have been exported more widely than vases? (not as fragile) What are the patterns and colors in the weaving? Which shapes are repeated?

Artists as Pioneers

291

### More About...

For over 75,000 years, people have used natural glass, such as obsidian from volcanoes. However, glass as we know it was developed much more recently, most likely in the Middle East. Ancient glassmakers used the **core-forming method** to hollow vessels such as the amphora: they molded clay and possibly animal dung on the tip of a metal rod, and then coated the rod by dipping it into a crucible of molten glass; after the glass had cooled, they dug out the clay core, leaving a hollow vessel.

### **Using the Large Reproduction**

### **Consider Context**

**Describe** What materials were used in this sculpture? **Attribute** In what geographical areas would sheep, goat, and camel hair be available in large quantities? **Understand** The title of this piece is *Womanhood*. In

**Understand** The title of this piece is *Womanhood*. In what ways does the "veiled" or "hooded" look of these

forms remind you of women's dress in a certain region of the world?

**Explain** Explain what you think are the reasons that the artist chose to work with the materials as she did.

# **Using the Text**

Art History Discuss Nomi Wind's statement. Ask: What local materials could you weave to express yourself? Where did Nomi Wind grow up? (Jerusalem) How did the Bedouin culture influence Wind's art? (Wind began to use the Bedouin type of raw, stained wool.) What does "art to wear" mean?

# **Using the Art**

Art Criticism What are the textures and patterns in Nomi Wind's artworks? What do both of these pieces have in common? What materials does Wind use in her sculptures? What do you think is the message in each artwork? Have students compare the energy or movement suggested in each piece.

### **Studio Connection**

Demonstrate several weaving techniques.

- Make a simple radial loom by crossing two or more sticks or straws at a central point and weaving yarn, rag strips, twisted crepe paper, ribbons, or cord around the crossing point.
- Make a rectangular loom from stiff cardboard. Cut 1/2" notches about 1/4" apart on the short sides of the rectangle. Thread a continuous piece of yarn to form the warp around each notch, from one end to another.
   Demonstrate weaving a weft of yarn or other fiber over and under each warp string.

Encourage students to be creative in their use of materials. You may wish to have students weave in nature objects such as feathers, leaves, and flower stems. **Ask**: How can you make your weaving suggest your heritage, locale, or interests?

Assess See Teacher's Resource Binder: Check Your Work 9.3.

### **Pioneering Across Boundaries**

"The process of my work [begins] with the use of local materials and the search for expression of my place and my self."

Nomi Wind (born 1940)

Many artists in Israel today continue the ancient techniques of weaving and needlework. Some artists, including Nomi Wind, also try to take the art form in new directions. Wind combines old and new techniques, as well as different cultural traditions, to create her fiber sculptures.

Born in West Jerusalem, Wind graduated with a degree in education from Hebrew University. As an Israeli, she was surrounded by the Judaic tradition of women doing needlework as a means of beautifying their home. But in 1967 in East Jerusalem, she came into contact with and was influenced by Bedouin fiber traditions. The Bedouin are a nomadic people who move from place to place in the desert. They use camel and goat hair, as well as plant fibers, to make tents and clothing.

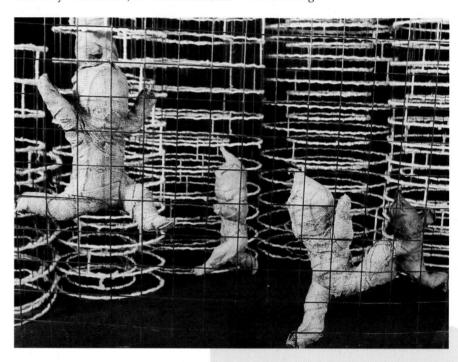

Fig. 9–20 The artist uses materials other than fiber in constructing her large-scale pieces. How do you think this piece was made? Nomi Wind, Defeated Childhood, 2000.

292

GLOBAL DESTINATIONS LESSON

# **Teaching Options**

### **Meeting Individual Needs**

Multiple Intelligences/Logical-Mathematical and Linguistic Have students identify how both the early Israelite glassmaker (Fig. 9–18) and Nomi Wind (Fig. 9–21) used repetition in their pioneering works. Ask: How are these two artworks similar, even though the materials are different? How does the repetition of line and pattern heighten the visual impact of each piece? Ask students each to imagine that they are the ancient Israelite glassmaker and to write a commentary on Wind's contemporary work. Ask: How do you think the glassmaker would have reacted to Wind's art? What questions might he or she have had for Wind?

# **Touched by the Desert**

The markets, sounds, and smells of the old city of East Jerusalem made an impression on Wind, as did the quiet beauty of the eastern desert. She observed how the Bedouin, in the fashion of their ancestors, pitched tents of camel wool and cared for their herds of camels and sheep. The Bedouin are highly skilled at spinning wool by hand. For Wind, the raw, stained wool they used seemed to hold traces and smells of the desert. She knew this was the material through which she could best express her ideas about her Middle Eastern heritage.

At first, Wind's interest in creating with wool resulted in "art to wear," pieces that allowed her to study the material's possibilities. By seeing people wearing her art, she moved to her next phase: sculptures based on the human form. In turn, these figurative pieces led to her present body of work: large, abstract sculptures influenced by the wild, open spaces of the desert. In these works, Wind has continued to explore the three-dimensional nature of fibers. In addition, she has introduced materials such as stone and iron into her large-scale fiber sculptures.

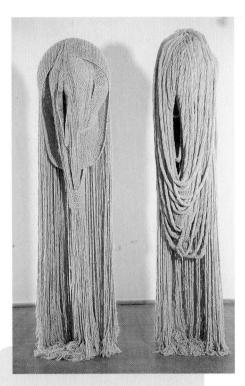

Fig. 9–21 Why would the artist title this sculpture Women of the Desert? Nomi Wind, Women of the Desert, 1992.

#### **Studio Connection**

Be a pioneer, and make an experimental weaving. Explore and experiment with traditional weaving techniques, forms, and

materials. Combine traditional weaving techniques with other fiber processes, such as knotting and braiding. Consider creating a weaving that has a geometric (circular, triangular, or rectangular) or other three-dimensional form. Experiment with found materials to create different surface textures and patterns. Try such materials as wire, foil, reeds, plastic, ribbons, and beads.

### Lesson Review

#### **Check Your Understanding**

- **1.** Name two areas in which the Israelites were pioneers of artistic production.
- **2.** How is the textile art of carpet-making important in Middle Eastern cultures? How are carpets used?
- **3.** What event influenced the direction of Nomi Wind's art?
- **4.** How is it possible to be a pioneer in weaving if it is an art form that has been practiced for thousands of years?

### Extend

Assign students to research textile art from their culture's heritage. Encourage them each to share actual examples from their family or to find examples in books and on the Internet.

### Assess

# Check Your Understanding: Answers

- 1. glassmaking, weaving
- 2. Middle Eastern carpets have both domestic and religious functions. Carpets cover floors and furniture and are hung as screens in homes and synagogues.
- **3.** her contact with Bedouin fiber traditions
- **4.** Answers will vary. Students may mention the use of innovative techniques, textures, or forms.

# Close

Display the weavings. Encourage students to point out unusual materials in the pieces, and to give adjectives for the various textures. Discuss students' answers to Check Your Understanding.

293

Artists as Pioneers

### Teaching Through Inquiry

Art Production Involve students in making posters or setting up a learning center—for younger, elementary-school students—that explains a specific form of fiber art. Have students work in groups to select a process to explain, such as braiding, knotting, applique, embroidery, weaving, quilting, or felting.

### More About...

The **Bedouin** are the desert-dwelling nomads of the Sinai and Arabian peninsulas. They migrated in small groups, herding their animals across vast expanses. They lived in tents, separated into men's and women's sections, woven by women from goat or sheep hair on flat looms that could easily be rolled up for transport. Bedouin weaving, by featuring geometric designs but rarely human figures, reflects Islamic traditions.

### **Assessment Options**

**Teacher** Have students identify areas of artistic production in which Israelites were pioneers.

**Self** Have students write a critique of their work, commenting on the extent to which they think they made creative and innovative use of materials.

# **Recycling for Sculpture**

# **Prepare**

### **Pacing**

One or more 45-minute periods

# **Objectives**

- Learn how some artists have pioneered the use of recycled materials in their artworks.
- Understand how artists incorporate real and implied texture in their artworks.
- Create a sculpture from recycled materials.

### Vocabulary

texture The way a surface feels (actual texture) or the way it is depicted to look (implied texture). Texture is an element of design.

# **Supplies**

- discarded objects, such as old toys, shoes, utensils, plastic containers, scrap metal, cardboard, packing materials
- small found materials, such as hardware, wire, string, pipe cleaners, plastic lids, feathers, buttons, game parts
- white glue, masking tape, duct tape
- · glue gun
- · scissors
- acrylic paint and brushes (optional)

# National Standards 9.4 Studio Lesson

1a Select/analyze media, techniques, processes, reflect.

**2a** Generalize about structures, functions.

**5c** Describe, compare responses to own or other artworks

Sculpture in the Studio

# **Recycling for Sculpture**

# Pioneering the Art of Trash

STUDIO LESSON

#### **Studio Introduction**

Isn't the ability to turn trash into art wonderful? Making something from nothing—or finding new uses for old

things—can be a real challenge. But not with some creative imagination. Perhaps you once pretended that an empty milk carton was a train engine, or that a wrapping-paper tube was a telescope.

If so, you used your imagination to turn trash into a useful object. Now you just have to turn that object into art!

In this studio experience, you will create a sculpture from recycled materials. Pages 296 and 297 will tell you how to do it. Your challenge is to be inventive with your choice of "junk" materials. Study the materials, and let your imagination pioneer

# **Studio Background**

### **Recycling Materials into Art**

For their artwork, many sculptors today find ideas and materials in trash cans and junkyards. They turn these found and recycled materials into objects of beauty, usefulness, or humor. Many artists see possibilities in disposed packaging, old shoes, pieces of jewelry, broken appliances and toys—in anything that sparks an idea.

Artists who work with discarded materials are inspired by the surfaces, textures, colors, and forms that the materials offer. As they sort through household rubbish and piece together a picture of our society, these artists somewhat become modern archaeologists. Sometimes with humor, sometimes with seriousness, they use found materials in their sculptures to challenge our ideas about art and about society.

Fig. 9–23 John Outterbridge, an African American artist from North Carolina, turned his father's junk into marketable artwork. This hobby became a full-time job. John Outterbridge, Ethnic Heritage Series: California Crosswalk, 1979.

Metal, wire, cloth, and other mixed media, 3'10" x6 x3" (117 x 183 x91.4 cm). Collection of the California Afro-American Museum Foundation. © California Afro-American Museum Foundation.

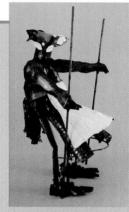

Fig. 9–22 Camp, a
Nigerian sculptor, works
with scrap metal and
other found materials.
Texture, movement,
and humor are important
elements of her artworks of costumed
performers. Sokari
Douglas Camp,
Masquerader with Boat
Headdress, 1995.
Steel and mixed media, height:
approx. 78" (200 cm). Courtey the
artist. Collection of the National
Museum of African Art, Smithsonian
Institution, Washington, D.C.

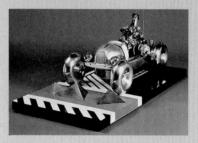

294

# **Teaching Options**

### Resources

Teacher's Resource Binder Studio Master: 9.4 Studio Reflection: 9.4 A Closer Look: 9.4 Find Out More: 9.4 Overhead Transparency 18 Slides 9f

### **Teaching Through Inquiry**

Art History From the artworks in this chapter, have students review those in which the artist gave new life to found objects or materials. Ask students each to select one of the artists to investigate, and then to work in a group with other students who selected the same artist. Have students use Inquiry Worksheet 7, "Biography of an Artist," (see Teacher's Resource Binder) to guide their investigation. Have groups each share their findings in a skit, song, video, bulletin-board, or Power-Point presentation.

a way to create your artwork. Do the shapes, forms, and textures of the materials suggest an idea or theme? Will your sculpture represent something, such as a bird, or will it be a form with no recognizable subject? Create a sculpture that will help people see old junk in a new

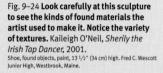

Fig. 9-25 Why, do you think, did this artist title his sculpture My Room? Merrick Treadway, My Room, 2000.

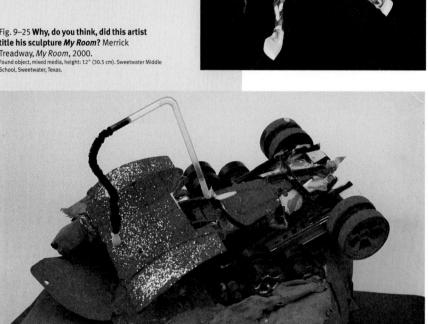

Artists as Pioneers

295

# Teach

### Engage

Take a clean, empty milk carton and move it in a hopping motion; then swing it about so that it seems to fly; and finally hold it in front of your face like a mask. Invite students to suggest ways to change the container so that it will resemble, respectively, a rabbit, a bird, and a mask.

# **Using the Text**

Art Production Discuss where sculptors find materials for junk sculptures. Ask: What would you like to include in a sculpture? Where could you find those materials?

# **Using the Art**

Art Criticism Ask: What materials were used in the junk sculptures? What are the textures of each? Aesthetics Ask: If you could have in your room either California Crosswalk or a model car that you assembled from a kit, which would you choose and why? Do you consider this an artwork or just a toy? Why?

### More About...

John Outterbridge was born in 1933 in Greenville, North Carolina. His father collected scrap metals and reassembled them into useful objects; his mother drew and quilted. In his own sculptures, Outterbridge, as his father did, uses everyday found objects, fabric scraps, and yarn. In the 1960s, he moved to Los Angeles, where assemblage artists influenced his art.

### **Using the Overhead**

### Think It Through

Ideas What ideas seem to be most important in this artwork? Why?

Techniques How did the artist use materials and techniques to express these ideas?

# **Recycling for Sculpture**

# **Studio Experience**

Discuss each step in Try This. Encourage students to be imaginative in using materials in unusual ways. How can they create textures in their sculpture? Discuss their ideas. Some students may wish to paint their sculpture.

### **Idea Generators**

- Have students study the main object that will form their sculpture so as to see what it suggests.
- Encourage students to work abstractly with their found objects.
   Suggest the use of paint and texture to emphasize form.

### Safety Note

Demonstrate safe use of the glue gun, and, if

possible, set up a gluing work center so that you can closely supervise students' use of glue guns. Have students use a piece of cardboard to protect their work surface from hot glue.

# **Studio Tips**

- Have students work in groups that each have a collection of found materials.
- Sort and store similar recycled objects in boxes.

### Sculpture in the Studio

# **Making Your Sculpture**

### You Will Need

STUDIO LESSON

- discarded objects, such as old toys, shoes, kitchen utensils, plastic, metal, and cardboard packaging
- small found materials, such as washers, nuts,
- bolts, screws, soft wire, string, pipe cleaners, plastic lids, feathers, and game parts
- white glue, masking tape,
- glue gun

**3.** Use glue or tape to attach pieces to the main form. As you work, look at your sculpture from all sides. Do you need to make any changes in your plan?

### Check Your Work

Display your sculpture with your classmates' sculptures. Take turns explaining why the features of the forms interested you. How did the forms inspire you to create your sculpture? What materials did you use to create interesting textures? How could your sculpture challenge the way people think about discarded materials?

### **Safety Note**

Do not use a glue gun without your teacher present. The tip of a glue gun and the glue itself get very hot and can burn you.

### Try This

- 1. Choose a main form for your sculpture. Turn the form over in your hands and study it. Does it remind you of any particular subject, such as an animal or
- person? Or are you simply drawn to its shape, texture, and color? What ideas for a sculpture come to mind?

2. Decide which found materials you will add to the main form. Will you create limbs or other recognizable features? Or will you add materials only to embellish the forms and colors that

already exist? What kinds of textures can you create?

#### **Computer Option**

You can use images from magazines to create a twodimensional "junk sculpture." Use a scanner and photo-

manipulation software to scan and resize images and to compose a composite collage artwork. As you work, think about the relationships between the sizes and placement of the images. You could also use a digital camera to photograph objects. Import the image files, and then combine and alter them as you wish.

296

# **Teaching Options**

### **Teaching Through Inquiry**

Aesthetics Ask students to work in small groups to address the following questions about art made from recycled materials: 1. Are there any materials that artists should *not* use when creating an artwork from found materials? Why? 2. Must an artist change the found material in some way in order for it to be considered an artwork? 3. Are there some general guidelines to follow when making artworks from found or recycled materials? Have groups present their answers in a full-class discussion.

### **Elements and Principles**

#### **Texture**

**Texture** is the way something feels to the touch. When you stroke a kitten, its fur feels soft. When you touch a rock, it might feel rough, smooth, or bumpy. Artists can create these textures, and

many others, in two ways. Sculptors, architects, and craftspeople use such materials as fiber, stone, metal, and glass to create real texture, texture you can actually feel. Artists who draw and paint use pastel, pencil, paint, and other media to create *implied texture*, the illusion or sense of texture. In a two-dimensional artwork, such as a painting or drawing, you don't actually feel the textures of the objects that are depicted. Instead, your eye senses, for example, the gritty, prickly, and silky surfaces of the objects.

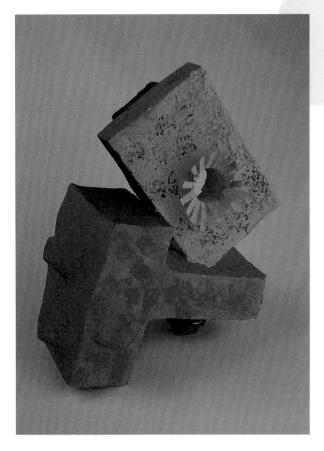

Fig. 9–26 This artist chose to create a nonobjective sculpture. The variety of geometric shapes are unified by his choice of color and pattern. Matthew Brady, Tints and Shades, Red, 2000.

Recycled boxes, papie-mâché, masking tape, tempera, height: 14" (3.5.5 cm). Fred C. Wescott Junior High, Westbrook. Mainty

Artists as Pioneers

297

Computer Option Ask students to select objects from a variety

of sources. Objects may include tools, household appliances, sports equipment, toys, and furniture. Encourage students to take the time to scan and carefully combine the individual elements into one work. As a way to promote creative problem solving, assign a minimum number of items and categories.

# **Elements and Principles**

Have students identify a variety of textures in the classroom. Discuss the difference between real and implied textures. Ask students to identify, from this book, artworks that feature real textures and those that have implied texture.

# **Assess**

# **Check Your Work**

Before students display their art, have them write their answers to the questions. Ask students to work in groups to explain their sculpture.

# Close

Display the sculptures, and have students identify interesting textures.
Ask students to explain the ways they have challenged others to think about discarded materials.

More About...

Assemblages, or constructions, are three-dimensional artworks made by combining found, recycled, or every-day materials in unusual ways. Picasso, in his Cubist artworks, was one of the first artists to use assemblage consistently. French artist Jean Dubuffet likely coined the term "assemblage" during the 1950s; by the 1960s, it was an accepted art term. Joseph Cornell, Alexander Archipenko, Robert Rauschenberg, David Smith, Jean Tinguely, and Niki de Saint Phalle are but a few of the many artists who have used this technique.

### **Assessment Options**

**Self** Have students find, in this chapter, two artworks that relate to their own finished art-

work—one that is similar to their own artwork and one that is very different from their own work. Ask students to explain their selections, which should indicate an understanding of how they and the other two artists incorporated found materials.

# **Social Studies**

Have students do research, online and in stamp catalogs, on the history of western expansion as portrayed in U.S. postage stamps. Ask students to work together to make an electronic time line of the images on the stamps. Challenge students to consider areas that are not represented, and have them design stamps to fill the oversights.

# Connect to...

# **Daily Life**

Do you see the **creative possibilities of everyday objects**? Many artists have used everyday objects in their artworks in new and inventive ways. By combining objects and presenting them as art, artists challenge us to see things in new ways. Artist Joseph Cornell is known for his inventive use of daily-life objects. He once said: "The question is not what you look at, but what you see." What does this statement mean to you?

Fig. 9–27 **What kinds of objects do you collect? How could you turn them into art?** Joseph Cornell, *A Pantry Ballet (for Jacques Offenbach)*, 1942.

(10) Tucques Offeribuctiff, 1942.
Mixed-media construction, 10 ½ \* 18\* x 6\* (2.6.6 x 48 x 15.2 cm). The Nelson-Atkins
Museum of Art, Kansas City, Gift of the Friends of Art. © The Joseph and Robert Cornell
Memorial Foundation/Licensed by VAGA, New York, NY.

# **Careers**

Do you enjoy fabrics that are unique in color, texture, or form? If so, you share such preferences with fiber artists. **Fiber artists**, or textile artists, work with many kinds of materials and fibers to create fabrics, wall hangings, sculptures, weavings, quilts, or wearable art. They must understand color theory, drawing, design, printing processes, and textile science and technology. Contemporary textile artists are pioneering new approaches in their fields and broadening the scope of the materials they use. A recent development in the profession is the use of computer software designed to aid in developing complex designs and patterns.

Fig. 9–28 **How did this artist use color? How did she create a complex design?** Erika Wade, *Duet*, 1991. Warp painted and embroidered cotton, 40° x 62° (102 x 157 cm). Courtesy the artis

298

# **Teaching Options**

### Resources

Teacher's Resource Binder:
Making Connections
Using the Web
Interview with an Artist
Teacher Letter

### **Video Connection**

Show the Davis art careers video to give students a reallife look at the career highlighted above.

# **Other Subjects**

#### **Social Studies**

What do you think of when you hear the word pioneers? If you're thinking about United States history, then covered wagons, log cabins, settlers, and prospectors might come to mind. The early settlers who headed west in search of land or gold have been called pioneers. These settlers believed in Manifest Destiny, a nineteenth-century idea that the United States had the right and duty to expand its territory and influence throughout North America. Under Manifest Destiny, many Native Americans were displaced, buffalo were slaughtered, lands were cleared, and railroads were built. How have our ideas about westward expansion changed over time? Why have views changed? What new perspectives do we have today?

#### **Mathematics**

Can you think of artists who pioneered the use of mathematics in their work? Two artists, M. C. Escher and Victor Vasarely, are known for creating tessellations and optical illusions. Tessellations are repeated patterns made up of congruent shapes—shapes that are exactly the same in size and shape. Optical illusions trick the eye and create the impression of three-dimensional space on a two-dimensional surface. Find examples of the work of Escher and Vasarely. What characteristics do they share?

Fig. 9–29 Fuller once said that he invented objects and waited for people to need them. Why do you think this type of structure never became popular? Buckminster Fuller, Southern Illinois University Chapel, 1950s. Located in Carbondale. Illinois. Photo courtey Davis Art Slides.

#### Science

Have you ever seen a geodesic dome? It is a lightweight, domed structure that is formed from triangular segments. Buckminster Fuller, a **pioneering scientist**, writer, and philosopher, patented the design of the dome in 1947. He used advances in technology to help him design projects that helped preserve the earth. In addition to the geodesic dome, his most famous inventions were a doughnut-shaped house and a three-wheeled car.

### **Mathematics**

Collaborate with a math teacher to help students make tessellations that are both mathematically correct and artistically designed. Encourage students to find examples of historical tessellations, and share with them the work of contemporary tessellation artist Jim McNeill, found online at <a href="http://hometown.aol.com/JMcne76382/findex.html">http://hometown.aol.com/JMcne76382/findex.html</a>. Additional resource materials—books, posters, and videos—about tessellations are available through many art-supply catalogs.

# Other Arts

#### **Dance**

The performing arts have had many pioneering artists. One such pioneer was dancer and choreographer Alvin Ailey (1931–1989). An African American, Ailey drew on his boyhood experiences for his works. In 1958, at a time when African Americans were not often accepted in dance schools, Ailey created his own dance company, the Alvin Ailey American Dance Theater. Today, his company continues to perform and also offers dance camps and other outreach programs for young people.

Internet Connection
For more activities related to this chapter, go to the Davis Website at www.davis-art.com.

Artists as Pioneers

299

### **Internet Resources**

### The Buckminster Fuller Institute

http://www.bfi.org/

This site is devoted to the design-science principles articulated by Buckminster Fuller.

### Jaune Quick-to-See Smith

http://www.nmwa.org/legacy/bios/bjgsmith.htm

Read about the artist on the Website of the National Museum of Women in the Arts.

### Weaving Granite: The Sculpture of Jesús Moroles

http://www.artsednet.getty.edu/ArtsEdNet/Resources/Moroles/index.html View Moroles's artworks, see images of the artist at work, and join an e-mail discussion group that includes the artist.

### **Community Involvement**

Arrange for students to interview residents at an assisted-living facility about products or inventions that were introduced in their lifetime. Assist students in doing research on the origins of the inventions.

# **Talking About Student Art**

When talking with students about their artwork, challenge them to consider how they could use different media—such as video, computer graphics, or performance art—to express the same ideas or send a similar message.

# Portfolio Tip

To help students see that artistic growth can be tracked chronologically.

encourage them to look for evidence of how their skills, attitudes, and understandings in art have changed over the course of the year. Ask students to consider reasons why they made remarkable progress in some areas, but didn't succeed as well in others.

# **Sketchbook Tip**

Review the value of sketchbooks and journals as research tools. Encour-

age students to add to their sketchbook beyond the school year.

# **Portfolio**

REVI

PORTFOLIO &

"When I first started this project, I thought it was very hard to find some of the pieces I was looking for, pieces that would make a pattern. Once I found them, it was quite easy from then on." Samantha Clark

Fig. 9-30 Six students each made a sculptural box inspired by the work of Louise Nevelson, the artist discussed on page 281. Juan Cabrera-Tovar, Khiem Nguyen, Evan Cyr, Matthew Tramont, Joe DeMaio, Samantha Clark, Louise Nevelson Assemblage, 2000. Wood, cardboard, tempera; each box is 4 1/2" x 3" x 3" (11.5 x 7.5 x 7.5 cm). Sedgwick Middle

"Once I chose to weave on a keyboard, it wasn't long until I decided to use wire. String or yarn just wouldn't look right. The actual weaving was a bit difficult, because sometimes the wire wouldn't bend very easily." Stephen Burrows

Fig. 9-31 The use of unusual materials makes this artwork part sculpture and part weaving. Stephen

Burrows, *Keyboard Wiring*, 2001. Keyboard, wire, rabbit's foot, copper foil, 8 ½ x 19° (21 x 48 cm). Mount Nittany Middle School, State College, Pennsylvania.

#### **CD-ROM Connection**

To see more student art view the Personal Journey Student Gallery.

Fig. 9-32 **Using a** photograph that already had a stretched-out subject, the artist created an exaggerated sense of movement. Kelli Ryder, Moving on Up. 2001. tographs on tagboard, 10 1/4" x 3 5/8" (26 x 9 cm). Les Bois Junior High School, Boise, Idaho.

"The idea for this picture came quickly. As my friend climbed up a tree, I snapped a shot without her knowing. As I cut the strips apart and glued them, I thought it was very difficult, but the end product was great." Kelli Ryder

300

# **Teaching Options**

### Resources

Teacher's Resource Binder Chapter Review 9 Portfolio Tips Write About Art Understanding Your Artistic Process Analyzing Your Studio Work

### **CD-ROM Connection**

For students' inspiration, for comparison, or for criticism exercises, use

the additional student works related to studio activities in this chapter.

# **Chapter 9 Review**

#### Recall

List three ways that twentieth-century sculptors were pioneers.

#### Understand

Explain the steps in making a plaster relief sculpture for a clay or sand mold.

### Apply

Produce a plan for a site-specific sculpture for the lobby or outside entrance of your school. Give reasons for your decisions.

#### Analyze

Compare similarities and differences in the way Jaune Quick-to-See Smith, Jesús Bautista Moroles, and Nomi Wind (*see example at right*) have been pioneers in art.

### For Your Sketchbook

Look through your sketchbook for evidence of a personal style or a change in the way you work. For

example, what have you done consistently? Do you seem to favor certain colors? What changes do you see in the way you sketch? Use a page in your sketchbook to comment on what you discover.

#### **Synthesize**

Create a timeline on which you locate each artwork shown in this chapter. Explain how three of the artworks show a new direction in art.

### Evaluate

Imagine you are giving the "Pioneering Spirit" award to an artwork from this chapter. Explain your first choice for the award. Then choose a work that you think shows no spirit of exploration. Explain why you think so.

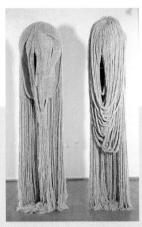

Page 293

#### For Your Portfolio

What evidence of your personal artistic growth can you see when you look at the works in your portfolio? Use these works

to discover where your personal journey in art has taken you. Select four artworks from your portfolio, and write one or two paragraphs that explain how you have grown as an artist.

Artists as Pioneers

301

# Advocacy

Create a Website to showcase students' art, and distribute a flyer to announce the site and invite community members to visit.

### **Family Involvement**

Involve family members in helping you collect discarded but recyclable materials for use in art classes.

# Chapter 9 Review Answers Recall

Twentieth-century sculptors have pioneered the use of new materials, new places for art, and new uses for traditional materials.

### **Understand**

Students should mention: cut the bottom off a box; reinforce sides, fill with one inch of sand or clay, press objects into sand or clay and lift them out; mix plaster, pour plaster into box; put hanger into wet plaster; peel away box sides; brush and finish.

### Apply

Plans will vary. Look for reasons that relate the sculpture to the specific site.

### **Analyze**

Jaune Quick-To-See Smith is a pioneer because of the important messages she sends about Native Americans; Moroles is a pioneer in his attempt to push the boundaries of stone; Nomi Wind has pioneered the three-dimensional use of fibers. Moroles and Wind have both pushed the boundaries of materials. Smith's pioneering work is with ideas.

### **Synthesize**

Time line should include correct placement of all artworks in the chapter. Make sure students have selected three artworks and have explained how they show a new direction for art.

#### **Evaluate**

Answers will vary, but look for appropriate reasons offered for each of the two selected works.

#### Reteach

Have students work in groups to plan a bulletin board for the whole school that shows how artists are pioneers. All groups should submit recommendations of artists and/or artworks to be featured. The whole class should vote on the final selections. Guide one group in planning the overall display, including its title and how the artworks will be arranged, while another group writes a short introduction that outlines the ways that artists are pioneers. A third group should write a label for each featured artist. Encourage a fourth group to write a letter to the school community about their bulletin-board display.

# **Acknowledgments**

We wish to thank the many people who were involved in the preparation of this book. First of all, we wish to acknowledge the many artists and their representatives who provided both permission and transparencies of their artworks. Particular thanks for extra effort go to Eileen Doyle at Art Resource and Bernice Steinbaum.

For her contributions to the Curriculum and Internet connections, we wish to thank Nancy Walkup. For contributing connections to the performing arts, we thank Abby Remer. A special thanks for the invaluable research assistance provided by Molly Mock and the staff at Kutztown University Library. Kevin Supples's writing and advice were greatly appreciated. Sharon Seim, Judy Drake, Kaye Passmore and Jaci Hanson were among the program's earliest reviewers and offered invaluable suggestions. We also wish to acknowledge the thoughtful and dynamic contributions made to the Teacher's Edition by Kaye Passmore.

We owe an enormous debt to the editorial team at Davis Publications for their careful reading and suggestions for the text, their arduous work in photo and image research and acquisition, and their genuine spirit of goodwill throughout the entire process of producing this program. Specifically, we mention Nancy Burnett, Nancy Bedau, Carol Harley, and Victoria Hughes Waters. Mary Ellen Wilson, our inhouse editor on the project, provided thoughtful and substantive assistance and support.

Our editors, Helen Ronan and Claire Golding, carefully guided the creation of the program, faithfully attending to both its overall direction and the endless stream of details that emerged en route to its completion. We thank them for

their trust and good faith in our work and for the spirit of teamwork they endorsed and consistently demonstrated.

For his trust in us, his vision and enthusiasm for the project, and for his willingness to move in new directions, we thank Wyatt Wade, President of Davis Publications

Although neither of us has had the privilege of being her student in any formal setting, we owe our grounding in the theory and practice of art education to the scholarship of Laura Chapman. She has been both mentor and friend to each of us throughout the years and especially in this project. We thank her for her loyal support and for providing us the opportunity to continue her work in art curriculum development in this program for the middle school.

We offer sincere thanks to the hundreds of art teachers who have inspired us throughout the years with their good thinking and creative teaching. We also acknowledge our colleagues at Kutztown University, Penn State University, Ohio State University, and other institutions who have contributed to our understanding of teaching and learning.

Finally, we wish to thank our families, especially Adrienne Katter and Deborah Sieger, who have provided loving support and balance in our lives during the preparation of this book.

Fldon Katter Marilyn Stewart

#### **Educational Consultants**

Numerous teachers and their students contributed artworks and writing to this book, often working within very tight timeframes. Davis Publications and the authors extend sincere thanks to:

Monica Brown, Laurel Nokomis School,

Nokomis, Florida

Beverly C. Carpenter, Amidon Elementary
School, Washington, DC

Debra Chojnacky, Les Bois Junior High

School, Boise, Idaho Terry Christenson, Les Bois Junior High

School, Boise, Idaho Ted Coe, Garfield School, Boise, Idaho Anita Cook, Thomas Prince School,

Princeton, Massachusetts Dale Dinapoli, Archie R. Cole Junior High School, East Greenwich, Rhode Island

Paula Sanderlin Dorosti, Associate Superintendent, District of Columbia Public Schools

Wendy Dougherty, Northview Middle School, Indianapolis, Indiana Leah Dussault, Plymouth Middle School,

Plymouth, Minnesota Pamela Flynn, West Hartford Public

Schools, West Hartford, Connecticut Cathy Gersich, Fairhaven Middle School, Bellingham, Washington Nancy Goan, Fred C. Wescott Junior High

School, Westbrook, Maine

Rachel Grabek, Chocksett Middle School, Sterling, Massachusetts Kerri Griffin, Springhouse Middle School,

Allentown, Pennsylvania Thelma Halloran, Sedgwick Middle School,

West Hartford, Connecticut
Lizabeth Lippke Haven, Kamiakin Junior
High School, Kirkland, Washington
Grace A. Herron, Hillside Junior High

School, Boise, Idaho Maryann Horton, Camels Hump Middle

School, Richmond, Vermont Anne Jacques, Smith Middle School, Fort Hood, Texas

Alice S. W. Keppley, Penn View Christian School, Souderton, Pennsylvania

Bunki Kramer, Los Cerros Middle School, Danville, California

Patricia Laney, Fletcher-Johnson Education Center, Washington, DC

Publisher Wyatt Wade

Editorial Directors: Claire Mowbray Golding, Helen Ronan

Editorial/Production Team Nancy Burnett, Carol Harley Mary Ellen Wilson

Editorial Assistance: Lynn Simon, Victoria Hughes Waters

Susan Christy-Pallo, Stephen Schudlich

Marguerite Lawler-Rohner, Fred C. Wescott Junior High School, Westbrook, Maine Karen Lintner, Mount Nittany Middle School, State College, Pennsylvania Betsy Logan, Samford Middle School, Auburn, Alabama Emily Lynn, Smith Middle School,

Fort Hood, Texas Patricia Mann, T.R. Smedberg Middle School, Sacramento, California Cathy Mansell, Art Consultant, Boise Public Schools, Idaho

Boise Public Schools, Idaho Cathy Moore, Sierra School, Arvada, Colorado

Arvada, Colorado Phyllis Mowery-Racz, Desert Sands Middle School, Phoenix, Arizona Deborah A. Myers, Colony Middle School, Palmer, Alaska

Jennifer Ogden, Victor School, Victor, Montana

Lorraine Pflaumer, Thomas Metcalf Laboratory School, Normal, Illinois Sharon Piper, Islesboro Central School, Islesboro, Maine

Islesboro, Maine Abby Porter, C. D. Owen Middle School, Swannanoa, North Carolina Sandy Ray, Johnakin Middle School,

Sandy Ray, Johnakin Middle School, Marion, South Carolina Connie Richards, William Byrd Middle

School, Vinton, Virginia Sandra Richey, Sweetwater Middle School, Sweetwater, Texas

Roger Shule, Antioch Upper Grade School, Antioch, Illinois Betsy Menson Sio, Jordan-Elbridge Middle

School, Jordan, New York Karen Skophammer, Manson Northwest Webster Community School, Barnum, Iowa

Evelyn Sonnichsen, Plymouth Middle School, Plymouth, Minnesota Bob Stimpert, South Junior High School, Boise, Idaho

Laura Crowell Swartz, R. J. Grey Junior High School, Acton, Massachusetts Ann Titus, Central Middle School,

Galveston, Texas Michael Walden, Gate Lane School, Worcester, Massachusetts Diana Woodruff, Director of Visual Arts,

Diana Woodruff, Director of Visual Arts, Acton Public Schools, Massachusetts

Photo Acquisitions: Jeanne Evans, Lindsay McCabe, Victoria Hughes Waters

Student Work Acquisitions. Nancy Bedau

Photographer of Student Work: Tom Fiorelli

Design:
Douglass Scott, Cara Joslin.
WGBH Design

Manufacturing: Georgiana Rock, April Dawley

# **Artist Guide**

Acoma (AHK-uh-muh) Pueblo, Southwestern US Alphonse, Inatace (ahl-fahnz, EE-nah-tahss) Haiti, b. 1943 Amrany, Omri and Julie Rotblatt US, 21st century Apollodorus of Damascus (uh-POL-uh-dore-us) Syria, active Greece, 2nd century AD Arcimboldo, Giuseppe (ar-cheem-BOLE-doh, jyuh-SEH-pee) Italy, c. 1530–1593

**Barragan, Luis** (bah-rah-GAHN, loo-EES) Mexico, 1902–1988

Bearden, Romare (BEER-den, ROH-mah-ray) US, 1912–1988 Biggers, John US, b. 1924 Blomberg, Hugo (blahm-burg) Sweden, 20th century

Bosch, Hieronymus (bosh, hee-RAHN-uh-muhs) Netherlands, c. 1450–1516 Brazille, Castera (brah-ZEE, kah-STAIR-ah) Haiti, 1923–1965

**Breuer, Marcel** (BROY-er mar-SEL) Hungary/US, 1902–1981 **Brooks, Romaine** (roh-MAYN) US, 1844–1970

Brueghel the Elder, Pieter (BROY-gul pee-ter) Flanders, c. 1564–1638

Bryer, Diana (BRY-er) US, 21st century Butterfield, Deborah US,

b. 1949

**Calder, Alexander** (CALL-dur) US, 1898–1976

Camp, Sokari Douglas (sohkah-ree) Nigeria, b. 1958

Chao Shao-an (chow shau-ahn) China, 1905–1988

**Chardin, Jean-Baptiste Siméon** (shahr-DAN, zhahn bahp-TEEST sam-ay-OHN)

France, 1699–1779 Chicago, Judy US, b. 1939 Chihuly, Dale (chi-HOO-lee)

US, b. 1941 **Christopher, Tom** US, 21st century

Coin, Willie US, 21st century Cornell, Joseph US, 1903–1972

Courbet, Gustave (koor-BAY, GOOHS-tahv) France, 1819–1877

**Dahomey** (duh-HOE-mee) African kingdom **Dalí, Salvador** (dah-LEE, SAHL-vah-door) Spain, 1904–1989

**Dancer, Daniel** US, 21st century

**de Saint Phalle, Niki** (duh sahn FAHLL, nee-kee) France, b. 1930

De Stijl (duh STILE) Doolittle, Beverly (DOO-littul) US, 21st century Duchamp, Marcel (doo-CHAHM, mar-SEL) France, 1887–1968

Escher, M. C. (EH-sher) Germany, 1898–1972 Acknowledgments/Artist Guide

Fallert, Caryl Bryer (FALL-urt) US, b. 1947 Fonseca, Harry (fon-SEE-kah) US, b. 1946 Frey, Viola (fry, vy-OH-lah) US, b. 1933 Fuller, Buckminster US, 1895–1983

Gehry, Frank O. (GEH-ree) US, b. 1929 Ghiberti, Lorenzo (ghee-BARE-tee, loh-REN-zoh) Italy, 1378?–1455 Gornik, April (GORE-nik) US, b. 1953 Graves, Michael US, b. 1934 Gray, Melinda US, b. 1952 Grooms, Red (groomz) US,

b. 1937

Halprin, Lawrence (HAL-prin) US, b. 1916 Hare, Frances US, 21st century Haring, Keith (HAIR-ing) US, 1958-1990 **Heade, Martin Johnson** (heed) US, 1819-1904 Henson, Jim (HEN-sun) US, 1936-1990 Hepworth, Barbara England, 1903-1975 Hockney, David (HOCK-nee) England, b. 1937 Holbein the Younger, Hans (HOLE-bine) Germany, 1497-1543 Hopi (HOE-pee) Pueblo, Southwestern US Huichol (hwee-chole) North central Mexico

**Iktinos** (IK-tih-nus) Greece, active 450–420 BC

Jahn, Helmut (yahn, HELmoot) Germany, b. 1940 Kahlo, Frida (KAH-loh, FREE-dah) Mexico, 1907–1954
Kallikrates (kah-LIH-kra-tees) Greece, 5th century BC
Kcho Cuba, b. 1970
Kita, Toshiyuki (kee-tah, toe-shee-yew-kee) Japan, b. 1942
Kollwitz, Käthe (KOHL-vits, KAY-teh) Germany, 1867–1945
Koons, Jeff US, b. 1955
Kruger, Barbara (KROO-gur) US, b. 1945
Kuniyoshi (koo-nee-yo-shee) Japan, 1797–1861

Lange, Dorothea (lang, dor-uh-THEE-uh) US, 1895–1965
Lanyon, Ellen (LAN-yun) US, b. 1926
Lawrence, Jacob US, 1917–2000
Legoretta, Ricardo (lay-goh-RAY-tah, ree-CAHR-doh)
Mexico, b. 1931
Leissner, Lawrence (LICE-nur) US, 21st century
Leonardo da Vinci (lay-uh-NAHR-doh dah VIN-chee) Italy, 1452–1519

Lewis, Maude (LOO-iss, mawd) Canada, 1903-1970 Lichtenstein, Roy (LICK-tenstine) US, 1923-1997 Limbourg Brothers (lahm-BOOR) France, 16th century Liu, Hung (lyoo, huhng) China, b. 1948 Lopez, Yolanda (LOH-pez, yoh-LAHN-dah) US, b. 1942 Lorenzetti, Ambrogio (lawren-ZET-tee, ahm-BROH-jyoh) Italy, c. 1290-1348 Lovell, Whitfield (LUHV-ul) US, b. 1959 Lysell, Ralph (lie-sel) US,

20th century

Mackall, Robert McGill (muh-KAWL) US, 1889-1982 Magritte, René (mah-GREET, ruh-NAY) Belgium, 1898-1967 Marc, Franz (mark, frahnz) Germany, 1880-1916 Matisse, Henri (mah-TEESS, ahn-REE) France, 1869-1954 Mattelson, Marvin (MAT-tulsin) US, b. 1947 Méndez, Lillian (MAYN-dez) US, b. 1957 Metsu, Gabriel (MET-soo, GAH-bree-ell) Netherlands, 1629-1667 Minoan (mih-NOE-un) ancient Greek civilization, c. 3000-1100 BC Miyake, Issey (mee-YAH-kay, ISS-ee) Japan/US, b. 1938 Moore, Henry England, 1898-1986 Moran, Thomas US, 1837-1926 Moroles, Jesús Bautista (moh-ROH-lace, hay-SOOS bow-TEES-tah) US, b. 1950 Navajo (NAH-vah-hoe)

Navajo (NAH-vah-noe) Southwestern US Nevelson, Louise (NEH-vulsin) Russia/US, 1899–1988 Oaxaca (wuh-HAH-kah)

Mexico
Obin, Philomé (OH-bahn, feeloh-MAY) Haiti, 1892–1986
Oleszko, Pat (oh-LESS-koh)
US, b. 1947
Oppenheim, Meret (OP-enhime, MER-et) Germany,
1913–1985
Oropallo, Deborah US,

b. 1954

Orozco, José Clemente (oh-ROHS-koh, hoh-SAY clay-MEN-tay) Mexico, 1883–1949 Outterbridge, John US, b. 1933

Peeters, Clara (PAY-turs, KLAH-rah) Flanders, 1594–1657
Pei, I. M. (pay) China/US, b. 1917
Penrose, Roland England, 1000, 1004

1900–1984 **Persian** (PUR-zhun) ancient Iran

Petyarre, Ada Bird (pet-YAR) Australia, b. 1930 Picasso, Pablo (pee-KAHSsoh, PAH-bloh) Spain,

1881–1973 **Poisson, Louverture** (PWAH-sohn, LOO-vair-toor) Haiti, 1914–1985

**Pollock, Jackson** (POL-uk) US, 1912–1956

Powers, Harriet US, 1837–1911

**Quick-to-See Smith, Jaune** (zhohn) US, b. 1940

Rauschenberg, Robert (ROW-shun-burg) US, b. 1925 Reid, Bill (reed) Canada, 1920–1998 Remington, Frederic US, 1861–1909 Rockwell, Norman US, 1894–1978 Rodin, Auguste (roh-DAN, ohgoost) France, 1840–1917 Ronibson, René (RON-ib-son, rah-NAY) Australia, 21st century

Rosenquist, James (ROH-zen-

kwist) US, b. 1933 **Ruisdael, Jacob van** (RIZE-dahl, YAH-kop fahn) Netherlands, c. 1628–1692 **Shahn, Ben** US, b. 1898–

**Sheeler, Charles** (SHEE-lur) US, 1883–1965

Sherman, Cindy US, b. 1954

Shimomura, Roger (shee-moe-MORE-uh) US, b. 1939 Shire, Peter (SHY-ur) US, b. 1947

Siqueiros, David Alfaro (sih-KAY-rohs, ahl-FAH-roh) Mexico, 1896–1974 Soleri, Paolo (soh-LARE-ee, POW-loh) Italy, b. 1919

Thiebaud, Wayne (TEE-boh) US, b. 1920 Tinguely, Jean (tan-GLEE, zhahn) Switzerland, 1925–1991 Tlingit (TLING-it) Northwest Coast, US Traylor, Bill (TRAY-ler) US,

c. 1856–1949 **Turner, J. M. W.** England, 1775–1850

VanDerZee, James (VAN-durzee) US, 1886–1983 Varo, Remedios (VAH-roh, reh-MAY-dee-ohs) Spain, 1908–1963 Vasarély, Victor (va-suh-RAY-lee) Hungary/France, 1908–1997

**Vázquez, Pedro Ramírez** (VAHSS-kez, PAY-droh rah-MEE-rez) Mexico, 20th century

Venturi, Robert (ven-TOORee) US, b. 1925 Vermeer, Jan (vur-MAIR, yahn)

Netherlands, 1632–1675 **Vu, Hoang** (voo, hwahng) Vietnam/US, 21st century

Waddell, Theodore (wah-DELL) US, b. 1941 Waqialla, Osman (wah-kee-AHL-lah, ohz-MAHN) Sudan, b. 1926

Webb, Doug US, b. 1946 Webb, Philip Speakman England, 1831–1915 Weems, Carrie Mae (weemz)

US, b. 1953 **Wen Boren** (wun boh-run)

Japan, 1502–1575 **Wind, Nomi** (NOE-mee) Israel, b. 1940

Wright, Frank Lloyd US, 1867–1959

**Wyeth, Jamie** (WHY-ith) US, b. 1946

**Yemadje, Joseph** (yeh-MAHDyeh) Benin, 20th century **Yoruba** (YOH-roo-bah) Nigeria

# World Map

The best way to see what the world looks like is to look at a globe. The problem of showing the round earth on a flat surface has challenged mapmakers for centuries. This map is called a Robinson projection. It is designed to show the earth in one piece, while maintaining the shape of the land and size relationships as much as possible. However, any world map has distortions.

This map is also called a *political* map. It shows the names and boundaries of countries as they existed at the time the map was made. Political maps change as new countries develop.

#### **Key to Abbreviations**

ALB. Albania AUS. Austria Bosnia-Hercegovina В.-Н. BELG. Belgium CRO. Croatia CZ. REP. Czech Republic EQ. GUINEA **Equatorial Guinea** HUNG. Hungary LEB. Lebanon LITH. Lithuania LUX. Luxembourg MAC. Macedonia NETH. Netherlands RUS. Russia SLOV. Slovenia SLCK. Slovakia SWITZ. Switzerland

Yugoslavia

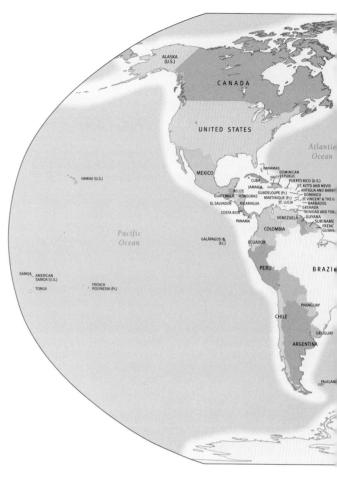

YUGO.

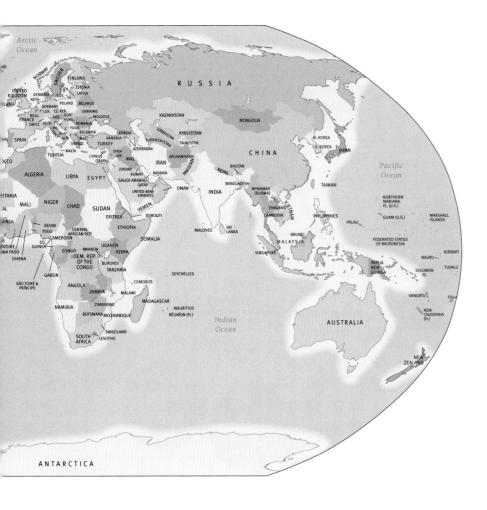

World Map

# **Color Wheel**

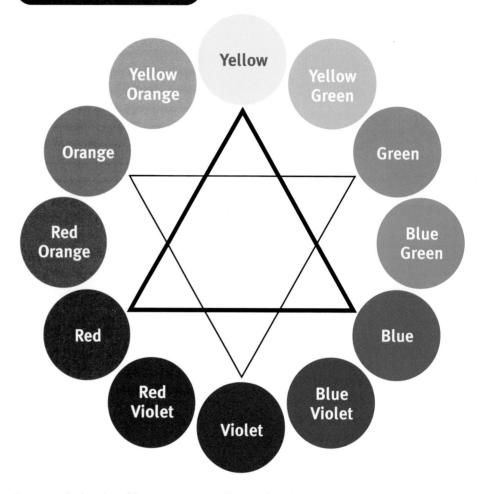

For easy study, the colors of the spectrum are usually arranged in a circle called a color wheel. Red, yellow, and blue are the three primary colors or hues. All other hues are made by mixing different amounts of these three colors.

If you mix any two primary colors, you will produce one of the three secondary colors. From experience, you probably know that red and blue make violet, red and yellow make orange, and blue and yellow make green. These are the three secondary colors.

The color wheel also shows six intermediate colors. You can create these by mixing a primary color with a neighboring secondary color. For example, yellow (a primary color) mixed with orange (a secondary color) creates yellow-orange (an intermediate color). Mixing the primary and secondary colors creates the six intermediate colors shown. Mixing different amounts of these colors produces an unlimited number of hues.

# **Bibliography**

#### **Aesthetics**

- Grimshaw, Caroline. Connections: Art. Chicago, IL: World Book, 1996.
- Magee, Brian. The Story of Philosophy. NY: DK Publishing, 1998.
- Varnedoe, Kirk. A Fine Disregard: What Makes Modern Art Modern. NY: Harry N. Abrams, Inc., 1994.
- Weate, Jeremy. A Young Person's Guide to Philosophy. NY: DK Publishing, 1998.

#### Art Criticism

- Antoine, Veronique. Artists Face to Face. Hauppauge, NY: Barron's, 1996. Cumming, Robert. Annotated Art. NY: DK Publishing, 1998.
- Franc, Helen M. An Invitation to See: 150 Works from the Museum of Modern Art. NY: Harry N. Abrams, Inc., 1996.
- Greenberg, Jan and Sandra Jordan. The American Eye. NY: Delacorte, 1995.
- ------ The Painter's Eye. NY: Delacorte, 1991.
- ------ The Sculptor's Eye. NY: Delacorte, 1993.
- Richardson, Joy. Looking at Pictures: An Introduction to Art for Young People. NY: Harry N. Abrams, Inc., 1997.
- Rosenfeld, Lucy Davidson. Reading Pictures: Self-Teaching Activities in Art Portland. ME: I. Weston Walch, 1991
- Portland, ME: J. Weston Walch, 1991. Roukes, Nicholas. *Humor in Art: A Celebration of Visual Wit.* Worcester, MA: Davis Publications, 1997.
- MA: Davis Publications, 1997. Welton, Jude. *Looking at Paintings*. NY: DK Publishing, 1994.
- Yenawine, Philip. How to Look at Modern Art. NY: Harry N. Abrams, Inc., 1991.

#### Art History General

- Barron's Art Handbook Series. How to Recognize Styles. Hauppauge, NY: Barron's. 1997.
- Belloli, Andrea. Exploring World Art. Los Angeles, CA: The J. Paul Getty Museum, 1999.
- D'Alelio, Jane. I Know That Building.
  Washington, DC: The Preservation
  Press, 1989.
- Gebhardt, Volker. *The History of Art.* Hauppauge, NY: Barron's, 1998.
- Hauffe, Thomas. *Design*. Hauppauge, NY: Barron's, 1996.
- Janson, H.W. and Anthony F. Janson. History of Art for Young People. NY: Harry N. Abrams, Inc., 1997.
- Remer, Abby. Pioneering Spirits: The Life and Times of Remarkable Women Artists in Western History. Worcester, MA: Davis Publications, 1997.

- Stevenson, Neil. Annotated Guides: Architecture. NY: DK Publishing, 1997
- Thiele, Carmela. Sculpture. Hauppauge, NY: Barron's, 1996.
- Wilkinson, Philip and Paolo Donati. Amazing Buildings. NY: DK Publishing, 1993.

#### **Ancient World**

- Corbishley, Mike. What Do We Know About Prehistoric People. NY: Peter Bedrick Books, 1994.
- Cork, Barbara and Struan Reid. The Usborne Young Scientist: Archaeology London: Usborne Press, 1991.
- Crosher, Judith. *Ancient Egypt*. NY: Viking, 1993.
- Fleming, Stuart. The Egyptians. NY: New Discovery, 1992.
- Giblin, James Cross. The Riddle of the Rosetta Stone. NY: Thomas Y. Crowell, 1990.
- Haslam, Andrew, and Alexandra Parsons Make It Work: Ancient Egypt. NY: Thomsom Learning, 1995.
- Millard, Anne. *Pyramids*. NY: Kingfisher, 1996.
- Morley, Jacqueline, Mark Bergin, and John Hames. *An Egyptian Pyramid*. NY: Peter Bedrick Books, 1991.
- Powell, Jillian. Ancient Art. NY: Thomsom Learning, 1994.

#### Classical World

- Avi-Yonah, Michael. Piece by Piece! Mosaics of the Ancient World. Minneapolis, MN: Runestone Press, 1993.
- Bardi, Piero. The Atlas of the Classical World. NY: Peter Bedrick Books, 1997.
- Bruce-Mitford, Miranda. Illustrated Book of Signs & Symbols. NY: DK
- Publishing, 1996.
  Chelepi, Chris. Growing Up in Ancient
- Greece. NY: Troll Associates, 1994 Cohen, Daniel. Ancient Greece. NY: Doubleday, 1990.
- Corbishley, Mike. Ancient Rome. NY: Facts on File. 1989.
- Facts on File, 1989. Corbishley, Mike. *Growing Up in Ancient Rome*. NY: Troll Associates, 1993.
- Hicks, Peter. The Romans. NY: Thomson Learning, 1993.
- Loverance, Rowena and Wood. Ancient Greece. NY: Viking, 1993.
- MacDonald, Fiona. A Greek Temple. NY: Peter Bedrick Books, 1992.

- McCaughrean, G. Greek Myths. NY: Margaret McElderry Books, 1992. Roberts, Morgan J. Classical Deities and Heroes. NY: Friedman Group, 1994.
- Wilkinson, Philip. Illustrated Dictionary of Mythology. NY: DK Publishing, 1998
- Williams, Susan. *The Greeks*. NY: Thomson Learning, 1993.

### The Middle Ages

- Cairns, Trevor. The Middle Ages. NY: Cambridge University Press, 1989
- Caselli, Giovanni. The Middle Ages. NY: Peter Bedrick Books, 1993.
- Chrisp, Peter. Look Into the Past: The Normans. NY: Thomson Learning. 1995.
- Corrain, Lucia. *Giotto and Medieval Art.* NY: Peter Bedrick Books, 1995.
- Howarth, Sarah. What Do We Know About the Middle Ages. NY: Peter Bedrick Books, 1995.
- MacDonald, Fiona. A Medieval Cathedral. NY: Peter Bedrick Books, 1994.
- Mason, Antony. If You Were There in Medieval Times. NY: Simon & Schuster 1996
- Robertson, Bruce. Marguerite Makes a Book. Los Angeles, CA: The J. Paul Getty Museum, 1999.

#### Renaissance

- Corrain, Lucia. Masters of Art: The Art of the Renaissance. NY: Peter Bedrick Books, 1997.
- Di Cagno, Gabriella et al. Michelangelo. NY: Peter Bedrick Books, 1996.
- Dufour, Alessia Devitini. *Bosch*. ArtBook Series. NY: DK Publishing, 1999.
- Fritz, Jean, Katherine Paterson, et. al. The World in 1492. NY: Henry Holt & Co., 1992.
- Giorgi, Rosa. Caravaggio. ArtBook Series.
- NY: DK Publishing, 1999. Harris, Nathaniel. *Renaissance Art*. NY: Thomson Learning, 1994.
- Herbert, Janis. *Leonardo da Vinci for Kids*. Chicago: Chicago Review Press, 1998.
- Howarth, Sarah. Renaissance People. Brookfield, CT: Millbrook Press, 1992.
- -----. Renaissance Places. Brookfield, CT: Millbrook Press. 1992.
- Leonardo da Vinci. ArtBook Series. NY: DK Publishing, 1999.
- McLanathan, Richard. First Impressions: Leonardo da Vinci. NY: Harry N. Abrams, Inc., 1990.
- Medo, Claudio. Three Masters of the Renaissance: Leonardo, Michelangelo, Raphael. Hauppauge, NY: Barron's, 1000

Color Wheel/Bibliography

- Milande, Veronique. Michelangelo and His Times. NY: Henry Holt & Co., 1995.
- Muhlberger, Richard. What Makes a Leonardo a Leonardo? NY: Viking,
- What Makes a Raphael a Raphael? NY: Viking, 1993. Murray, Peter and Linda. The Art of the
- Renaissance. NY: Thames and Hudson, 1985.
- Piero della Francesca. ArtBook Series. NY: DK Publishing, 1999.
- Richmond, Robin, Introducing Michelangelo. Boston, MA: Little, Brown, 1992.
- Romei, Francesca. Leonardo da Vinci. NY: Peter Bedrick Books, 1994.
- Spence, David. Michelangelo and the Renaissance. Hauppauge, NY: Barron's 1998.
- Stanley, Diane. Leonardo da Vinci. NY: William Morrow, 1996.
- Wood, Tim. The Renaissance, NY: Viking, 1993.
- Wright, Susan. The Renaissance. NY: Tiger Books International, 1997
- Zuffi, Stefano. Dürer. ArtBook Series. NY: DK Publishing, 1999.
- Zuffi, Stefano and Sylvia Tombesi-Walton, Titian, ArtBook Series, NY: DK Publishing, 1999.

#### Baroque and Rococo

- Barron's Art Handbooks. Baroque Painting. Hauppague, NY: Barron's, 1008
- Bonafoux, Pascal, A Weekend with Rembrandt. NY: Rizzoli, 1991
- Jacobsen, Karen. The Netherlands. Chicago, IL: Children's Press, 1992 Muhlberger, Richard. What Makes a Goya
- a Goya? NY: Viking, 1994. -. What Makes a Rembrandt a
- Rembrandt? NY: Viking, 1993. Pescio, Claudio. Rembrandt and
- Seventeenth-Century Holland. NY: Peter Bedrick Books, 1996.
- Rodari, Florian. A Weekend with Velázquez. NY: Rizzoli, 1993.
- Schwartz, Gary. First Impressions: Rembrandt. NY: Harry N. Abrams, Inc., 1992.
- Spence, David. Rembrandt and Dutch Portraiture. Hauppauge, NY: Barron's, 1998
- Velázquez. ArtBook Series. NY: DK Publishing, 1999.
- Vermeer. ArtBook Series. NY: DK Publishing, 1999.
- Wright, Patricia. Goya. NY: DK Publishing, 1993.
- Zuffi, Stefano. Rembrandt. ArtBook Series. NY: DK Publishing, 1999.

#### Neoclassicism, Romanticism, Realism

- Friedrich, ArtBook Series, NY: DK Publishing, 1999.
- Goya. Eyewitness Books. NY: DK Publishing, 1999. Rapelli, Paola. *Goya*. ArtBook Series. NY:

### DK Publishing, 1999

- Impressionism & Post-Impressionism Barron's Art Handbooks. Impressionism.
- Hauppauge, NY: Barron's, 1997. Bernard, Bruce. Van Gogh. Eyewitness
- Books, NY: DK Publishing, 1999. Borghesi, Silvia. Cézanne. ArtBook
- Series. NY: DK Publishing, 1999. Crepaldi, Gabriele. *Gauguin*. ArtBook Series. NY: DK Publishing, 1999.
- -. Matisse. ArtBook Series. NY: DK Publishing, 1999. Kandinsky. ArtBook Series. NY: DK
- Publishing, 1999.
- Monet. Eyewitness Books. NY: DK Publishing, 1999.
- Muhlberger, Richard. What Makes a Cassatt a Cassatt? NY: Viking, 1994 -. What Makes a Degas a
- Degas? NY: Viking, 1993. -. What Makes a Monet a
- Monet? NY: Viking, 1993. -. What Makes a van Gogh a van Gogh? NY: Viking, 1993.
- Pescio, Claudio, Masters of Art: Van Gogh. NY: Peter Bedrick Books, 1996. Rapelli, Paola. Monet. ArtBook Series.
- NY: DK Publishing, 1999. Sagner-Duchting, Karin. Monet at Giverny. NY: Neueis Publishing.
- 1994
- Skira-Venturi, Rosabianca, A Weekend with Degas. NY: Rizzoli, 1991.
- . A Weekend with van Gogh NY Rizzoli 1994
- Spence, David. Cézanne. Hauppague, NY: Barron's, 1998.
- . Degas. Hauppague, NY: Barron's, 1998.
- Gauguin. Hauppague, NY: Barron's, 1998. -- Manet: A New Realism.
- Hauppague, NY: Barron's, 1998.
- . Renoir. Hauppague, NY: Barron's, 1998.
- --. Van Gogh: Art and Emotions Hauppague, NY: Barron's, 1998.
- Torterolo, Anna. Van Gogh. ArtBook Series. NY: Dk Publishing, 1999.
- Turner, Robyn Montana. Mary Cassatt. Boston, MA: Little, Brown, 1992. Waldron, Ann. Claude Monet. NY: Harry N. Abrams, Inc., 1991.
- Welton, Jude. Impressionism. NY: DK Publishing, 1993.
- Wright, Patricia, Manet, Evewitness Books. NY: DK Publishing, 1999.

#### 20th Century

- Antoine, Veronique. Picasso: A Day in His Studio. NY: Chelsea House, 1993.
- Beardsley, John. First Impressions: Pablo Picasso. NY: Harry N. Abrams, Inc., 1991.
- Cain, Michael. Louise Nevelson. NY: Chelsea House, 1990.
- Children's History of the 20th Century. NY: DK Publishing, 1999. Faerna, Jose Maria, ed. Great Modern
- Masters: Matisse. NY: Harry N Abrams, Inc., 1994. Faerna, Jose Maria, ed. Great Modern
- Masters: Picasso. NY: Harry N. Abrams, Inc., 1994. Gherman, Beverly. Georgia O'Keeffe: The
- Wideness and Wonder of Her World.
- NY: Simon & Schuster, 1994. Greenberg, Jan and Sandra Jordan. *Chuck* Close Up Close. NY: DK Publishing, 1998.
- Heslewood, Juliet. Introducing Picasso. Boston, MA: Little, Brown, 1993.
- Paxman, Jeremy. 20th Century Day by Day. NY: DK Publishing, 1991.
- Ridley, Pauline. Modern Art. NY: Thomson Learning, 1995.
- Rodari, Florian. A Weekend with Matisse. NY: Rizolli, 1992.
- -. A Weekend with Picasso. NY: Rizolli, 1991.
- Spence, David. Picasso: Breaking the Rules of Art. Hauppauge, NY: Barron's, 1998
- Tambini, Michael. The Look of the Century. NY: DK Publishing, 1996.
- Turner, Robyn Montana. Georgia O'Keeffe. Boston, MA: Little, Brown, 1991
- Woolf, Felicity. Picture This Century: An Introduction to Twentieth-Century Art. NY: Doubleday, 1993.

#### **United States**

- Howard, Nancy Shroyer. Jacob Lawrence: American Scenes, American Struggles. Worcester, MA: Davis Publications, 1996
- William Sidney Mount: Painter of Rural America. Worcester, MA: Davis Publications, 1994
- Panese, Edith. American Highlights: United States History in Notable Works of Art. NY: Harry N. Abrams, Inc. 1993.
- Sullivan, Charles, ed. African-American Literature and Art for Young People. NY: Harry N. Abrams, Inc., 1991. ------ Here Is My Kingdom:
- Hispanic-American Literature and Art for Young People. NY: Harry N. Abrams, Inc., 1994.
- -. Imaginary Gardens: American Poetry and Art for Young People. NY: Harry N. Abrams, Inc.,

#### Native American

- Burby, Liza N. The Pueblo Indians. NY: Chelsea House, 1994.
- D'Alleva, Anne. Native American Arts and Culture. Worcester, MA: Davis Publications, 1993.
- Dewey, Jennifer Owings. Stories on Stone. Boston, MA: Little, Brown, 1996.
- Garborino, Merwyn S. The Seminole. NY: Chelsea House, 1989. Gibson, Robert O. The Chumash. NY:
- Chelsea House, 1991.
- Graymont, Barbara, The Iroquois. NY: Chelsea House, 1988.
- Griffin-Pierce, Trudy. The Encyclopedia of Native America. NY: Viking, 1995
- Hakim, Joy. The First Americans. NY: Oxford University Press, 1993.
- Howard, Nancy Shroyer. Helen Cordero and the Storytellers of Cochiti Pueblo. Worcester, MA: Davis Publications,
- Jensen, Vicki. Carving a Totem Pole. NY:
- Henry Holt & Co., 1996. Littlechild, George. This Land Is My Land. Emeryville, CA: Children's Book Press, 1993.
- Moore, Reavis, Native Artists of North America. Santa Fe, NM: John Muir Publications, 1993.
- Perdue, Theda, The Cherokee, NY: Chelsea House, 1989.
- Remer, Abby. Discovering Native American Art. Worcester, MA: Davis Publications, 1996.
- Sneve, Virginia Driving Hawk. The Cherokees. NY: Holiday House, 1996

## **Art of Global Cultures**

- Bowker, John. World Religions. NY: DK Publishing, 1997
- Eyewitness World Atlas. DK Publishing (CD ROM)
- Wilkinson, Philip, Illustrated Dictionary of Religions. NY: DK Publishing, 1999
- World Reference Atlas, NY: DK Publishing, 1998.

#### Africa

- Ayo, Yvonne. *Africa*. NY: Alfred A. Knopf, 1995.
- Bohannan, Paul and Philip Curtin. Africa and Africans. Prospect Heights, IL: Waveland Press, 1995.
- Chanda, Jacqueline. African Arts and Culture. Worcester, MA: Davis Publications, 1993.
- -. Discovering African Art. Worcester, MA: Davis Publications, 1996.
- Gelber, Carol. Masks Tell Stories. Brookfield, CT: Millbrook Press, 1992
- La Duke, Betty. Africa: Women's Art. Women's Lives. Trenton, NJ: Africa World Press, 1997.

- . Africa Through the Eyes of Women Artists. Trenton, NJ: Africa World Press 1996
- McKissack, Patricia and Fredrick McKissack. The Royal Kingdoms of Ghana, Mali, and Songhay. NY: Henry Holt & Co., 1994.

#### Mexico, Mesoamerica, Latin America

- Baquedano, Elizabeth, Eyewitness Books: Aztec, Inca, and Maya. NY: Alfred A. Knopf, 1993.
- Berdan, Frances F. The Aztecs. NY: Chelsea House, 1989.
- Braun, Barbara. A Weekend with Diego Rivera. NY: Rizzoli, 1994.
- Cockcroft, James. Diego Rivera. NY: Chelsea House, 1991.
- Goldstein, Ernest. The Journey of Diego Rivera. Minneapolis, MN: Lerner, 1996.
- Greene, Jacqueline D. The Maya. NY: Franklin Watts, 1992.
- Neimark, Anne E. Diego Rivera: Artist of the People. NY: Harper Collins, 1992.
- Platt, Richard. Aztecs: The Fall of the Aztec Capital. NY: DK Publishing,
- Sherrow, Victoria. The Maya Indians. NY: Chelsea House, 1994.
- Turner, Robyn Montana. Frida Kahlo. Boston, MA: Little, Brown, 1993.
- Winter, Jonah. Diego. NY: Alfred A. Knopf, 1991.

- Doherty, Charles. International Encyclopedia of Art: Far Eastern Art. NY: Facts on File, 1997.
- Doran, Clare. The Japanese. NY
- Thomson Learning, 1995. Ganeri, Anita. What Do We Know About Buddhism. NY: Peter Bedrick Books, 1997
- What Do We Know About Hinduism. NY: Peter Bedrick Books, 1006
- Lazo, Caroline, The Terra Cotta Army of Emperor Qin. NY: Macmillan, 1993.
- MacDonald, Fiona, David Antram and John James, A Samurai Castle, NY: Peter Bedrick Books, 1996.
- Major, John S. The Silk Route. NY: Harper Collins 1995
- Martell, Mary Hazel. The Ancient Chinese. NY: Simon & Schuster, 1993

#### Pacific

- D'Alleva, Anne. Arts of the Pacific Islands. NY: Harry N. Abrams, 1998.
- Haruch, Tony. Discovering Oceanic Art. Worcester, MA: Davis Publications, 1996
- Niech, Rodger and Mick Pendergast, Traditional Tapa Textiles of the Pacific NY: Thames and Hudson, 1998.
- Thomas, Nicholas, Oceanic Art, NY: Thames and Hudson, 1995.

- Drawing Basic Subjects. Hauppauge, NY: Barron's, 1995.
- Ganderton, Lucinda. Stitch Sampler. NY:
- DK Publishing, 1999. Grummer, Arnold. Complete Guide to Easy Papermaking. Iola, WI: Krause
- Publications, 1999. Harris, David. The Art of Calligraphy. NY: DK Publishing, 1995.
- Horton, James. An Introduction to Drawing. NY: DK Publishing, 1994. Learning to Paint: Acrylics. Hauppauge,
- NY: Barron's, 1998
- Learning to Paint: Drawing. Hauppauge, NY: Barron's, 1998.
- Learning to Paint: Mixing Watercolors.
- Hauppauge, NY: Barron's, 1998. Learning to Paint in Oil. Hauppauge, NY: Barron's, 1997.
- Learning to Paint in Pastel. Hauppauge, NY: Barron's, 1997
- Learning to Paint in Watercolor. Hauppauge, NY: Barron's, 1997.
- Lloyd, Elizabeth. Watercolor Still Life. NY: DK Publishing, 1994
- Slafer, Anna and Kevin Cahill. Why Design? Chicago, IL: Chicago Review Press, 1995.
- Smith, Ray. An Introduction to Acrylics.
- NY: DK Publishing, 1993. . An Introduction to Oil Painting. NY: DK Publishing, 1993.
- . An Introduction to
- Watercolor, NY: DK Publishing, 1993. --. Drawing Figures.
- Hauppauge, NY: Barron's, 1994. -----. Oil Painting Portraits. NY: DK Publishing, 1994.
- . Watercolor Color. NY: DK Publishing, 1993.
- Wright, Michael, An Introduction to Pastels. NY: DK Publishing, 1993.
- Wright, Michael and Ray Smith. An Introduction to Mixed Media. NY: DK Publishing, 1995.
- . An Introduction to Perspective. NY: DK Publishing, 1995. Perspective Pack. NY: DK Publishing, 1998.

# Glossary

**abstract/abstraction** A style of art that is not realistic. The artist often simplifies, leaves out, rearranges, or otherwise alters some elements. One of the four general style categories that art experts use to describe an artwork. (abstracto/abstraction)

aesthetician (es-tha-TISH-un)
A person who asks why art is made
and how it fits into society. One
who studies questions about art or
beauty. (esteta)

**analogous colors** (*ah-NAL-uh-gus*) Colors that are closely related because they have one hue in common. Analogous colors appear next to one another on the color wheel. (*colores análogos*)

**appliqué** (ap-li-KAY) A process of sewing pieces of cloth onto a cloth background. (aplique)

**arabesques** (ah-ruh-BESKS) Geometric designs and curves, often connected with calligraphic writing. (arabescos)

**architect** A person who designs the construction of buildings or large structures. (*arquitecto*)

architectural model A small, three-dimensional representation of a building, often made of paper, cardboard, wood, or plastic. Architects usually create such a model during the process of designing a building. (modelo araulitectónico)

architecture Buildings and other large structures. Also the art and science of planning and constructing such buildings. (arquitectura) art critic A person who expresses a reasoned opinion on any matter concerning art. Art critics often judge the quality of artworks and suggest why they are valuable or important. (critico de arte) art form A technique or method that is used to create an artwork, such as painting, photography, sculpture, or collage. (forma artistica)

**art historian** A person who studies the history of artworks and the lives of artists. (historiador del arte)

**art media** The materials used by the artist to produce a work of art. (*medios artísticos*)

**artisan** A person skilled in creating handmade objects. (*artesano*)

**artist** A person who creates art. (*artista*)

**assemblage** (ah-SEM-blij) A threedimensional artwork made by joining together objects or parts of objects. (ensamblaje)

**asymmetrical balance** (*ay-sih-MET-trih-kul*) A type of balance in which things on each side of a center line in a composition are different, yet equal in weight or interest. Also called informal

balance. (balance asimétrico)
balance A principle of design that describes how parts of an artwork are arranged to create a sense of equal weight or interest. Types of balance are symmetrical, asymmetrical, and radial. (balance)

bas-relief (bah re-LEEF) A form of sculpture in which portions of the design stand out slightly from a flat background. (bajorrelieve) calligraphy (kah-LIG-rah-fee) Precise, beautiful handwriting.

(caligrafia)
cantilever (kan-tih-LEE-ver) A
structure, such as a beam or roof,
that is supported at one end only.

(ménsula)
casting A multistep process for creating sculptures in bronze, concrete, plaster, plastic, or other materials. Some casting techniques allow an artist to create several sculptures from a single mold.

(vaciado)
center of interest The main, or first, thing you notice in an artwork. (centro de interés)

**ceramics** (*suh-RAM-iks*) The art of making objects of fired clay. The clay is baked, or fired, at high temperatures in an oven called a kiln. Ceramics are also the objects made using this method. (*cerámica*)

**collage** (*koh-LAHZH*) A work of art created by gluing pieces of paper, fabric, photographs, or other materials onto a flat surface. (*collage*)

**collagraph** (*KOLL-oh-graf*) A print made from a collage with raised areas on its surface. (*colografia*)

**color** Another word for hue, which is the common name of a color in (or related to) the spectrum, such as yellow, green, or yellow-orange. *See* hue. (*color*)

**color scheme** A plan for using colors. Common color schemes are warm, cool, neutral, monochromatic, analogous, complementary, and triad. (*gama de color*)

**complement** *See* complementary colors. (*complemento*)

complementary colors Colors that are opposite one another on the color wheel, such as red and green. When used near each other, complementary colors create a strong contrast. (colores complementarios)

**contour drawing** A drawing that shows only the edges (contours) of objects. (contorno)

contrast A great difference between two things. Contrast usually adds drama or interest to a composition. (contraste) cool colors The family of colors ranging from the greens through

cool colors The family of colors ranging from the greens through the blues and violets. Cool colors are often connected with cool places, things, or feelings. (colores frios)
crafts Works of art, either decora-

tive or useful, that are skillfully made by hand. (artesanía) **crop** To frame an image by removing or cutting off the outer edges. (recortar)

**cultural style** The use of materials, design qualities, methods of work, and choice of subject that is specific to or identified with a culture. (*cultura*)

design The plan for arranging the parts or elements of an artwork. Design can also refer to the work itself. (diseño)

**elements of design** The visual "tools" that artists use to create an artwork, such as line, color, value, texture, and shape.(*elementos de diseño*)

emphasis A principle of design in which some visual elements are given more importance than others to catch and hold the viewer's attention. (énfasis)

ergonomic (er-goh-NOM-ik) A design that is built to increase the user's comfort and/or productivity. (ergonómico)

Expressionist/Expressionism A style of art in which the main idea is to show a definite mood or feeling. Also, one of the four general style categories that art experts use to describe an artwork. (expresionista/Expresionismo)

expressive color Color that communicates an artist's ideas or feelings. (color expresivo) fantasy One of the four general style categories that art experts use to describe an artwork. The images in fantasy art often look like they came from a dream. (fantástico) fiber artist An artist who works with various materials and fibers to create fabrics, wall hangings, weavings, quilts, or wearable art. Also called textile artists. (artista textil) form An element of design; any three-dimensional object such as a cube, sphere, or cylinder. A form has height, width, and depth. Form is also a general term that refers to the structure or design of a composition. (forma)

**fresco** (FRES-koh) A technique of painting in which pigments are applied to a thin layer of wet plaster. The plaster absorbs the pigments, and the painting becomes part of the wall. (*fresco*) **function** A general term that refers

to how the structure or design of a composition works. (función) general style One of four categories that art experts use to describe an artwork: Expressionism, Realism, abstraction, and fantasy. (estilo)

**genre scene** (*ZHAHN-ruh*) A scene or subject from everyday life. (*escena costumbrista*)

**geometric shape** A shape that is precise and regular in outline, such as a circle, square, triangle, or ellipse. Geometric forms are three-dimensional; they include cones, pyramids, and spheres. (forma geométrica)

**gesture drawing** A drawing done quickly to capture movement. (dibujo a mano alzada)

**graphic designer** An artist who plans the lettering and images for books, packages, posters, and other printed materials. (diseñador grafico)

**guild** A group of skilled craftspeople. Each guild has a specialty, such as working with metal or carving stone. (*gremio*)

hacienda (hah-see-EN-dah) A Spanish word used to describe a large plantation or residence. (hacienda)

Harlem Renaissance (ren-ih-SAHNS) 1920–1940. A name of a period and a group of artists who lived and worked in Harlem, New York City. The members of the Harlem Renaissance used a variety of art forms to express their lives as African Americans. (Renacimiento de Harlem)

historical style The use of materials, design qualities, methods of work, and choice of subject that is specific to or identified with a specific time period. (estilo histórico) horizon line The line where water or land seems to end and the sky begins. (horizonte)

**hue** The name of a color, such as red or blue, based on its position in the spectrum. *See* color, spectrum. *(tono)* 

**implied line** The way objects are arranged so as to produce the effect of seeing a line in a work, but where a line is not actually present. (linea implicita)

**implied texture** The way a surface appears to look, such as rough or smooth. (textura implicita)

individual style The themes, use of materials, methods of working, and design qualities that make one artist's work different from that of other artists. (estilo individual) installation art Art that is created for temporary display in a particular site. (instalación) intensity The brightness or dullness of a color. (intensidad) intermediate hue (in-ter-MEE-deeit) A color made by mixing a secondary color with a primary color. Blue-green and yellow-green are examples of intermediate hues. (tono terciario)

**landscape** A work of art that shows a single view of natural scenery. (*paisaje*)

line A mark with length and direction, created by a point that moved across a surface. Lines can vary in length, width, direction, curvature, and color. A line can be two-dimensional (drawn on paper), three-dimensional (a wire), or implied. (linea)

**linear perspective** (*LIN-ee-ur*) A technique that uses guidelines to create the illusion of three-dimensional space on a two-dimensional surface. (*perspectiva lineal*) **local color** The representation of

**local color** The representation of colors as they appear in the natural world. (*color local*)

**luminism** (*LOO-min-izm*) A style of painting, popular in the United States in the nineteenth century, in which artists focused on the realistic depiction of light and its effects. (*luminismo*)

mechanical lettering A clear form of writing in which all letters are capitals and square in shape. Graphic designers often use mechanical lettering for posters, advertisements, and billboards. (rótulo)

**mobile** (*MOH-beel*) A hanging balanced sculpture with parts that can be moved, especially by the flow of air. (*móvil*)

model To shape clay, or another similar material, by pinching, pulling, or other manipulation with the hands. A model is also a person or thing that an artist uses as a subject. It can also be a small copy of a larger object. (modelo)

**monochromatic** (*mon-oh-kroh-MAT-ik*) A color scheme that uses several values of one color, such as light blue, blue, and dark blue. (*monocromático*)

monotype A print that is usually limited to one copy. (monotipo) montage (mon-TAHZH) A special kind of collage that is made by combining pieces of photographs or other pictures. (montaje) monument An artwork created for a public place that preserves the

momument An artwork created for a public place that preserves the memory ofa person, event, or action. (monumento)

mosaic (moh-ZAY-ik) An artwork made by fitting together tiny pieces of colored glass, stones, paper, or other materials. The small pieces are called tesserae. (mosaico) movement A principle of design, in which visual elements are combined to produce a sense of action. This combination of elements also helps the viewer's eye to sweep

manner. (movimiento) mural (MYUR-ul) A large painting or artwork, usually designed for and created on a wall or ceiling of a building. (mural)

over the composition in a definite

**narrative art** (*NAR-uh-tiv*) Art that clearly depicts a story or idea. (*arte narrativo*)

**negative shape/space** Shapes or spaces surrounding a line, shape, or form. (forma negativa/espacio negativo)

**neutral color** A color not associated with a hue. In art, black, white, and gray are neutral colors. (color neutral)

**nonobjective art** A style of art that does not have a recognizable subject. In a nonobjective artwork, the composition itself is the subject. Also known as nonrepresentational art. (arte subjetivo)

organic shape A shape that is often irregular or curved in outline, such as many things in nature. An oak leaf, for example, is an organic shape. (figura orgánica) path of movement The lines that guide the eye over and through different areas of an artwork. (sentido del movimiento)

**pattern** A choice of lines, colors, or shapes that are repeated over and over, usually in a planned way. (natrón)

perspective (per-SPEK-tiv) A group of techniques for creating a look of depth on a two- dimensional (flat) surface. (perspectiva) petroglyph (PET-roh-glif) A line drawing or carving made on a rock or rock surface, often created by prehistoric people. (petroglifo) pictogram (PIK-tuh-gram) A picture that stands for a word or an idea. Also called pictograph. (pictograma)

**planned pattern** A pattern thought out and created in an organized way. (patrón planificado)

portrait An artwork that shows the likeness of a real person.

**positive shape/space** Shapes or spaces that you see first in an artwork, because they stand out from the background or the space around them. (forma positiva/espacio positivo)

Post-Modernism A style that reacts against earlier modernist styles, sometimes by using them to extremes. Post-modern architecture often combines some styles from the past with more decoration, line, and/or color. (Posmodernismo)

poster A large, printed sheet, usually made of paper or cardboard, that advertises, teaches, or announces something. A poster usually combines pictures and words. (afiche/cartel)

**primary colors** (PRY-mar-ee) The three basic colors, or hues, from which other colors can be made: red, yellow, and blue. (colores primarios)

principles of design Guidelines that help artists to create designs and plan relationships among visual elements in an artwork. They include balance, unity, variety, pattern, emphasis, rhythm, and movement.

(principlos de diseño)

print An image made from a printing block or other object. The block is covered with ink or paint and pressed onto a surface, such as paper. Most prints can be made over and over again. (grabado) proportion The relation of one object to another in size, amount. or number. Proportion is often used to describe the relationship between one part of the human figure and another. (proporción) radial balance A kind of balance in which lines or shapes spread out from a central point. (balance radial)

**random pattern** A pattern caused by accidental arrangement or produced without a consistent design. A random pattern is usually asymmetrical and irregular. (*patrón al azar*)

real texture The actual surface of an object; it is what you feel when you touch a surface. (textura real)
Realism/Realist One of the four general style categories that art experts use to describe an artwork. Realist art portrays subjects with lifelike colors, textures, and proportions. (Realismo/realista) relief print A print made from a design that is raised from a flat background, such as a woodcut. (grabado en relieve)

relief sculpture A three-dimensional work designed to be viewed from one side, in which surfaces are raised from a background. (escultura a relieve)

rhythm (RIH-thum) A principle of design, in which repeating elements create visual or actual movement in an artwork. Rhythms are often described as regular, alternating, flowing, or jazzy. (ritmo)

Romantic/Romanticism A style of art whose themes focus on dramatic action, exotic settings, imaginary events, and strong feelings. (romantico/Romanticismo) sabi (sah-bee) A traditional rule of Japanese design that refers to the timelessness or simplicity of a design. (sabi)

**santeros** (*sahn-TAY-rohs*) Artists who make santos. (*santeros*)

which an artist shows himself or herself. (autorretrato) series A group of related artworks, such as a group of sculptures, paintings, or prints. (serie) shade Any dark value of a color,

usually made by adding black. (matiz)

shape A flat figure that is created when actual or implied lines meet and surround a space. A change in color or shading can also define a shape. Shapes can be geometric (square, triangle, circle) or organic (irregular in outline). Shape is an element of design. (forma) site-specific sculpture A

sculpture created for a particular space, usually outdoors. They may be permanent, but site-specific sculptures are often temporary. (escultura sitial)

space The empty or open area between, around, above, below, or within objects. Positive space is filled by a shape or form. Negative space surrounds a shape or form. Space is an element of design. (espacio)

spectrum (SPEK-trum) The complete range of color visible in a beam of light. (espectro) split complementary A color scheme based on one color and the colors on each side of its complement on the color wheel. Orange, blue-violet, and bluegreen are split complementary colors. (complementario análogo) stabile (STAY-bile) A sculpture that is similar to a mobile but without any moving parts. (stabile)

still life An artwork that shows nonliving things, such as fruit, flowers, or books. A still life is usually shown in an indoor setting. (naturaleza muerta)

style The result of an artist's means of expression—the use of materials, design qualities, methods of work, and choice of subject. In most cases, these choices show the unique qualities of an individual, culture, or time period. The style of an artwork helps you to know how it is different from other artworks. (estilo)

subject What you see in an artwork, including a topic, idea, or anything recognizable, such as a landscape or a figure. (asunto) Surrealist/Surrealism A style of art in which dreams, fantasy, and the human mind are sources of ideas for artists. (surrealista/ Surrealismo)

symbol Something that stands for something else, especially a letter, figure, or sign that rep-resents a real object or an idea. A red heart shape, for example, is a common symbol for love. (símbolo) symmetrical balance (sih-MET-rikul) A type of balance in which things on either side of a center line are exactly or nearly the same.

like a mirror image. Also known as

formal balance. (balance simétrico)

tapestry (TAP-iss-tree) A stitched or woven piece of cloth or fabric, often one that tells a story. (tapiz) texture The way a surface feels (actual texture) or the way it is depicted to look (implied texture). A texture may be described by words such as smooth, rough, or pebbly. Texture is an element of design. (textura)

theme The topic or idea that an artist can express and interpret in many ways with different subjects. For example, a work may reflect a theme of love, power, or discovery. (tema)

three-dimensional Artwork that can be measured three ways: height, width, and depth. Artwork, such as sculptures or architecture. that is not flat. (tridimensional)

tint A light value of a color; a color mixed with white. For example, pink is a tint of red. (tinte)

tonal drawing A drawing in which an artist uses value or various tones of color to create the illusion of three-dimensional space. Tonal drawing techniques include hatching, stippling, and blending and smudging. (dibujo tonal)

triad (TRY-ad) Three colors spaced equally apart on the color wheel, such as orange, green, and violet.

two-dimensional Artwork that is flat and is measured in only two ways: height and width. (bidimensional)

unity A principle of design, in which all parts of a design work together to create a feeling of wholeness. (unidad)

value The lightness or darkness of a color. Tints are light values of colors. Shades are dark values of colors. Value is an element of design. (valor)

vanishing point In a perspective drawing, the point on the horizon line where the edges, lines, or shapes appear to meet in the distance. (punto de fuga) variety The use of different lines. shapes, textures, colors, or other elements of design to create interest in an artwork. Variety is a principle of design. (variedad) wabi (wah-bee) A traditional rule of Japanese design that refers to the idea of finding beauty in simple, natural things. (wabi)

warm colors The family of colors that ranges from the reds through the oranges and yellows. They are usually connected with fire and the sun and remind people of warm places, things, and feelings. (colores cálidos)

woodcut A relief print created by carving into a smooth block of wood, inking the wood, and pressing paper against the ink. (xilografía)

# **Spanish Glossary**

abstracto/abstracción Estilo de arte que no es realista. El artista suele simplificar, recomponer, omitir o alterar algunos elementos. Es una de las cuatro categorías generales de estilo que usan los expertos de arte para describir una obra artística. (abstract/abstraction)

afiche, cartel Una hoja impresa de gran tamaño, por lo general hecha de papel o cartón, que anuncia, enseña o avisa algo. Un afiche combina con frecuencia imágenes y palabras. (poster) aplique Es el proceso de coser piezas de tela sobre un fondo también de tela. (appliqué) arabescos Dibujos geométricos y curvas, que suelen estar conectados mediante la caligrafía. (arabesques)

**arquitecto** Persona que diseña la construcción de edificios o grandes estructuras. (*architect*) **arquitectura** Edificios y otras grandes estructuras. Es también el arte y la ciencia de planear y construir tales estructuras. (*architecture*)

arte narrativo Arte que describe claramente una historia o una idea. (narrative art)

arte subjetivo Estilo de arte que no tiene un tema reconocible. En una obra de arte subjetivo, la composición en sí misma es el tema. (nonobjective art)

**artesanía** Trabajos artísticos, ya sean decorativos o utilitarios, hábilmente realizados a mano. (*crafts*)

**artesano** Persona experta que crea objetos hechos a mano. (*artisan*)

**artista** Persona que crea arte. (artist)

artista textil Artista que trabaja con varios materiales y fibras para crear telas, cortinas, tejidos, mantas de parches, o arte que se usan como ropa. (fiber artist)

asunto Lo que ves en una obra de arte, incluyendo un tópico, una idea o cualquier cosa identificable, como un paisaje o una figura. (subject) autorretrato Obra de arte en la que el artista se muestra a si

mismo. (self-portrait) bajorrelieve Tipo de escultura en que partes del diseño se destacan ligeramente sobre un fondo plano. (bas-relief)

balance asimétrico Tipo de balance en el que los objetos que se colocan a cada lado de la línea central de una composición son diferentes, aunque iguales en peso o interés. También se le llama balance informal. (asymmetrical balance)

balance Principio de diseño que describe cómo se colocan las partes de una obra de arte para crear un efecto de igual peso o interés. Los tipos de balance son: simétrico, asimétrico y radial. (balance)

balance radial Es el tipo de balance en el que las líneas o las formas se distribuyen a partir de un punto central. (radial balance)

balance simétrico Tipo de balance en el que las cosas a cada uno de los lados de la línea central son exactas o casi iguales, como en un espejo. También se conoce como balance formal. (symmetrical

balance)
bidimensional Obra de arte plana
que se mide de dos

maneras: alto y ancho. (two-dimensional)

caligrafía Escritura bonita hecha a mano. (calligraphy) centro de interés Es lo principal, lo primero que uno percibe en una obra de arte. (center of interest) cerámica Arte de realizar objetos a partir de la arcilla tratada con fuego. La arcilla se hornea, o se quema a altas temperaturas, en un horno de calcinación. Cerámicas son también los objetos que se hacen utilizando este método. (ceramics)

collage Obra de arte creado pegando pedazos de papel, tela, fotografías u otros materiales sobre una superficie plana. (collage)

**colografía** Impreso hecho a partir de un collage con áreas elevadas en su superficie. (*collagraph*)

color expresivo Color que comunica las ideas o sentimientos de un artista. (expressive color) color local Representación de los colores tal y como aparecen en la naturaleza. (local color) color neutral Un color que no se asocia con un tono. En arte el

asocia con un tono. En arte, el negro, el blanco y el gris son colores neutrales. (neutral color) color Otra palabra para tono, que es el nombre común de un color (o relacionado con) en el espectro, como amarillo, verde o amarillo-naranja. Ver tono.

colores análogos Colores que están estrechamente relacionados porque tienen un tono en común. Los colores análogos aparecen uno junto al otro en la rueda de colores. (analogous colors)

colores cálidos Familia de colores que va desde los rojos hasta los naranjas y los amarillos. Por lo general se asocian con el fuego y el sol y recuerdan lugares, cosas y sentimientos cálidos. (warm colors)

colores complementarios
Colores que están opuestos uno al
otro en el círculo de colores, como
el rojo y el verde. Cuando se usan
uno junto al otro, crean un fuerte
contraste. (complementary colors)

colores básicos, o tonos, con los que se pueden hacer los otros colores: rojo, amarillo y azul. (primary colors)

complementario análogo Gama de color basado en un color v los colores que están a cada lado de su complementario en la rueda de colores. Naranja, azul-violeta y azul-verdoso son colores complementarios análogos. (split comple-

complemento Ver colores complementarios. (complement) contorno Dibujo que muestra sólo los bordes (contorno) de los objetos, (contour drawing) contraste Gran diferencia entre dos cosas. El contraste, por lo general añade dramatismo o interés a una composición. (contrast)

crítico de arte Es la persona que expresa una opinión razonada sobre cualquier materia relativa al arte. Los críticos de arte juzgan la calidad de las obras artísticas y sugieren por qué son valiosas o importantes. (art critic)

cultura El uso de materiales. las cualidades del diseño, los métodos de trabajo y la elección de los temas que son específicos o se identifican con una cultura. (cultural style)

dibujo a mano alzada Un dibujo realizado rápidamente para captar el movimiento. (gesture drawing)

dibujo tonal Dibujo en el que el artista usa valores o varios tonos de un color par crear la ilusión de un espacio tridimensional. Las técnicas de dibujo tonal incluyen el sombreado, el puntillismo, el matizado y el difuminado. (tonal drawing)

dinastía Grupo de gobernantes de una misma familia o relacionados de alguna otra manera. (dynasty)

diseñador gráfico Artista que diseña las letras y las imágenes de los libros, paquetes, carteles y otros materiales impresos. (graphic designer)

diseño Plan para disponer las partes o elementos de una obra de arte. El diseño también puede referirse a la obra en sí. (design)

elementos de diseño "Herramientas" visuales que emplean los artistas para crear una obra artística tales como la línea el color, la luz, la textura y la forma. (elements of design) énfasis Principio del diseño en el que a algunos elementos visuales se les da más importancia que a otros para captar y mantener la atención del espectador. (emphasis) ensamblaje Obra de arte tridimensional que se realiza colocando objetos o partes de objetos unos junto a otros, (assemblage) ergonómico Diseño construido para aumentar la comodidad del usuario y/o la productividad. (ergonomic)

escala Relación en cuanto a tamaño entre dos grupos de dimensiones. Por ejemplo, si una imagen se dibuja a escala, todas sus partes deben ser igualmente más pequeñas o más grandes que las partes del original. (scale) escena costumbrista Escena o tema tomado de la vida cotidiana. (genre scene)

escultura a relieve Una obra tridimensional diseñada para ser vista desde un solo lado, en el que la superficie se eleva desde el fondo. (relief sculpture)

escultura sitial Una escultura creada para un espacio particular, por lo general al aire libre. Pueden ser permanentes, pero a menudo estas esculturas son temporales. (site-specific sculpture)

espacio El área vacía o abierta entre, alrededor, debajo o dentro de los objetos. El espacio positivo se llena con una figura o forma. El espacio negativo rodea a una figura o forma.El espacio es un elemento de diseño. (space)

espectro La gama completa de color visible en un haz de luz. (spectrum)

esteta Es la persona que se pregunta por qué se hace el arte y cómo se inserta en la sociedad. Estudia los temas relacionados con el arte y la belleza. (aesthetician)

estilo El resultado de los medios de expresión de un artista—el uso de los materiales, las cualidades del diseño, los métodos de trabajo v la elección de los temas. En la mayoría de los casos, estas elecciones muestran las cualidades únicas de un individuo, cultura o época. El estilo de una obra de arte te ayuda a saber por qué es diferente de las otras. (style) estilo histórico El uso de materiales, calidad del diseño, métodos de trabajo y elección de temas que son específicos o identifican un determinado período de tiempo. (historical style) estilo individual Temas, uso de materiales, métodos de trabajo y cualidades del diseño que hacen que el trabajo de un artista sea diferente al de otros. (individual style)

estilo Una de las cuatro categorías de arte que usan los expertos para describir una obra de arte: expresionismo, realismo, abstracción y fantasía. (general style)

expresionista/Expresionismo Estilo de arte en el que la idea principal es mostrar un estado de ánimo o sentimiento. También es una de las cuatro categorías generales de estilo que los expertos utilizan para describir una obra de arte. (expressionist/Expressionism)

fantástico Una de las cuatro categorías generales de estilo que los expertos utilizan para describir una obra de arte. Las imágenes en el arte fantástico a menudo son vistas como si vinieran de un sueño. (fantasy)

Spanish Glossary

figura orgánica Una forma que a menudo es irregular o curva en su contorno, como muchas cosas en la naturaleza. Una hoja de roble, por ejemplo, es una forma orgánica. (organic shape) forma artística Técnica o método usado para crear una obra de arte, tales como pintura, fotografía, escultura o collage. (art form)

forma Elemento de diseño. Cualquier objeto tridimensional, como el cubo, la esfera, el cilindro. Una forma tiene alto, ancho y profundidad. Forma también es un término general que se refiere a la estructura o diseño de una composición. (form)

forma geométrica Una forma que es precisa y regular en su contorno, como el círculo, el cuadrado, el triángulo o la elipse. Las formas geométricas son tridimensionales, incluyen los conos, las pirámides y las esferas. (geometric shape)

**forma negativa/espacio negativo** Formas o espacios que rodean una línea, figura o forma. (*negative shape/space*)

forma positiva/espacio positivo Formas o espacios que se ven primero en una obra de arte, porque se destacan sobre el fondo o el espacio alrededor de ellos. (positive shape/space)

forma Una forma plana se crea cuando las líneas reales o implícitas se encuentran y rodean un espacio. Un cambio de color o de matiz también puede definir una forma. Las formas pueden ser geométricas (cuadrado, triángulo, círculo) u orgánicas (irregulares en su contorno). La forma es un elemento de diseño. (shape)

fresco Técnica de pintura en que los pigmentos se aplican sobre una fina capa de masilla húmeda. La masilla absorbe los pigmentos, y la pintura se convierte en parte de la pared. (fresco)

función Término general que se refiere a cómo funciona la estructura o el diseño de una composición. (function) gama de color Plan para usar los colores. Las gamas de colores más comunes son: cálidos, fríos, neutrales, monocromáticos, análogos, complementarios y tríada. (color scheme)

**grabado en relieve** Impreso hecho a partir de un dibujo que se destaca en un fondo plano, como en un taco de madera. (*relief print*)

grabado Una imagen hecha a partir de una plantilla u otro objeto. La plantilla de madera se cubre con tinta o pintura y se presiona contra una superficie, como papel. La mayoría de los grabados se pueden repetir una y otra vez. (print)

gremio Grupo de experimentados artesanos. Cada gremio tiene una especialidad, como trabajar el metal o tallar la piedra. (guild) hacienda Palabra española que describe una residencia o plantación de gran tamaño. (hacienda)

historiador del arte Persona que estudia la historia de las obras de arte y la vida de los artistas. (art historian)

horizonte Línea donde el agua o la tierra parece terminar y donde empieza el cielo. (horizon line) instalación Arte que se crea para ser exhibido temporalmente en un determinado lugar. (installation art) intensidad Luminosidad u opacidad de un color. (intensity) línea implícita Manera en que son dispuestos los objetos para producir el efecto de que se ve una línea, pero en realidad no hay presente una línea. (implied line) línea Una marca con largo y dirección, creada por un punto que se mueve sobre una super-ficie. Las líneas pueden variar en largo. ancho, dirección, curvatura y color. Una línea puede ser bi-dimensional (dibujada sobre papel), tridimensional (un alambre) o implícita.

**luminismo** Estilo de pintura, popular en Estados Unidos en el siglo XIX, en el que los artistas se concentraban en la descripción realista de la luz y sus efectos. (*luminism*) matiz Cualquier valor oscuro de un color, por lo general se logra añadiendo negro. (shade) medios artísticos Materiales usados por los artistas para producir una obra de arte. (art media)

ménsula Estructura, como una viga o un techo que se sostiene por un solo lado. (cantilever) modelo arquitectónico Pequeña representación tridimensional de un edificio, hecho generalmente de papel, cartón, madera o plástico. Por lo general, los arquitectos crean tales modelos durante el proceso de diseñar un edificio. (architectural model) modelo Darle forma a la arcilla u otro material similar amasando. estirando o manipulándolo con las manos. Un modelo es también una persona o un objeto que los artistas utilizan como tema. También puede ser la copia a menor escala de un objeto grande. (model)

monocromático Una gama de color que usa varios valores de un mismo color, tales como azul claro, azul y azul oscuro. (monochromatic)

**monotipo** Un impreso que se limita a una sola copia. (*monotype*)

**montaje** Tipo especial de collage que se hace combinando pedazos de fotografías u otras fotos. (*montage*)

monumento Una obra de arte que ha sido creada para exhibir en un lugar público con el fin de recordar a una persona, un suceso o una acción. (monument) mosaico Obra de arte que se realiza colocando unos junto a otros pedacitos de papel u otros materiales. Las piezas pequeñitas se llaman teselas. (mosaic) móvil Una escultura que cuelga y se balancea, con partes que se pueden mover, en especial por el paso del aire. (mobile)

mural Pintura u obra de arte de gran tamaño, por lo general diseñada en una pared o en el techo de un edificio. (mural) naturaleza muerta Obra de arte que muestra objetos inertes, tales como frutas, flores o libros. Una naturaleza muerta se exhibe por lo general en un ambiente bajo techo. (still life)

paisaje Obra de arte que muestra una vista única de un escenario natural. (landscape) patrón al azar Es un patrón que resulta de la disposición accidental o producto de un diseño inconsistente. Es usualmente asimétrico e irregular. (random pattern)

patrón Determinada selección de líneas, colores o formas que se repiten una y otra vez, por lo general de manera planificada.

(pattern) patrón planificado Patrón pensado y creado de manera organizada. (planned pattern) perspectiva Grupo de técnicas para crear un efecto de profundidad en una superficie bidimensional. (perspective) perspectiva lineal Técnica que usa las líneas para crear la ilusión de un espacio tridimensional en una superficie de dos dimensiones. (linear perspective) petroglifo Dibujo lineal o talla hecha en una roca o en la superficie de una roca, a menudo creada por hombres prehistóricos. (petroglyph)

pictograma Imagen que representa una palabra o una idea. También llamado pictografía. (pictogram) Posmodernismo Estilo que reacciona contra los primeros estilos modernistas, a veces llevándolos al extremo. La arquitectura posmoderna a menudo combina algunos estilos del pasado con más decoración, línea y/o color. (Post-Modernism)

principios de diseño Guías que ayudan a los artistas a crear diseños y planear las relaciones entre los elementos visuales en una obra de arte. Comprenden el balance, la unidad, la variedad, el patrón, el énfasis, el ritmo y el movimiento. (principles of design) proporción Es la relación entre dos objetos, en cuanto a tamaño, cantidad o número. La proporción se usa a menudo para describir la relación entre dos partes de la figura humana. (proportion) punto de fuga En un dibujo en perspectiva, el punto en el horizonte en donde los bordes, líneas o figuras parecen encontrarse en la distancia. (vanishing point) Realismo/realista Una de las cuatro categorías generales que usan los expertos para describir una obra de arte. El arte realista retrata los objetos con colores, texturas y proporciones semejantes a los de la vida real. (Realism/Realist) recortar Enmarcar una imagen quitando o cortando los bordes exteriores. (crop)

Renacimiento de Harlem 1920—1940. Nombre de un período y de un grupo de artistas que vivieron y trabajaron en Harlem, en la ciudad de Nueva York. Sus miembros usaron una variedad de formas artísticas para reflejar sus vidas como afroamericanos. (Harlem Renaissance)

retrato Obra de arte que muestra semejanza con una persona real.

**ritmo** Principio del diseño, en el que al repetir elementos se crea un movimiento visual o real en una obra de arte. Los ritmos son descritos a menudo como regulares, alternos, fluidos o animados. (*rhythm*)

romántico/Romanticismo Estilo de arte en que los temas se concentran en la acción dramática, los ambientes exóticos, los sucesos imaginarios y la exaltación de los sentimientos. (Romantic/Romanticism)
rótulo Clara forma de escritura en que todas las letras son ayúsculas y de forma cuadrada. Los diseñadores gráficos usan a menudo el rótulo en carteles, avisos y vallas publicitarias. (mechanical lettering)
sabi Reela tradicional del

**sabi** Regla tradicional del diseño japonés que se refiere a la intemporalidad o simplicidad de un diseño. (*sabi*)

**santeros** Artistas que hacen santos. (*santeros*)

**santos** Tallas, figuras religiosas por lo general hechas de arcilla, piedra o madera. (*santos*)

sentido del movimiento Las líneas que guían al ojo a través de las diferentes áreas de una obra artistica. (path of movement) serie Grupo de obras de arte relacionadas, tales como un grupo de esculturas, dibujos o grabados. (series)

sémbolo Algo que significa otra cosa, especialmente una letra, una figura o un signo que representa un objeto real o una idea. Un corazón rojo, por ejemplo, es un símbolo común para el amor. (symbol)

stabile Una escultura que es similar a un móvil pero sin partes que se mueven. (stabile) surrealista/Surrealismo Estilo de arte en el que los sueños, la fantasía y la mente humana son las fuentes de las ideas para el

artista. (Surrealist/Surrealism)

tapiz Una pieza de paño o tela, bordada o tejida que a menudo cuenta una historia. (tapestry) tema El tópico o idea que un artista puede expresar e interpretar de muchas maneras con diferentes asuntos. Por ejemplo, una obra puede reflejar el tema del amor, el poder, o el descubrimiento. (theme)

**textura implícita** Manera en que luce la superficie, como áspera o suave. (*implied texture*)

textura La forma en que se siente una superficie (textura real) o la manera en que luce (textura implícita). Una textura puede ser descrita con palabras como suave, áspera, o granulada. La textura es un elemento de diseño. (texture) textura real La superficie real de un objeto; es lo que sientes cuando tocas una superficie. (real texture)

tinte El valor más claro de un color; un color mezclado con blanco. Por ejemplo, el rosado es un tinte de rojo. (tint) tono Nombre de un color, como rojo o azul, basado en su posición en el espectro. Ver color, espectro. (hue)

tono terciario Color hecho a partir de la mezcla de un color secundario con uno primario. El azul verdoso y el amarillo verdoso son ejemplos de tonos terciarios. (intermediate hue) tonos secundarios Colores que se hacen mezclando a partes iguales dos colores primarios. Verde, naranja y violeta son los tres colores secundarios. (secondary hues) tríada Tres colores que están separados por la misma distancia en la rueda de color, como el naranja, el verde y el violeta. (tríad)

tridimensional Obra de arte que se puede medir en tres maneras: alto, ancho y profundidad. Obras de arte tales como la escultura o la arquitectura, que no son planas. (three-dimensional)

unidad Principio del diseño, en el que todas las partes de un diseño trabajan juntas para crear una sensación de totalidad. (unity) vaciado Proceso de varios pasos para crear esculturas en bronce. concreto, masilla, plástico u otros materiales. Algunas técnicas de vaciado en yeso le permiten crear al artista varias esculturas a partir de un solo molde. (casting) valor Luminosidad u oscuridad de un color. Los tintes son los valores más claros de los colores. Los matices son los valores más oscuros de los colores. El valor es un elemento de diseño. (value) variedad El uso de las diferentes líneas, formas, texturas, colores u otros elementos de diseño para crear interés en una obra de arte. La variedad es un principio de diseño. (variety)

wabi Regla tradicional del diseño japonés que se refiere a la idea de encontrar la belleza en las cosas simples, naturales. (wabi) xilografía Técnica de grabado que resulta de tallar un diseño en un taco de madera suave, por lo general de boj, se le pone tinta y se presiona contra un papel. (woodcut)

abstraction, 12

| 1 | 1 |  |
|---|---|--|
|   |   |  |

Acoma Polychrome Jar, 4 A Court Scene from the "Chahar Maqaleh," 73 Aerospace Museum, 253 aestheticians, 60-61 aesthetics, 60-61 Africa Benin, 82, 83, 84 Dan Culture, 41 Nigeria (Yoruba), 202 Aholi Kachina, 53 Ailey, Alvin, 299 Alphonse, Inatace (Haiti), 110-111 Harvest with Cows, 110 Market, 111 Amphoriskos, 290 Amrany, Omri (United States), and Julie Rotblatt-

Amrany (United States), The Spirit, Michael Jordan, 47 Amusement, 33

Ancient Greece, 25, 128, 256 Ancient Rome, 4, 55, 72

Another World II, 229 A Pantry Ballet (for Jacques Offenbach), 298

A-POC "King" and "Queen," 123 arabesque, 161 architect, 251

architectural model, 262-263 architecture, 24, 251

daily life and, 28 Mexican urban and rural, 264-267 studio lessons

building architectural model, 256-267 roller-coaster track constructions,

268-270 Arch of Constantine, 4

Arcimboldo, Giuseppe (Italy), Vertumnus, 229 Arcosanti, 255

Arneson, Robert (United States), Pablo Ruiz with Itch, 18

communication of message through, 72. See also portrait; poster; symbols criticism, 56-57 history, 54-55

production, 58-59 as a teaching tool, 150-151

art critics, 56 art forms, 18-27 art historian, 54-55 artist, 58-59 art media, 18-27 assemblage, 280 Australia, Aboriginal culture, 212, 212-215, 213 Azaleas, 189

balance, 42, 271 Bal en plein air (Outdoor Dance), 109 Barragan, Luis (Mexico), Casa Antonio Galvez, 265 bas-relief, 82 Bauhaus school, 128 Bayeux Tapestry, 76 Beaded Jaguar Head, 2 Bearden, Romare (African American) Jazz Village, 281 Serenade, 90 Bedouin traditions, 292-293 beliefs, art and, 154-155 Bezalel School, Marvadia Workshop (Israel), "Song of Songs" Carpet, 292 Bicycle Wheel, 280 Biggers, John (United States) Shotgun, Fourth Ward, 49

Shotgun, Third Ward #1, 39 billboard, 157 Blanket, 18 blending, 107 Blomberg, Hugo (Sweden), Ralph Lysell, Gosta Thames, Ericofon, 124

Blue Poles, 53 Boren, Wen (Japan), River Landscape with Towering Mountains, 187

Bosch, Hieronymus (Netherlands), The Temptation of St. Anthony, 228

Brazille, Castera (Haiti), Coumbite Communal Fieldwork, 109

Bread Line, 151 Breuer, Marcel (Hungary), Side Chair, Wohnbedarf Model, 129 Broadway Steps, 2

Brooks, Romaine (United States), The Soldier at Home, 34

Bruegel, Pieter, the Elder (Flemish), The Wedding Dance, 116

Bryer, Diana (United States), The Jewish Fairy Blessing the Menorah of the Southwest, 59

| Builders, The, 71<br>Bull Leaping, 20<br>Bunraku puppets, 152                | China<br>art of, 186–188<br>Ming dynasty, 186, 187    |
|------------------------------------------------------------------------------|-------------------------------------------------------|
| Burning of the Houses of Lords and Commons, October                          | Qing dynasty, 194                                     |
| 16, 1834, 181                                                                | Tang dynasty, 177                                     |
| Butterfield, Deborah (United States), Cottonwood                             | Chinese Profile II, 39                                |
| Creek, 176                                                                   | Christopher, Tom (United States), Broadway Steps, 2   |
| Byzantine art, 26                                                            | Circus Parade, 7                                      |
|                                                                              | clay, figure modeling, 88                             |
| C                                                                            | Coin, Willie (Hopi Indian), Aholi Kachina, 53         |
| Cage, John, 195                                                              | collage, 21, 282                                      |
| Calder, Alexander (United States), Goldfish Bowl,<br>242                     | studio lessons<br>mixed-media collagraph, 282–283     |
| "California Peach" Cup, 129                                                  | package design, 140–141                               |
| Calligraph, 163                                                              | symbol stamps, 204–205                                |
| Calligraph: "Deep sorrow defies definition," 162                             | collagraph, 282<br>color, 36–37                       |
| calligraphy, 158–159, 160–163                                                | mixing, 184–185                                       |
| Camina Real Hotel, 266                                                       | spectrum, 193                                         |
| Camp, Sokari Douglas (Nigeria), Masquerader with                             | color wheel, 36                                       |
| Boat Headdress, 294 cantilever, 259                                          | Column of Trajan, 72                                  |
| careers                                                                      | Commedia dell'Arte, 62                                |
| aesthetician, 220                                                            | complementary color, 185, 193                         |
| art critics, 195                                                             | Composite Eye Beads, 292                              |
| art historian, 116                                                           | computer art, 23                                      |
| art teacher, 168                                                             | Connoisseur, 56                                       |
| computer graphic artist, 48                                                  | contour drawing, 80                                   |
| fashion designer, 142                                                        | contrast, 115                                         |
| fiber artist, 298                                                            | Cook, Peter, Plug-in City, 254                        |
| jewelry designer, 246                                                        | Cornell, Joseph (United States), A Pantry Ballet (for |
| mural artist, 14                                                             | Jacques Offenbach), 298 corrugated paper              |
| museum educator, 62                                                          | studio lessons                                        |
| painter, 90                                                                  | building a roller-coaster track, 268–270              |
| printmaker, 272                                                              | mixed-media collagraph, 282–283                       |
| woodworkers, 28                                                              | Cottonwood Creek, 176                                 |
| Carousel Horse, 177<br>Casa Antonio Galvez, 265                              | Coumbite, Communal Fieldwork, 109                     |
| casting, 288–289                                                             | Courbet, Gustave (France), 180                        |
| Cat and Spider, 42                                                           | Seaside at Palavas, 181                               |
| Catlett, Elizabeth (United States), 216                                      | Coyote Leaves the Reservation, 209                    |
| Harriet, 216                                                                 | crafts, 26                                            |
| Sharecropper, 216                                                            | Creation of the Birds, 227                            |
| Cave Painting (serigraph transcription): Horse, 53                           | crosshatching, 107                                    |
| ceramics, 26                                                                 | cylindrical symmetry, 143                             |
| Champollion, Jean-François, 194                                              |                                                       |
| Chardin, Jean-Baptiste-Siméon (France), The                                  |                                                       |
| Monkey-Painter, 207                                                          |                                                       |
| Chemistry Versus Magic, 235                                                  |                                                       |
| Chicago, Judy (United States), The Dinner Party, 151                         |                                                       |
| Chihuly, Dale (United States), Victoria and Albert<br>Rotunda Chandelier, 33 |                                                       |

| )                                                     | Dishes, 112                                             |
|-------------------------------------------------------|---------------------------------------------------------|
| Dahomey kingdom, 82–85                                | Divided Sky, 183                                        |
| laily life                                            | Dominoes and Dragons, 234                               |
| architecture and, 28                                  | Double Grandmother, 86                                  |
| art critics in, 63                                    | drawing, 20                                             |
| design and, 129-131, 142. See also Japan              | contour, 80                                             |
| documenting, 102–105                                  | gesture, 80–81                                          |
| elements and principles of design in, 49              | studio lessons                                          |
| inventors and, 247                                    | designing a poster, 164–166                             |
| keeping records and, 116                              | drawing a fantasy world, 230–231                        |
| meaning of art in, 14                                 | fashion drawing, 126–127                                |
| objects' creative possibilities, 298                  | recording daily life in, 100–101                        |
| personal messages, 221                                | still-life drawing, 112–114                             |
| photography as a recording of, 96–97                  | symbol stamps, 204–205                                  |
| planning a trip, 272                                  | techniques, 106-107                                     |
| popular culture interpretation, 195                   | tonal, 106–107                                          |
| teacher's role in, 169                                | Drawing Hands, 13                                       |
| Dali, Salvador (Spain), Mae West, 230                 | Duchamp, Marcel (France), Bicycle Wheel, 280            |
| dance, 28                                             | dynasties, in China, 186                                |
| choreographer, 272                                    |                                                         |
| elements and principles of visual art applied to,     | E                                                       |
| 48                                                    | Earthen Relief #1, 83                                   |
| pioneering artist, 299                                | Egypt                                                   |
| Dancer, Daniel (United States), The Fern Hope Hoop,   | hieroglyphics interpretation, 194                       |
| 285                                                   | Middle Kingdom, 2                                       |
| Dash for the Timber, 117                              | Electric Guitar (Flying V model), 246                   |
| Defeated Childhood, 292                               | elements of design, 32, 34–41. See also color; form,    |
| design                                                | line; shape; space; texture; value                      |
| daily life and, 129–131                               | emphasis, 44                                            |
| for every need, 125–126                               | line and, 219                                           |
| fashion, 122–123                                      | England, Middle Ages, 76                                |
| jewelry, 246                                          | Ennis Horses #5, 175                                    |
| movements in, 128                                     | environmental design, 24                                |
| nature and, 135<br>principles of, 32, 42–47           | ergonomic design, 129, 143                              |
| process, 126                                          | Ericofon, 124 Ericofon, M. C. (Halland), 200            |
| studio lesson                                         | Escher, M. C. (Holland), 299<br>Another World II, 229   |
| paper package design, 138–141                         | Drawing Hands, 13                                       |
| technological, 143                                    | Ethnic Heritage Series: California Crosswalk, 294       |
| through time, 124                                     | Ewer for Use in Tea Ceremony, 2                         |
| tradition of. See Japan                               | Exploration of the Sources of the Orinoco, 224          |
| Website, 125                                          | expressionism, 10                                       |
| designer. See also fashion designer; graphic designer | enpressionism, ro                                       |
| for the theater, 143                                  | _                                                       |
| De Stijl movement, 128                                | F                                                       |
| Diary: December 12, 1941, 77                          | Fallert, Caryl Bryer (United States), Refraction        |
| Digital Clock, 136                                    | #4-#7,36                                                |
| Dinner Party, The, 151                                | fantasy, 13, 232–235. See also Puerto Rico, art of      |
| Disguise, The, 235                                    | fashion designer, 122–123, 142                          |
| Dish, 186                                             | FDR Memorial. See Franklin Delano Roosevelt<br>Memorial |

| Fern Hope Hoop, The, 285                                  | Gehry Residence, 252                                  |
|-----------------------------------------------------------|-------------------------------------------------------|
| fiber art. See also fashion designer; Wind, Nomi          | genre scenes, 102                                     |
| (Israel)                                                  | geometric shape, 89                                   |
| artists, 298                                              | gesture drawing, 80–81                                |
| carpet, 291                                               | Ghiberti, Lorenzo (Italy), Gates of Paradise, 247     |
| storytelling banners, 83–85                               | Gladioli, 188                                         |
| tapestry, 76                                              | Glass and Bottle of Suze, 282                         |
| Figure of Hippopotamus, 2                                 | glassmaking, 290                                      |
| Figures, Construction, 202                                | Gluelam House, The, 261                               |
| film, 23                                                  | Goldfish Bowl, 242                                    |
| Flying-Saucer Dress, 122                                  | Gornik, April (United States)                         |
| Fon Appliqué Cloth, 84                                    | Divided Sky, 183                                      |
| Fon Men Making Appliqué Cloth, 85                         |                                                       |
|                                                           | Light at the Equator, 182                             |
| Fon people, 83–85                                         | Granite Weaving, 286                                  |
| Fonseca, Harry (Native American), 208–209                 | graphic design, 22                                    |
| Coyote Leaves the Reservation, 209                        | graphic designer, 138–139                             |
| Rose and the Reservation Sisters, 208                     | Graves, Michael (United States)                       |
| Football Player, 34                                       | Mantel Clock for Alessi, 131                          |
| form, 35, 271                                             | Whistling Bird Teakettle with Matching Sugar Bowl     |
| architecture and creation of, 259–260                     | and Creamer for Alessi, 130                           |
| design and, 124                                           | Gray, Melinda (United States), 260–261                |
| found materials                                           | The 13° House, 260                                    |
| studio lessons                                            | The Gluelam House, 261                                |
| building a wire sculpture, 242–244                        | "Green Stripe" Fresh Produce Containers, 138          |
| sculpture from recycled materials,                        | Grooms, Red (United States), Looking along            |
| 294–297                                                   | Broadway towards Grace Church, 86                     |
| Fragment with Bird, 26                                    | Group of Three Baskets, 63                            |
| France, Prehistorical period, 53                          | Guatemala, Pre-Columbian, 117                         |
| Franklin Delano Roosevelt Memorial, 15, 151               | Guggenheim Museum, Bilbao, 250                        |
| fresco, 20, 154                                           | Guggenheim Museum Bilbao Design Sketch, 250           |
| Frey, Viola (United States), Double Grandmother, 86       | guild, 82                                             |
| Frieze of the Parthenon: Mounted Procession, 25           |                                                       |
| Fuentes family (Mexico)                                   | н                                                     |
| Untitled (Fish), 190                                      | haciendas, 265                                        |
| Untitled (Lizard), 190                                    | Haiti, art of, 108–111                                |
| Fuller, Buckminster (United States), Southern Illinois    | Halprin, Lawrence (United States), Franklin Delano    |
| University Chapel, 299                                    | Roosevelt Memorial, 151                               |
| function, design and, 124                                 | Handball, 98                                          |
| functions of art, 4–5                                     |                                                       |
| promises and the sub-sub-sub-sub-sub-sub-sub-sub-sub-sub- | Hare, Frances (United States), Sixteen Feet of Dance: |
| G                                                         | A Celebration, A Self-Portrait, 43                    |
|                                                           | Haring, Keith (United States), 199–201                |
| Garrowby Hill, 40                                         | Icons (Barking Dog), 200                              |
| Gates of Paradise, 247                                    | Icons (Radiant Baby), 200                             |
| Ga-Wree-Wre-Mask, 41                                      | Untitled (Poster for anti-nuclear rally, New York),   |
| Gehry, Frank (United States), 251–253                     | 201                                                   |
| Aerospace Museum, 253                                     | Untitled, 198, 201                                    |
| Gehry Residence, 252                                      | Untitled (for Cy Twombly), 12                         |
| Guggenheim Museum, Bilbao, 250                            | Harlem Renaissance, 103                               |
| Guggenheim Museum Bilbao Design Sketch, 250               | Harriet, 216                                          |
| Vitra Headquarters, 253                                   | Harvest with Cows, 110                                |
|                                                           | hatching, 107                                         |
|                                                           |                                                       |

| Heade, Martin J. (United States), Sunset over the Marshes, 181 Henson, Jim, 147–149 Hepworth, Barbara (Great Britain), Oval Sculpture Number Two, 284 hieroglyphics, 194 history, visual, 109                                                                                      | K kachina figures, 150 Kahlo, Frida (Mexico), The Little Deer, 207 Kangaroo and Hunter, 212 Karuk Spoons, 14 Kaufmann House: Fallingwater, The, 259 Kcho (Cuba), The Regatta, 61                                                                                                                                                                                                                                                                                                                  |
|------------------------------------------------------------------------------------------------------------------------------------------------------------------------------------------------------------------------------------------------------------------------------------|---------------------------------------------------------------------------------------------------------------------------------------------------------------------------------------------------------------------------------------------------------------------------------------------------------------------------------------------------------------------------------------------------------------------------------------------------------------------------------------------------|
| Hockney, David (United States), Garrowby Hill, 40 Holbein, Hans, the Younger (Germany), The Ambassadors, 206 Holzer, Jenny (United States), 15 horizon line, 236 House, 279 human proportions, 132–133 Hydria, 128                                                                 | Kermit, 146 King's Crown, 202 Kita, Toshiyuki (Japan) design for changing lifestyle, 136–137 Digital Clock, 136 Urushi Tableware, 137 Wink Chairs, 136 Kitchenetic Energy, 46 Kollwitz, Käthe (Germany), Rest in the Peace of Hi.                                                                                                                                                                                                                                                                 |
| l Icons (Barking Dog), 200<br>Icons (Radiant Baby), 200<br>Iktinos and Kallikrates (Greece), The Parthenon, 256<br>Illumination, 40<br>illusion, of depth, 230<br>Imaginarium KangarooHop! Package Design, 138<br>imagination, art and, 228–229<br>Incense Burner, 187             | Hands, 9 Koons, Jeff (United States), Puppy, 285 Kruger, Barbara (United States), 15, 156–157 Untitled (Think Twice), 156 Untitled (We Don't Need Another Hero), 157 Kunisada, Utagawa (Japan), Scene from a Kabuki Play, 90 Kuniyoshi, Utagawa (Japan), Tameijiro dan Shogo Grapples with His Enemy under Water, 77                                                                                                                                                                              |
| India, Seated Ganesha (Orissa), 6 industrial design, 27 installation art, 104–105 intensity, color, 184 scale, 185 In the Iowa Territory, 74 In the Iowa Territory (sketch), 74 In the Iowa Territory (unfinished), 74 inventors, 247 Islamic art, 160–161 Israel, art of, 290–293 | L Laboratory Starbust, 120 Lamp, 28 landscape Aboriginal messages about the land, 213 as art, 180–183 interpretation of, 174–175 Lange, Dorothea (United States), 94–97 Migrant Agricultural Workers Family, 100 Migrant Mother, Nipomo, California, 100 Tagged Girl, Oakland, 97                                                                                                                                                                                                                 |
| Jahn, Helmut (Germany), State of Illinois Center, 29 Japan, 42, 134–137 Momoyama period, 2 Owari province, 134 tradition of design, 134–135 Java, storytelling with shadow puppet, 168 Jazzmin, 126 Jazz Village, 281 Jewish Fairy Blessing the Menorah of the Southwest, The, 59  | Three Families, Fourteen Children on U.S. 99, Sa Joaquin Valley, California, 96 White Angel Breadline, San Francisco, 94 Language Arts art and, 169 hieroglyphics interpretation, 194 planning a written work, 273 poetry's rhythmical pattern, 49 reading and understanding of others, 91 science fiction books, 143 secret messages and codes, 221 words and art, 15 writing as a way to keep records, 117 Lanyon, Ellen (United States), 234–235 Chemistry Versus Magic, 235 The Disguise, 235 |

Large Tense Hand, 10 Martha Graham: Letter to the World (Kick), 48 Lawrence, Jacob (African American), 69, 70-71 mask, 238 The Builders, 71 Masquerader with Boat Headdress, 294 In the Iowa Territory, 74 Mathematics In the Iowa Territory (sketch), 74 cylindrical symmetry, 143 In the Iowa Territory (unfinished), 74 figures, 29 The Migration of the Negro, 71 illusion of depth on a flat surface, 247 St. Marc (Toussaint L'Ouverture), 68 mathematical ideas in art, 15 Through Forest, Through Rivers, Up Mountains, 70 measurement and planning, 273 Legorreta, Ricardo (Mexico), 266-267 recording of numbers, 117 Camina Real Hotel, 266 use in artistic works, 299 Solana Complex, 267 Matisse, Henri (France), Toboggan, 204 Leissner, Lawrence (United States), The Second Mattelson, Marvin (United States), Subway Poster for Trigram, 60 School of Visual Arts, 22 Memphis design group, 129 Les Très Riches Heures du Duc de Berry, 99 Lesson, The, 108 Méndez, Lillian (Puerto Rico), 240–241 Letter Reader, The, 102 Vejigante Made from Goya Rice Bags, 240 Lewis, Maud, 5 Vejigante Made from Puerto Rican Flags, 241 Lichtenstein, Roy (United States), Whaam!, 77 meter, in poetry, 49 light, landscape and, 183 Metsu, Gabriel (The Netherlands), The Letter Light at the Equator, 182 Reader, 102 Limbourg Brothers (The Netherlands), Les Très Mexico, art, 264-267 Riches Heures du Duc de Berry, 99 Migrant Agricultural Workers Family, 100 line, 34 Migrant Mother, Nipomo, California, 100 emphasis and, 219 Migration of the Negro, The, 71 linear perspective, 236 mime, 220 linoleum Mimesis, 227 studio lesson Minoan culture, 20 block print, 216-219 Miss Suzie Porter, Harlem, 103 Listening Room, The, 232 Miyake, Issey (Japan), 122–123 A-POC "King" and "Queen," 123 Flying-Saucer Dress, 122 Little Deer, The, 207 Liu, Hung (China), Chinese Profile II, 39 Looking along Broadway towards Grace Church, 86 Laboratory Starbust, 120 Lopez, Yolanda M. (United States), Portrait of the mobile, 25 Artist as the Virgin of Guadalupe, 44 Monet's Sheep #3, 174 Lorenzetti, Ambrogio (Italy), Peaceful City, 154 Monida Angus #7, 172 Lovell, Whitfield (United States), 104-105 Monkey-Painter, The, 207 Whispers from the Walls (table and monoprinting, 210-211 vanity installation view), 105 montage, 21 Whispers from the Walls (bedroom Moore, Henry (Great Britain) installation view), 104 Nuclear Energy, 220 Luminism, 180 Sheep Piece, 7 Moran, Thomas (United States), Shin-Au-Av-Tu-Weap (God Land), 169 Morgan, Barbara (United States), Martha Graham: Mackall, Robert McGill (United States), Circus Letter to the World (Kick), 48

Mackall, Robert McGill (United States), Circus Parade, 7 Mae West, 230 Magritte, René (Belgium), The Listening Room, 232 Manifest Destiny, 299 Mantel Clock for Alessi, 131 Marcus Aurelius, Equestrian, 55 Market, 111

| Moroles, Jesús Bautista (United States), 286–287  Granite Weaving, 286  Round Wafer, 287  Morse code, 221  mosaic, 26  Mosque Lamp, 161  Mountain Devil Lizard, 215  movement, 47, 245  Muppets, 148–149, 149  mural, 155  Music, 15  electric guitar, 246  interpretation of nature in, 195 | organic shape, 89 Original Wall of Respect, The, 155 Oropallo, Deborah (United States), Amusement, 33 Orozco, José Clemente, 155 Outterbridge, John (United States), Ethnic Heritage Series: California Crosswalk, 294 Oval Sculpture Number Two, 284  P Pablo Ruiz with Itch, 18 Page from the Quran, 160 paint experimentation with, 174 |
|----------------------------------------------------------------------------------------------------------------------------------------------------------------------------------------------------------------------------------------------------------------------------------------------|--------------------------------------------------------------------------------------------------------------------------------------------------------------------------------------------------------------------------------------------------------------------------------------------------------------------------------------------|
| as a record of time or place, 116<br>Muybridge, Eadweard, 117                                                                                                                                                                                                                                | tempera, 74, 152, 192                                                                                                                                                                                                                                                                                                                      |
| May bridge, Each Card, 117                                                                                                                                                                                                                                                                   | Painted Tree Bark with Crosshatching Pattern, 213 painting, 20                                                                                                                                                                                                                                                                             |
| N                                                                                                                                                                                                                                                                                            | as a record, 108                                                                                                                                                                                                                                                                                                                           |
| Nanbu Iron Kettle, 135                                                                                                                                                                                                                                                                       | studio lessons, picture series that tells a story, 74                                                                                                                                                                                                                                                                                      |
| narrative art, 76–79                                                                                                                                                                                                                                                                         | Parthenon, The, 256                                                                                                                                                                                                                                                                                                                        |
| narwhal, 247                                                                                                                                                                                                                                                                                 | pattern, 45, 141                                                                                                                                                                                                                                                                                                                           |
| National Museum of Anthropology, The, 265                                                                                                                                                                                                                                                    | meaning of, 214–215                                                                                                                                                                                                                                                                                                                        |
| Native American, 4, 14                                                                                                                                                                                                                                                                       | Peaceful City, 154                                                                                                                                                                                                                                                                                                                         |
| changing perceptions of, 279                                                                                                                                                                                                                                                                 | Peeters, Clara (Holland), Still Life of Fruit and                                                                                                                                                                                                                                                                                          |
| Huichol Indian, 2                                                                                                                                                                                                                                                                            | Flowers, 203                                                                                                                                                                                                                                                                                                                               |
| Navajo, 18                                                                                                                                                                                                                                                                                   | Penrose, Roland (Great Britain), Winged Domino—                                                                                                                                                                                                                                                                                            |
| Sio Hemis, 150                                                                                                                                                                                                                                                                               | A Portrait of Valentine, 233                                                                                                                                                                                                                                                                                                               |
| Tlingit, 63                                                                                                                                                                                                                                                                                  | People Receive Books, The, 155                                                                                                                                                                                                                                                                                                             |
| nature in art 173 See also Wadall Theodore (United                                                                                                                                                                                                                                           | Persian art, 73                                                                                                                                                                                                                                                                                                                            |
| in art, 173. See also Wadell, Theodore (United States)                                                                                                                                                                                                                                       | perspective, 229, 230, 236–237<br>petroglyphs, 279                                                                                                                                                                                                                                                                                         |
| in Chinese art, 186–188                                                                                                                                                                                                                                                                      | Petyarre, Ada Bird (Australia), 214–215                                                                                                                                                                                                                                                                                                    |
| designs tied to, 135                                                                                                                                                                                                                                                                         | Mountain Devil Lizard, 215                                                                                                                                                                                                                                                                                                                 |
| images of, 176–177                                                                                                                                                                                                                                                                           | Sacred Grasses, 214                                                                                                                                                                                                                                                                                                                        |
| negative shape, 34, 89                                                                                                                                                                                                                                                                       | photography, 23. See also billboard; Lange,                                                                                                                                                                                                                                                                                                |
| negative space, 34, 271                                                                                                                                                                                                                                                                      | Dorothea; Lovell, Whitfield; Weems, Carrie Mae                                                                                                                                                                                                                                                                                             |
| Nevelson, Louise (United States), Royal Tide, 281                                                                                                                                                                                                                                            | montage, 21                                                                                                                                                                                                                                                                                                                                |
| Nghe, 58                                                                                                                                                                                                                                                                                     | as a record of daily life, 96–97                                                                                                                                                                                                                                                                                                           |
| North Africa, Islamic art of, 160–163                                                                                                                                                                                                                                                        | Picasso, Pablo (Spain), Glass and Bottle of Suze, 282                                                                                                                                                                                                                                                                                      |
| Nuclear Energy, 220                                                                                                                                                                                                                                                                          | pictograms, 202, 279                                                                                                                                                                                                                                                                                                                       |
|                                                                                                                                                                                                                                                                                              | pioneering                                                                                                                                                                                                                                                                                                                                 |
| 0                                                                                                                                                                                                                                                                                            | materials and scale, 280–281                                                                                                                                                                                                                                                                                                               |
| Obin, Philomé (Haiti), Bal en plein air (Outdoor                                                                                                                                                                                                                                             | questions about art, 280                                                                                                                                                                                                                                                                                                                   |
| Dance), 109                                                                                                                                                                                                                                                                                  | sculpture, 284–287                                                                                                                                                                                                                                                                                                                         |
| Object (Lunch in Fur), 233                                                                                                                                                                                                                                                                   | ways of thinking, 279                                                                                                                                                                                                                                                                                                                      |
| Oleszko, Pat (United States), Jazzmin, 126                                                                                                                                                                                                                                                   | women artists, 280 planning, architecture and, 254–255, 258–260                                                                                                                                                                                                                                                                            |
| one-point perspective, 236                                                                                                                                                                                                                                                                   | Plug-in City, 254                                                                                                                                                                                                                                                                                                                          |
| Oppenheim, Meret (Germany), Object (Lunch in                                                                                                                                                                                                                                                 | Poisson, L'Ouverture (Haiti), The Lesson, 108                                                                                                                                                                                                                                                                                              |
| Fur), 233                                                                                                                                                                                                                                                                                    | Pollock, Jackson (United States), Blue Poles, 53                                                                                                                                                                                                                                                                                           |
|                                                                                                                                                                                                                                                                                              | Ponce Mask, 238                                                                                                                                                                                                                                                                                                                            |
|                                                                                                                                                                                                                                                                                              | portrait, 206–209                                                                                                                                                                                                                                                                                                                          |
|                                                                                                                                                                                                                                                                                              | as messages, 206                                                                                                                                                                                                                                                                                                                           |

| Portrait of Orca Bates, 8 Portrait of the Artist as the Virgin of Guadalupe, 44 positive shape, 35, 89 poster studio lesson, designing a poster, 164–166 teaching with, 164 Post-Modernism, 259 primary colors, 184 principles of design, 32, 34–41. See also balance; emphasis; movement; pattern; proportion; rhythm; unity; variety                                                                                                                                                                                                                                                                                                                                                                 | Rietveld, Gerrit T., Roodblauwe Stoel, 142 Rivera, Diego (Mexico), The People Receive Books 155 River Landscape with Towering Mountains, 187 Rockwell, Norman (United States) Connoisseur, 56 Save Freedom of Speech, 164 Rodin, Auguste (France), Large Tense Hand, 10 Rolling Power, 37 Romantic artists, 180 Ronibson, Rene (Australia), Snake Dreaming, 213                                                                                                                                                                                                                                                                                                                                                                                                                                                               |
|--------------------------------------------------------------------------------------------------------------------------------------------------------------------------------------------------------------------------------------------------------------------------------------------------------------------------------------------------------------------------------------------------------------------------------------------------------------------------------------------------------------------------------------------------------------------------------------------------------------------------------------------------------------------------------------------------------|-------------------------------------------------------------------------------------------------------------------------------------------------------------------------------------------------------------------------------------------------------------------------------------------------------------------------------------------------------------------------------------------------------------------------------------------------------------------------------------------------------------------------------------------------------------------------------------------------------------------------------------------------------------------------------------------------------------------------------------------------------------------------------------------------------------------------------|
| orintmaking, 21 collagraph, 282 monoprinting, 210–211 relief print, 216 studio lessons linoleum block print, 216–219 symbol stamps, 204–205 woodcut, 77                                                                                                                                                                                                                                                                                                                                                                                                                                                                                                                                                | Roodblauwe Stoel (Red, Yellow, and Blue Chair), 14<br>Rose and the Reservation Sisters, 208<br>Rosenquist, James (United States), Dishes, 112<br>Rouillard, André, Commedia dell'Arte, 62<br>Round Wafer, 287<br>Royal Tide, 281<br>Ruisdael, Jacob van (Holland), Wheatfields, 180                                                                                                                                                                                                                                                                                                                                                                                                                                                                                                                                           |
| roportion, 46, 167 human, 132–133 public memorials, 15 Puerto Rico, art of, 238–241 puppets  Bunraku, 152 Hand Puppets, 152 storytelling and, 168 studio lesson puppetmaking, 152–153 puppeteer, 148–149 Puppy, 285  R Rauschenberg, Robert (United States), Retroactive I, 54 realism, 11 Realist artists, 180 recycling, material into art, 294–297. See also sculpture Red House, The, 258 Refraction #4–#7, 36 Regatta, The, 61 Reid, Bill (Canada), The Spirit of Haida Gwaii, The Jade Canoe, 57 relief print, 216 relief sculpture, 25, 288–289 Remington, Frederic (United States), Dash for the Timber, 117 Requiem, 279 Rest in the Peace of His Hands, 9 Retroactive I, 54 rehythm, 47, 245 | Sacred Grasses, 214 Saint Phalle, Niki de (France), and Jean Tinguely, Illumination, 40 santos, 239 Santos Figure: Virgen de Hormigueros, 239 Save Freedom of Speech, 164 scale, 46 Scene from a Kabuki Play, 90 scheme, color, 38 Science ancient Chinese pottery, 194 chemical elements in, 29 ergonomic designs, 143 expeditions and art, 169 light and prism, 49 Morse code, 221 narwhal and unicorn, 247 photography as record, 117 pioneering scientist, 299 scientific method in, 63 sculpture, 25 casting relief, 288–289 pioneering the modern, 284–287 site-specific, 285 studio lessons animal constructions from wood, 190–192 building architectural model, 256–267 building a wire sculpture, 242–244 cardboard scene with clay figures, 86–88 puppetmaking, 152–153 sculpture from recycled materials, 294–297 |
|                                                                                                                                                                                                                                                                                                                                                                                                                                                                                                                                                                                                                                                                                                        | traditions of, 284–287                                                                                                                                                                                                                                                                                                                                                                                                                                                                                                                                                                                                                                                                                                                                                                                                        |

archeological dig planning, 273 Seated Ganesha, 6 Second Trigram, The, 60 artworks and cultures, 49 Segal, George (United States), Bread Line, 151 banners and flags, 221 different approaches to artifacts, 63 self-portrait, 207 interpretation of colors, 194 Serenade, 90 series, 71 learning and teaching among cultures, 169 shade, 184 passing of knowledge in different cultures, 247 pioneers and settlers, 299 Shahn, Ben (United States) primary and secondary sources, 29 Handball, 98 You Have Not Converted a Man Because You public memorials, 15 Have Silenced Him, 164 storytelling in artifacts, 91 Solana Complex, 267 Shao-an, Chao (China), 188-189 Soldier at Home, The, 34 Azaleas, 189 Soleri, Paolo (Italy), Arcosanti, 255 Gladioli, 188 Solomon R. Guggenheim Museum, 254 shape, 35 negative, 89 "Song of Songs" Carpet, 292 Southern Illinois University Chapel, 299 positive, 89 Sharecropper, 216 space, 40, 245 spectrum, color, 193 Sheeler, Charles (United States), Rolling Power, 37 Sheep Piece, 7 Spiral Transit, 226 Sherman, Cindy (United States), Untitled Film Still, Spirit, Michael Jordan, The, 47 Spirit of Haida Gwaii, The, 57 St. Marc (Toussaint L'Ouverture), 68 Shimomura, Roger (Japanese American), 77–78 Star-Spangled Banner, 221 Diary: December 12, 1941, 77 Untitled, 78 State Names #2, 276 Shin-Au-Av-Tu-Weap (God Land), 169 State of Illinois Center, 29 Still from the Warner Bros. Cartoon "Feed the Kitty," Shire, Peter (United States), "California Peach" Cup, 129 still life, 112 Shotgun, Fourth Ward, 49 symbolism of Dutch painting, 203 Shotgun, Third Ward #1, 39 Side Chair, Wohnbedarf Model, 129 Still-Life of Fruit and Flowers, 203 Sio Hemis, Katsina, 150 Siqueiros, David Alfaro, 155 stippling, 107 storytelling site-specific sculpture, 285 in art and series, 71 Sixteen Feet of Dance: A Celebration, A Self-Portrait, in artifacts, 91 artistic forms of, 73 Smith, Jaune Quick-to-See (Native American), 276–279 in Dahomey, 83-85 personal style in, 79 with puppets, 168 House, 279 Requiem, 279 in theater, 90 State Names #2, 276 Study of Woman's Hands, 11 Trade (Gifts for Trading Land with style, of a painting, 2 styles of art, 10-13 White People), 278 smudging, 107 subject Snake Dreaming, 213 of artworks, 6 of a painting, 2

Subway Poster for School of Visual Arts, 22

Social studies

Seaside at Palavas, 181

| Trade (Gifts for Trading Land with White People), 27 tradition artistic expression of, 239. See also Méndez, Lillian (Puerto Rico) preservation in Israeli art, 291 teaching of, 150  Turner, J. M. W. (Great Britain), The Burning of the Houses of Lords and Commons, October 16, 1834, 181 two-dimensional artworks, 20–23 two-point perspective, 237  U Unicorn in Captivity, The, 247 unity, 43, 89 Untitled (from the Sea Island series), 103 Untitled Film Still, 23                                                                      |
|--------------------------------------------------------------------------------------------------------------------------------------------------------------------------------------------------------------------------------------------------------------------------------------------------------------------------------------------------------------------------------------------------------------------------------------------------------------------------------------------------------------------------------------------------|
| Untitled (for Cy Twombly), 12<br>Untitled (Haring), 198, 200<br>Untitled (Fish), 190                                                                                                                                                                                                                                                                                                                                                                                                                                                             |
| Untitled (Lizard), 190 Untitled (Shimomura), 78 Untitled (Think Twice), 156 Untitled (We Don't Need Another Hero), 157 urban life, recording, 103 Urushi Tableware, 137                                                                                                                                                                                                                                                                                                                                                                          |
| <b>V</b><br>value, 37–39<br>scale, 115                                                                                                                                                                                                                                                                                                                                                                                                                                                                                                           |
| VanDerZee, James (United States), Miss Suzie Porter, Harlem, 103 vanishing point, 236 Vanna Venturi House, 259 variety, 43, 89 Varo, Remedios (Spain), 224–227 Creation of the Birds, 227 Exploration of the Sources of the Orinoco River, 22 Mimesis, 227 Spiral Transit, 226 Vasarély, Victor (Hungary), 299 Vase, 35 Vázquez, Pedro Ramírez (Mexico), The National Museum of Anthropology, 265 Vejigante Celebrant in a Loiza-style Costume and Mask, 239 Vejigante Made from Goya Rice Bags, 240 Vejigante Made from Puerto Rican Flags, 241 |
|                                                                                                                                                                                                                                                                                                                                                                                                                                                                                                                                                  |

Venturi, Scott Brown and Associates (United States),
Vanna Venturi House, 259
Vermeer, Jan (Holland), View of Delft from
the South, 182
Vertumnus, 229
Victoria and Albert Rotunda Chandelier, 33
View of Delft from the South, 182, 183
Vinci, Leonardo da (Italy), Study of Woman's
Hands, 11

Vitra Headquarters, 253 Vu, Hoang (Vietnamese

Vu, Hoang (Vietnamese American), Nghe, 58

#### W

Wade, Erika (United States), 298
Wadell, Theodore (United States), 172–175
Ennis Horses #5, 175
Monets Sheep #3, 174
Monida Angus #7, 172
Wall Hanging with Lion and Battle Scenes between
Europeans and Africans, 83
Waqialla, Osman (Sudan), 162–163
Calligraph, 163
Calligraph: "Deep sorrow defies definition," 162
Wayang Kulit (Shadow Puppet), 168
Webb, Doug (United States), Kitchenetic Energy, 46
Webb, Philip (Great Britain), The Red House, 258
Wedding Dance, The, 116
Wedding Ensemble, 194
Weems, Carrie Mae (United States), Untitled, 103
Whaam!, 77
Wheatfields, 180

Whispers from the Walls, 104, 105 Whistling Bird Teakettle, 130

Defeated Childhood, 292 Women of the Desert, 293

White Angel Breadline, San Francisco, 94 Wind, Nomi (Israel), 292–293

Winged Domino—A Portrait of Valentine, 233

Wink Chairs, 136 women artists, 280 Women of the Desert, 293 wood studio lesson animal constructions from wood, 190-192 woodcarving, 190 woodcut, 77 Wooden Statue of Behanzin, King of Dahomey As the Figure of a Shark, 82 Woods, Leah (United States), Lamp, 28 Wright, Frank Lloyd (United States) The Kaufmann House: Fallingwater, 259 Solomon R. Guggenheim Museum, 254 Writing Board, 161 Wyeth, Jamie (United States), Portrait of Orca Bates, 8

#### Υ

Yemadje, Joseph, 84 You Have Not Converted a Man Because You Have Silenced Him, 164

#### Z

Zoomorph P from Quiriga, 117

# Teacher's Reference Material

T334 **Program Overview** T334 Why Themes? Curriculum Structure T334 T336 **Program Fundamentals** T338 Assessment Meeting Individual Needs T338 T339 Relating Other Subjects to Art Building Support for the Art Program T340 T341 Maintaining the Artroom T344 **Teacher Bibliography** T348 **Internet Resources The National Visual Arts Standards** T352 **Professional Articles** T353

Photo courtesy Karen Miura, Kalakaua Middle School, Honolulu, Hawaii.

# **Program Overview**

# Why Themes?

We believe that art is inescapably linked to the experience of being human. As humans throughout the world and over time have sought ways to understand the world and their place within it, they have created objects and rituals to assist them. The series draws upon the activities and inclinations that humans have in common. It makes the connection between those commonalities and the art that people have made in the past and continue to make in the present.

The themes found throughout the program are informed by the ideas of educator Ernest Boyer, who proposed a list of shared human experiences. Boyer generally proposed that all humans experience life cycles, develop symbols, respond to the aesthetic dimension of experience, and develop various forms of bonding together socially. He claimed that humans have the capacity to recall the past and anticipate the future. Humans are inseparably a part of nature and, as such, are connected to the ecology of the planet. Humans share a tendency to produce—to work—and to consume. Boyer also proposed that all humans seek to live their lives with a sense of meaning and purpose. Boyer proposed that a quality curriculum might be grounded in a recognition of these shared human needs and interests—that all school subjects include directly-related content and inquiry modes.

In the chapters throughout the series, art is presented as an inseparable part of each of these common human themes. Art is an important way in which people communicate their ideas while seeking to live a meaningful life. In cultures throughout the world, people develop ways to communicate through visual symbols. The ideas are tied to cultural value and belief systems, as are the specific purposes that art serves within the culture. Art forms vary according to traditions within the culture. Changes in tradition occur when cultures connect, or when individuals and groups seek to expand ideas and techniques central to art-making practice.

Understanding art made throughout the world and over time is inextricably linked to the study of culture and tradition.

# **Curriculum Structure**

The art curriculum presented in *Art and the Human Experience* builds upon student learning in relation to expression through and response to art. Students learn to create artworks and to express their experiences visually. They also learn how and why artists of the past and present have created art. Students learn to perceive, think, talk and write about art they encounter—their own artworks, those made by their classmates, and those created by others throughout the world and over time. Students become aware of beauty in the environment, understanding the importance of art and design in everyday life. They learn about careers in art and community art resources. Students learn to truly enjoy the processes involved in creating and responding to art.

# **Text Organization**

The texts are organized into two major parts. "Foundations" includes an overview of basic content in and inquiry approaches to art. Depending upon your students' prior knowledge, you may wish to use the Foundations chapters as a way of reviewing or, in some cases, introducing this content. "Themes" approaches the content through multi-layered themes drawn from Boyer's list of human commonalities. The Core Lesson of each chapter introduces the theme and its art-related key ideas. The additional four lessons of the chapter explore the theme in more depth, considering the ideas through art history, art foundations, global connections, and studio production. Depending upon the structure for teaching art in your school, you may only have the opportunity to explore the Core Lesson of each chapter. Alternatively, you may be able to include one or more of the additional lessons, providing your students with opportunities for gaining deeper understanding of the thematic content.

# **Creating and Responding to Art**

Art is above all a creative activity, one that develops students' abilities to visually express their experiences. Throughout the many studio experiences in the program, students are encouraged to be purposeful as they make artworks. They are helped to generate ideas and to develop skills in the use of materials and techniques to achieve desired effects.

Photo courtesy Betsy Logan, Samford Middle School, Auburn, Alabama.

Learning to perceive artworks with an active eye and responsive mind is the foundation for a lifelong interest in, and appreciation of, art. The program is designed so that students gain new insights as they examine and investigate artworks and offer possible interpretations about their meaning. They learn from each other in discussing important questions about art. Talking about art provides students with opportunities to voice their opinions and hear those of their classmates. Writing about art also provides them with opportunities to clarify their own thinking about the artworks they encounter.

The Disciplines of Art

The content of *Art and the Human Experience* is based upon knowledge in the various disciplines of art. These include the creation of art (art production), art history, aesthetics and art criticism. The content is informed by research in related areas of inquiry such as art education, the psychology of art, the sociology of art, and cultural anthropology. Students are introduced to central ideas and perspectives of the disciplines as well as to the characteristic methods of disciplinary inquiry.

**Art Production** The program includes many opportunities for students to express their ideas and feeling by using a variety of materials and techniques. As students observe the world, recall and reflect upon past experience, and use imagination to engage purposefully in the creation of their own artworks, they learn that reflection is an important part of the art-making process. Through discussion and self-reflection, students consider the ways their artworks reflect their ideas and feelings. They consider the decisions they make during the creative process, focusing on their ideas, their choice of materials, their ways of using materials, as well as their work habits. Reflection upon the creation of art involves consideration of artworks students have made in the past and how their current work builds upon or departs from past art-making experiences. Reinforcing the notion that much of what humans make reflects memories of, preferences for, or connections to certain artworks or art traditions, students consider the influences that other artworks have had on their art-making decisions.

Art History Students learn to seek information regarding the social and historical context in which artworks are made. The study of human history and cultures reveals how humans have created and used art for important social and individual purposes. Students study themes, styles, traditions, and purposes of art throughout the world and over time. They learn about individual artists and how their artworks reflect or influence ideas and beliefs of the time in which they were created. Using arthistorical inquiry processes, students learn to consider their own perceptions of artworks along with contextual information, and to propose historical explanations.

Art Criticism Art criticism is critical thinking about individual artworks or groups of artworks. Students learn how to carefully observe and describe details in artworks. They learn how to analyze the structure and organization of artworks. Interpretation involves making inferences about possible meanings of artworks. Students learn how to offer interpretations of artworks, supported by what they perceive, relevant contextual information, and their own experiences and points of view. As they learn how to offer interpretations, they also learn how to make judgments about the plausibility of those offered by others. Students also learn how to judge the merit and significance of artworks, using standards from individual and socio-cultural beliefs, values, purposes and traditions.

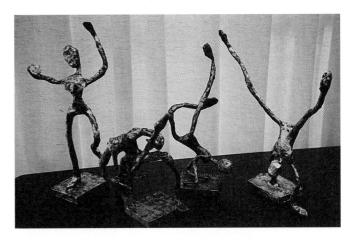

Photo courtesy Bunki Kramer, Los Cerros Middle School, Danville, California.

**Aesthetics** Aesthetics is a branch of philosophy that developed out of an interest in explaining the concept of beauty. It has evolved into a discipline in which a wide range of philosophical questions are addressed. Rarely do students engage in inquiry about the meaning or merits of particular artworks, about the history of art, or about the processes involved in making art without asking questions that are essentially philosophical questions. Students wonder what art is, why people create it, why people in some cultures are considered artists while others are not, what counts as good art, and how we can know what an artwork means. In *Art and the Human Experience*, students are provided opportunities to raise and address philosophical questions related to their art

study. They are encouraged to reflect on their ideas about art in general and to keep track of their changing ideas. Through reflection and discussion, students learn that ideas about art vary among individuals and cultures. They are encouraged to respect alternative points of view. They learn to listen to and learn from their classmates as they engage in the study of art of the past and present from around the world.

## Multicultural and Global Content

As we become increasingly aware of cultural and ethnic diversity in our nation and increasingly aware of the broad spectrum of artistic expression throughout the world, teachers of art are challenged to create ways in which this diversity can be recognized and understood by our students. We must provide students the opportunity to gain insights about themselves, about others, and about the world in which they live by attending to diversity in artistic expression. Art and the Human Experience addresses this task in two ways: 1. through the study of art that reflects ethnic and cultural diversity within our own culture, and 2. through the study of art with a global perspective. The disciplines of art provide lenses through which students learn to understand and appreciate the richness of artistic expression close to home and throughout the world.

# The Importance of Contemporary Art

If students are to understand and appreciate the integrative role that art plays in their lives, they need to see, study, and appreciate artworks made by people living along with them in their local and worldwide communities. The study of art from the past helps students understand the origins of and traditions associated with contemporary artworks. They learn that artists today, as in the past, respond to ideas, needs, issues, and events in the time and place in which they live. Art and the Human Experience includes many examples of contemporary art from close to home and around the world. It proposes that students be encouraged to seek out contemporary artworks and to learn from local artists.

# Content Knowledge, Disciplined Inquiry, and Learning for Life

When students construct knowledge, they organize, synthesize, interpret, explain, or evaluate information. To do this well, they must build upon prior knowledge that others have produced—the content knowledge in the art disciplines. As students assimilate prior knowledge, they hone their skills through guided practice in producing artworks, conversation, and writing. *Art and the Human Experience* encourages thoughtful use and application of content knowledge.

Disciplined inquiry is important cognitive work. It employs the facts, concepts, and theories that other inquirers have produced. Students are encouraged to

develop in-depth understanding of problems as they raise questions and explore issues, relationships, and complexities within focused topics and themes.

Through the construction of knowledge through disciplined inquiry, students are offered opportunities to produce artwork and discourse that have aesthetic, useful, and personal meaning and value beyond demonstration of success in school. *Art and the Human Experience* proposes connections to life in the school and local community, to the performing arts, and to other curriculum areas.

# **Program Fundamentals**

Photo courtesy Karen Miura, Kalakaua Middle School, Honolulu, Hawaii.

# The Importance of Inquiry

Teaching strategies within *Art and the Human Experience* are aimed toward developing deep understanding. Toward this end, we have included many opportunities for students to raise and address questions prompted by the chapter content. Such opportunities can be found in the student book where questions are posed in the body of text, in captions, and in review questions in the lessons and at the end of each chapter. The teacher's edition includes many suggestions for engaging students in inquiry. These can be found in sections such as "Using the Text," "Using the Art," and "Teaching Options." We believe that inquiry is enhanced when students collaborate with each other. Many teaching suggestions include activities in which students collaborate in pairs or in small or large groups.

# **Creating an Environment for Learning**

We know that teachers want their artrooms to be safe places—places where students feel comfortable sharing their ideas, concerns, fears, and dreams. Students need to know that they are respected as learners. They need to know that their ideas are valued, that what they have to say will be heard. They need to trust that they will not be put down by their peers. If students are to be comfort-

able raising and addressing questions, they need to know that they are free to voice their concerns and their ideas—that their opinions matter.

The learning environment must be a place where inquiry is encouraged and where curiosity is important. These aspects not only need to be valued, but they also need to be modeled. Teachers who want their students to ask and address questions must be willing to ask questions themselves. Learners are far more likely to engage authentically in inquiry when their teacher assumes the role of a fellow inquirer, someone who is curious and who shares with students that sense of wonder that is at the root of all learning.

The teacher's role is as a facilitator or "coach" in the learning process. Breaking away from the role of one who has most of the answers is not always easy. It means shifting away from the experience of our own schooling, where the teacher knew the answers and we saw the teacher as one who imparts truth. In many cases, it means being willing to admit to not having all the answers. This takes confidence, and it takes commitment to the belief that students learn best when they are addressing questions that stem from their own experiences.

## **Instructional Strategies**

In *Art and the Human Experience*, students are engaged in the fundamental activities of learning; along with artmaking, they are engaged in reading, listening, speaking, and writing. Suggested strategies aim toward helping students acquire, evaluate, organize, interpret, and communicate information. You will note that many suggested strategies involve helping students to learn to reach beyond resources in the school for information.

**Reading the Text** Students' interests and abilities in reading vary within and across classes. It is important to recognize that reading in art, like reading in other subjects, is a tool for learning and a means of communication. Students who are still learning to read may not be able to acquire information from the text rapidly. Even so, slow readers are often fascinated with art texts precisely because the written text is a supplement to the visual information.

Throughout the student text, captioned images, boldface headings and topically coherent page layouts have been used to aid students. Many captions also contain questions to guide perception and reflective thinking.

Preparation for Reading Always plan ahead and read each chapter before making any assignments. You might assign a full lesson or divide it into manageable and meaningful units. When you give a reading assignment within a new lesson, first have students preview the text. Have students scan the reading assignment to understand the main ideas in each part. They should look at the introduction, headings, subheadings and images. If review questions come at the end of the section, students can use them to help identify main points of the reading assignment.

Students should next **analyze** the text. A useful strategy to help students understand the purpose of a particular section is to have them turn a heading into a question. If the heading is, "Artists Show Us at Work and Play," recast it as the question, "How do artists show us at work and play?" The question helps readers search for supporting details in the text. As students carefully **read** the text, they can jot down and try to find answers to questions they have about the topic.

As they read, they can **evaluate** the material in the text, taking notes about main ideas. Show students how to take brief notes that are clear enough to understand when they return to them. The teacher's text has many suggestions for discussing the ideas presented in the student text.

**Review** is the final important step in the reading process. Students should review their notes to make sure they have highlighted the most important information. They may need to reread a section to clarify the main ideas. Help students make connections, asking them how the new information challenges, refutes, supports, or enlarges their understanding of the subject.

One way to help students make sense of what they have read is to have them create **graphic organizers**. The Teacher's Resource Binder (TRB) has blank concept maps and other organizers to assist students in this process. In completing a concept map, students can put the main idea in the center of the map and draw spokes to connect related ideas. Graphic organizers can be used to study or to take notes for discussions, art-making experiences, and written or oral work. The teacher's text periodically suggests that students create graphic organizers to help understand or explain the major ideas in a lesson

Class time devoted to reading can be reduced by assigning sections of chapters as homework, by assigning teams to read and report on sections, and by selective oral or silent reading within the text. Oral reading by students is most effective when it is preceded by silent reading. This gives students time to become familiar with the content and try out unfamiliar vocabulary.

Writing Assignments Written assignments can be an integral part of learning about art. Writing is a form of reflective thinking, and is especially helpful for developing vocabulary, practicing art criticism, and reflecting about artwork, and keeping a journal. Various assignments engage students in descriptive, persuasive, expository, narrative, and imaginative writing. Students can apply what they have learned in other subjects about preparing drafts, revising, and completing finished work. Throughout the program, they are encouraged to share their writing with peers.

Photo courtesy Betsy Logan, Samford Middle School, Auburn, Alabama.

Talking About Art Throughout the program, you will find suggestions for having students engage in discussions about specific artworks and issues related to art. At times, we suggest large group discussions in which the teacher functions as the facilitator. Eventually, students can assume the facilitator role, using the teacher as a model. Talking about art also takes place in small groups or in pairs of students. Students who are reluctant to contribute to large group discussions often will gain confidence by working in smaller groups. We can help students to hone their listening skills and their skills in providing cogent arguments for their positions. Through these discussions, students gain insights about their own thinking as well as that of their peers. These insights are important to their experiences in meaningful art making.

# **Assessment**

As we encourage students to acquire deep understanding of important concepts and skills associated with art, it is important to establish means for determining the extent to which students have developed such understandings. The objectives within Art and the Human Experience are aligned with national standards. The content of the student text and the instructional strategies in the teacher's edition are aligned with these standards and the lesson objectives. There are opportunities throughout the program to assess student learning. For example, each lesson is followed by a Check Your Understanding component, aimed at helping students identify the main ideas of the lesson. In addition, the Teaching Options within the teacher's edition contain suggestions for assessment. In some cases, the assessment strategies are designed so that the teacher reviews the work and determines the extent of learning on the part of the student. Such strategies are marked as "Teacher Assessment." Strategies are also designed for "Peer" or "Self" Assessment. In every case, criteria are embedded in the description of the assessment strategy.

We suggest that teachers discuss the learning objectives for each lesson with the students. Students and teachers can plan and negotiate activities that will pave the road to achievement. Inform students about what they are expected to know and be able to do as a result of their engagement. The road to achievement should be clearly marked so as to avoid the appearance of a guessing game or treasure hunt—a frustrating state of affairs for all involved.

The questions in each Chapter Review are based on the commonly used system for asking questions and developing tests, *The Taxonomy of Educational Objectives: Handbook I: Cognitive Domain* (White Plains, NY: Longman 1956, 1977). Higher-order thinking is used increasingly as students move through questions requiring them to recall important information, show that they understand key ideas, apply their understanding to new situations, analyze information, synthesize and communicate what they have learned, and make judgments based upon criteria. Negotiate which of the items students will complete in order to demonstrate their understanding.

Teaching suggestions and options provide opportunities to engage in Formative Assessment, judging the extent to which students understand key ideas and demonstrate important skills stated in the objectives. In addition, each chapter contains a Reteach component, with suggestions for reviewing major concepts and skills.

# **Meeting Individual Needs**

The lessons in *Art and the Human Experience* were designed with attention to the challenge that teachers face in adapting instruction to the needs of all learners. After defining and identifying students' areas of strength, teachers can adapt suggested strategies in the lessons to address the different ways in which their students best learn.

**Kinesthetic Learners** Some students learn best when actively engaged in hands-on approaches, body-movement activities, and other tactile experiences.

**Verbal Learners** Verbal or auditory learners seem to learn most readily through speaking and listening activities.

**Logical Learners** Some students seem to learn best when engaged in problem-solving or step-by-step explorations. Logical learners tend to seek quantitative results.

**Spatial Learners** Spatial learners tend to explore the world around them. They are visually oriented and learn best with pictures, three-dimensional props, and with activities that require them to translate verbal or written materials into visual terms.

**Musical Learners** Some students learn best when they have the opportunity to listen to or create rhythms. Such students tend to be musically inclined.

**Gifted and Talented Learners** Students who learn at an accelerated pace or show a particular talent need assignments that challenge their abilities. When working with these students, teachers can employ the strategies suggested for all of the learning styles above.

**ESL Learners** Students acquire English as a second language in successive stages, from nonverbal understanding to fluency. To aid these students, consider using picture clues, real-life scenarios, and peer work with English-speaking classmates. Students who are learning English as a second language may exhibit characteristics of any of the above learning styles.

# **Other Special Needs**

To the extent possible, introduce the regular curriculum to students with special needs.

**Visual impairments** These students can respond to discussions of artwork, especially themes related to the students' experiences and imagination. For studio work, create tactile, kinesthetic artwork out of materials such as clay, textured paper and cloth, small boxes or wood blocks to arrange.

**Speech and hearing impairments** Slow down the process of verbal communication, and use nonverbal means of communication. Have students point out what they see or encourage them to use pantomime to express their responses. Present information through diagrams, charts, and other visual aids. These nonverbal forms of communication are valuable for all students.

**Impaired mobility and medical problems** These students may require the use of alternate tools and materials for some activities. In most instances, rehabilitation specialists can help you solve unique problems. A number of special tools—such as scissors and a mouthpiece that holds a pencil or brush—are available for students who have physical impairments.

Photo courtesy Karen Miura, Kalakaua Middle School, Honolulu, Hawaii.

# Relating Other Subjects to Art

The subject of art is a distinct and important part of the total curriculum. Just as the study of art can enrich students' understanding of other subjects, so, too, can their studies of other subjects be linked to art. A few of these possibilities are outlined here.

# **Language Arts**

- **1.** Develop the art vocabulary of students.
- Write art terms and concepts on the chalkboard. Refer to them during the entire lesson.
- Develop lists of adjectives and adverbs to describe art elements and moods in artworks: Lines can seem lazy, energetic, or bold. (A useful resource is the set of Expressive Word Cards found in the Teacher's Resource Binder.)
- Ask for complete and complex descriptions: "I see a large, red square near the center of the painting."
- **2.** Encourage reflective inquiry into art.
- Engage students in analysis and comparison: "This large, simple form seems to balance this small, patterned form." "This drawing has many more details than that one."
- Develop skills in critical thinking. Ask for interpretations of visual evidence, explanations based on "visual facts." Hypothesize about what an artist wanted us to see, feel, and imagine.
- 3. Have students read about art.
- Encourage oral and written reports on favorite artworks and artists.
- Create original art based on poems or stories.
- Study the arts of book illustration, alphabet design, and calligraphy.

## **Social Studies**

- 1. Teach students about the role of art in everyday life.
- Acquaint students with places where they can see art in their community: parks, malls, and plazas; outstanding examples of architecture; and art museums and galleries.
- Study the useful products artists design, such as advertisements, illustrations in books and magazines, dinnerware, appliances, automobiles, and clothing.
- Introduce students to careers in art and to people in their communities whose primary work centers on art and design.
- **2.** Teach students about the rich heritage of art, past and present.
- Stress the process of looking at art and reasons people around the world create art. Appreciation of varieties of art is more important than names, dates, and technical information.
- Make students aware of the accomplishments of men and women and specific cultural groups.

# Science, Mathematics, and Technology

- **1.** Teach students how artists interpret the natural world and use scientific knowledge.
- Emphasize the importance of careful observation in art and in science, identifying things by their shape, size, texture, color, weight, and so on.
- Explore the many ways artists have expressed their ideas and feelings about the natural world—changing seasons, weather, the beauty of forms in nature, etc.
- Have students create original artwork based on their observations of the subtle colors, textures, patterns, and movement of natural forms, plants, animals, and clouds.
- **2.** Teach students how skills in mathematics and computer technologies apply to art.
- Emphasize how artists use their knowledge of measurement and geometric shapes and forms in designing architecture, in planning beautifully proportioned vases, and in many other aspects of art.
- Demonstrate the many uses of computers in creating art and in research on art.

### Other Arts

A complete education in the arts will include studies of the visual arts along with the language arts (written and oral expression) and performing arts (music, dance, and theater). Each art form provides a unique avenue for sharing ideas and feelings with others.

- 1. Teach concepts that apply to all the arts.
- In each art form, there are creative originators of ideas—composers of music, choreographers of dance, playwrights, poets, and authors.
- All artists explore and master their chosen media. Artists transform sounds into music, movements into dance, interactions of people into theater, qualities of paint into images, and words into meaningful poems and stories.
- Every art form has compositions, designs, or arrangements that are unique to its medium. This explains why each artwork and each art form is unlike others.
- 2. Illustrate relationships among the arts.
- Note how terms from music are sometimes used to describe things we see: "loud" colors, "rhythmic" patterns of shapes, and "harmonious" designs.
- Relate the qualities of movement in dance to actual or implied movement in visual art: A line may seem to "twist and turn" in space, as if it is "dancing."
- Have students create masks, puppets, and plays. Discuss the visual qualities of these elements, including stage scenery, makeup and costumes, as important facets of the art of theater.
- Help students appreciate how television, video, and film, major art forms of our time, uniquely combine other art forms: music, choreography, etc.

Photo courtesy Bunki Kramer, Los Cerros Middle School, Danville, California.

# Building Support for the Art Program

It is important to have support for your program. Educate teachers, administrators, counselors, parents, and community groups about your program. Prepare information on how they can assist your efforts. Organize a parent or business group to give special support by volunteering—arranging field trips, collecting recyclable materials, or sponsoring special events.

Develop a teacher-student art newsletter or Web page. It might include samples of artworks, aesthetic observations, special requests for the art program, invitations to see exhibits, and the like.

Develop a plan and timetable for student involvement in exhibitions within and beyond the school. Delegate some of the responsibilities to students. For example, rotate student work in main offices, the teacher's lounge, and halls. Always include captioned descriptions of the art concepts or student descriptions of the ideas and processes.

There are several periods during which you may plan special exhibits and related activities to focus attention on the art program. In the United States, for example, March has been designated Youth Art Month by the National Art Education Association. At this time, teachers in all schools are urged to make parents and the community aware of the enthusiasm young people have for art and the ways they are engaging in creating and studying art. In addition, many teachers in North America have special exhibitions near the end of the year, when students are best able to demonstrate what they have learned.

Develop skills in preparing press releases and contacting the news media, so that exceptionally newsworthy or timely activities can be reported to the community.

Participate in art education and art associations. They are the most valuable paths to professional growth, renewal, and awareness of developments that might help you in your work.

Find out about artists-in-education programs available in your community. Art supervisors and arts councils can provide information. Find out about the educational programs offered by art museums and what is required of you and your students to take advantage of them.

# **Maintaining the Artroom**

# Safety

Concerns about safety make it essential for you and your students to be particularly aware of hazardous art materials or processes. Safety glasses, dust masks or

respirators, and rubber gloves are among the most common items you should have on hand.

Throughout *Art and the Human Experience*, Safety Notes are highlighted. However, the responsibility for safety in your artroom rests first and foremost with you. Review all safety procedures required for an art activity with students. Before you allow them to begin, make sure all students understand safety precautions and the reasons for them. Written safety rules with tests and active demonstrations of understanding are especially important prior to beginning any activity that involves chemicals, fumes, dust, heat, cutting tools, or electricity.

Art programs utilize all kinds of specialized equipment, materials and tools. Precautions must be taken to insure that working with art materials does not lead to student illness or injury. Failure to take necessary precautions may result in litigation if students become ill or are injured in the artroom. While restrictions are necessary, the teacher should be assured that nontoxic materials can usually be substituted for toxic ones with little or no extra cost, and good artroom management will prevent accidents.

Under the art material labeling law passed by Congress in October, 1988, every manufacturer, distributor, retailer and some purchasers (schools) have a legal responsibility to comply with this law. The law amended the Federal Hazardous Substances Act to require art and craft materials manufacturers to evaluate their products for their ability to cause chronic illness and to place labels on those that do.

The Art & Creative Materials Institute, Inc. (ACMI) has sponsored a certification program for art materials, certifying that CP and AP labeled products are nontoxic and meet standards of quality and performance. ACMI recently began the launch of its two new seals (the new AP and the CL seals shown here) to replace the current six seals (the former AP and CP seals with and without the word "Non-toxic" and the two versions of the HL seal).

CP (Certified Product art nontoxic, even if ingested, inhaled, or absorbed, and meet or exceed specific quality standards of material, workmanship, working qualities, and color. AP (Approved Products) are nontoxic, even if ingested, inhaled, or absorbed.

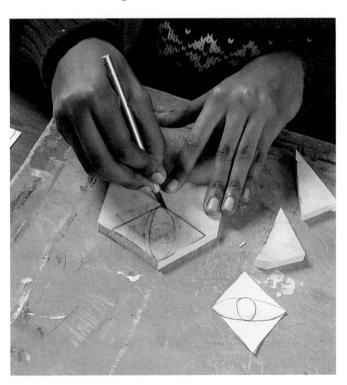

Photo courtesy Sara Grove Macauley and Sharon Gorberg, Winsor School, Boston, Massachusetts.

Some nontoxic products bear the HL (Health Label) seal with the wording, "Nontoxic," "No Health Labeling Required." Products requiring cautions bear the HL label with appropriate cautionary and safe use instructions.

Teachers should check with their school administrators to determine if the state board of education has prepared a document concerning art and craft materials that cannot be used in the artroom, and listed products that may be used in all grade levels. If no list is locally available, contact The Art and Craft Materials Institute, Inc., 1280 Main St., 2nd floor, P.O. Box 479, Hanson, MA, 02134 (781) 293-4100 www.acminet.org for a list of art products bearing the CP, AP, or HL/Nontoxic Seal.

In addition to determining that only nontoxic media are available in the classroom, the teacher is responsible for instruction in how to use all tools and equipment correctly and safely.

Make sure that the artroom has accident-preventing items such as the following:

- Signs on or near all work areas and equipment where injury might occur if students are careless, or should have instruction prior to use of the equipment.
- Protective equipment such as safety glasses, respiratory masks and gloves.
- A first aid kit containing antiseptics, bandages and compresses.
- Adequate ventilation to exhaust fumes.
- Safety storage cabinets and safety cans for flammable liquids. It is preferable not to keep them in the classroom.
- Self-closing waste cans for saturated rags.
- Soap and water wash-up facilities.
- Lock cabinets for hazardous tools and equipment.
- Rules posted beside all machines.

Precautions the teacher may take:

- Always demonstrate the use of hand and power tools and machines.
- During demonstrations, caution students concerning any potential hazards related to incorrect use of equipment
- Give safety tests before permitting students to use tools and machines, and keep the tests on file.
- Establish a safety zone around all hazardous equipment.
- Establish a dress code for safety indicating rules about clothing, jewelry and hair in order to prevent accidents.
- Establish a code of behavior conducive to the safety of individuals and their classmates, and enforce it.

- · Keep aisles and exits clear.
- Be aware of any special problems among students such as allergy, epilepsy, fainting or handicap.

Some "Do Nots" for the Safety Conscious Art Teacher:

- Do not absent yourself from the studio when pupils are present.
- Do not ignore irresponsible behavior and immature actions in the artroom.
- Do not make the use of all tools and machines compulsory.
- Do not permit students to work in the artroom without supervision.
- Do not permit pupils that you believe to be accident prone to use power equipment. Check on the eligibility of some mainstreamed students to use power tools.

Teachers should demonstrate constant concern for safety in the artroom, and teach by example to help students accept responsibility for accident prevention. For a thorough discussion of health and safety hazards associated with specific media and procedures see *Safety in the Artroom* by Charles Qualley, 1986.

# **Finding and Organizing Resources**

Most teachers realize that the environment of the artroom should announce its purpose and be pleasing and functional. The following ideas may help achieve these goals.

**Room-Organizing Resources** Save sections of newspapers with colored advertising, and unusual black-and-white photographs of people, places, and events. Picture-dominated magazines that can be cut up will be useful for a variety of activities. Old newspapers should be available in quantity for covering tables or other uses. Save and develop a file of all news and magazine articles related to art.

Color-code storage bins and boxes. Cover the boxes with contact paper or paint them (with interior house paint) so they reflect definite color schemes.

Reserve space in the room for display of student work, art reproductions, and related teaching aids. If you want to feature biographies and works by selected artists on a regular basis, develop a weekly or monthly plan that provides for balance among art forms, and among men, women, and art from various cultures.

**Visual Resources** Images are essential for teaching about the world of art. A few of the most common types of resources are described below.

**Collections of everyday objects.** Use ordinary objects to help students understand basic art concepts. Reserve an area for display of still-life items. Stacked wood or plastic crates can double as shelves for the items. Move

Photo courtesy Sara Grove Macauley and Sharon Gorberg, Winsor School, Boston, Massachusetts.

and rearrange the crates and items within them. Living or dried plants, shells, pinecones, and other intriguing natural forms are valuable resources for drawing, design, and other activities.

**Field trips to see original art.** Plan carefully for trips to art museums and artists' studios as well as tours to study architecture, murals, public sculpture, and the like. To enhance the educational value of such trips, plan several lessons that focus on the purpose of the trip and what students should notice during it. Always follow district rules and procedures for trips beyond school grounds.

Many art museums have special programs for schools. Some programs offer an orientation to the museum so students are well-prepared for their first visit. Other programs introduce students to the process of looking at artworks and acquaint students with the differences between original works and reproductions.

**Visiting experts on art.** You may also invite local artists, craftsworkers, designers, and architects to school for special demonstrations. Arrangements for this should be made with your art supervisor or state or local arts council. Always interview guests in advance to assess their qualifications and ability to present ideas related to your educational goals.

**Reproductions of artwork.** Photographic reproductions of works of art are available in different sizes. Although they are not a substitute for seeing original works of art, every teacher should have access to a library of art prints. Larger prints can be displayed to make part of the room resemble an art museum. Intermediate sizes are excellent for study at a table or desk. Use smaller postcard prints for matching and sorting games.

**Art resource books for students.** Your library or resource center should routinely order art books for students. (See the bibliography in the student text, page 309, for ideas.) Students should also be introduced to the artistry of book design and illustration.

#### **Publisher's Acknowledgments**

Publisher: Wyatt Wade

Editorial Directors: Helen Ronan, Claire Mowbray

Golding

**Editorial/Production Team:** Nancy Bedau, Nancy Burnett, Karl Cole, Carol Harley, Matt Mayerchak, Victoria Hughes Waters, Kaye Passmore, Glen Schultzberg, Mary Ellen Wilson

Editorial Assistance: Jane Reed, Lynn Simon

**Illustration:** Susan Christy-Pallo, Stephen Schudlich **Design:** Douglass Scott, Cara Joslin, WGBH Design

**Manufacturing:** Georgiana Rock

# **Teacher Bibliography**

### **Teaching and Learning**

- Alger, Sandra L.H. *Games for Teaching Art*. Portland, ME: J. Weston Walch, 1995.
- Barton, James and Angelo Collins. *Portfolio Assessment*. Reading, MA: Addison-Wesley, 1996.
- Beattie, Donna Kay. Assessment in Art Education. Worcester, MA: Davis Publications, 1997.
- Comstock, Charles W. Jr. *How to Organize and Manage Your Art Room.* Portland, ME: J. Weston Walch, 1995.
- Cook, Ande. *Art Starters*. Worcester, MA: Davis Publications, 1994.
- Ervin, Barbara Mickelsen. *Making Connections: Interdisciplinary Art Activities for Middle School.* Portland, ME: J. Weston Walch, 1998.
- Greer, W. Dwaine. *Art as a Basic: The Reformation in Art Education*. Bloomington, IN: Phi Delta Kappa, 1997.
- Greh, Deborah. New Technologies in the Artroom. Worcester, MA: Davis Publications, 1999.
- Hume, Helen D. Art History & Appreciation Activities Kit. Paramus, NJ: Prentice Hall, 1992.
- Hume, Helen D. A Survival Kit for the Secondary School Art Teacher. Paramus, NJ: Prentice Hall, 1990.
- Hume, Helen D. *The Art Teacher's Book of Lists*. Paramus, NJ: Prentice Hall, 1998.
- Lazear, David. *Multiple Approaches to Assessment*. Tucson, AZ: Zephyr Press, 1998.
- Levi, Albert William and Ralph A. Smith. *Art Education: A Critical Necessity.* Chicago, IL: University of Illinois Press, 1991.
- Qualley, Charles. A. *Safety in the Artroom*. Worcester, MA: Davis Publications, 1986.
- Thompson, Kimberly and Diana Loftus. *Art Connections: Integrating Art Throughout the Curriculum.* Reading, MA: Addison-Wesley, 1994.
- Walkup, Nancy Reynolds. *Art Lessons for the Middle School: A DBAE Curriculum*. Portland, ME: J. Weston Walch, 1992.
- Watson, George. Teacher Smart: 125 Tested Techniques for Classroom Management & Control. Paramus, NJ: Prentice-Hall, 1996.

#### **Aesthetics**

- Dissanayake, Ellen. *What is Art For?* Seattle, WA: University of Washington Press, 1988.
- Parsons, Michael J. and H. *Gene Blocker.* Aesthetics and Education. Chicago, IL: University of Illinois Press, 1993.
- Parsons, Michael J. *How We Understand Art.* NY: Cambridge University Press, 1987.
- Stewart, Marilyn. *Thinking Through Aesthetics*. Worcester, MA: Davis Publications, 1997.

### **Art Criticism**

- Artchart Poster Series: Elements and Principles of Design Posters. Glenview, IL: Crystal Productions.
- Barrett, Terry. *Talking About Student Art*. Worcester, MA: Davis Publications, 1997.
- Barrett, Terry. Criticizing Art. Understanding the Contemporary. Mountain View, CA: Mayfield Publishing Co., 1994.
- Hobbs, Jack and Richard Salome. *The Visual Experience*. Worcester, MA: Davis Publications, 1995.
- Wolff, Theodore F. and George Geahigan. *Art Criticism and Education*. Chicago, IL: University of Illinois Press, 1997.

### **Art History**

#### General

- Addiss, Stephen and Mary Erickson. *Art History and Education*. Chicago, IL: University of Illinois Press, 1993.
- Art: A World History. NY: DK Publishing, 1997.
- Artchart Poster Series: Know the Artist Posters: Sets 1 and 2. Glenview, IL: Crystal Productions.
- Brommer, Gerald F. *Discovering Art History.* Worcester, MA: Davis Publications, 1997.
- Cerrito, Joan, ed. *Contemporary Artists*. Detroit, MI: St. James Press, 1996.
- Chilvers, Ian, Harold Osborne and Dennis Farr. *The Oxford Dictionary of Art.* NY: Oxford University Press, 1994.
- Cumming, Robert. *Annotated Guides: Great Artists.* NY: DK Publishing, 1998.
- Chronicle Encyclopedia of History. DK Publishing. (CD-ROM)
- Chronicle of the 20th Century. DK Publishing. (CD-ROM) Eyewitness History of the World 2.0. DK Publishing. (CD-ROM)
- Janson, H.W. *History of Art.* NY: Harry N. Abrams, Inc., 1995.
- Sister Wendy Beckett. *Sister Wendy's 1000 Masterpieces*. NY: DK Publishing, 1999.
- Sister Wendy Beckett. Sister Wendy's Story of Painting. NY: DK Publishing, 1997.
- Stokstad, Marilyn. *Art History*. NY: Harry N. Abrams, Inc., 1995.
- Strickland, Carol and John Boswell. *The Annotated Mona Lisa: A Crash Course in Art History from Prehistoric to Post-modern*. Kansas City, MO: Universal Press Syndicate Co., 1992.

#### **Time Lines**

- Bridges, Barbara and Peter Furst. *Arts of Mexico Timeline*. Tucson, AZ: Crizmac.
- Mackey, Maureen. *Ceramic Innovations: Global Art Timeline*. Worcester, MA: Davis Publications, 1997.
- Millard, Anne. *A Street Through Time*. NY: DK Publishing.
- Millennium Timeline Sticker Book. NY: DK Publishing, 1999.
- Scarre, Chris. Smithsonian Timelines of the Ancient World. NY: DK Publishing, 1993.
- Time Line of Culture in the Nile Valley and its Relationship to Other World Cultures. NY: Metropolitan Museum of Art, 1979.

#### **Ancient World**

- Arnold, Dorothea. *An Egyptian Bestiary*. Metropolitan Museum of Art, 1995.
- Burenhult, Goran, ed. *The First Humans*. San Francisco: Harper San Francisco, 1993.
- Celenko, Theodore, ed. *Egypt in Africa*. Indianapolis Museum of Art, 1996.
- Chauvet, Jean-Marie, Eliette Brunel Deschamps, and Christian Hillaire. *Dawn of Art: The Chauvet Cave: The Oldest Known Paintings in the World.* NY: Harry N. Abrams, Inc., 1994.
- Clottes, Jean and Jean Courtin. *The Cave Beneath the Sea:* Paleolithic Images at Cosquer. NY: Harry N. Abrams, Inc., 1991.
- Haynes, Joyce L. *Nubia: Ancient Kingdom of Africa*. Boston: Museum of Fine Arts, 1992.
- O'Halloran, Kate. *Hands-on Culture of Ancient Egypt.* Portland, ME: J. Weston Walch, 1997.
- Reeves, Nicholas. *The Complete Tutankhamun*. NY: Thames and Hudson, 1995.
- Rhodes, Toni. Wonders of World Cultures: Exploring Near & Middle East. Portland, ME: J. Weston Walch, 1999.
- Sandison, David. *The Art of Ancient Egypt.* San Diego, CA: Laurel Glen Publishing, 1997.
- Taylor, Tim & Mick Aston. *The Atlas of Archaeology*. NY: DK Publishing, 1998.

### **Classical World**

- Boardman, John. *Greek Art*. NY: Thames and Hudson, 1996.
- Boardman, John. *Greek Sculpture*. NY: Thames & Hudson, 1985.
- Boardman, John, Ed. *The Oxford Illustrated History of Classical Art*. NY: Oxford University Press, 1993.
- Moatti, Claude. *In Search of Ancient Rome*. NY: Harry N. Abrams, Inc., 1993.
- O'Halloran, Kate. *Hands-on Culture of Ancient Greece & Rome*. Portland, ME: J. Weston Walch, 1998.
- Philip, Neil. Myths & Legends. NY: DK Publishing, 1999.
- Ramage, Nancy H. and Andrew. Roman Art: Romulus to Constantine. NY: Harry N. Abrams, Inc., 1991.
- Wheeler, Mortimer. *Roman Art and Architecture*. NY: Thames and Hudson, 1985.

### The Middle Ages

- Biedermann, Hans. *Dictionary of Symbolism*. NY: Facts On File, 1998.
- Favier, Jean. *The World of Chartres*. NY: Harry N. Abrams, Inc., 1990.
- Ferguson, George. *Signs and Symbols in Christian Art.* NY: Oxford University Press, 1972.
- Korn, Irene. *A Celebration of Judaism in Art.* NY: Todtri, 1996.
- Treasures of the Holy Land: Ancient Art from the Israel Museum. NY: Metropolitan Museum of Art. 1986.

#### Renaissance

- Labella, Vincenzo. *A Season of Giants*. Boston, MA: Little, Brown, 1990.
- Vasari, Giorgio. *The Lives of the Artists*. NY: Oxford University Press, 1991.

### Impressionism & Post Impressionism

- Adriani, Gotz. Cezanne: Paintings. NY: Harry N. Abrams, Inc., 1995.
- Bade, Patrick. *Degas: The Masterworks*. NY: Portland House, 1991.
- Barnes, Rachel, ed. *Degas by Degas*. NY: Alfred A. Knopf, 1990.
- Barnes, Rachel, ed. *Monet by Monet*. NY: Alfred A. Knopf, 1990.
- Cachin, Francoise, et al. *Cezanne*. Philadelphia, PA: Philadelphia Museum of Art, 1996.
- Effeny, Alison. *Cassatt: The Masterworks*. NY: Portland House, 1991.
- Feaver, William. Van Gogh. NY: Portland House, 1990.
- Forge, Andrew. Monet. NY: Harry N. Abrams, Inc., 1995.
- Freches-Thory, Claire, et al. *Toulouse-Lautrec*. New Haven, CT: Yale University Press, 1992.
- Herbert, Robert L., et. al. *Georges Seurat*. NY: Metropolitan Museum of Art, 1991.
- Loyette, Henri. *Degas: The Man and His Art.* NY: Harry N. Abrams, Inc., 1995.
- Mathews, Nancy Mowll. *Mary Cassatt: A Life*. New Haven: Yale University Press, 1998.
- Sutton, Denys. *Degas*: His Life and Work. NY: Abbeville Press, 1991.
- Tucker, Paul Hayes. *Claude Monet: Life and Art.* New Haven, CT: Yale University Press, 1995.
- Witzling, Mara R. Mary Cassatt: A Private World. NY: Universe, 1991.
- Zemel, Carol. Vincent Van Gogh. NY: Rizzoli, 1993.

### 20th Century

- Christo & Jeanne-Claude, Wrapped Reichstag, Berlin, 1971–1995. Benedikt Taschen, Cologne, Germany, 1995.
- Elderfield, John. *Henri Matisse: A Retrospective*. NY: Museum of Modern Art, 1992.
- Eldredge, Charles C. *Georgia O'Keeffe: American and Modern*. New Haven, CT: Yale University Press, 1993.
- Herrera, Hayden. *Matisse: A Portrait*. NY: Harcourt Brace, 1993.

Kordich, Diane. *Images of Commitment: 20th Century Women Artists.* Tucson, AZ: Crizmac, 1994.

Paul, Stella. Twentieth Century Art: A Resource for Educators. NY: Metropolitan Museum of Art, 1999.

Phillips, Lisa. *The American Century, Art & Culture*, 1950–2000. Whitney Museum of American Art, New York and W. W. Norton, New York, 1999.

#### **Popular Culture**

Ash, Russell. Factastic Millennium Facts. NY: DK Publishing, 1999.

Hamilton, Jake. *Special Effects in Film and Television*. NY: DK Publishing, 1998.

Karney, Robyn. *Chronicle of the Cinema*. NY: DK Publishing, 1997.

1000 Makers of the Millennium. NY: DK Publishing, 1999.

Thorgerson, Storm and Aubrey Powell. 100 Best Album Covers. NY: DK Publishing, 1999.

#### Art in the United States, Multicultural

Albany Institute of History and Art. *The Natural Palette: The Hudson River Artists and the Land.* Tucson, AZ: Crizmac, 1997.

Hispanic Folk Art and the Environment: A New Mexican Perspective.

National Museum of American Art. *African American Artists: Affirmation Today.* Glenview, IL: Crystal Productions, 1994.

National Museum of American Art. *Latino Art & Culture in the United States*. Glenview, IL: Crystal Productions, 1996.

National Museum of American Art. Land & Landscape: Views of America's History and Culture. Glenview, IL: Crystal Productions, 1997.

National Museum of American Art. *Public Sculpture: America's Legacy.* Glenview, IL: Crystal Productions, 1994.

#### **Native American**

America's Fascinating Indian Heritage. Pleasantville, NY: Reader's Digest Association, Inc., 1990.

Feder, Norman. *American Indian Art*. NY: Harry N. Abrams, Inc., 1995.

Hill, Tom and Richard W. Hill Sr., eds. *Creation's Journey*. Washington DC: Smithsonian Institution Press, 1994.

Jacka, Lois Essary. *Enduring Traditions: Art of the Navajo.* Flagstaff, AZ: Northland Publishing, 1994.

Jonaitis, Aldona. *From the Land of the Totem Poles*. Seattle, WA: University of Washington Press, 1991.

Penney, David W. and George C. Longfish. *Native American Art*. Southport, CT: Hugh Lauter Levin Associates, 1994.

Rosenak, Churck and Jan. *The People Speak: Navajo Folk Art.* Flagstaff, AZ: Northland Publishing, 1994.

Stewart, Hilary. *Totem Poles*. Seattle, WA: University of Washington Press, 1993.

## Art of Global Cultures General

Bowker, John. World Religions. NY: DK Publishing, 1997.

Chalmers, F. Graeme. *Celebrating Pluralism: Art*, *Education, and Cultural Diversity.* Los Angeles, CA: The Getty Education Institute for the Arts, 1996.

Mack, Stevie and Deborah Christine. *Tribal Design*. Tucson, AZ: Crizmac, 1988.

Museum of International Folk Art. Recycled, Re-Seen: Folk Art From the Global Scrap Heap. NY: Harry N. Abrams, Inc., 1996.

World Reference Atlas. NY: DK Publishing, 1998. Eyewitness World Atlas. DK Publishing (CD-ROM)

#### **Africa**

Courtney-Clarke, Margaret. African Canvas: The Art of West African Women. NY: Rizzoli, 1990.

National Museum of African Art. *The Art of West African Kingdoms*. Washington, DC: Smithsonian Institution Press, 1987.

O'Halloran, Kate. *Hands-on Culture of West Africa*. Portland, ME: J. Weston Walch, 1997.

Rhodes, Toni. Wonders of World Cultures: Exploring Africa. Portland, ME: J. Weston Walch, 1999.

Robbins, Warren M. and Nancy Ingram Nooter. *African Art in American Collections*. Washington, DC: Smithsonian Institution Press, 1989.

#### Mexico, MesoAmerica, Latin American

Herrera, Hayden. *Frida Kahlo*. NY: Harper Collins, 1991. Lowe, Sarah M. *The Diary of Frida Kahlo*. NY: Harry N. Abrams, Inc., 1995.

Poupeye, Veerle. *Caribbean Art.* NY: Thames and Hudson, 1998.

Mack, Stevie. *Gente del Sol.* Tucson, AZ: Crizmac, 1991. Mack, Stevie, Amy Scott Metcalfe with Nancy Walkup. *Days of the Dead.* Tucson, AZ: Crizmac, 1999.

Mack, Stevie and Jennifer Fiore. *Oaxaca*, *Valley of Myth and Magic*. Tucson, AZ: Crizmac, 1995.

Mack, Stevie and Jennifer Fiore. World Beneath a Canopy: Life and Art in the Amazon. Tucson, AZ: Crizmac, 1997.

Miller, Mary Ellen. *The Art of MesoAmerica*. NY: Thames and Hudson, 1996.

O'Halloran, Kate. *Hands-on Culture of Mexico and Central America*. Portland, ME: J. Weston Walch, 1998.

Poupeye, Veerle. *Caribbean Art*. NY: Thames and Hudson, 1998.

Rochfort, Desmond. *Mexican Muralists: Orozco, Rivera, Siqueiros*. NY: Universe Publishing, 1994.

Stebich, Ute. A Haitian Celebration: Art and Culture. Milwaukee, WI: Milwaukee Art Museum, 1992.

Walkup, Nancy and Judy Godfrey. *Haitian Visions*. Tucson, AZ: Crizmac, 1994.

Walkup, Nancy and Sharon Warwick. *Milagros: Symbols of Hope*. Tucson, AZ: Crizmac, 1996.

#### Asia

- Baker, Joan Stanley. *Japanese Art*. NY: Thames and Hudson, 1984.
- Berinstain, Valerie. *Discoveries: India and the Mughal Dynasty*. NY: Harry Abrams, 1998.
- Cooper, Rhonda and Jeffery. *Masterpieces of Chinese Art.* London: Tiger Books International, 1997.
- Craven, Roy C. *Indian Art*. NY: Thames and Hudson, 1997.
- Fong, Wen C. and James C.Y. Watt. Possessing the Past: Treasures from the National Palace Museum, Taipei. NY: Harry N. Abrams, Inc., 1996.
- Kerry, Rose, ed. Chinese Art and Design: Art Objects in Ritual and Daily Life. NY: Viking, 1992.
- O'Halloran, Kate. *Hands-on Culture of Japan*. Portland, ME: J. Weston Walch, 1997.
- O'Halloran, Kate. Hands-on Culture of Southeast Asia. Portland, ME: J. Weston Walch, 1998.
- Pearlstein, Elinor L. and James T. Ulak. *Asian Art in The Art Institute of Chicago*. Chicago, IL: The Art Institute of Chicago, 1993.
- Rawson, Jessica, Ann Farrer, Jane Portal, Shelagh Vainker, and Carol Michaelson. *The British Museum Book of Chinese Art*. NY: Thames and Hudson, 1993.
- Rhodes, Toni. Wonders of World Cultures: Exploring Asia & The Pacific Rim. Portland, ME: J. Weston Walch, 1999.
- Zephir, Thierry. Khmer: The Last Empire of Cambodia. NY: Harry Abrams, 1998.

#### **Pacific**

- Nordin, Julee and Pat Johnson. *Australian Dreamings*. Tucson, AZ: Crizmac, 1996.
- Pacific Resources for Education and Learning. Island Worlds: Art and Culture in the Pacific. Tucson, AZ: Crizmac, 1999.

#### **Art Studio**

- Artchart Poster Series: Drawing Posters. Glenview, IL: Crystal Productions.
- Artchart Poster Series: Watercolor Posters. Glenview, IL: Crystal Productions.
- Artchart Poster Series: Ceramics Posters. Glenview, IL: Crystal Productions.
- Brown, Maurice and Diana Korzenik. *Art Making and Education*. Chicago, IL: University of Illinois Press, 1993.
- McKim, Robert. *Thinking Visually*. Palo Alto, CA: Dale Seymour Publications, 1997.
- Roukes, Nicholas. *Art Synectics*. Worcester, MA: Davis Publications, 1982.

# **Internet Resources**

#### **American Museum of Natural History**

www.amnh.org/

Use this site to inspire students about the natural world, or check out art-related special features.

#### **Artonline: Printmaking Techniques**

www.nwu.edu/museum/artonline/resources/prints.html Printmaking processes are explained on this site.

#### **Art Learner Guides**

http://schools.brunnet.net/crsp/general/art/ Developed for secondary students, these extensive PDF files are available on a wide variety of media and techniques.

#### **ArtLex Visual Arts Dictionary**

www.artlex.com/

This online dictionary provides definitions of more than 3,100 art terms, along with numerous illustrations, pronunciation notes, artist quotations, and links to other resources on the Web.

#### **ArtsEdNet**

www.artsednet.getty.edu

Developed by the Getty Education Institute for the Arts, this site offers a wealth of information on art and artists, an image bank, suggested activities, and more.

#### Asian Art Museum of San Francisco

www.asianart.org/

The Asian Art Museum is one of the largest museums in the Western world devoted exclusively to Asian art. The museum is a public institution whose mission is to lead a diverse global audience in discovering the unique material, aesthetic, and intellectual achievements of Asian art and culture.

#### **Barbara Kruger**

www.artcyclopedia.com/artistss/kruger\_barbara.html Learn more about the artist from artcyclopedia's online guide.

#### **Canadian Museum of Civilization**

www.civilization.ca/cmc/cmceng/welcmeng.html Take a virtual tour of the halls; investigate diverse works of art from Japanese kimonos to African ritual figurines.

#### **Chaco Culture National Historical Park**

www.nps.gov/chcu/

Learn about the architecture and pottery of Chaco Canyon, a major Pueblo cultural center A.D. 850–1250.

#### **Color Theory**

www.presscolor.com/library/ctindex.html Learn more about the physics of color theory and concepts of light.

#### Cooper-Hewitt, National Design Museum

www.si.edu/ndm/

The Museum's collection encompasses graphic design, applied arts and industrial design, architecture, urban planning, and environmental design.

#### Dia Center for the Arts

www.diacenter.org/

Check out artists' Web projects, environmental art, earthworks, and installations, along with contemporary works using more traditional art forms.

#### **Diane Stanley**

www.dianestanley.com

Visit the author's Website and view paintings from her books.

#### Diego Rivera Virtual Museum

www.diegorivera.com/diego\_home\_eng.html Available in both Spanish and English versions, this extensive site highlights the artwork and life of the celebrated Mexican muralist Diego Rivera.

#### **Drawing Grids and Tile Floors in Perspective**

pc38.ve.weber.k12.ut.us/art/ChalkBoard/lp-grids.htm Diagrams and text explain linear and atmospheric perspective, shading, and composition.

#### **Drawing in One-Point Perspective**

www.olejarz.com/arted/perspective/ A step-by-step guide with interactive features and explanatory text.

#### **Exploring Leonardo**

www.mos.org/sln/Leonardo/LeoHomePage.html Visit this extensive site to discover more about Leonardo da Vinci's futuristic inventions and use of perspective. Lesson ideas are also to be found here.

#### **Getty Museum**

www.getty.edu/museum/

Take an architecture tour of the Getty Center, investigate the museum's collections and history, and more.

#### **Glenbow Museum**

www.glenbow.org/home.htm

Located in Calgary, Alberta, the Glenbow showcases Canada's Native and Inuit art in their online Art Gallery.

#### Guggenheim Museum, Bilbao

www.guggenheim-bilbao.es/idioma.htm Investigate the museum's breathtaking architecture, its exhibitions and permanent collection.

#### Hayward Gallery on the South Bank, London

www.hayward-gallery.org.uk/

Visit this contemporary arts center that contains the largest and most versatile temporary exhibition space in London.

#### **Heard Museum**

www.heard.org/education/resource/index.html Use the museum's online guide, Native American Fine Art Movement: A Resource Guide for Teachers, to learn about the art (painting and sculpture) produced by native Americans since 1900. The guide explores such topics as narrative painting, Southwest painting, and the San Ildefonso watercolor school.

#### Hints and Tips from Grumbacher

www.sanfordcorp.com/grumbacher/hints\_and\_tips\_from \_grumbacher.htm

Advice on using watercolor, oil, and acrylic paints.

#### Hung Liu

www.unc.edu/depts/ackland/hung-Liu.htm Read about the artist and see some of her works that were featured in the touring exhibit Hung Liu: A Ten-Year Survey 1988–1998.

#### Jacob Lawrence Catalogue Raisonné Project

www.jacoblawrence.org/

This online archive and education center provides images and documentation of the entire body of Lawrence's work.

#### Japan Ukiyo-e Museum

www.cjn.or.jp/ukiyo-e/index.html Compare works by Hokusai and Hiroshige, plus see other works of ukiyo-e artists, at this museum.

#### Jaune Quick-To-See Smith

www.nmwa.org/legacy/bios/bjqsmith.htm Learn more about this renowned Native American artist on her biographical page at the National Museum of Women in the Arts.

#### Jenny Holzer

http://adaweb.walkerart.org/

Enter the artist's elegant and constantly changing interactive Web project.

#### Louvre Museum Paris, France

http://mistral.culture.fr/louvre/louvrea.htm In a virtual tour of one of the most famous museums in the world, you will find a broad spectrum of subjects, styles, and themes of art, including the *Mona Lisa*.

#### Modern Art Museum of Fort Worth

www.mamfw.org/menu.htm

Search the collections and view the special exhibitions that focus on modern and contemporary art.

#### MuralArt.com

www.MuralArt.com/

This site features murals in various categories, including a mural of the month.

## Museum of Indian Arts and Culture Laboratory of Anthropology

www.miaclab.org

Extensive information about the Museum's collections of Indian pottery, paintings, textiles and clothing, basketry, and jewelry, and archeology is presented here.

#### **Museum of Modern Art**

www.moma.org/

The Museum of Modern Art in New York City houses the world's first curatorial department devoted to architecture and design, established in 1932. The design collection contains more than 3,000 everyday objects that are both functional and well-designed, including furniture, tableware, tools, sports cars, and even a helicopter.

#### **National Gallery of Canada**

http://national.gallery.ca/ Search the exhibitions and collections; experience CyberMuse.

#### National Museum of African Art

www.si.edu/organiza/museums/africart/nmafa.htm Experience online tours of current exhibitions as well as the permanent collection.

#### **National Museum of American Art**

www.nmaa.si.edu/

The NMAA in Washington, D.C. is home to American paintings, sculptures, graphics, folk art, and photographs from the eighteenth century to the present. Browse the online collection of more than 3,000 digitized images classified by subject and artist.

#### National Museum of the American Indian

www.si.edu/nmai/

Explore the Smithsonian's National Museum of the American Indian online. See artifacts and find links to other Native American Web sites.

#### National Museum of Natural History

www.mnh.si.edu/

The seven scientific departments of the National Museum of Natural History offer comprehensive collections and research information online.

#### **Nelson-Atkins Museum of Art**

www.nelson-atkins.org/

This Kansas City museum includes a sculpture park with works by many modern masters. Don't miss *Shuttlecocks*, four larger-than-life sculptures of badminton "birdies."

#### Oakland Museum of Art

www.museumca.org/

Check out past, present, and upcoming exhibitions such as What is Art For? and Women of Taste: A Collaboration Celebrating Quilt Artists and Chefs.

#### Picasso Museum

www.musexpo.com/english/picasso/index.html Tour the Paris museum dedicated to Pablo Picasso.

#### **Pueblo Cultural Center**

www.indianpueblo.org/

Visit the eight Northern Pueblos in New Mexico to compare cultural traditions specific to each pueblo. See twelve outstanding artworks (with explanations) completed for the Mural Project.

#### **Richard Haas**

www.richardhaas.com/introfra.html

Experience the work of this artist while you visit his official Website.

#### Rock and Roll Hall of Fame and Museum

www.rockhall.com/

Take a virtual tour of the Museum or read the latest rock news.

#### **Roy Lichtenstein Foundation**

www.lichtensteinfoundation.org/

Browse through this site to learn more about the artist's paintings, sculpture, and drawings, along with ongoing exhibitions, publications and photographs.

#### Save Outdoor Sculpture! (SOS!)

www.heritagepreservation.org

Save Outdoor Sculpture! is a collaborative effort to document, repair, and preserve public monuments and outdoor sculpture in the United States. Inventories on the site detail public art from every state being preserved. There are also interactive activities for students and teachers.

#### **Studio Diana Bryer**

www.dianabryer.com

Visit the artist's Website that features images from her books and posters.

#### **Sydney Opera House**

www.soh.nsw.gov.au/

View Australia's international cultural landmark designed for its harbor setting. Explore *The Past* for planning and construction details.

#### **Teaching About Architecture and Art**

www.artsednet.getty.edu/ArtsEdNet/Resources/Maps/ Sites/index.html

World cultural heritage places are featured in detail on this site, including Trajan's Forum, Rome; Pueblo Bonito, Chaco Canyon, New Mexico; Great Mosque, Djenné; Katsura Villa, Kyoto; and the Sydney Opera House.

#### The Art Gallery of New South Wales

www.artgallery.nsw.gov.au/about/index.html
The Collection of Aboriginal Art and Torres Strait
Islander Art, the largest collection of the Art Gallery of
New South Wales' collections in Australia, includes a
wide range of artworks from historic bark paintings to
contemporary sculptures.

#### The Bayeux Tapestry: The Battle of Hastings 1066

http://battle1066.com/index.html

This site documents an important artwork that has survived from the eleventh century. Individual highlights and the complete tapestry are included. There is a section on tapestry construction.

#### The British Museum

www.british-museum.ac.uk/

The British Museum is particularly notable for its collection that includes the Greek world from the beginning of the Bronze Age, Italy and Rome from the Bronze Age; and the whole of the Roman Empire except Britain under the Edict of Milan (AD 313). You can visit the Egyptian Antiquities department; this site includes extensive information and images.

Also at the British Museum: *Cracking Codes: The Rosetta Stone and Decipherment*. The Rosetta Stone is the remains of a stele in three scripts; hieroglyphic, a cursive form of ancient Egyptian, and ancient Greek. The Stone is a cultural icon of script and decipherment, and is one of the most sought-after displays at the British Museum.

#### The Civilized Explorer: Art on the Internet

www.cieux.com/Arthome.html

This is worth a visit simply for the annotated listing of fascinating Web sites that originate outside the United States—but there is much, much more, including experimental sites, galleries, and museums. Have fun!

#### The Electric Franklin

www.ushistory.org/franklin/index.htm
Browse for resources, interactive games, a time line, and streaming videos about Benjamin Franklin. See
Franklin's print shop, artworks, and other artifacts at Franklin Court.

#### The Labyrinth: Resources for Medieval Studies

www.georgetown.edu/labyrinth/

Everything medieval is here, including manuscripts, music, mythology, maps, fonts that recreate medieval handwriting, a virtual tour of a medieval city, and more.

#### The Metropolitan Museum of Art

www.metmuseum.org

The world-renowned Metropolitan Museum of Art houses a collection of over three million objects. The site is an excellent one to explore, especially for the Museum's Egyptian and Byzantium collections. A time line of museum objects, highlighted by thumbnail images, is particularly useful.

#### The Periodic Table of Comic Books

www.uky.edu/~holler/periodic/periodic.html This clever table of periodic elements links each element to comic book pages involving that element.

#### The Photography of Lewis Hine

www.ibiscom.com/hnintro.htm View photos of miners, mill workers, and newsboys taken by Lewis Hine while investigating child labor practices. Includes some of Hine's field notes.

#### The Saint Louis Art Museum

www.slam.org/

This beautifully designed site has examples of works from the collections, plus information about the current Featured Exhibition.

#### The Unicorn in Captivity

www.metmuseum.org/collections/department.asp?dep=7 www.met.org

Visit the Cloisters at the Metropolitan Museum of Art, home of the *Hunt of the Unicorn* tapestry.

#### The Victoria and Albert Museum, London

www.vam.ac.uk/

Explore the Victoria and Albert Museum in London, the world's finest museum of the decorative arts. Founded in 1852, the Museum's vast collections include sculpture, furniture, fashion and textiles, paintings, silver, glass, ceramics, jewelry, books, prints and photographs.

#### The Web of Life: The Art of John Biggers

www.artsednet.getty.edu/ArtsEdNet/Resources/Biggers/index.html

An online exhibition and discussion that includes images, lessons, and other curriculum resources.

#### **Uffizi Gallery**

www.uffizi.firenze.it/welcomeE.html
Take a virtual tour of the Uffitzi Gallery in Florence,
Italy. Enter the gallery and click on the floor maps to
discover which artworks are in each room.

#### **UNESCO World Heritage List**

www.its.caltech.edu/~salmon/world.heritage.html Visit more than 500 sites which have been designated as deserving of protection and preservation.

## University of British Columbia Museum of Anthropology

www.voice.ca/tourism/moa/anthrop.htm
Art and artifacts in the Museum of Anthropology illustrate the achievements of the First Peoples of the Northwest Coast.

#### Vietnam Veteran's Memorial Homepage

www.nps.gov/vive/index2.htm Learn more about the three Vietnam veterans' memorials in Washington, D.C.

#### WebMuseum, Paris

www.oir.ucf.edu/wm/

This site delivers more than ten million documents, with special focus on artist biographies, works of art, and art history concepts.

#### **Winsor & Newton**

www.winsornewton.com/

Visit the site of a major manufacturer of artist materials, the inventor of the world's first moist watercolor pan. Take an online factory tour and browse an encyclopedia of hints, tips, and techniques for using pastels and watercolor, acrylic, and oil paints.

#### **World Art Treasures**

http://sgwww.epfl.ch/BERGER/ Browse a significant collection of images and themebased "itineraries" that concentrate on art history, art criticism, and aesthetics.

# **National Visual Arts Standards**

**1. Content Standard:** Understanding and applying media, techniques, and processes

#### **Achievement Standard:**

- **a.** Students select media, techniques, and processes; analyze what makes them effective or not effective in communicating ideas; and reflect upon the effectiveness of their choices.
- **b.** Students intentionally take advantage of the qualities and characteristics of art media, techniques, and processes to enhance communication of their experiences and ideas.
- **2. Content Standard:** Using knowledge of structures and functions

#### **Achievement Standard:**

- **a.** Students generalize about the effects of visual structures and functions.
- **b.** Students employ organizational structures and analyze what makes them effective or not effective in the communication of ideas.
- **c.** Students select and use the qualities of structures and function of art to improve communication of their ideas.
- **3. Content Standard:** Choosing and evaluating a range of subject matter, symbols, and ideas

#### **Achievement Standard:**

- **a.** Students integrate visual, spatial, and temporal concepts with content to communicate intended meaning in their artworks.
- **b.** Students use subjects, themes, and symbols that demonstrate knowledge of contexts, values, and aesthetics that communicate intended meaning in artworks.
- **4. Content Standard:** Understanding the visual arts in relation to history and cultures

#### **Achievement Standard:**

- **a.** Students know and compare the characteristics of artworks in various eras and cultures.
- **b.** Students describe and place a variety of art objects in historical and cultural contexts.
- **c.** Students analyze, describe, and demonstrate how factors of time and place (such as climate, resources, ideas, and technology) influence visual characteristics that give meaning and value to a work of art.

**5. Content Standard:** Reflecting upon and assessing the characteristics and merits of their work and the work of others

#### **Achievement Standard:**

- **a.** Students compare multiple purposes for creating works of art.
- **b.** Students analyze contemporary and historic meanings in specific artworks through cultural and aesthetic inquiry.
- **c.** Students describe and compare a variety of individual responses to their own artworks and to artworks from various eras and cultures.
- **6. Content Standard:** Making connections between visual arts and other disciplines

#### **Achievement Standard:**

- **a.** Students compare the characteristics of works in two or more art forms that share similar subject matter, historical periods, or cultural context.
- **b.** Students describe ways in which the principles and subject matter of other disciplines taught in the school are interrelated with the visual arts.

# **Professional Articles**

### **Portfolios and Displays**

**portfolio** 1: a flat portable case (as a briefcase, a large heavy envelope, or a loose-leaf binder) for carrying papers or drawings. <sup>1</sup>

Explain to students how professional artists, designers, and artisans utilize portfolios. Portfolios contain a select representation of an artist's best work. Artists show the art in their portfolios to gallery owners with the hope of having their work displayed. Graphic artists and interior decorators encourage clients to preview the art in their portfolios to facilitate an understanding of their style. Even floor tile installers display portfolios featuring photographs of their past projects.

Similarly, students who are planning a career in art or design will wish to collect their best work in a portfolio to show to university or art school admissions staff. They may wish to use their artwork from this course as a basis for assembling such a portfolio.

There are further reasons for all students to create portfolios as the semester progresses. Assessment (both by the teacher and self-assessment) is a key component of learning and in an art curriculum, the portfolio is integral to assessment. For an understanding of portfolios and their use as assessment tools, read Portfolios on the next page.

#### **Portfolios**

As each chapter is completed, students add to their course portfolio by saving their most successful work. Sculpture or other three-dimensional work can be photographed and the slide or print included in the portfolio.

At the close of the semester, students can choose their best work for inclusion in a final portfolio and/or art show

- Students may make their portfolio from two pieces of posterboard hinged together with tape.
- In their portfolio, students should include artwork that is representative of the categories discussed in the text.

- Unless their work is on heavy board, it should be matted or mounted to preserve it. Students may also produce slide portfolios of their works.
- A placeholder can be made for any artwork that is currently on display and therefore not included in the student's portfolio. Information can be written on a piece of paper, including the chapter or project, medium, and title of work. When the display is dismantled, the work should be returned to the portfolio.

The following materials will be needed for student portfolios.

- · student work
- · heavy paper or posterboard
- tape

#### **Displays**

The following materials will be needed for displaying student work.

- · matting or mounting board
- standards
- tape
- utility knives
- straightedges

To display student art, you will need standards (structures built for or serving as a base of support for three-dimensional art), easels, bulletin boards, or walls on which art may be taped or hung. Display standards may be made from large cardboard boxes which are either painted or covered with craft paper.

Labels for each student's work may be made using a computer. In addition to the student's name, these may include their age, title of artwork, medium, and name of art course. If you group the projects together by assignment, include a card that briefly describes the assignment.

<sup>1</sup>Webster's Third New International Dictionary, Springfield, MA: G. & C. Merriam Co., 1981.

### **Portfolios**

Excerpted from Assessment in Art Education by Donna Kay Beattie

In the past, the student art portfolio was viewed as a container for, or collection of, student artworks or products. More recently, as the art portfolio is increasingly used as a means of understanding and revealing processes, its definition has expanded to include a "purposeful collection of student work that tells the story of the student's efforts, progress, or achievement in (a) given area(s)".1

Whether referred to generally as the "art portfolio," or more specifically as the "process folio," "mini-portfolio,"<sup>2</sup> and "best-works portfolio,"<sup>3</sup> the portfolio as used in the art classroom today emphasizes significant evidence about the progress, achievements, and experiences of the student. The art portfolio, in its expanded definition, can replace other types of assessments and function as a teaching tool as well in that it motivates and challenges students, promotes learning through reflection and self-assessment, encourages studentteacher collaborations, validates different learning styles and approaches, and encourages the research, resolution, and communication of ideas. The art portfolio underscores to both students and parents the importance of growth and development. Finally, the portfolio provides an important tool for evaluating the curriculum and determining necessary changes.

#### Terms to Know

best-works portfolio Includes only students' best work, accumulated over a specified time period. expanded art portfolio A thick base of information representing rich qualitative and ample quantitative evidence pertaining to a wide variety of thinking processes and art products.

mini-portfolio An abbreviated portfolio that focuses on a collection of art products based on a single theme, project, or artistic activity; a collection of evidence derived from a holistic task that addresses each of the four art disciplines; or a single unit of study. Several mini-portfolios can serve as the basis for a larger portfolio.

**process folio** A portfolio of evidence about student growth and learning, with an emphasis on process.

#### **Evidence**

The earmark of a good art portfolio is its depth, regardless of the amount of time it spans. To be used as a performance assessment tool, the art portfolio should:

- specify the goals of the school, program, or student in a letter of introduction by the student.
- reveal evidence about learning in the four disciplines including knowledge of content, processes, conditions (or why certain processes are more appropriate), metacognition, art motor skills, and values, attitudes, and interests.
- reveal three kinds of physical evidence: primary, secondary, and extrinsic.<sup>4</sup>
- reveal a complete picture of and relate to specific goals of the art curriculum, a unit of study, or a specific discipline area.
- show progress over time.
- show significant achievements. A "best piece" can be specified with a note of explanation.
- reveal learning difficulties.
- reveal what is significant to the student.
- involve the student in the process of selection, reflection, and justification.
- include didactic information, (i.e., materials annotated by the student and/or teacher to include dates, explanations relating evidence to assignments and objectives, and reasons for inclusion).
- reflect adherence to performance standards.

In addition to such evidence, the art portfolio might also include a table of contents or outline of portfolio organization, a timeline of due dates for required entries, an exit letter describing major entries and reflection on learning outcomes, and a skills chart in which students indicate skills emphasized in specific entries or in the entire portfolio. A scoring rubric describing performance criteria and qualifying standards can be included in the portfolio. A statement explaining how performance standards are translated into exit levels of achievement might also be added to the portfolio. The Student Checklist for Portfolio Evidence shows a sample checklist of evidence the art educator might require for student portfolios.

#### **Evaluation**

Because of their breadth, depth of content, and amenability to diverse reviewing and assessing techniques, portfolios offer a wealth of multi-layered information about student learning. Portfolios reveal students in both maximum and typical performance postures and, for this reason, serve in both summative and formative assessment roles.

Three scoring approaches are applicable to portfolio evaluation: holistic, analytic, and modified holistic. The teacher might use the holistic approach to score the portfolio if he or she is not interested in the separate entries but in the portfolio as a single example of student performance—or, if time does not permit separate scoring of key individual entries. If the portfolio is a summative examination of students' abilities to produce a body of work on their own based on a theme, or is a mini-portfolio focusing on a unit of study, then the holistic approach is also appropriate.

A holistic approach judges, rates, or scores the entire portfolio as a single corpus of information. The following assessment criteria can be used to score the art portfolio holistically.

#### Researching:

- selection and development of themes, problems, issues, techniques, and processes through study, research, or exploration
- variety of appropriate sources

#### Creating:

- personalized and expressive approach to the area of study (i.e., art history, criticism, aesthetics, or art production)
- · conceptual importance
- intellectual and creative curiosity driving art study and work
- demonstration of knowledge and skills pertaining to visual language, structures, forms, and vocabulary Responding:
- responsiveness to personal, social, cultural, historical, philosophical, technological, environmental, economic, and aesthetic contexts and stimuli in the area of study
- demonstration of description, classification, analysis, interpretation, and judgment of information and art images
- responsiveness to feedback
- depth of revision

#### Resolving:

- personalized and expressive solutions to problems or tasks in area of study
- completeness of collection (depth and breadth of entries)
- achievement of predetermined goals and objectives (student's, teacher's, school's)
- improvement from past performances

#### Communicating:

- presentation
- · demonstration of self-reflection and self-assessment
- connection to other content areas and to daily life

### Student Checklist for Portfolio Evidence Please place a check beside all evidence that you have included in your portfolio. 1 Include in your portfolio two letters to the teacher. introductory letter explaining your portfolio, your main purpose for creating it, and your goals pertaining to it exit letter describing major entries and reflecting on your learning outcomes in modes of thinking related to the artist, art historian, critic, and aesthetician 2 Include a Table of Contents or outline of the organization of the portfolio. Table of Contents 3 Include in your portfolio all materials that relate to solving your assigned problem(s). notes on the way you think about the problem, your interpretation of it, and how your thinking has changed "brainstorming" ideas for solving the problem research materials and sources that helped you solve the problem(s) or gave you insights or hints about what direction to pursue notes on the way you solve problems (i.e., your personal artistic problem-solving process) sketches, studies, or rough drafts that helped you practice and/or determine the solution(s) to the problem(s) 4 Include in your portfolio your final product(s) and specific materials that relate to it. final product(s) or visual evidence of it brief self-evaluation statement and judgment or scoring of the process that you went through to arrive at the final work piece(s) ☐ brief self-evaluation statement and judgment or scoring of the final work piece(s) brief argument (oral or written form), supporting your judgment of your portfolio. Your argument should take into account the total situation and the above-stated guidelines. Present

your main points clearly and include reasons and

brief description of your commitment and

rebuttals for anticipated challenges.

attitude toward creating the portfolio

When the portfolio is perceived as a repository of different types of knowledge, each requiring its own mark, then an analytic scoring approach is preferred. This approach evaluates and scores parts or characteristics of the product or process separately. For example, a teacher might give a separate score for the art history component, the art studio process, and the metacognitive skills of reflection. Each of the above-stated holistic criteria could be defined with degrees of quality, given a separate score, and then summed to obtain a single score. Cognitive processes, discipline-specific processes, and basic core skills also might be set up as criteria, examined, and rated.

The analytical scoring approach to portfolio evaluation need not exclude a holistic score. If the teacher wants discrete information about various areas of art learning, but also wants an overall or global score, then the modified holistic approach is best. A modified holistic scoring approach combines both scoring plans by scoring the whole first and then several major individual parts or attributes that support the global score. When combining both scoring plans, neither the holistic nor the analytic component is usually as detailed or comprehensive as each is when used independently.

Whatever approach art educators choose, portfolio evaluation utilizes a variety of assessment and scoring and judging strategies, such as checklists; rating scales; questionnaires; teacher, peer, parent, and other interviews; and student self-assessments. Different types of assessment strategies yield different kinds and levels of information. Assessment strategies, along with performance criteria and judging or scoring strategies, should be clearly understood by all involved. Ideally, evaluation should provide supportive information for judgments made by the art educator and enable the art educator to make needed changes in teaching and instruction. Evaluation should be documented in progress charts.

#### Interpretation

When the portfolio has been evaluated, the results need to be interpreted. Beyond a score or grade, the teacher determines what the portfolio really says about student learning, as individuals and as a class; the effectiveness of the curriculum; and the learning environment. The portfolio helps teachers address crucial questions about these three topics.

For a more meaningful interpretation of the portfolio, teachers might want to consider the following:

- To what extent have students' needs been met?
- What new needs have emerged for the students?
- Where will students go from here?

- What do the portfolios say about the classroom context? The learning environment? The art curriculum?
- What other kinds of information are revealed? Unexpected information?
- What evidence should be retained? What evidence might go to the next teacher?

#### Assessment hint

After answering these questions, write a summary or, even better, a personal letter to the student that describes what you discovered. The summary or personal letter can be placed in the student's portfolio.

#### Management

One of the most crucial issues the art teacher faces is managing the portfolios. Start by thinking about the design of the portfolio container. Will the portfolio container be large folded or stapled sheets of cardboard? A box? The computer?

What about storage? Where the portfolios will be stored is a major consideration (and problem) for the art educator. For storing large portfolios, consider cupboards or shelving accessible to students. If the portfolio will be used to examine students' abilities to produce a body of work independently within a specified time period, or, if it contains secondary evidence such as the teacher's observation notes, logs, evaluative reports, quizzes, assessment formats, or report cards, then security is crucial, and such portfolios would need to be kept in locked spaces.

How and when will the portfolio be integrated with instruction? How will portfolios be managed and monitored in a classroom setting? How will portfolios be shared? Classroom time should be periodically set aside for students and teachers to organize and work on the emerging portfolios. Blocks of time are also required for reviewing and evaluating portfolios. Moreover, the art educator needs time to develop, implement, monitor, and make changes and revisions in the entire portfolio management system. Finally, procedures for sharing portfolios with parents, other teachers, other students, and other stakeholders also need to be planned and executed.

Certainly, the art teacher of 700 students will have to create a portfolio style and management system that accommodates so many children. The portfolio may be conceived differently, as a smaller corpus of information—a mini-portfolio.

#### The Mini-Portfolio

The mini-portfolio can be likened to a thick file containing all manner of materials relating to the file's label. An easy way for students to organize their art learning, the mini-portfolio sorts the art curriculum into bite-size chunks. Because of its brevity and documentary nature, the mini-portfolio can be used to collect evidence representing each of the four art disciplines as demonstrated in a single integrated task or a unit of study.

The mini-portfolio might be a collection of art products, with supporting procedural evidence and materials, based on a theme or an art activity. As such, the mini-portfolio might be used to assess how well students can set a personal theme and develop a body of work independent of the teacher or in some degree of collaboration with the teacher. The smaller portfolio could also be used to examine skills and processes specific to one particular unit of study. For the elementary teacher of art whose curricula may be organized around many units of study, the mini-portfolio works well for documenting each unit.

The mini-portfolio maintains characteristics of the expanded portfolio in that it contains all significant evidence of a performance, performance criteria and a scoring rubric, skills chart, places to enter grades or marks, and a progress chart. Yet, it remains manageable and relatively simple to monitor. The mini-portfolio is simple to create, using lightweight tag board or construction paper, and is easily stored. Using the mini-portfolio enables students to take less significant work home dur-

ing the course or school year, while retaining in the school setting benchmark works in each discipline to serve as the basis of a best-works portfolio. Finally, the mini-portfolio can be assessed and scored using holistic, analytic, or modified holistic scoring approaches.

#### Notes

<sup>1</sup>J.A. Arter, "Portfolios in Practice: What Is a Portfolio?" (paper presented at the annual meeting of the American Educational Research Association, San Francisco, CA, April 1992) ERIC, ED 346156.

<sup>2</sup>D.K. Beattie, "The Mini-Portfolio: Locus of a Successful Performance Examination," Art Education 42: no. 2 (1994): pp. 14–18.

<sup>3</sup>A.J. Nitko, *Educational Assessment of Students*, 2d ed. (Englewood Cliffs, NJ: Charles E. Merrill Publishing Co., 1996).

<sup>4</sup>H.G. Mackintosh, "The Use of Portfolios in School-Based Assessment: Some Issues" (paper presented at the nineteenth annual conference of the International Association for Educational Assessment, Reduit, Mauritius, 1993).

This excerpt is reprinted from:

Beattie, Donna Kaye. Assessment in Art Education. Art Education in Practice Series, ed. Marilyn G. Stewart. Worcester, MA: Davis Publications, Inc., 1997.

# **Notes**